About the Author

ANTON GILL is the author of more than twenty-four books and plays, including *The Journey Back from Hell: Conversations with Concentration Camp Survivors* (William Morrow), which won the H. H. Wingate Award for nonfiction in 1988. He has worked as an assistant director of the English Stage Company, as a senior producer for BBC radio and television, and as drama officer for the Arts Council of Great Britain.

art | lover

art lover

A Biography of | Peggy Guggenheim

Anton Gill

Perennial

An Imprint of HarperCollins*Publishers*

First published in the United Kingdom in 2001 by HarperCollins Publishers.

A hardcover edition of this book was published in 2002 by HarperCollins Publishers.

First Perennial edition published 2003.

Designed by Joseph Rutt

The Library of Congress has catalogued the hardcover edition as follows:

Gill, Anton.
 Art lover : a biography of Peggy Guggenheim / Anton Gill.—1st ed.
 p. cm.
 Includes bibliographical references and index.
 ISBN 0-06-019697-1
 1. Guggenheim, Peggy, 1898–. 2. Art collectors—United States—Biography. 3. Art collectors—Europe—Biography. I. Title.

 N5220.G886 G55 2002
 709'.2—dc21
[B] 2001051731

 ISBN 0-06-095681-X (pbk.)

HB 06.06.2023

To Marji Campi (who started all this),
with admiration, gratitude, and love

London, New York, Paris, Venice, 1997–2001

contents

Illustrations follow pages 112, 208, and 336.

f a m i l y

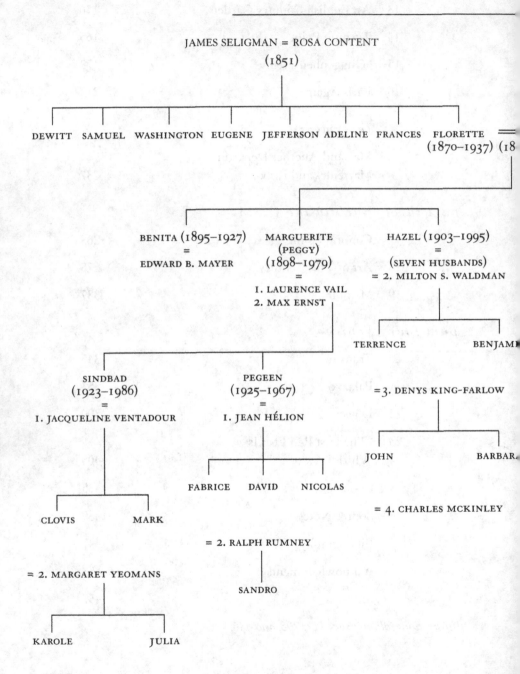

JAMES SELIGMAN = ROSA CONTENT
(1851)

DEWITT SAMUEL WASHINGTON EUGENE JEFFERSON ADELINE FRANCES FLORETTE ==
 (1870–1937) (18

BENITA (1895–1927) MARGUERITE HAZEL (1903–1995)
= (PEGGY) =
EDWARD B. MAYER (1898–1979) (SEVEN HUSBANDS)
= = 2. MILTON S. WALDMAN
1. LAURENCE VAIL
2. MAX ERNST

TERRENCE BENJAMI

SINDBAD PEGEEN = 3. DENYS KING-FARLOW
(1923–1986) (1925–1967)
= =
1. JACQUELINE VENTADOUR 1. JEAN HÉLION
JOHN BARBAR

FABRICE DAVID NICOLAS

CLOVIS MARK = 4. CHARLES MCKINLEY

= 2. RALPH RUMNEY

= 2. MARGARET YEOMANS

SANDRO

KAROLE JULIA

tree

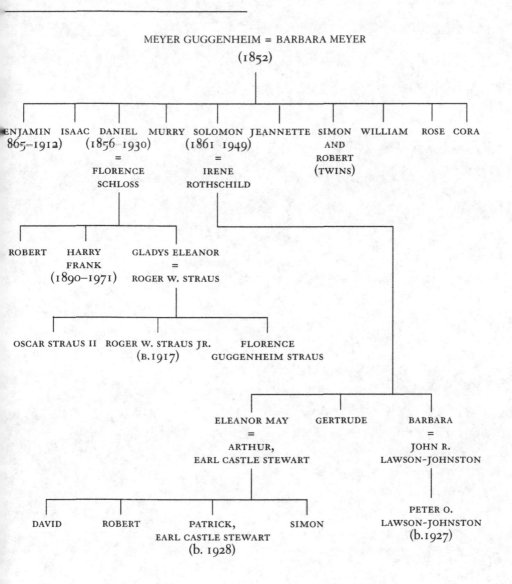

MEYER GUGGENHEIM = BARBARA MEYER
(1852)

BENJAMIN ISAAC DANIEL MURRY SOLOMON JEANNETTE SIMON WILLIAM ROSE CORA
(1865-1912) (1856 1930) (1861 1949) AND
= = ROBERT
FLORENCE IRENE (TWINS)
SCHLOSS ROTHSCHILD

ROBERT HARRY GLADYS ELEANOR
FRANK =
(1890-1971) ROGER W. STRAUS

OSCAR STRAUS II ROGER W. STRAUS JR. FLORENCE
(B.1917) GUGGENHEIM STRAUS

ELEANOR MAY GERTRUDE BARBARA
= =
ARTHUR, JOHN R.
EARL CASTLE STEWART LAWSON-JOHNSTON

DAVID ROBERT PATRICK, SIMON PETER O.
EARL CASTLE STEWART LAWSON-JOHNSTON
(b. 1928) (b.1927)

preface

This book draws on material derived from private and public archives and collections, published works, unpublished works, letters, diaries, interviews, gossip, e-mails, telephone conversations, videotapes, faxes, Web sites, and so on. Despite the fact that the subject is recent, a number of discrepancies have cropped up in the spelling of proper names. Where that has happened, I have used the version most commonly used by others.

I have not tampered with usage, grammar, or spelling in direct quotations from original material such as letters, though I have tidied up typographical errors—for many years Peggy Guggenheim used an ancient typewriter with a faded blue ribbon, and her typing was not accurate. I have left eccentricities of spelling alone (Peggy habitually spelled *thought* "thot," and *bought* "bot"), and have provided an explanation only if the level of obscurity seemed great enough to warrant one.

Titles of artworks in Peggy's collection are generally the same as those used by Angelica Z. Rudenstine in her catalog of the Peggy Guggenheim Collection. Other paintings and sculptures are given the names by which they're most commonly known.

I'd like to express my thanks here at the outset to all who helped. A lot of people had profound personal contact with Peggy, and shared their memories of her with me generously. I am most grateful to them—their names are

in the acknowledgments at the end of the book. I have had to be selective in the use of some tangential detail for reasons of both focus and of space. Readers interested in further exploration of the background to this book are referred to the bibliography. Inevitably what I have written will lead to a certain amount of disagreement. Some of the material conflicted, and some was clogged with gossip and rumor. I can only say that to the best of my ability I have checked for correctness all the matter I have used, and that I have tried to keep speculation to a minimum. I thank Marji Campi, Barbara Shukman, and Karole Vail for looking over the manuscript, but I alone am accountable for any errors in this record of the life of a complex, anarchic, remarkable woman.

introduction

A Party

> Her obduracy in contention and her warmth in friendship, her
> generosity and her stinginess, her plunges into gloom and
> wholehearted abandonment to laughter, her puritan streak
> and her reckless addiction to the erotic were all contradictions
> of the essence of her personality.
>
> MAURICE CARDIFF,
> *Friends Abroad*

The rain, which had not stopped for a week, ceased in the late afternoon of September 29, 1998, so that by the evening the flagstones in the garden were dry. The heat and the humidity relented too, so that as the crowd gathered the atmosphere and the temperature were perfect.

The garden was that of the Palazzo Venier dei Leoni, an eighteenth-century pile in Dorsoduro, on the Accademia bank of the Grand Canal in Venice, between the Accademia Bridge and Santa Maria della Salute, close to where the Grand Canal debouches into the Canale di San Marco. The palazzo is exotic. It was never finished. It has only a sub-basement and one story, with a flat roof that doubles as a terrace; but the garden is one of the largest in Venice. The trees are huge. When Peggy Guggenheim owned and lived in the palace, the garden was muddy and overgrown, and the sculptures planted in it—the bronze trolls of Max Ernst; the minimalist, organic

forms of Arp and Brancusi—inhabited it as mysterious beings might lurk in a wood, waiting for the traveler to come upon them unaware.

Several hundred guests were gathering that Tuesday evening twenty years after her death in a more manicured space: neatly flagstoned and graveled, with the sculptures openly displayed. Not all the sculptures still belong to the art collection Peggy Guggenheim brought here in the late 1940s. Many are now part of the collection of the Texan collectors Patsy and Raymond Nasher.

The crowd has assembled in the electrically lit, mosquito-free night. The garden is full. Dress ranges from superelegant to T-shirt and jeans, but everyone is stylish. *Le tout Venise* is here to mark the opening of an exhibition commemorating the centenary of Peggy's birth. Organized by one of her granddaughters, the exhibition has come here from New York, where it opened at the Solomon R. Guggenheim Museum. Solomon was Peggy's uncle, though their two art collections were separate entities during most of her lifetime. The granddaughter, Karole Vail, is the only Guggenheim grandchild to work for the Solomon R. Guggenheim Museum. She is among the guests, in a Fortuny dress, elegantly echoing the Fortuny dresses Peggy often wore. Her sister, Julia, and her cousins are there too—six of the seven surviving grandchildren. Mark has not come. Fabrice died in 1990.

Philip Rylands is the curator of the Peggy Guggenheim Collection. He has been in charge since the palazzo became a public gallery in 1980. Philip is English, and originally came to Venice from Cambridge University to research a doctoral thesis on Jacopo Palma il Vecchio. He makes a speech in impeccable Italian. During it, as the light through the trees throws changing shadows on the people below, Mia, Julia's daughter, the only one of Peggy's great-grandchildren present, twenty-one months old, clambers onto *Untitled* (1969) by Robert Morris—a huge rectangle of steel balanced on a massive section of steel doweling, stretched horizontally on the ground. Mia runs up and down. Her activity turns a few heads.

After two hours people have begun to filter away, and in another hour the garden will be empty. In a corner a stone slab set into a wall marks the resting places of Peggy's "beloved babies"—fourteen little dogs, until almost the end all purebred Lhasa apsos, which in a series of generations shared Peggy's life in the palace. Next to it is another plaque. On it is written: "Here rests Peggy Guggenheim 1898–1979."

* * *

The party in 1998 filled the garden. Eighteen years earlier, on April 4, 1980, only four people had been present for the interment of Peggy's ashes. She had died an isolated death just before Christmas the previous year.

Although Peggy's claim to fame is as one of the foremost collectors of modern art of the first half of the twentieth century, her "offstage" life as a restless combination of wanderer and libertine has attracted so much gossip, obloquy, scandal, and delight that it has overshadowed her influence as a patron of painters and sculptors. When she was at the peak of her career, feminism was in its infancy and, apart from the woman suffrage movement, not organized on any major scale. Men took it for granted that they had precedence over women, and it would be hard to find a more sexist bunch than the male artists who flourished between 1900 and 1960. Peggy took on their world with a mixture of low self-esteem and aggression, aided by money. She couldn't enter that world as an artist—a difficult task for any woman at the time—but she could use her money to buy a position in it. In her endeavors she never quite found herself, but she supported three of the most important art movements of the last hundred years: cubism, surrealism, and abstract expressionism.

It took Peggy some time to come to modern art. She was twenty before she held a contemporary painting in her hands, at the photographer Alfred Stieglitz's boundary-breaking 291 Gallery in New York City—a picture by Stieglitz's wife-to-be, Georgia O'Keeffe. If she was flirting with bohemia as early as that—the introduction to Stieglitz stemmed from work in a cousin's avant-garde bookshop—it would be another twenty years, one husband, and many lovers later before she started work on her own account.

At twenty-one Peggy came into the first slice of what was a relatively slender fortune. In the years following World War I, Europe beckoned young Americans, and Peggy, used to childhood holidays on the Continent, and for other reasons too, was among the first to go. There she plunged into the world to which she was to belong for the rest of her life, and in which she was to be a star.

World War II forced her, as a Jew, to retreat to the United States. There, in New York, she created a gallery the like of which had not been seen anywhere before, and through it and the salons—if such a word can be applied to the whiskey-and-potato-chips parties she held—in her house overlooking

the East River on East Fifty-first Street, she created a forum where young American artists could meet and confront the old guard of European modern art in exile.

The war over, and another marriage unhappily over too, she returned to Europe and made her home in Venice. It was there that she set about the task of consolidating her collection. She'd been a flapper, she'd been a profligate, she'd been a Maecenas, she'd been a wife, she hadn't been much of a mother. Now it was time to become a grande dame. Inside there had always been an inquisitive and lively girl who had never been able to find love.

When I first visited the Peggy Guggenheim Collection I was struck by the refreshing contrast to the splendors of Renaissance and baroque art in which Venice is so rich. It was a palate cleanser after which one could return happily to the glories of the Scuola San Rocco or the Frari. Peggy herself, hesitating to name any picture in her own collection as her favorite, did have a favorite painting: *The Storm* by Giorgione (c. 1505), in the Accademia, a stone's throw from her palazzo. She once said she would swap her entire collection for it.

The *festa* to mark her one-hundredth birthday would have amused Peggy by its contrast to her lonely departure from this world, and it would have touched her that so many people were there. She would also have been appalled at the expense.

Later that evening it began to rain again.

part one

Youth

I was born in New York City on West Sixty-Ninth Street. I don't remember anything about this. My mother told me that while the nurse was filling her hot water bottle, I rushed into the world with my usual speed and screamed like a cat.

PEGGY GUGGENHEIM,
Out of This Century (1979)

one

Shipwreck

*T*hings had been going badly for Benjamin Guggenheim for a long time. The fact that his marriage was falling apart was something he'd gotten used to a while back; and, as he admitted to himself, there had been ample consolation—though through it all a nagging lack of satisfaction—for the rapid cooling of his relationship with his wife. The business was another matter. He'd left the family firm eleven years earlier, in 1901, full of injured dignity at what he saw as the high-handed attitude of most of his brothers, determined to go it alone and show them: After all, the expertise he'd picked up in mining and engineering should have stood him in good stead. And, to be fair, it had. Wasn't his International Steam Pump Company responsible for the elevators that now ran all the way to the top of the Eiffel Tower? And Paris hadn't been a bad alternative, this past decade, to a loveless, even inimical, New York. If it weren't for his daughters, Benita, Peggy, and Hazel, the three unlikely products of his and Florette's rare moments of passion (informed by duty) over the first eight years of their union, he might well have cut loose altogether.

But the business was going downhill, and he could see no way of turning it around. He'd never been a businessman, any more than he'd been an enthusiastic student—though the family never failed to remind him that he was the first of the first-generation American Guggenheims to go to a university. The

failure of his business was worse than the failure of his marriage. Excluded from the family concern, how could he ignore the vast strides that it had made since he'd left at the turn of the century, drawing a modest $250,000 a year from his then-existing interests? Now, in April 1912, he'd decided to return to the States. It would be Hazel's ninth birthday on the thirtieth. He'd be home for that. And he might drum up some extra capital once home, too, though asking his brothers for a loan would be a long shot, and his wife's money was too tied up for him to reach, even if he'd had the courage to ask for it. At least no one in the family but himself knew how bad things were. Mismanaged capital, shaky investments, and an extravagant lifestyle were to blame.

He'd married Florette on October 24, 1894. She was twenty-four, he was twenty-nine. He'd played the field beforehand, and he was handsome enough to have attracted a better-looking partner; but she was a Seligman, and therefore, though her family looked down on his, a real catch. The Seligmans didn't have the kind of money the Guggenheims had, but they had the New York *cachet* the Guggenheims needed, and at that time Ben was still a paid-up member of the family.

Since the birth of his youngest daughter, Ben had spent more and more time in France, looking after his business interests and several mistresses. He'd hardly seen his children in the past year, and not at all in the last eight months, though a letter survives from him to Hazel, written from Paris in early April 1911, which testifies to the affection he had for them. It also indicates that he wanted to see his wife again, though its tone is more dutiful than sincere:

> *Have just received your letter, am sorry it takes so long for the doll to get through the custom house but when he does reach you I am sure you will like him. We had quite a lot of snow and cold weather yesterday so you see that even in Paris we sometimes are disappointed. However it is again pleasant today and I think we will soon see the leaves on the trees. Tell Peggy I have just rec'd her letter of the 30th Mch but as I just wrote her yesterday I shall not write again today. Tell her also I was very glad to receive this her [?]kind letter and hope that she and you will frequently find time to write me. I am writing Mummie asking if she wants me to rent a beautiful country place at Saint Cloud near Paris. If we take it she can invite Lucille and [?]Doby, and can remove there for July.*
>
> > *With much love from your*
> > *Papa*

He missed his children, especially the younger two, who adored him and were rivals for his affections. His oldest, Benita, named for him, was almost seventeen—already a young woman, self-possessed, a little cool, beautiful, unlike her mother, but showing signs of wanting nothing more than the moneyed, inactive life of bridge, tea parties, and gossip that Florette enjoyed. Ben was well aware that Florette regarded him as a loser. She had her own means, but she liked money, and she liked acquiring it more than spending it.

What a pity they hadn't produced a son. But that was something the Guggenheim clan was seldom capable of.

The closest Ben had to a son was his nephew Harry, one of the five boys the seven brothers had managed to produce to carry the family name forward—though Ben's sisters also had sons. Ben had had lunch with Harry in Paris on April 9, shortly before leaving for Cherbourg to board his ship for the States. Harry was a shade straitlaced already at twenty-two, but Ben talked to him about his business affairs, playing down his difficulties; Harry's father was Daniel, the most dominant, though by no means the richest, of Ben's brothers. Ben steered clear of personal observations. A few years earlier, when Harry was fourteen or fifteen, Ben had gotten into hot water by offering him this piece of advice: "Never make love to a woman before breakfast for two reasons. One, it's wearing. Two, in the course of the day you may meet somebody you like better."

Shortly before the meeting with Harry, Ben had a problem to deal with. The ship he was booked on, with his chauffeur, René Pernot, and his secretary-valet, Victor Giglio, was suddenly unable to sail, owing to an unofficial strike over pay by its stokers. Ben was one of a number of irritated passengers who were forced to find alternative berths, but after a number of wires to London, New York, and Southampton, luck appeared to favor him. He managed to get two first-class cabins, for his valet and himself, and a second-class berth for his chauffeur, on the White Star Line's new flagship, RMS *Titanic*, which was making its maiden voyage, stopping at Cherbourg on the evening of April 10, en route from Southampton to New York via the French port, and Queenstown (now Cobh) in Ireland. It wasn't cheap— the first-class cabins cost $1,520 each one way—but the ship was very fast, on the cutting edge of technology and, in first class at least, the last word in elegance. Ben, used to the good things in life even in adversity, was pleased that the switch had had to be made. And when he looked at the passenger list and saw in what august company he'd be traveling, he wondered whether the

manner of his crossing the Atlantic might send a message to his brothers that he was doing better than he actually was.

Ben was the fifth of seven brothers. Only William, the youngest, might have been sympathetic, but William had cut loose from the family firm at the same time as Ben, and while he shared Ben's love of the good life, he was a self-absorbed young man. Like Ben, he had become a "poor" Guggenheim. Each of the two brothers had given up a capital interest of $8 million when they'd left the business—something else Ben had kept secret from his wife.

Nevertheless, as he settled into his cabin on B deck, Ben could reflect that "poor" was a relative term. He still had plenty of money by most people's standards, and his older brothers, as far as he could see, had yet to make serious money themselves. In his forty-seventh year, Ben still had time to turn his fortunes around.

But it was not to be. We don't know where Ben was at 11:40 P.M. on the night of April 14, but the chances are that he had already retired to his cabin. Wherever he was, he would have felt the faint, grinding jar that came from the bowels of the ship at that moment. He may well have seen the iceberg as it glided past. But, like most on board, he did not feel any concern. After all, the *Titanic* was supposed to be unsinkable. Relying on this, and ignoring ice warnings that had come from other ships in the area throughout the day, the captain, Edward J. Smith, a veteran sailor making his last voyage before retirement, had continued to sail virtually at full speed. Egged on by J. Bruce Ismay, White Star's president, he was attempting to set a new transatlantic record.

At about midnight, by then joined by Giglio, Guggenheim was being helped into a life jacket by the steward in charge of that set of eight or nine cabins. Henry Samuel Etches urged Guggenheim, against the latter's protests, to pull a heavy sweater over the life jacket (few aboard, cocooned from the elements in the well-heated, brilliantly lit liner, had any idea of how cold the North Atlantic was), and sent him and his valet on deck. As first-class passengers, their places in lifeboats were assured. However, in the next hour or so, as confusion mounted and it became clear that women and children might be left aboard the sinking ship as the inadequate (and, in the event, woefully underfilled) lifeboats began to be cast off, Benjamin Guggenheim and Victor Giglio did a stylish and brave thing: They returned to their cabins, changed into evening dress, and then set about helping women and

children into the boats. Ben is reported to have said, "We've dressed in our best, and are prepared to go down like gentlemen."

The rest of the story may belong to the corpus of *Titanic* myth, but it's reasonable to believe some of the details of Ben's last moments. However, as neither Giglio nor the chauffeur, René Pernot, survived either, it is impossible to verify them. The first-class cabin steward, Etches, was ordered to take an oar in a lifeboat, and did survive. He subsequently made his way to the St. Regis Hotel in New York, where several members of the Guggenheim family had apartments, and asked to see Ben's wife, as he had been entrusted with a message from her husband. Florette, who already knew that Ben was missing, was too grief-stricken to see him; he was received by Daniel Guggenheim. The encounter was widely reported, but the fullest account of Etches's story appeared in the *New York Times* on 20 April:

> . . . I could see what they [Ben and Giglio] were doing. They were going from one lifeboat to another, helping the women and children. Mr. Guggenheim would shout out, "Women first," and he was of great assistance to the officers.
>
> Things weren't so bad at first, but when I saw Mr. Guggenheim and his secretary three-quarters of an hour after the crash there was great excitement. What surprised me was that both Mr. Guggenheim and his secretary were dressed in their evening clothes. They had deliberately taken off their sweaters, and as nearly as I can tell there were no lifebelts at all.

It is possible that Etches concocted a tale of heroism with an eye to a reward of some kind from the wealthy family; but in view of the fact that Ben and his valet were not the only men who went down with the ship rather than take what could have been seen as the cowardly expedient of getting into lifeboats, it seems unlikely. Other newspapers reported that among the prominent people on board, John Jacob Astor IV, of the Waldorf-Astoria Hotel; President Taft's military aide, Major Archibald Butt; and Isidore Straus of Macy's department store also helped others into the boats and thus sacrificed their own lives. Etches added that Ben had told him, "If anything should happen to me, tell my wife in New York that I've done my best in doing my duty," and that "No woman shall go to the bottom because I was a

coward." Significantly, Bruce Ismay, who did save himself, was profoundly affected from the moment he was taken aboard the rescue ship, *Carpathia*. As one chronicler of the disaster, Walter Lord, records in his book *A Night to Remember*: "During the rest of the trip Ismay never left [his] room; he never ate anything solid; he never received a visitor . . . he was kept to the end under the influence of opiates. It was the start of a self-imposed exile from active life. Within a year he retired from the White Star Line, purchased a large estate on the west coast of Ireland, and remained a virtual recluse until he died in 1937."

Ben's family was devastated by his loss. Strangely, eight hours *before* the *Titanic* struck the iceberg, Florette and her three daughters were returning home from the eighty-ninth birthday party given for Florette's father, James Seligman, when Benita's attention was drawn to a news vendor shouting, "Extra! Extra!" By some clairvoyance, she urged her mother to buy a paper, insisting that "something terrible must have happened to Poppa's boat," as Hazel later recounted to a Guggenheim family chronicler, John H. Davis.

Though there is no reason to disbelieve Etches's account, many apocryphal stories did grow up around the disaster. The newspapers had a field day, and this was not surprising. In the days before film, pop, and sports celebrities figured largely in the public consciousness, it was the rich, the great, and the good who filled these roles, and the *Titanic* had taken a fine crop of them to the bottom. There was another element too, which became apparent only months and even years later. The sinking of the unsinkable was a defeat of humankind by nature. Total and assured belief in technology foundered. The same year, Captain Robert Falcon Scott and his party died on their return journey from the South Pole: Their bodies were discovered in November, another blow to the world's self-confidence. World War I would soon decisively break down the old order.

In the rush to report the news of the sinking, various journalistic errors occurred. On 20 April the *Daily Graphic* brought out a commemorative edition focusing on the disaster, in which a photograph of Ben's younger brother Simon appeared over the caption, "Benjamin Guggenheim"—a further source of distress to the family. Etches is referred to as "James Johnson"—another steward—in several accounts, and, most wildly of all, it was claimed that Ben had left a fortune of $92 million, "mostly to his family."

As his family had no idea of how much he was actually worth, this news aroused mixed feelings; but any optimistic reaction must have been tempered by the fact that Ben had carried a life insurance policy of only $23,000. Not a bad sum in itself—as a comparative guide, the prominent British journalist and sex reformer William T. Stead, who also drowned in the disaster, was insured for $10,000; but the highest level of insurance of those on board was $50,000.

There were other myths. Throughout her life Hazel, who lost her father a few days short of her ninth birthday, was profoundly affected by the experience. At her own funeral in 1995, she had arranged for "Nearer, My God, to Thee" to be played—but despite popular belief, the hymn was never played as the great ship died. The ship's band bravely played on until the end—and not a single musician survived—but what they played was ragtime. Another myth that affected the Guggenheims was the story of a "Mrs. Guggenheim" being on board with her "husband," a story which quickly inflated to produce a "blond singer," a mistress of Ben's whom he'd brought aboard at Cherbourg. No such person appears on the *Titanic*'s passenger list, and it is highly unlikely that even the womanizing Ben would return home for his youngest daughter's birthday, expecting to be met at the New York quayside by his family, with a woman in tow. (It is possible, though unlikely, that he picked someone up on board.)

For a time Florette continued to cling to the hope that her husband was not dead but simply missing—the first survivor lists issued were confusing, and the *Carpathia* aroused press anger by refusing to wire ahead a definitive schedule of who had been picked up. This was not mischievous or malicious: Captain Rostron was giving wireless priority to ship's business and survivors' messages to their families. However, the *Carpathia* was a slow ship, and it didn't reach New York until the Thursday following the Sunday night that had seen the *Titanic* sink.

There is no record of Benita's reaction to the loss of her father, but Hazel and Peggy left behind their own testimonies. Hazel, who became a painter, was almost always concerned with ships and water in her pictures, and as late as 1969, on the anniversary of the sinking, she produced a five-stanza poem, "*Titanic* Lifeboat Blues." A year later she had it set to music and recorded it, singing the words herself. The first stanza will suffice to give an impression. Despite its shortcomings, there's no doubting its sincerity:

Half four score and seventeen years ago
My father stood on deck, declined towards safety to row.
Gave his place in lifeboat to the weaker sex.
That ship that sank midst wreck of trunk and bunk,
Titanic was her name; Titanic was her shame!
All this to win Atlantic speeding fame,
That ocean sport; near coast of Halifax
Had nearby ship been lax?
Who knows, not even writer Walter Lord.
Perhaps He knows—Almighty God our Lord
Can tell what caused death's knell.

Peggy, approaching fourteen at the time of her father's death, is more suc-
cinct in her autobiography, written in the mid-1940s: "My father's death
affected me greatly. It took me months to get over the terrible nightmare of
the *Titanic*, and years to get over the loss of my father. In a sense I have never
really recovered, as I suppose I have been searching for a father ever since." It
is hard to determine how far either woman in later life was being disingenu-
ous. Each may have needed an excuse for the wildness in her life. However,
neither was particularly introspective.

Amidst all the press speculation, Florette and her daughters were to dis-
cover the true extent of Ben's fortune. But it would be a long process.

Heiress

After Ben's death his powerful brothers, Daniel, Murry, Solomon, and Simon, put aside the differences they'd had with him during his life, and pulled together to help his widow and her family. Ben's International Steam Pump Company, together with a variety of lesser business interests, not to mention his lavish personal tastes, the maintenance of his staff, his mistresses, and a Paris apartment, had absorbed almost all his capital.

As a temporary measure, without her knowledge, the brothers discreetly advanced money from their own pockets to Florette via a private account, and set about the business of unraveling Ben's affairs. It took seven years to sort everything out and pay off the many creditors. By the time this had been done, all that remained was about $800,000 for Florette and $450,000 for each of the girls. The brothers estimated that Ben had run through about $8 million.

Although the inheritances were no mean sums, they were small compared with the wealth of the Guggenheim empire, and they dictated a change in Ben's family's way of living. Florette was proud, and when she discovered that the income she'd been receiving had come from her brothers-in-law, "she nearly had a fit," according to Peggy. (When Florette's father died in 1916, leaving her $2 million, her circumstances improved considerably, and she was able to repay the loan.) Since Ben had more or less permanently

absented himself in 1911, the family had moved into a residential suite at the St. Regis Hotel—a Guggenheim stronghold—and the house on East Seventy-second Street had been let to an aunt of Peggy. Now, in 1912, the St. Regis became too expensive, and Florette moved with her daughters to a more modest place on the corner of Fifth Avenue and Fifty-eighth Street—though it did have a Fifth Avenue address. Evidently the Seligman family couldn't or wouldn't help, and Florette reluctantly started to live on her own money. It is possible that her blood relatives thought she had quite enough to survive on, or perhaps, as she had married into the Guggenheims, it was felt that her maintenance was *their* responsibility. Either way, no one was going to starve.

But it was a blow to find out just how little Ben had left them with. Hazel Guggenheim told a friend, somewhat melodramatically, that "my mother made eggs by the hot water from the faucet." Servants had to be dismissed, and paintings, tapestries, and jewelry sold. Hazel remembered that her father bought paintings by Corot, and "owned gorgeous suits and shoes and ties, and wore slippers of Moroccan leather," and that "my mother and he went to the opera every night." That way of life was gone, and Peggy wrote, "from that time on I had a complex about no longer being a real Guggenheim. I felt like a poor relative and suffered great humiliation thinking how inferior I was to the rest of the family."

The context in which she felt this is best understood by making comparisons. The oldest Guggenheim brother was Isaac. When he died in 1922 he left $10 million. Murry died in 1939 leaving $16 million; Dan in 1930 leaving $6 million. Although Peggy and Hazel were to inherit a further $500,000 apiece from their mother on her death in 1937—their beloved older sister, Benita, having died ten years earlier—they still saw their cousins, Murry's children, Edmond and Lucille, coming into $8 million each, and Dan's children, Robert, Harry, and Gladys, getting about $2 million apiece. Everybody lived in close proximity in New York City and on Long Island, and it isn't surprising that Peggy, at least, wanted to get away—with Hazel following suit. Benita, at seventeen significantly older at the time of Ben's death, and gentler and more conventional than her sisters, would follow a different path.

"After his death," Hazel recalled much later to Virginia Dortch, who compiled a portrait of Peggy through the reminiscences of her friends, "in order not to offend the Guggenheims, my mother would never marry or

even sit alone in a room with a man. I suppose, if father had lived, Peggy would have married bourgeois men and I would have stayed married to them." However, this may be disingenuous, and does not take into account Florette's own eccentricity, however mild it was by comparison with that of her own brothers and sisters. In any case it isn't helpful to speculate on what might have been. Peggy and Hazel were rivals for their father's love and for Benita's love; later they were rivals for fame and notoriety. For the moment, they turned to religion. "After my father's death I became religious," wrote Peggy. "I attended the services in Temple Emanu-El regularly, and took great dramatic pleasure in standing up for the *Kaddish* (the service for the dead)." The family went into mourning, and Peggy felt "important and self-conscious in black."

Ben's death as a hero when they were both young girls, and the mythic element lent his death by the fact that his body was never recovered, led Peggy and Hazel to idolize his memory more than they might otherwise have done; but it is doubtful whether his death fundamentally affected the course their lives were to take. More important was the comparative lack of money. The youngest of the Guggenheim brothers, William, sued his older siblings in 1916 over what he considered his illegal exclusion from profits from ventures that had flourished since his departure, specifically a fabulously profitable foray into copper mining in Chile. Unfortunately, he and Ben had signed a disclaimer to participation in the mining ventures of the family firm in January 1912. Florette, loyal to the Guggenheims because of their kindness to her, would have nothing to do with William's case. The other Guggenheim brothers settled out of court for $6 million, which William, with a reputation for poor investments that led Wall Street to nickname him "Willie the Plunger," and a taste for starlets and beauty queens, big cars, a large staff, and a big house, as well as a flirtation with vanity publishing, managed to reduce over the next twenty-five years to virtually nothing. After his estranged wife and her son by him had successfully claimed their rightful shares under New York State law, and after debts and taxes had been deducted, all that the two chorus liners and two beauty queens who had hoped to be William's principal heirs at his death in 1941 received was about $1,000 apiece. Fortunately for William's descendants, Simon Guggenheim, knowing his younger brother's ways, had set up a $1 million trust for his heirs after the lawsuit.

Ben and William had been born and brought up under a less onerous bur-

den than their brothers, to the latters' resentment; but with hindsight they
had cause to be grateful for their father's severity. Ben and William were the
ones singled out for university education before joining the family firm.
William, for all his failings, had a sensitive and intellectual streak, and a
sense of history that prompted him to write an eccentric but nevertheless
important memoir of himself and, more importantly, the early days of the
Guggenheim empire. And although Solomon Guggenheim was to demon-
strate that an artistic sensibility existed within the family, it was Ben who was
the principal inspiration for his middle daughter's decision to live in artistic
circles, and for her love of Europe.

Above all, despite all attempts at assimilation, Peggy was marked by her
Jewishness. She belonged to a family within the Jewish New York commu-
nity which was still regarded as *arriviste* despite its great wealth, and she was
a member of the poorest branch of that family. She experienced anti-Semitism
early on and understood the refugee society's eternal need to stick together
and find security in money—Peggy was only second-generation American.
Both her grandfathers had come from the Middle European Jewish peasantry
and had started out in the United States as peddlers. From them she inherited
two basic characteristics of the successful trader: a love of money and a disin-
clination to part with it without good reason. If she didn't set out to make
money, in the end what she invested in pictures repaid itself a thousandfold:
In leaving Peggy without the fortune her cousins enjoyed, Ben, ironically, did
her a favor.

three

Guggenheims and Seligmans

\mathcal{B}oth Peggy's grandfathers left Europe—Meyer Guggenheim in 1847, James Seligman in 1838—to escape the financial and professional restrictions placed on Jews in the Old World. The Jewish communities of Europe were centuries old, but since the Crusades, Jews had found themselves increasingly the object of mistrust, suspicion, and fear. The communities defensively kept to themselves and did not integrate, but the countries in which they lived regarded them as at best unwelcome guests, and promulgated laws that ensured that life for them was as difficult and uncomfortable as possible. The majority of them lived in small rural settlements in Eastern Europe and Russia, and were not allowed to farm or own land other than their own homes; even such ownership was subject to tariffs and taxes Christians were exempt from. Jews were not allowed to engage in mining, or the smelting of metal, or any other major industrial enterprise, or to practice in any of the professions outside their faith. The only jobs that remained open to them were tailoring, peddling, small-time retail in commodities, and moneylending. The Church permitted them to deal in moneylending because it considered Jews exempt from two tenets, ironically enough from the Old Testament: Exod. 22.25: "If thou lend money to any of my people that is poor by thee, thou shalt not be to him as an usurer, neither shalt thou lay upon him usury"; and Deut. 23.19: "Thou shalt not lend upon usury to

thy brother; usury of money, usury of victuals, usury of any thing that is lent upon usury." Pragmatically the Church acknowledged the necessity for moneylending, but also saw that it was unpopular, and so, with political acumen, accorded the right to practice it to the Jews.

The origin of the Guggenheim family is uncertain, but it is possible that they originally came from what is now called Jügesheim, to the southeast of Frankfurt-am-Main. By the end of the seventeenth century the Guggenheims had moved to Switzerland from Germany, where the treatment of the Jews was harsher. In Switzerland the Jewish community enjoyed a monopoly on moneylending; but as commerce grew and money increasingly began to be used as capital for ventures, the advantages of lending it on interest began to be seen as sound business practice, and the Church's prohibition on Christian usury was relaxed at the Fifth Lateran Council of 1512–18. The principal function of Jews in Switzerland thus became superfluous, and, with a growing Christian population, the cantons began to expel them. By the end of the eighteenth century the Jewish population of the entire country was reduced to two small communities, in Oberendingen and Lengnau.

It was in Lengnau, a small village about twenty-five miles northwest of Zurich, that the Guggenheims settled. The earliest of Peggy's ancestors on her father's side whom we can trace for certain was a man called Jakob. Jakob Guggenheim was an elder of the synagogue and a respected local scholar of the Talmud, whose acquaintance was sought by a relatively enlightened Protestant Zurich pastor called Johann Ulrich, who had taken his arthritic wife to the nearby spa town of Baden in about 1740. As a result of their meeting, Ulrich, already interested in Judaism, became a friend, but unfortunately the pastor's proselytizing zeal led him to persuade one of Jakob's sons, Josef, to convert to Christianity. The procedure took sixteen tormented years as the sensitive and intellectual Josef struggled with his conscience. It broke up the friendship; but the Guggenheims had had their first brush with the politically dominant religion. Jakob's protest at his son's conversion was so angry that he incurred the wrath of the Christian community, which obliged him to pay a massive 600-florin fine in order to remain in Lengnau. That he could afford it shows how prosperous the family was.

Jews were still allowed to lend money, and another of Jakob's sons, Isaac, displayed a particular gift for the business. When he died in 1807 at an advanced age, he left 25,000 florins in coin, plate, and goods; but life contin-

ued to be hard for the Jews of Lengnau, and by the time Isaac's grandchildren reached maturity, his patrimony had all but disappeared.

One of them, Simon, worked as a tailor in the village for thirty years without any significant financial gain to show for it. He lost his wife in 1836, and had to bring up a son, Meyer, and four surviving daughters alone. By 1847 Meyer was nearly twenty and worked as a peddler, traveling in Switzerland and Germany. The younger daughters, though, presented a problem: Simon didn't have enough of the money required by Swiss law (as applied to Jews) to provide them with dowries (which would then be taxed), so they were not allowed to marry.

The problem of matrimony touched Simon personally. He was fifty-five in 1847, but had become attached to a widow, Rachel Weil Meyer, fourteen years his junior. She had three sons and four daughters, but she also had a reasonable amount of capital. This, together with the value of Simon's home and contents, should have been enough, they hoped, to persuade the authorities that they themselves had sufficient money to get married. But the authorities were unimpressed. Simon and Rachel had had enough. They began to look for a solution away from home.

In 1819 the *Savannah*, built at Savannah, Georgia, the first steam-assisted sailing ship designed to cross the Atlantic, had made the passage from its home port to Liverpool in twenty-five days. The ship had a full rig of sails, and only used its steam-driven paddles for the small proportion of the voyage when there was no wind, but its successful crossing suddenly brought the young republic of the United States much closer to Europe, and foreshadowed an era of relatively cheap, quick, and reliable crossings of the ocean. Other, more sophisticated ships soon followed. America sought talent, labor, and immigrants to bolster its still comparatively small European population and to people its huge virgin territories. For the Jews of Europe the country had one massive attraction: There were no ghettos and no discriminatory restrictions—unless, of course, you were a Native American.

Jews from rural Germany, especially rural Bavaria, a very hard-pressed region, started emigrating early on, and their letters home carried nothing but praise for the New World. It was a huge step for Simon and Rachel, by the standards of the time already both well advanced in years, and rural Swiss-Germans with no other experience of the world; but repression at home offered them little alternative. Here was a place where they could live

freely, not as barely tolerated and exploited "guests," even though their family roots reached back centuries. They sold Simon's property, pooled their resources, and set off with their children overland for Koblenz.

From there they continued to Hamburg, where they spent only a short time before taking steerage berths on a sailing ship—the cheapest passage they could find—bound for America. The voyage took eight weeks, the conditions were cramped, and the travelers had to share them with a flourishing population of rats. Although dried fruit was supplied, the food was basic—chiefly hardtack—and water was rationed very strictly. There was no privacy.

For Simon's son Meyer and Rachel's fifteen-year-old daughter Barbara, however, the discomfort of the journey was eclipsed by something far more important: They fell in love. By the time the American coastline rose on the horizon, they had decided—as soon as they could afford it—to marry. This strengthened Meyer's resolve to do well. He was a small, energetic man, with strong features and a bulbous nose that many of his descendants, including his granddaughter Peggy, would inherit. Capable of kindness, and not averse to the finer things in life (good cigars and fine white wine featured in his later prosperity), he had a liberal side and a certain sense of humor. As a businessman, however, he was habitually mistrustful, cold, and acute. He was obsessed with making money, and though he had an aptitude for it, he also worked at it relentlessly.

The joint families' destination was Philadelphia, where they may already have had friends or relatives—it was the usual method for second- or third-wave immigrants to follow to where cousins or neighbors from the old country had already established bridgeheads, one reason being that few immigrants spoke the language of the new country when they arrived. Away from the Northeast, the United States in 1848 was still more or less unexplored: the rapid colonization and urbanization of the next seventy years or so were only just getting under way. Philadelphia, however, founded by William Penn in 1682, was by now a prosperous and important city of some 100,000 people, including 2,500 Jews. The Jews were integrated into the local community, but held positions of only minor social and financial standing.

Once they had disembarked, organized their modest baggage, and adjusted to the unfamiliar, exciting, and frightening environment, the large family set about finding a place to live. They rented a house in a poor district outside the city center, and immediately Simon and Rachel married. The

next thing to do, before their slender savings were exhausted, was to find work. Rather than seek employment, Simon and Meyer decided to work for themselves. As it would take more capital than they could afford to set up a tailor's shop for Simon, they both took to peddling, the work Meyer already had experience in. Stores were few and far between, and transport was hard, so most people, especially in outlying areas, tended to buy whatever they needed from traveling salesmen. Old Simon worked the streets of the town, while young Meyer left home each Sunday with a full pack for the country districts, not returning until the following Friday. It can't have been easy, walking miles on foot, sleeping in the cheapest lodgings, with robbery and abuse a constant worry, but before long he had established both routes and a routine.

The Guggenheims had to learn fast—both the language and local business practice—but on the other hand they were free of all the laws and taxes imposed on Jews back in Switzerland, so there was a sense of liberation that made the graft easier to bear, and also motivated them. For Meyer especially this new beginning was stimulating, and he quickly discovered within himself a great aptitude for business. Iron stoves were rapidly replacing the old open hearths, and one of his bestselling lines was a form of blacklead for cleaning them. Meyer saw that if he could find a way of making his own polish, rather than buying it from the manufacturer, he could make a far greater profit while keeping his retail price low. In those days there was no law restricting such a practice, and history doesn't relate how the manufacturer reacted to the loss of one small client, but Meyer took a can of the stuff he was buying to a friendly German chemist, who analyzed it for him. Thus armed with the recipe, and after several messy experiments in his scant time off, Meyer not only produced his own stove blacking, but improved upon the original by making a version that would stay on the stove rather than on the hands of the person cleaning it. Before long he was selling his polish in such quantities that Simon gave up his own round and stayed home to produce it, using a secondhand sausage-stuffing machine. Soon Meyer was making eight to ten times the profit he had formerly made.

He didn't stop there. Coffee was already taking hold as the favorite American drink, but real coffee was extremely expensive. Poorer people used coffee essence, a liquid concentrate of cheap beans and chicory. Meyer's stepbrother Lehman had already started to produce some of this at home, and now Meyer added it to his list of wares. By this time he was an experi-

enced salesman with a reliable body of customers who trusted him. Four years after getting off the boat he was, at twenty-four, an established figure in the stoveblack and coffee-essence businesses. He married Barbara at Philadelphia's Keneseth Israël Synagogue, and the newlyweds set up house for themselves. It was a good match and a successful marriage. Barbara's gentle and selfless personality made her the perfect complement to Meyer. She never questioned his authority and always supported him. She was a good mother to their children, and if she had a fault at all it might have been the overindulgence of her younger offspring. Meyer, on the other hand, could be a stern disciplinarian. His youngest son, William, recalls in his memoirs that his father had "no tendency to spare the rod. Whippings were not infrequent; he employed a leather belt, a hairbrush, or any convenient paddle whenever the need suggested itself to him. . . . None was allowed to doubt for long that his father's word was law or to think that that law might be broken with impunity."

From the start, Barbara showed an inclination to charitable work, which increased as her means did, though throughout her life she showed no inclination to use the money her husband earned to spoil or pamper herself. Just as Meyer established the business empire, ruthlessly developed by the abler of his sons after his death, so perhaps did their mother's influence incline them to set up the charitable foundations for which the family remains famous, after they had made their fortune.

In the course of the next twenty years, Meyer and Barbara produced eight sons, including twin brothers, and three daughters. One of the twins, Robert, died in childhood, and their daughter Jeannette lived to be only twenty-six. But the survivors would grow up to be the heirs and developers of a business empire that was among the biggest half-dozen in the United States a century ago, and that was gathering strength when Meyer's granddaughter Peggy was born.

Meanwhile Meyer expanded and diversified his business interests, always driven by the desire to increase the security of his position in society by making ever larger sums of money. He didn't necessarily cling to it—the years following his marriage would be punctuated by a series of house moves that tracked his rise in Philadelphia society—but he was extremely careful with it, and would never spend it unless there were some material, political, business, or social gain to be made. One of his favorite proverbs came straight

from the rural peasantry of his birth: "Roast pigeons don't fly into your mouth by themselves." This dictum was one he tried to inculcate into each of his sons: with Isaac, the oldest, born in 1854, he was not altogether successful, but with the three middle sons, Daniel (1856), Murry (1858), and Solomon (1861), he had greater success. The surviving twin, Simon (1867), also remained within the family fold; the surviving daughters, Rose and Cora, born in 1871 and 1873, following nineteenth-century practice, both made good marriages and remained a credit to their parents. Benjamin (1865) and William (1868), however, followed their own paths, as we have seen.

As for education Meyer, unlike his wife not particularly observant of his faith, chose the best for his children, regardless of religious affiliation, and they were sent to Catholic day schools, which paved the way for their disassociation from the religion and mores of their forefathers. Though Ben and William enjoyed the advantages of further education, only William showed any serious propensity for scholarship; the others were encouraged by their father to enter the family firm as soon as they could, and learn business through hands-on experience. The older boys, who worked hard alongside their father, were later aggrieved when Meyer decided to divide profits equally between all his sons; but Meyer countered their objections by pointing out that in time it would be the younger ones who would carry the burden of the work. He alluded to another piece of peasant wisdom: a *bundle* of sticks cannot be broken; individually the sticks *can* be broken. The older boys knuckled under but were not reconciled.

In the 1870s, having made small fortunes by the standards of the time in ventures as diverse as lye (used in soap making) and the burgeoning railroads, Meyer turned his attention to lace. In 1863, all proscriptive laws against the Jews in Switzerland had been repealed, and one of Barbara's uncles had established a lace factory back home. With a supplier established, Meyer now entered the lucrative lace business. His flair for diversification once again paid off, to the extent that by 1879 he was worth almost $800,000. But his greatest gamble was yet to come. Two years later he was offered a third of the interest in two silver and lead mines outside the boomtown of Leadville in Colorado by a Quaker friend, Charles Graham. Graham had borrowed money to buy two-thirds, but the mines, called the A.Y. and the Minnie after the original prospector and his wife, who had sold out for very little, were not doing well, and Graham couldn't afford to repay the loan on half his share when it became due. William Guggenheim records that Gra-

ham's price was $25,000, though it may have been as little as $5,000—sources differ. In any event Meyer, who knew nothing about mining, thought it was worth the risk. His other partner was one Sam Harsh.

Before too long Meyer made his way to Leadville, in the wake of the disturbing news that the mines were flooded. To pump them out would cost $25,000, more than his two partners could afford. Meyer hesitated, but reflected that after all the investment in relation to his capital was still relatively small—and maybe too he was following what had so far proved to be an unerring instinct. He had steam pumps developed for the job, the forerunners of a hydraulic power system that would be the cornerstone of his son Benjamin's later business interests. He bought out his partners, had the mines cleared and repaired, watched the expenses mount, and worried and waited. But he didn't have to wait long. In August 1881 rich seams of both lead and silver were struck. Soon the mines were bringing in $200,000 a year; by the end of the decade the yield had risen to $750,000.

Based on his experience with stove polish, Meyer saw that if he established his own smelting business, he need not pay anyone to process his ore for him. With the help of his then twenty-three-year-old son Benjamin, a smelter was established at Pueblo at the end of 1888. In the same year the family moved to a new home and new offices in New York, which had by now gained ascendancy over all other cities in the East as the center of commerce.

Lace was forgotten. Mining became the center and the soul of the Guggenheim firm. The world was their unexploited oyster, and with the funds available to them over the years that followed they would gain control of the American smelting industry and expand their mining operations to Mexico, Chile, Alaska, and Angola. Profits would run into the hundreds of millions. They were not always good or ethical employers, their business practice could be sharp, and in those days nobody gave a damn about the ecological effects of mining operations, but they were phenomenally successful. Simply as a family they were formidable: Meyer and Barbara had to remember the birthdays of twenty-three grandchildren. The Guggenheim fortunes would continue to prosper until Peggy's generation, less interested in business, came into its own.

Barbara, who had contracted diabetes, died on March 20, 1900. Ben and Will pulled out—and were partly pushed out—of the family firm soon after. The other brothers were only too happy to be rid of the interference of their

pampered, college-educated siblings, whose ideas of how to run the business clashed with their own. Furthermore, Will, who fancied himself something of a ladies' man, had blotted his copybook by making a very ill-advised marriage late in 1900, to a woman of dubious virtue. The older brothers coerced him into divorce but then had to come up with a hefty $78,000 to satisfy the aggrieved ex-wife, although the whole business dragged on for another thirteen years, and in 1904 even threatened to bring scandal upon Will's second and only slightly more successful marriage. Ben and Will were left with handsome incomes and some interest in the business, but only as far as it had come by the turn of the century. They were cut off from the vast amounts that would accrue to the Guggenheim companies after 1900.

Meyer, growing old, increasingly left the reins of the business to his son Daniel, dabbling in the stock exchange as a means of recreation. "When my grandmother died," Peggy wrote, "my grandfather was looked after by his cook. She must have been his mistress." This is a typical Peggyism and need not necessarily be true—she always loved amorous intrigue. "I remember seeing her weep copious tears because my grandfather vomited. My one recollection of this gentleman is of his driving around New York in a sleigh with horses, he was unaccompanied and always wore a coat with a sealskin collar and a cap to match." The cook-mistress may be an exaggeration by Peggy, but a woman servant called Hannah McNamara sued Meyer for $25,000 shortly after Barbara's death, claiming to have been his mistress for the past twenty-five years. Meyer denied the whole thing, and the unfortunate business blew over; but the servant's allegations are not outside the bounds of possibility, and most of Meyer's sons had one mistress or more at some stage in their lives.

But if there was someone who consoled him during his final years, Meyer kept her secret. He died in Florida—where he'd gone to recover from a cold, in 1905—nearly five years to the day after Barbara.

When Ben Guggenheim successfully wooed and won Florette Seligman in 1894, his family was already substantially richer than hers. But the Seligmans, though they had arrived in the States only about ten years earlier than the "Googs," formed part of the Jewish elite of New York, and looked down on the family that had made so much money from mining and smelting. A Seligman family telegram to cousins back home in Germany may have been deliberately miswritten to show their contempt: FLORETTE ENGAGED

GUGGENHEIM SMELT HER. However, no objection was raised to the match. No one could fail to respect the Guggenheim wealth, or the speed with which it had been made. Benjamin was a bit of a dandy and a bit of a womanizer; he had a warm personality and a delightful smile. Florette was on the plain side, and her temperament was difficult. But from each family's point of view, the union was advantageous.

Despite the difference in the status of the two families in New York, the story of the Seligman origins is remarkably similar to that of the Guggenheims. The little town of Baiersdorf lies midway between Bamberg and Nuremberg in Franconia, Germany. There had been a Jewish community there from at least the mid–fourteenth century, and the last Jews belonging to it were deported to a concentration camp in Poland, where they died, in 1942. A large Jewish cemetery remains, and the town, as so many in Germany do, has its Judengasse—Jews' Street. The Seligmann family—they would drop the second *n* on arrival in America—arrived in Baiersdorf around 1680. In 1818 David Seligmann, a local weaver, married Fanny Steinhardt. The couple set up house in the Judengasse, and over the next twenty years produced eight sons and three daughters, just as the Guggenheims had done. Today there is a Seligmannstrasse in Baiersdorf, and a David and Fanny Seligman Kindergarten, endowed by the family.

Using some of her dowry, Fanny bought a stock of bed linen, bolts of cloth, lace, and ribbons. With them she set up a small shop in the family home, and did so well that David's none-too-impressive fortunes improved. He called himself a wool merchant and started a sideline in sealing wax. He had to travel frequently on business, so that the upbringing of the children was left, to his misgivings, to his wife.

Travelers from outside Baiersdorf started to use Fanny's shop, and by the mid-1820s their oldest son, Josef, had begun a modest currency exchange business. In those days much of Germany consisted of small principalities, and coinage was not standardized, so Josef did a brisk trade, taking a small profit from each exchange. It was a short step from changing money for the convenience of users of his mother's dry-goods store to running a regular currency exchange, and by the age of twelve the precocious Josef was even handling the occasional U.S. dollar, among other truly foreign coinage.

Fanny was ambitious for all her children, but Josef was the apple of her eye. However, by the mid-1830s, the German rural economy was declining, as more and more people migrated to the increasingly industrialized cities,

and Jews, subject to severe legal restrictions, found it ever harder to make ends meet. Some moved to the cities but received no welcome there. Others began to look outside their native land. As Jewish migrants moved westward through the country, fleeing oppression farther east, in Poland and Russia, word spread about the opportunities awaiting those who could afford, or who dared, to emigrate to the United States. In time, so great was the emigration that a duality arose in New York Jewish society not only between the insiders and the outsiders, but between those "older" emigrants with German names, and those who mainly came later, with Russian and Slavic names—these last being at the bottom of the social heap.

Fanny Seligmann had a strategy. Josef was now fourteen, and she took the unprecedented step in her family of sending him to the university in nearby Erlangen, where for two years he studied German literature and learned some Latin, Greek, English, and French. By the time he had graduated, at sixteen, he wanted nothing more than to spread his wings and go to the United States. Father David, now forty-six years old, a conservative, dour man, raised objections: Emigrants were widely regarded as failures, and besides, there were rumors that Jews in America lost sight of their religion. But Fanny was adamant, and although it took her some time to persuade her husband, Josef was allowed to set off, aged eighteen, in July 1837, in the company of eighteen other men, women, and children from the town. Fanny had managed to scrape together the money for his passage, and from somewhere too—possibly relatives in her hometown of Sulzbach—she'd obtained $100 in U.S. currency, which she carefully sewed into Josef's knee breeches. Then she waved him good-bye. She would never see him again. In 1841, aged only forty-two, Fanny died. She had given birth to her eleventh child, a daughter, two years earlier. It was clear that Fanny had been the backbone of the family. Soon after her death, her widowed husband, with several children still at home to look after, ran into financial difficulties.

The journey from Baiersdorf to Bremen, where Josef's party was to take ship, took seventeen days, traveling overland in two wagons. The crossing on the schooner *Telegraph* took a further sixty-six days. Including Josef's party, there were 142 people crammed on board. Passage cost $40, and included a cup of water and one meal a day—which unfortunately consisted of pork and beans, so Josef quickly had to ignore his father's parting injunction not to forget the Jewish dietary laws. Even so he lost weight on the journey—no bad thing, as he always had a tendency toward corpulence. On the journey

he also fell in love, with the daughter of his group's leader, Johannes Schmidt. But unlike Meyer's, it was simply a shipboard romance, ending in a tearful parting when the *Telegraph* docked at New York.

Josef, who immediately anglicized his name—to Joseph Seligman—on arrival in America, as all his brothers who followed would, had more on his mind than regretting the girl. He was a young man driven by ambition, and with a similar motivation to Meyer's: In money lay security. Soon after his arrival he set off on a hundred-mile hike—he wasn't going to waste any money on transport, and must have been innocent of the perils of the road—down to Maunch Creek, Pennsylvania, where he had an introduction to a cousin of his mother's. Maunch Creek wasn't much of a place, but Joseph quickly got a job, at $400 a year, as financial clerk to a canalboat-building company. He made friends with the boss; the Seligmans would always have the knack of striking up good relationships with the right people, in this case Asa Packer, a small-town businessman who would prove to be an invaluable contact. Packer went on to become a multimillionaire, the founder of a university, the president of a railroad, and a U.S. congressman.

After a year Joseph turned down the offer of a generous raise and invested the $200 he'd saved in various portable goods. With them he set off on foot, carrying a two-hundred-pound pack, peddling to farms in the region. It was hard and sometimes dangerous work, but Joe was tough and single-minded. He was also a brilliant salesman, and within six months he had made a profit of $500, part of which he sent off to his two next eldest brothers, Wolf and Jakob, who were longing to join him, as their passage money.

Wolf and Jakob—renamed William and James on their arrival in America—were not all-arounders like Joseph. William was idle and liked the good life, which annoyed his older brother. James, however, while not particularly good at accountancy, turned out to be the best salesman of all of them. By 1840 the brothers had bought a place to use as their headquarters in Lancaster, fifty miles west of Philadelphia; the following year the next brother, Jesaias (who became Jesse), came over, aged fourteen, and quickly proved to be the accountant the enterprise needed. Over the next two years, growing profits enabled Joseph to get the rest of his family, including his father, over to the New World.

James, handsome, confident, and intelligent, showed an aptitude for salesmanship that surpassed even his oldest brother's, and in 1846 he was dele-

gated to open the New York branch of the family's fast-expanding dry-goods business. At about the same time Jesse and his youngest brother, Henry (Hermann), were establishing another branch at Watertown, in upstate New York. There Jesse made friends with an army lieutenant stationed nearby. This would turn out to be another fortunate relationship, since the lieutenant's name was Ulysses S. Grant.

The Seligmans continued to live modestly, even after their business expanded to cover most of the country. As a result of the gold rush to San Francisco in the 1850s they were able to reap mighty profits, since gold fever led to enormous price hikes. A blanket bought for $5 could sell for $40, and a quart of whiskey went for $25. Profits from California became the mainstay of the Seligman organization.

But a new dimension soon crept into their interests. Much of the profit from the West Coast took the physical form of gold bullion, which the New York branch used not only to buy new stock but also to trade on the market. Banking in the United States didn't become formally regulated until after the Civil War, and there was no bar to anyone entering the field. It didn't take long for the Seligmans to realize that interest never stopped earning. They loaned, bought, and sold IOUs, and eventually offered deposit accounts. By 1852 Joseph, aged thirty-three, was a major New York banker and investor. The only mistake the family made, based no doubt on their traditional thinking, was to avoid tying anything up in property: By and large they rented. Thus at one point they passed up the chance to buy about one-sixth of Manhattan.

The Seligmans were now solidly established. During the Civil War they sold uniforms to the Union Army and took the risk of being paid in Treasury bonds. It paid off, and when the war was over, with their old friend Grant a Yankee hero, they were able to cash in on the postwar boom. Although New York high society was riddled with elaborate rules and regulations, which tacitly excluded Jews from its inner sanctum, no one in business could afford to ignore them. By the mid-1860s the Seligman brothers and sisters had produced about eighty children between them. When Grant became president in 1869, he offered Joseph the post of secretary of the treasury. For the first time Joseph faltered. He may have been a millionaire at fifty, but at heart he was still an immigrant Jewish kid, and his confidence failed him. On his own turf, however, he remained king, and the linchpin of the clan's business activities.

Although by no means on a par with the Astors, Morgans, Vanderbilts, or Whitneys, the Seligmans continued to expand. They never had as big a break as the Guggenheims had in mining, but like them they diversified into railroads and, famously, into the Panama Canal venture. After the builder of the Suez Canal, Ferdinand de Lesseps, failed to achieve the same success in Central America, the Seligmans were able not only to divert interest from a rival canal construction in Nicaragua, but to finance a revolution for Panamanian independence from Colombia in return for the canal contract.

The Guggenheims were always out-of-towners, and were thus less affected by the implicit anti-Semitism of New York society than the Seligmans were. As the Seligmans' wealth increased, so did their desire to be accepted. Joseph had long since forgotten his father's injunctions to be strictly observant of his faith, and he and his brothers wanted nothing more than to be accepted by the great and the good. Being Jewish and having a German accent didn't help, no matter how much money one had, and however much one learned which knives and forks to use when and how to hold them properly, and the correct manner of presenting a calling card. As in the Great Plague of the Middle Ages, so in the temporary financial panic year of 1873, Jews were blamed.

Oddly enough Sephardic Jews were more likely to be accepted. Moses Lazarus had been one of the founders of New York's Knickerbocker Club, second in exclusivity only to the Union Club. His daughter Emma even wrote the verse that adorns the Statue of Liberty: "Give me your tired, your poor . . ." For Ashkenazic Jews, especially those from Germany, it was a different matter. Just as in time they would look down on the Slav and Russian Jewish immigrants, so now they were the newcomers, and their financial acumen meant that they were the victims of envy and its attendant spite.

Still they longed to be accepted. Their synagogue, Temple Emanu-El on Fifth Avenue, was reformed and Americanized. But they also took pride in their old country. They founded their own exclusive clubs: Until 1893 the Harmonie Gesellschaft hung a portrait of the kaiser on its walls. And although the Seligmans had anglicized their first names, they wouldn't touch their surname (except for dropping the second *n*). When William once suggested it, Joseph retorted that if he wanted to, he had better change his to *schlemiel*. By the late nineteenth century the Ashkenazic Jews of New York comprised a formidable group, including the Contents, the Goldmans, the

Kuhns, the Lehmans, the Lewisohns, the Loebs, the Sachses, and the Schiffs. However, when it came to names for their children, Gentile and patriotic American ones were chosen. The thing to do for prominent Jews was to play down their Jewishness. But whatever they did, anti-Semitism remained a core element of society, and Jewish new arrivals found it impossible to avoid or ignore. That it rankled long with Joseph is proved by one dramatic incident.

The Grand Union Hotel in Saratoga had been owned by one Alexander T. Stewart. On his death in 1876 Stewart had left its management to a friend, Harry Hilton, who shared his right-wing views. Stewart had envied Joseph Seligman from the time that Seligman had turned down the Treasury post, which Stewart coveted. It hadn't helped that Stewart's subsequent application for the job had been rejected by the Senate.

The hotel had begun to lose money even before Stewart's death, and Hilton and he believed this was because the Gentile clientele didn't like the admission of Jews. It wasn't uncommon for expensive hotels, clubs, and even restaurants to refuse admission to Jews in those days, and Saratoga was a major resort for the wealthy. It isn't clear whether the Seligman family actually went to the hotel in the summer of 1877, or whether they were forewarned: It seems highly unlikely that they would not have booked beforehand. It is possible that Joseph arrived with his family and his baggage in the knowledge that he would provoke a rejection. If so, the humiliation he received must have been half expected. Whatever the truth of the matter, they were rebuffed.

There was a storm in the press, and a furious exchange of letters. Seligman sued Hilton. The liberal elements in society took up Joseph's cause. But Hilton stuck to his guns: He didn't like Jews, and they were bad for business. The courts did not find in favor of Seligman, and several other hotels in the Adirondacks, emboldened by Hilton's move, also introduced a "no-Jews" policy. The only satisfaction Joseph could derive from the affair was the successful boycott of the largest New York department store, also formerly owned by Stewart and now managed by Hilton, which closed as a result. The effect of the case on Joseph was profound: He never recovered from it, perceiving it as the ultimate rejection by a society he had strived all his life to belong to, and into which he had put so much. He died at the end of March 1879, in his sixtieth year. A sad postscript is the resignation as late as 1893 by Jesse Seligman from the Union League Club, his favorite, which his brothers Joseph and William had also been involved in, when, extraordinarily, Jesse's

son Theodore was refused membership on anti-Semitic grounds. Like his older brother, Jesse found that New York was soured for him, and that he had never been truly accepted, even after forty-odd years in the city. He died a year later, leaving $30 million.

While Joseph had sought a wife back home in Germany, and married his cousin Babet, his younger brother James married into one of New York's oldest and most established Jewish families. The Contents, originally of Dutch-German stock, had been in America since the late eighteenth century. To marry one of them was to gain an entrée into the best circles of Jewish New York society; but that society was small and closed. Despite wealth and respectability, the Jewish elite remained in an unofficial ghetto, without walls or other tangible demarcations to fence it off, but no less real for all that—and it may be that it was one they did not choose to leave. A disinclination by Gentiles to marry into it was matched by a disinclination to marry out, and even if such a thing had been possible, it would have meant social anathema for the couple involved. The inevitable result was inbreeding. Cousins married cousins, and their children intermarried, so that within a couple of generations physical and psychological problems inevitably occurred.

The Contents looked down on just about everybody, although James was not the first German parvenu to marry one of them. On December 4, 1851, in the presence of Rabbis Isaacs and Merzbacher, he took the hand of Rosa Content. He was twenty-seven, and she was a slender, dark girl of seventeen. They hadn't known each other long, and didn't know each other well.

James was easygoing, but he knew the value of money and he was careful with it. Peggy, his granddaughter, describes him as "a very modest man who refused to spend money on himself." Rosa was far from easygoing, and very extravagant. From the first she felt that she had married beneath her, and the wealth the marriage brought did little to mollify her. Throughout her life she would trade on her superiority: She habitually referred to her husband's family as "the peddlers." The couple's English butler was also called James. Rosa would call him "James" at all times, and in his presence would refer to her husband as "Jim." This calculated humiliation caused James Seligman great hurt. He wasn't a good dancer; she was. "Germans are so heavy on their feet," she complained.

Still, he must have loved her, at least at first, because he indulged her as far as he could bear to, compensating for the expense by stinting himself. His

nature led him to take the line of least resistance, and although it was never a happy one, for some time the union worked reasonably well, producing eight children. One of them, Florette, born in 1870, went on to marry Benjamin Guggenheim and become the mother of Peggy.

With time Rosa became increasingly eccentric. As they grew up, the children were not allowed to bring their friends home, on the grounds that they would be of a lower social order "and probably germy." Rosa didn't like children anyway, not least her own, and her horror of germs was such that she had a habit of spraying everything with Lysol, a practice Florette and Peggy would inherit. She also began to spend more and more of her time shopping. Eventually James took a mistress. As a result of this, Rosa would astonish shop assistants by asking them out of the blue, and with a dark expression in her eyes, "When do you think my husband last slept with me?"

In the end James could stand it no more and moved out of the family home and into the Hotel Netherland. There he spent his remaining years, and became something of an eccentric himself. He had a horror of new technology, and always had an assistant place his telephone calls. He lived to be ninety-two, and when he died in 1916 he was the oldest member of the New York Stock Exchange. A reporter who interviewed him for the *New York Times* in his rooms at the Netherland on the occasion of his eighty-eighth birthday found an

> old gentleman clad in black, with snow-white, flowing locks and
> [a] long, spare, white beard, deeply immersed in the contents of a
> newspaper, his slippered feet extended before him on a velvet
> hassock. Perched upon his shoulder was a bright yellow canary
> bird, which sang at intervals, and it fluttered between its open
> cage and its master.

Rosa, having herself moved to a hotel in the latter part of her life, predeceased her husband, dying of pneumonia at the end of 1907. Peggy remembered her as her "crazy grandmother."

Although Peggy's Guggenheim uncles and aunts were, with the possible exceptions of her own father and her uncle William, what one might call solid citizens, it is hardly surprising, given their background and their mother's inbred genes, that the same cannot be said for her Seligman relatives. Despite James's injection of new blood, despite their tuition as children

by the novelist Horatio Alger (though the fact that he'd been sacked by the Unitarian Church for tampering with choirboys may not have helped), Peggy's Seligman uncles and aunts were all, in her own words, "very eccentric." Unlike her Guggenheim uncles, none of the children of James and Rosa Seligman achieved anything much. They lived on their incomes and lived out their lives. But what lives they were, as Peggy wrote:

> One of my favorite aunts was an incurable soprano. If you happened to meet her on the corner of Fifth Avenue while waiting for a bus, she would open her mouth wide and sing scales trying to make you do as much. She wore her hat hanging off the back of her head or tilted over one ear. A rose was always stuck in her hair. Long hatpins emerged dangerously, not from her hat, but from her hair. Her trailing dresses swept up the dust of the streets. She invariably wore a feather boa. She was an excellent cook and made beautiful tomato jelly. Whenever she wasn't at the piano, she could be found in the kitchen or reading the ticker-tape. She was an inveterate gambler. She had a strange complex about germs and was forever wiping the furniture with Lysol. But she had such extraordinary charm that I really loved her. I cannot say her husband felt as much. After he had fought with her for over thirty years, he tried to kill her and one of her sons by hitting them with a golf club. Not succeeding, he rushed to the reservoir where he drowned himself with heavy weights tied to his feet.
>
> Another aunt, who resembled an elephant more than a human being, at a late age in life conceived the idea that she had had a love affair with an apothecary. Although this was completely imaginary, she felt so much remorse that she became melancholic and had to be put in a nursing home.

There is much more along these lines in Peggy's autobiography, and there are interesting indications of her own personality in the characters. The operatic Frances was also a good cook and read the ticker tape, as well as having a mania for Lysol; the morose Adeline's lover was entirely a figment of her imagination. But the list by no means ends there. Peggy's uncle Washington Seligman lived principally on whiskey, and charcoal and ice cubes, which he kept in the zinc-lined pockets of a specially designed waistcoat.

This hideous diet was apparently dictated by chronic indigestion, but notwithstanding that and his black teeth, he maintained a mistress in his room in the family house, and threatened to commit suicide if ever the talk turned to her eviction. He was also an inveterate gambler. In the end, in 1912, he *did* kill himself—not because of the girlfriend but because he was unable to bear the pain of his indigestion any longer. His father, James Seligman, then eighty-eight years old, showed a certain tenderness but shocked the congregation when he walked up the aisle at the funeral service with his late son's mistress on his arm. Washington's death was followed by another suicide. A second cousin, Jesse II, shot first his wife, for presumed infidelity, and then himself. Yet another relative, Peggy's second cousin Joseph Seligman II (old Joseph's grandson), committed suicide at about the same time because he couldn't cope with being Jewish. This is a measure of how much strain the Jewish society-within-a-society was under, striving for acceptance from without and riddled with snobbery within.

James's next two sons were Samuel, who was so obsessed with cleanliness that he spent all day bathing; and Eugene, who was so bright that he was ready for Columbia Law School at eleven but put it off until fourteen in order to avoid being conspicuous. He graduated with high honors and practised law subsequently; but he was so miserly, a trait he shared with many of his siblings, that he would constantly arrive in their houses unannounced at mealtimes in order to freeload. By way of recompense, he would delight the children of the house after the meal by arranging a line of chairs and then wriggling along them, an act he called "The Snake."

The remaining brothers were Jefferson and DeWitt. Jefferson married Julia Wormser, a cultivated woman who took Peggy to the opera when she was little, but he neglected his wife and soon left her to live alone in a small hotel apartment on East Sixtieth Street. There he devoted himself to showgirls, or rather, to clothing them. He bought armfuls of dresses and coats from Klein's Department Store and kept them in the wardrobes in his rooms. When his nieces visited him, he'd invite them to take their pick; on at least one occasion his sister Florette helped herself, saying, "I don't see why I shouldn't have some too." Jefferson had further interesting traits: He considered shaking hands unsanitary and advocated kissing instead, and he was a firm believer in the beneficial effects of plenty of fruit and ginger. Every day he would turn up at the Seligman offices (none of James's sons contributed significantly to the family business) and distribute them to everyone, starting

with the partners and working down to the office boys. DeWitt, Peggy's own favorite, took a law degree but never practiced, preferring instead to devote his time to the writing of unactable plays, none of which was ever produced, in which the characters, brought by their creator into impossibly complicated situations, are all invariably blown up at the end—the only way DeWitt could cut through the Gordian knot of his entanglements.

Of the eight children, the ones closest to normality were arguably Samuel, DeWitt, and Peggy's mother, Florette. Florette's eccentricities were slight but palpable. She shared the family trait of tightfistedness, and had a habit of repeating certain words and phrases three times. On occasion she would wear three cloaks, or three wristwatches. There are stories of Florette that sound apocryphal: Stopped for driving the wrong way down a one-way street, she told the policeman: "But I was only going one way, one way, one way." Another time she told a milliner that she wanted a hat "with a feather, a feather, a feather," and was given one with three. Her habit of triple repetition used to drive her husband, Ben, mad.

A picture emerges of a wan figure, in love with her handsome husband but unable to reach him, and only secure in the strict confines of the society she'd been brought up in, acknowledging its mores and happy not to move outside its social calendar or its topics of conversation. On the other hand she had the strength to live with her unhappiness over her husband's infidelities, and to carry on alone for the twenty-five years she survived him, especially in the difficult few years of belt tightening that followed his death, before her own father's death rescued her financially. Then at least Florette had shown herself capable of adapting, though nothing in her upbringing had prepared her to fend for herself without the help of servants in even the simplest domestic matters, such as bed making, cleaning, and cooking. Nor could she pass on any such skills to her daughters. In more important matters of upbringing, too, neither she nor Ben was a good parent; but Ben had been spoiled, and Florette had been given no good example of motherhood. In her eyes probably the most successful daughter of the three she bore her husband was the oldest, Benita, who conformed to her ideal. Perhaps Benita would succeed in her marriage where Florette had failed in hers.

If Ben and she had been able to be happier together, the story would have been different. Ben, coming from a less straitlaced background, and himself more relaxed than his brothers, might have been able to liberate Florette

from the constraints of her upbringing; but by the time he met her it was too late for that, and in any case theirs was a marriage of powerful families as much as of two individuals. Almost as soon as they had set up home together, Ben resumed his philandering. So it was a suffocatingly well-heeled, desperately genteel, and very unhappy world into which Peggy was born.

four

Growing Up

\mathcal{N} ot only was my childhood excessively lonely and sad," Peggy wrote, "but it was also filled with torments." And again: "My childhood was excessively unhappy. I have no pleasant memories of any kind. It seems to me now that it was one long protracted agony."

She was born on August 26, 1898, at the family home, which was then an apartment in the Hotel Majestic on West Sixty-ninth Street, New York City. Her parents gave her the name Marguerite, not a family name, but not a Jewish one either, and disguised their disappointment that she was not a son. The Guggenheims had a habit of bearing daughters, to the extent that there was already some mild worry about the future of the surname.

Marguerite would have had a "Baby's Record" book similar to her younger sister Hazel's, which is still extant. From it we learn that baby's first gifts included $500 from Grandpa Seligman, and diamond buttons and a bracelet from his wife. Aunts Fanny and Angie provided a baby carriage. Hazel's nurse was Nellie Mullen, and her first teacher (in 1909) was Mrs. Hartmann, who commented, "a very clever child." Baby Hazel's first word was "Papa." Older sister Marguerite gave her a music box for her first birthday.

Peggy—as she soon became, via her father's pet name for her of "Maggie"—was the second child. Her sister Benita was nearly three years old, and

as soon as Peggy was able to focus emotionally, she settled her affections on Benita, rather than her remote mother and her frequently absent father.

"She was the great love of my early life. In fact of my entire immature life. But maybe that has never ended," Peggy wrote nearly fifty years later in her autobiography. It's difficult not to suspect her motives here, because although she and her younger sister both claimed to be rivals for the affection and attention of their older sister, as they were for the affection and attention of their father, it is probably true to say that Ben and Benita provided no more than a focus for a rivalry that was innate between the younger sisters. Both Peggy and Hazel were highly individualistic, both chose unconventional paths through life, and each always wanted to outdo the other—Hazel, as the younger of the two, forcing the rivalry more than Peggy. They were never close. Hazel suffered not only from being the younger, but from having less talent for self-publicity.

Both came to hanker for what the father and the elder sister represented: Ben was a typical absentee father, especially for Hazel, who had not even reached adolescence when he died, and as time went on his increasingly rare and brief visits to the family home, accompanied by presents and an exotic sense of travel, made him a more glamorous figure in their eyes than if he had been a humdrum, day-to-day, office-bound kind of father. Benita took on the standard role of adored older sister. She was more docile and conventional than either of her younger siblings, able to slip uncomplainingly and even gladly into the milieu her mother was at home in. Perhaps that, too, was an object of admiration and even envy for the younger two. There was something else as well: Both Ben and Benita died young. A martyr's death, in these cases through heroism in a shipwreck, and through a striving for motherhood, can attract acolytes. But there are also simpler explanations. Peggy was four and a half when Hazel was born, and "I was fiendishly jealous of her."

Within a year of Peggy's birth the family had moved out of the Majestic and into a "proper" home. Ben had not yet split with his brothers, the Guggenheim fortunes were riding high, and, with little of the financial caution most of his brothers had learned from their father, he set up his family in style at 15 East Seventy-second Street, near Central Park. Not only was it an expensive place—Rockefellers, Stillmans, and President Grant's widow were neighbors—but Ben had it completely redesigned and renovated in the best late-nineteenth-century taste.

Peggy revisited the house with her daughter, Pegeen, when she returned to America from Europe, after a prolonged absence, in 1941. Her Aunt Cora, to whom it was rented in 1911, still lived there, and Pegeen all but let Peggy down when they were admitted by the butler. As Peggy tells it, "When we were in the elevator, my daughter of sixteen, who was accompanying me, suddenly burst out with, 'Mama, you lived in this house when you were a little girl?' I modestly replied 'Yes,' and to convince her added, 'This is where Hazel was born.' My daughter gave me a surprised look and concluded with this statement: 'Mama, how you have come down in the world.' From then on the butler, who was ushering us upstairs, looked upon me with suspicion and rarely admitted me to the house. However, my memories alone warranted my admission."

The house is still there, with its imposing facade. When Peggy lived in it, one entered through a glazed door to a porch, from which further glazed doors led to what Peggy called a "small" lobby, though it had a fountain, dominated by a stuffed bald eagle her father, strictly against the law, had shot at the family's summer retreat in the Adirondacks. The eagle had its heraldic broken chains at its feet, which showed that Ben had either had a keen sense of irony or none whatsoever.

The marble-clad vestibule contained a marble staircase that led to the *piano nobile*, where a large dining room "with panels and six indifferent tapestries" looked southward, while to the rear there was a small conservatory. The main floor also contained a reception room dominated by another tapestry, of Alexander the Great, and here it was that Peggy's mother gave a weekly tea party for the other ladies of the New York Jewish *haute volée*. Peggy, forced to attend these functions as a child and already feeling rebellion stirring within her, found them excruciatingly boring. This is not hard to understand, because the conversation, informed by the participants' obsession with social standing and correctness, was always about which people were on or off the visiting list, the quality of one's silver—it should be heavy but not *look* heavy—the quality but lack of ostentation of one's dress, what jewels to wear, what colleges were really acceptable for one's sons (Harvard and Columbia yes, Princeton no), and so on. Also important was whom to marry, and whom not to. You couldn't marry a Gimbel or a Straus, because they were "storekeepers." At the same time, because Gimbel's and Macy's were great rivals, no Gimbel ever married a Straus either. Then there was the question of the "old" New York Jewish families and the "new" ones—

approximately pre- and post-1880—a stratified snobbery that mirrored the English concept of "old" and "new" money, and that still exists today. The Guggenheims, arriving in New York relatively late, after the older Jewish clans had already formed their group, had to contend with this despite their wealth.

The chronicler of Jewish New York of the time, Stephen Birmingham, paints a telling picture of this closed society:

> In the evenings the families entertained each other at dinners large and small. The women were particularly concerned about what was "fashionable," and why shouldn't they have been? Many of them had been born poor and in another country, and now found themselves stepping out of a cocoon and into a new and lovely light. They felt like prima donnas, and now that their husbands were becoming men of such substance, they wanted to be guilty of no false steps in their new land. They wanted desperately to be a part of their period, and as much as said so. Beadwork was fashionable. One had to do it. It was the era of the "Turkish corner," and the ladies sewed scratchy little beaded covers for toss pillows. At one dinner party, while the ladies were discussing what was fashionable and what was not, Marcus Goldman rose a little stiffly from the table, folded his heavy damask napkin beside his plate, and said, "Money is *always* fashionable," and stalked out of the room.

In her reaction to all this, shared with her father who, significantly, not only got out of it but returned to a much more relaxed Europe, specifically France, Peggy's individualistic nature found itself—and she was a rebel too, though a reluctant one. Hers was a mixed nature and a mixed nurture: She was born into a nouveau riche bourgeoisie, but she had peasant roots. She never succeeded in shaking off either influence, though she had more success with the former, which was imposed, than with the latter, which was inborn.

The first floor of the house contained a further grand room—a Louis XVI "parlor," complete with mirrors and more tapestries. Even the furniture was covered in fake tapestry material, and every window in the house was draped with claustrophobic lace curtains in the German manner. Reading between the lines of Peggy's reminiscences, one can sense the repugnance she

still felt even as she wrote her descriptions almost half a century later. The parlor also contained a bearskin rug, whose snarling, open red mouth still contained its teeth and a plaster replica of its tongue, which kept breaking off, giving the head a "revolting appearance." The teeth worked loose from time to time as well, and had to be glued back in.

But this room and this floor contained poignant memories for Peggy. Apart from the moth-eaten bearskin, "There was also a grand piano. One night I remember hiding under this piano and weeping in the dark. My father had banished me from the table because, at the tender age of seven, I had said to him, 'Papa, you must have a mistress as you stay out so many nights.' " This innocent but perceptive remark was undoubtedly true, and in its precocious directness it gives a foretaste of the person Peggy was going to grow up to be. But there is another, pleasanter memory, which is described with keenly remembered yearning: "The center of the house was surmounted by a glass dome that admitted the daylight. At night it was lit by a suspended lamp. Around this was a large circular winding staircase. It commenced on the reception floor and ended on the fourth floor where I lived. I recall the exact tune which my father had invented and which he whistled to lure me when he came home at night and ascended the stairs on foot. I adored my father and rushed to meet him."

Peggy's parents had separate bedrooms and dressing rooms (Ben's dressing room adjoined Florette's bedroom, with its twin beds, in the approved nineteenth-century manner) on the third floor, and here too was the library, a necessary room in any well-heeled establishment whose owners wanted to make a good impression, though neither Florette nor Ben was a great reader. The room had a tigerskin on the floor and four *faux*-ancestral portraits of Peggy's grandparents on the walls. In this dismal place Peggy was condemned to eat. As a child she had no appetite, so a maid stood over her while she sat at a glass-topped Louis XV table and toyed with her meal. Peggy cried in protest as the food was spooned into her, and then threw up.

Apart from her parents' conventional and sometimes vulgar taste, it wouldn't take a Freud to deduce that Peggy's later love of vivid abstraction in art was a reaction to that gloomy library where she was force-fed, overseen by depressing portraits of her immediate forebears. Ben was a collector himself, and on this floor of the house hung a number of good paintings by Corot and a couple by Watteau. And the bright spot in Peggy's day was early in the evening, when she was allowed to play in her mother's room, lined in pink

silk, as Florette had her hair brushed before dinner by her French maid, "or by a special hairbrusher who came in for that purpose." She does not say if she ever shared this moment with Benita or Hazel.

The fourth floor of the mansion contained the children's rooms, and temporarily provided a sanctum for James Seligman during his retreat from his own home to the Netherland Hotel. Here the girls were attended by a succession of governesses and nurses, and given private tuition; Peggy didn't attend a school until she was fifteen, and in consequence looked back on a lonely and restricted childhood. Like her own mother, Florette never invited friends' children to her house, and the sisters had only one another's company. Benita must have been the loneliest of them, being those significant three years older than Peggy; and Peggy and Hazel seem to have been locked in a more or less unfriendly rivalry from their very earliest days.

The girls' unhappiness was compounded by the remoteness of their parents and the severity of their upbringing—a fate shared by so many children of that era. The narrow-minded and straitlaced Prince Albert had set the tone in Victorian England, and German ideas of education and disciplinary training had crossed the Atlantic with the Jewish German immigrants. The folk stories collected by the Grimm brothers, never intended for children, and containing a great degree of sadism and depravity, were routinely sold as nursery tales; Heinrich Hoffmann's admittedly satirical *Struwwelpeter* was first published in 1845 (it is still in print) to inculcate in children a proper sense of behavior by illustrating the dire consequences that await those who don't toe the line. A similar tone was taken by Wilhelm Busch in *Max und Moritz* twenty years later. Hideous punishments await the children who in the stories commit nasty tricks.

The violence implicit in the stories was often visited on children in real life. Ben and Florette may have cared for their children, but they were content to leave them for most of the time in the hands of their nurses and governesses, and these women proved at times to be as awful as the monsters of fiction. Peggy's cousin Harold Loeb vividly remembered a governess who would lock him in a cupboard and then insult his family through the door. Peggy remembered "a nurse who threatened to cut out my tongue if I dared to repeat to my mother the foul things she said to me." She was brave enough to ignore this injunction, and, to her credit, as soon as Florette knew the truth, the nurse was dismissed. But it is small wonder that the dark and narrow staircase that led to the fifth floor and the servants' quarters filled

Peggy's childish imagination with dread. As for the tutors, while it was Ben's intention to give his daughters the best education possible, there is little evidence in Peggy's or Hazel's later grasp of grammar that he got value for his money.

Discipline and education were not the only trials that had to be survived:

> I was not at all strong and my parents were perpetually fussing about my health. They imagined I had all sorts of illnesses and were forever taking me to doctors. At one period of my life, when I was about ten, they decided I had some intestinal disturbance and found a doctor who ordered me to have colonic irrigations. These were administered by Hazel's nurse and, as she was quite unqualified for her task, the result was catastrophic. I got an acute attack of appendicitis and was rushed off to hospital at midnight and operated on. For days I was kept in ignorance of the operation since they thought I was too young to be told. However, I did not believe their silly stories and insisted that my stomach had been cut open.
>
> Soon after this, my sister Benita developed the whooping cough and we had to be separated lest I catch it and cough open my newly healed, and let me add, enormous wound. My mother took a house in Lakewood, New Jersey, for herself and Benita, and I was sent to a hotel with a trained nurse. Needless to say I passed a lonely winter and only occasionally was I permitted to speak to Benita on the street and at a great distance. My mother had several nieces who were marriageable and she was perpetually giving house parties for them while she shut poor Benita up in a wing of the house. As a result Benita became melancholic.

There were compensations. Peggy added a note that indicates something of her future: "I must have been very precocious and spoiled, since I was allowed to visit my mother and entertain her visitors. I fell in love with one of them. His name was Max Rossbach and he taught me to play pool." She also mentions taking lessons with a girl called Dulcie Sulzberger (of the *New York Times* Sulzbergers), "she had two brothers who fascinated me, one in particular, Marion." At fourteen Peggy fell in love with her riding teacher, "a fascinating Irishman who flirted with all his pupils," after she had taken up

riding again following an accident. Her horse had bolted when disturbed by some roller-skating boys, thrown her, and dragged her by the stirrup in which her foot was caught. She damaged an ankle, broke her jaw, and lost a tooth. The rest of the story is another testimony to her early confrontation with pain, and there is a significant reference to her undergoing a "process of being beautified," which provides a clue concerning her lifelong preoccupation with and self-consciousness about her looks:

> A policeman, finding the tooth in the mud, returned it to me in a letter, and the next day the dentist, after disinfecting it, pushed it back into its original position. This did not end my troubles. My jaw had to be set. During the operation a great battle took place among the attending [dental] surgeons. Finally, one of them triumphed over the other and shook my poor jaw into shape. The vanquished dentist, who was called Buxbaum, never got over this. He felt he had superior rights over my mouth, as he had been straightening my teeth for years. The only good that came out of this was that it put an end to the agonies I had been suffering in the process of being beautified. Now that had to end. The first danger incurred was the possibility of being blood-poisoned. When that passed, the only risk I ran was of getting hit in the mouth and losing my tooth again before it was properly implanted. In those days my sole opponents were tennis balls, so that when I played tennis I conceived the bright idea of tying a tea-strainer in front of my mouth. Anyone seeing me must have thought I had hydrophobia. When it was all over, my father received a bill for seven thousand five hundred dollars from the dentist who had never admitted his defeat. My father persuaded this gentleman reluctantly to accept two thousand.

The young Peggy had other difficulties to surmount. All her life she suffered from weak ankles, and when, as a child, she was forced to go ice-skating in Central Park, her memories of the agonies of both cold and pain were such that she avoided the park ever after—though during her reluctant return to New York in World War II her friend and colleague the art historian and curator Alfred Barr did persuade her to visit it once more—"but everything had changed. Only the Ramble with its old castle remained, true

to my childhood memories." But the park wasn't all bad. Peggy remembered driving in it when very young "in an electric brougham" with her mother. She liked the look of "a certain rock on the East Drive that resembled a panther about to spring. I called it 'the cat' and whenever we passed it I pretended to telephone to it to say hello." There were other diversions. The actor William Gillette wrote and starred in a popular play about the Civil War called *Secret Service* in 1895, which played in New York when Peggy was a child: "I went to all his matinées and virtually screamed to warn him when I thought he was going to be shot by an enemy." And there were other early delights, which may not have compensated for the horrors but certainly prompted fond memories later:

> The only toys I can remember were a rocking horse with an enormous rump and a doll's house containing bearskin rugs and beautiful crystal chandeliers. The doll's house must have left me with a fearful nostalgia, because for years I tried to reproduce it for my daughter. I spent months papering walls and buying objects to furnish her house. In fact I still can't resist buying toys. I immediately give them away to children but I must buy them for my own delight. I also remember a glass cabinet filled with tiny hand-carved ivory and silver furniture, which had an old-fashioned brass key. I kept the cabinet locked and allowed no-one to touch my treasures.

The presence of an early car, and the casual knowledge of a telephone, as well as access to riding and tennis, to a little girl at the beginning of the twentieth century are indications of the world of privilege into which Peggy had been born. She enjoyed other benefits, which may not have compensated for the loneliness of her life and the nastiness of those in authority over her, but did widen her horizons. From very early on the girls were taken to Europe for the summers. Florette had plenty of Seligman relations—the family concern was by now an international merchant bank—in London and Paris, and they also took in the fashionable watering places and spas of France and Germany, Monte Carlo, and Vienna. Benita and Peggy especially benefited from this, as by the time Hazel was born Ben was beginning to show a greater preference for traveling alone. By 1904 Peggy's father had begun to take mistresses. There was even a live-in nurse, perhaps the first of many

amours, whose job was to massage Ben's head, since he suffered from neuralgia. Florette, never quite sure that the girl was her husband's lover, nevertheless blamed her for being an evil influence, and in the end she was dismissed. But Ben's sisters remained on good terms with the nurse, which turned Florette against them, and led to family arguments. "All this affected my childhood," remarks Peggy dryly. "I was perpetually being dragged into my parents' troubles and it made me precocious." She adds: "I adored my father because he was fascinating and handsome, and because he loved me. But I suffered very much as he made my mother unhappy, and sometimes I fought with him over it."

Her troubles also made her an intolerable and rude little girl. Ben was not the only one whom she insulted by her outspoken behaviour. She told one of her parents' friends that she knew her husband had run away from her, and asked another, whose command of English was not perfect, why he couldn't learn to speak it better. Hazel later reported that Florette tolerated this behavior adoringly, but she may have been influenced by childhood envy. Both the younger girls desperately needed the attention of an adult: Their older sister Benita, calm, beautiful, kind, and a little bit remote, was all that was available. Hungrily they vied for her attention.

On early European tours the two older girls, Peggy and her adored Benita, had their portraits painted in Munich by Franz Lenbach, a well-known and fashionable portraitist. He painted Peggy when she was four, and also did a double portrait of Peggy and Benita a year or so earlier. Peggy, while saying, probably truthfully, that the pictures were "the greatest treasures of my past," also complained that Lenbach "gave me brown eyes instead of green, and red hair instead of chestnut." But the great man was getting on by the time he met Peggy, and by that stage of his career he was increasingly finishing his portraits from photographs, which in those days were black-and-white. The portraits still exist, and are duly stately and decorative. Later in life Peggy, since Lenbach had dated one of them, had an artist friend paint out the date, for fear that people would see it and realize that she was older than she wanted to admit. Later still, discovering that Lenbach was most famous for his paintings of Bismarck, she had the same friend paint the date back in, for fear that people would think she was older than she was. If this story sounds apocryphal, we have the assurance of the artist concerned, Peter Ruta, that it is not.

While Florette's stinginess got her into trouble with hotel staff—she wouldn't tip, and that meant porters would mark the family baggage with discreet white crosses to ensure minimal service at their next destination—Ben was still taking care of his daughters' education. He had their tutor, Mrs. Hartmann, accompany them to Europe on their tour in about 1909. Mrs. Hartmann had broad authority: She took the girls to the main museums of Paris, and to the châteaux of the Loire, in those days not suffering from tourist saturation. She taught them French history and had them read the English nineteenth-century classics, as well as treating them to "a complete course in Wagner's operas." Peggy's mind, however, was elsewhere. She'd fallen for a friend of her father's called Rudi, who was traveling with them, as Florette was trying to matchmake between him and an older cousin of Peggy's, also brought along on the trip. Peggy became wildly jealous and wrote a series of letters, sadly lost, in which she went in for expressions like "my body was nailed to the fire of the cross." Despite these effusions—had she been reading *The Lustful Turk* secretly, along with Dickens and Thackeray and George Eliot?—she was still enough of a little girl to collect wax dolls and dress them, in clothes designed and made by herself, in a manner inspired by the ultrachic ladies of both the high society and the demimonde of Trouville.

There were other distractions. While having tea with Benita and their governess at Rumpelmeyer's in Paris, Peggy couldn't help noticing a woman at the next table who seemed equally interested in them. She must have had an intuition about the identity of the woman, and she knew her father had a mistress, so that months later, after she'd been pestering her governess for some time about the mistress's identity, and the governess finally replied, "You know her," Peggy realized she meant the woman at tea.

She was Countess Taverny, whom Peggy refers to as the Marquise de Cerutti in the first edition of her memoirs, and simply as "TM" in the second; and there was more than one embarrassing and unplanned meeting between them. Unsurprisingly people of fashion and money visited the same shops, and there was a disagreeable encounter between Florette and the countess at Lanvin's on one occasion. On another, when Florette was with Ben and they ran into Taverny in the Bois de Boulogne, Florette noticed her rival's expensive lamb's wool suit, knew who'd bought it, and protested to her husband about his extravagance. Ben, humbled, gave his wife a similar sum so that she could have a suit made for herself. Florette invested the

money instead. But by the time of the countess, Florette and Ben were virtually estranged. Divorce had already loomed when Ben had fallen for the sister of a brother-in-law, Amy Goldsmith. On that occasion disaster had been averted by the intervention of the Guggenheim family, which dissuaded Ben from being foolhardy, bought Amy off, and placated Florette. But by the time Ben died in 1912 the family had, effectively, broken up.

The St. Regis Hotel had been a center for great Guggenheim family get-togethers, a ritual performed every Friday evening; but once Florette had moved out she was set at one remove from the center of the Guggenheim clan, though she was still part of the family. Naturally for some time the idea of Atlantic crossings—quite apart from the expense—did not appeal, and so the family spent their summers at one or another of the more or less hideous Victorian-Gothic piles Guggenheims and Seligmans had built as country retreats at Jewish resorts just outside Manhattan like Deal Beach, Elberon, and West End. Peggy remembered the relatively modest pile belonging to her Seligman grandfather: "It was completely surrounded by porches, one on each floor. The porches were covered with rocking chairs where the entire family sat and rocked all day. It was so ugly in its Victorian perfection that it was fascinating."

This was nothing new; as children they had spent the summers that they did not go to Europe "on this horrible [New Jersey] coast." But the stifling atmosphere of these places bred in Peggy an abiding dislike of the United States, which was abetted by the still-prevalent anti-Semitism that had forced families like hers into self-imposed wealthy ghettos. Uncle Isaac Guggenheim, refused membership at the Sands Point Bath and Golf Club, built his own nine-hole golf course at his nearby estate of Villa Carola. When the hotel in nearby Allenhurst, which did not admit Jews, burned down one summer, the children watched the conflagration with delight.

By 1913 Florette was taking the girls back over to England to visit her Seligman relatives in Ascot, Berkshire. But then came an interruption to European travel in the form of World War I.

In the meantime Peggy ended private tuition and started going to the Jacoby School, a private establishment for rich Jewish girls on the west side of Central Park, across which she walked to school every day. It was more of a finishing school than a place of learning, for it was not considered that the girls who attended would ever have to do much; what was important was

how to behave, how to be decorative, and how to navigate the intricacies of etiquette and social convention that permeated New York society. Peggy would have become bored quickly if that had been all the place had to offer, but by luck the Jacoby's drama teacher, Mrs. Quaife, took to the mawkish fifteen-year-old, encouraged her to read Browning, and gave her the part of Amy in a school production of *Little Women*. In addition Peggy began what was to become a lifelong love affair with books. In her loneliness she had discovered the comforts of literature, and at the Jacoby she became acquainted with, and read and reread, most of the modern classics, from J. M. Barrie to George Bernard Shaw. More daringly she also read Ibsen, Strindberg, and Wilde, as well as Tolstoy and Turgenev. Soon she would develop a passion for Dostoevsky and Henry James that would never leave her, and in later life she would take periods of illness or enforced inactivity as opportunities to explore new authors such as Lawrence or Proust in depth. These literary interests might have taken her further. For a time she was tempted by the idea of going on to college, but Benita talked her out of it. Benita by now had an odd relationship with her younger sister. Although she was still the object of Peggy's adoration, it was becoming clear that Peggy was the dominant partner. Peggy took Benita's advice, but she regretted it. A lifelong autodidact, she always longed to be more learned than she was—or than she perceived herself to be. With her hunger for knowledge, it is a pity that she forewent such a chance.

Another important thing happened at the Jacoby: She began to make friends. This process was sadly interrupted almost immediately when she succumbed to whooping cough and had temporarily to be withdrawn from the school. As her illness coincided with Benita's "coming out" as a debutante—an event that occupied Florette's every waking minute—Peggy, swamped in self-pity, spent a "lonely and neglected" winter. During it she read a lot; reading in bed was something she always loved. Meanwhile her mother, always paranoid about infection, doused the place with Lysol and tried to take her daughter's temperature, with panic-stricken inefficiency.

Once she'd recovered Peggy returned to school and reentered its cultural and social life with a vengeance. She'd already discovered boys: One of her first loves was Freddy Singer, of the sewing-machine family, whom she met in England while staying at Ascot. This was innocent fun—she and Benita, who'd conveniently fallen for Freddy's older brother, had spent an agreeable early summer in 1914 playing tennis and dancing. War broke out in Europe

at the end of July, and a darker side of the sexual *corrida* manifested itself later in the year, in Kent, where Peggy's family were staying with other Seligman relatives. The man in question was a German medical student of American birth—and thus not interned. He played on Peggy's quivering and untried emotions, making her half terrified of being, and half longing to be, seduced. They later met again in New York, where he resumed his Svengali-like role. But by this time Peggy had wised up, and she diverted him to a nice cousin of hers, fifteen years his senior, whom he fell for and married. The marriage was a success, and they had twin girls.

In her second year at the Jacoby, Peggy organized a dance club that held a monthly ball. The girls were allowed to invite a couple of eligible young men to each dance, the choice being made from a list of boys who were auctioned off by Peggy; the two or three who received the highest bids were duly invited by the girls who'd bid successfully for them: "These parties were gay and really not at all stuffy." At the same time she developed a heavy crush on a friend called Fay Lewisohn. In her autobiography Peggy, always keen on a chance to *épater les bourgeois*, hints heavily at lesbian undertones, at least on her part.

In later life Peggy's opportunistic and rare forays into homosexuality are not in question, but Fay "was interested in young men." In fact she seems to have been a flibbertigibbet, but the two girls had one thing in common: a profound dislike of the constrictive society in which they lived.

Peggy had her first kiss in the summer of 1915, with a young man of whom Florette disapproved because he was "penniless." She probably disapproved of him even more because every evening he'd borrow her car to take Peggy out for a ride. Once he'd brought Peggy back, he'd keep the car to drive himself home, returning it early the next morning on his way to work in New York City. Things reached a crisis on the night of the first kiss. The young man and Peggy had driven back after their evening out and were in the car in the garage at the Guggenheims' out-of-town summer retreat. As he reached for her he inadvertently leaned on the horn, and its noise awakened Florette, who threw a tantrum: "Does he think my car is a taxi?" The young man fled, never to return. But Florette's judgment of him as penniless turned out to be ill founded, as he went on to inherit a million dollars. (Florette's social antennae were out of tune for once.) Peggy was not turning out to be the prettiest of girls, her fortune was not spectacular, and any decent match should not have been sneezed at.

Peggy left school in 1916 and made her debut into society. The venue was the Ritz Tent Room, but though she enjoyed the dancing, she found the life that followed vacuous. She took a course in stenography but gave it up after being frozen out by the poorer girls in the class, who resented her. The idea of getting a war job had, however, been planted in her mind. She never mastered typing (or spelling), though she laboriously typed all her letters on a venerable Remington until relatively late in life.

The same year, her grandfather James Seligman died, and with what he willed Florette the family's fortunes improved. They moved to 270 Park Avenue, near the corner of Forty-eighth Street. Here Peggy's wild streak led her into more trouble: "My mother permitted me to choose furniture for my bedroom, and I was allowed to charge it to her. But unfortunately I disobeyed her and went shopping on the sacred Day of Atonement, the great Jewish holiday *Yom Kippur*. I had been expressly warned not to do this and I was heavily punished for my sin." Her mother refused to pay for the furniture. Benita bailed her out, and not only that, she treated her to a makeover at Elizabeth Arden.

The United States entered World War I in April 1917, but Peggy had already been supporting the war effort before that. She began knitting socks for soldiers, and the activity became an obsession. She took her knitting with her wherever she went, even to dinner and to the theater. Before his death, her aged Seligman grandfather had complained about the expense of all the wool she bought. On a vacation to Canada she missed most of the scenery because she sat in the back of the car and knitted. Her attention was distracted only twice: by the nice Canadian soldiers in Quebec, and on the way home when, as Jews, the family was refused longer than overnight accommodation (obligatory by law) at a Vermont hotel.

Peggy took an official war job in 1918. Her duty was to advise and help newly recruited young officers to buy uniforms and equipment at the best rate—a job for which her family contacts made her eminently suitable. She shared it with a close school friend, who dropped out owing to illness. Peggy took on her workload, and with what was becoming typical application—anything to keep away from those suffocating salons—she overworked herself into a nervous breakdown. It's more than possible that her imagination cued the thought that some of the young men she was equipping would never return. Sent to a "psychologist," she told him she thought she was los-

ing her mind. "Do you think you have a mind to lose?" quipped the doctor, who evidently had not yet read the recently translated works of Freud. But Peggy provided a serious comment on the encounter, which gives a significant key to the future workings of her mind: "Funny as his reply was, I think my [concern] was quite legitimate. I used to pick up every match I found and stayed awake at night worrying about the houses that would burn because I had neglected to pick up some particular match. Let me add that all these had been lit, but I feared there might be one virgin among them."

Florette asked her late father's nurse, a Miss Holbrook, to look after her disturbed daughter. Slowly this sensible woman weaned Peggy from what had become a fantasy-identification with Dostoevsky's Raskolnikov, and brought her back to what passes for most of us as normal. During this psychological rite of passage, however, Peggy had—if she can be believed— become engaged to a pilot yet to be transferred overseas. But she adds: "I had several fiancés during the war as we were always entertaining soldiers and sailors."

Peggy turned twenty in August 1918, and two and a half months later the war came to an end. New York society settled back with relief. The fight was over, the danger was past, and the United States was much too far away from the carnage to have suffered any physical damage. Except for the bereaved families of the fallen, the distant European war seemed unreal—an awful event, better forgotten; and Jewish Germans were most anxious that no taint of the kaiser should attach to their names.

In one more year Peggy would reach her majority. Then she could really spread her wings.

five

Harold and Lucile

ℭlthough there wasn't a general penchant for marrying well-placed
Englishmen among the Guggenheim girls, several did manage it.
There was a pronounced anglophilia in some branches of the family.
Uncle Solomon adored Great Britain. He went grouse shooting in Scotland
and set up his aristocratic elder son-in-law as a beef farmer in Sussex by giv-
ing his daughter Eleanor what she later described as a "useful little cheque."
Eleanor married Arthur Stuart, the Earl Castle Stewart (the family seat was
in County Tyrone, Northern Ireland, until it was blown up by the IRA in
1973), and lived most of her life in England, a pillar of the Women's Institute
and a great contrast to her cousin Peggy, though one of her sons recalls that
she had even less time for Hazel. Solomon's daughter Barbara married
Robert J. Lawson-Johnston, who, though brought up as an American citi-
zen, had been born in Edinburgh (he was the son of the founder of the com-
pany that makes Bovril) and educated at Eton. Their son Peter was later
raised to the head of the Solomon Guggenheim concerns by his mother's
cousin Harry.

Uncle Solomon's third daughter, Gertrude, also lived in England, in a
house specially built for her by her father—Windyridge in Sussex, where
Eleanor's son Simon now lives—though few concessions were made for her
in its design. Gertrude was disabled and well below average height. She gave

her life to good works; during World War II she took in evacuees, and she habitually made it possible for underprivileged children from London's East End to take summer vacations with her in the country. "She used to take them through the millpond to get the lice off them," her nephew Patrick, Earl Castle Stewart, remembers.

This love of Britain and Ireland was partly motivated by a desire to disguise Jewish mainland European peasant antecedents, and went along with the desire to assimilate, to cease to be the target of anti-Semitism, against which no amount of wealth was proof. Within the society in which Peggy grew up, the marriage one made was crucial. It's probable that Florette and Ben, though less conventional than Ben's brothers, wished for similar marriages to those their cousins had made, for their three daughters. And Peggy and Hazel did grow up to feel a great affection for England.

But marriage was the last thing on Peggy's mind in 1918, and already she was showing signs of having no intention of following her mother and older sister into the social round of the New York Jewish upper crust. One influence in particular must have made Florette shudder, yet it was one that profoundly shaped Peggy's thinking, though she was never overtly political, at least until her middle years. Religious belief never played any role in her life whatsoever.

After her couple of years at the Jacoby School were over, Peggy was at a loose end. Her active mind had been stimulated in a way that could never now be satisfied by the narrow bounds of the society into which she had been born, and she took private courses in economics, history, and Italian. Through them she met a teacher called Lucile Kohn.

Kohn was Peggy's first mentor. In her mid-thirties by 1918, she had initially been a supporter of the Democratic president Woodrow Wilson, but, becoming disaffected with him during his second term of office, she had embraced the socialist cause. Kohn may have seen a disciple in the rebellious teenager before her, a poor little rich girl from a conservative background; but if she did, she sought to persuade by example rather than by proselytization. Kohn was a pragmatic socialist, believing that socialism was the only way to improve the lot of humankind. Peggy was not an immediate convert, but Lucile planted seeds in her mind that would grow and bear fruit in the future, though not in the way the teacher imagined. Later on, when Peggy had come into her inheritance and moved to Europe, she sent Kohn "count-

less $100s." Kohn was the first of many individuals whose talent Peggy thought worth supporting for a greater or lesser period of their lives, and Peggy's subsidy changed Kohn's life more than Kohn's influence changed hers, for it enabled her to devote herself to her chosen cause full-time. "As I look back over my long life (ninety years) I list the few people who made a tremendous change in my life," Kohn wrote to Peggy in 1973, "—a change for the better—and Peggy Guggenheim is one of the four." She told Virginia Dortch, "I really think we learned and felt together that people like the Guggenheims had an obligation to improve the world." This was an obligation to which the Guggenheims responded through a number of foundations and trusts set up when the various family fortunes had been made.

Peggy was politically influenced by Kohn, but she still didn't know what to do with herself. Together with a desire for education had come a desire to work, to occupy her life positively. She had had a run of boyfriends—whom, as we've seen, she called "fiancés"—during the war, but she was dismissive of them. Benita's marriage in 1919 to an American airman, Edward Mayer, who had just returned from Italy—a marriage of which Florette disapproved because Mayer did not come from the right background and had only a modest fortune—affected Peggy only in the sense that she felt abandoned by her sister. She disliked Mayer, and is profoundly unkind about him in her autobiography, though she was a witness at the City Hall wedding, together with a lifelong friend, also called Peggy (who would later marry Hazel's second husband after his divorce and one of the most traumatic episodes in the entire Guggenheim family story). Benita and Edward, who seems to have been, if anything, rather straitlaced, had a successful marriage, marred only by Benita's inability to have children. The marriage ended only with Benita's untimely death in 1927, following another unsuccessful pregnancy. Edward was even blamed for this, since it was felt that Benita should not have been permitted to try again for a child.

An outlet for Peggy's energies still didn't suggest itself, and in the summer of 1919, passing her twenty-first birthday, she came into the money she was due to inherit from her father. The timing was good, for it was seven years since Ben's death, and it had taken her Guggenheim uncles exactly that long to sort out his affairs. Half of the inheritance had to be maintained as capital in trust. The uncles sensibly suggested that the entire amount be absorbed into the trust fund, and Peggy just as sensibly agreed, with the result that her

capital yielded an income of about $22,500 a year—not bad in those days, even for a "poor" Guggenheim.

Hitherto in 1919, apart from Benita's wedding, the only major excitement had been winning first prize at the Westchester Kennel Club dog show with the family Pekingese, Twinkle—one of the first of many small dogs that Peggy would keep throughout her life. Now things could really take off. Above all she was legally independent and could free herself of her mother's influence—much to Florette's distress.

Peggy decided to embark on a grand tour of North America, taking as her companion a female cousin of Edward Mayer. They traveled to Niagara Falls, and thence to Chicago and on to Yellowstone National Park. After that they spent time in California, visiting the nascent Hollywood, which didn't impress her: She dismissed the film industry people she met as "quite mad." Then they dipped into Mexico, before traveling north along the west coast all the way to Canada. From there they returned to Chicago, where they rendezvoused with a demobilized airman, Harold Wessel, whom Peggy described as her fiancé. He introduced her to his family, whom she proceeded, perhaps deliberately, to insult, telling them with typical forthrightness that she found Chicago, and them, very provincial. As she prepared to leave on the train to New York, Wessel broke off the engagement, which didn't cause Peggy distress. She probably only became engaged to him to copy Benita, and was relieved to get out of it.

Peggy's allusions to fiancés and boyfriends and romantic—though still platonic—attachments are frequent and insistent enough to make one suspect that she was either protesting too much or trying to prove to herself that she was genuinely attractive to the opposite sex. If that was the case, the cause is not far to seek. All three sisters had been very pretty children, but while Benita and Hazel grew into beautiful women, Benita with a placid temperament, Hazel with an unruly and scatterbrained one, Peggy lost the early delicacy of her looks. With her lively eyes and a personality to match, her long, slim arms and legs, and her too-delicate ankles, her attractiveness was not in doubt; but she had one very serious flaw: She had inherited the Guggenheim potato nose. Now she decided to have something done about it.

Plastic surgery, not perfected until World War II, was in its infancy early in 1920, when Peggy went to a surgeon in Cincinnati who specialized in improving people's appearances. She had set her heart on a nose that would

be "tip-tilted like a flower," an idea she'd gotten partly from her younger sister's pretty nose and partly from reading Tennyson's *Idylls of the King*:

> *Lightly was her slender nose*
> *Tip-tilted like the petal of a flower.*

Unfortunately the surgeon, though he was able to offer her a choice of noses from a selection of plaster models, wasn't up to the job. After working on his patient for some time he stopped. Peggy was under only local anesthetic, which wasn't enough to prevent her from suffering great pain, so when the surgeon told her he was unable to give her the nose she'd chosen after all, she told him to stop, patch up what he'd done, and leave things as they were.

According to Peggy, the result was worse than the original, but to judge by the photographs taken of her in Paris by Man Ray only four years later, the nose is not as offensive as she makes it sound, though in the years that followed, it coarsened, and she was careful to avoid being photographed in profile. She made light of the whole experience, which was brave of her, given that she also tells us that her new nose behaved like a barometer, swelling up and glowing at the approach of bad weather. It is hard to judge from "before" and "after" pictures whether the surgeon actually altered her nose all that much. Its shape was inherited by her son Sindbad. One person who knew her well in later life wonders if the whole story of the nose job wasn't an invention, but this seems unlikely. Peggy was obsessed with the shape of her nose, and with the idea that because of it she was ugly. It has been said that she was still thinking of having a fresh operation late in life, though her nose never impeded her sex life (something that was extremely important to her); and by the 1950s, when cosmetic surgery was much safer and more predictable, she had moved on emotionally and psychologically from serious concern about such things.

People were cruel about Peggy's nose throughout her life. In the thirties Nigel Henderson, the son of her friend Wyn, said that she reminded him of W. C. Fields, and the same resemblance was called to mind by Gore Vidal decades later. The painter Theodoros Stamos said, "She didn't have a nose—she had an eggplant," and the artist Charles Seliger, full of sympathy and regard for Peggy, remembered that when he met her in the 1940s her nose was red, sore-looking, and sunburned: "You could hardly imagine anyone

wanting to go to bed with her, to put it cruelly." Peggy's heavy drinking during the twenties, thirties, and early forties didn't help. And however much she made light of what she regarded as an impediment, there is no doubt that the shape of her nose reinforced her low self-esteem.

Notwithstanding his failure the surgeon relieved her of about $1,000 for the operation. Bored and in need of consolation, Peggy took a friend to French Lick, Indiana, and proceeded to gamble away another $1,000 before returning to New York, still with little or no idea of what to do with herself, though some of the seeds Lucile Kohn had planted were showing signs of sprouting. Margaret C. Anderson, founder-editor of the then six-year-old *Little Review*, perhaps prompted by Kohn, approached her for money and an introduction to one of her moneyed uncles. Peggy didn't help with cash, but sent Anderson off to Jefferson Seligman, in the hope that even if she didn't get the $500 she sought, she might at least get a coat out of the uncle.

The *Little Review* was one of the most important and long-lived of the literary and arts magazines that flourished in the first half of the twentieth century, before most of them were superseded by television. It moved home in the course of its fifteen-year life from Chicago to San Francisco, thence to New York, and finally to Paris, publishing many of the great names of contemporary literature, including T. S. Eliot, W. B. Yeats, William Carlos Williams, Ford Madox Ford, and Amy Lowell. Ezra Pound was its foreign editor from 1917 to 1919, and its major claim to fame was its serialisation, beginning in 1918, of James Joyce's *Ulysses*. It may seem odd that Peggy was not keener to associate herself with a review that was concerned with so many of the people and ideas she was soon to embrace; but it wasn't long before she became involved, albeit tangentially, with the literary world.

Needing above all to work, and to meet people outside her immediate social circle, Peggy took a job with her own dentist as a temporary nurse-cum-receptionist, filling in for the regular girl, who was out sick. The work came to an end when the proper nurse returned, much to Florette's relief; she hadn't liked the idea of her friends and acquaintances discovering that one of her daughters was working as a dental nurse. Florette's relief was, however, short-lived. Peggy now took a much more significant, though unpaid, job, as a clerk in an avant-garde bookshop, the Sunwise Turn, not far from home, in the Yale Club Building on 44th Street. The bookshop was run by Madge Jenison and Mary Mowbray Clarke. Clarke was the dominant partner, and ran the store as a kind of club. She only sold books she believed

in, and literati and artists were constantly dropping in and staying to talk. Peggy quickly found that here was a society to which she wanted to belong.

She'd gotten the job through her cousin Harold Loeb, seven years her senior, who had injected $5,000 into the Sunwise Turn when it ran into financial difficulties, and was now a partner in the enterprise. Harold was the son of Peggy's aunt Rose Guggenheim and her first husband, Albert Loeb, whose brother James was the founder of the Loeb Classical Library.

Harold inherited a strong literary inclination. He joined the great exodus of young Americans to Europe in the early 1920s, published three novels and an autobiography, and founded and ran, first from Rome and then from Berlin, a short-lived but immensely important arts and literature magazine called *Broom*, which published, *inter alia*, the works of Sherwood Anderson, Malcolm Cowley, Hart Crane, John Dos Passos, and Gertrude Stein. Aimed at an American readership, *Broom* also ran reproductions of works by such artists as Grosz, Kandinsky, Klee, Matisse, and Picasso, all then little known in the New World, and many of whom were still struggling for recognition in the Old. It was always a struggle to keep *Broom* afloat, and at the outset Harold appealed to his uncle Simon for funds. This may not have been tactful. Harold belonged to another "poor" Guggenheim branch—his mother had been left only $500,000 by her father. Uncle Simon had given him a well-paid job with the family concern as soon as he graduated from Princeton, but a life in business had not suited Harold at all and he had left to become, to all intents and purposes, a bohemian. His request was frostily rejected: "I have since discussed with all your uncles the question of the endowment you wished for *Broom*, and I am reluctantly obliged to inform you we decided we would not care to make you any advances whatsoever. Our feeling is that *Broom* is essentially a magazine for a rich man with a hobby. . . . I am sorry that you are not in an enterprise that would show a profit at an earlier date."

Harold had already left for Europe, where his uncle's letter reached him. He replied sharply: "From what little I know of your early career, it seems to me that you have more than once chosen the daring and visionary to the safety-first alternative. . . ." He did not get a reply.

The biographer Matthew Josephson was an associate editor of *Broom* as a young man, and a recollection in his memoirs provides an interesting footnote to this contretemps:

The curious thing about this episode is that a while later those same hard-boiled Guggenheim uncles of his wound up by imitating their poor relation Harold Loeb, and becoming patrons of the arts on a gigantic scale. Beginning in 1924, Uncle Simon donated some $18 million to the John Simon Guggenheim Memorial Foundation [named for one of his sons who had died of pneumonia in 1922, aged seventeen] which provided fellowships for hundreds of artists and writers, including quite a number of contributors to *Broom* whom Simon Guggenheim had formerly been unable to understand.

Broom ceased publication in 1924, and it was then that Harold went to Paris to work on his first novel. There he met the young Ernest Hemingway. Hemingway had had a few stories and poems published, but was still feeling his way as a writer. He was ambitious and insecure. What started as a friendship developed into rivalry and ended in an unpleasant schism.

The bottom line is that Hemingway was envious of Loeb, who was both better educated and richer than he was. Loeb could and did outbox the boastful Hemingway, and he was a better tennis player. He also had more success with women, and at the time it looked as if he would outstrip Hemingway as a writer. When a party was made up to go to the running of the bulls in Pamplona, which Hemingway had attended before, and on which he held himself to be an expert, Loeb actually grappled a bull, was lifted aloft as he gripped the animal's horns, then managed to disengage successfully, landing on his feet, eyeglasses still securely on his nose. The crowd roared its approval. Hemingway, whose association with bulls was limited to talking about them and watching them die (something Loeb found distasteful), couldn't forgive the perceived humiliation—the more so since Harold was making headway with Lady Duff Twysden, whom Hemingway had also hoped to impress.

Loeb did not set out to needle Hemingway, but the younger man's resentment ran deep, and spilled out in his first novel, *The Sun Also Rises* (1926), in which a number of those present on the Pamplona trip in the summer of 1925 are cruelly portrayed; but none more so than Loeb, who appears in the book as Robert Cohn. Written in hot blood—Hemingway finished the novel in late September 1925—*The Sun Also Rises* appears today so anti-Semitic

(even when one allows for a period when anti-Semitism was, in certain circles, semiacceptable) as to beggar belief. The real focus for Hemingway's hatred of Cohn lies in the fact that he was in all ways bested by Loeb. Loeb rose above it, but never in his long life (he died in 1974) got over the betrayal.

The extent to which Hemingway caused offense is best described by Matthew Josephson:

> After *The Sun Also Rises* came out, Harold said no more about Hemingway. Their friendship was ruptured. It seemed that in completing his story of the so-called "Lost Generation," the young novelist had painted his circle of friends in Paris from life . . . there were at least six of [the novel's] characters who recognised themselves in its pages and set off in search of the author in order to settle accounts with him, according to the reminiscences of James Charters [Jimmie the Barman], a retired English pugilist who was Hemingway's favorite barman in Paris. . . .
>
> I had paused for a moment at the bar of the Dôme for an apéritif, and stood beside a tall slender woman who was also having something and who engaged me in conversation, at once informed and reserved. She had a rather long face, auburn hair, and wore an old green felt hat that came down over her eyes; moreover, she was dressed in tweeds and talked with an English accent. We were soon joined by a handsome but tired-looking Englishman whom she called "Mike," evidently her companion. They drank steadily, chatted with me, and then asked me to go along with them to Jimmy's Bar near the Place de l'Odéon, a place that had acquired some fame during my absence from France. In a relaxed way we carried on a light conversation, having three or four drinks and feeling ourselves all the more charming for that. Then Laurence Vail came into the bar and hailed the lady as "Duff." At this, I began to recall having heard about certain people in Paris who were supposed to be the models of Hemingway's "lost ones"; the very accent of their speech, the way they downed a drink ("Drink-up-cheerio"), and the bantering manner with its undertone of depression. It was all there.
>
> Suddenly Harold Loeb himself strode in vigorously, saw Duff, and stood stock-still; he had evidently heard she was in town and

gone looking for her. He sat down at our table and said little, but looked his feelings much as Robert Cohn was described as doing. Duff's English friend then made little signs of irritation at Harold's presence (quite as in the novel). Laurence Vail ventured the remark: 'Well now, all we need is to have Ernest drop in to make it a quorum.'

Laurence Vail was one of the people Peggy met and was fascinated by during the time she worked at the Sunwise Turn, and he was the one destined to have the most profound effect on her life; but at the time there were plenty of others: the poets Alfred Kreymborg and Lola Ridge were frequently there, as were the painters Marsden Hartley and Charles Burchfield, and, among the writers, F. Scott Fitzgerald. Peggy idolized Mary Mowbray Clarke, who became a role model for her as a liberated woman and a friend of artists.

Peggy, though she had no idea of how to mix with these new and intriguing people, and though she came to work swathed in scent, wearing pearls and "a magnificent taupe coat," still had to work. And it wasn't always fun. Her mother was suspicious of the bookshop and constantly popped in to check up on her daughter, embarrassing her by bringing her a raincoat if the weather turned bad, and irritating her with her questions. Equally embarrassing, though welcome to the bookshop (which throws a sidelight on Clarke), was a succession of Guggenheim and Seligman aunts who ordered books by the yard to fill up the shelves of their apartments and houses. These books were never intended to be read: They were a kind of wallpaper.

The work itself was mainly dull, routine filing, but Peggy did it willingly, for the joy of being in such a place more than compensated for the grind. One thing she did resent, however, was that she was only allowed down into the shop itself, from the gallery where her desk was, at lunchtimes, and even then she was only allowed to sell books if no one else was on hand. Whether Clarke considered her too much of a greenhorn or too much of a liability if let loose on the floor of the shop is unclear.

However, Peggy did gradually get to meet the people she wanted to meet, and she softened any reservations Clarke had by being not only a good employee but a good customer. In lieu of a wage, she was allowed a 10 percent discount on any book she bought. To give herself the impression of getting a good salary, she bought modern literature in stacks and read it all with her usual voraciousness.

Among the other luminaries who frequented the Sunwise Turn were
Leon and Helen Fleischman. Leon was a director of the publishers Boni
and Liveright, and Helen, who like Peggy came from a leading New York
Jewish family, had embraced the bohemian life. Following one of the fash-
ions that succeeded the social upheaval marked by the end of World War I,
Leon and Helen played at having an open marriage. Peggy, who latched
on to them as substitutes for Benita, whom she still missed bitterly,
promptly fell for Leon. In a passage omitted from the bowdlerized 1960
edition of her autobiography, she tells us: "I fell in love with Leon, who to
me looked like a Greek God, but Helen didn't mind. They were so free."
We do not learn whether or not the crush led to any kind of affair. Peggy
then was more interested in settling into and being accepted by an artistic
milieu.

The Fleischmans introduced Peggy to Alfred Stieglitz. Stieglitz, then in
his mid-fifties, was a pioneer of photography and the founder of the avant-
garde Photo-Secession group. Leon and Helen took Peggy to meet him at
291, his tiny gallery on Fifth Avenue. How formative the meeting was at the
time for Peggy we do not know, but Stieglitz, whose interests were not con-
fined to photography, was the first to show Cézanne, Picasso, and Matisse in
the United States, and at the time of their meeting was increasingly inter-
ested in modern abstract art. The 291 Gallery became an important center
for avant-garde painting and sculpture, and on this occasion Peggy had her
first experience of it. She was shown a painting by Georgia O'Keeffe, later
Stieglitz's wife. We are not told what the picture was, but it was clearly an
abstract, because Peggy "turned it around four times before I decided which
way to look at it." Her response must have been positive, because the reaction
of her friends and of Stieglitz was one of delight. Peggy further tells us that
although she didn't see Stieglitz again for another twenty-five years, "when I
talked to him I felt as if there had been no interval. We took up where we left
off." By then, of course, Peggy had become a *doyenne* of modern art herself.
But was seeing the O'Keeffe her epiphany? Or did abstract painting simply
provide a focus for her rebellious spirit, symbolizing as it did the unconven-
tional and questioning psyche of her new friends, with whom she was begin-
ning to feel more and more at home? It would still be a long time before her
own association with modern art began, and as she was never a reflective
person, it's possible that epiphanies, whether conscious or unconscious, were
not in her line.

What she wanted was to belong. What got in the way was her own inability to give.

Laurence Vail was also a friend of the Fleischmans. He was the son of an American mother and a Franco-American father, and although he was an American citizen, he had been brought up in France and educated at Oxford, where he studied modern languages. Fluent in English, French, and Italian—he served as a liaison officer in the U.S. Army with the heavy artillery during the war—European in manner, speaking with an Anglo-French accent, he could be charming and debonair. He turned twenty-nine in 1920, but still had not found his way into any particular artistic field, though there was no doubt that it was in the arts that his talents lay, being both a passable painter and, which seemed to be his forte, a writer. Based in Paris, he was in New York because a short play of his, *What D'You Want?* was to be produced by the Provincetown Players, an innovative group with their roots in Provincetown, Massachusetts, but who by now were producing work at the Playwrights' Theater in Greenwich Village and at the Greenwich Village Theater. Vail's one-acter was to be performed as a curtain-raiser to a Eugene O'Neill play. In Vail's cast was a woman who would later play a significant part in Peggy's life, Mina Loy. Vail also had a bit part in O'Neill's *The Emperor Jones*, already a Provincetown success, now playing in New York.

Greenwich Village had begun to fill with artistic life. Rents were low, and word spread. Perhaps the most striking single symbol of the new order in New York, though far from the most important, was a German, the Baroness Elsa von Freytag-Loringhoven. She had drifted from an unhappy and poor home into prostitution, but later managed to enrol as an art student in Munich, whence she moved via a wretched marriage into German literary circles. A colorful lover brought her to America as he sought to escape the clutches of the police at home, but he abandoned her in Kentucky in 1909. The thirty-five-year-old Elsa made her way to New York, where she married the impoverished exiled German baron from whom she got her title. He left her at the outbreak of war and killed himself in Switzerland at its end. Remaining in New York, she drifted into modeling for artists, lived hand-to-mouth, was adopted as an occasional contributor and cause célèbre by the *Little Review*, and turned herself into the living embodiment of the age. To visit the French consul she wore an icing-sugar-coated birthday cake on her

head, complete with fifty lit candles, with matchboxes or sugarplums for ear-
rings. Her face was stuck with stamps as "beauty spots" and she had painted
her face emerald green. Her eyelashes were gilded porcupine quills, and she
wore a necklace of dried figs. On another occasion she adopted yellow face
powder and black lipstick, setting the effect off with a coal scuttle worn as a
hat, and on yet another—and this was in 1917—she met the writer and
painter George Biddle dressed in a scarlet raincoat, which she swept open
"with a royal gesture" to reveal that she was all but naked underneath:

> Over the nipples of her breasts were two tin tomato cans, fastened
> with a green string about her back. Between the tomato cans
> hung a very small birdcage and within it a crestfallen canary. One
> arm was covered from wrist to shoulder with celluloid curtain
> rings, which she later admitted to have pilfered from a furniture
> display in Wanamaker's. She removed her hat, which had been
> tastefully but inconspicuously trimmed with gilded carrots, beets
> and other vegetables. Her hair was close cropped and dyed ver-
> milion.

This true original could not last. Living as she did in squalor, and always
in trouble with the police, her popularity faded with her looks, and her mind
gradually crumbled. Abandoned by all but a few, one of them being the nov-
elist Djuna Barnes, she made her way back to Europe, where she ended up in
dire poverty in Potsdam. Her body was found shortly before Christmas 1927,
her head resting in a gas oven. Peggy never knew her, but she heard of her,
and was fascinated and scared of such a complete personification of non-con-
formity.

It wasn't just in Greenwich Village that America was enjoying the sense
of relief and the economic boom that followed the war. This revolution had
started before the war, finding its greatest expression in the visual arts and in
music. Modern art really was new then. In the time of the frock coat and the
hobble skirt, of the horse-drawn carriage and the steam engine, cubism was
born, and Stravinsky wrote *The Firebird*. There had never been an artistic
revolution quite like it.

It was fired by World War I, which speeded up similarly revolutionary
technological progress, but Picasso and Braque were painting cubist pictures
well before 1914, and in Italy, Balla and Severini were experimenting with

arresting the visual impression of movement while motion photography was still in its infancy. The period around the turn of the nineteenth and twentieth centuries was one of frantic technological progress, yet in 1920 the bicycle was still one of the fastest modes of transport, air travel was unknown to all but a few, and cars, telephones, and radios were rare. The telegraph had been developed further during the war but was not yet in common use. The *Titanic* was the first to transmit SOS signals as it sank. There was no television yet. Computers as we know them lay far in the future.

Peggy was born in the Victorian era. By 1920 she was in the Jazz Age; her life had been contemporaneous with the transition, and, having the will, she moved effortlessly with the times.

In the meantime a party was in progress. In the few years following 1918, American women changed their wardrobe by 45 percent: The sartorial revolution typified by the flapper showed how strong the desire was to get away from the prewar atmosphere, with its restrictive morals, nationalism, class divisiveness, and provincialism. When the conservative establishment tried to curb the new and alarming tendencies, most obviously in a fundamentally puritanical America by introducing the prohibition of alcohol nationwide in 1920, the result was an unprecedented crime wave and a record increase in the consumption of alcohol.

Nothing could stopper the bottle again. The genie had been let out. Peggy was a child of her time; and along with many young Americans, she didn't just bob her hair, wear short skirts, and dance and drink—she left.

Departure

eggy, still living at home, began to feel that the boundaries of the Sunwise Turn were also too narrow. She liked Laurence Vail, responding to his European manner and finding him less daunting than most of the habitués of the bookshop. Now, to Florette's great relief, her daughter announced her intention of giving up work. Instead she wanted to travel. She had been to Europe frequently as a girl, but not yet as a woman. The idea seemed to Florette to chime more harmoniously with her idea of what Peggy should be doing. Florette was unaware of the influence Laurence's acquaintance had had on her; though it is just as likely that Peggy's decision to go abroad was based on her cousin Harold's own imminent departure.

Greenwich Village had been an undiscovered country for Peggy, but her sympathies lay with those who lived there. Many young male artists had been hardened in the fire of the war, but everyone was enjoying the euphoria that followed it, and many were also enjoying the economic boom it had created. Men who had served either in the army or with the ambulance corps in Europe had had their first experience of the Old World, and had liked what they saw.

There had been precursors. Henry James had left America for Europe in 1875, and Gertrude Stein settled in Paris in 1902. The painter Marsden Hartley had lived in Berlin before World War I, and when his German lover, an

infantry officer, was killed during it, his death inspired Hartley to carry out a moving series of paintings. To someone from provincial America, New York was stunning enough, and provided a kind of halfway house; but for the artist the attractions of such cities as Paris, Rome, Berlin, and London were irresistible.

It was Paris that most of them had gotten to know, and it was to Paris that they wished to return. France quickly became the focus of artistic expression in Europe after the war—an expression that reflected both disenchantment with the established order, which the war had called into question, and the joy of freedom that succeeded it. Paris was at its center, and for young artists from America there was an added, practical dimension: In the 1920s one dollar bought twenty French francs, and though this dropped back to fourteen francs, there it stabilized. You could live easily and even well on five dollars a day in France, including hotels and traveling expenses. The cost of living in general was half that in the United States. Matthew Josephson reports that a liter of Anjou wine could be had for nine centimes, and a good meal for two would cost only between two and three francs; John Glassco and his friend Graeme Taylor stayed at the Hôtel Jules César in Paris for the equivalent of twenty dollars a month, and breakfast in bed only cost fifteen cents a day on top of that.

Peggy, with a private income of more than $20,000 a year, could look forward to living as well as she pleased. But the money was a mixed blessing. Unlike the people with whom she sought to associate, she had no need to earn a living.

Three of Peggy's close contemporaries with whom her life was to interact, the poet and designer Mina Loy and the writers Djuna Barnes and Kay Boyle, were all aware of nascent feminism, in the form of woman suffrage and a consciousness that women artists should achieve the same recognition as men. In 1913, as an eleven-year-old, Boyle had been taken by her ambitious and artistic mother to the Armory Show in New York, an influential exhibition staged by the Association of American Painters and Sculptors, of which Alfred Stieglitz was honorary vice president, that put on show more than 1,100 international modern works of art. Peggy, about fifteen at the time, did not have the advantage of such a parent, and was scarcely feeling her way toward an artistic sensibility then. The somewhat older Mina Loy (she was born in London in 1882) was living in Florence when the Armory Show was on, but her friend, the iconoclastic Mabel Dodge, was closely

involved in its inception. Mina, furthermore, had already spent some time, in 1900, at the Künstlerinnenverein in Munich, the academy for women artists founded in the year of her birth.

The real point here is that all these women had an early association with the artistic world, wanted to join it as active artists, and had to work for a living. Barnes never married, but Boyle and Loy did and, like Peggy, were poor mothers. Had they been born in a later age it is open to question whether they would have had families at all. They were essentially independent spirits, and they would not be fobbed off with the "image" of emancipated womanhood portrayed in the drawings of Charles Dana Gibson. The Gibson girl may have been self-assured and vivacious, but she was still an idea of women as men would like them to be. She had none of the muscle of the suffragette. Women had a long struggle ahead of them, and it would take at least another sixty years before they even began to enjoy some truly equal rights, in the Western world at least. In artistic circles as elsewhere, men held sway, and male artists were more often than not sexual chauvinists. Peggy has been presented as a protofeminist. She was never anything of the sort. But she did make her presence felt, and asserted her independence.

But not yet. Nor was she as free of her mother as she would have liked to be or cared to admit. When she started her preparations for departure to Paris, her plans included Florette and a cousin of Peggy's aunt Irene, Valerie Dreyfus, as traveling companions. Nor of course were they destined for the Left Bank.

part two

Europe

Soon after, I went to Europe. I didn't realize at the time that I was going to remain there for twenty-one years but that wouldn't have stopped me. . . . In those days, my desire for seeing everything was very much in contrast to my lack of feeling for anything.

<div align="right">

PEGGY GUGGENHEIM,
Out of This Century

</div>

Paris

*T*he first trip was a toe-in-the-water affair—Peggy isn't being entirely truthful when she says she didn't return to the United States for twenty-one years. What is more important is that, whether the encounter with the Georgia O'Keeffe abstract kindled an interest in modern art or not, a desire to know more about painting was growing within Peggy by then.

She sailed with her mother and Valerie to Liverpool. From there they visited the Lake District, then took a tour of Scotland, and meandered through England before crossing to France and "doing" the châteaux of the Loire. By the time they arrived in Paris, Florette was exhausted and only too happy to settle down in the Crillon, then as now one of the most expensive and most agreeable hotels in Paris, and still as far a cry from the Left Bank as it was then. Peggy had quickly developed a passion for travel and the new experiences it brought. Valerie, already an experienced traveler, shared her enthusiasm, and guided her through Belgium and Holland, and afterward Italy and Spain. In 1920–21, they were in the vanguard: Europe lay before them unspoiled and unexplored.

Above all their exploration was centered on art. Just as she had felt at home among the people who had frequented the Sunwise Turn, now Peggy felt at home in Europe, the land of her grandparents, which she had liked as

a child, and after four years' separation because of the war, now found that as an adult she adored. "I soon knew where every painting in Europe could be found, and I managed to get there, even if I had to spend hours going to a little country town to see only one."

Valerie may have been a valuable cicerone, but as far as art was concerned another figure was more significant. He was Armand Lowengard, the nephew of Sir Joseph Duveen. (Duveen, later elevated to the peerage, was a noted art dealer and a friend of the English branch of the Seligman family. His name is commemorated in the Duveen Galleries at the British Museum, his gift to that institution, which house the Elgin Marbles from the Parthenon.) Armand was a great aficionado of Renaissance Italian painting, but when they met in France, he told Peggy that she would never be able to understand the work of the art historian Bernard Berenson. This fired her up: "I immediately bought and digested seven volumes of that great critic." She read about what to look for in a painting—tactile values, space-composition, movement, and color—absorbed her lessons, and tried to apply them. Later in life she met the great man himself, who was horrified by modern art (though he noted a tapestrylike quality in the work of Jackson Pollock), and was able gently to tease him.

No doubt Peggy was sincere in her desire to learn, but she was also no slouch when it came to self-aggrandizement. From the well-used library she left at her death, one can see that she'd read all the great art historians and critics of her day, but along with her interest in paintings, she was becoming equally interested in sex. She was certainly too much for Armand: "My vitality nearly killed him and though he was fascinated by me, in the end he had to renounce me, as I was entirely too much for him."

In Paris there were other diversions and at least one other boyfriend. Peggy mentions a boy called Pierre who was "a sort of cousin of my mother's." Whoever he was, she boasts that she kissed him on the same day as she kissed Armand, and displays a naive guilt at being so daring. There were the fashion houses to explore and enjoy with a Russian girlfriend she had made, Fira Benenson. Peggy took Russian lessons so that Fira could have no secrets from her, but did not get very far. They visited Lanvin, Molyneux, and Poiret, dressed to kill, and vied with each other in collecting proposals of marriage. But they had a good, conventional, rich-girl time at the Crillon, under the protective eye of Florette. As far as Peggy's interest in

art was concerned, there was no problem. Uncle Solomon's wife, Aunt Irene (Valerie's cousin), was a collector of Old Masters and had a good eye.

This pleasant idyll, which lasted the better part of nine months, was interrupted by a brief return home to attend the wedding of Peggy's younger sister, Hazel. Hazel was marrying within "the Crowd": Sigmund M. Kempner was a respectable graduate of Harvard, and Florette was probably relieved to see her maverick youngest daughter safely wed. Peggy remained a bit of a wild card, but with luck she would soon follow her sisters' examples. Meanwhile, Benita was failing to produce an heir, and, given her delicate constitution, that was a worry.

Hazel's wedding took place at the Ritz-Carlton in New York at the beginning of June 1921. The marriage lasted a year, and for her it was the first of seven. For the moment, though, Florette was content.

Back in New York, Peggy renewed some old acquaintances, among them the Fleischmans. Leon had by now resigned from Boni and Liveright, and the couple had produced a baby. They had little money and no clear idea of what to do next, so when Peggy suggested that they join her when she returned to Paris, they accepted her invitation gladly.

Peggy couldn't wait to get back. In Europe, and especially in Paris, she had encountered none of the stuffiness and none of the anti-Semitism she associated with home. It is true that she hadn't entered the *vie bohème* at all, but the Fleischmans would be more stimulating companions than her mother or even her second cousin. However, Florette and Valerie were not left behind when Peggy returned to Paris, and the only immediate change was of hotel—instead of the Crillon, they stayed at the Plaza-Athénée.

Paris itself was changing fast. Americans of Peggy's generation were forming colonies in Montparnasse, where the rents were low, and around what was then the Hôtel Jacob on the rue Jacob, just north of the boulevard St.-Germain; but as we've seen, arrivals in 1921 were still in the vanguard. U.S. land forces had taken an active part in the fighting for only the last four or five months of the war. The traumatic losses sustained by the British, French, and Germans over four years had not been experienced by the Americans, who came to the Old World fresher, richer, and more innocent than the people they discovered there. In return for their curiosity they learned to be more cosmopolitan, to shed prejudices, and to lose their fear of

the unknown. They came into contact with the artistic influences that were part of their heritage, but from which distance had set them apart. The United States, just over 140 years old in 1920, was confident enough to start tracing its own roots. The people born around 1900 were the ones to do it, and at the same time to throw off the bourgeois and materialistic values of their parents. More prosaically, they could live very well indeed on a very few dollars, and unlike at home they could get a decent drink without risking their livers on bathtub gin. Many of them lived on allowances from those same "rejected" parents.

The war had shaken many beliefs to the core. No longer could anyone say that "history is bunk," or get away with a blind belief in scientific progress. The flower of young European manhood had been killed off. There was a surge of interest in mysticism. Theosophy, which leaned toward Buddhism in an attempt to synthesize man's aspirations with the greater forces of nature and the Supreme Being, and theories of universal brotherhood, already promoted in the nineteenth century by Helen Blavatsky and later on by Annie Besant and Sir Francis Younghusband, was much in vogue. Brancusi, Kandinsky, and Mondrian were all Theosophists; there were few practicing Christians among the modern artists. Besant declared the Indian Jiddu Krishnamurti to be the new saviour, and for a time he enjoyed a huge following. Charlatans like Ivan Gurdjieff and Raymond Duncan (the brother of Isadora) flourished as the idea of communes and a return to the simple life took root. Spiritualism became such a vogue in the United States that Harry Houdini made a second career out of exposing fake mediums. The Dadaist movement, born in Zurich during the war, mocked and questioned everything, but the old order was its particular target. There were other potent influences. The Communist revolution had taken place in Russia, and in 1913 Freud's *Interpretation of Dreams*, which was to have such an influence on the surrealists, appeared in an English translation.

The term "lost generation," which was applied to the young postwar American émigrés in Europe, to whom Peggy was soon to attach herself, derives from a disparaging remark Gertrude Stein made to Hemingway when he, the painter André Masson, and the poet Evan Shipman arrived late and drunk at one of her salons. As Masson and Shipman later related the story to Matthew Josephson, Stein had said, "*Vous êtes tous une génération fichue.*" Stein got the expression from her garage mechanic, who used it to describe his apprentices.

Stein had arrived way ahead of the postwar émigrés, and as a patron of painters she quickly established friendships with many of them, notably Picasso, Matisse, Masson, Picabia, Cocteau, and Duchamp. Among the other prewar arrivals in Europe were the poets Ezra Pound, T. S. Eliot, Hilda Doolittle ("HD"), and Robert Frost. In England, Eliot integrated completely and later became naturalized, but few of the others cut their links with their home country. The Americans who arrived en masse after the war stuck together. The Right Bank crowd was led by F. Scott Fitzgerald, while the Left Bank attracted the poorer artists and writers. By all logic Peggy should have belonged to the former group, but luckily for her, fate was to decree otherwise. There were two other American groups: the old, established, rich patrician community, to which Laurence Vail's mother belonged, and the casual tourists who quickly filled all the restaurants that got into the guidebooks.

In the forefront of the artistic postwar immigrants were John Dos Passos, E. E. Cummings (later "e. e. cummings"), and Hemingway, all three of whom had worked as volunteer ambulancemen during the war. Ambulancemen enjoyed greater freedom of movement than regular soldiers, and had more contact with local people. Dos Passos did make contact with French writers, though Cummings, despite his fluent French, did not. The writer and critic Malcolm Cowley, alone in Montpellier writing a thesis on Racine, also managed to bridge the gap, as did Matthew Josephson, who became friendly with a broad group of writers and artists including Jules Romains, Tristan Tzara, and Louis Aragon. There was some reciprocation: Aragon and his friend the poet Philippe Soupault both read English, adored America, read all the Nick Carter dime novels they could find, and were committed fans of Charlie Chaplin.

The quiet streets and dim bars recorded by the pioneer photographer Eugène Atget before the war were giving way to noisy thoroughfares and brassy cafeterias. Workers' cafés, such as the Dôme, quickly became the stylish haunts of young American drinkers; but the charm of the old Paris didn't disappear overnight. John Glassco, who lived in the rue Broca district, wrote that "in the rue de la Glacière I met a man with a flock of goats, playing a little pipe to announce that he was selling ewe's milk from the udder." And in *A Moveable Feast* Hemingway recalled a similar scene when he was living on the rue Cardinal Lemoine in 1921: "The goatherd came up the street blowing his pipes and a woman who lived on the floor above us came out onto the

sidewalk with a big pot. The goatherd chose one of the heavy-bagged, black milk-goats and milked her into the pot while his dog pushed the others onto the sidewalk." In *The Sun Also Rises* Hemingway lamented how things had changed four years later: "We ate dinner at Mme. Lecomte's restaurant on the far side of the island. It was crowded with Americans and we had to stand up and wait for a place. Someone had put it in the American Women's Club list as a quaint restaurant on the Paris *quais* as yet untouched by Americans, so we had to wait forty-five minutes for a table." Elsewhere in *A Moveable Feast* he records poignantly that the old waiters at the Closeries des Lilas, Jean and André, had been forced to shave off their drooping moustaches and don white "American" jackets to serve their new clientele. With flashy new establishments like La Coupole opening only a few hundred meters away along the boulevard du Montparnasse, and Americans flocking to the Select and the Rotonde, something had to be done to smarten up the Closerie's image.

Up on the boulevard St.-Germain the Flore and the Deux Magots are still there, side by side, dispensing expensive but good cognac to French people and tourists alike, the Magots just having an edge over the dingier Flore; but many of the other bars Peggy was soon to be frequenting around what is now the Place Pablo Picasso, the junction of the boulevard du Montparnasse and the boulevard Raspail, have either disappeared or changed beyond recognition. The Dôme is an expensive fish restaurant, though its bar is still there. The Select and the Rotonde still have a slightly seedy charm, while La Coupole is as grand a piece of art deco as ever it was. The Falstaff is now a cheap restaurant, and the Jockey and the Dingo have disappeared.

In the 1920s, though, this was the center of bohemia for the American expatriates in Paris, and it was waiting to be introduced to Peggy.

Leon and Helen Fleischman had taken up with Laurence Vail, now back in Paris, and through them he met Peggy again. Laurence was an original. He looks bad-tempered and intense in photographs, though those who knew him well were fond of him, and many think that as an artist he sold himself short. By modern standards he looks physically weak, though he was an expert skier and alpinist. By the standards of the day he wore his blond hair long, and he avoided hats. He dressed extravagantly, buying curtain or furniture material in Liberty prints to be made into shirts, with yellow or blue canvas or corduroy trousers, and white overcoats or jackets all the colors of the rainbow. As he was pigeon-toed he preferred sandals to shoes, but made

a great fuss over buying any kind of footwear, to the extent that Peggy suspected him of having a mild complex on the subject.

Vail was a handsome man, despite a beaky, aquiline nose, with a volatile and childish personality that overshadowed his better points. Seven years Peggy's senior, he had been born in Paris. His mother, Gertrude Mauran, came from a wealthy New England family, and was every inch a Daughter of the American Revolution. His father, Eugene, was the product of a New York father and a Breton mother, and a moderately successful landscape painter (particularly of Venice and Brittany) by profession.

From his mother Laurence had inherited a love of the mountains. She was one of the first women ever to climb Mont Blanc, and had encouraged her son to be a mountaineer from an early age. From his father he inherited the less attractive traits of advanced neurosis, and an egotism that manifested itself in temper tantrums when he thought he was not the center of attention. Eugene Vail was also a hypochondriac with a strong suicidal tendency. It was from his father that Laurence inherited his artistic sensibility, and a sense of humor that never had enough of a chance to show itself. And if Peggy's family had its share of eccentrics, mention should be made here of Laurence's uncle George, Eugene's brother. George was a great aficionado of roller-skating. Roller skates had been around for more than a hundred years, but with the introduction of the ball bearing in the 1890s their efficiency was much improved, and it was possible to go very much faster on them. George added to his speed by holding on to the backs of trucks, and thus it was that he would meet his end, when in his sixties. He was also a great lover, and made an album collection of his mistresses' pubic hairs.

Neither parent—Gertrude cold and domineering, and Eugene self-obsessed—had much time for Laurence or his younger sister, Clotilde, and the children in consequence were drawn close together. Though suggestions of incest are without foundation, their relationship did inspire William Carlos Williams's 1928 novel *A Voyage to Pagany*, in which an American doctor and writer, Evans, returns to Paris to see his sister, who is pursuing a career as a singer (Clotilde had a brief career as an actress and opera singer herself).

> ... differing [physically] as the brother and sister did, they had
> grown up intimately together, almost as one child. They had
> shared everything with each other. . . . The thing which had always

kept them together was the total lack of constraint they felt in each other's company—a confidence which had never, so far, been equally shared by them with anyone else.

Elsewhere in the book, a minor character called Jack Murry, a writer, is given a description based on Laurence:

The firm, thin-lipped lower face, jaw slightly thrust out, the cold blue eyes, the long downward-pointing, slightly-hooked straight nose, the lithe, straight athletic build ... [Evans] loved his younger friend for the bold style of his look at life. Often, when Jack demolished situations and people with one bark, Evans smiled to himself at the rudeness of it, the ruthlessness with which so much good had been mowed down.

Both Eugene and Gertrude had private money, though Gertrude, with an income of $10,000 a year, was considerably the richer of the two. From this she paid her husband's hospital and medical consultancy bills (he had already run through his own patrimony on such things), and gave Laurence a small allowance of about $1,200 a year—just enough to live on without working, and enough to make him rich in comparison with the artists with whom he associated. This, coupled with a great love of the bottle, was the main reason why Laurence never exploited to the full what artistic talents he had. On the other hand, a streak of humorous self-awareness runs through his own writings and recorded pronouncements. "I take my medicine," he writes in his autobiographical novel *Murder! Murder!*, "gulp down without a murmur a tumbler of imported New York whiskey. My stomach sinks, bravely reacts. And suddenly I know that I have it in me to do great things. But what great things? Just what?" His son-in-law Ralph Rumney, who was also a friend, has remarked that as far as he is concerned, Laurence was never given his due as an artist or as a man. Peggy loyally said that Laurence "was always bursting with ideas. He had so many that he never achieved them because he was always rushing on to others."

Peggy and Laurence met again at a dinner party given by the Fleischmans. At the time he had a minor reputation as an artist and writer, but a much greater one as a man-about-town and roué. He was very popular with women, and when Peggy met him again in Paris he was in the middle of an

affair with Helen Fleischman. It was an affair that her husband, Leon, had encouraged, since the thought of such a thing excited him, and Helen warned Laurence not to flirt with Peggy—for fear of offending Leon. She may, however, also have realized that Laurence found Peggy attractive. Peggy's dark brown hair was parted at the center and worn short and waved. Her light blue eyes had a pensive, intelligent look. She was young, very pretty despite her nose, which had not yet coarsened, and had a beautiful, long-limbed body. She was charmingly naive but eager to learn, and had a private income twice as big as Laurence's mother's.

For Peggy, not only was Laurence an artist and a good-looking and charming man, he embodied the cosmopolitan sophistication she admired. He knew Paris backwards. He knew about art, and he had friends in the world of modern art. He wasn't a callow youth from a similar background to her own, and his world had little connection with Jewish New York. Here was the teacher she sought. They got on very well at dinner. Laurence owed no woman any loyalty at the time, and was well aware of the casual nature of his affair with Helen.

A few days later, Laurence telephoned the Plaza-Athénée, where Peggy was staying with her mother and Valerie, and asked her out for a walk. Laurence at thirty was still living with his sister and their parents in a large flat close to the Bois de Boulogne. Peggy dressed for the date in an outfit "trimmed with kolinsky fur," the most expensive kind of mink, in order to advertize her material charms. She and Laurence walked up the Champs-Elysées to the Arc de Triomphe and then along the Seine. Dropping into an ordinary bistro for a drink in the course of what was a very long walk, Peggy ordered a porto flip—a cocktail that wouldn't have raised an eyebrow at the Plaza but which hadn't reached the Left Bank in 1921.

But Peggy had other things on her mind, and didn't see Laurence as a teacher simply in terms of art. In another passage omitted from the 1960 version of her autobiography she remarks candidly:

> At this time I was worried about my virginity. I was twenty-three and I found it burdensome. All my boyfriends were disposed to marry me, but they were so respectable they would not rape me. I had a collection of photographs of frescos I had seen at Pompeii. They depicted people making love in various positions, and of course I was very curious and wanted to try them all out myself.

It soon occurred to me that I could make use of Laurence for this purpose.

Unaware of Peggy's thoughts, but preparing to woo her, Laurence decided to leave the parental apartment and find himself an independent place. He told Peggy his plan, and she immediately suggested that she move in with him and share the rent. Balking at this—even in the progressive and permissive 1920s Peggy was going a bit too fast for his taste—he settled on a room in a hotel on the rue de Verneuil, between the Seine and the boulevard St.-Germain, and only a block south of the bohemian rue de Lille. Not wanting to lose the initiative, however, he soon visited Peggy in her room at the Plaza-Athénée, choosing a time when her mother, whose own room was nearby, was out with Valerie. Laurence took advantage of the situation and immediately made his move, only to be taken aback at the speed of Peggy's acquiescence. But she stopped him anyway, saying that her mother might return at any moment and interrupt them. He suggested a tryst at his hotel sometime, but had his breath taken away when Peggy immediately fetched her hat. She later observed dryly that she was sure Laurence had not meant things to happen so quickly. Laurence was caught and cornered, and they both knew it. It would not be the last time, and it would be the cause of many violent rows in the future.

What could Laurence do but give in? He had, after all, made the first move. So she got her wish and lost her virginity, and in just the way she wanted. Peggy, typically, jumped in with both feet: "I think Laurence had a pretty tough time because I demanded everything I had seen depicted in the Pompeian frescos. I went home and dined with my mother and a friend gloating over my secret and wondering what they would think of it if they knew."

Peggy had launched herself on a long sexual career, which she makes much of in her autobiography. She had lovers in such numbers that individually they were of no consequence. What is significant is how few relationships she had. Some of the bons mots associated with her sexual profligacy are well known. When the conductor Thomas Schippers asked her, "How many husbands have you had, Mrs. Guggenheim?" she replied, "D'you mean my own, or other people's?" There is also the allegation, which Peggy denied in later life, that she had a thousand lovers. The number of abortions she may have had reaches seventeen, though other sources give seven. The true number is almost certainly three.

Peggy's sexual voracity is well documented, and there can be no doubt that for periods in her life she was extremely promiscuous. The reasons for this are complex. In part she was always looking for love, and she sought it through sex. It has been said that she had no interest in courting or even foreplay: She liked to go directly to the act of making love, and once it was over her detachment could be abrupt. In part she was both using sex as an expression of her own liberation, and in part she was conforming to the prevailing nonconformity. She was far from the only "liberated" woman in artistic circles to behave in this way. In part, getting men (and occasionally women) into bed with her reassured her that she was not as ugly as she thought herself to be. In part, sex was a hedge against loneliness. It is significant that as she became established as an art collector of great standing in the middle decades of the twentieth century, she was increasingly known as "Mrs. Guggenheim." She approved of the name. But despite the fact that there were to be two real husbands, innumerable lovers, and one great love, the isolation symbolized by that name tells its own story.

Laurence and Peggy's affair continued discreetly throughout the rest of 1921 and into 1922. As their romance blossomed, he introduced her to his world. Peggy, completely in his thrall, dubbed him "the king of Bohemia," although he was that in her eyes only. Early on in their relationship, she speaks of him as playing a heroic central role in the move by the American artistic fraternity from the Rotonde to the Dôme. In *This Must Be the Place*, the memoir of James Charters, the Liverpudlian ex-boxer who became the most famous expatriate cocktail provider in Paris in the 1920s, "Jimmie the Barman," the story is rather different:

> This came about because, back in those moralistic days, a "lady" did not smoke in public. Neither did she appear on the street without a hat. But one Spring morning the manager of the Rotonde looked out on the *terrasse*, or sidewalk section, of his establishment to discover a young American girl sitting there quite hatless and smoking a cigarette with a jaunty air. Her hatlessness he might have overlooked, but her smoking—No! He immediately descended on her and explained that if she wished to smoke, she must move inside.
>
> "But why?" she asked. "The sun is lovely. I am not causing any trouble. I prefer to stay here."

Soon a crowd collected. The onlookers took sides. Several English and Americans loudly championed the girl. Finally the girl rose to her feet and said that if she could not smoke on the terrace she would leave. And leave she did, taking with her the entire Anglo-American colony!

But she didn't move far. Across the street was the Dôme, which up to that time had been a small bistro for working men, housing on the inside one of those rough green boxes which the French flatteringly call a billiard table. Accompanied now by quite a crowd, the young lady asked the manager of the Dôme [a lucky man by the name of Cambon] if she might sit on the terrace without a hat and with a cigarette. He immediately consented and from that time the Dôme grew to international fame and became the symbol for all Montparnasse life.

Laurence threw big parties at his parents' large apartment when his mother was away. Peggy has left us a recollection of one of them—her first. She sat on the lap of an unknown playwright, and self-consciously remembers the drunken ardor of Thelma Wood. (Wood was a native Kansan, at the time a pretty and slim twenty-one-year-old; she was a notorious lesbian and the then lover of Djuna Barnes, whose path was to cross Peggy's often in the coming years.) The party provided other sideshows to titillate Peggy: two young men weeping together in one bathroom, two "giggling girls" in another—all of which caused considerable distress to Laurence's father, cast adrift among all this *jeunesse dorée*, and completely unable to cope with it.

Soon afterward Peggy met two of Laurence's ex-mistresses, Djuna Barnes, recently arrived in Europe as correspondent for *McCall's* magazine (thanks in part to a subsidy of $100 for her fare from Leon Fleischman, who'd borrowed the money from Peggy), and Mary Reynolds, a woman of great integrity who would become the longtime mistress of Marcel Duchamp. Both were great beauties; both had attractive noses. Neither, however, was as well off as Peggy. Djuna in particular was strapped for cash, and Peggy, at Helen Fleischman's suggestion, gave her some lingerie. This caused a row. According to Peggy, Djuna was affronted at the gift, since the underwear, from Peggy's own wardrobe, was not even her second best and was darned; she goes on to describe an odd scene in which she burst in on Djuna, who was seated at her typewriter, dressed in the offending garments.

In a letter to Peggy much later, in 1979, Djuna explained that the insult was in Peggy's mind: "If you are 'correcting' the re-issue of your book, you might remove the remark that I was 'embarrassed' by being 'caught' wearing the handsome (mended) Italian silk undershirt—I was not annoyed at that, (or I should not have worn it). I was annoyed, and startled, that someone had come into my room, unannounced and without knocking."

Peggy, who clearly felt guilty about her stinginess at the time, made amends by the gift of a hat and cape, and the incident did nothing to damage what turned out to be a lifelong relationship, though never quite a true friendship, since Djuna was forever financially needy, and Peggy supported her for most of her life. This aspect of their association was not helped by the fact that Djuna considered herself in every way an infinitely superior being to Peggy.

Meanwhile the affair with Laurence continued apace. In order to give themselves greater freedom of movement, Peggy persuaded her mother to take a trip to Rome; although Valerie was left behind as chaperone, she was easier to outwit than Florette. Matters came to a head soon afterward, when Laurence took Peggy to the top of the Eiffel Tower—did she tell him that her father was responsible for the elevators?—and proposed to her. Quite how ardent the proposal was, we don't know; but she accepted him immediately, and he promptly got cold feet.

Laurence continued to dither, and Peggy continued to hang on. As soon as she got wind of the engagement, Laurence's mother, disapproving of a liaison with a Jew, however rich, packed her son off to Rouen to think things over, sending Mary Reynolds with him (and paying her fare) in the hope that old embers might be rekindled, or at least that Mary might talk some sense into her former beau. Her plan misfired: Laurence and Mary did little but argue, and Laurence sent Peggy a telegram telling her he still wanted to marry her after all.

Peggy pressed home the advantage by letting her mother in Rome know that she was engaged. This brought Florette back to Paris in a panic. She disapproved of Peggy's "marrying out," and in any case knew nothing of Laurence's credentials. He wasn't rich, that was for sure. Laurence was, however, able to come up with the names of one or two people who would speak on his behalf: One of them was King George II of Greece, whom Laurence, with his wide circle of acquaintants, had once met at St. Moritz. Luckily, Florette didn't follow up any of the references, but she mobilized Peggy's relatives and friends to dissuade her.

Despite this the couple went ahead with their plans, Peggy taking care that the lawyer they engaged ensured that her money should remain in her control, and the banns were posted. Laurence promptly started to dither again, but this only strengthened Peggy's resolve. Then, when it looked as if he might be going off to Capri with his sister, and Peggy would be bound to return to New York with Florette, he turned up at the Plaza-Athénée, where Peggy was sitting in the unlikely company of her mother and his, and asked her to marry him "the next day."

Peggy accepted this new proposal, but decided to buy only a hat, not a new outfit, for the ceremony, just in case there was another hitch; and there was what looked like a final hiccup when Gertrude called Peggy on the morning of the wedding to tell her, "He's off." Peggy took this to mean that Laurence had gone on the lam, but his mother only meant that he was on his way.

The civil ceremony took place at the town hall of the sixteenth arrondissement on March 10, 1922. Later there was a party at the Plaza-Athénée, attended by a mixed bag from four different backgrounds: Florette invited a phalanx of Seligman cousins and friends from the Right Bank; Gertrude asked members of her set, the old-established American community; Peggy asked her new friends, mainly drawn from the circle of suitors she had established with Fira Benenson—one of whom, Boris Dembo, wept at the thought that he was not marrying Peggy himself; Laurence's guests were a motley band of poor expatriate American writers and artists, along with his French friends.

After a champagne reception at the Plaza, the party moved on, collecting all manner of people as it passed various bars on the way to the Boeuf-sur-le-Toit and Prunier's. The next morning Peggy, the worse for wear, was visited by Proust's doctor, who gave her a flu injection.

She awoke to find herself disappointed in marriage. Her disaffection was reinforced at lunch with her mother. Florette asked loudly about the finer points of the wedding night, drawing attention to the smell of Lysol Peggy had about her, making the waiters prick up their ears. This caused Peggy some embarrassment, but Florette approved of her daughter's inherited belief in the curative and disinfectant properties of Lysol, especially in getting rid of the nasty smells and risks of infection that sex involved.

Before the honeymoon, Florette brought Peggy a passport in her new name. As a married woman, Peggy was now on Laurence's passport, but

with this independent one she could run away if Laurence became too much for her. This action of Florette's may have been prompted by Peggy herself, since Laurence had already, even before the wedding, begun to show a less attractive side. When drunk, which he often was, he could become violent. He would make scenes in restaurants, smash bottles, wreck furniture in hotel rooms, and attack Peggy physically. The worst of this was yet to come. Although there is no excuse for Laurence's extravagant behavior, Peggy sometimes consciously taunted him into it, knowing exactly how to provoke an angry reaction. It was one way of satirizing the male dominance she instinctively despised, and she deployed it often in her life, despite the violence she brought on herself. At this stage, however, no one could have accused Peggy of not indulging him. He was so depressed at the thought of being separated from Clotilde that Peggy suggested his sister should join them in Capri, where they were to spend most of their honeymoon. But when Peggy also suggested that she bring along her Russian teacher, Jacques Schiffrin, Laurence refused.

En route to Capri, the newlyweds stopped in Rome, where Peggy's cousin Harold Loeb was running his magazine *Broom*. Laurence had already published one or two pieces in it, and Harold now asked him for a poem. Laurence had already taken against the Guggenheim family, specifically the brothers who controlled the family firm, and was to remark that he would happily throw them all over a cliff. His dislike was probably prompted by the fact that Peggy's capital was carefully protected; but it found an outlet in the poem he submitted:

> *Old men and little birds*
> *Too early in the morning*
> *Make squeaks.*

> *Little birds are more brazen;*
> *Primly, they dip their feet in puddles.*
> *Old men have delicate feet.*

> *Old men have delicate bowels,*
> *Little birds are careless,*
> *Near love of neither*
> *Is sweet.*

Little birds chirp, chirp, chirp, chirup;
Old men tell stories, tell stories;
Both die too late.

When the piece appeared in the September 1922 edition of *Broom*, it provoked a querulous reaction from Peggy's cousin Edmond. Loeb calmed him down, but Laurence felt a flicker of grim satisfaction.

Peggy and Laurence, bare legged and besandaled to underline their contempt for anything bourgeois, proceeded on their expensive honeymoon. Privately, Peggy continued to nurse her sexual and personal disaffection with marriage; but at least getting married had achieved one goal for both of them: independence from their families.

Capri in the early 1920s was a beautiful and still isolated place, a resort for the rich and the eccentric. Here a young French nobleman consorted with the goatherd he had adopted as his boyfriend, had educated, and had introduced to opium; here lived the German industrialist Gustav Krupp von Bohlen und Halbach in a magnificent mansion; and here too, more modestly, lived the Compton Mackenzies. An old lady, reputed to have been the lover of a former queen of Sweden, sold coral in the streets; and during the season before Peggy's arrival, Luisa Casati, an exotic figure who became the mistress of the poet, womanizer, and war hero Gabriele d'Annunzio, had wandered the island in the company of a pet leopard. Casati owned a palace in Venice, the Palazzo Venier dei Leoni, which thirty years later would become Peggy's final home.

Despite the exotic nature of the place, Peggy didn't enjoy it much, since her style was cramped by the presence of Clotilde. If Laurence's mother had accepted Peggy—though Peggy was never allowed to address her as anything other than "Mrs. Vail"—Clotilde was not going to relinquish one iota of her hold over her brother. It was humiliating to be treated as the unwelcome third person on one's own honeymoon, and as Peggy put it, "[Clotilde] always made me feel that I had stepped by mistake into a room that had long since been occupied by another tenant, and that I should either hide in a corner or back out politely." Peggy also, despite her own ambitions in that direction, found her sister-in-law's libertinage shocking. She was also envious of it. To make matters worse, Clotilde's lovers drove Laurence into a jealous frenzy. Clotilde was three or four years older than Peggy, more attractive, and more worldly. She delighted in making Peggy feel inferior,

but resented Peggy's wealth. Peggy quickly came to realise what a weapon her money was.

She had enough obduracy not to let herself be undermined by the Vails' snobbery and anti-Semitism. At the end of the summer they left Capri, traveling to St. Moritz via Arezzo, San Sepolcro, Venice, Florence, and Milan. By then the two sisters-in-law seem to have come to some kind of accommodation. Laurence and Peggy played tennis together so well that they won a tournament, and they seemed, if not passionately in love, at least genuinely fond of each other. Nevertheless, when the autumn came, Peggy left for New York for a long-arranged visit to Benita, while Laurence took Clotilde off on a tour of the Pays-Basque on a motorbike, which Benita had given him as a wedding present.

In New York, Peggy arranged for the publication of Laurence's short work *Piri and I*, and had an enjoyable time with her sister despite the jealousy she still felt for Benita's husband.

Before she returned to Europe and her own husband, she discovered that she was pregnant.

Laurence,
Motherhood,
and "Bohemia"

At the end of 1922 Peggy returned to Europe with her aunt Irene. Laurence was at Southampton to meet the ship. The couple were delighted to see each other again, and Laurence behaved himself right through a visit to Peggy's cousin Eleanor in Sussex, where she lived with her cattle farmer husband, the Earl Castle Stewart. But the Vails were an ill-matched pair, and no sooner were they back in Paris than they began to quarrel. Laurence had boundless energy and great, if misused, intelligence. He would invite anyone he met on the street, including whores and *clochards*, to parties, he would spend up to three days on binges, and he was deeply frustrated by Peggy's apparently placid nature.

Peggy, however, knew exactly how to provoke him, and frequently did so. She was still in touch with her former teacher Jacques Schiffrin, and had advanced him money to help set up his imprint, Les éditions de la Pléiade. When she told Laurence she was in love with Schiffrin he went berserk, smashing an inkpot and the telephone in their suite in the Hôtel Lutétia, where they were living. The splattered ink ruined the wallpaper, which had to be replaced, and Peggy had to engage a man to remove ink from the carpets and floors, which took weeks. There is nevertheless a hint of enjoyment in Peggy's recounting of the story, as if this were all part and parcel of the anarchic, artistic life she believed she was living. And she retaliated in a way

that was calculated to stir Laurence up further, by reminding him that it was she who held the purse-strings. Through that she controlled the relationship. Laurence, too weak to break free, revenged himself for his humiliation by harping on Peggy's lack of finesse, education, and sophistication. In fact Peggy, a natural autodidact, was continuing to educate herself through the artists and writers she came into contact with, though it was a slow process, and her real relationship with the artistic life of Paris was not to come until much later.

Peggy had an acute perception of both the situation and her husband's character:

> Laurence was very violent and he liked to show off. He was an exhibitionist, so that most of his scenes were made in public. He also enjoyed breaking up everything in the house. He particularly liked throwing my shoes out of the window, breaking crockery and smashing mirrors and attacking chandeliers. Fights went on for hours, sometimes days, once even for two weeks. I should have fought back. He wanted me to, but all I did was weep. That annoyed him more than anything. When our fights worked up to a grand finale he would rub jam in my hair. But what I hated most was being knocked down in the streets, or having things thrown in restaurants. Once he held me down under water in the bathtub until I felt I was going to drown. I am sure I was very irritating but Laurence was used to making scenes, and he had had Clotilde as an audience for years. She always reacted immediately if there was going to be a fight. She got nervous and frightened, and that was what Laurence wanted. Someone should have told him not to be such an ass. Djuna tried it once in Weber's restaurant and it worked like magic. He immediately renounced the grand act he was about to put on.

These tantrums often got Laurence into trouble with the police, but it was a mania that stayed with him for most of his life. In 1951 he got into a row in the dining room of the Hotel Continental in Milan with a friend of Peggy, Carla Mazzoli. As Maurice Cardiff, who knew Peggy and was there at the time, remembers: "When he had worked himself into what seemed a simulated rather than genuine frenzy, he left the table to return with a pot of jam

he had taken from the restaurant kitchen. Dipping his finger into the pot he tried, unsuccessfully, for we all intervened, to rub the jam into Carla's hair."

Ample reasons for his pique at Peggy's behavior can be found in Laurence's novel *Murder! Murder!*. Written in the closing years of the marriage, it is an account of the near-hysterical relationship between its protagonists, Martin Asp and his wife, Polly (in Vail's unpublished memoir *Here Goes*, Peggy appears under the equally thin guise of Pidgeon Peggenheim). Even allowing for the prevalent anti-Semitism of the time, the novel is particularly unpleasant about the Jews, and though at its most extravagant it shows the influence of Lautréamont's *Les Chants de Maldoror*, the 1868 novel that had such a profound effect on the surrealists, and describes a man possessed of a singularly nasty imagination, it nevertheless also displays a rather dutiful attempt to "horrify the bourgeoisie." But while the book is honest, and skillfully exposes some of Peggy's less attractive traits, such as an obsession with the details of petty spending, and an obstinate, ingrained selfishness, a huge resentment is apparent. Laurence (in the character of Martin Asp) describes how his sleeping wife's lips "move as she dreams of sums," and says "it makes her nervous to follow one train of thought for any length of time. She goes in for action. She tries to reckon out how much money she has spent on tips since the first of June."

In their own recollections, each partner paints the other in darker colors than they deserve, but one longer passage from the novel can be quoted without comment (except to express the hope that some of it is meant ironically) to complement that quoted above from Peggy's autobiography:

> Suddenly, even while I speak and drink, my brain expands, parts, opens. It will be a great thing, the great thing I shall do—a very great thing. A little later, when I am kindly drunk, I shall, magnanimously, fundamentally, make it up with my young wife. It will be a great thing—this making up. For we have been quarrelling for nearly fifty hours.
>
> Forty-six hours ago I had been reading one of my poems to a friend. Now it is not often that I thus hazard friendship. On this occasion, however, the friend had particularly insisted. Three times I met his odd request with fairly firm refusals. The fourth, I weakened. Too much false modesty, I argued, is bad for the

morale; I may suddenly feel modest. And why not, just this once, give myself a treat? Besides, my friend might not ask a fifth time.

And now to Poll. Since Sunday noon she had been reading a novel of Dostoyevsky. She had read 114 pages on Saturday, 148 on Sunday, 124 on Monday, on this day, Tuesday, 96. Still the night was young. She was in form. She might still break her record.

Meanwhile, disrespectful of these facts, I settled myself in my chair, happily began reciting:

Some who believe in God
Take pills.

Some patient women
Lean perhaps with stout hope
Perhaps behind their hungry features
Hopeless . . .

It was at this moment that I became aware of a loud continuous whisper. I glanced up. Polly was leaning over her book, her lips were moving. My recital, it was evident, interfered with her concentration; still, by murmuring the words quite loud, she could manage not to hear me. She still hoped, if not to achieve a record, to equal her daily average of 130 pages.

Abruptly, I stopped reciting. My silence, I thought, will certainly move her to repentance and confusion. I was mistaken. Now, unimpeded by my own gloating voice, I could hear the words of the immortal Russian. . . .

Suddenly I lost my temper. Then, with sarcasm:

"Sorry, if I disturbed you."

She glanced up with bright friendly eyes: "Oh not at all. Do go on with your poetry."

My friend laughed lightly. "Don't you like Martin's poem?"

"A lot. But, you see, I've heard it once already."

I bit my tongue. "My mistake. I thought you could stand a second reading."

"Go on," said my friend. "Let's hear the rest of it."

I shook my head. Who was I, after all, to compete with Dostoyevsky? . . . My temper rose. Carefully tearing my manuscript in two parts, I turned my back on both friend and wife, concealed the fragments in my pocket.

When finally after ten minutes my friend left, I gave vent to my indignation:

"You should have married a Wall Street broker. Or a Russian taxi-driver."

I continued in this strain for upwards of two hours, including in my torrent of reproach my wife, her mother, her sisters, her cousins, her aunts, her uncles, in short, a considerable part of the Jewish people. Still, had she at any time during this period knelt or wept, I would, eventually, have vouchsafed her my forgiveness. Not once, however, did she show the slightest sign of ardent love, of deep, complete repentance. Several times, probably noting I was embarked on a symphony of abuse whose themes to develop must take at least some minutes, her eyes would quickly stray towards "The Brothers Karamazov." Once, having turned my back, I heard, or thought to hear, the dry sound that a page makes when a hand turns it over.

In the meantime, though Peggy does make one reference in her memoirs to anxiety on its behalf, their child crouched in the womb, its welfare largely unheeded.

In the meantime, too, Laurence carried on his role as king of bohemia, largely by virtue of having enough money to throw parties, and through him Peggy immersed herself more and more in the expatriate cultural life of Paris. The waves of newcomers continued unabated as the 1920s progressed. Matthew Josephson, who had returned to New York after the collapse of *Broom* in 1923, but, disliking the respectable Wall Street job he had taken, went back to Paris with his wife in 1927, was struck by the speed of the change wrought upon the Left Bank by the new influx of Americans: "Our ship alone had brought 531 American tourists in cabin class. . . . There were certain quarters of Paris that summer where one heard nothing but English, spoken with an American accent. . . . The barmen [were] mixing powerful cocktails, dry martinis, such as one never saw there in 1921 or 1922." Away from Prohibition, Americans relaxed. Everybody drank. Most people drank

too much at one time or another. Drinking was part of the culture, and one regret was that the French authorities had banned the sale of true absinthe, the ruling drink of the 1890s. Dull green in color, true absinthe has a spirit base in which the flowers and leaves of wormwood are instilled, together with star anise, hyssop, angelica, mint, and cinnamon. The toxic qualities of absinthe led to its proscription: It had an alcohol percentage of between fifty and eighty-five. John Glassco, who managed to get hold of some in Luxembourg, left a vivid reminiscence of its effect:

> The clean sharp taste was so far superior to the sickly liquorice flavour of legal French Pernod that I understood the still-rankling fury of the French at having that miserable drink substituted for the real thing in the interest of public morality. The effect also was as gentle and insidious as a drug: in five minutes the world was bathed in a fine emotional haze unlike anything resulting from other forms of alcohol. *La sorcière glauque,* I thought, savouring the ninetyish phrase with real understanding for the first time.

By 1928 Scott Fitzgerald could write that Paris "had grown suffocating. With each new shipment of Americans spewed up by the boom the quality fell off, until towards the end there was something sinister about the crazy boulevards." The Dôme, which had been the social centre and bush-telegraph office, the place you went to find a job or a place to stay, became so swamped by Americans that "real" artists moved down the road to the Closerie des Lilas, where Hemingway sat and wrote. A literary crowd centered on the Hôtel Jacob; its numbers included Djuna Barnes, Sherwood Anderson, Edna St. Vincent Millay, and Edmund Wilson. The photographer Man Ray and his mistress, the model Kiki (Alice Prin), who wore extraordinary makeup designed by him, also formed part of the circle: "Her maquillage," wrote Glassco of Kiki, "was a work of art in itself: her eyebrows were completely shaved and replaced by delicate curling lines shaped like the accent on a Spanish 'n', her eyelashes were tipped with at least a teaspoonful of mascara, and her mouth, painted a deep scarlet that emphasized the sly erotic humor of its contours, blazed against the plaster white of her cheeks on which a single beauty-spot was placed, with consummate art, just under one eye."

Peggy was not the only member of the American artistic circle in Paris who was not herself an artist; many others used their money to encourage and subsidize creative but impecunious talents. Though hardly a champion of the avant-garde—she favored the arts of the *belle époque*—Natalie Clifford Barney had inherited $3.5 million from her father and in 1909, when she was thirty-three, bought number 20 rue Jacob, a vast seventeenth-century mansion in which she lived very stylishly for the next half-century. As an early arrival she, like Gertrude Stein, was able to make contacts within the French cultural arena, though her house became a specialized center for lesbian culture—Natalie had known she was a lesbian since the age of twelve, and she is the original for Valerie Seymour in Radclyffe Hall's *The Well of Loneliness*, published in 1928. Thrifty like Peggy, she was also a benefactress to Djuna Barnes, though unlike Peggy, she never supplied the novelist with a regular stipend.

Mary Reynolds, one of the circle's most striking members, was the widow of Matthew Reynolds, killed in 1918 while fighting in France with the U.S. Thirty-third Infantry Division. She moved to Paris to escape pressure at home to remarry. Her group of friends included Cocteau, Brancusi, and the American author and journalist Janet Flanner, who wrote *The New Yorker*'s "Letter from Paris."

Later in the decade the heiress Nancy Cunard founded the Hours Press, which she ran between 1927 and 1931; she was the first person to publish the young Samuel Beckett: *Whoroscope* appeared in 1930, in a hand-set edition of one hundred, followed by a second edition of two hundred. She also published, among others, Robert Graves, Ezra Pound, and Laura Riding. Nancy had acquired her first printing press from William Bird, who ran the Three Mountains Press on the Ile St.-Louis.

Perhaps the Left Bank's most famous artistic haven was the bookshop Shakespeare and Co., at 12 rue de l'Odéon (it has since moved to rue de la Bûcherie), founded by Sylvia Beach, the daughter of a minister from Princeton, New Jersey, in 1919. In this literary mecca could often be found Allen Tate, Ezra Pound, Thornton Wilder, Hemingway, and, on occasion, the great literary lion of the expatriate community, James Joyce.

It was at the bookshop that Robert McAlmon founded his Contact Editions Press in the early 1920s, the title deriving from William Carlos Williams's mimeographed poetry magazine, *Contact*. Early in 1921, in New York, McAlmon married the English novelist Bryher—the nom de plume

(taken from the name of one of the Scilly Isles) of Winifred, the daughter of the vastly wealthy English shipping magnate Sir John Ellerman. McAlmon said he was unaware of Winifred's true identity (and therefore of her money) until after they were married, but this seems unlikely, since it was from the first a marriage of convenience: Both parties were homosexual, but in those days Bryher needed the cover of marriage in order to be able to travel freely and to adopt when necessary a respectable place in society (according to Matthew Josephson she was at odds with her family, though McAlmon was received by her father in London). By marrying she also made herself eligible to inherit a fortune. The couple scarcely lived together; Bryher was a friend of the Sitwells, and was already involved in a long-term relationship with the more considerable poet and novelist "HD," Hilda Doolittle, a native of Bethlehem, Pennsylvania, who had followed her friend Ezra Pound to Europe in 1911.

While his wife traveled, McAlmon stayed in Paris, drinking too much and indulging in some minor writing and a memoir, later revived by his friend Kay Boyle, of his life and of the artistic life of the time.

McAlmon was a fine editor, with a well-developed sense of what was best in the new writing, and used the money he derived as an "income" from his marriage to set up his small publishing house. Despite personal differences between the two men (McAlmon could be very bitter), he was the first to publish Hemingway, and he also produced volumes of verse by William Carlos Williams, Mina Loy, and Marsden Hartley. Though he had dreaded the thought of being destitute once Bryher—as she inevitably did, after about six years—divorced him, he found himself in fact with a handsome settlement of about £14,000, which led his friends Bill Williams and Allan Ross Mcdougall to dub him "Robert McAlimony."

Gertrude Stein, though she stood apart from the 1920s set, having been in Paris since 1903, was among the first great female collectors of modern art. As patrons in the United States, Katherine Dreier and the Cone sisters were not far behind her. The Cones were distant cousins of Stein, and Etta Cone had typed the manuscript of Stein's first book, *Three Lives*. At Stein's home at 27 rue de Fleurus, crammed with paintings and sculpture, many of the new arrivals rubbed shoulders with the older established expatriates and some of their French colleagues too. Any given salon might include Virgil Thomson, Hemingway, Pound, Duchamp, Cocteau, Picabia, Matisse, T. S. Eliot (on visits from London), Mina Loy, Djuna Barnes, and Robert McAlmon. And

Picasso, of course, whom Stein's friend Nelly Jacott called "a good-looking boot-black."

In the early days Picasso had exhibited his work in a little furniture shop; and Leo and Gertrude Stein had been able to pick up Matisse's *Femme au Chapeau* for 500 francs from the dealer Vollard. Things were changing fast, though. Daniel Kahnweiler, the great pioneer modern art dealer, had set up shop in Paris a couple of years before World War I. Ignoring Picasso's advice to become a French citizen (he was married to a Frenchwoman but had already done national service in his native Germany and didn't want to have to go through it a second time, especially with a war looming), Kahnweiler had his effects sequestered at the outbreak of war and all his pictures were auctioned off—notably most of the cubist work painted between 1911 and 1914. When he returned to Paris soon after the war, his former artists except Juan Gris had become "too successful to have need of him," Stein tells us. Certainly the three other great cubists, Picasso, Braque, and Léger, had begun to be seriously collectable by this time, though the prices asked for their work remained low compared to the levels they subsequently reached.

Hemingway quoted Gertrude Stein, whose family-derived income was comfortable but not great, with a respect born of admiration: " 'You can either buy clothes or buy pictures,' she said. 'It's that simple. No one who is not very rich can do both. Pay no attention to your clothes and no attention at all to the mode . . . and you will have the clothes money to buy pictures.' " But not all the new arrivals treated Stein with particular reverence. The poet, artist, and filmmaker Charles Henri Ford called her "Sitting Bull," while John Glassco wrote that she

> projected a remarkable power, possibly due to the atmosphere of adulation that surrounded her. A rhomboidal woman dressed in a floor-length gown apparently made of some kind of burlap, she gave the impression of absolute irrefragability; her ankles, almost concealed by the hieratic folds of her dress, were like the pillars of a temple: it was impossible to conceive of her lying down. Her fine close-cropped head was in the style of the late Roman Empire, but unfortunately it merged into broad peasant shoulders without the aesthetic assistance of a neck; her eyes were large and much too piercing. I had a peculiar sense of mingled attraction and repulsion towards her. She awakened in me a feeling of

instinctive hostility coupled with a grudging veneration, as if she
were a pagan idol in whom I was unable to believe.

As backdrop and inspiration to all the artistic activity that was going on,
there was the city itself. The writer Malcolm Cowley has observed:

> Prohibition, puritanism, philistinism and salesmanship: these
> seemed to be the triumphant causes in America. Whoever had
> won the war, young American writers came to regard themselves
> as a defeated nation. So they went to Paris, not as if they were
> being driven into exile, but as if they were seeking a spiritual
> home. Paris was freedom to dress as they pleased, talk and write
> as they pleased, and make love without worrying about the
> neighbors. Paris was a continual excitation of the senses.

And if you were lucky enough to be working for an American publication
as a correspondent and were paid in dollars, all the better.

How close to all this were Peggy and Laurence? Given that they were
caught in an unsatisfactory marriage and expecting their first child, it is
understandable that they had little time to immerse themselves fully in the
cultural life of the time; but there seems to have been no profound connec-
tion at all, other than through parties and jaunts through the bars and bistros
of the Quartier Latin. They were generous hosts—though Peggy secretly
resented the amount of money spent on entertaining—and the guests came
largely because of the prospect of free food and drink.

Although Laurence's slim output of work shows the influence of the sur-
realists, he was never seriously involved with them, and Peggy had yet to
show any hint of the interest in modern art that was to define her life later.
She had as yet no conscious sense of purpose. If Laurence told her, as she
attests he did in order to humiliate her, that "I was fortunate to be accepted in
Bohemia and that, since all I had to offer was my money, I should lend it to
the brilliant people I met and whom I was allowed to frequent," his remark
at least planted another seed—but it took time to grow.

The Vails' money set them apart, but they did not hold salons like Stein or
Barney, nor did they patronize the arts. They lived in the grand Hôtel Luté-
tia, far from the Left Bank. Peggy did make friends within the artistic com-
munity, and might have become more involved with that world earlier in her

life had it not been, paradoxically, for the presence of her husband, who partly facilitated and partly inhibited her entrance to it. She had not forgotten the lessons and the principles instilled in her by her teacher Lucile Kohn, but she was handicapped by her lack of confidence, something Laurence was at pains to undermine anyway, on account of his own sense of inadequacy and inferiority, which stemmed from a similar source to Peggy's: parental neglect.

That they saw themselves as doyens of artistic life, however—Laurence more so than Peggy—is clear from contemporary observations of them during the 1920s. The contradictions in Laurence's character—charm and intelligence struggling with petulant egotism—are noticeable too. Matthew Josephson remembered:

> A few Byronic figures loomed among us; they owned private incomes and showed no great urge or haste to fill many volumes with their written words. Laurence Vail was such a one, who wrote and also painted a little, but more often and more seriously seemed bent on painting the Left Bank of the River Seine red. . . . With his long mane of yellow hair always uncovered, his red or pink shirts, his trousers of blue sailcloth, he made an eye-filling figure in the quarter. Moreover he was young, handsome, and for all his wild talk, a prince of a fellow; whenever he came riding in, usually with a flock of charming women in his train, he would set all the cafés of Montparnasse agog.
>
> Laurence literally "knew everyone"; and even if he didn't, would buy him a drink. His vivacious sister, Clotilde, who resembled Laurence in appearance as in high spirits, would usually be one of his café-crawling party, a band of Dionysiacs gathering followers at one bar or another.

Marriage to Peggy curtailed Laurence's freedom; she knew it, she was jealous of his company, and yet felt unable to satisfy him. So they took it out on each other. They were caught in a vicious circle that it would take a long time yet to break. Meanwhile, their incompatibility invaded every part of their lives. Laurence says that he tried to teach Peggy about the things that interested him, but as she had a perfectly biddable mind and profited happily from the education of other male companions, his allegation that "she

knew nothing when I met her and doesn't know much now" is more a reflection of the failure of their relationship than of her. The sharpness of his tongue didn't help. He was particularly unsparing about Florette. Once, flirting with his mother-in-law at dinner, he tickled her playfully. "Shush," she is reputed to have replied, "Peggy will see, Peggy will see, Peggy will see." Florette's mannerism of repeating things threefold is exploited in *Murder! Murder!*:

> Without waiting for outside encouragement the door caves in. Is it the mistral? The police? No, it is Flurry, my mother-in-law, paying an informal morning call.
>
> "What's this about murder, 'bout murder, murder . . ."
>
> Agitatedly, Flurry proceeds to make herself at home. Having flung one of her two extra cloaks on a chair, she places the other one on the bed. Then, having removed the cloak she wears, she puts on the lighter of the two extra cloaks. Then, having found the lighter one too light . . .

And so on in a similar vein. Shortly afterward, Laurence goes on to mock Florette's meanness, and writes of her "large, flabby face. . . . All the woes of Israel seem to be assembled on her dark face."

After a visit late in the year from Peggy's sister Hazel, who was already divorced from her first husband and about to marry number two, a London-based American journalist called Milton Waldman, the Vails took a house on the Riviera for the winter of 1922–23, where Peggy became ill and spent her time rereading Dostoevsky. The fighting continued. Peggy was always able to use her money as a stick to beat Laurence with; indeed it was her only defense, and whenever he wanted to be generous with her money (since he had relatively little of his own) it gave her a perverse pleasure to frustrate him. This time it was over a loan of $200 to their friend the writer and art critic Robert Coates, to enable him to return to the United States.

Peggy was well aware of the power her money gave her, and she used it throughout her life, often cruelly, to bolster her low self-esteem and to help her stand up to the sexism many of her men displayed. Often generous in important matters, she was nearly always—but by no means consistently— miserly in the little things. This was a trait acquired from her forebears, which she could no more help than the shape of her nose or her weak ankles.

But at this period she might have felt a sense of justification. It was she who paid for most of their expenses. Now she purchased a secondhand Gaubron from "one of my cousins in the automobile business." The car wasn't up to much, but they hired a chauffeur and Laurence learned to drive, which immediately caused him to fall in love with fast cars. They returned to Paris in the New Year, exchanged the Gaubron for a new Lorraine-Dietrich, one of the most expensive makes available, and welcomed Peggy's older sister, who had come over from the States to be with her for the birth of her child, now only two months away. Benita was horrified at Peggy's manner of living.

In the following month, April, the family crossed the Channel to London. It had been decided that the baby, who had been given the provisional nickname "Gawd," should be born outside France to avoid the later risk of French national service should it turn out to be a boy. Peggy and Fira Benenson found a house to rent in Holland Park, while Benita and her husband, Edward, joined by Florette, took rooms at the Ritz Hotel in Piccadilly. Florette had been kept in ignorance of the pregnancy until now, to minimize the chance of her making too much of a fuss over the imminent arrival of her first grandchild.

Michael Cedric Sindbad Vail put in his appearance on May 15, 1923. Peggy nursed him for a month, until her milk gave out. A month later she and Laurence were back in Paris with their little boy for the July 14 celebrations—a three-day binge for Laurence—which featured a drunken attack by Malcolm Cowley, Laurence, and others on the unfortunate *patron* of the Rotonde. Once the partying and the vandalism were over, the Vails took a house in Normandy for the summer. Peggy missed Benita, who had returned to New York, but they had a constant stream of visitors, including Man Ray and Kiki; Harold Loeb; Clotilde and her latest lover; the poet Louis Aragon; and, on one occasion, James and Nora Joyce, en route to visit their daughter, Lucia, who was attending a boarding school on the coast.

Their rootless life continued. Sindbad (as he came to be called—the name was Laurence's choice), attended by an English nanny called Lilly, who, Peggy noticed, had a magnetic effect on men, went with them. They traveled back to Capri in the autumn, where Laurence got into yet another fight, with a new lover of Clotilde's, broke a policeman's thumb, and was sent to jail for ten days. Laurence's bad behavior, exacerbated by alcohol, continued throughout his life until age mellowed him; but he behaved, as far as one can judge, worse during his marriage to Peggy than at any other time. He con-

stantly longed to get a reaction out of her, but she maintained an almost gla-
cial and calculated indifference. It was however an indifference that
extended to almost everything about her, as if she were watching life rather
than participating in it; and though such an attitude was a fashionable pose
at the time, Peggy was like a sleeping beauty, waiting to be woken up by the
right stimulation. Laurence wasn't her Prince Charming.

The Vails spent the winter in Egypt with just Lilly and Sindbad in atten-
dance, and while Peggy followed the prevailing fashion and collected large
numbers of pairs of earrings, a habit she never abandoned, Laurence bought
himself brightly patterned bolts of cloth in the souks and had coats-of-many-
colors made up. He also indulged himself, with Peggy's consent, in a night
with a Nubian belly-dancer who, he told her later, wore white underwear
and "had a very high bed. When he could not climb up to it she took him
under the armpits and lifted him up like a doll." She also gave him crabs,
which not unnaturally horrified Peggy.

Apart from Laurence's habitual tantrums and Peggy's quibbling over
money, this seems to have been a relatively happy period for the couple.
Leaving Sindbad in a hotel with Lilly, they explored Upper Egypt before
returning to Cairo and, again leaving Sindbad and Lilly, traveling to
Jerusalem. Peggy had responded enthusiastically to ancient Egyptian art and
architecture, but in Jerusalem she was repelled by the sight of Orthodox Jews
at the Wailing Wall: "It mortified me to belong to my people. The nauseat-
ing sight of my compatriots [sic] publicly groaning and moaning and going
into physical contortions was more than I could bear, and I was glad to leave
the Jews again." In the New Year they returned at last to Paris, successfully
smuggling in all the wares they had bought, together with a gigantic rag doll
stuffed with four hundred illegal Turkish cigarettes.

Owing to the arrival of Sindbad, the rooms at the Lutétia were now too
small, and Peggy, whom motherhood suited when it suited her, had already
promised Laurence "a girl next time." The family moved to a rented apart-
ment on the boulevard St.-Germain, at the heart of the Left Bank, appalling
their aristocratic landlord by shifting all his good Louis XVI sofas, tables,
and chairs into a back room and replacing them with fashionable rustic
French furniture. They stayed for six months through 1924, holding another
round of wild parties, though this was seldom to Peggy's liking. She was
scared that some of the guests (Laurence, it will be remembered, tended to
invite all and sundry) might make off with the silver, and she hated having to

clean up people's vomit the following day, or to change the sheets on her bed after someone else had made love in them. On the morning after she would purge the apartment, Lysol bottle in hand. Insult was added to injury by the fact that at the time Peggy scarcely drank; there can be nothing more boring to a nondrinker than a drunk, and she found herself frequently surrounded by them. For similar reasons, the long nights idling on the terraces of bars bored her to sleep.

Florette, back in Paris to hover over her daughter and grandchild, attended one or two of these parties, and on the whole enjoyed them, though she became enraged when Kiki once drunkenly called Man Ray "a dirty Jew," and made her feelings known. By now she had made friends with Gertrude Vail, but the two women's attempts to lure their married offspring back into the wealthy fold of the American colony in Paris came to nothing, though in the years to come Peggy accepted annual presents of either a fur coat or a new car from her mother, and noted gratefully that Florette was "forever putting money into trusts for me."

Laurence encouraged Peggy to continue to shop at Poiret's, and in 1924 she bought herself a flowing dress in Oriental style that she liked so much, now she had got her figure back after her pregnancy, that she wore it again and again. To go with it she had Stravinsky's fiancée, Vera Sudeikin, design a golden turban. Man Ray took a series of photographs of her in it, which she adored. Except as a little girl, Peggy never looked more attractive. So pleased was she by the dress that she ordered one for Mary Reynolds too. Mary had by now become a good friend, and was a frequent guest at the Vails' parties. She was enjoying a wild sex life, partying all the time, but such pastimes were soon to be brought to a halt by a closer encounter than hitherto with someone she already knew—Marcel Duchamp. Mary had been unable to get home after a party and spent the night with Duchamp, who generally disapproved of her way of life, but the next day, out of cash and unable to bring herself to ask him for more than ten francs toward the fare she needed for a cab home, she called on Peggy to rescue her.

Throughout his life Duchamp was an *éminence grise*. Aged thirty-seven in 1924, he had returned to France a year earlier after three sojourns in the United States (he first visited New York in 1915), but though he aligned himself with the surrealists, his work remained independent, and he was never a member of any specific artistic party. As much a theoretician as an artist, he had long since abandoned obviously creative work for chess, of

which he was a master. Ascetic and essentially solitary by nature, his life would be bound up with Mary's until she died, and his aesthetic influence on Peggy was to be profound.

In 1924 the cultural life of Paris was enriched when the comte de Beaumont initiated a ballet series at La Cigale in Montmartre, producing work by Stravinsky, Milhaud, Honegger, and Satie among others, with decors by Picasso, Ernst, Picabia and Miró. Peggy liked ballet, especially as a backdrop to socializing, but she was never much of a one for the performing arts, and the couple grew restless. She had her hair bobbed, which occasioned another outburst from Laurence, and then later in the spring another visit to Europe from Benita and Edward provided a welcome means of escape for a time. Peggy, with Florette in tow, joined her sister in Venice.

She had been there three times before on her trips through Europe with Laurence. Equipped with a little knowledge of her own, she proceeded to act as the family guide. At the end of spring she returned to Paris to find that Laurence had had an affair. His mistress had a baby nine months later, but Peggy reports that they never discovered whether it was Laurence's doing or, rather improbably, Robert McAlmon's, or—a welcome possibility—the woman's husband's. Peggy forgave Laurence, but the fighting went on as relentlessly as ever. Once, when they were staying at his mother's flat, they yelled at each other so loudly that Clotilde came in from the next room, immediately took her brother's part, and told Peggy to get out of the apartment. "I was so upset," said Peggy, "I began rushing around the flat as I was, quite naked." The situation was saved by the appearance of Gertrude, who said, "This is my apartment, not Clotilde's, and you are not to leave."

Restless still, the Vails set off for another holiday, with Clotilde, Lilly, and Sindbad, heading first for the Austrian Tyrol. They would spend the fight-ridden summer partly with Laurence's family and partly with Peggy's. They went hill walking with the Vails, which Peggy loathed, played tennis, and swam. When they joined Peggy's family, poor Benita, still on her European tour with Edward, showered affection on Sindbad; her own attempts at having a child had ended in a series of miscarriages.

Finally shedding their various relatives, Peggy and Laurence made their way back to Venice with Lilly and Sindbad, and here there was a lull in the storm. Laurence knew the city well, as his father had often painted there. Throughout their relationship Peggy had a high regard for Laurence's intelligence—something she always generously and unreservedly admired in

others, thinking as she did so little of her own—and, as she responded positively to the city herself, so she responded to what he taught her about it: "Laurence knew every stone, every church, every painting in Venice: in fact he was its second Ruskin. He walked me all over this horseless and autoless city and I developed for it a lifelong passion." They started to buy antique furniture for the home they hoped they would some day have—among other things, a thirteenth-century chest, which would end up immured in a country cottage in England. Peggy conceived the idea of buying a palazzo, but was prevented from doing so because her capital remained locked in trusts. Sindbad became rather a bore when Lilly fell ill and Peggy had to look after him "every day instead of on Thursdays, as was my habit."

From Venice they went to Rapallo, where they played tennis with Ezra Pound, who lived there and who had become a friend of sorts; but the place bored Peggy, and the fights with Laurence resumed. On one occasion he smashed a tortoiseshell dressing set that she had acquired after what she calls "months of bargaining in the Italian fashion." Dressing sets were important to Peggy: As a child she had bought an ivory set in Paris, which had long since disappeared, and this one had been intended to replace it. Many years later, in Venice after World War II, she herself smashed some tortoiseshell: An anonymous male friend, wishing to patch up a quarrel he'd had with her, brought her a tortoiseshell box as a peace offering. "As she took it from him," Maurice Cardiff recalls, "she remarked that if it was genuine it would be almost unbreakable. Putting her theory to the test she hurled it onto the marble floor where it predictably shattered."

Having spent New Year's in Rapallo they set off early in 1925 in a leisurely way for Paris. Peggy was pregnant again, her new baby expected in August. As they drove along the Provençal coast they came across a hamlet called Le Canadel, on the Corniche des Maures toward Cap Nègre. It was an enchanting place, and they decided that it was here they would like their home to be. As luck would have it, a tiny, primitive hotel was for sale nearby—La Croix Fleurie, which had artistic associations, since Cocteau had used to spend his winters here with his lover Raymond Radiguet. It was irresistible anyway: "a nice little white plaster building in the Provençal style. It had a double exterior staircase ascending to a balcony which gave access to three spacious rooms. . . . The wing consisted of one large room with a huge fireplace and three French windows that reached to the high ceiling and gave out on a lovely terrace with orange trees and palms, forty feet above the sea." There

may have been no telephone or electricity, but there was a mile of private beach. Impetuously they bought it but then got cold feet about the price. They managed to wriggle out of the ensuing difficulties and got the sum reduced by a third, provided that they undertook never to use the house as an inn; and they were obliged to repudiate the right to call it La Croix Fleurie.

They returned to Paris in triumph, but as the house would not be ready for them to move into until the summer, when Peggy was expecting her baby, they put off moving until the autumn. In the meantime Peggy decided to visit Benita in New York. Laurence, by now immersed in writing what was to become *Murder! Murder!*, did not at first want to go, but was persuaded to join her. With them they took a selection of flower collages by Mina Loy to sell.

Mina had arrived in Paris at the turn of the century, and had returned there in 1923 after extensive travels and a checkered, romantic, and sometimes tragic life had taken her to South America, Florence, Berlin, and New York. Born in London in 1882, she was a highly talented poet—published in the *Little Review* and by McAlmon's Contact Editions—as well as a designer and painter. Having very little money, she had to work hard to make a living without compromising her creativity. Her latest idea had been born of frequent visits to the Parisian flea market, in those days more a place of genuine wonder than it is today, but still only if you could see the potential beyond the junk. Mina had a superb eye, and one of her aims was to train her two daughters, Fabi and Joella, to develop their own. "One had to buy the real thing, a piece of old lace," she explained, "or something funny, but nothing from a department store."

In the course of several such expeditions Mina had got hold of a number of Louis-Philippe picture frames for a price well below their real value. As her biographer Carolyn Burke explains:

> Her latest fantasy, devised to earn the money for a larger apartment, crossed the traditional still-life with Cubist collage. She cut leaf and petal shapes from coloured papers, layered them to form old-fashioned bouquets, and arranged these pressed flowers in découpé bowls and vases painted with meticulous attention to surface texture. These "arrangements" were then backed with gold paper and set in Mina's flea-market frames: instant antiques,

they looked expensive but were made from the cheapest materials. She had created a medium that lived beyond its means.

Mina had known Eugene Vail in Paris twenty years earlier, and had gotten to know Laurence and Clotilde in Florence—it was they who had encouraged her to go to New York to sell her designs. Once in the United States she had played a role, though not one to her liking, in Laurence's play *What D'You Want?*, and had met and fallen in love with the extraordinary pugilist-poet Arthur Cravan (who claimed to be a nephew of Oscar Wilde, a relationship that was never proved). She later followed him to Mexico, where they married. Toward the end of 1918 Cravan, as erratic as he was romantic, conceived the plan of purchasing a boat and sailing it to Chile. He took up a collection and bought a hulk, which he proceeded to patch up. When it was ready he went for a test sail in the Gulf of Mexico and was never seen again. Whether he was wrecked or whether he ran away is not known, but he left behind a pregnant wife. Mina was still grieving for him when the Vails agreed to take her work to New York for her and try to sell it in 1925.

Laurence invented a title for the collection, "Jaded Blossoms," and Peggy organized exhibitions for it at department stores and art galleries, as well as having a showing of Mina's drawings and portraits on Long Island. The catalog, written anonymously by Laurence, boasted of Mina's grand English background—in fact it was relatively humble. But the portraits sold, as did the Jaded Blossoms, and the reviews were good. More important for Peggy, she had discovered a gift: Although most of the clients were friends or members of her extended family, she found that not only was she quite good at selling, but she had an appetite for it. There was no need for her to make use of her gift, because she had money already, and in any case her upbringing militated against her working seriously in any kind of commerce. That was a field better left to the Guggenheim and Seligman men.

The Vails wanted to avoid having their new baby in France, for the same reason as before, and set about looking for a place to stay temporarily in the States, but both of them quickly became fed up with New York (neither of them ever liked living in America) and preferred to return to the greater freedom of Europe. Once again Florette came too. This time, in an attempt to stop her fussing, they'd told her the baby was due much later than in fact it was.

At the end of July they settled at Ouchy, near Lausanne in Switzerland.

Gertrude Vail arranged for a doctor, an easy task for her, since her hypochondriacal husband had frequented practically every sanatorium in the country, and the Vails, with Florette and now Clotilde in attendance, moved into the Beau Rivage Hotel, taking an extra room for the midwife they'd engaged, a handsome woman whom Peggy later (mischievously?) wrote she'd felt attracted to.

The physician had told Peggy that she would give birth between August 1 and 18, but the baby took its time. True to form, on the night of the seventeenth Laurence flew into a temper in the hotel restaurant, tipping a plate of beans into Peggy's lap. Perhaps he was just desperate about having to compete for attention with yet another person. Whatever the cause of his anger, its effect was to trigger his wife's labor. Laurence attended the birth, which took place the following evening at about ten o'clock. Peggy, who had had a hard time giving birth to Sindbad but who refused chloroform on this occasion, went through such pain that in the end she had to beg the midwife for "a few whiffs," although she didn't scream once. Laurence and Peggy now had the daughter she'd promised him. They named the baby Pegeen Jezebel.

Peggy was convinced she would never have another child. It was eight days before she could get out of bed and transfer to a chaise longue. One day when the midwife was out and Peggy was alone with Pegeen, "she began to cry. I could hardly walk across the room to her and I felt as if all my insides would fall out. I nursed her for a month and then I couldn't any more."

By now Peggy and Laurence had had enough of Ouchy and Lake Geneva and were impatient to get down to their new home on the Corniche des Maures, which was ready for them. The plan was that Laurence would drive there (the Lorraine-Dietrich, which he'd collected from Paris in the meantime, was a two-seater), while Peggy and the children, together with Lilly, the midwife, and most of the luggage, would travel down by train. They got as far as Lyons, where they had to change, and were told that there would be a forty-five-minute wait before the onward train left. Depositing the midwife, the baby, and the luggage—fifteen suitcases—in their compartment, Peggy and Lilly took Sindbad with them in search of some lunch. But when they returned, the train had gone—it had left a few minutes early. The midwife had never traveled anywhere before, and Peggy was beside herself. She got the stationmaster to telegraph ahead to the next station and have the train stopped there long enough to deposit her party and her luggage. She picked them up on the next train, which also obligingly stopped for two min-

utes. However, the shock of the experience had the immediate effect of drying up her milk, and the hungry Pegeen had to make do with powdered milk for the rest of that day.

The new house was on the edge of the little village of Pramousquier, no more than a railway station and a handful of houses on the St.-Raphaël–Toulon line, and still an attractive seaside resort. Pramousquier was to be the scene of some happiness and one tragedy, and the stage on which a liberation took place that would radically alter Peggy's life.

Pramousquier

"*P*romiscuous" was what Florette called the place—a labored but still witty pun Peggy chose to attribute to her mother's inability to pronounce the village's name. As it lay four hours by train from Toulon in one direction, and four hours from St.-Raphaël in the other, the Vails bought a little Citroën runabout to use as a workhorse, in which Peggy learned to drive. The nearest town of any consequence was Le Lavandou.

It wasn't idyllic at first. Food had to be kept in an old icebox, which was constantly running out of ice. The beautiful but rocky Provençal countryside was not the place for dairy farming, so regular forays had to be made for milk. They hired Italian maids, who were illegal labor and worked for cash, and were therefore cheaper than regular French employees. They were, however, sluttish and lazy. On the other hand, Peggy's money and Laurence's taste ensured that their comfort was not otherwise compromised. They imported the furniture they had bought in Venice, to which Laurence added sofas and armchairs. He'd already had a studio built for himself near the main house, and in time they added a library, another studio over the garage for Clotilde, and later a small house for their friend Robert Coates and his wife.

When the local railwaymen went on strike for more pay, the socialist precepts inculcated in Peggy by her old teacher Lucile Kohn paid off in an unex-

pected way. Peggy had been sending Lucile $100 at more or less regular intervals since she had come into her inheritance. Laurence objected to this, and disapproved of Peggy's socialist tendencies, believing that all political movements, especially those of the Left, were "so boring." Despite this, Laurence, who understood the French character well, proposed that they subsidize the strikers to the tune of $1,000—a suggestion Peggy was happy to go along with. The strike was more like a "work-to-rule," since the trains continued to run; but as a result of their support only the Vails benefited from the railway's services, which included a daily delivery of ice for the old tin icebox. This was thrown off the train in a sack near where the line passed their house, but sometimes the railwaymen threw it out near the neighboring village of Cavalière by mistake, and Peggy had to leap into the Citroën and fetch it before it melted. Once the strikers had brought their action to a successful conclusion, in gratitude the Vails were given the right to travel free on the branch line that connected Pramousquier with Cavalière, where there was a grocery, and Le Canadel, where they often drank a few pastis at Madame Octobon's little bar-restaurant, which also rented a few rooms, made use of by Vail guests when there wasn't enough space at Pramousquier.

Gradually they settled down to a sort of routine. Peggy enjoyed being the mistress of the first real home she had ever had in her own right, and promptly began to annoy Laurence with her habit of keeping precise, even anal, household accounts. No centime could be left unaccounted for, and no groceries went unremarked. It wasn't simply stinginess: Peggy enjoyed accountancy, and a sense of the value of money was in her blood.

At Pramousquier, for the first time since she had left the family home in New York, Peggy was able to indulge her fondness for animals, and very soon she had established an eccentric menagerie. One of the first arrivals was Lola, a half-wild sheepdog who was the unwelcome gift of Gabrielle Buffet-Picabia, wife of the painter Francis Picabia and one of the earliest champions of modern art. Lola turned out to be perfectly friendly to anyone not in uniform, so that only the postman was ever bitten; though local farmers suffered too, since she produced a litter as undisciplined as she was. The Vails frequently had to pay compensation for chickens that had met their end in the jaws of the dogs. Subsequently, Lola and her pups were joined by nine cats, but the dogs often ate the kittens produced by unspayed queens.

There was also a pig called Chuto, who rooted amiably about everywhere. Chuto was especially devoted to Joseph, the gardener, who fed him on the

choicest scraps and even gave him wine. Alas for Chuto, it was a false friendship: Joseph was fattening him for the pot. Peggy, who had the tenderest heart where animals were concerned, for once shows herself in a harder light: "It was painful to have to kill and eat Chuto and see his blood turned into black sausages." But Chuto had his revenge from beyond the grave. As Laurence and Peggy drove up to Paris in a car laden with his ham, the bitterly cold winter weather spoiled the meat, making it inedible.

The dogs drove Joseph mad, tearing up the flowerbeds and defecating everywhere in the extensive gardens. Unable to confront his employers directly, he tried to hint that the dogs were a nuisance by shoveling up their excrement and depositing it at dawn around the table on the terrace where the family breakfasted, but it was months before the Vails realized that the dogs hadn't actually dumped it there themselves.

Though Peggy kept a sharp eye on the day-to-day accounts, in those days she didn't stint on entertaining. They employed professional chefs from Paris, persuading one to stay by buying a whole set of expensive copper cooking pots, and they kept a well-stocked cellar. Among the first guests was Mina Loy, with her young daughters. She decorated her bedroom with a mural of lobsters and mermaids.

Laurence, who'd begun to work on a series of collages glued to empty wine bottles, enjoyed the role of local seigneur, and the pace of country life agreed with him. He continued to write *Murder! Murder!*, his most sustained piece of published writing, and there are few records of major fights.

Winter in Provence was not for them. At the end of 1925 they set off for Wengen in Switzerland, with Clotilde, to ski. Laurence and Clotilde were expert skiers and loved the sport, but Peggy, who had not only weak ankles but a poor sense of balance, couldn't master or enjoy it. So brother and sister set off each day for the slopes, while Peggy sat around at the hotel with the children and grew bored. The one day she took Sindbad out sledding, they had a spill and she cracked a rib.

That settled it for Peggy. She announced that she was leaving for Paris, and met with no objection. Once there, with Sindbad and Pegeen and the new nanny (Lilly having returned to England) safely installed in the Lutétia, where Peggy's money continued to make her a welcome guest despite her husband's excesses, she set about looking for a good time. She was fed up

with playing second fiddle to Clotilde, and fed up with Laurence's patroniz-
ing attitude, while taking advantage of her money. She decided to find her-
self a lover.

She gave a party in Laurence's studio, which he had retained. It was an
old workshop in a cul-de-sac, ideal, she thought, for bohemian parties. This
was the first party she'd given alone, and at the end of it, pretty drunk, she
fell into bed with someone whose identity is unknown. The act itself meant
nothing to her except in terms of getting even, so she made sure Laurence
heard about it. He turned his fury at first on the entirely innocent Boris
Dembo, Peggy's former swain, who'd become a friend, with whom she was
dining on the night of Laurence's unexpected arrival in Paris. Dembo with-
drew immediately, but Laurence set about demolishing her hotel room yet
again, throwing her shoes out of the window, hammering at the door of the
children's room (fortunately the nanny had locked herself in with them), and
then rushing out into the night on what was the start of a four-day binge.

Laurence continued to brood, and exploded again one night when he,
Peggy, and Clotilde were having dinner with some friends at Pirelli's. Work-
ing there at the time was James Charters, "Jimmie the Barman," who knew
the Vails well, having frequently been engaged by them for their private par-
ties. In his memoir he describes what happened:

> . . . at the further end of the room were five Frenchmen, chatting
> and laughing. Vail, who was sometimes taken with sudden tem-
> pers, decided the Frenchmen were making fun of him and his
> guests. Coming to the bar, he picked up a bottle of vermouth and
> a bottle of Amer-Picon and threw them in rapid succession at the
> back of the room. One man just missed being killed by a fraction
> of an inch, and the dent in the wall could still be seen at the Col-
> lege Inn [as Pirelli's later became] the last time I was in Paris!

Although this story varies slightly according to the teller, the essentials are
the same, and all are agreed on the outcome. The police were called, and
Laurence was arrested and taken to jail to cool off. The victims of his out-
burst, all army officers, wanted to press charges, but Clotilde managed to
persuade most of them to drop the matter. Unfortunately one went ahead,
and Laurence was given a six-month suspended sentence, which under
French law would be added to any subsequent conviction.

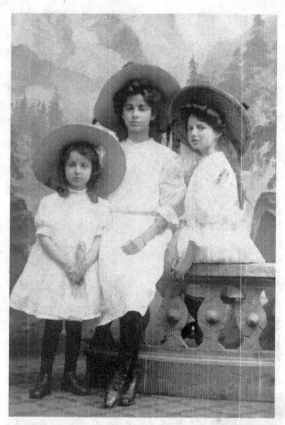

Three sisters. *Left to right*: Hazel, Benita, and Peggy in Lucerne, 1908.

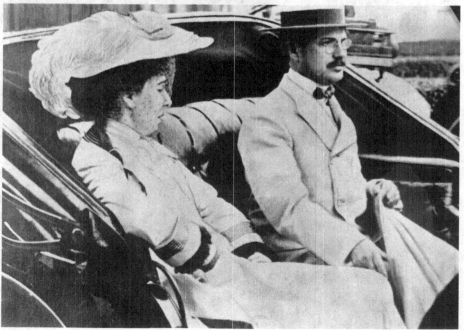

Peggy's parents, Florette and Benjamin, in their carriage in New York, about 1910.

Peggy with her children, Sindbad and Pegeen (on Peggy's knee); photographed by Peggy's friend and protégée Berenice Abbott in France in the mid-1920s. This is a rare profile shot of Peggy: she was always sensitive about her nose.

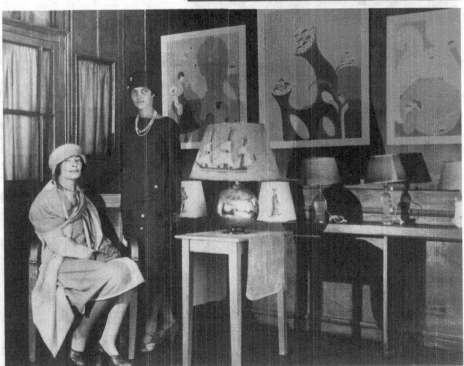

Peggy and Mina Loy (seated) in their Paris shop before the rift between them.

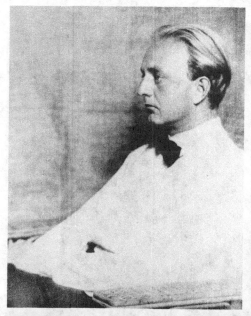

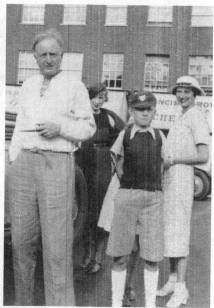

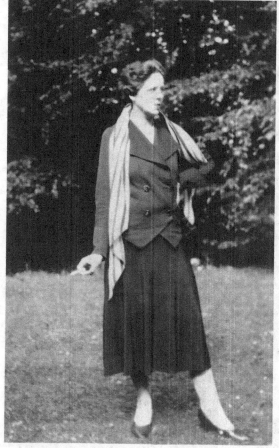

Top left: Peggy's first husband and lifelong friend, the writer, artist, and heroic drinker Laurence Vail. *Top right*: Laurence in England in 1931 with (from his left) his second wife, the writer Kay Boyle, Sindbad in prep school uniform, and Peggy.

Peggy's friend and protégée the novelist Djuna Barnes, probably photographed at Hayford Hall in about 1936.

Peggy at Hayford with John Holms, the love of her life, and Sindbad and Pegeen.

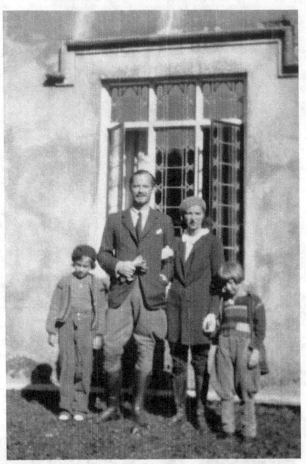

Bottom left: Emily Holmes Coleman.
Bottom right: Peggy with Herbert Read in the late 1930s, when they were working on Peggy's proposed museum of modern art in London, a project dashed by World War II. The photograph is by Gisèle Freund. Peggy wanted her legs in the shot, and behind Read and Peggy hangs one of her 1938 Guggenheim Jeune purchases: Yves Tanguy's *Le Soleil dans Son Écrin*.

From left: Max Ernst, Leonora Carrington, and Roland Penrose; behind them, E. L. T. Mesens, photographed by Lee Miller on vacation at Lambcreek, Cornwall, in 1937.

Peggy's friend, and the administrator at Guggenheim Jeune, Wyn Henderson.

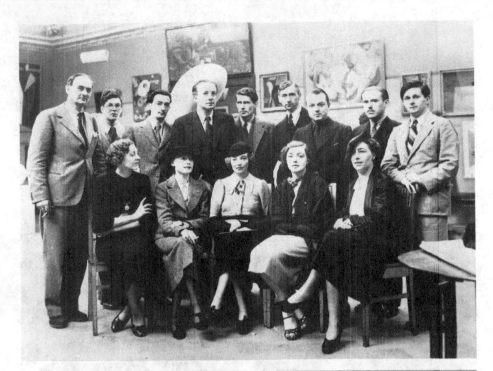

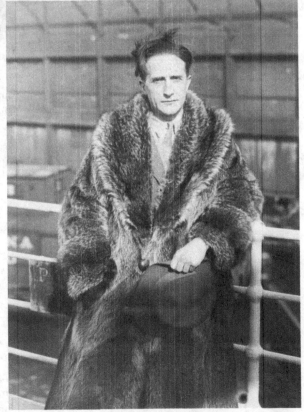

A group of artists and art lovers at the 1936 Surrealist Exhibition in London. Standing in the back row from the left are Rupert Lee, Ruthven Todd, Salvador Dalí, Paul Éluard, Roland Penrose, Herbert Read, E. L. T. Mesens, George Reavey, and Hugh Sykes-Davies. Seated in the front row are Diana Lee, Nusch Éluard, Eileen Agar, Sheila Legge, and an unidentified woman.

Mentor, friend, and possibly even lover, Marcel Duchamp.

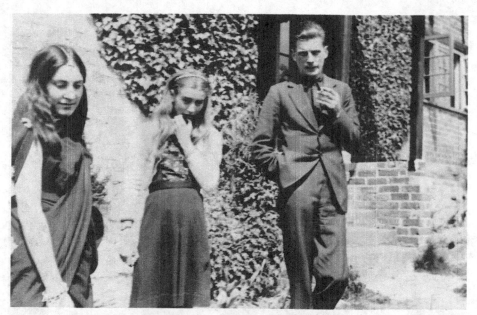

Samuel Beckett at Yew Tree Cottage with (to his right)
Pegeen and, next to her, Deborah Garman.

Peggy and Yves Tanguy en route to
London for his exhibition at Guggenheim
Jeune which opened on July 6, 1938.

Douglas Garman.

Peggy on the balcony of the apartment she rented from Kay Sage on the Île St.-Louis in Paris in 1940. On the parapet is a recent purchase: Brancusi's *Maiastra*.

One of the other victims, Captain Alain Lamerdie, was so smitten by Clotilde that soon afterward he proposed marriage. She refused him, but he persisted, undaunted by the very different world Clotilde belonged to—he himself came from an old military family. In the end, yielding to sheer pressure, she did accept him, but not until 1932, seven years later. Her marriage would drive Laurence into a frenzy of jealous rage.

Peggy tells us that she spent the remainder of the night following Laurence's bottle-throwing stunt wandering the streets of Paris with Marcel Duchamp, whom Clotilde had enlisted to help her plead Laurence's cause with the officers. They were "longing to go to bed together, but we did not consider it an appropriate moment to add to the general confusion." This is an interesting early glimpse of Peggy's desire to seduce artists, perhaps in the hope that their creativity might rub off on her. Just as in some cultures it was believed that if you ate the heart of the enemy you killed in battle you would obtain his strength, so Peggy used sexual intercourse as a means of associating herself with people whose imaginative resourcefulness she admired but could never hope to emulate. In this case the thought of bed was in Peggy's head only. Duchamp kept her at arm's length, and it would be twenty years before she slept with him—although we only have her word for it that she actually did.

In the morning Peggy collected Laurence from the police cells and took him home. Soon afterward, according to Peggy, he abruptly announced that they were returning to Provence there and then; but once they were on the train, waiting for it to leave, he changed his mind and they wandered off into the streets of Paris (he was in the habit of going out in search of nightlife after Peggy had retired to bed). He pushed her through a doorway into a brothel, where fifteen girls set about importuning them both. Peggy's desire to appear *mondaine* carried her through the experience, and in her memoirs she is at pains to let us know that this wasn't her first visit to a brothel anyway.

One of the girls struck up a friendship of sorts with Peggy, and the following summer turned up at Pramousquier while holidaying in Provence, proceeding to bore Peggy with a long disquisition on the prices of things. Peggy may have liked money, but wasn't interested in it as a topic of conversation. Laurence's own recollection of the visit to the brothel was that his action was provoked by finding Peggy drunk and dancing on a table at the Select, her face covered with lipstick-warpaint, and that his original intention was to take her back to the Lutétia, not Provence. Neither version sounds especially trustworthy.

Laurence drank less at Pramousquier than he did in Paris; his behavior always worsened when he reached the capital. Matthew Josephson, an associate of the surrealists and one of the few Americans to make friends with French artistic counterparts, recalled a fight he had with Laurence in 1927 that shows the two most significant facets of Laurence's character:

> I had just returned from a vacation trip to the Riviera during which I had visited Laurence and Peggy Vail for several days. Laurence and I used to disagree in our opinions of almost everything, yet so long as I was a guest under his roof he was so much the gentleman that he would never dispute with me. But once we were back in Paris together, on neutral ground, the case was different. In a restaurant one night in October we came to angry words. Pushing our chairs aside, we rose and drew back our fists, while Peggy, also present, gave forth little agonized screams that drew the attention of the crowd. Suddenly a tall figure stepped between us. It was [Louis] Aragon, who led me to a table at the other end of the room where he had been dining with a companion.

Sober, Laurence could be a delightful friend. Drunk, the Mr. Hyde side of his personality came to the fore with a vengeance. At bottom he was a weak man with no strongly held ideas. He was intelligent enough to know this. Marriage to Peggy reinforced his bitterness and made her hard.

Peggy may have been stingy when it came to the everyday running of the house at Pramousquier, but she could be generous to causes. Laurence moaned about her domestic penny-pinching, but he was just as opposed to her generosity in charitable matters. The year 1926 saw the General Strike in Britain, and, still influenced by Lucile Kohn's socialist principles, Peggy identified particularly with the plight of the miners. She now set about organizing the greatest single charitable act of her life. It was also a conscious or unconscious comment on the fact that the Guggenheims had made the greater part of their fortune through the exploitation of miners. She instructed her uncles in New York to realize $10,000 of stock remaining from her inheritance from Grandfather James. At first the uncles demurred, but it was her stock, not part of the trust, so they could do nothing but comply. By the time they had done so, however, and the money had been dis-

patched to a fighting fund in England, the strike was over. Laurence muttered that at least there would be enough to buy each miner a pint of beer.

It was about then that Peggy first began to show an interest in patronage, and to see it as another means of bringing herself closer to people whose talents she admired. She had inherited her wealth, not earned it, and felt, in keeping with what was becoming a Guggenheim family tradition, that some of it should be used to promote the arts and sciences. The mere act of giving, however, was not conducive to establishing any real relationship between the giver and the recipient, which is what Peggy wanted. Lucile Kohn was much older than Peggy, devoted to a cause for which she used the money Peggy sent her, and lived far away in America. Peggy's aid to the miners was almost an abstract act. But when it came to subsidizing close contemporaries, who could welcome and at the same time resent her help, relationships could become complex. It is significant that Peggy never had many true friends. Whereas in the beginning she may have sought to buy her way into a milieu where she would otherwise have found no place, later in life, an established member of the art world, she became suspicious, thinking that everyone had an ulterior motive in seeking her company. Only those who, regardless of their comparative wealth, made absolutely no call on her money were accepted with genuine trust and affection.

But in the mid-to-late 1920s, none of these complications had crept in. When her contemporary, the budding photographer Berenice Abbott, asked Peggy for a loan of 5,000 francs to buy a camera in order to start a freelance career, Peggy happily gave her the money. Abbott repaid her by taking a series of photographs of her and Sindbad and Pegeen that Peggy found delightful. At about the same time she started the payment of a monthly stipend of $40 to Djuna Barnes, who was never going to enjoy material success as a novelist, and who remained indebted to Peggy throughout her long life. Peggy kept up the stipend almost continuously, increasing it every so often, and after her death her son Sindbad maintained the payments until Barnes's death in 1982. But Peggy wrote to her friend Emily Coleman in 1940:

> The truth about Djuna first of all is that she is not a friend of 25 years but an acquaintance whom I helped since 1920. . . . I think Djuna the most ungrateful and spoilt person I have ever helped. . . . She thinks everything I do for her is quite natural and

every little thing anyone else does wonderful. She hates me really
at bottom because I help her. She has been nastier and nastier to
me as time goes on & I finally felt that her dreadful [alcoholic] col-
lapse was due to her having too much money to live on.

This letter was written in hot blood; and Peggy did cut off Djuna's
allowance for a time, but a kind of friendship persisted between the two
throughout their lives, though they scarcely ever saw each other after 1945.

Among those who sought Peggy's help during the 1920s was Mina Loy,
who had a greater effect on her life then than any of the other beneficiaries,
as she actively involved Peggy in a project. Peggy had already successfully
marketed Jaded Blossoms in New York. Now the plan was to open a shop
selling Mina's work in Paris.

Mina needed the shop, since she had to work for a living. Sixteen years
Peggy's senior, she had been at the forefront of a loose-knit international
group of women who had made a conscious effort in America and Europe to
liberate themselves from the constraints of their upbringing and to try to do
something positive with their lives. All of them found the transition difficult,
and all could subscribe to the sentiment voiced by Bryher: "We were the last
group to grow up under the formidable discipline of the nineteenth century,
whose effect, however much we resented [it], cannot be entirely eradicated
from our systems."

Mina was a talented poet, painter, and designer, who as early as 1904 had
begun to influence dress designers like Paul Poiret, who with Mariano For-
tuny was *the* designer for the avant-garde rich. Under Mina's influence
corsets, frills, and ruches were shed in favor of more natural lines, and blocks
of bold color replaced patterns. Her then husband, Stephen Haweis, went so
far as to suggest that Poiret imitated Mina's designs after watching for a year
or two to see how well they would do. Mina had also been associated, though
not always actively, with the modern art movement since its inception, and
with Roger Fry's boundary-breaking "Manet and the Post-Impressionists"
exhibition in London late in 1912. Later, in New York, she became involved
in *soirées* given by the collector Walter Arensberg, where she met many
artists, including Marcel Duchamp (on the first of his many extended stays in
America), his friend Henri-Pierre Roché, Francis Picabia, Edgar Varèse, the
art collector Katherine Dreier, and others. Duchamp, excused from military
service in France because of heart trouble, was largely responsible, with

Arensberg, for setting up the "Independents' Show" in spring 1917, at which any artist could exhibit two paintings provided he or she paid $6, and to which Duchamp submitted, under the name "R. Mutt" ("R. Mutt" is one of Duchamp's wordplays: It refers to the German word for "poverty"—*Armut*), his famous early "readymade"—an ordinary porcelain urinal laid on its side and entitled *Fountain.*

Among other ways Mina had made money in New York by starting a modest business selling her own lampshades. Peggy admired Mina greatly, and all looked well when she offered to back her friend in whatever project she chose to undertake. However, Mina resented Peggy's wealth, and Peggy exploited Mina's dependence on it. Peggy put all investments connected with the business in Mina's name, with the lame excuse that as Mina was English they would thus avoid French tax. Mina found herself obliged by her partner to make the first purchases of material herself, since Peggy argued that the franc was going to fall, and when it did she would exchange dollars at the better rate and so have more to invest in Mina. But that didn't mollify Mina much when she changed her British pounds at 100 francs each to buy goods, only to see the exchange rate climb soon afterward to 250 francs. Then promised funds from Peggy were not forthcoming. Having given $10,000 to the miners in England, Peggy got cold feet about pouring more into her business enterprise. With no funds to refurbish the shop, Mina improvised, which she was always good at, and managed to save the day; but she still had to put up with nagging letters from Peggy, who wasn't even around as the opening day approached, but was in Pramousquier. Finally she appealed to another friend, Heyward Mills, who gave her sensible business advice and actually advanced the money she needed to open the shop in September 1926.

The rent was high, for the shop was in the rue du Colisée, in the fashionable eighth arrondissement, just north of the Rond Point des Champs-Elysées, but its location, argued Peggy, would attract the right kind of clientele. The shop was to sell tasteful lamps, made from antique bottles, and lampshades designed by Mina and made by her and a team of workers in a studio near Laurence's on the avenue du Maine in Montparnasse. Mina was initially in charge of the design and production end of the business, leaving Peggy to run the shop. Mina was not amused when Peggy added expensive lingerie, slippers designed and made by the ubiquitous Clotilde, and some mediocre paintings by Laurence to the merchandise. Mina refused to attend the shop's opening, dubbed a *vernissage* by Peggy. It was not an auspicious beginning for

the partnership. When he heard that his niece by marriage was working in a shop, Laurence's uncle George was horrified. Laurence was amused.

Against all odds, the shop was an immediate success. Peggy was less than enthusiastic in her involvement, however, and spent much time in Pramousquier. In her absence her mother, then staying in Paris, made the unwelcome suggestion that Mina bulk out her stock with a supply of scarves from the Galeries Lafayette. Mina declined, but remained polite—Florette's influence with the American colony could bring her customers. When Peggy returned to Paris she repaid Heyward Mills what he'd advanced, accused Mina of disloyalty to her, and reiterated her intention to give Mina unlimited funds and carte blanche.

Throughout 1927 the two women remained uneasy allies, though there were compensations for Mina. The young American Julien Levy, a future New York art dealer and pioneer champion of modern art, was on a visit to Paris and fell in love with Mina's nineteen-year-old daughter Joella, who was managing the lampshade "factory." He married Joella, but it was her mother who became his muse. One splendid side effect of this was that Mina, never a very able businesswoman, was able in 1928 to borrow $10,000 from Julien's wealthy property developer father, Edgar Levy, and buy Peggy out. The Vails, she wrote to Edgar, "are scandalising the most *outré* of bohemians, and their children are being brought up in a manner that frightens me." Peggy was if anything relieved that the venture was over: She'd already decided that business partnerships were not for her.

Even so, before it ended she had successfully peddled (bought for a few cents and sold for $25 each, as she gleefully reports) another fifty of Mina's lamps and shades in New York while on a visit to Benita, and had enjoyed the experience. She may have had a captive clientele in the usual form of her New York relations and their friends, but it was stimulating to indulge the flair for selling she had inherited, selling the articles even to shops Mina had asked her not to approach, for fear of her designs being copied. The acrimony that existed between the two women is discernible in Peggy's bitchy and not strictly truthful footnote to the affair:

> I sold five hundred dollars' worth, and sent Mina a check, but she
> was furious because I had not obeyed her instructions. She was
> afraid her invention would be cheapened by the department
> stores. Finally in Paris all her ideas were stolen, and although she

had copyrights she had to give up her business. It was impossible
for her to conduct it without a businessman and a lot more capital.

This trip to New York was made in the winter of 1926–27, and during it
Benita told Peggy that she was expecting a baby the following August.
Benita had already had five miscarriages, but this time she had cause for
optimism: This baby had survived longer in the womb than the others had.
Laurence dragged his wife off to Connecticut, along with the children and
yet another nanny, a pretty English girl called Doris who enjoyed New York
in the company of one of the Italian maids from Pramousquier, who com-
pleted the entourage. Peggy at that time seemed to Matthew Josephson to be
like a "young matron, somewhat shy in manner and plain in appearance, but
beautifully dressed." In Connecticut, Laurence continued working on *Mur-
der! Murder!* The family lodged with the poet Hart Crane, whom they'd got
to know in Paris, and for whom their presence was a welcome temporary
release from his self-imposed writer's isolation; and in Laurence he found an
equally welcome drinking partner. When the time came for them to return
to Europe, Peggy promised Benita that she would be back in September to
meet her new niece or nephew.

In Europe the Vails continued to divide their time between Pramousquier
and Paris. In the capital they stayed at the Lutétia and gave parties at Lau-
rence's studio, where by now they were the undisputed social leaders of the
American artistic set. At the hotel Peggy met the faded Isadora Duncan, in
her forty-ninth year and strapped for cash, yet staying at the Lutétia, dis-
pensing champagne, and driving the Bugatti in which she would meet her
death soon afterward. Isadora nicknamed Peggy "Guggie Peggleheim,"
advised her never to refer to herself as a wife, and hinted that any small
financial gift or even loan would be welcome. Peggy didn't take the hint.

At Pramousquier their existence took on a routine. Peggy rose at nine or
ten, breakfasted, and went in search of bread, milk, and ice; by now she'd
arranged for shops in Le Lavandou and Hyères to deliver the rest of the gro-
ceries. She would then sunbathe until lunch at two, always al fresco, all year
round. Local restaurants could provide six-course dinners for eight francs.
Guests could stroll along the private beach or wander into the hills behind
the house. An evening swim completed the day. Peggy read and reread her
favorite authors, Dostoevsky and James as always well to the fore, but Lau-
rence noticed that she was sometimes bored. She didn't care much for swim-

ming, and the harsh Provençal countryside oppressed her. He correctly defined her as a "city girl" who only liked the manicured countryside of Switzerland, Austria, or southern England: "She enjoys bustle, people, intriguing and excitement, and some business—buying and peddling."

Laurence became an expert player of *boules*, and finished his novel at last. (It was published in 1931, and dedicated to the writer Kay Boyle, whom Laurence would marry the following year—the year of his sister's wedding.) When invited to read the manuscript Peggy enjoyed most of it and found it "extremely funny." However, she did raise some objections, which caused Laurence to fall into one of his rages. He burned the manuscript—a dramatic gesture more than anything, since he had a carbon copy.

Toward the end of July 1927 a telegram arrived for Laurence from New York that Peggy opened by mistake. It said that Benita had died in childbirth on the twenty-first, and asked him to break the news gently to Peggy. The shock hit her like a sledgehammer. Benita had been more than a sister to Peggy, who scarcely communicated with Hazel, then living in England, or with her mother.

Peggy wept for weeks. The sight of her own children excited feelings of guilt. At first all she wanted was flowers, which Laurence and Clotilde fetched in large quantities from Toulon. Clotilde suspended her jealous feud with Peggy, for she recognized in Peggy's love for Benita a mirror of her own for Laurence. Laurence, however, as Peggy's grief refused to abate, became jealous of Benita's memory. The fact that he threw tantrums at such a time, and that Peggy blamed him for taking her away from her sister, created a serious and permanent fracture in their already badly strained relationship.

Florette came over to France in the autumn—Laurence drove Peggy up to Cherbourg to meet her—and laid the blame for Benita's death squarely on Benita's husband, Edward Mayer, whom she'd never liked. There continued to be little communication between mother and daughter—indeed, Peggy was beginning to find Florette increasingly irritating. She blamed herself for not having been with Benita throughout her pregnancy, and she joined her mother in blaming Edward for having made Benita pregnant again. She also blamed the doctors, and this was not unjustified: Benita had inherited some of the physical weaknesses engendered by inbreeding. Her child had been stillborn as a result of *placenta previa*. She should have been dissuaded from any more attempts at motherhood.

Florette bought Peggy and Laurence a Hispano-Suiza to replace the Lor-

raine-Dietrich. The Hispano was one of the biggest, most expensive, and most powerful cars available in those days, and Laurence drove it as if all the devils in hell were after him, exulting in the speed and the joy of truly open roads. The gift didn't improve his behavior, however: In Paris he tore up enlargements Peggy had had made of snapshots of Benita and used to decorate her room at the Lutétia. Pegeen and Sindbad were with them to see their grandmother.

Peggy inherited money from Benita's estate but gave it away to charities. She decided never to return to the United States, and probably would not have if it hadn't been for World War II. She consulted fortune-tellers, one of whom predicted that she would meet a man in the South of France who would become her next husband. She laughed, as the thing seemed so impossible. Another man, a "Roman Rosicrucian," read her palm and predicted a new husband for her too, which so angered Laurence that he knocked her down in the street when she told him. According to Peggy he then proceeded to set fire to a thousand-franc note, making some bitter point about her wealth. For that, rather than for hitting his wife, the police arrested him, but he was, as usual, soon released.

As the dispiriting year drew to a close, Peggy began to pick up the threads of her old life. It wasn't very edifying. She went with Laurence to watch blue movies in a brothel in Marseilles with their friends Kitty Cannell and Roger Vitrac, who were staying with them at Pramousquier. During the screening Kitty fainted, and Roger borrowed 100 francs from Laurence to take one of the whores to bed, while the others looked after Kitty most tenderly. By the time she recovered, Roger was back and she was none the wiser.

More significantly, Peggy made the acquaintance of the veteran anarchists Alexander (Sasha) Berkman and Emma Goldman. Goldman, with whom Peggy was to fall out later, now became one of her beneficiaries. "Lovers once, comrades forever," as Kay Boyle's biographer Joan Mellen describes them, Sasha and Emma had been expelled from the United States in 1919. Sasha had served fourteen years in jail for the attempted assassination of the Pittsburgh industrialist and art collector Henry Clay Frick in the 1890s. Both Sasha and Emma had then been dedicated Communists. Deported to the new Bolshevik state of Russia, they'd quickly become disillusioned by what they saw as the betrayal of the pure socialist ideal, and drifted to France. Both were now in late middle age. Emma was described by John Glassco as "short, squat, with feet turned outward like a web-footed bird, and the famous red

hair was now streaked with grey; but her eyes were sparkling with shrewd-
ness, pugnacity and fun." When asked, "Why do you go on living?" she
replied, "I suppose because my will to life is stronger than my reason."

Sasha and Emma were poor when they met Peggy through a mutual
friend, Eleanor Fitzgerald, and their appeal to Peggy, who had not forgotten
the lessons of Lucile Kohn, was immediate. Laurence didn't share her enthu-
siasm, but he chauffeured Emma about in the Hispano, which she adored.
She was laboriously trying to write her memoirs, and Peggy set up a fund to
enable her to live while she was doing so, setting her up in a small house in
St.-Tropez. Emma was a woman of action, and a brilliant Jewish-cuisine
cook, but she was not naturally inclined to be a writer (Laurence said she'd
have been better off writing a cookbook), so she engaged a twenty-nine-year-
old American, Emily Coleman, as her secretary.

Emily, who'd been in France since 1925, had a son from a failed marriage
who was a few months younger than Sindbad. She was a good writer, and
had contributed to the avant-garde literary magazine *transition*, edited by
Eugène Jolas, another acquaintance of Peggy's from the Parisian circle. She
was also very highly strung and a little crazed. Shortly after the birth of her
son she had had a nervous breakdown and been confined in a mental hospi-
tal. The experience led to her only novel, *The Shutter of Snow*, which
appeared in 1930, an atmospheric stream-of-consciousness work whose style
predates Djuna Barnes's masterpiece *Nightwood* (1936). Her responsibility
was to rescue Emma's manuscript and make it readable. The job was
unsalaried, but she got free board and lodging.

In the summer of 1928, Peggy was enjoying her involvement with Emma
and her new friends, and was getting tired of the erstwhile king of bohemia,
with his tantrums, his continuing obsession with his sister, his blithe use of
her money, his laziness, and the lip-curling sarcasm he reserved for her and
her family. Laurence's charm and intelligence were also wearing thin where
Peggy was concerned. Because of the alcohol and out of boredom even their
hitherto active sex life was failing. Never well matched, they had fallen out
of love with each other.

Peggy was on the brink of a new chapter in her life. But one more family
tragedy intervened.

Her younger sister Hazel, by now a none-too-successful artist, had inherited
her share of the Guggenheim family's eccentricities. A beautiful woman,

twenty-five years old in 1928, but still profoundly affected by her father's death sixteen years earlier, she was having to come to terms with the fact that her marriage was over. Her second husband, Milton Waldman, was a talented journalist who had encouraged her interest in art and literature. Now, however, he was tiring of Hazel's less attractive traits—scattiness mingled with intellectual disorganization—and could no longer bear the strain which her willful personality put upon the marriage. He announced his desire to separate and divorce. The couple had been married for five years.

At the time they had been living in England. Angry and humiliated, Hazel took her two sons, Terrence, aged four, and Benjamin, fourteen months, and returned to New York. There, after spending a few days at the Plaza, she decided to pay a visit to her cousin Audrey Love, who had recently married and who lived in an apartment on the sixteenth floor of the Surrey Hotel on East Seventy-sixth Street. Mrs. Love was out when Hazel called with her children, but the maid admitted them and suggested they wait, as she had only gone out for a few minutes and would soon be back. The Loves' apartment opened onto the roof, part of which had been fenced and enclosed to make a garden, separated from the open area by a gate. Hazel took the children into the garden.

The reason for the ensuing tragedy is a mystery, though some were quick to draw the worst conclusions. Hazel opened the gate and took her children onto the open roof, which had a parapet wall only two feet high. Apparently Hazel sat on it, with Terrence at her side and Benjamin in her arms. Perhaps she put him down for a moment. The sad truth is that within minutes both boys were dead, having fallen onto the roof of a neighboring building thirteen floors below. What actually happened will never be known. That a tragic accident occurred is possible: Hazel was in a highly nervous state, and was by nature maladroit and absent-minded. Vague reports on October 20 and 28 in the *New York Times* tell of an "accident," and relate that afterward Hazel was "a little dazed."

The maid found Hazel hysterical when she reentered the apartment, and by the time Audrey Love returned the building was surrounded by police and ambulancemen. If there was an official investigation there seems to be no record of it, and it has been suggested by various sources that the Guggenheim family paid the authorities to forget the whole matter. Hazel was taken to a nearby hospital, and thence to a sanatorium in Europe. A few years later she married an Englishman, Denys King-Farlow, with whom she had two more children, in 1932 and 1934.

Hazel must have had an iron psyche to recover as quickly from the trauma of the event as she seems to have done, but until her death in 1995 her life was overshadowed by the suspicion that she murdered her sons. Julien Levy tells a story, reported variously in various sources, that she once kicked a turtle to death, but this is probably a confused memory of Peggy's or Laurence's smashing of one of the tortoiseshell dressing sets. Whatever the truth of the matter, it added to a suspicion that Hazel had psychopathic tendencies. The ghastly incident cast a pall over the closing months of 1928, almost destroyed Milton Waldman, and sullied the reputation of the Guggenheim family, still wealthy and influential, but by now no longer the vigorous captains of industry of two decades earlier. Within the family itself, the general tendency was to shut out the fact of the event entirely, and Peggy was no exception. She doesn't mention it in any of the three versions of her autobiography, and never referred to it in life.

ten

Love and Literature

Emily Coleman had fallen in love in St.-Tropez. The object of her affection was a tall, athletic Englishman of thirty-one, a decorated war hero and struggling writer, already involved with a woman who'd been his companion for so long that she was effectively his common-law wife. John Ferrar Holms was descended from Nicholas Ferrar, a graduate of Clare College, Cambridge, who founded a famous religious community at Little Gidding in Huntingdonshire in the early seventeenth century, and more recently from Indian Empire administrators.

Peggy tells us that Emily produced John and Dorothy Holms—Dorothy had assumed his name de facto—"in the way she always produced everything she thought she had discovered—with the delight a magician manifests in bringing something out of a hat." The couple were living in St.-Tropez on very little—there was a trickle of money from home—and John was conducting a fencing match within himself between his desire to write and his desire to do nothing but talk and drink.

Holms had joined a battalion of the Highland Light Infantry in 1914, fresh from the British Military Academy at Sandhurst, at the age of seventeen. He was not a naturally belligerent man, and in his bizarre way he was a very principled one. Since the end of the war he had lived an itinerant life in Europe, constantly failing to write, despite a short spell in an artists' commu-

nity at Hellerau near Dresden, where he managed a little. He shared some
character traits with Laurence, who when he met him immediately
smelled a rat, perhaps recognizing an alter ego. Referring to Holms's red
hair and northern, sunburnt skin, he quickly applied the soubriquet "Pink
Whiskers," and in his unpublished memoir referred to Holms by the
pseudo-Elizabethan and faintly Scottish (on account of the red hair) name
"Jacobeaus."

On the surface Holms's personality was less frantic than Laurence's,
though his psyche had been damaged during the war. As a subaltern he had
surprised four German soldiers, unprepared for an attack, and killed them
all. The onslaught led to Holms being awarded the Military Cross. Though
he did not refuse the honor, the experience affected him profoundly, and to it
was added the ordeal of serving in the trenches, for some time in the espe-
cially dangerous role of night fighter. When he was taken prisoner in 1916,
the Germans, in the words of one of his fellow prisoners, "unfortunately
allowed him all the liquor he could buy." The primrose path revealed itself,
and the long escape began.

Holms was taken to Karlsruhe prisoner-of-war camp, where in 1917 he
met the writer (and later editor of the *New Statesman*) Hugh Kingsmill.
They were both transferred to Mainz, where they remained until the end of
the war. Kingsmill recalled seeing Holms standing at roll-call "in mournful
abstraction, a look of distaste on his face. His air of superiority was not con-
ciliating, but when I met him . . . a little later I found that though only nine-
teen he had read a great deal and was an extraordinarily interesting
companion, in spite of his dogged omniscience, which derived partly from
his youth and partly from his Scotch blood."

The two became firm friends, though there was always, even in those
days, something missing in Holms's makeup. He was charming and erudite,
but one had to listen hard to discern an original remark in his highly allusive
literary conversation. Edwin Muir, the poet and translator (with his wife
Willa) of Kafka, met Holms after the war and found him "the most remark-
able man he had ever met," though his admiration was not completely unre-
served.

Kingsmill found Holms committed to rebellion against his father, a capa-
ble, strong-minded, but emotionally unexpressive Scot who had enjoyed a
distinguished career in the Indian Civil Service. Family money came from
Holms's paternal grandfather, a successful Glaswegian tobacco broker.

Holms's mother was an Irishwoman, whom he loved, according to Peggy, and from whom he had inherited both his gentleness and his mournful streak. It was through her that he traced his descent from Nicholas Ferrar—one of her ancestors was Ferrar's brother John. The religious community at Little Gidding spent its waking hours in unceasing repetition of the Psalms. Hugh Kingsmill rather fancifully believed that some of the weight that seemed to lie on Holms's soul was attributable to "this ancestral treadmill." A bullying nurse in childhood had given him a "growing aversion from social life," or so he told Kingsmill, who believed him until their friendship faltered and he lost faith in him.

Holms rarely saw any of his family, who were living in the English county town of Cheltenham, Gloucestershire, at the time Peggy and he met. He was melancholy and self-absorbed, and though he had a sense of humor, one had to dig for it. He had studied English literature in great depth, and was able to quote at length anything from *Beowulf* to T. S. Eliot, though his favorite period was the seventeenth century, and his favorite writers the metaphysical poets. While a prisoner of war he had plenty of time for reading, and a surprising number of books. He toyed with the idea of attempting to escape to Switzerland, but it never got farther than that, for his principal fault was creative inertia, later made worse by alcoholism.

Paradoxically Holms was always athletic, winning prizes at Rugby School; and despite his addiction to alcohol he seems never to have lost his affection for physical activity—something he shared with Laurence Vail. Edwin Muir said that "in his movements he was like a powerful cat; he loved to climb trees or anything else that could be climbed, and he had all sorts of odd accomplishments: he could scuttle along on all fours without bending his knees." Kingsmill recalled him as "an extraordinary athlete with very flexible limbs, [who] preferred to read with his feet rigid in mid-air above his head, his body sunk deeply in a deck-chair." This chimes well with Peggy's first impression: "I was impressed by his elastic quality. Physically, he seemed barely to be knit together. You felt as if he might fall apart anywhere. When you danced with him it was even more apparent, because he could move every muscle of his body without its being noticeable and without the usual jerks one suffers in such cases."

It is possible that Holms's erudition disguised a void; if Peggy never detected it, others were at least suspicious that it existed. Kingsmill himself might not have cleaved to Holms so affectionately had it not been for the cir-

cumstances of meeting him in a prison camp. As for Holms, so important
was Kingsmill's company to him that soon after the war he would write: "I
am sure that neither of us will ever meet anyone else in life who could supply
one quarter of what has made our friendship. As I told you, in my last letter,
the whole of these six months when suicide has hardly been out of my brain
for 24 hours I have thought of you as my only refuge in life. . . . I should cer-
tainly have killed myself before now if you had not been in the world." Muir
remembered that Holms's body "seemed fit for every enjoyment, and his will
for every frustration. Though his sole ambition was to be a writer, the mere
act of writing was an enormous obstacle to him."

Holms produced very little original work. There is only one published
short story, which appeared in the literary magazine The *Calendar of Modern
Letters* in 1925. Called "A Death," it is a telling seven-page piece dealing
with a man's end in a hospital, and it shows what might have been if only
Holms had been able to pick up his pen more often than his whiskey glass.
He also wrote literary criticism for the *Calendar*, which is trenchant though
sometimes patronizing. Holms could be envious of more energetic creative
talents. However, he boosted his friend Kingsmill's confidence by praising
his work unreservedly, while Kingsmill gave Holms the sympathy he craved
for his own creative impotence. Peggy Guggenheim's entrance onto the
scene, with her money, relieved Holms of the most basic of stimuli—the
need to work to live. Kingsmill, who disliked Peggy as much as she disliked
him, wrote to fellow novelist and fellow ex–prisoner of war Lance Sieveking
in 1930:

> A rich American woman sees to it that when he asks for bread he
> shall get it fresh. . . . In return, he has become a competent chauf-
> feur and motors her round Europe. It was 8am when I roused
> him. He peered out a little fretfully in white silk pyjamas edged
> with pink . . . I asked him why he didn't write. He sighed. "Life
> is—er—rather difficult." I'm afraid he'll never do anything. He
> has lost his old intensity and gloom and seems merely preoccu-
> pied with being comfortable.

Nicknamed "Oxo" (for the British beef-flavored bouillon cubes) at Karls-
ruhe because of his ruddy complexion, Holms was tall—over six feet—with
a broad chest and shoulders, and narrow hips. He had kind, rather weak

eyes, and a loose mouth below a straight nose. His hair was auburn, and later he would grow a Florentine beard which Peggy thought made him look like Christ. This he would twirl when searching for a word. He loved the sun and he loved flowers. Kingsmill remembered that he used to lie on the roof of their barracks at the prison camp "lamenting the constitution of the universe . . . 'Oh God, God! Here I am with my marvellous brains and marvellous physique . . . and yet . . . oh, WHY?' "

Unworldly, however, he was not. Once released at the end of the war, the men had a day or two free in Mainz before being ferried home. In that time Holms "got out his best tunic, made a round of the . . . cafés, and when we left Mainz in a Rhine steamer two days later, [he] was seen off by a girl, whose longing piteous gaze as the steamer drew away profoundly affected him on her behalf."

John had been with his companion, Dorothy, for nine years. Seven years his senior, she was an attractive woman with the same fair skin and red hair that he had. The years they had spent together had begun to pall, however. Dorothy was depressed that John would not marry her, and that they had had no children. She worried that they had no money, and his inability to put pen to paper irritated her, though she had literary ambitions of her own. Their sex life had become moribund, but they depended upon each other— she more than he—for emotional security; and she loved him more than he loved her.

The Vails met them on July 21, 1928, the first anniversary of Benita's death. Peggy hadn't been in the mood to go out at all, but Laurence had felt that a night on the tiles in St.-Tropez would be good for her, so they joined Emily Coleman, John, and Dorothy in a bar. Peggy was by now habitually drinking steadily, and this evening the combination of alcohol and grief for Benita made her "quite wild"—she got up and danced on a table. But something else had happened. From the moment she set eyes on John she was determined to have him, and he was far from reluctant himself. If Peggy is to be believed, he managed to get her on her own and kissed her that same night.

On her part it seems to have been a genuine *coup de foudre*, but it wasn't completely irrational. Holms was a heavy drinker, like Laurence, but in his case alcohol didn't lead to alarming mood swings and fits of temper. Like Laurence, he was a well-educated and cultivated man; but he was also a gifted teacher. Peggy adored and idolized him in the way she had originally

adored and idolized Laurence. Here was someone new at whose feet she could sit. Temperamentally Holms was a better match for her than Laurence: He was only a year older than she; he was also an English gentleman who spoke with an Oxford accent. The fact that in her search for a man who would replace her father she had simply found another "son" did not occur to her.

Soon after their first meeting, Peggy invited the Holmses to spend a night with them at Pramousquier. They went skinny-dipping in the sea after dinner, Peggy and John contrived to be alone, and for the first time they made love. The fact that John was attached to Dorothy bothered Peggy as little as it bothered Emily, but if Dorothy was unaware that something was going on, Laurence was not: For one thing, Peggy was never one to conceal her emotions.

The Vails' annual retreat inland to the mountains from the summer heat on the coast meant that the two would-be lovers were separated for a month, but this in no way dampened Peggy's ardor. As soon as she returned she sought John out and, learning that he—or more likely Dorothy—had decided to return to England, offered them the little house she had had built on her land for the Coateses, who had long since gone back to America. Dorothy was reluctant, but as she was working on a book of her own at the time and needed somewhere peaceful and secure to finish it, she reluctantly allowed John to persuade her to accept the offer. Peggy felt that in this way she could both play Maecenas and have her new boyfriend close at hand. By now she and John had gone for long walks inland, comparing the rough Provençal countryside to the "English moors." Peggy hung on every word John said, and felt that the fortune-teller's prophecy of the year before was coming true.

Until Dorothy finally began to suspect that something was up, she and Peggy got along well. Peggy, amoral then where sex was concerned, only chose to impute bitchiness to her rival once Dorothy felt threatened and tried to defend her ground. But Laurence had well and truly caught the scent. His reaction was a predictable tantrum. At a bistro in St.-Tropez the Vails and Clotilde were drinking with Emily, Emma Goldman, and Sasha Berkman. The Vails and Clotilde were drunk, but Clotilde was the one showing off this time, dancing with her skirt hitched above her thighs. This infuriated Laurence, but he chose to take it out on Peggy. Peggy probably made a disparaging remark about her sister-in-law, but the real issue was Laurence's

jealousy of Holms. As Peggy melodramatically put it, he started to "tear off all my clothes." She was rescued by an appalled Berkman, though he couldn't prevent Laurence from giving her a violent and sobering slap across the face. Soon afterward, Clotilde returned to Paris.

The following morning Peggy, mustering all the powers of detachment that had enabled her to survive the hurly-burly of life with Laurence, reviewed her situation. Over the past few months Laurence's violence had increased: He had set fire to a sweater of hers, had thrown her down a flight of stairs, and had "walked" on her stomach "four times in the same evening." Even allowing for exaggeration on Peggy's part, the assaults were intolerable.

On the other hand, the move to Pramousquier had brought her into close contact with people who wrote, or had political ideals, or were expert communicators of cultivated ideas. Although Holms was a tarnished idol, unable to develop original thoughts, he could feed Peggy's hungry mind with his knowledge. Emma Goldman had already drawn her aside and asked her how on earth she could live in the way she did. Peggy had replied that she wouldn't leave Laurence, for the sake of the children. But now she could abandon such security as the relationship with her husband offered, because there was another partner in view. Holms was thinking along similar lines, and Peggy's wealth played a role in his reflections. She was determined to leave Laurence, whatever the consequences. In the meantime her relationship with Holms, as the days passed, deepened and became more complex:

> In the beginning I was not in love with John, but one night when he disappeared for an hour, I got quite frantic. Then, for the first time, I knew I loved him. We used to go out into the country together and make love. Sometimes we went down to the rocks under his house. The minute Laurence went up to his studio and I saw his light lit, I ran over to John's house to fetch him. That was our hour. Soon John began getting difficult about Laurence and asked me to discontinue my matrimonial relations. I found this hard to do. It was all getting too much and I wanted John to take me away, but he couldn't make up his mind. He lived in a perpetual paralysis of will, and he hated to give up Dorothy. Dorothy didn't think I was a serious person, but John realized what he could do to me and he was fascinated by the idea of

remolding me. He knew I was half trivial and half extremely pas-
sionate, and he hoped to be able to eliminate my trivial side.

The impression Peggy wants to give here, that Laurence and she still had
a sex life for her to abjure, is interesting, but what boded ill for the future was
the suggestion that Holms was incurably weak willed. Peggy was the oppo-
site: She was a person who would, in the end, have what she wanted; and if
what existed didn't measure up to what she wanted, she would rewrite the
script of her life so that it did. Her self-knowledge is in evidence here too. If
only Holms had been a stronger man, or less of a drinker. Peggy was doomed
as far as relationships were concerned because she would never compromise
her will. This sensitive, gentle man, who enjoyed physical action but was
paralyzed by any other kind, who was a scholar *manqué* and an irredeemable
alcoholic, might in the end and despite everything have been her ideal com-
panion. He never resented her money, nor did he take *selfish* advantage of it;
he was faithful, he did not make scenes (or at least made them only rarely).
Peggy adored him in the way that she desperately needed to adore someone.
In her eyes he was a great intellectual and man of letters, and he was when
necessary quickly brought to heel. When Peggy moved in on him he did not
have a chance, though he made one gesture that effectively scotched her
highest ambition for their relationship. Even that she tolerated, just to be
with him, and although it meant that she could not marry him, she always
regarded herself as his wife, and she did have a kind of moral right to the
title, if love confers any moral rights at all.

Holms, with his paralysis of will, continued to prevaricate, but Peggy,
with all her Guggenheim energy, did not put up with this for long. In order
to bring matters to a head, she deliberately chose a time when she knew Lau-
rence was around and sober to sneak over to Holms and kiss him. Laurence
had followed her and saw what happened, precisely as Peggy intended, and
flew into a violent rage, attacking Holms physically. Peggy says she hadn't
foreseen this, but given her knowledge of Laurence that is unlikely. Holms
was much larger and more powerfully built than Laurence, and restrained
him as best he could while Peggy went to get help. The help she sought, mis-
chievously enough, was Dorothy's, who at the time was having a bath at the
main house (there was no bathroom in the cottage). However, Dorothy was
slow to respond (perhaps diplomatically), and Peggy was forced to summon
the gardener, Joseph. By that time Laurence was trying to brain John with a

pewter candlestick. Joseph wanted to go to his boss's defense, but by the time he arrived the fire had gone out of the fight, and both protagonists were exhausted, physically and emotionally.

The aftermath was no less dramatic. Dorothy arrived, and Laurence told her of John's infidelity, which she refused to believe was true, though the news wounded her enough to show that she certainly *could* believe it. Laurence informed Peggy that he wanted the couple out of Pramousquier, and that if he ever saw Holms again he'd kill him. Laurence then retired, but Peggy's mind was racing. She knew that it would be impossible for the Holmses to stay, so that night she arranged for them to go to Madame Octobon's little *pension* at Le Canadel.

The next day Laurence was nursing his usual hangover, but Peggy went briskly into her domestic routine. His description of her getting dressed in *Murder! Murder!* is full of hatred: "pull up panties, into frock, right shoe, left shoe, couple tugs at the hair, two strenuous and misplaced dashes of lipstick." Then came the laundry list and the shopping list and the daily housekeeping account. All her life Peggy loved lists. Tapping her teeth with the pencil's end, going over the figures, muttering to herself, setting Laurence's own teeth on edge, she played the part supremely well. There could be no question of an open confrontation: Heaven only knew what he'd do then. No, he had to be lulled and gulled.

She bribed Joseph to take a message and some money to the Holmses. They made their way to Hyères, and soon afterward took the train to Avignon, where Peggy had arranged to meet them. The following morning she sent Laurence to Hyères (somewhat crazily, since she knew the Holmses had not yet left the little town) in the Hispano to cash a check. She kissed him good-bye and wept as she did so, wondering how he could be so unsuspicious. At any rate their seven years together were over.

Papi, the sister of Clotilde's future husband Alain Lamerdie, was staying with the Vails at the time; she had a crush on Laurence, and Peggy patronizingly described her as "a very nice, primitive sort of girl." As soon as Laurence was out of the way, Peggy got her to drive her to the railway station at St.-Raphaël in the Citroën. Once there, she told her what she intended to do, gave her a note for Laurence, and asked her to look after him.

When Laurence returned home to the note and Papi Lamerdie's sympathy, he was shattered. The agreeable domestic setup at Pramousquier was over, though he still hoped against hope: Peggy had gone off not to ren-

dezvous just with John, but with Dorothy too. And then there were the children, Sindbad and Pegeen. Was she simply going to abandon them? Peggy's note was brief: "Don't know if I'll come back. Life too hellish. I'll write you."

Pegeen had a cold. Leaving her with the nanny at Pramousquier, Laurence took Sindbad and Papi Lamerdie and traveled up to Paris. This was a situation he needed to talk to his mother and sister about.

With a certain dryness, Peggy describes her first actions and impressions on arriving in Avignon:

> . . . the first thing I did was to throw away my wedding ring. I was standing on a balcony, and I threw it into the street below.
>
> Though this was a symbolic gesture, I have regretted it ever since. It was such a nice little ring, and I have found myself so often in need of one. Dorothy . . . still did not know that John was really in love with me, as he had not the courage to tell her. He always put off everything. We somehow still managed to make love without her suspecting it. But I don't think that would have worried her so much as the fact that we intended to live together.

Naturally Dorothy was very much afraid. Without John, she would be bereft, and at the time there was no reason for her to believe that he had fallen in love with Peggy, though she could see that he was in great danger of being taken over by her. There followed a good deal of desperate maneuvering. Peggy was all for going to London with John to get him away from Dorothy, but Dorothy wanted the position clarified. They agreed to meet Peggy's lawyer—who unfortunately was also her mother-in-law's lawyer—in Dijon, halfway to Paris. He advised Peggy to divorce Laurence, but to return to Pramousquier immediately to take possession of the house. There was also the question of custody of the children to be settled.

Peggy and the Holmses returned to the South, and she broke the news to Emma Goldman, Sasha Berkman, and Emily Coleman. Emily was upset because of her own attraction to Holms, but seems, unusually for her, to have accepted the status quo philosophically. John and Dorothy were dispatched to a hotel in nearby Grimaud, and Peggy rejoined Pegeen and Doris, the nanny at Pramousquier.

Emma Goldman appealed to Laurence to be generous hearted and allow Peggy custody of the children, but her intervention merely irritated him, and

battle was joined. Peggy, eager to get things settled so that she could set up house with John, didn't fight hard; she also felt that she owed Laurence a degree of generosity. The arrangement was that Peggy should have custody of Pegeen, now three years old, and Laurence of Sindbad, five, with the provision that Sindbad should spend sixty days a year with Peggy. By January 1929 the first formalities were over, though it would be two years before the divorce was officially complete; Peggy covered most of the considerable legal costs. In the meantime Dorothy, in a state of great anguish, had left for Paris, on the understanding that she was leaving John to Peggy for a trial period of six months.

Alone at last, Peggy and John took to traveling, using Pramousquier as their base and leaving Pegeen, who was fretful at being left behind by her mother, in Doris's care. Peggy was well aware of her daughter's anxiety but could not or would not respond to it. As she cheerfully admitted, she was only ever unselfish when it suited her, and she had enough mothering to do with John; but this she enjoyed as much as she enjoyed the sex.

The sex ultimately palled—for all his youth and vigor, John's alcoholism cramped his performance. Although Peggy said she had seven abortions during the time she was with John, claiming that she hadn't wanted children born out of wedlock, it is unlikely that she became pregnant by him that often.

More important for Peggy was the nourishment John gave her intellect. He would talk and talk, mainly about literature, but he was well informed about many topics, though inclined to be pedantic. In spring 1923 the Muirs had shared a villa with John and Dorothy near Forte dei Marmi, just up the coast from Viareggio. Muir later wrote of the experience:

> I think we should have known Italy better had it not been for Holms. He had been in Italy before; we were newcomers, and he could not resist the temptation of acting as a benevolent Virgilian guide, making us see everything with his more expert eyes. His tone at these moments was indulgently authoritative, and I can still hear him, as he gazed at a particular effect of light one calm evening, while he plucked at his beard: "It's pure Leonardo da Vinci." He was always eager for agreement at these moments; when anyone confirmed his momentary perceptions it doubled his own pleasure in them, so that sometimes I could scarcely resist

the unspoken solicitation. But his predigested Italy, of whose
authority he never had a doubt, came between us and the Italy we
wished to see for ourselves.

Muir was normally loud in Holms's praise, but it is easy to see how he
could become tiresome to anyone with an equally intellectual or independent
mind. Peggy, however, not trusting her own judgment in such matters, made
an eager disciple of herself. It was to be a pattern she'd repeat often. It took
her a while to attune herself to what John had to say—in the beginning she
hardly paid him any attention at all—but as their relationship became less
passionate and more stable, she realized fully what a fount of knowledge she
had stumbled upon.

John was dangerous company in a different way from Laurence. Though
less violent, he was more truly, profoundly manic. Muir says, "it was as if the
technique of action were beyond his grasp, a simple, banal, but incompre-
hensible mystery. He knew his weakness, and it filled him with the fear that,
in spite of the gifts which he knew he had, he would never be able to express
them: the knowledge and the fear finally reached a stationary condition and
reduced him to impotence." Though others have been less kind about
Holms's merits as a talker, both Peggy and, more reliably, Muir give the
impression that, like Oscar Wilde, his conversation was as valuable as his lit-
erary contribution—though in Holms's case there was virtually no literary
contribution. After his death Peggy tried in vain to get his letters published,
and she was still trying to do so unsuccessfully toward the end of her life.
The letters are now lost: Lent to a would-be biographer of Holms by Peggy's
family, they have disappeared, along with the biographer. To judge by sur-
viving letters between Holms and Kingsmill, they are good, but of no great
literary merit.

Peggy taught John to drive, and they spent the first two years of their rela-
tionship motoring the length and breadth of Europe in a new Citroën—
Peggy had given Laurence the Hispano to cover his divorce expenses. Peggy
idolized Holms in a way that was very bad for him, for there was a side of
him which was simply vain and lazy; a more critical companion would have
been more use in helping him come to terms with himself. Peggy spruced
him up and took him to expensive London tailors for the tweeds in which he
looked his best. She had his hair cut and his beard trimmed.

John paid a duty visit to his family in England on his own, but didn't mention Peggy; they all assumed he was married to Dorothy, whom they'd never met. Meanwhile the six-month probationary period passed, and Dorothy became frantic. When he and Peggy were in Paris, John foolishly told Dorothy where he was staying, without having the courage to tell her he was staying there with Peggy. The result was that she caught them together and attacked her rival. Peggy relished the battle for possession that ensued, as Dorothy wrote him plaintive letters and told anyone who would listen what a wicked woman Peggy was; but Dorothy had a better grasp of how to manipulate John's weak character than Peggy, and, choosing a moment in late spring 1929 when Peggy was confined to Pramousquier looking after Pegeen during the nanny's annual vacation, she told John that she had decided to return to England. As everyone assumed that he and she were married, she explained, she could not face the humiliation of telling them the truth; and in any case, she felt herself to be an abandoned wife, de facto if not de jure. John told her he had no wish to marry her, but she applied all the emotional blackmail she could, and, in order to give her a "name," Holms took the extraordinary step of going to Paris and marrying her.

If Dorothy had hoped that somehow thereby she would get him back, she was mistaken. Peggy was too powerful an adversary, and Peggy was rich. But John couldn't have married Peggy, who was still in the throes of her divorce. Nevertheless a heartbroken Dorothy returned to England alone. Peggy triumphantly crowed in her autobiography that John was so attracted to her "because I was just the opposite of Dorothy. I took life rather less seriously and never fussed. . . . I was completely irresponsible and had so much vitality that I am sure I was quite a new experience to him. I was light and Dorothy was heavy. She was always sick and my health was marvelous. . . . Dorothy was dowdy and dressed with no taste. She had piano legs while mine were just the opposite." Peggy was especially delighted that John appreciated her long, lithe limbs (he called her "Bird Bones") and even had no objection to her nose, though his other nickname for her—"Dog Nose"—sounds pretty backhanded.

Meanwhile Pegeen clung to Peggy, never wanting to let her out of her sight; and though she got along with John (who was good with children), she was suspicious of him. When Peggy proposed a trip to Paris, she insisted that she be taken along.

On that occasion Peggy saw her son for the first time since the split with

Laurence. Sindbad had been staying with his grandmother Gertrude Mau-
ran Vail, who had scant sympathy for Peggy; and Laurence would not allow
him to see his mother alone, so the meeting was more than a little strained.
Laurence had already embarked on an affair with Kay Boyle, the American
novelist who was to become his second wife, and for a time it looked as if
they would do their utmost to alienate Sindbad from Peggy permanently.
This they failed to do, largely because John persuaded Peggy to take a con-
ciliatory line with Laurence, something that went against her grain, as the
divorce settlement they finally reached was generously tilted in his favor, but
later in life Sindbad looked back at all three parental figures, Laurence,
Peggy, and Kay, with a bleakness that should have shamed them. Relations
between Peggy and Kay were never easy.

After the uncomfortable period in Paris, John and Peggy, with Pegeen,
the nanny, Doris (now back from vacation), and Lola, the dog, set off in the
Citroën for a grand tour of northern Europe in summer 1929. Although
always a keen traveler, Peggy was a natural southerner, and could not sum-
mon up much enthusiasm for Copenhagen, Stockholm, Oslo, or Trondheim,
where Lola became pregnant. They drove home through an uneasy Ger-
many, to which Peggy was oblivious. For the entire period, John carried the
manuscript of Dorothy's book with him. She had asked him to suggest revi-
sions for it, and though no doubt this was a ploy to stay in touch, he hadn't so
much as opened it, something even Peggy found uncaring. And despite a
month spent at Bad Reichenhall specifically to give John time to write one
article, he didn't even start it.

But Peggy never became really irritated by John's inertia. There was
something about the success of their relationship that lay in their interde-
pendent and complementary qualities—which mattered more to her than
his creativity. She was wealthy and used to giving orders, and she was by
nature self-centered—the result of her defensive mechanisms as much as her
wealth—and domineering. He was happy to be looked after, and more than
happy to be able to indulge tastes and experiences from which modest cir-
cumstances had up until now precluded him. Like Laurence, he loved driv-
ing, particularly the large and fast cars Peggy provided; he loved travel and
exotic locations, and he loved living in splendid houses. Laurence may have
struggled in the net; John was happy just to lie there.

Despite its drawbacks the tour was one of the happiest times of Peggy's
life. Loving Renaissance art as she did, she was delighted to have such a

knowledgeable guide, and John liked the role of mentor. The love of good music and the wider knowledge of literature that John drew out of her were to become the main recreational stimulations and comforts of her life. But it was not to fall to John to awaken her interest in modern art. He had no interest in it himself.

On their return home in the autumn, in the nick of time for Lola to have her puppies, they quickly found life at Pramousquier dull, and John disliked living in what had been a matrimonial home. The place held no pleasant memories for him either, associated as it was with violence and guilt. Peggy was not affected in the same way, but felt that the house had run its course. Then Lola went missing, probably poisoned by one of the local farmers. The fate of her offspring is unknown.

Peggy decided to put the house on the market, agreeing generously to give the profits to Laurence and to share the contents with him, something that was amicably arranged. In the course of the negotiations, Peggy discovered that Laurence had had a daughter at the end of 1929 by Kay Boyle. "Apple-Joan," as their daughter was christened (Laurence had threatened "Apple-Jack"), would later provoke Pegeen's envy, as she appeared to replace her in Laurence's affections. At the time of her birth, both Laurence and Kay were still married to their former spouses. In accordance with French law of the time, Laurence declared himself the father and gave the child his family name. She was officially registered as "of a mother unknown."

About now Peggy had an abortion. No reason can be traced for this, other than that she did not want another child, though the fact that it would have been born out of wedlock was the excuse. Peggy had known somehow that after Pegeen she would never have another child, and she never did. Whether John was even aware that she was pregnant is not known. If he had been, whether he would have contested her decision is open to question. Meanwhile, Peggy discreetly paid Laurence and Kay a monthly allowance.

Returning to Paris, Peggy and John moved into a hotel in the place du Palais Bourbon, in the Invalides district.

Relations with Laurence became less edgy, and Peggy saw Sindbad once a week for a while. The new couple then moved with Pegeen and the nanny to a rented apartment, and among their other friends and acquaintances took up with Emily Coleman again, who was now in Paris with her son Johnny. Peggy began to realize to her pleasure that Holms was not a man devoid of jealousy. When one day she moved from their table at a café to the one where

Laurence was sitting, John became distressed. On the other hand, the fact that the rented apartment (which Peggy paid for) had to be taken in her married name of Vail annoyed Laurence. Before the divorce proceedings were completed, Peggy reverted to Guggenheim, and thereafter stuck to it.

Among other people in Peggy's resumed circle of expatriate friends was Helen Fleischman, now separated from Leon, and the constant companion of Giorgio Joyce, James Joyce's son, whom she would soon marry, and Giorgio's sister, Lucia, who was training to become a ballet dancer. Holms was introduced to Joyce *père*, sixteen years his senior, who had published *Ulysses* in 1922. Peggy recorded loyally: "John enjoyed talking to Joyce but, since he never could have been one of Joyce's sycophants, the relationship was casual."

Dorothy, still in Paris at the time, was an occasional thorn in their side, but Florette, who decided to come over from New York for a visit, was a worse one. She was happy that Peggy had left Laurence, but regarded John with equal suspicion and contempt; despite his solid English background she regarded him as an idle, two-faced wastrel. Luckily Edwin and Willa Muir provided a counterbalance. Peggy genuinely liked and admired them, both as people and artists. As we know, Muir admired John, and after the latter's untimely death he wrote a tribute for Peggy, which he later included in his own autobiography, sections of which have already been quoted.

Early in 1930 Peggy and John escaped on another long motoring excursion, taking Pegeen with them. Their travels took them from Brittany to the Basque country, where they ran into Giorgio and Helen at St.-Jean-de-Luz, to Poitiers and the Loire Valley (where they met Emily Coleman again). For a time Sindbad, now aged six, was with them, and Peggy found that his head was full of stories aimed at keeping him on his guard against her; but gradually she regained his confidence, and seems to have been genuinely glad to see him. Emily's company, on the other hand, was a mixed blessing: She and John discussed literature together passionately, which made Peggy jealous. Among the châteaux of the Loire, John proved himself to be as much of a gourmet as he was a connoisseur of wines.

By the autumn Peggy had her final divorce decree, and she and John returned to Paris to look for somewhere permanent to live. The financial crash on Wall Street the previous year had not affected her, and she could continue to live in France while many of her compatriots were forced to return home, either because their parents' investments, and hence their

allowances, had dried up, or because a new sense of responsibility born of the great financial collapse urged them to return.

The search for a proper home took a while, as John was extremely fastidious about such things, but at last they found an apparently ideal house in the extreme south of the city, on the avenue Reille, which runs along the north side of the Parc Montsouris. It was an artistic district—the house had been built for Georges Braque, and their neighbors included the painter Amedée Ozenfant, whose art school was next door—and in those days they were practically in the country. The house was tall and narrow, with only a couple of rooms on each floor. John's study was cold and damp, completely unconducive to work, so they sat and played records of classical music all day in a more congenial room.

They made this place their base for the next three years, but interspersed their stay with frequent and lengthy trips, for which they used the new Delage Peggy bought, which John drove "as if it were an airplane." They became reacquainted with Harold Loeb, and John settled into a routine. He would sit up all night talking and drinking, and spend the following day recovering from the resultant hangover. They also saw something of the Joyces, and of Herbert and Jean Gorman. Herbert was writing a study of Joyce, not published until 1941, and the two couples saw a lot of each other. Peggy reports that Jean must have complained to Joyce about how much time Peggy and John spent with her husband and herself, which gave rise to a famous and perceptive little bit of doggerel Joyce wrote her as a result:

> Go ca' canny with the cognac, and of the wine fight shy—
> Keep a watch upon the hourglass, but leave the beaker dry;
> Guest-friendliness to callers is your surest thief of time:
> They're so much at Holms when with you, they can't dream of
> Guggenheim.

Pegeen was settled in the bilingual school for the children of American expatriates founded at Neuilly by Marie Jolas, Eugène's wife, who became a friend as well. Peggy and John saw Pegeen in the evenings, but not in the mornings, for they were not awake when she went to school.

The drinking got on Peggy's nerves: She was not a natural drinker, and couldn't keep up with John—nor did she want to. She says she felt cheated of his company during the day, when she was awake and he was nursing his

head. But their sense of mutual dependency was strong, and as John's temperament was generally placid, there were no real storms to weather. At the same time, he was unemphatically patronizing, making sure that Peggy maintained a proper sense of his superiority, and always speaking of things she didn't know much about, such as the art of the seventeenth and eighteenth centuries, or avant-garde literature.

They took themselves off to Italy in the Delage in May 1931, with Mary Reynolds and Emily Coleman for company. There was still snow in the Alpine passes, and crossing one of them they became stuck in a blizzard. Then something happened that nearly cost them their lives:

> ... the wires of the car froze. We had stopped on a very slippery road covered with snow to see the scenery a few feet before the peak. On our right was a drop of thousands of feet. John insisted before we died of cold we turn the car around and go back. We could start it by rolling downhill, but the danger of pushing it over the cliff while we turned it around was terrifying. We had to calculate it to an inch, and it was almost impossible because the car kept slipping on the ice. I really don't know how we ever did it; it must have been the fear of dying in the cold that egged us on.
>
> Emily ... refused to help in any way; she disliked the blizzard, and she just sat in the Delage while Mary and John and I, by sheer force of will, managed to get it turned around without its going over the side. John put his scarf under the front wheel to stop it from skidding and then we rocked the car back and forth, fearing any moment it might fall over the precipice. Even this did not make Emily budge. We pushed and pulled and made tracks in the snow for the wheels to be free. Finally we got to an inn at Norcia in the valley below where we were treated regally. It was the most primitive place I had ever been in. A whole baby goat was brought on the table for us and gallons of Abruzzi wine. Our beds were warmed with copper warming pans. The innkeepers were so sweet to us that we were happy not to have perished in the blizzard.

After this escape they continued their journey. Its only sour point was when Peggy found that John didn't like Venice. "He did not share my pas-

sion for this miracle city," she writes, and adds: "I think it is the feeling of death which permeates Venice which upset him." Peggy knew Venice well, having been schooled by Laurence, and had a natural affinity for the city. Perhaps the reason for John's discomfiture was that here he was not in confident control of the upper ground. The fact that he could speak neither French nor Italian, however, unsettled his sense of superiority not a jot.

Their journey continued, aimlessly, luxuriously, all along the southern French coast. They dipped back into Paris, but were soon on the road again, driving back to St.-Jean-de-Luz, and on into Spain, which they explored thoroughly. Peggy developed a passing fascination for bullfights. And so the time went by, agreeably and emptily.

In April 1932 Laurence and Kay married at last at the town hall in Nice. The marriage caused a stir in artistic circles, and Wambly Bald wrote up the coming event in his column in the Paris edition of the *Chicago Tribune* for March 22. When the couple tied the knot they were attended by Bobby, Kay's seven-year-old daughter (by the poet and editor Ernest Walsh, who had since died); Sindbad, nearly nine years old; Pegeen, six; and Apple, two and a half. Sasha Berkman sent the happy couple an ironic telegram, given that they'd been together for well over two years and had already produced a child: MAY LOVE LAST IN SPITE OF LEGAL BONDS AND SANCTION.

Peggy attended the wedding with John, none too enthusiastically and mainly for the sake of her children. When it was over they returned to Paris, but immediately set off for London. Once there, John conceived the idea of staying for the summer. He hadn't been in England for years, and sentimentally settled on the West Country. Peggy dutifully hired a car and they explored possibilities in Cornwall, Devon, and Dorset, but returned home still undecided before John finally plumped for a Victorian pile on the edge of Dartmoor, which they duly rented. The children, the cook, the maid, and Doris—who had learned to drive the family's newly acquired runabout, a Peugeot—were collected, and the entire troop set off via the Le Havre–Southampton night boat for Devonshire, and Hayford Hall.

Hayford

*H*ayford Hall stood in its own spacious grounds. It belonged to a family of industrialists who left two of their staff behind to look after the tenants and keep an eye on them. The house was larger than they needed, having eleven bedrooms and whole suites of reception rooms. The children were banished to one wing, and most of the social activity took place in the large central hall, while the family took their meals in a gloomy dining room. Peggy, mistrustful of English cuisine, had brought her French cook, Marie, with her.

They had been joined at Le Havre by Djuna Barnes, whom Peggy had invited partly because Djuna had had a bad asthma attack in Paris, and it was hoped that the country air in England might help her. Djuna was still mourning the end of her affair with Thelma Wood, who had left her for a new lover, Henriette Metcalf, in 1928. She was looking for somewhere peaceful and secure to work on her current novel, a *roman à clef* dealing with her affair with Thelma and with the Parisian milieu, and serving as a meditation on her own philosophy of life. The book, *Nightwood*, makes difficult reading today, but was highly acclaimed—as much as a *succès de scandale* as anything, since it deals with lesbian themes—when it was published in London and New York in 1936 and 1937 respectively. It was dedicated to Peggy and John, though Peggy later suspected that John was added as a sop to her-

self. Djuna acknowledged John's intelligence but neither admired nor liked him very much. The dedication was as close as Djuna would get to acknowledging Peggy's financial help and hospitality.

Djuna was given a bedroom in the rococo style, which Peggy felt suited her, although Djuna thought she was put there because no one else wanted it. Nevertheless she spent much of her time in the room, writing, and guarding her manuscript from Emily Coleman, who joined the party from London a short time later. There was always tension between Emily and Djuna: Emily was Djuna's champion, going to great lengths to see that her friend's work was published, and that Peggy and other benefactors kept up their financial support. But Emily was also envious of Djuna's literary *cachet*. Torn between irritation and gratitude, Djuna could at least take comfort from the fact that Emily's frenetic, unstable personality put her at odds with the rest of the world.

Despite the tensions, cultivated conversation in the evenings at Hayford, presided over by John, gave a civilized cohesion to the summer months of 1932, though Djuna sometimes became irritated by Emily's attempts to monopolize him, and both of them annoyed Peggy. John was already an alcoholic; Djuna was well into the foothills; and although Emily scarcely drank, her hyperactivity led Djuna to observe that she would be "marvelous company slightly stunned."

Hayford's gardens were large and beautiful, and the harsh beauty of the moors beyond offered scope for hiking and riding. The sea was a short drive away, and there one could swim. So there was plenty for the athletic Holms to do, and it was generally Emily and he who took the children off for strenuous rides on unruly and poorly tackled hired moorland ponies: There was only one decent horse available, over which Emily and John frequently bickered. Riding on the moors was not for the fainthearted; they were treacherous and full of pitfalls, and concealed bogs as lethal as quicksand, but the one-armed epileptic who owned the ponies was a good guide, and John was a responsible guardian of the children. Peggy must have been grateful that he and they got along so well most of the time. The only person to make difficulties was Emily, who was prone to tantrums. She also had no social graces and appalling table manners. Peggy felt at times that there was a limit to being bohemian.

Djuna stuck to her work, only emerging for the evening meal and for a ten-minute walk in the rose garden once a day. Peggy's weak ankles made most sports unpleasant for her, though she occasionally enjoyed swimming.

The other distraction was guests, of whom a regular supply turned up for a few days from London and elsewhere. Their presence was welcome, because Hayford was remote; the nearest town, Buckfastleigh, being some distance away. Among the visitors was Emily's staid New England father, who criticized her table manners—she ate like an uninhibited child, seizing and cramming food into herself. "I don't want to be a pig," she countered mournfully. Peggy chipped in quickly: "What are you going to be instead?"

Other guests included several English literary figures, among them William Gerhardi (much later Gerhardie), the novelist, and his mistress. Milton Waldman came down, but could not find even a temporary escape from the depression he was still suffering after the death of his sons. Florette visited, but did not stay in the house, since her daughter and Holms (whom she continued to regard with suspicion) were not married. And so the summer passed—another empty one, except for Djuna, who was the only person (apart from the servants) doing any work.

In September, Djuna took Sindbad back to Paris with her, where he rejoined Laurence. Peggy and John, with Emily and her father, made some desultory visits to tourist sights in southwest England before the two pairs separated and Peggy and John went to Cheltenham, so that he could visit his family. Peggy stayed in their hotel, unacknowledged, since they were not married, though she did receive an awkward visit from John's sister, who begged her to look after him. Peggy was taken aback, as she had always seen *him* as looking after *her*.

They returned to France, and spent the winter holidays skiing in Austria. Pegeen and Sindbad were reunited once more, and the family party was again joined by Emily Coleman, this time with her Scots companion, Samuel Hoare, whom Peggy describes as a frustrated writer who worked (*faute de mieux*) for the British Foreign Office. Hoare was in fact a successful politician who was briefly foreign secretary in 1935–36. He got along with John and Peggy, though he was shocked by Peggy's frankness. Like her mother and her maternal grandmother, Peggy was disconcertingly candid. Djuna, not one for winter sports, had gone to Tangiers, where she'd entered into a potentially disastrous love affair with the much younger poet and painter Charles Henri Ford, who, like her, was predominantly gay.

The following spring Peggy and John briefly rented the London house formerly occupied by Milton Waldman, in Trevor Square, Knightsbridge. By now Peggy and Dorothy had buried the hatchet and were becoming

friends; Dorothy focused her dislike on Emily, the woman Peggy had supplanted as John's mistress.

During the previous summer John had read Djuna's 1928 novel *Ryder*, and wanted to find a British publisher for it. He approached his old friend Douglas Garman, one of the founder editors of the *Calendar of Modern Letters*, to which he had occasionally contributed in the past. When Peggy met Garman, "some immediate combustion must have occurred."

Garman joined them in Paris for Easter, and Peggy fell in love with him. She did not tell John, nor did anything "happen," but she was pleased for a change to be in the company of a man who was a moderate drinker, five years her junior, a gentleman, who noticed her clothes and complimented her on them, and who above all did not oppress her with his intellectual superiority. Garman, who was separated from his wife, had a daughter, Debbie, of about Pegeen's age, and when they met, the girls got along. Peggy's mind began to race. Garman was very handsome, though one eye had been slightly damaged by an infection he'd picked up years earlier farming in Brazil. He was also a creative artist, a poet with one book to his credit. Holms deemed him an inferior talent but dissimulated. Similarly he disparaged Djuna behind her back. Garman did not get *Ryder* published, but the contact with Peggy was made. Peggy had begun to get John into perspective. She was to describe him to Djuna as "a washout," though this was as much in exasperation as anything.

In the summer of 1933 Peggy and John rented Hayford Hall again. Hitler had taken power in Germany, and unpleasant rumors were filtering out of that country, but its politics seemed far away and of no consequence. New servants were engaged—a mildly crooked Cockney called Albert, recruited in London, and his mournful Belgian wife. Otherwise the staff and even the guests were more or less the same, though with the addition of the novelist Antonia White, a close contemporary of Peggy's who had just had published the novel that made her name, *Frost in May*, on which she had been working since the age of sixteen. Another addition to the party was Wyn Henderson, a typographer by profession and a sexual profligate and gourmande by nature, whom Peggy had met and made friends with in London. The painter Louis Bouché arrived with his wife, Marian, and daughter, Jane, a pretty little girl with whom Sindbad fell in love. Garman was invited too, but couldn't make it. Later Peggy tried to rendezvous with him in Lon-

don—"my intentions were very clear to me"—but this attempt misfired, and Garman did not suspect her motives.

Louis and Marian Bouché drank as much as John did, and soon between them they'd renamed the house "Hangover Hall." Albert pocketed the refunds on the empty bottles behind Peggy's back until she caught him at it. Djuna, who'd returned to Hayford, continued work on *Nightwood*. Her affair with Charles Henri Ford had resulted in a pregnancy. Though Ford had suggested that they marry and keep the child, Djuna had borrowed 1,600 francs from Nathalie Barney to have an abortion performed in Paris by Dan Mahoney, a quack who made his money as a "maker of angels," and who appears as a character in *Nightwood*. Djuna and Ford had parted on cordial terms. Another guest from the previous year was Emily Coleman, with her son, Johnny.

Pegeen and Sindbad were dispatched with Doris to rejoin Laurence in Munich. Peggy accompanied them to London, where she had hoped to meet Garman, and then returned to Hayford. There the routine continued: heavy drinking and literary and artistic conversation, interspersed with parlor entertainments that had the advantage of a certain edginess, like the Truth Game, whose butt Emily usually was. She confided to her diary some of the tensions at work at Hayford even during the *previous* summer:

> John said Djuna was more sympathetic . . . than I, in spite of stu-
> pidity, because she has a developed taste, while mine is still being
> formed. . . . Djuna had made superficial compromises with life,
> and lived on that, with people, but inside was a dreadful neu-
> rotic. . . . I said that I could endure Djuna's quips because I felt
> there was goodness beneath, but Peggy's malice I simply could
> not face. . . . I said, "What does Djuna think of me?" He said.
> "She thinks you're mad, and very young [Djuna was seven years
> older], but she thinks you have a talent. . . ." He said Djuna was
> very conceited, and she could not write without thinking she was
> a very great genius. Said this was due to a very great inferiority
> complex underneath.

Here, all Holms's manipulation, and potlike ability to call kettles black, is exposed—though it is true that Djuna had observed that she and Emily

Brontë were the only two women to have written books worth reading. Emily Coleman's awful behavior accounts for the sharpness of Peggy's barbs:

> Finally, at the end of the summer, I decided Emily had gone too far. When she was about to leave in a few days she said to me, "I had such a happy summer." I replied, "You're the only one who has." She was so insulted she rushed upstairs and began to pack her bags. She intended to leave at once. Everyone hoped that I would ask her to remain. I didn't and not even at the station did I relent. John begged me to change my mind, but I would not. I was adamant.

Strangely enough, their friendship weathered it all.

Although Djuna regarded the summer of 1933 as more tranquil than that of the previous year at Hayford, there were spats that made Peggy furious. She reports:

> Once Djuna said to John, "why, I wouldn't touch you with a ten-foot pole." I replied for him that he could easily touch her with one, a gentle compliment meant for John, not Djuna. One night Djuna appeared looking quite different. She had just washed her hair. I called her "cutie redcock." Later I fell asleep, as was my habit when fatigued by Emily's conversations with John, and when I woke up, John was playing with Djuna's soft fluffy hair. I looked at them and said to John, "If you rise, the dollar will fall." Djuna said to John, "You smug little red melon of a Shakespeare. Busy old fool, unruly son [sic]."

Peggy's jealousy, keenness to take part, and refuge in sleep from conversation that was beyond her are all present in this little scene. But another description of the same incident, in Emily's diary, throws a different light on it:

> [Djuna's] hair was thick and very red, and she was loving. "This looks like a rape," said Peggy. She had been asleep on the couch. Djuna threw herself on John and kept hugging him. Peggy said,

"he'll assert his lump." Then she made a comprehensive survey of her person and said, "It's all right." She said, "If you rise, the dollar will fall." Djuna said he had no technique. John said his technique was so varied he must get another bottle.... She flung herself on him perpetually, kissing him. She looked very pretty with her hair falling down. She kept twirling and untwirling a handkerchief. John told her she had written the best things of any woman in the last 50 years. She kissed him passionately on the neck. Then she began to pound Peggy in the bottom and Peggy shrieked, "My God, how this woman hates me," and Djuna kept pounding her, then she began to pound me. She hadn't hit me four times before I had an orgasm.

Somehow Djuna and Peggy maintained a balance that Peggy couldn't achieve with Emily. She found Emily's habit of creeping into bed with her and John particularly hard to take, not because anything sexual happened—it didn't—but because John would sit up between them, continue to drink, talk endlessly about literature to Emily, and prevent Peggy from sleeping.

During that summer a far more significant event occurred, though at the time it seemed trivial. In late August, Peggy and John went riding on Dartmoor in the rain. It was no more than a mild drizzle, but it was enough to cloud John's glasses and, unable to see properly, he allowed his horse to stumble on a rabbit hole and throw him. He fell on his right wrist and fractured it. For a moment Peggy felt a certain pleasure at his distress, but pulled herself together and got him home. A doctor was summoned from Totnes, who set the wrist, but incorrectly. It was reset the following day at the local hospital, and had to remain in a cast for six weeks. When they returned to Paris, Peggy took John to the American Hospital, where his wrist was X-rayed. The doctors recommended massage once the cast was removed, but it seemed to do nothing to ease the pain he had developed in it, although the fracture healed enough to allow John to use his hand and to drive.

Meanwhile, John was tiring of France. He had never learned the language, and he wanted to live in England permanently again, thinking that if he did he might start to write at last. He hated his own indolence, and when drunk would exclaim in a way reminiscent of his manner when a prisoner of war, "I'm so bored, so bored!" Agonized, he lived in a cage of his own making, and could not realize that changing location would not remove it.

Peggy, always an Anglophile, was happy to accommodate him. Pegeen was put into a *pension*, with Doris to look after her, near Madame Jolas's school, and the house on the avenue Reille was sublet. Toward the end of 1933 they left Paris for London, where, with Wyn Henderson's help, they had found a place in Woburn Square, in the heart of Bloomsbury, though it was a little late to share in that quarter's glory days. Nevertheless, once they had settled in and Peggy had made the decor and furnishings a little less formal, they were ready to look forward to a new phase of their life together.

Love and Death

*P*eggy always insisted that Holms broadened her outlook and intro-
duced her to writers and music she might not have encountered oth-
erwise, though it is hard to pinpoint how profound his educational
effect on her was. They had a different kind of social life in England, with
men of letters like Hugh Kingsmill and Edwin Muir reentering John's life.
Peggy's response was her usual self-protective one. She was a good actress,
and could hide indifference, lack of understanding, or even simple fear
behind a facade of pretended interest. She could ask bright, general ques-
tions, and then punctuate the answers she got with bright, general com-
ments, but half the time she was either not understanding what was being
said to her or not listening. She had built a protective wall around herself,
which in time would imprison her.

Shortly after moving into Woburn Square, Peggy and Holms had a
drunken fight, in the course of which she told him about her desire for Gar-
man, and made unfavorable comparisons between them. Holms's reaction
was chilling—worse in its way than Laurence's frantic tantrums: "John
nearly killed me. He made me stand for ages naked in front of the open win-
dow (in December) and threw whiskey into my eyes. He said, 'I would like
to beat your face so that no man will ever look at it again.' " Peggy knew the
kind of reaction her taunting could provoke—she did it again and again

with various men throughout her life—but in her recounting of this particular incident there is a real sense of fear.

In the meantime Dorothy had been pestering Holms for greater financial security than he had been able to offer, though he turned over his entire allowance from his father of £200 a year to her. Peggy undertook to pay her an annuity of £360 for the rest of her life, and that her estate would continue to pay it if Peggy predeceased Dorothy. When, however, John's father turned over a lump sum of £5,000 to John in order to avoid death duties, Peggy ensured that John made her, rather than Dorothy, his legal heir. John talked about divorcing Dorothy but didn't get around to it.

By the time they moved to London John's drinking had become so heavy that he was never completely sober. His will to do anything, let alone write, had failed. His damaged wrist still gave him much pain. While house hunting they had stayed in Buckinghamshire with Milton Waldman, who was now married to Peggy's old friend and namesake, Peggy David. Waldman recommended a masseur, who did what he could, but told John that the only hope of a complete cure lay in an operation; this view was confirmed by a Harley Street consultant. The operation was a simple one, and could even be performed at home. John decided to have it done but postponed it when he caught the flu.

All this happened in a very short space of time. Sindbad came over for Christmas 1933, and he and Pegeen were taken to an endless round of movies, circuses, and pantomimes. At the end of the holiday Peggy decided to take her son all the way back to Zurich, where he would be met by Laurence. On her way home she stopped off briefly in Paris, where she saw Mary Reynolds, but set off for London almost immediately. The parting with Sindbad had been hard, and Peggy found herself blaming Holms for the separation from her son that had been imposed on her. If she had not met Holms, she might still at least have both her children with her. Holms was clearly beginning to get on her nerves. She found herself wishing that she might never see him again.

He met her boat train at Victoria Station. When she got home she discovered that Emily Coleman had arranged for his operation to take place, and that it was scheduled for the following morning. A group of friends had gathered at the house, but Peggy had a sense of foreboding. John stayed up late, drinking hard, and no one stopped him.

The next day, January 19, 1934, John awoke with his customary hangover. Peggy dithered about allowing the operation to go ahead, but as it had been postponed once already, and as it seemed such a straightforward job, she said nothing to the doctors when they arrived—though it is odd that they didn't notice John's condition. As the surgery involved breaking the wrist and resetting it, John had to have a general anesthetic. Peggy held his hand until he went under, and then left the room.

Half an hour passed, by which time everything should have been over, but no one emerged from the bedroom where the operation was taking place. Peggy grew nervous, the more so when one of the doctors came out briefly to fetch his bag. In the end all three of them—GP, anesthetist, and surgeon—came down to the drawing room where she was waiting.

Peggy knew what had happened before they told her. John had died of a heart attack under the anesthetic, which had reacted with the alcohol that filled his body. The embarrassed doctors arranged for Milton and his wife to come down from Buckinghamshire, and took their leave. Peggy was all alone in the house. For some reason neither Emily Coleman nor Wyn Henderson was summoned. Peggy went upstairs and looked at John: "He was so far away it was hopeless. I knew that I would never be happy again." For a moment after the doctors had confirmed her worst fears, she felt relief, as if she had been released from a prison. But soon a different emotion came upon her: fear. She *was* free, but freedom is a frightening thing if one does not know what to do with it. They had moved into the house with the intention of starting a new life there. It had lasted barely six weeks.

Emily moved in to help Peggy through the ordeal of the autopsy, which exonerated the doctors from any blame, since alcohol had already ruined John's internal organs. He was only thirty-seven years old. Then came the cremation, which Peggy couldn't bring herself to attend. Instead she went to a Catholic church in Soho and lit a candle. Finally she plucked up the courage to tell Pegeen the truth: Up to now, she had been told that John had gone to a nursing home. Soon afterward Pegeen returned from her Bloomsbury school, and refused to go back. Peggy transferred her to a school in Hampstead, where she was happier. The faithful nanny, Doris, had left shortly before to get married; though she had been willing to return to work, Peggy wrote that "I was so jealous of her that I used her marriage as an excuse to look after Pegeen myself."

The other loose end to be tied up concerned Dorothy. An agreement was

reached whereby Peggy gave her all John's money and books, and engaged informally to pay her £160 a year for life, in place of their previous arrangement. There was also the house in the avenue Reille to be dealt with; the lease for the current tenants was coming to an end. Peggy returned to Paris in February, in the midst of the uproar surrounding the Stavisky corruption scandal, which threatened to bring down the government. Royalists and communists were fighting in the streets, thousands were injured, and a general strike was declared. This was a mere backdrop to Peggy's personal tragedy. She put all the furniture she'd shared with John into storage. Empty, the house had less poignant memories.

Worst of all was the desolation after John had gone. Peggy returned to London and sat around the house in Woburn Square, seeing very few people, apart from Emily, and Wyn Henderson, whose son Ion she allowed to come and listen to the phonograph.

Her thoughts turned to Douglas Garman.

An English
Country Garden

*B*y the time Peggy and Douglas met again, he had separated from his wife after much heart searching and at the end of a long period of unhappiness. The fact that he attended Holms's funeral—Holms was a friend for whom he truly grieved—brought them closer together. Both were, in a sense, free; but Peggy found that she was less so than she had imagined. Although she wanted Garman, and he fell in love with her, the memory of John cast a very long shadow. Garman wrote her love poems, quoted *Antony and Cleopatra* to her, and was in every way kind and attentive. But Peggy had fulfilled Holms's ambition to mold her to his will. She was unable to think independently. Everything she knew, everything she had become, was as a result of Holms's influence. For a long time she continued to regard herself as his "wife."

Garman, from a line of doctors, abandoned medical studies at Cambridge to become a publisher and poet. His family was large: He had a brother and seven extremely individualistic sisters. Handsome and sensitive, he had become head of the family after his father's death, which meant taking financial responsibility for them when he was still at Cambridge, where he had become an early neophyte of communism. With his first wife he had visited the USSR as early as 1926. When Garman met Peggy he had just moved his

mother into a cottage at South Harting, a village not far from Petersfield, on the edge of the Sussex Downs.

Garman's youngest sister, Lorna, had married (at sixteen) a close Cambridge friend, Ernest Wishart, who had plenty of money but shared Garman's socialist views. Lorna went on to become the mistress and muse of the writer Laurie Lee, and later of the painter Lucian Freud. Together Wishart and Garman would establish the publishing house of Wishart & Co., which would become the largest publisher of Marxist texts outside the USSR. Garman was to be chief reader and adviser. But much of this lay in the future. For the moment his chief literary exploit had been an involvement with *The Calendar of Modern Letters*, which appeared between March 1925 and July 1927, and which had enormous influence, not least upon its more famous successor, *Scrutiny*, founded in 1932 under the principal editorship of F. R. Leavis. Garman became assistant editor of *The Calendar*, which appeared first as a monthly and later as a quarterly literary-critical magazine. He had cofounded it with two slightly older Oxford friends, Edgell Rickword and Bertram Higgins, in response to T. S. Eliot's rather stodgy (in their view) *Criterion*, and it was made a reality by an investment of cash from Ernest Wishart.

Peggy's liaison with Douglas began slowly, and was interrupted almost immediately when she had to leave for mainland Europe at Easter 1934, so that Pegeen could join Sindbad for a skiing vacation with Laurence. It was a mixed experience for Peggy. Kitzbühel, where Laurence was living with Kay Boyle, had happy memories for her of travels with John. At least her relations with Laurence had eased, though those with Kay remained as tense as ever. Nevertheless Laurence made no attempt to hide his satisfaction at Holms's death, so it was with relief that Peggy returned to England, where Garman was waiting for her. He had been unwell, so she took him down to the country in her new Delage (the old Delage, with its associations with John, and the Peugeot, had been sold). They visited Garman's mother at South Harting, and also Ernest and Lorna Wishart. Peggy found the English countryside dead, but attractive and restful, as she remained restless and unsettled in the wake of Holms's death.

When the lease expired on Woburn Square she moved to Hampstead, with relief, and she also allowed Garman to persuade her to find a place in the Sussex countryside near his mother, where the children could spend their

summer vacations. She took a manor, Warblington Castle, and there they were joined by Sindbad, and by Douglas's daughter, Debbie, who was living with her grandmother. Debbie remembered that her father took her for a walk on the Downs and told her that she was "going to come and live with me and that lady you met at a party in London the other day." She still thinks of the experience as upsetting, brought up as she was by her paternal grandmother and her aunts.

As the place was large, Peggy and Douglas invited various other guests, including some who had been with Peggy the previous summer on Dartmoor, such as Emily Coleman and Antonia White. The Waldmans were also guests. Peggy and Douglas were at great pains to conceal their affair, especially from the children, and kept separate bedrooms; but so pronounced was Douglas's pedagogical habit with Sindbad that the boy had to be let in on the secret: He had begun to resent what he saw as the officiousness of this new friend of his mother's. Peggy bought a croquet set, and found a mate for the Sealyham terrier Milton Waldman had given her and John shortly before John's death.

The lease at Warblington only lasted that summer. Toward the end of it Pegeen and Sindbad were sent back to Kitzbühel to Laurence, traveling alone. Douglas was editing a book, and he and Peggy moved into his mother's house during her absence on her summer holiday. After a short tour of Wales they returned to Sussex, and Peggy bought a small cottage near Petersfield, not far from where Garman's mother lived. She had her furniture brought over from Paris, and arranged for Pegeen to attend the local school with Debbie. They went to a little dame school along with Debbie's cousin, and later, in 1936, to the recently founded liberal Beltane's boarding school.

Yew Tree Cottage had two reception rooms and four bedrooms, and a large sloping garden, through which a stream ran, where there was "a wonderful old yew tree." The house was probably two old cottages knocked into one. There was a tiny hallway, a dining room, a drawing room with a big fireplace, and a passageway with a terrible curve in it, which the cook couldn't negotiate when carrying a tray. Peggy built a living room onto the kitchen for the cook and the gardener, Kitty and Jack, who later married. Upstairs there were a bathroom, a spare bedroom, bedrooms for Pegeen and Debbie, and another for Peggy and Douglas.

Guests found the food and wine of alarmingly variable quality, which

Peggy sought to improve by arranging cooking lessons for both Kitty and herself. In winter the rooms were cold as only rooms in English country houses can be.

After an unfortunate interlude at Kitzbühel, where Douglas felt out of things and only really got along with Kay Boyle, which irritated Peggy, they returned to England, and Douglas and Debbie moved into Yew Tree Cottage with Peggy and Pegeen. Peggy loved Debbie, and the two girls got along well together. For Pegeen it was a boon to have a settled friendship; so many had been disrupted by her many shifts in school, and the indifference of her parents had left her isolated and confused, feelings that had been exacerbated since the birth of Laurence's first daughter with Kay, Apple, in 1929, when Laurence appeared wholly to transfer his affection from Pegeen to Apple. Debbie remembers Pegeen as a "very affectionate but unhappy girl" who was always pleased to have company. Debbie remembers Peggy as affectionate and immensely tender: "She had a fund of kindness toward humanity. That's probably why she got on with my father so well." Life at the cottage was cultivated and comfortably domestic: Douglas, or sometimes Peggy, would read Dickens or *The Last Days of Pompeii* to the children; Peggy would wash the girls' hair.

Peggy managed to persuade Douglas, whose health continued to be poor, to give up his job with Wishart's publishing company and to write himself, working from home. He had already built a small study (known as "the hut") at the end of the garden in which to work. He immersed himself in *Das Kapital*. Peggy, meanwhile, read Proust and made the cottage as comfortable as possible. In this she was joined enthusiastically by Douglas, a natural homemaker and redesigner of rooms, who, however, in his enthusiasm, effectively immured one of the antique chests Peggy had bought years earlier in Venice. He was no less keen on the garden, in which he took a special pride. He didn't cut off all ties with London, however, and they rented a flat there largely for his use when he went to the city to work. Peggy, still feeling guilty about the speed with which she had gone to Garman after John's death, preferred to bury herself in the countryside. They bought a horse, and Douglas rode often. The girls bicycled. Once, Debbie remembers, "we found some glowworms in a gully and at twilight we all piled into the car and drove out onto the Downs, and there they were—dozens and dozens and dozens of glowworms, and we picked them up in our handkerchiefs and brought them back to light up the river."

In the early stages the relationship was a happy one. Life at the cottage was cultivated and stimulating, as Debbie recalls. Garman was good for Peggy—she was drinking less and leading a far more regular life—but there is little doubt that she soon found him dull, and was pigheaded enough to tell him so. She even told him that John had found him dull—a cruel insult, since Holms and Garman had been close friends long before Peggy's arrival on the scene; Dorothy had lent the Garmans her flat so that Mrs. Garman could give birth to Debbie there.

Peggy's selfish spirit rebelled: "Garman and I were really not at all congenial and the situation got more and more obvious and painful. We did not like the same people and we did not like the same things. He hated me to drink and for some perverse reason I now found it necessary to do so." She had not gotten over John, and she found Garman's preoccupation with Marx boring. But they remained together, varying the placid rural life with summer trips to France and to Wales. Peggy only once provoked Garman so much that he slapped her, after which he immediately cried with remorse, and only went on one vacation that she truly loathed, a boating trip on the Norfolk Broads. On the other hand, she busied herself with typing up Holms's correspondence with Hugh Kingsmill and preparing it for publication. Garman's own writing was sporadic, as he became more and more involved in Marxist theory.

In spring 1936 Sindbad came over and spent two months with them. He was to go to Bedales, a new and progressive coeducational boarding school near Petersfield, in the autumn, and Laurence and Kay with their daughters had come to England to be with him as he got settled in the new country. The decision to leave Kitzbühel was not so much dictated by alarm at the rise of Nazism in neighboring Germany and the growing political instability of Austria, as by Sindbad's contracting bronchitis, leading to pleurisy, which demanded a milder climate for his recovery.

Douglas taught Sindbad Latin, and Peggy taught him English grammar. Laurence and Kay settled at Seaton in Devon, and hated the whole of the year they spent there. "Life's too short to spend it in the UK," moaned Kay. Sindbad, however, took to England, and began a lifelong passion for the game of cricket.

Laurence had had a sad year. His beloved sister Clotilde had died in November 1935, while under anesthetic awaiting an appendectomy. The loss took

Laurence many years to come to terms with. Not long afterward, both his father and his uncle George died—though George left Laurence enough money to buy a chalet at Megève, in the French Alps, where he was able to set up a permanent home for his wife and an increasing number of little girls. Desperate for a son, Kay Boyle was only able to produce daughters with Laurence. Bobby, her daughter by the poet Ernest Walsh, lived with them, and they already had two daughters of their own, Apple, and Kathe, born in 1934. Pegeen and Sindbad spent most holidays with them at Megève from then on, and the house came to be called the Châlet des Cinq Enfants—later, with the birth of Kay and Laurence's last child, Clover, in 1939, the "Cinq" was changed to "Six." It was not a harmonious household, and Kay was as bad a mother as Peggy.

Garman's former wife now wanted to remarry, and Peggy unwillingly agreed to be cited as his corespondent. The divorce went through successfully, and Peggy and Garman continued to live together, though she went on harboring thoughts of leaving him, and referred to their relationship in her diary as "fighting all day, f——" all night." There were few guests during the winter months, and she drooped around, reading Tolstoy, James, and Defoe; but she was not entirely lonely. Emily Coleman visited, and although her relationship with Peggy was as edgy as ever, the children adored her. Djuna Barnes came once, and Dorothy Holms, now on the friendliest terms with Peggy, paid several visits. Even Laurence and Kay traveled up once, but the visit was not a success. Peggy and Kay were barely on speaking terms, and Douglas afterward declared that the Vails would not be welcome again, since he disapproved of "false" friendship. It is unlikely that the Vails would have been offended at this. Kay deeply resented the fact that they depended on Peggy's allowance to Laurence, though she tried her best to block out the fact of its existence.

Ironically Peggy and Djuna ignored the important surrealist exhibition mounted at the New Burlington Galleries in London in the summer of 1936. Veterans of Paris in the 1920s, they felt that they had already seen it all. Despite Garman's eagerness to go, they both refused.

Garman, meanwhile, had become completely taken up with Marxism. He attempted to interpret everything in its light, gave lectures, and finally joined the British Communist Party. He contributed articles to the *Marxist Review*, was a member of the party's Central Committee in England, and later became head of the Education Department. He persuaded Peggy to

become a party member herself, though he foresaw difficulties in her accept-
ance as a member if she failed to get a paid job. She argued that looking after
Pegeen and Debbie counted as a job, wrote to the CP's general secretary,
Harry Pollitt, pointing this out, and, having money, was accepted, which
pleased her as it proved her point. But she managed to hang on to her money,
and was never actively involved in any communist proselytizing. She noted
dryly that whenever Garman was angry with her he didn't call her a
"whore" but a "Trotskyite." She makes no reference to events that may have
been exercising Garman's mind at the time: the rise of Oswald Mosley's
Blackshirts—the only real manifestation of a fascist party in Britain—and
the Spanish Civil War. Garman felt that the world was becoming increas-
ingly unstable, and that the only way of reintroducing stability and fairness
was through Marxism.

Their personal relationship continued to decline. Peggy became increas-
ingly impatient with Douglas's zeal, and found his uncritical acceptance of
everything Stalin did, purges included, demeaning to his intelligence.
Worse, his personality had become flattened, so devoted had he become to
the cause. Later in life he became disillusioned, not with Marxism, but with
the uses to which politicians put communism. He died in 1969, a disap-
pointed man.

Apart from their guests from London and elsewhere, the two of them
were isolated in the countryside. As they were unmarried, they were not
welcomed in the local community, which Peggy found insufferably strait-
laced anyway. Their immediate neighbor was a horror called "the General,"
who went so far as to poison their pet Siamese cat, though not all their neigh-
bors were as grim: Bertrand Russell lived nearby, though their paths did not
cross. But by and large, local society was suffocating.

Peggy fled for a ten-day break to Venice in the summer of 1936, using as
an excuse the necessity of returning Sindbad to Laurence for the school vaca-
tion, Laurence and Kay having by now abandoned England with relief.
Once there and alone, she reveled in her solitude and freedom, though she
resisted the possibility of a brief affair. She tells us she did so because she was
still in love with Garman. She visited all her old familiar haunts, the Frari
Church, San Marco, and the Carpaccios in San Giorgio degli Schiavoni, in
which she had always taken a great delight.

On her way home she met her mother in Paris. Florette had visited Yew
Tree Cottage a few times, but was as disapproving of Peggy's living in sin

with Garman as she had been of her living in sin with Holms. She did, however, offer her a pearl necklace, which Peggy refused to accept for fear that Garman would sell it and give the proceeds to the Communist Party.

By the autumn, Sindbad had started at Bedales, and Pegeen and Debbie had gone to boarding school at Wimbledon. There the two girls drifted apart, for though they shared a room, their tastes diverged. However, the children were all close enough to be able to come home at weekends. Debbie remembers that Sindbad was in a production of *The Merchant of Venice* at Bedales. Peggy read the play and there was a long discussion about it afterward, centering on Shylock's ethics and morality. What Peggy said shows that she had forgotten neither her Jewish nor her American cultural background, despite long years of assimilation and living in Europe.

Garman had exchanged the London apartment for a larger one near Coram's Fields on the edge of Bloomsbury, which he shared with their friend Phyllis Jones. The American newspapers were full of speculation about whether the as-yet-uncrowned Edward VIII would defy family pressure and marry the American divorcée Wallis Simpson. Peggy and Douglas had had a bet that if the king were to wed Mrs. Simpson—which he finally did in June 1937—Douglas would marry Peggy. But Douglas now refused to do so, claiming that the bet had, after all, only been a joke. However ambivalent Peggy's feelings toward Douglas were, she took his action as a great snub, and reacted furiously. During his absence in London she went out into the garden one night and tore up "his best flower bed. It contained many rare plants and I took every one of these and hurled them over the fence into the field next door." The following day, however, she repented, and got the gardener to replant all of them, with the exception of the few that had become frostbitten.

December of 1936 brought matters to a head between Peggy and Douglas. If he had tried her patience, she had certainly exhausted his. They no longer shared any interests beyond the children and the cottage, and her act of vandalism in the garden pushed things over the edge. They agreed to separate, but the break was not clean: Although he would live in London and she at Yew Tree, where Debbie would still visit at weekends, he would also come over on Friday and stay until Monday. At weekends they still slept together, and perhaps still hoped for a reconciliation, but none came. Instead Garman hit her once again in response to her jibes about the value of communism.

So things dragged on until Easter 1937, when Peggy left for Paris for a

break. When she returned she was confronted with the news that Douglas had met a girl, also in the Communist Party, and had fallen in love with her. It wasn't simple: The girl was married to a much older man, also a party member, and they had a child. Soon the husband and wife were sent together on a mission by the party and were away for some weeks, during which Garman once more gravitated toward Peggy. It would be six months before the process of splitting up had run its course.

In the summer of 1937, to make matters worse, Florette arrived in Europe again. She had had several operations for cancer, but now all hope was lost. She had six months to live. Peggy spent time with her in London and Paris in the autumn, but confided to Emily that she felt as if her own life were over. The ever-tactful Emily replied, "If you feel that way, perhaps it is."

It was the kind of remark to put Peggy on her mettle.

Turning Point

Since the break was not clean, the exact moment of Douglas's departure was blurred; but that the affair was over long before the couple had ceased to sleep together was clear to them both. Douglas had his cause to turn to, and a new love. Peggy, having spent all her life since leaving New York as a wife—she saw herself as wife to Holms and also to Garman, with some justification—all that had been lacking was the formality of an officially recognized union—was left high and dry. Now she was nearly forty, living in the English countryside, with nothing to do, and only herself to turn to.

The children continued to visit her on weekends; Debbie did so at least until the split with Douglas was complete. She remembers Peggy's love of music. Peggy had a good record collection, rare then, and a huge phonograph, a big HMV: "and it was a great treat to be allowed to put a record on oneself, though as a child one was always in the fear of God about scratching it." There was a piano too, and a large collection of books about the art of the Middle Ages and the Renaissance—for Peggy still sat at the feet of Bernard Berenson. Peggy loved it when the children tried to copy works from them.

Peggy's mentors had been predominantly literary men. The idea of supporting modern artists had scarcely entered her mind. She had shown no interest in visiting the great, groundbreaking exhibition of surrealism at the

New Burlington Galleries in 1936, for example. She had not kept in touch with developments within the movement, nor had she been aware of what was going on during those hectic years in Paris and the South with Laurence.

And yet Peggy's life was contemporaneous with the development of modern art, from which there have been no radically new departures since. Its roots, as far as Peggy's interest in it is concerned, can be found in the proto-Dada and protosurrealist work of the beginning of the twentieth century of such artists as Chagall, de Chirico, Duchamp, Picabia, and Picasso. Dada, loosely the forerunner of surrealism, spread early from Zurich to Berlin and Paris, where it split between a politically associated form (Berlin) and an artistic, anarchic form (Paris), though tendrils spread to New York, partly through the first of Duchamp's many migrations, together with the arrival there of Picabia, and partly through the work of such people as Cravan, von Loringhoven, and Stieglitz. The iconoclastic movement scarcely took root, but some seeds lodged in crevices. At the time, Peggy was unaware of this, or of magazines like *Rongwrong*, or *The Blind Man*, which ran a *faux*-irate feature on Duchamp's *Fountain*: "As for plumbing, that is absurd. The only works of art America has given are her plumbing and her bridges" (the latter reference being to the Brooklyn Bridge).

At about the same time, just before World War I, cubism was developing independently through the work of Braque, Gris, Léger, and Picasso in Paris. As early as 1912 Giacomo Balla was painting a dachshund scurrying along, showing its movement (inspired by newly invented film) in a more formal way than did Duchamp in *Nude Descending a Staircase* (1911–12), and which was affectionately reminiscent of the impressionists. A year later Jacob Epstein produced the vorticist sculpture *The Rock Drill*, which adumbrates the politically run man/soldier/machine that was to dominate the world in the first half of the twentieth century.

In the wake of Dada came surrealism. Dominated by André Breton, with the poet Paul Eluard, until shortly before the outbreak of World War II, when Eluard became politicized—a heinous offense in Breton's view—and the movement split, surrealism was in fact always subject to bitter internal wrangling, to rules and regulations as strict and sometimes as ridiculous as those of the political, military, and civic organizations it mocked. Its heyday lasted from the mid-1920s until World War II, and a rump survived thereafter. Its influences were on the one hand profound and on the other ironic. The great works of de Chirico, Ernst, Magritte, Miró, Tanguy, and Dalí con-

tinue to stimulate and provoke; and their influence is still evident in media
such as advertising, which was quick to take up the striking visual imagery
of Dalí and Magritte in particular. Dalí participated actively: He designed
the windows for the New York department store Bonwit Teller in 1939, and
a perfume bottle for Schiaparelli in 1946.

Surrealism encompassed poetry and prose as well as painting, but Breton
was the ultimate arbiter. Himself a writer, born in 1896, he'd spent World
War I as a psychiatric intern treating the victims of shell shock, beginning to
use their dreams as a route toward understanding their psychoses (it wasn't
until the mid-1920s that Freud's major work was translated into French).
Breton was less interested, as an artist, in the curative potential of dreams
than in the imagery, the shamanistic qualities they encompassed. The idol-
ized antecedent of the surrealists, *pace* Breton's thinking, was Isidore
Ducasse, who wrote his one great work, *Les Chants de Maldoror*, under the
nom de plume of Le Comte de Lautréamont. This extraordinary novel, first
published in 1868, is famous for the passage, so often quoted, and so beloved
of the surrealists that it became a kind of *summum bonum* for them:

> He is as handsome as the retractility of the claws in birds of prey;
> or, again, as the unpredictability of muscular movement in sores
> in the soft part of the posterior cervical region; or rather, as the
> perpetual motion rat-trap which is always reset by the trapped
> animal and which can go on catching rodents indefinitely and
> works even when it is buried under straw; and, above all, *as the
> chance juxtaposition of a sewing machine and an umbrella on a dis-
> secting table.*

But this famous sequence, the most celebrated phrase of which has here
been italicized, is only one of many: The descriptions of the primeval ocean,
of the mad omnibus, of the hero's coupling with a voracious female shark (so
reminiscent of Balzac's short story in which the protagonist makes love to a
panther), of rape, bestiality, matricide, and cannibalism—all appealed to the
anarchy and unrestrained expressionism of the early surrealists. Many of
them, such as Max Ernst and Paul Eluard, had fought in World War I and
even, as these two believed, fired upon one another from opposite sides. It is
not only unsurprising but fitting that in the years that followed they should
share Helena Ivanovna Diakonova—then Eluard's wife, later Dalí's, and

better known as Gala—in an uneasy (at least for poor Eluard) ménage à trois.

While these areas were growing in importance and significance during the years following the war of 1914–18, the United States was also awakening to new possibility. The geographical distance from Europe was decreased after the war by cheaper and faster, safer and more predictable means of transportation; and influences were inevitably going to be the same, since European Americans shared the culture of their forebears.

Far from the source of inspiration, however, and suppressed by the popular conservatism led by Theodore Roosevelt, it is all the more remarkable that the dutiful efforts of such people as Kenyon Cox and Thomas Anshutz should be overtaken so quickly, by way of art nouveau influences such as those that affected Pamela Colman Smith, by innovators like the potter George Ohr, and those artists angered and inspired by social injustice—the poster work of John Sloan and the photographs of Jessie Tarbox Beals, for example. The Armory Show didn't happen in isolation. The work of Arthur G. Dove, Marsden Hartley, Stanton Macdonald-Wright, and John Marin, among many others painting before 1920, testify to a rich seam in American painting of which the Europeans were in ignorance. As for a painter like Stuart Davis, influenced by Léger, there was no one comparable working in Europe: Davis prefigured Pop Art by forty years.

Peggy, abroad from 1921, missed all of it: the Jazz Age, the skyscrapers rising as a result of a boom economy, and the advent of the movies. It is futile to speculate on how she might have reacted to this very different set of influences; and in any case, film, the quintessential American art form, never held much appeal for her.

It is more difficult to define her lack of interest in contemporary art movements. She had associated with intellectuals, and had had long relationships with three intelligent and articulate men; but Vail and Holms were not politically involved, and Garman was too extreme. Peggy herself was, through the influence of Lucile Kohn, always inclined to sympathize with the Left, but in no structured way, and she was not essentially interested in politics.

The exhibition of surrealism at the New Burlington Galleries in London in 1936 could scarcely have fallen at a more opportune moment. By nature insular and conservative, with a firm belief in homegrown values and a mistrust of others, the English had not been exposed to the artistic ferment that

had gripped Paris in the 1920s; and with the exception of a few small bridge-heads set up by pioneer artists and their dealers, not many people had more than a hazy idea of what was going on. However, the second half of the 1930s, following the earlier shake-up of the General Strike, demanded a reappraisal of received notions. The Spanish Civil War and the rise of Nazism indicated sinister forces at work in mainland Europe. People were beginning to ask questions, however much the answers frightened them. The technology developed by World War I would make a second even more damaging war. That the horror of World War I was a very real memory, whose effects had been explored by overtly political artists like Otto Dix and George Grosz in Germany, and Edward Burra and Paul Nash in England, made the new threats all the sharper. A substantial number of younger artists and writers had had direct experience of the Spanish Civil War as well.

The surrealist exhibition that André Breton opened in London on June 11, 1936, displayed nearly four hundred paintings, sculptures, objects, and drawings. Works were included by Picasso, de Chirico, Miró, Ernst, Klee, Dalí, Magritte, Man Ray, Duchamp, Moore, Giacometti, Arp, Brancusi, and Calder. Roland Penrose, one of the show's principal instigators, was also its treasurer, and records in his memoir the wry note that the insurance premium for the entire exhibition was £20.6s.11d.

In 1935, Herbert Read published an essay, "Why the English Have no Taste," in *Minotaure*. A British surrealist magazine, the *International Surrealist Bulletin*, appeared about the same time, though the first definitively surrealist issue was number 4, September 1936. That the English seemed tardy in catching up with the movement was given the lie by the fact that interested English artists and critics had easy access to France and had already made themselves aware of the movement there; and by the fact that English literature contained a number of representatives of protosurrealism: William Blake, Jonathan Swift, Laurence Sterne, Lewis Carroll, and Edward Lear are examples. Louis Aragon translated "The Hunting of the Snark" into French in three days. However, as Penrose pointed out, English traditionalism was a contributory factor to resistance to new ideas.

The British press, with the exception of articles by Cyril Connolly and John Betjeman, refused to take the exhibition seriously; the tabloid press predictably bayed its indignation. But the exhibition was a popular and a financial success. Harrods changed its windows to reflect the craze for surrealism sparked by the exhibition, and fashion houses and advertising followed suit.

In Yew Tree Cottage, preoccupied with her collapsing relationship with Garman, Peggy was worlds away from all this. But the seeds planted within her so long ago, coupled with a family tendency to use the money it had amassed to support a range of scientific, humanitarian, and artistic projects, made her sympathetically disposed to any such ideas. Her uncle Solomon, with his wife, Irene, had amassed a priceless collection of old master paintings, and since 1926 Solomon, under the influence and guidance of a minor German aristocrat and painter, Hilla von Rebay, had turned to supporting a very specific area of abstract art, the work of Wassily Kandinsky and Rudolf Bauer.

Old masters were beyond Peggy's budget. Modern artists were not: There were many of them, but very few dealers. Their work was not yet fashionable or taken seriously, except by a few. For years she had absorbed Laurence's views on modern art and through him met many of the artists themselves. Her sister Hazel, living in England with her third husband, Denys King-Farlow, had continued her career as a painter (a rumor that she succeeded in seducing the sixteen-year-old Lucian Freud about this time can be laid to rest. She found herself politely but firmly turned down, though she did encourage his artistic ambitions with the gift of a set of paints). Given Peggy's gregariousness and her desire to be associated with artists and writers, all the right ingredients were in place. But it is still open to question whether or not she would ever have entered their world had not she received a letter from her old friend Peggy Waldman in May 1937:

> *Darlingest Peggy,*
> *... I'm only sorry that you're so upset and unhappy and I wish you would do some serious work—the art gallery, book agency—anything that would be engrossing yet impersonal—if you were doing something for good painters or writers, or better still, a novel yourself. I think you'd be so much better off than waiting for G. [Garman] to come weekends and tear you to bits. ... I mean that you'd have a more painless perspective if you had another active interest besides, and particularly one that brought you in contact with stimulating people. ... Anyway I love you, please write again. ...*

There is evidence in the first sentence quoted that this was a topic that had been discussed before. Whatever the truth of the matter, a decision was soon

made. A literary agency or a publishing house was out of the question. Though Peggy had the capital (or could get it) to start either, what might have put her off was her own lack of confidence in the field of contemporary literature. Her guide, John Holms, was dead. But an art gallery was another matter. She knew little about modern art, but at least she had experience of it, and knew that what was available was affordable. Guided by her old acquaintance and new mentor Marcel Duchamp, she made her first purchase at the end of 1937. It was the first of five bronze castings by Jean (Hans) Arp, a tiny piece entitled *Tête et coquille* (*Head and Shell*), which she bought directly from Arp in Meudon, on the outskirts of Paris, for $300. (Ironically Arp had been Hilla von Rebay's lover years before, and had introduced her to the two painters who were to dominate both her life and Solomon Guggenheim's: Kandinsky and Bauer.) But there were a few bridges still to cross before she launched herself into what was going to occupy her for the rest of her life.

fifteen

"*Guggenheim Jeune*"

*P*eggy had much to preoccupy her during the summer and autumn months of 1937. She spent time with her mother in London and Paris: The fact of Florette's imminent death, and the additional inheritance that would follow it, influenced her thinking with regard to her art gallery idea. She had found a *raison d'être*.

Although very ill, Florette had lost none of her edge. She enjoyed visiting Sindbad and Pegeen, whom she adored, at Yew Tree Cottage, but when Peggy described how Laurence had been brought to heel by Kay, who "frightened him," Florette replied, "Too bad he wasn't frightened of you, frightened of you, frightened of you." Describing her fast passage from New York on the *Île de France*, she told Emily Coleman that "the vibration is terrible, terrible, terrible." (Florette came to like Douglas, whom she affectionately called "Garman." He was a good mimic and often parodied her manner of triple repetition, which delighted her.)

In London, Florette treated the children to sumptuous teas at the Ritz. In Paris she stayed at the Crillon with Peggy. By this time Hazel and Denys King-Farlow had presented Florette with two new grandchildren—John and Barbara Benita. The King-Farlows had been living in Hanover Terrace in London, but Florette had given them the money to buy a seaside house called Children's Delight, later renamed White Horses, at Birling

Gap near Eastbourne. The house, which was to be held in trust for John and Barbara, was bought principally for the sake of young John's health, which was delicate.

For Peggy, looking after her mother was, paradoxically, a distraction from following through on the notion of a gallery; but the plan did not go away, and she was further encouraged in it by meeting the artist and film-maker Humphrey Jennings through Emily Coleman. Jennings, ten years Peggy's junior, had been Emily's lover, but she had tired of him and was in the process of shedding him. Peggy describes him as "a sort of genius [who] looked like Donald Duck." He was at the time working on a massive tome entitled *Pandaemonium*, an "immense collage of written materials about the imaginative changes wrought by the Industrial Revolution," which remained unfinished at the time of his early death in 1951, when the material for it filled a tea-chest (it was finally published in 1985). He did some painting, and was involved in the surrealist movement, but his major contribution was in the making of a number of documentaries for the General Post Office Film Unit, which work earned him the Order of the British Empire—an honor he accepted, to the despair of some of his fellow surrealists.

Jennings was a man bursting with ideas and enthusiasm, and was soon helping Peggy look for a suitable space in London for her gallery. Peggy, however, continued to prevaricate: She was preoccupied with her mother's illness, and planned to settle nothing at least until after a visit to New York in December, by which time Florette would have returned there for her last Christmas.

Embarking on what was to be a very active period of sexual promiscuity in the wake of her split with Garman, Peggy accepted Humphrey as a lover in the wake of his affair with Emily. He followed her to Paris, and they took a room for the weekend in a small hotel on the Left Bank, leaving Florette at the Crillon. Peggy quickly discovered that Humphrey held little sexual charm for her, and when he returned for a second weekend she refused to leave the Crillon herself. She did introduce him to Marcel Duchamp, at his request, and in return Jennings took her to meet André Breton at Breton's little Gradiva Gallery, where Peggy remembered him looking "like a lion pacing up and down in a cage."

Duchamp had been reunited with Peggy's friend Mary Reynolds in 1928. He had met her at the beginning of the decade, and their relationship, despite his determination not to let it affect his essential freedom, lasted twenty years, not without interruptions and difficulties (including his first

short and disastrous marriage to Lydie Sarazin-Levassor, the unprepossessing twenty-four-year-old daughter of a car manufacturer, which lasted for the latter six months of 1927); and he would be at Mary's bedside at her death from cancer in 1950. In 1937 Duchamp was in his fiftieth year, a grand old man, idolized by Breton, of both the Dada and surrealist movements, but belonging to neither. He preferred an ascetic independence: He never had many belongings, never owned a home, and his austerity permitted him great freedom of movement. A truly free spirit, he had created boundary-breaking and highly influential works, like his "readymades"—ordinary objects like a bicycle wheel, a bottle rack, or the famous urinal, presented in a perspective that transformed them into works of art—a technique that is breeding bastard children.

Since about 1920, and until about 1933, he had indulged in little artistic activity, devoting himself to the game of chess, at which he became a master—his book on strategy is understood only by the most advanced adepts of the game. However, he never abandoned his role as a much-sought-after authority in the modern art world. While in the United States toward the end of the World War I he had taught the great collector Katherine Dreier French, and in the wake of the Armory Show and the huge 1917 Independents' Exhibition (the biggest ever mounted in the United States, with 2,125 works by 1,200 artists) she became, though not as single-mindedly as Walter Arensberg, an important collector of his work. She came to own Duchamp's *Large Glass—the Bride Stripped Bare by Her Bachelors, Even*, one of his most important works; and, much to Arensberg's annoyance, Peggy herself bought *Sad Young Man on a Train* from Walter Pach, the chief administrator of the Armory Show, in 1942. She was lucky. Pach refused to sell it to Arensberg, "against whom," in the words of Duchamp's biographer Calvin Tomkins, "he seems to have harbored an obscure grudge."

Early in 1920, with Katherine Dreier and Man Ray, Duchamp had founded the so-called Société Anonyme (the name was Man Ray's suggestion—he didn't know at the time that it meant "Limited Company" in French until Duchamp told him, but the name appealed to them and it stuck) to fulfil Dreier's ambition to educate people in the appreciation of modern art through exhibitions of her growing collection—she believed in the arts' "spiritual mission to improve the human race." The Société functioned for twenty years, mounting eighty-five exhibitions in that time. So great was its

influence that when the Museum of Modern Art came into existence in New York in 1926, Dreier was irritated, thinking her idea was being stolen.

Duchamp had been back in Paris since 1923, though he made occasional trips to America over the next two decades, and continued to advise Dreier and to scout new works for her. He would soon take on a similar unpaid role for Peggy. By 1938 the Société was petering out, and Dreier wanted his advice on what to do with her huge collection (the bulk of it eventually went to Yale University); at the same time, he was designing a large surrealist exhibition at the Galerie des Beaux-Arts in Paris, which opened early in 1938. Typically Duchamp did not attend, but took the boat train to London with Mary Reynolds instead. Whether Peggy attended the exhibition is not recorded, though she had visited the exhibition of modern art held in Paris the previous year. Duchamp's daring design—1,200 coal sacks stuffed with newspapers hung from the ceiling of the main gallery, and electric-eye sensors illuminating paintings as people stood in front of them—influenced aspects of the gallery Peggy was to open in New York a few years later, by which time Duchamp was firmly established as a friend and mentor, with perhaps a trace of the father figure she had always sought, though Duchamp's reserve would never allow him to satisfy her need in that direction. However, Duchamp always excelled as a teacher and guide, and he was unsurpassed at the beginning of her collecting career. Only much later, when she moved into areas unfamiliar to both of them, and for which he had little sympathy, did his influence wane. When he encountered Peggy again in Paris in 1937 and she enlisted his aid for her idea for a gallery, he saw at once that here was another wealthy neophyte through whom the cause of modern art could be promoted and disseminated. But he also helped simply because he wanted to. What he didn't know was that his new "pupil" had a natural talent for self-promotion that would serve the same cause. One of the differences between Peggy and her fellow collectors was simply that she was more colorful, and in many ways more simpatico, than the rest of them. She was not the most important collector, and she was not the first, but as her life in the art world progressed, her collection became a substitute for all that was missing in her life as a human being. The collection and the collector became one: Her identity and her ego were bound up in it.

Peggy was still caught up in the turmoil of her domestic life. Things were not going well with Humphrey Jennings. His hyperactivity wore Peggy out, and despite the success of an introduction to the surrealist painter Yves Tanguy, and a serious discussion with him about the possibility of an exhibition

of his work at the as yet still notional gallery, Peggy felt that she ought to
bring emotional matters to a close. She tried to do this gently, blaming it on
her continuing attachment to Garman: "We were standing on one of the
bridges of the Seine, and I remember how Humphrey wept. I think he had
hopes of some kind of a wonderful life with me, surrounded by luxury, gai-
ety and Surrealism."

Shortly before Florette's departure for New York, Sindbad and Pegeen,
who had been staying with their father at Megève, came up to see their
grandmother for the last time, at the Crillon. They returned with Peggy to
England, and she and Garman finalized the practical arrangements of their
separation. She took over the London flat, and generously undertook to rent
Yew Tree Cottage from him to augment the meager income he received
from the Communist Party. In the meantime she continued to send an
allowance to Laurence Vail and Kay Boyle.

In November, Florette, who had fought a long illness bravely and uncom-
plainingly, died at the age of sixty-six. There would be no last Christmas
with her. Neither Peggy nor Hazel went to America to attend her funeral
service at Temple Emanu-El. The sisters received hundreds of telegrams and
letters of condolence, none more telling than the letter from Aunt Irene:

> *Dear Peggy and Hazel,*
> *I know you will want to know from one who was very close to your*
> *Mother how peacefully and mercifully her passing away came to her.*
> *I had inquired whenever I went to town whether I could see her and for*
> *the past fortnight she was either resting or awaiting the doctor who had*
> *been treating her for asthma. On Monday 15th [November; the letter is*
> *dated the twenty-first] I again telephoned to her apartment and Miss*
> *Fenwick told me that she had been in a comatose state since the 12th. It*
> *seems she turned blue on the Friday morning and the Dr. ordered her to be*
> *put under an oxygen tent to which she acceded when told her breathing*
> *would be easier and she never came back to consciousness after that—but*
> *on Monday at 3.15 p.m. Mlle. [Hoffman, Florette's companion] and the*
> *nurse went to have a look at her and she was moving her lips and went out*
> *like a candle with just a flicker.*
> *Well, Dear [sic], she is out of all her sorrows and what a blessing for her*
> *that she had no struggle or pain. Would that her living had been so carefree*
> *as her dying!*

There are not many mortals who suffer as she did: the mental anguish and in silence. Her life was ever a tragic one.

Florette never realized that she would go so rapidly therefore kept putting off in her unselfish and sacrificing way sending for you.

The funeral services were dignified and impressive and she looked very peaceful and young—the blanket on the coffin and all the floral offerings were an indication of her many loving friends, and very beautiful.

Well, Dears, I hope her memory may be ever green and alive as her deep love of you girls deserves this last token.

> *With much love from Uncle Sol and myself—*
> *As ever affectionately . . .*

Peggy and Hazel each inherited about $500,000 from Florette's estate, held in trust but producing a healthy extra investment income. The ever-prudent Florette, well aware of her daughters' dispositions, had also set up trust funds in favor of her *great*-grandchildren, the first of whom would not be born for another nine years.

Peggy's friendly collaboration with Humphrey Jennings fizzled out, because without the impetus of an affair he moved on to other things. He and his fellow artists were becoming increasingly alarmed by the rise of Hitler, and responded to the threat by drawing attention to its seriousness. Though a Jew (and by 1937 the intentions of the Nazis toward the Jews were plain), Peggy showed little interest in what was happening in Germany.

A new helper presented herself in the form of Peggy's old friend Wyn Henderson. This plump, energetic redhead, who would vie with Peggy for the number of lovers she took, gave fresh impetus to the art gallery scheme toward the end of 1937. Peggy found premises at 30 Cork Street in the West End of London, then just beginning to become a center for art dealers. Wyn, put on a modest salary, took over the day-to-day running of the new gallery, and designed its posters and catalogs. Peggy set off for Paris to try (with Duchamp's help) to arrange an exhibition of Brancusi's sculpture—Brancusi, like Duchamp, was well known in the United States but not yet appreciated in France—while Wyn saw to it that the gallery was refurbished and decorated. Wyn even found a name for the gallery: Guggenheim Jeune, which, though chosen in honor of the Bernheim Jeune modern art gallery in Paris,

got Peggy into trouble with Hilla von Rebay, her uncle Solomon's adviser on art, before long. Solomon had established the Solomon R. Guggenheim Foundation in June 1937, which would lead, two years later, to the opening of the Museum of Non-Objective Painting in New York, with Rebay as its director. Rebay was not about to brook any rivals, or to see the Guggenheim name taken in vain.

But for the moment there was the question of how to open Guggenheim Jeune. Busy as he was at the end of 1937, Duchamp not only introduced Peggy to the artists he knew in Paris, but also taught her the fundamentals of understanding modern art. Peggy had to be shown the difference between what was abstract and what was surrealist, and between the "dream" surrealism of, for example, Dalí or de Chirico and the "abstract" surrealism of, say, André Masson. She was an eager and quick learner, showing a natural affinity and sympathy for what she saw, and adapting the eye she had begun to develop with regard to the Old Masters under the tutelage of Armand Lowengard many years before to new shapes and forms. They rewarded the applications, such as tactile values, movement, space-composition, and color, laid down by Bernard Berenson.

Peggy didn't pay Duchamp for his advice and teaching; it wouldn't have occurred to him to ask for money any more than it would have occurred to her to pay unless asked—and even then she would have quibbled. There are subtler reasons too: In the age in which they lived, it wasn't usual for men to accept formal payment from women, and it wasn't usual for women to expect them to. Another element is the sexist attitude Duchamp shared with most of his contemporaries. Paradoxically Duchamp also, though never rich himself, was usually in a relationship with a wealthy woman.

Brancusi was away from Paris and could not be located, and in his place Duchamp suggested that Peggy approach Jean Cocteau for the opening show. Cocteau, approaching fifty, was a well-established polymath, a writer of poems and plays, a designer, a painter, and involved with the ballet, for which he had written several scenarios. Peggy visited him first in his hotel room, where he lay regally in bed amid a cloud of smoke from his opium pipe. Later Cocteau invited her to dinner, but spent the evening admiring himself in the mirror on the restaurant wall behind her. Despite the distractions, he agreed to put together an exhibition for her, with Duchamp's help, though his poor health would not permit him to attend in person. An open-

ing date was set for January 24, 1938. Exhibitions of works by Kandinsky, proposed by Duchamp, and by the portrait painter Cedric Morris, a friend of Mary Reynolds, were to follow, and would take the gallery through to April.

Peggy meanwhile had time to renew old acquaintances in Paris. Among them were Helen Fleischman, now married to Giorgio Joyce, and James and Nora Joyce themselves, whom she had last met when she was living in Paris with John Holms. She also met someone again whom she'd known only very briefly, through Joyce, when she'd last lived in Paris: Joyce's young friend, acolyte, and fellow countryman Samuel Beckett.

Beckett, thirty-one in 1937 and twenty-four years Joyce's junior, had known the novelist since 1927, when the two men had met in Florence. Beckett much admired Joyce's work, and soon afterward was helping him informally with research for what would become *Finnegans Wake*, as well as reading to him and occasionally taking dictation, for Joyce's sight was all but gone by this time. Beckett was already emerging as a poet of striking originality, and when Peggy met him again he was beginning, shakily (for his work was hard to deal with), as a novelist. His relationship with Joyce had survived one hard knock: Beckett first met Joyce's daughter, Lucia, in 1928. Over the next couple of years he became a regular visitor to the apartment in what is now le square de Robiac. Lucia was training as a dancer, and as his intimacy with the family grew, Beckett from time to time would accompany James and Nora to see her perform. Though in the end she lacked the stamina for a career in dancing, she was also a talented singer. She was a vibrant, high-strung girl with a slender, beautiful body, her looks marred by a slight strabismus, of which she was painfully conscious. She had had several lovers, or at least crushes, before her attention focused on Beckett early in 1929.

Unknown either to Beckett or the Joyces, Lucia was already in the foothills of a mental instability that would dog her all her life. Beckett did not return her ardor, but took her out for meals or a drink more to bind himself to the family than anything else. In the end he had to recognize her longing for him and tell her that it was not reciprocated. Lucia was shattered by this news, and it led to a rift between Beckett and Joyce healed only when Joyce himself came to recognize his daughter's mental disturbance. Being cut off from his idol was no less distressing for Beckett.

Reconciled with Joyce when Peggy met him again, Beckett was a serious, thin, ascetic man (though at the time he did drink copiously), who had no regard for his clothes and was in many ways completely unworldly. There

was something about him—Beckett was no mean athlete and had boxed and played cricket for his university—that reminded her of Holms. That Beckett was earnest, awkward, and taciturn put her off not one bit. She liked his intensity and his penetrating gray-green eyes. The combination of drink, intellectualism, and literature was more than she could resist.

She met him again at a dinner party thrown by Joyce on Boxing Day at Fouquet's, then his favorite restaurant. Beckett was recovering from a bitter libel case in Ireland in which he had been involved as a witness, and it was a relief to him to be back in Paris and among friends. After dinner Beckett and Peggy went home with the Fleischmans for a nightcap, whereupon Beckett, in the abrupt way he had, asked Peggy if he could escort her home. He proceeded to take her arm and walk her all the way back to her borrowed apartment on the rue de Lille, in St.-Germain-des-Près. Once inside he lay on the sofa and invited her to join him. She suggested bed, and they spent all night and the next day there. At one point Peggy mentioned that she'd like some champagne, and Beckett went out forthwith, returning with several bottles, which they drank in bed. When the party broke up—Peggy had been invited to dine with Jean and Sophia Arp, and as they didn't have a telephone she couldn't call to say she couldn't make it—Beckett took his leave by saying, "fatalistically," as Peggy puts it, "Thank you. It was nice while it lasted."

Quite possibly Beckett thought that was the end of the "affair." His tone suggests that he hoped it was. But Peggy had found, as she thought, a new John Holms, and one who at least did write, even if she couldn't make much of his writing: She thought his poems "childish," though she saw that there was something "rather extraordinary" in his recently published novel *Murphy*, and she was on much firmer ground with his work on Proust, which she found "excellent."

After their night together she didn't see him for some time, but then bumped into him "on a traffic island in the boulevard [du] Montparnasse," by chance, as she puts it, though as she knew that Beckett's lifelong predilection for the Closerie des Lilas was already well established, the likelihood of their meeting having been purely by chance is slight. She herself archly adds "it was as though we had both come to a rendezvous," though within her character a canny self-knowledge coexisted with a tendency to romanticize both the mundane and the planned.

Mary Reynolds had gone into the hospital, and Peggy had moved into her place to house-sit. She took Beckett back there, and they spent the next twelve days together. Peggy wrote: "Out of all the thirteen months I was in love with him, I remember this time with great emotion. To begin with he was in love with me as well, and we were both excited intellectually. Since John's death I had not talked my own, or rather his, language. And now I suddenly was free again to say what I thought and felt." The sex wasn't always wonderful—often it wasn't there at all—but in that case they would get drunk together and walk around Paris, talking until dawn.

From Beckett's point of view the situation was slightly different. Eight years Peggy's junior, he was still feeling vulnerable after his experience of the Dublin libel courts. He was attracted to Peggy because of her vivid personality and her independence of spirit, and because she was sexually liberated: She didn't disguise what she wanted. Her knowledge of literature was wide, and they shared an interest in modern art. For a time Beckett became another mentor. It was he who finally persuaded Peggy that she should detach herself from the old masters and immerse herself in the work of the moderns. He was intrigued by Kandinsky's work and interested to learn of her plans for her gallery in London. She offered him work—he translated Cocteau's introduction to the catalog for his exhibition at Guggenheim Jeune, for example—and probably he was already considering persuading her to give his friend, the painter Geer van Velde, an exhibition too. Beckett liked the life that a wealthy woman opened up to him, and appreciated her for wanting to spend her money on modern art and artists. Like Vail and Holms before him, he enjoyed driving the fast cars she made available, and a love of sports cars never left him. Interestingly enough, in his first full-length play, *Eleutheria*, written ten years later, a character called Madame Meck (*mac*=pimp in French) drives a Delage, as Beckett's biographer James Knowlson points out. But Beckett found Peggy's pursuit of him too predatory, and on account of this they often quarreled; he was never in love with her, and he was involved with two other women at about the same time.

Their uneasy relationship was soon interrupted. On January 6, 1938, as Beckett remembered the date, at about 1 A.M., he was escorting a couple of friends home when a man emerged from the shadows and started to pester them—it later emerged that he was a pimp. When they attempted to brush him off, the man, whose name was Prudent, produced a knife and stabbed

Beckett, upon which the assailant ran off, leaving Beckett bleeding on the pavement. His friends managed to get him into their apartment, and then rang the police—they were visitors to Paris and didn't know whom else to contact. Beckett was rushed to a hospital. Joyce and other Parisian friends were alerted. The wound was serious. Joyce summoned his own doctor, Thérèse Fontaine. The knife had missed the lung and heart by a minute margin, but had penetrated the pleura, and there were fears at first for Beckett's life. He remained in the hospital until January 22, and it was a long time before he recovered fully. While there, he wrote a short poem reflecting on his love life:

> they come
> different and the same
> with each it is different and the same
> with each the absence of love is different
> with each the absence of love is the same.

The other two women Beckett was involved with were a married Irish antique-shop owner, Adrienne Bethell (the affair was short-lived), and a Frenchwoman, Suzanne Deschevaux-Dumesnil, six years his senior, whose solicitude during his convalescence led to her becoming his lifetime companion and lover, though they did not marry until 1961.

As for the pimp, he was known to the police. Beckett identified him and he was arrested. Beckett didn't want to press charges, but the police insisted, which meant that he had to go through another court case. The clothes he had been wearing at the time of the attack were taken away as evidence (he never got them back). He met Prudent in the entrance hall of the court and asked him why he'd done it. "I don't know, sir; I'm sorry," was the reply. Prudent was sentenced to two months at the Santé prison—it was his fifth conviction. Years later Beckett's study in his Paris apartment had a view of the same prison.

Peggy, who was frantic when she heard the news of the stabbing, sent flowers to the hospital, and visited Beckett with Joyce the following day, though work in London on the new gallery took her away from Paris for much of the time he was in the hospital. Their affair proper only lasted from December 27 until January 6, but it continued to drift on, so that the events

are narrated below need not have taken place between those dates, and it is not easy to pinpoint when the lovemaking ended, giving way to friendship and then, in time, acquaintanceship. Peggy's pursuit of Beckett didn't end with his hospitalization, although she was to complain that when she asked him what he was going to do about their life together, "he invariably replied, 'Nothing.' "

The relationship was turbulent from the start. They would stay in bed all day. Beckett was frequently drunk, and his comings and goings were unpredictable, which Peggy found exciting. He told her that for him "making love without being in love was like taking coffee without brandy." He also confessed to the liaison with Mrs. Bethell, according to Peggy:

> On the tenth day of our amours, Beckett was untrue to me. He allowed a friend of his from Dublin to creep into his bed. I don't know how I found it out, but he admitted it saying that he simply had not put her out when she came to him. . . . From this I inferred that I was the brandy in his life, but nevertheless I was furious, and said that I was finished with him. The next night he phoned me, but I was so angry that I refused to speak to him.

The same night Beckett was attacked in the street.

In London, Peggy spent a busy two weeks getting everything ready for the opening, as well as organizing her new apartment, a task complicated by the fact that she had given Garman all the furniture from the old one. Having avoided the opening of the surrealist exhibition in Paris, Duchamp and Mary Reynolds arrived in time to help her in the last stages before the opening, and Duchamp hung the show. Cocteau had sent over thirty drawings for the decor of his play *Les Chevaliers de la Table Ronde*, as well as some of the furniture he had designed for it. Most important there were two large linen sheets with drawings on them, one of which was to give Peggy her first brush with the British customs authorities. They depicted *Fear Giving Wings to Courage*, a group of four figures, three of whom displayed their genitalia and pubic hair. Cocteau had pinned leaves over the offending parts, but the pubic hair still showed, and so the work was detained at Croydon Airport.

Duchamp and Peggy hurried down to negotiate, and were allowed to take the sheets away provided that they were not put on public display. She hung them in her private office at the gallery and showed them to a few friends. At the end of the exhibition, she bought the piece. This was the unwitting beginning of her collecting career, since she soon developed the habit of buying at least one item from each of her exhibitions—partly to encourage the artists. On occasion her purchase was the only one. Running a gallery of modern art in those days, long before there was a market or a fashion for such material, was hard work, and few dealers made a profit.

The opening of Guggenheim Jeune on January 24, 1938, was a success (as usual Duchamp did not attend). At the party Peggy wore a pair of earrings designed by Alexander Calder, and her warmhearted, somewhat gauche manner captivated everyone. She was overjoyed to receive a telegram from Beckett wishing her luck and signed "Oblomov"—her nickname for him, derived from the nineteenth-century Russian novel of the same name by Goncharov, whose eponymous hero is reluctant to leave his bed. She returned to Paris with Duchamp and Mary as soon as the Cocteau show was up and running, leaving it in Wyn Henderson's hands, and resumed her pursuit of art and Beckett, stimulated by her new career. It was as if she had found herself at last. By that time her sister Hazel had separated from Denys King-Farlow (they were divorced later in 1938) and had taken an apartment on the Île St.-Louis. King-Farlow had custody of the children, John and Barbara, who were sent to school in England. Hazel herself was now seeing Alexander Ponisovsky, the brother-in-law of Beckett's secretary. Ponisovsky had been engaged to Lucia Joyce, and as Peggy was chasing Beckett, James Joyce was upset. He wrote to his daughter-in-law Helen: "I really know nothing about Mrs K-F except the two versions of her children's death (neither of which seems to trouble her overmuch). . . . It is rather curious that the two men in whom poor Lucia tried to see whatever it is she or any other woman or girl is looking for should now be going round with two sisters." As Hazel's apartment was free, Peggy moved into it and tried to inveigle Beckett there too, but he demurred—he was already seeing a lot of Suzanne Deschevaux-Dumesnil.

His lack of interest frustrated Peggy, who taunted him about his passivity and flagging sex drive, broadly hinting that his friend Brian Coffey was after her. She was taken aback when Beckett suggested that she should therefore

go to bed with Coffey, which she proceeded to do. Coffey, innocent of any knowledge of his friend's sexual involvement with Peggy, went to Beckett to apologize as soon as he knew, but Beckett, according to Peggy in her presence, "gave me to Brian." This was not the end of the business, though it certainly was for Coffey, who very soon afterward married a woman to whom Peggy had introduced him.

Beckett continued his liaison with Peggy. It was not without its lighter moments. Joyce turned fifty-six in February 1938, and Maria Jolas gave a party for him at Helen and Gorgio's place. Joyce enjoyed parties, and Beckett wanted to give him something special: a bottle of the Swiss white wine that was Joyce's favorite drink. Peggy remembered a restaurant she'd dined at with Joyce and Holms years before, and she and Beckett went there and bought a bottle. Peggy gave Joyce a blackthorn stick. The party was a success, though Peggy cannot have enjoyed it much: She describes the other guests as "only Joyce's sycophants." Joyce got drunk and danced a jig.

While her relationship with Beckett remained on her mind, Peggy was very much occupied with her new gallery. The Kandinsky show was due to open on February 18. Peggy had met Kandinsky through Duchamp (Kandinsky's work was much more to Duchamp's taste than Cocteau's work). Overprotected by his much younger wife, Nina, Kandinsky was delighted to accept a show, his first ever in London. At seventy-two, Kandinsky, a dapper and reserved man who looked more like a broker than an artist, had for a long time enjoyed great eminence in the modern art world. He had been associated with a number of important art movements, including the Blue Rider and the Bauhaus, and his publication in 1912, *On the Spiritual in Art*, established him as the father of abstract painting. He had long ago established relations with Solomon Guggenheim's art consultant (and for a time mistress), the Baroness Hilla von Rebay, who had bought several of his works for Solomon's collection; but subsequently Hilla had fallen in love with another painter, Rudolf Bauer, in reality an obnoxious careerist who imitated Kandinsky's style without manifesting a fraction of his talent. In one sense, then, the Guggenheim Jeune show would be a chance for Kandinsky, the politest of men, indirectly to nudge the Americans into a renewed awareness of his work.

The show, a retrospective of work from 1910 to 1937, was meticulously planned by Kandinsky and his wife themselves—though Peggy was never to

get along with the proprietary and businesslike Nina. André Breton, among others, wrote critical commentaries for the catalog. The exhibition was a critical success—the influential weekly arts and literature magazine *The Listener* gave it a glowing review on March 2—but very little sold. Kandinsky was philosophical about this, but the only major painting which went was his *Courbe Dominante (Dominant Curve)*, which Peggy bought for $1,500. Later advised by a friend that its content was "fascist," she sold it during the war to the dealer Karl Nierendorf, who sold it to Solomon Guggenheim in 1945. Much later Peggy expressed regret that she had not bought every single picture in the show.

In an attempt to drum up business for her client (Kandinsky had no dealer of his own at the time), on February 15 Peggy wrote to her uncle Solomon and aunt Irene, offering them two pictures in the show, one of which, according to Kandinsky, Solomon had expressed interest in years before:

> Dear Aunt Irene and Uncle Sol,
>
> The day after tomorrow I am opening a show of Kandinsky's complete works.
>
> We are showing 34 oil paintings and 9 gouaches. This is the first time that he has had such an important show in London and I hope to place some paintings in museums in England.
>
> I am enclosing the catalogue for you to see and also a photograph of Kandinsky with "Tache Rouge" 1921. It seems that this picture interests you very much and you do not want anybody else to buy it without your being warned.
>
> I have here also 1 black and white picture called "Trente." It is the last one left out of his four black and whites. . . .
>
> If you would like to buy anything from my Gallery I should of course be delighted. It would encourage me very much and give me a very good send-off for this important show. I am therefore enclosing a price list in the catalogue.
>
> In any case I hope when you are in London in the summer that you will come to see the Gallery.
>
> > Much love,
> > Peggy

Peggy's letter was referred to Hilla von Rebay for reply. Hilla never quite mastered English, but that did not prevent her from sending a haughty response:

> Dear Mrs Guggenheim *"jeune"*
>
> Your request to sell us a Kandinsky picture was given to me, to answer.
>
> First of all we do not ever buy from any dealer, as long as great artists offer their work for sale themselves & secondly will be your gallery the last one for our foundation to use, if ever the need to get a historically important picture, should force us to use a sales gallery.
>
> It is extremely distasteful at this moment, when the name of Guggenheim stands for an ideal in art, to see it used for commerce so as to give the wrong impression, as if this great philanthropic work was intended to be a useful boost to some small shop. Non-objective art, you will soon find out, does not come by the dozen, to make a shop of this art profitable. Commerce with real art cannot exist for that reason. You will soon find you are propagating mediocrity; if not thrash [sic]. . . .
>
> Due to the foresight of an important man since many years collecting and protecting real art, through my work and experience, the name of Guggenheim became known for great art and it is very poor taste indeed to make use of it, of our work and fame, to cheapen it to a profit.
>
> <div align="right">
> Yours very truly,

> H. R.

> P.S. Now, our newest publication will

> not be sent to England for some time

> to come. [This last is handwritten—

> Hilla's handwriting is strikingly

> similar to Peggy's.]
> </div>

Peggy wrote back by hand to Solomon, who had also written to her:

> Dear Uncle Sol,
>
> Thank you for your letter. . . . I do not in the least mind your not buying the Kandinsky from me. . . . But I do very much mind receiving an insulting letter like this [Peggy enclosed a copy of Hilla's letter] from Mme Rebay. . . . I am sure you could not have allowed her to write to me so

insolently had you known of it. . . . I think this is all very sordid and
unpleasant

> *Your fond niece,*
> *Peggy.*

She also enclosed a copy of her reply to Hilla, dated March 17, 1938:

Dear Baroness Rebay,
 *I was very amused by your letter. Herbert Read suggests that I frame it
and hang it in my Gallery. He also suggested that I had the right to use my
own name, which you seem to object to.*
 *I think you have quite the wrong idea about my Art Gallery. It can
hardly be called a business enterprise or a small shop. For 16 years I have
lived amongst and befriended artists. This is just a new way and a more
practical one of continuing my life's work. I now hope to enable foreign
artists to be known in England. This can hardly cause prejudice to the
name of Guggenheim as some other scandals in connection with art have
done recently [an oblique reference to Hilla's partisanship for Bauer]. My
motives are pure, and as I do not belong to the first but the third generation
of Guggenheims, I do not seek to make money but to help artists.*
 *I also have a good and growing collection of paintings. However it does
not and never will include second-rate painters like Bauer.*

> *Yours truly*
> *Marguerite Guggenheim.*

The bottom and lefthand margin of the letter are covered with furious
scribblings by the recipient, including: "Aha! <u>Read</u>! Moholy-Nagy and Co."
Hilla's horizons were not wide, but she fought hard for the cause of abstract
art and knew her enemies (except for Bauer, who was to lead her a dance yet).
 The correspondence reveals that the art historian Herbert Read was
already interested in Peggy's gallery. Actual professional involvement with
her was to come later.
 The next show but one at Guggenheim Jeune really caused a stir.
Duchamp had suggested to Peggy that she mount an exhibition of contem-
porary sculpture, including works by Brancusi, Arp, Sophie Täuber-Arp,
Raymond Duchamp-Villon (Duchamp's sculptor brother), Henry Moore,
Antoine (Anton) Pevsner, and Alexander Calder. Moore was delighted to be

included in a show with mainland European fellow artists, and was always grateful to Peggy for the attention she gave him.

In the time leading up to the exhibition, Arp came over to help Duchamp with the arrangements; he stayed with Peggy at Yew Tree Cottage, and as she was still obsessed with Beckett at the time, he was left alone. Arp, indeed, who remained one of Peggy's lifelong friends, is one of the few men she knew at the time whom she didn't either make a pass at or sleep with. He was enthusiastic about the English countryside, admired the local Gothic churches, and learned one word of English: "candlesticks." Together they visited Epstein's studio, despite his unwillingness to admit Arp, as Epstein was an avowed enemy of the surrealists. They were soon to encounter a far more irritating example of prejudice.

James Bolivar Manson was the then director of the Tate Gallery. Born in 1879, and since 1930 in charge of Britain's national gallery of contemporary and British art, he had been secretary of the London Group, which exhibited works by a broad range of progressive British artists including Sickert, Nash, Mark Gertler, Wyndham Lewis, and Epstein. A portraitist and landscape artist himself, in a minor post impressionist mold, he had published studies on Rembrandt and Degas. By 1938, however, he was anything but progressive.

The majority of the sculptures for the exhibition had to be brought in from France. Much of the work had not been seen before in England. British customs would not admit the works into England as they could not be certain that they were works of art, and did not wish to contravene a recent national law protecting the interests of stone and monumental masons. Manson had the authority to arbitrate in the matter. His track record was not good: He had turned down a Cézanne as a gift to the Tate, and had recently had to weather a lawsuit brought by Maurice Utrillo, who'd been described in a Tate catalog as dead through alcoholism: Utrillo was, in fact, alive and relatively abstemious. It is possible that by 1938 Manson was suffering from mild dementia, and alcohol may have played a role in it: In any case, he dismissed the sculptures out of hand as "not art."

This was a shock. No difficulties had been anticipated, least of all from the "aesthetic sensibilities of the English customs authorities." But unfortunately Manson had had the power of veto conferred on him by the government, and he abused it. As John Richardson has observed in his life of the collector Douglas Cooper, quoting an anonymous source, Manson was a man who had "grown gray in the service of art and purple in its disservice."

Manson's decision left Guggenheim Jeune in a quandary. There had been a similar case eleven years earlier concerning one of Brancusi's bronze *Bird* sculptures—and if Manson's decision were upheld, the sculptures could only be imported as pieces of bronze, wood, stone, and so on—on which duty would have to be paid. A number of leading artists and patrons wrote to the British broadsheets immediately in protest, Wyn Henderson got up a petition, and enough pressure was exerted by influential people to cause Manson to relent. In late March 1938 the *Daily Telegraph* carried a letter jointly signed by a number of artists, including Moore and Graham Sutherland, which stated: "Are the new regulations at fault in placing upon one man the necessary decisions, or is Mr J. B. Manson ignorant of the international reputation of these artists?" Another, from Sir John Hutchinson, K.C., warned, "Let us avoid dictators even if the dictator of taste is the Director of the Tate Gallery." Norman Demuth wrote in similar vein from the Royal College of Music: "We want no 'Nazification of art' in this country"—a reference to recent oppression in Germany. Other papers, such as the *Manchester Guardian* and the *Daily Express* took up the cause.

Manson, whose intemperance had led him to declare not long before that "over my dead body will [a] Henry Moore ever enter the Tate," soon afterward met his nemesis. At an inaugural luncheon in Paris of the great 1938 exhibition of British Art at the Louvre, Manson drunkenly berated the speakers, and crowed in satirical (and abusive) imitation of the *Coq Gaulois*. His resignation from office swiftly followed, and he died seven years later.

The publicity did Peggy no harm at all, and she knew how to court the press, but no matter how much *succès de scandale* she achieved, sales stayed slow. As far as she could recall later, nothing was sold at the sculpture exhibition, though prices were modest. At about this time Walter Hayley, then working as an office boy in Sackville Street at 12s. 6d. (about 63p/$1) a week, who'd worked as a picture hanger for the Surrealist Exhibition in 1936 around the corner, remembers drinking horses' necks in a modern bar nearby. Roland Penrose, then in his thirty-sixth year, paid for the rounds because he was better off than most of the others present. Hayley, still in his teens, met Peggy, who offered him a Picasso collage for £10, plus "services rendered." "But," he remembered, "she was very discreet in her sexual advances." He also remembered that Peggy "had a pretty good conceit of herself." He didn't have the £10, so the offer was withdrawn. Years later, in 1980, he saw the collage again in the National Gallery in London.

Peggy's morale remained low because she was still carrying a torch for Beckett. At times she felt homesick for America, and Debbie Garman remembers Peggy taking Pegeen and her to a place in Chelsea called Nick's, where they could get Coca-Cola, waffles, and maple syrup. Peggy behaved like a kid at Nick's too. Wyn Henderson (whom the art historian James Lord has described as Peggy's "female Leporello") tried to wean her off her woes, even suggesting her sons Ion and Nigel as possible diversions, to no avail. At least Peggy could leave the gallery in her friend's hands while she went off to Paris again.

It didn't go well. In Paris, Helen Joyce suggested that Peggy simply "rape" Beckett, but Peggy didn't have the heart for such an enterprise and when she met him she had to admit to herself that the whole experience was vapid. When she insisted on staying in his apartment for the night, he fled. She was so furious that she wrote him a poem and left it on his pillow before leaving:

A woman storming at my gate—
Is this inevitable fate?
From far away the hammer fell:
Was that my life or death's last knell?

To my void she came much wanting
Shall I chance this fear unending?
Shall I face the pain of rupture?
Shall I execute the future?

Every step I take she battles,
Every inch the death-knell rattles.
Shall I kill her Holy passion?
Destroying life, not taking action.

The Geer van Velde exhibition opened to little interest on May 5. Like so many of his generation, the Dutchman van Velde, a contemporary of Peggy, stood in the long shadow of Picasso, and few of his works sold. Peggy, to please Beckett, quietly bought a number of paintings from the exhibition under a variety of assumed names. Van Velde was delighted, and was able to brush aside the tepid press reactions. He was further encouraged by an undertaking from Peggy to subsidize his painting for a year. However, if she hoped that Beckett would react gratefully she was mistaken.

Beckett came over for the exhibition, his fare almost certainly paid by Peggy, and stayed in London at a friend's lodgings. Peggy hung on his every word when they looked at pictures together, finding him immensely knowledgeable about art. When he joined the van Veldes at Yew Tree Cottage, Peggy, who'd given up her room to them, slept in the corridor, strategically placing her camp bed between the guest room, where Beckett slept, and the bathroom. Beckett told her all about Suzanne, but Peggy refused to be put off—she did not accept that he was in love with her; besides, Peggy had met her and found her too plain to be worth considering a rival. In any case Beckett continued to throw out ambivalent signals, and the chances are that he wasn't in love—at least ardently—even with Suzanne. A year or so later he wrote of Suzanne to a friend: "There is a French girl . . . whom I am fond of, dispassionately, and who is very good to me. The hand will not be overbid. As we both know that it will come to an end there is no knowing how long it may last." Peggy compared Suzanne unfavorably with herself: "She sounded to me more like a mother than a mistress"—but Suzanne was more suited to Beckett's temperament than Peggy could ever be.

After the exhibition was over, Peggy followed Beckett back to Paris. The mutual friendship with the van Veldes was used by Peggy as an excuse for seeing as much of Beckett as possible. On one occasion, in his apartment, he and Geer undressed and dressed again in each other's clothes. Peggy sniffily describes this as "a rather homosexual performance, disguised, of course, by the most normal of gestures"; though it sounds like nothing more than a drunken party game. They dined with the van Veldes, and drove them down to Cagnes in the south. They broke the return journey for a night at Dijon, where Beckett booked a twin-bedded room "because it was cheaper" than two singles, but then spent the night slipping out of the bed he was in as Peggy slipped into it. Even this extremely awkward episode failed to deter Peggy, though the clothes-swapping episode had diminished Beckett somewhat in her eyes.

As late as July, Peggy was still writing to Emily Coleman that "I love being with him. It is more and more my real life. I have decided now to give up every thing else even sex if necessary and concentrate on him. I am very happy when I am away from him and when we are in the same city and together but he gives me an awful time. However I know he can't help it." But the affair was doomed to fizzle out: even Peggy's determination wasn't

proof against what she saw as Beckett's emotional paralysis, and Peggy had never been as important to Beckett as he had been to her.

Meanwhile, she had punctuated her pursuit of Beckett—more out of pique than anything—with a brief fling with the director of the art gallery next door to hers. In her memoirs she wrote:

> E. L. T. Mesens was a Surrealist poet and the director of the London Gallery, my neighbor in Cork Street. We had a united front and we were very careful not to interfere with each other's exhibitions. I bought paintings from Mesens. He was a gay little Flamand, quite vulgar, but really very nice and warm. He now wanted me as his mistress, so we were to have dinner together. Before Beckett went back to Paris I went off with Mesens and took a diabolical pleasure in doing so.

Edouard Mesens, thirty-five years old in 1938, was born in Belgium but had recently made London his adopted home. He was already a veteran dealer, and his greatest coup had been to rescue an important group of paintings by his friend and fellow countryman René Magritte during the economic slump five or six years earlier, which had adversely affected many galleries in Paris. In October 1932 the entire stock of the Galerie Le Centaure was up for auction, including 150 early Magrittes. Mesens snapped up the lot for an agreed price prior to their going under the hammer. This act of charity to a friend would ultimately make Mesens a multimillionaire, for these pictures were not bought to be traded, but formed the foundation of his own private collection.

As a prominent surrealist whose presence in London and Brussels made him something of a human bridge between the British and the mainland European groups, he had become friendly with Roland (later Sir Roland) Penrose, himself more at home in France than England. Penrose, following the lead set by Herbert Read, funded the London Gallery at 28 Cork Street, which opened its doors in April 1938 with Mesens in charge. At the same time, a magazine devoted to surrealism, the *London Bulletin*, was launched, under the editorship of Mesens and Humphrey Jennings. The gallery opened with a Magritte retrospective, followed by an exhibition of paintings and collages by John Piper. The first issue of the *Bulletin* was effectively a

catalog issue, but the second broadened its scope to cover the work displayed in Guggenheim Jeune and in the other Cork Street Gallery, the Mayor, at number 19, which had been started as early as 1925 at number 18 with an exhibition of thirty-one modern French paintings, including works by Dufy and Dufresne. In 1933 the publication by Faber & Faber of Herbert Read's seminal *Art Now* was linked with an exhibition at the Mayor that included work by Arp, Bacon, Baumeister, Braque, Dalí, Grosz, Hélion, Hitchens, Kandinsky, and Klee. Mayor showed Cocteau in 1935 and gave an exhibition of modern American abstracts in 1936. Freddy Mayor, born in 1903, can be said to be the first real pioneer of modern art dealership in England. In those days galleries of such daring specialization and such limited returns pooled their resources and backed one another up to survive. Peggy, though she arrived on the scene relatively early, was by no means a true pioneer.

The *Bulletin* ran to twenty issues, but was stopped in 1940 by the war. The war closed the galleries in Cork Street too, and of the three, only the Mayor is still there today. The final issue contained a call to arms published anonymously but written by Mesens, reflecting the spirit of an age in which freedom had to fight for survival:

NO dream is worse than the reality in which we live.
No reality is as good as our dreams.
The enemies of desire and hope have risen in
violence. They have grown among us, murdering,
oppressing and destroying. Now sick with their
poison we are threatened with extinction.
FIGHT
HITLER
AND HIS IDEOLOGY WHEREVER IT
APPEARS
WE MUST
His defeat is the indispensable prelude to the total
liberation of mankind.
Science and vision will persist beyond the squalor of
war and unveil a new world.

The clouds were gathering in 1938, and it was impossible to ignore them; but the present time offered a chance of renewal. Mesens got on well with

Mayor, and after his fling with Peggy he was to remain on good terms with her. In later life (he died in 1971) he would refer to her as "the old cathedral"—a phrase that satirized her *dogaressa* status in Venice in the closing years of her life, but the affair was as light an interlude for him as it was for her. Mesens, a bisexual who after the war indulged in an enjoyable ad hoc ménage à trois with his wife, Sybil, and the much younger singer and writer George Melly, always kept a copy of Peggy's unexpurgated 1946 edition memoirs on the top shelf of one of his bookcases. When he showed it to Melly, proud of his mention in it, he would at the same time admonish his young friend, "Don't tell Sybil," even though the fling with Peggy was long over before he met his wife.

Roland Penrose had augmented his own nascent collection through the intervention of Mesens in 1936. Mesens offered him the chance to buy a large section of a collection owned by the Belgian René Gaffé, which included "12 Cubist Picassos of a high order, including *Girl with a Mandolin*" (1910: now at MoMA, New York), 12 early de Chiricos and 12 good Mirós. "To my surprise," Penrose wrote, "Gaffé accepted my offer, which today would be considered derisory." The point here is that modern art was cheap to buy then—a good investment, except that the people buying, however rich they were (like Peggy and like Penrose, both enlightened heirs to large fortunes), weren't buying as investments but in aid of an ideal. Eminent artists whose pictures fetch fortunes today, from Le Douanier Rousseau to Mondrian, lived modestly and frequently died poor. There was no market for modern art: there was no investment value in modern art. Only Picasso, already grand, stood aloof. Peggy and he would cross swords on a couple of occasions. When she approached him through their mutual friend, the now forgotten artist Benno, to contribute to a collage exhibition at Guggenheim Jeune, he refused; later in Paris during the phony war he would treat her with contempt.

For Penrose, on the back of the Gaffé acquisition came another, even more spectacular purchase. In 1938 Paul Eluard needed hard currency badly. In his memoirs Penrose recalls:

> Eluard, always in need of more money than his writing could
> provide, made me the proposal that he should sell to me the
> entire collection which he had begun in 1921 when he bought
> from Max Ernst in Cologne his latest work, the great painting

now in the Tate, the *Elephant Célèbes*. There was only one condi-
tion, he said; there must be no discussion about money. He would
make out a list giving what he believed to be the market value of
each item and all I had to do was say 'yes' or 'no' and in either
case we would remain friends. As one looks at the list today, writ-
ten out by Eluard himself, it might seem that in accepting his
price I was swindling my best friend. Eluard wrote [translated
from the French]:

> *I, the undersigned Paul Eluard-Grindel, state that I have sold to*
> *Roland Penrose my collection of pictures and objects, this being 100*
> *pictures and objects among which; 6 Chirico, 10 Picasso, 40 Max*
> *Ernst, 8 Miró, 3 Tanguy, 4 Magritte, 3 Man Ray, 3 Dalí, 3 Arp, 1*
> *Klee, 1 Chagall and various other paintings and objects, all for the*
> *sum of £1,500, which will be paid on the 1st November at the latest.*
>
> *Roland Penrose agrees to take delivery of these pictures at his*
> *domicile.*
> *Paul Eluard the 27th June 1938*
> *54 rue Legendre, Paris.*

Years later Eluard tried to reacquire some of his collection, without suc-
cess. Prices had risen somewhat by then.

Penrose also used his money to promote artists, and he was not always well
repaid. Max Ernst, for whom he had a special admiration, had one-man shows
at the Mayor Gallery in 1933 and 1937. The latter show included Ernst's semi-
nal work *Fireside Angel*, foretelling the coming horror of war. Also in 1937
Penrose financed a luxury edition with the Cahiers d'Art, *Max Ernst: Oeuvres
de 1919 à 1936*. The year 1937 was a fateful one for Penrose. In Paris he went
with Ernst to a costume ball given by the Rochas sisters. The ball was notable
for two reasons: Ernst dyed his hair bright blue for the occasion (he would do
so again in different circumstances a few years later in Lisbon), and Penrose
met and immediately fell in love with a young, independent-spirited Ameri-
can photographer called Lee Miller, who had starred in Cocteau's 1931 "surre-
alist" film *Le Sang d'un poète*. Breton hated it, as did Miller's former boss, Man
Ray, and many other surrealists, who despised Cocteau.

As for Ernst, who met Peggy in London about now, he had given Penrose
lessons in painting. However, Penrose's first wife, the poet Valentine Boué,
recalled once overhearing Ernst talking to Eluard. Ernst said, "Roland is no

good as a painter and never will be." Eluard, a person of fundamental integrity, replied: "But why do you encourage him then?" Ernst answered cynically: "It is always good to have friends like Penrose—he has money."

Peggy would soon become closer to Ernst, with results that would bring both of them advantages as well as unhappiness.

In the summer of 1938 the New Burlington Galleries mounted an exhibition of modern German art, held in defiance of the Nazis' presentation of "Degenerate Art" (which included works by Ernst) in Munich the previous autumn. To the Nazis' irritation, two million Germans had gone to see and say goodbye to hundreds upon hundreds of works of art banished from museums and galleries because the new order deemed them subversive. Among the works were paintings by Franz Marc, who had died aged thirty-six at Verdun in 1916, and who had been awarded the Iron Cross.

The London exhibition helped Ernst's reputation in the West. At the time, although she was to include his work in exhibitions at Guggenheim Jeune, Peggy was more interested in her next one-man show, and its artist, Yves Tanguy.

Tanguy, born in 1900, was the son of a French naval official—he first saw the light of day in the Marine Ministry in Paris, where his family had an apartment. Throughout his life a quiet and secretive man, his first indirect association with the art world was through his friendship with Pierre Matisse, the son of the painter and later an eminent New York art dealer, whom he met at the Lycée Montaigne when they were both in their teens. Tanguy was expelled at fourteen for possession of ether. His career as a drinker started at about the same time, and although he could be gregarious and affectionate, alcohol brought out a violent streak in him.

He was proud of his Breton ancestry and spoke the Breton language, steeping himself in Brittany's culture and myths, but at eighteen he followed his father, three uncles, grandfather, and great-grandfather into a naval career by joining the merchant marine as an apprentice officer. He traveled the world, though later he seldom spoke of his experiences, even to his best friend, Marcel Duhamel, an actor and translator of American pulp fiction who would found the French *Série Noire* thriller imprint. His first wife, Jeannette, to whom he was still married at the time he met Peggy, is described as robust and plump, more jolly than pretty, a woman who loved a laugh and a drink.

It wasn't until 1925 that Tanguy began to paint. Duhamel, understanding Yves better than he did himself, encouraged him and bought him paints and canvas. Self-taught, he began to work. Then came his epiphany. The famous story is told of how, passing Paul Guillaume's Paris art gallery on a bus, he noticed a de Chirico, *Cerveau de l'enfant*, in the window, and was so impressed that he got off at the next stop and returned to look at it properly. It was a *coup de foudre*: He went home and immediately destroyed most of what he had done so far; he had found the direction he wanted.

His decisive moment came later in 1925, when, in the company of Duhamel and their friend Jacques Prévert, he was introduced by the poet Robert Desnos to André Breton. Tanguy was immediately impressed, and remained Breton's disciple from then on. On his part, Breton, in common with many others, was captivated by Tanguy's openness and charm. By 1930 Tanguy was a well-established member of the surrealist group, and beginning to hit his stride as an artist, inspired by the chiaroscuro on rock formations he'd seen that year in North Africa. But the following seven years, which saw very few sales, were lean and unhappy ones for him.

When Peggy was introduced to him in 1937 by Humphrey Jennings, who had proposed the exhibition, she was as charmed by the man as she was intrigued by his work. The prospect of a selling exhibition in London must have seemed like manna from heaven for the impoverished Tanguys. Peggy arranged to pick them up in Paris on her way back from Dijon with Beckett (they had quickly become reconciled, at least to the point of reestablishing friendship, after the awful night in the hotel), and take them to London with her. Leaving Beckett in Paris with mutual expressions of regret, she picked up Yves and Jeannette after a delay caused by her car's refusing to start, and then drove like the wind to catch the Boulogne ferry, which they did in the nick of time. It was the Tanguys' first time in England, and the extravagant and wealthy woman who escorted them turned their heads.

Settling the Tanguys with a London friend, Peggy set off for Yew Tree Cottage; she hadn't seen Pegeen or Debbie in five weeks. Hazel had taken up temporary residence there, looking after the girls in Peggy's absence, and the sisters spent the weekend dividing up an enormous chest of their mother's silver that had arrived from New York. As neither of them wanted any of it, they decided to sell it later and split the proceeds. After the weekend Peggy drove the two girls back to school in Wimbledon, and then returned to the center of London for the opening of the Tanguy exhibition on July 6, 1938. It

had been rather a rushed job: there was no catalogue and Yves himself had hung the pictures. But the show went well, and several pictures were sold. Peggy herself bought two for her own collection, including the important *Le Soleil dans son écrin* (*The Sun in Its Jewel Case*), painted the previous year.

The exhibition lasted ten days, a period punctuated by parties, often hosted by the rich and generous Penrose at his Hampstead house. At one of these, given by Mesens during Penrose's absence abroad, Peggy and Yves became better acquainted, and slipped off together to her flat, leaving Wyn Henderson to look after the unsuspecting (and drunken) Jeannette. After that trysts were harder to arrange, though Wyn was able to distract Jeannette for some afternoons.

Before returning to France, Yves and Jeannette spent a long weekend at Yew Tree Cottage. Hazel, whom Yves liked, and whom he nicknamed "Noisette," was asked to leave to make room for the new arrivals, but didn't seem to mind. Tanguy already suffered from a stomach ulcer, and the tension of the show now brought on a severe attack. Peggy had gone to some lengths in London before setting out for the country to find him the precise medicine he needed, which endeared her to him even more.

At Yew Tree Cottage, the atmosphere might have been tense had it not been for the children, with whom the Tanguys got along very well. Sindbad was staying for the summer, and Pegeen and Yves exchanged paintings they'd done. However, Jeannette was not blind to the fact that Peggy monopolized her husband's company; as they were in Peggy's debt, she said nothing, but her unhappiness led her to drink even more than usual. On one occasion she disappeared, and was nowhere to be found, until late in the day there was a telephone call from the landlord of a nearby pub, to say he had Peggy's girls' French governess drunk on his hands.

The exhibition—and Peggy's first season, for the gallery was to close for the summer, reopening in mid-October—ended with a drunken party on a boat cruising up and down the Thames. From everyone's point of view the visit and the exhibition had been a success. Tanguy's career was launched, and he had money—though he spent it, gave it, and even threw it away as soon as it reached his pocket; Peggy had a new lover; and Guggenheim Jeune had earned its spurs. Only Jeannette and the neglected Pegeen might feel aggrieved.

Peggy doted on Tanguy: "He had a lovely personality, modest and shy and as adorable as a child. He had little hair (what he had stood straight up from

his head when he was drunk, which was quite often) and beautiful little feet of which he was very proud." The only problem was surrealism, to which Tanguy seemed as single-mindedly devoted as Garman had been to communism; but it was easier to cope with, and Peggy was certainly more in sympathy with it. Yves also had engaging ways: for example, while in London he sent his fellow artist, the impoverished Victor Brauner, £1 a week to look after Yves's pet Manx cat: Everyone knew that most of the £1 was meant for Brauner, but Yves was too delicate to offend his friend with charity.

There were tears at Newhaven when the Tanguys set sail for Dieppe, but Peggy was already planning her next move. Pegeen now had to be sent off to Laurence in Megève, and as soon as she could, Peggy arranged to send Sindbad to Garman for a weekend. Peggy accompanied Pegeen to Paris, where Laurence's mother would put her on the Megève train. Meanwhile Peggy could arrange a tryst with Yves. Fearful of being seen together, they took a train to Rouen and thence to Dieppe, where, having missed the last boat, they spent the night in the best hotel, picking up Peggy's car in Newhaven, where she'd left it, the following day. They collected Sindbad and returned to Yew Tree Cottage, where they spent several days, during which Tanguy made an abstract drawing Peggy felt was a surrealist portrait of herself. Her description of it is worth noting: "It had a little feather in place of a tail, and eyes that looked like the china eyes of a doll when its head is broken and you can see inside."

The rural idyll didn't last long. The English countryside and Sindbad's adored game of cricket held few charms for Tanguy, who in any case was wondering what the effect of his disappearance might have been on his wife. The only person to see him and Peggy together in Paris had been the socialite and publisher Nancy Cunard, who was not likely to report back to Jeannette, but Tanguy had some sense of marital responsibility. There was another matter: Breton was returning to Paris from a lengthy lecture tour in Mexico, and Tanguy wanted to be at his master's side on his reappearance.

Peggy reluctantly took him back to Newhaven and once more put him on the ferry; but she had by no means given up on him. Returning to London via a visit to Hazel in Kent, where she was then living, she was surprised to find Beckett there, on his way to Dublin. Subsequently she invited him around to her apartment, where he noticed a photograph of her with Tanguy. She was due to pick up Sindbad and take him back to Paris to put him on the Megève train the next day, so she offered Beckett her apartment for as

long as he was in London. Having failed to persuade her to spend the night with him—she felt he only wanted to sleep with her because she was now with someone else, and in any case she was trying to make the transition from love to friendship—he reciprocated by offering her his Paris apartment, which she accepted, as it was well away from the center, in the fifteenth arrondissement, and had no telephone, ensuring her privacy.

After a mad dash through northern France, Peggy put Sindbad on his train in Paris with a minute to spare, and immediately went to meet Tanguy, with whom she had already arranged a rendezvous. They went to Beckett's flat and spent the night there. Tanguy was preoccupied and left the next day, after which Peggy heard nothing of him for forty-eight hours. When he returned he told her that he had attended a party at which there had been a horrible accident. In the course of a drunken fight, the painter Oscar Dominguez, a huge man who suffered from elephantiasis, had hurled a bottle at another guest. It had shattered, and one of the shards had struck Victor Brauner in the right eye, blinding it.

This meant canceling a holiday in Brittany they had planned. Then matters got worse. Lunching with Mary Reynolds, Peggy was horrified to see the Tanguys, who didn't notice them, take a table in another part of the restaurant. Mary suggested that Peggy should say hello, which she did, only to have Jeannette fling pieces of fish at her from her plate.

The whole thing was a mess. Both the Tanguys drank too much, and had terrible fights. Sometimes after them Jeannette disappeared for days. Peggy was not Yves's first mistress, and his infidelities hurt Jeannette terribly. Peggy wrote, "I really liked her and did not want to make her unhappy. I never meant to take her husband away from her." But it's hard to believe that she was sincere. In any case, Jeannette's jealousy now had a firm focus, since until the restaurant incident she'd had no idea that Peggy was in Paris. Then Beckett returned. He didn't want his apartment back, but borrowed Peggy's car to take Suzanne Deschevaux-Dumesnil on vacation to Brittany.

Meanwhile there had been a major rift among the surrealists that affected Tanguy profoundly: Breton had returned from Mexico to find that Eluard and several others had refused to follow Breton's lead in rejecting Stalinism. Ernst and Miró had long gone, having committed the sin of designing sets for Diaghilev; as had Artaud, Desnos, Masson, Prévert, and Queneau. Eluard had distanced himself from Breton's dictatorial stance, but now a rift was unavoidable. Tanguy's loyalties were divided, though in the end he was to

remain within Breton's camp. But it was the beginning of the end of the movement. Peggy herself, never in any sense an orthodox surrealist, was perfectly happy to sit at Breton's feet. She admired his loquacity and wasn't immune to his considerable charm. And if she wasn't jealous of Tanguy's devotion to him, it was because she realized that in Yves, despite her avowed intention of finding someone to replace her father, she had once again only found another son. For Breton's part, it wasn't unwelcome to have a rich American disciple among his entourage.

After losing his eye, Brauner managed to overcome his disability, and his painting became stronger.

Peggy arrived back in England from Paris, her affair with Tanguy unresolved (it would soon peter out), at about the same time as British prime minister Neville Chamberlain returned from Munich with what he hoped was a lasting peace agreement wrung from Hitler. The first exhibition of the new season at Guggenheim Jeune was of paintings by children—an idea borrowed from the French surrealists—but it attracted little attention. Attention of the moment was focused on an exhibition mounted by Penrose at the New Burlington Galleries of Picasso's *Guernica*. At least Peggy sold all the paintings exhibited that had been done by her daughter, now showing an interest in a career as an artist. There were several other paintings by the children of friends and acquaintances in the show, and buyers included Mesens and Penrose. Among the others shown were works by the poet Roy Campbell's daughter (he had married one of Garman's sisters) and by the young Lucian Freud. But it was a low-key start to the season.

In November she followed it with an exhibition of collages, *papiers collés*, and photomontages, largely organized by Penrose, in which heavier guns featured: There were works by Arp, Braque, Breton, Duchamp, Eluard, Ernst, Elsa von Freytag-Loringhoven, Gris, Jennings, Kandinsky, Mina Loy, Man Ray, Masson, Mesens, Miró, Penrose, Picabia, Picasso, Kurt Schwitters—and Laurence Vail (whose work was so obscene they had to hide it, she says), among others. This list indicates how widely Peggy was now able to cast her net, and of how, in the midst of the great and the good, she did not forget her friends and ex-husband.

Tanguy, now feeling better, visited briefly, and was generous with his newfound wealth. By now he and Peggy had settled for friendship. A new acquaintance, of almost equal importance, was the English sculptor Henry Moore. Soon afterward Peggy had a new lover, also a sculptor, to whom she

gave the pseudonym "Llewellyn" in her memoirs. This man has been identified with Henry Moore, among others, but there is not nearly enough evidence to be conclusive, and "Llewellyn," perhaps one of the many now-forgotten sculptors of the day, retains his anonymity.

Peggy went with Tanguy and Penrose to a dinner party given by Henry and Irina Moore. Peggy had earlier expressed an interest in Moore's work, but it had all been too large for her to give it houseroom. Now he showed her a series of miniature works, which pleased her so much that a few months later she bought a small bronze from him, *Reclining Figure*, the original of which is now lost.

Roland Penrose doesn't mention Peggy at all in his memoirs (he explains in his preface that he's decided to leave out people he disliked), but she has a good deal to say about him in hers.

In the first half of the 1930s, on the death of both his parents, heirs to a Quaker merchant bank, Penrose and his four brothers became seriously rich. In the second half of the 1930s, after many years in France, Penrose had returned to England, after he had fallen for Lee Miller at a party given by the Rochas sisters in Paris in 1937. Lee was married to an amiable Egyptian, Aziz Eloui Bey, and had gone to live with him in Cairo, though she found the dull way of life there stifling.

Penrose had parted from his first wife and returned to England the same year. Later in 1937 he borrowed his younger brother's house in Cornwall for a month in the summer. He'd invited several fellow surrealists to join him, among whom were Max Ernst, extricating himself from his second marriage and presently in love with the young English surrealist painter Leonora Carrington, twenty-six years his junior, whom he'd recently met in London; Man Ray and his girlfriend Ady, Paul and Nusch Eluard, and Lee Miller. During that month Eluard completed his poem *La Victoire de Guernica*, and Penrose and Lee Miller went to bed together. The affair caught fire, but Lee felt obliged to return to Aziz. The fire, however, wasn't that easily put out, and the following year the pair went on vacation to the Balkans together— Aziz was evidently an understanding spouse—with the same result. So that at the time Peggy met Roland, he was at an emotional crossroads. The girl he loved was in Cairo—but what could he do about it?

Roland's house in Downshire Hill, Hampstead, was filled with his collection of surrealist works. Peggy still had a stock of Tanguy paintings to sell.

They were going well, but there was one Peggy especially wanted Penrose to have. Peggy managed to sell him the piece, in the meantime the two of them became better acquainted, and it wasn't long before they went to bed together.

In the first (the 1946 Dial Press) edition, of her autobiography, she wrote: "He looked like a man of straw and he really seemed quite empty. His ex-wife had once said of him, 'He is a barn to which one could never set fire.' If he had no passion, he replaced it by charm and good taste. . . . [He] was a bad painter himself, but he was extremely attractive, quite good-looking, had great success with women and was always having affairs." In 1946 Penrose was hidden beneath the scarcely indecipherable pseudonym of "Wrenclose," and in the bowdlerized 1960 edition he is omitted. Peggy had much more to say about him, however:

> He had one eccentricity: when he slept with women he tied up their wrists with anything that was handy. Once he used my belt, but another time in his house he brought out a pair of ivory bracelets from the Sudan. They were attached with a chain and Penrose had a key to lock them. It was extremely uncomfortable to spend the night this way, but if you spent it with Penrose it was the only way.

Many years later, when Peggy wanted to reissue her autobiography, Penrose asked only that she omit the wounding words "[he] was a bad painter himself." He didn't care at all about the handcuffs, though he would grumble to his son Antony that "I only used an ordinary pair of police handcuffs—I can't think where she got her ideas about ivory bracelets."

Peggy encouraged Penrose to go after Lee. After the opening of the collage show, she gave a party at the Café Royal in London ("as was my habit," she grandly says). But then comes the unexpected and, in her, delightful gush of kindness:

> I remember suddenly, in the middle of dinner, urging Penrose to go to Egypt to get his ladylove. He was surprised and asked me why I took such an interest in his affairs. I said, "Because I like you so much I want you to be happy, and if you don't go and storm her gates she will never come." He was touched by my

interest and followed my advice and brought back the lady he
had been pining for [for] so long.

As for the handcuffs, they are a good example of Peggy's playfulness with
the truth. Penrose tells us in his memoir (published in 1981) that he set out
for Egypt early in 1939, on the pretext of joining an archaeological expedi-
tion. (It should be said that nowhere does he give Peggy the credit for
encouraging him to go after Lee, and the fact that he did not really like her
much seems undeniable.) However:

> For years I had had a habit of looking for amusing pieces of sen-
> timental jewellery, counting on the originality of the design
> rather than their market value. These I had offered to girl-
> friends, feeling that their acceptance was for me in some way the
> symbolic equivalent of an orgasm. On one occasion a jeweller
> produced an exact copy of a pair of handcuffs in gold, complete
> with keys and signed "Cartier." Armed with these and the illus-
> trated manuscript of *The Road Is Wider than Long*, [a com-
> pendium of *aperçus* in words and pictures by Penrose] bound in
> thick shoe leather and dedicated to Lee, I set off on my quest. She
> was not in Cairo but with Coptic friends in Assiout, where she
> greeted me warmly and said she found both presents thoroughly
> captivating.

As for the outcome, Penrose is discreet; but Aziz seems not to have been a
jealous man, and perhaps bowed to the inevitable. Lee joined Roland in
England in the summer of 1939.

That Roland may have had a passing interest in bondage is borne out by
the *Vogue* journalist Rosamond Bernier, who told Penrose's son Antony
many years later:

> There were a few whips around. I think that really it was he who
> wanted to be whipped. The French call this a very English thing,
> don't they? I remember that in 1947 I met Dylan Thomas, and
> when I said that I was living with the Penroses he said, "I won't
> have you tied up." Some girlfriend of his had been tied up in
> Roland's house. It was funny that Dylan, who was very hard

drinking and living, had quite a conventional attitude to that. I told him, "thanks, but I can look after myself." Then there was Peggy Guggenheim. . . . Roland said to me once, "I've decided to have a little fun with Peggy and tie her up."—He said it with a beaming smile, there was no malevolence in it.

After an exhibition of portrait masks and other objects by the now-forgotten artist Marie Vassilieff, the next show at Guggenheim Jeune was again in the nature of a surrealist-inspired experiment. Soon to be banished by Breton for "using Surrealism as a tool in their mutual Freudian analysis," as George Melly puts it in his memoir of Mesens, Dr. Grace Pailthorpe and her much younger lover Reuben Mednikoff put on a show involving the exploration of the artistic subconscious. Given generous publicity by the *London Bulletin*, these amateurish manifestations of "automatic" painting caused scarcely a ripple, and nothing sold.

Peggy was making new contacts, by virtue of Guggenheim Jeune's proximity to the London and the Mayor Galleries. She'd already met Max Ernst and exhibited his work. She had gotten to know Herbert Read and Roland Penrose, and her success in selling Tanguy had aided her reputation as a dealer—though nobody was making money at it. She could pass for an idealist along with her new colleagues, even if at bottom she did not share their dedication, for there was always in Peggy an element of detachment. Through Penrose again she met the surrealist Wolfgang Paalen and gave him a show in February and March. In the meantime she met Piet Mondrian, whom Mesens had included in a show at the London Gallery. (Léger and Miró, also new acquaintances, had had one-man shows at the Mayor the previous year.) Mondrian, in his sixty-seventh year in 1939, was very interested in nightclubs and dancing and jazz, rather to Peggy's astonishment. Tanguy reappeared with a present of a pair of handpainted earrings on a rose base. Peggy was so excited about them that she tried them on before the paint was dry, smudging one, so that Tanguy was obliged to repaint it, at Peggy's request on a blue base this time. Herbert Read later called them the most exquisite works Tanguy had done. Yves also designed a phallic motif for her cigarette lighter, which he had engraved by Dunhill. Unfortunately Peggy left the lighter in a taxi, and it has not been seen since.

A larger-than-life figure, a British jazz aficionado and painter called John Tunnard, had exhibited alongside Mondrian at the London. He wandered

into Peggy's gallery one day, dressed in broad checks, looking like Groucho Marx, with a portfolio under his arm. She liked the gouaches he showed her and decided to give him a show. Tunnard was in his late thirties when they met, and although he was not a true adherent of surrealism, his semiabstract landscapes and whirling biomorphic forms appealed to her. She gave him an exhibition from March to April 1939, buying one picture, *Psi*, at the time, and another a few years later in New York. At Guggenheim Jeune he sold quite well, but the high point was reached at the private view when, hearing a woman say, "Who is this John Tunnard?" he turned three somersaults in her direction and, arriving in front of her, bowed, and said, "I am John Tunnard."

"Llewellyn," the sculptor with whom Peggy had an affair around the end of 1938 and the beginning of 1939, supported the Republican cause in the Spanish Civil War, and Peggy joined in his efforts at fundraising, in particular in a mismanaged auction of works donated by well-known artists that achieved nothing like the prices they should have. Llewellyn was married, and their affair had to be kept secret from his wife. War work provided a good cover. The affair itself was desultory, and if Peggy can be believed both Llewellyn and his wife, a painter, came from old-established, upper-class English families, with a lot to lose if things went wrong. What started as a naughty weekend trip to Paris at a time when Llewellyn's wife was ill ended disastrously when Peggy became pregnant. Ignorant of this, Llewellyn invited Peggy to his family house. To her horror Peggy saw that the wife was also pregnant. Worse was to come: Soon afterward the wife miscarried. Knowing how much they had wanted a child, Peggy (again one can only take her word for it) offered him the child she was carrying. As she wrote later, "he refused it on the grounds that he could make a lot more."

Peggy then approached her physician, who respected her confidence but told her he could not take the risk of performing what was then an illegal operation. She turned to a German expatriate doctor living in London who told her that of course he would perform an abortion for her: She was too old for another child and it would in any case be dangerous to try, as she had not had one for fourteen years. This is only the second abortion Peggy admits to in her memoirs. Llewellyn neither visited her in the hospital nor did he offer to help pay for the operation.

* * *

By spring 1939 it had become clear to Peggy that Guggenheim Jeune was never going to make money. She'd lost £600 in the first year's trading—hardly a huge sum, and one she could well absorb, but the loss triggered a further ambition in her—to do something on a grander scale for modern art. In this she may have been stimulated by a desire to irritate Hilla von Rebay further, and she may also have been inspired to head Helena Rubinstein off at the pass. Rubinstein was then living in Berkeley Square and had a considerable collection of her own—though Penrose didn't think it an exceptional one. The sixty-eight-year-old self-made cosmetics millionairess brushed off all criticism: "I may not have quality, but I have quantity. Quality's nice, but quantity makes a show." Neverthless she had had the idea of establishing a museum devoted to modern art in London, with E. L. T. Mesens as its director, as a response to the founding of the Museum of Modern Art in New York in 1929.

Whatever the source of her inspiration, Peggy approached the art historian Herbert Read with a similar idea. He was at first resistant to it, as it seemed too insecure a project, and consulted friends, including T. S. Eliot, about Peggy's reliability. They responded positively, she won him over by the offer of a five-year contract as director; and accepted his request for a year's salary in advance, to give him the capital to buy enough shares in the publishing house of Routledge to become a partner—a move that would provide him with security if things went wrong. In exchange for this favor, he undertook not to go on salary until the museum was established. Their relationship, always friendly, remained strictly on a business footing. Peggy warmed to him as a father figure, though he was only five years her senior (she called him "Papa"), and he responded affectionately but cautiously to her charms. He was happily married to a wife who was very much aware of Peggy's reputation. But the fact that they never overstepped the bounds of friendship meant that their business association was a success for the short period that it lasted, and once convinced of the viability of the project, Read saw real possibilities in it, and became, if anything, even more enthusiastic about it than Peggy.

She persuaded him to resign as editor of the *Burlington Magazine* in order to work for her full-time. Wyn Henderson was brought aboard as "registrar." Their association was reported in the *Sunday Times* and the *Manchester Guardian* in late May 1939. Read had clear ideas about what the purpose of the museum should be and told the *Sunday Times*:

Peggy and Ernst arrive in New York after their exhausting flight from Lisbon, to be interviewed by reporters.

The surrealist gallery at Art of This Century. Frederick Kiesler sits on one of his biomorphic chairs in the left foreground.

Peggy operating the "peep-show," Art of This Century, 1942.

Kiesler's design for the surrealist gallery at Art of This Century, 1942.

Peggy with her large mobile by Alexander Calder.

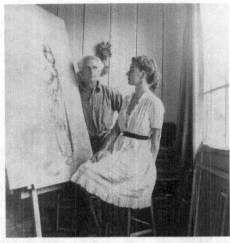

An uneasy relationship: Peggy and Pegeen in New York during the war.

Happier times for some: Max Ernst with his fourth wife, Dorothea Tanning, in Sedona, Arizona, in 1946. Dorothea was the love of his life (as he was of hers), and they stayed together until his death in 1976.

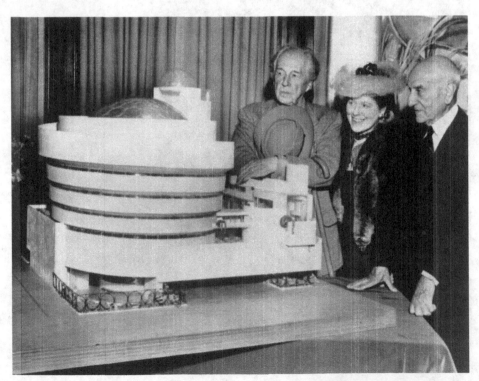

Frank Lloyd Wright next to his model of the famous Solomon R. Guggenheim Museum in New York. Next to him is Hilla Rebay, and next to her is Uncle Solomon himself.

Jacket design by Max Ernst (front) and Jackson Pollock (back) for *Out of This Century*, published by the Dial Press in 1946.

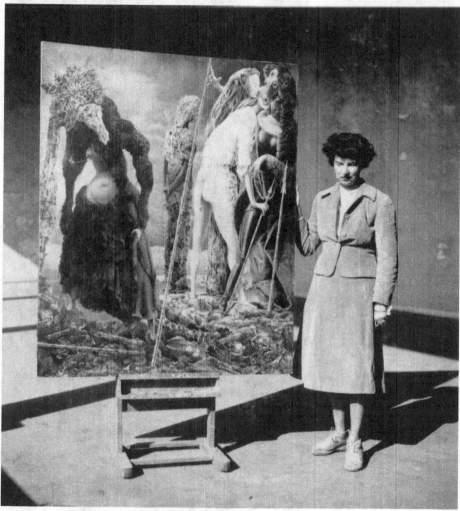

Peggy looking disconsolate next to her husband's autobiographical painting *The Antipope*. The monstrous horse-headed figure standing apart on the left is Ernst's presentation of Peggy—or at least of how he thought of her—at the time.

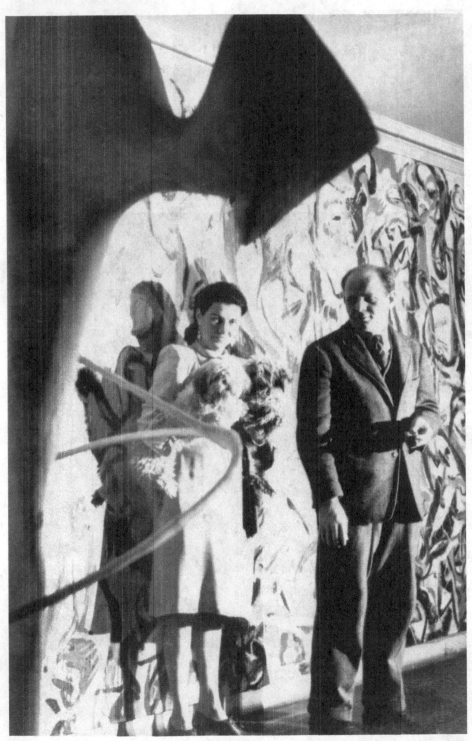

Jackson Pollock with Peggy in front of
the recently installed *Mural* at 155 East Sixty-first Street.

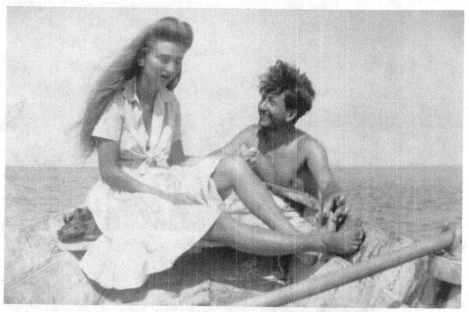

Pegeen and her first husband, the artist Jean Hélion,
on a boat off Long Island in the early 1950s.

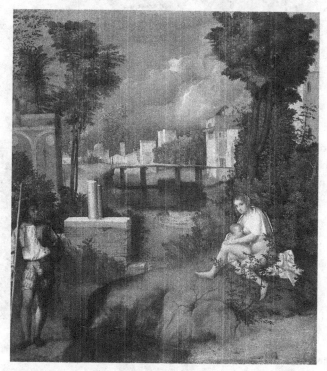

This, Peggy said, was her favorite painting in the world: Giorgione's *The Storm*,
painted in about 1505. It was purchased by the Accademia Gallery in Venice from
Prince Alberto Giovanelli in 1932, and remains there.

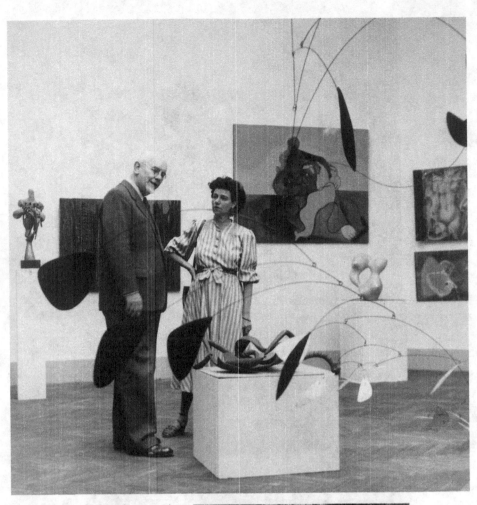

Lee Miller took this photograph
of Peggy with Lionello Venturi
at her pavilion at the Venice
Biennale in 1948.

Peggy on the steps of the Palazzo
Venier dei Leoni at the time of
the first exhibition of sculptures
in her garden.

the new museum, which according to present plans will open [in London] in the autumn, will not be limited in its scope by any narrow definition of modern art, though special attention is to be paid to those movements that have grown out of cubism. Nor will it necessarily confine itself to painting, but will aim at showing the interrelation of all the modern arts, including architecture, sculpture and music. The basis of its activities will be educational in the widest sense of the word. With this in view a permanent collection is to be formed as a background for temporary exhibitions of a special nature, as well as for a regular programme of lectures, recitals and concerts.

Read's reputation went before him, and the London and national press responded enthusiastically to the idea. Through the fact that advertising had picked up ideas from modern art, it was rapidly becoming more easily accepted, and there was also a question of national pride: If New York had a museum of modern art, why shouldn't London have one too?

Peggy earmarked $40,000 for the development of the museum. This was produced at some sacrifice, which is an early indication of the serious commitment she was beginning to make to her chosen cause. It wasn't that easy to raise the money without dipping into capital, a move her uncles would have resisted, and she was already paying several thousand dollars a year (some sources say $10,000) in stipends and allowances to a handful of artists, including Djuna Barnes, and as much as a further $15,000 for her children, and Laurence and Kay Vail. Although her own annual investment income, from the trusts set up as a result of Benjamin's and Florette's legacies, amounted to somewhere in the region of $40,000 (some sources say as much as $50,000), she cut down on her wardrobe, once her pride and joy, and exchanged her latest Delage for a more modest Talbot. Modern art may have been cheap relative to prices today, but it wasn't *that* cheap: And setting up a whole museum was a big undertaking, especially as everything was coming out of Peggy's pocket. But there were nonfinancial advantages.

Peggy knew that she could draw not only on the academic and highly regarded Read, but possibly on Penrose and certainly on Duchamp as well. She had also recently made the acquaintance of the widow of Mondrian's collaborator in the De Stijl group, Theo van Doesburg, who'd died young in

1931. Petra (Nelly) van Doesburg introduced herself to Peggy in late May 1938 at Guggenheim Jeune, and the two women became close friends from then on. Nelly would be an influence in the work for the new museum, but did not seriously come into her own as an adviser until later.

Naturally the project was not without its opponents. Mesens was annoyed that his plans with Rubinstein had been thrown awry, and Penrose commented that "if there had not been World War II, there would have been a war between Peggy and Helena." Djuna Barnes remarked that Peggy would pretty soon find herself in the position of sleeping partner and money provider only, while Read ran the show. Despite intervening disagreements and rows, Penrose ultimately decided that he wanted to be associated with the project. He wrote to Lee Miller on 15 April 1939:

> Peggy Guggenheim has been all honey to me and what she wants in return is that I should be one of the three big bugs on her selection committee. She is starting a Museum of Modern Art in London. Herbert Read is to be director and it is to be a grand effort to establish a "home" for art in this barbarous country. All very ambitious and lacking in funds—(I am not going in on that side).

The next task facing Peggy and Read was to find suitable premises. Several were considered and rejected, either because they were too cramped or because of fire regulations. Finally Peggy arranged with the wealthy art historian and collector Kenneth Clark to rent his London house in Portland Place. The grand house had room not only for the gallery but for Peggy to live on one floor and the Reads on another (to Peggy's slight annoyance: She didn't care for Mrs Read; the feeling was reciprocated, and there was bickering).

Peggy left for Paris in August to begin buying works for the new museum. She was armed with a list Read had prepared. This list is now lost—Peggy herself told the compiler of the catalog of her collection, Angelica Z. Rudenstine, that she believed it had gone missing during World War II, and no copy has been found in Read's papers. Rudenstine writes: "By the 1970s she [Peggy] was unable to recall a single specific work that had been on the list, and it has not been possible to reconstruct it." However, it may be possible partially to do so, though without academic certainty, from the pattern of Peggy's purchasing in the following months, though the original list

was subsequently altered and augmented by Duchamp and Nelly van Does-
burg. Peggy also remarked that she had to keep reminding Read to go no
farther back than 1910, the year on which he had decided as the cutoff point,
as it was approximately the time of the first abstract and cubist works—"but
every now and then he would relapse into Cézanne, Matisse or [Le
Douanier] Rousseau and other painters whom I thought we ought to omit."
Interviewed years later by Thomas Messer, she was, however, hazier on these
points, and especially on why she never included Matisse in her collection.

While Peggy was abroad, it became clear to her that war was indeed inevitable,
and although Read remained optimistic that they could continue despite this,
at the eleventh hour Peggy decided that the project should be postponed,
though she made the decision with great reluctance. If there had been no war,
London would now have another major art collection to its credit. But the war
would change many things, and after it was over, there was no possibility of
resuming the plan. The idea did not die, however. Mesens remained opposed
to it, since he always suspected Peggy of commercial motivation. Penrose's atti-
tude was more open minded, largely because of his respect for Read; but he
could also see that Read's enthusiasm prevented him from seeing how mis-
timed such a project was, given the imminence of war. The legacy of Peggy's
aborted plan, however, was the Institute of Contemporary Art, the major
academy founded by Read and Penrose in London nearly ten years later.

Once she had made her decision, Peggy settled with Read, paying him
half the salary for the five-year contract they had agreed upon, and thanked
her lucky stars that he hadn't yet signed any lease with the Clarks. She made
no offer to indemnify the Clarks for her late withdrawal (though Clark
asked for one in terms of a contribution to a fund for "artists in distress"),
since Clark was richer than she, and might still find someone to take his
house for the duration of the war.

All this happened while she was having, and recovering from, the abor-
tion resulting from her affair with "Llewellyn." At Guggenheim Jeune,
three shows followed the Tunnard. The last exhibition at the gallery was a
joint one showing works from the English printmaker Stanley Hayter's
New York–based graphics Studio 17, and paintings and other works by
Julian Trevelyan. The gallery closed its doors finally with a party on 22 June
1939, at which the photographer Gisèle Freund showed color slides (then a
very new technique) of a selection of modern works.

But the closing of Guggenheim Jeune and the abandoning of the museum project did not mean the end of Peggy's commitment to modern art. She decided to use the $40,000 set aside for the museum to purchase important works in France. She had some idea of how limited her time was, and she set about the task with renewed and ferocious energy.

Paris Again

\mathcal{P}eggy hadn't set out alone for France in August 1939. If her resolve in collecting ever wavered, Nelly van Doesburg was there to strengthen it, and Nelly was more aware than Peggy that if ever there was an advantageous time to buy modern art, this was it. Both women had faith in the artists from whom they were buying, and the venture was not speculative, because no one then had an inkling of how fast prices would rise after the war. In any case Peggy had not abandoned her idea of a museum. War might be imminent, but there was no reason to think it would last long.

Nelly's husband, Theo van Doesburg, had died in 1931, only three years before John Holms, so the two "widows" were drawn together by an understanding of each other's bereavement. Nelly frequently visited Yew Tree Cottage, and got along well with the children, for she was full of vitality. She invited Peggy to spend time with her in the house Theo had built at Meudon, on the southwest perimeter of Paris, but as Tanguy lived in Meudon too, Peggy did not accept. Since Tanguy's and Peggy's last meeting, his letters to her had grown rarer and more formal. He had separated from his wife and found a new mistress, the wealthy American artist Kay Sage, herself still married to an Italian nobleman, but in the process of disentanglement. Peggy believed that her affair with Tanguy was over but didn't like the idea of his having found someone else. Partly because she was still

unwell, exhausted by the abortion, the nervous strain she had put herself under as a result of winding up Guggenheim Jeune, and the negotiations for the new museum; and partly because she wished to avoid Tanguy, she decided, so she tells us, not to pay a visit to the English surrealist Gordon Onslow Ford, who had taken a château on the river Rhône near Bilignin for the summer. Ford had invited Tanguy, with the Chilean painter Matta, and Breton, with their wives, to spend a working summer vacation with him there, and Peggy's original intention had been to see if he would sell or lend her some of the pictures in his collection for the museum. In a letter to Virginia Dortch in 1982, Ford tells a different story:

> Tanguy, who at that moment was estranged from his wife Jeannette, was fancy free. His company was being sought by several ladies. Kay Sage and Peggy both expressed an interest in coming to visit. I suggested to Yves that to prevent complications, he should choose between them. He chose Kay Sage, and I had to write Peggy saying that unfortunately there was no more room at the château. She never quite forgave me.

At this point Nelly's suggestion that they travel down to the South of France together was extremely welcome. Peggy knew that she needed a break, and she was always happier when she had someone at her side when embarking on a new venture. Nelly was very knowledgeable about modern art, and had already made certain suggestions and emendations concerning Herbert Read's list. But first they would travel to the South.

They set off in the Talbot from Yew Tree Cottage in August, taking Sindbad with them, as he was going to join his sister and his father. Though she didn't know it at the time, Peggy would never live in England again. She allowed the sixteen-year-old Sindbad to drive the car through Normandy, and once in Paris put him on a train for Megève. In Paris, Peggy's health gave out and she felt unable to continue their journey immediately; while in the French capital she and Nelly did no research into the possibility of buying paintings. When Peggy was well enough, they drove down to Megève themselves, since Peggy had not yet seen the chalet in which Laurence and Kay had installed themselves with their children. Peggy was relieved to have Nelly with her, so that she could stay in a hotel and not have to sleep in the chalet—a prospect she was not comfortable with. She didn't find Megève an

inspiring place, and they left after a week. Though Kay and Laurence were hospitable, tensions between Peggy and Kay still simmered. It was an uncomfortable time for the Vails. Their youngest daughter, Clover, was born on March 29 that year, but cracks had already begun to appear in their relationship. Kay was firmer with Laurence than Peggy had ever been, but his drinking and his tantrums had begun to wear her out. In addition she was a hard worker; he was not. He resented her industry, and envied her output as a novelist. For her part, aged thirty-seven, frustrated at not having yet produced a son, and finding herself overwhelmed by the work of looking after four and sometimes six children, she cast around for some means of escape. In the process she fell in love with a handsome ski instructor ten years her junior, called Kurt Wick.

Peggy and Nelly continued their journey south to Grasse, where they spent some time staying with a Monsieur Sides, a businessman with an interest in modern art who had put on three exhibitions of abstract art with Nelly in Paris. From there they visited some of Peggy's old haunts on the coast, though Peggy was sad to see that the "bourgeois" people who now lived in her old home at Pramousquier had transformed it into a conventional "Midi home."

Luckily the old inn at Le Canadel was still intact, and Madame Octobon still ran it. As the Kandinskys were staying not far away in a grand hotel, Peggy looked them up and took them for a drive, showing them Madame Octobon's pension, and taking delight in the Kandinskys' astonishment at the thought of her staying in such a lowly place. The Kandinskys were not rich, and Peggy took spiteful pleasure in assuming that their choice of hotel had been dictated by Nina, whom she had never liked, probably because Nina drove a hard bargain over her husband's work. Peggy was always happy to live and travel cheaply if it meant saving money—unnecessary expenditure on such things was something she sought to avoid.

On August 23, 1939, Hitler and Stalin signed their nonaggression pact, and a week later Germany invaded Poland. Britain and France declared war on Germany on September 3. Poland fell, undefended by her allies, but in the meantime the streets of Grasse filled with soldiers. They were, however, in such a state of disorganization that Peggy wondered what the outcome would be if they were actually called upon to fight.

Peggy was already trying to settle her property affairs in London, a busi-

ness that entailed the sending of many telegrams to England, which was
tedious and involved a good deal of lining up in post offices. On one such line
a gay man just ahead of her, alive to the tense atmosphere, suddenly quipped:
"Dear me, the way everyone is acting anyone would think France was at
war." No one laughed, though. Peggy, unsure of what to do, allowed herself
to be advised by Laurence. He decided that for the time being they should all
stay together in France. Peggy had been thinking about taking Pegeen and
Sindbad back to England, but now dropped the idea. Laurence, for all his
wildness, was not without a sense of responsibility, and could keep his head
in a crisis. Significantly, Peggy could still defer to his judgment.

The war, however threatening, still seemed far away, and people clung to
the hope that it might after all never happen. Peggy now busied herself with
another scheme, which was to set up an artists' colony and haven in the South
for the duration of the hostilities. Nelly and she drove around, managing to
find gasoline by some miracle, looking for a suitable place to lease; but the
scheme came to nothing and may have been little more than displacement
activity. With hindsight, Peggy realized that it would have been quite impos-
sible for a group of highly individualistic artists to live together with any suc-
cess. Indeed, a similar colony had been set up by Albert Gleizes years earlier
at Sablons. Intended to be a self-sufficient community for artist-craftsmen, it
soon foundered. In 1934 he was writing to Hilla von Rebay offering a pack-
age deal of thirty large canvases for $200,000 in order to keep it going.

Rested and reenergized, Peggy now reverted to her original plan of buy-
ing pictures. She returned to Paris with Nelly and at last agreed to stay with
her at Meudon. Kay Sage, along with an increasing number of Americans
who could arrange and pay for their passage home, had already left for the
United States, leaving Tanguy, who was due to follow her once his papers
were in order, in her flat on the Île St.-Louis. Peggy quickly found herself
sidetracked by the need to aid a handful of old friends. She helped Tanguy
with his travel documents, only to find that he then suddenly disappeared—
she discovered that he had gone to spend his last few days in France with
Jeannette. Peggy and Jeannette buried the hatchet, and Peggy agreed to
Tanguy's entreaties to look after her. She bought a painting of his that she
had long wanted, *Palais promontoire*, from Jeannette, and undertook to pay
her in installments, which would ensure an income for her at least for a
while. Tanguy would never see Jeannette again. Alcohol, his departure, and
the war would all conspire to damage her mental state. She was finally com-

mitted to the psychiatric hospital of Sainte-Anne, where Tanguy and Kay Sage, by then married, managed to trace her after 1945. They continued to support her for the rest of their lives, though Tanguy never returned to France to live.

Peggy also took care of Djuna Barnes, who was adrift in Paris and drinking heavily, though Peggy's patience with her old friend and protégée was wearing thin. The previous February in London, she had rescued Barnes after a suicide attempt, though her choice of doctor—the same one who had attended John Holms at his death—would have panicked Djuna had she known. Djuna, as usual, was not grateful for Peggy's help, and in Paris the novelist's drinking and fatalism almost caused a permanent rift—as it was, Peggy cut off the allowance for a time, refusing to subsidize her alcoholism any more. But she managed to get Barnes onto the *Washington*, the same ship that was taking Tanguy to the United States, and she asked Tanguy to look after Djuna during the voyage—a measure, perhaps, of her desperation, since Tanguy, an alcoholic himself, was scarcely equal to the responsibility. Djuna safely arrived in New York, and was met by family and friends who took care of her. In 1950 she paid her last visit to Europe, and stopped drinking in the same year. She died in 1982, nearly three years after Peggy.

Meanwhile Peggy moved into the house of her old friend Mary Reynolds. Duchamp and Mary had left Paris for the South of France in September, and did not return until mid-December. By then the threat of an immediate German invasion appeared to have receded, and Mary had no desire to sit out the war in the provinces. Duchamp's return was fortunate for Peggy, since she was able to enlist his aid in her purchasing campaign, and he could help her track down works by the painter Jacques Villon (a half-brother of Marcel Duchamp) and by Marcel's late brother, the sculptor Raymond Duchamp-Villon, who had died in 1918.

For the time being, however, other friends returning to Paris after the initial panicky exodus occupied Peggy's time.

Her old friend Helen Fleischman, married to Giorgio Joyce, had had a mental breakdown. Peggy describes the situation vividly. Helen "was rushing around Paris with two blue Persian kittens which she took everywhere in order to attract attention. She was also having an affair with a house painter in the country, and also tried to seduce every man she met." Giorgio sought Peggy's help, and the possibility exists, though it is a slim one, that they may have had a brief affair, born of his desperation, for his main con-

cern was to gain custody of his child. Helen surprised him and Peggy in a restaurant and made a dreadful scene, which led Giorgio to the decision that he would have to have her committed, though Peggy implored him not to do so. Helen's condition worsened, however, and finally she was admitted to a sanatorium. Her brother came over from the United States to assess the situation, and as soon as her condition had become more stable, some months later, she was able to leave for the States. Peggy inherited the kittens, which in the interim had become rather smelly and neurotic cats, but she called one Giorgio, because it looked like Helen's husband. Both cats had been spayed, so the second was called "Sans Lendemain" (No Future).

Soon afterward she met Beckett again, who had returned to France from Ireland and would spend the war working for the Resistance. While he was visiting her one day, she fell downstairs in Mary's house and dislocated her knee. Nelly took her to the American Hospital, but the injury put her out of action for a few weeks, though she was well enough by the time Mary and Marcel Duchamp returned to Paris to find somewhere else to live—she managed to rent Kay Sage's old apartment on the Île St.-Louis—and to pay a Christmas visit to Megève.

She was delighted with her new apartment, though there wasn't enough wall space for many of her pictures, most of which were now in storage. By now she had begun to renew her acquaintance with some of the artists she had exhibited at Guggenheim Jeune, and some she had known in the old days. She had already bought a painting from Victor Brauner, whom she went to see with Tanguy before he left. Though she gave that painting to her doctor, who admired it, in part settlement of his bill, during the winter of 1939–40 she started at last to make the rounds of artists' studios and art dealers "to see what I could buy. Everyone knew that I was in the market for anything that I could lay my hands on. They chased after me, and came to my house with pictures. They even brought them to me in bed in the morning before I was up." Artists were very eager to sell. Younger ones were being drafted into the army. In the prevailing atmosphere, not many people were buying paintings and sculpture with any enthusiasm, the turnover at art galleries was slow, and although the Maginot Line looked strong enough to withstand any German invasion, it never hurt to be able to sell for a hard currency like the dollar. Otherwise the only arguable measure of an undercurrent of panic was the briskness of the diamond trade.

* * *

For the artists there was another element. Hitler had already expressed his own views on art, and in 1937 had made a speech attacking modern art, warning artists that they should represent only forms seen in nature in their work in an "unadulterated" way. Museums and galleries were stripped of any nineteenth- and twentieth-century art that did not conform to his ideas. Toward the end of the year in Munich, the exhibition of so-called Degenerate Art was held. Thirteen hundred artists were represented and reviled, including Ernst, Grosz, Dix, Metzinger, Baumeister, Schwitters, Picasso, Beckmann, Klee, and Kandinsky. Germany was to be purged of modern art. Luckily the Nazis did not burn the works on display after the exhibition (though many other works of art were burned) but sold them.

Many German dealers, and all the German Jewish dealers, had already moved their businesses outside Germany. Some of them returned to the auctions through which the Nazis now sought to convert the paintings they didn't want into hard currency. An important auction was held in Lucerne on June 30, 1939, featuring 126 works by artists including Braque, Picasso, van Gogh, Klee, and Matisse. Among the bidders were dealers from New York such as Pierre Matisse and Curt Valentin, who had recently left Berlin for New York and who had brought Joseph Pulitzer Jr. (in Europe on his honeymoon) with him. There were many other dealers and representatives of museums from around the world, ready both to save those pictures and to get astonishing bargains. Paintings were sold for Swiss francs, and at the end of the auction, with twenty-eight lots unsold, the proceeds amounted to 500,000 Swiss francs. The Germans converted this into sterling and deposited it in accounts controlled by them in London. Some of the prices were astonishingly low: A Max Beckmann went for $20; a Kandinsky for $100, a Klee for $300, and a Lehmbruck for $10.

Hilla von Rebay had attended the exhibition of "Degenerate Art" and saw the potential of buying some works, when they came onto the market, for Solomon Guggenheim's Museum of Non-Objective Painting. Through a dealer she bought six works by Kandinsky and one by Delaunay. Along with many museum directors, dealers, and private collectors from outside Germany, some of whom have already been mentioned, she believed that in making these purchases she was saving for posterity art that was otherwise in danger of being destroyed. But by making such purchases they were also handing hard currency over to the Nazi cause.

Somehow Peggy was spared involvement in this moral dilemma. No

record appears to exist in the admittedly sparse archive material that she ever shopped at any of the Nazi art auctions. On the face of it this seems strange. Perhaps it was simply that she was too busy doing other things at the time of the auctions to attend them or to send a representative. Peggy was not politically aware, and the full horror of what was to befall the Jews was still some way off.

Certainly she had enough to do in Paris in 1939 and 1940—so much so that some have accused her of profiteering. But it doesn't seem reasonable to suppose that she did so consciously. It was a buyer's market, and she was able to take advantage of that; of course she did not know that what she was buying would appreciate so much in a few years—or that it ever would. What was certain was that artists were beating a path to her door. Most of them were far from rich, and artists like Ernst and Mondrian were genuinely poor. Some artists were eager to leave despite the false lull of the "phony war," and almost all were keen to profit from the heiress with the open purse, eager, she said, to buy "a picture a day." Prices were low. Gabrielle Buffet-Picabia sold Peggy her ex-husband's 1915 *Very Rare Picture Upon the Earth* for $330, and his 1919 (some sources say 1916) *Child Carburetor*, which she subsequently sold in the States, for $200. Picabia himself would not have needed the money: He came from wealthy Cuban-French stock, and in his flamboyant lifetime went through 127 cars and seven yachts. At about the same time Peggy purchased André Masson's *The Armor* (1925) for $125.

Nelly van Doesburg was Peggy's principal guide in making purchases such as these, though the relationship was not tranquil. The two women quarreled seriously from time to time. Nelly criticized the catalog Peggy was compiling of her acquisitions, and didn't always agree with the choices that Peggy made.

Peggy had first met the Romanian sculptor Constantin Brancusi in the 1920s in Paris, where he had been living since 1904. Brancusi had traveled widely in the East, and was a devotee of the eleventh-century Tibetan mystic and poet, Milarepa. Peggy had for a long time wanted to buy one of his supremely elegant, simple biomorphic forms in bronze (he also worked in limestone and marble), but hitherto had not been able to afford one. Brancusi sold his works himself and had a keen sense of their value. Indeed, he was frequently disinclined to sell at all, regarding his sculptures with almost as much affection as if they had been his children.

The negotiations were to go on for months. First Peggy rekindled their acquaintance and cultivated the artist's friendship. He invited her to dine with him in his studio in a shabby cul-de-sac, where he char-grilled the food himself in the furnace he used by day to heat his tools and melt bronze. To accompany the meal he served cocktails prepared with the utmost care. At sixty-two, with blazing eyes and a patrician beard, he looked like a troll, or a gnome from the Transylvanian woodlands. And although he adored Peggy and called her "Pegitza," when it came to prices he drove a hard bargain. Peggy was after a recent piece, *Bird in Space*. Despite her turning the full force of her charm on him, he asked $4,000 for one of the bronze edition. Peggy was appalled at the price, refused to pay it, and they had an argument. She withdrew and considered other means of acquiring the piece. "Laurence suggested jokingly that I should marry Brancusi in order to inherit all his sculptures. I investigated the possibilities, but soon discovered that he had other ideas, and did not desire to have me as an heir. He would have preferred to sell me everything and then hide the money in his wooden shoes." Peggy herself, as everyone around her knew, "liked to stay close to her dollars," and parted reluctantly with each one.

During the standoff, Peggy managed to buy an early Brancusi bird bronze, a *Maiastra*, which the dress designer Paul Poiret and his wife Denise had bought in about 1912. Peggy now purchased it from Poiret's sister, Nicole Groult, to whom she was introduced by Gabrielle Buffet-Picabia. Poiret had separated from Denise, and Denise, needing money, had given the *Maiastra* to Nicole to sell. Peggy got it for $1,000, which she paid (profiting from the exchange rate) in French francs. She paid 50,000 francs for it; Poiret had paid 10,000 francs for it twenty-six years earlier.

This coup did not, however, put her off her campaign to obtain a *Bird in Space*. She therefore dispatched Nelly to see if she could mollify Brancusi. This she did, and the two parties were brought together once again. This time she agreed to a price of 200,000 francs—"and by buying them in New York I saved a thousand dollars on the exchange. Brancusi felt cheated but he accepted the money," Peggy notes, with satisfaction. When she drove by in the Talbot to collect it, the sculptor cried. By now the war had resumed in earnest, and the Germans were approaching Paris, where Brancusi would sit out the war.

Peggy continued her crusade while negotiations with Brancusi had been going on. In her quest for pictures, she only experienced one serious rebuff.

When she visited Picasso's Paris studio she found him already engaged in conversation with a group of Italian admirers. By 1940 Picasso's standing and ego were very great indeed. It is clear that he thought her a dilettante, a woman with money to spend who did not, however, take art seriously. He had heard of her energetic picture-buying activity, and did not like it—lacking immediate focus, it would have smacked of vulgarity to him. He deliberately ignored her for some time, until finally he turned to her and said: "Madame, you will find the lingerie department on the second floor."

Nelly drew Peggy's attention to the work of a young French artist, Jean Hélion, and she decided that she would like to buy one of his works. Hélion had been drafted into the army by that time, but was stationed at a barracks not far from Paris and was able to make a quick trip to the center of town to meet Peggy and Nelly to show them his paintings, which were stored all over the place in the houses and apartments of various friends. Peggy selected one, *The Chimney Sweep*, bought it for $225, and presented Hélion with a little anthology compiled by Herbert Read for use by soldiers, *The Knapsack*. Peggy was quite taken by Hélion, a handsome if slightly aloof young man in his early thirties, but imagined that this would be their first and last meeting. A handful of years later he was to become her son-in-law.

Gala Eluard had left her husband and had now married Salvador Dalí. Peggy, not especially keen on Dalí's work, had nevertheless dutifully decided to include him in her collection of surrealists and had already bought a small picture from a Paris dealer. The Dalís had retreated from Paris to the small Atlantic coastal town of Arcachon, to the southwest of Bordeaux, and when Gala came up to Paris on a visit, Mary Reynolds invited her to meet Peggy. Though the two women did not agree about approaches to art patronage— Gala's view was that it was best to devote oneself to the promotion of one artist, as she had now decided to do—Peggy bought *The Birth of Liquid Desires* from her, which is still in the collection. Peggy remarked that it "is horribly Dali." At about the same time she bought from Alberto Giacometti the first sculpture of his to be cast in bronze, the 1940 *Woman with Her Throat Cut*. He brought it to her in his arms.

In most cases during this period she bought directly from artists, though she bought two works from Duchamp, and nine from dealers. She also

bought five from Nelly, who needed the money: two by Theo van Doesburg, a Severini, Balla's *Abstract Speed + Sound,* and an El Lissitzky, for which Peggy paid $400.

In her endeavors Peggy found herself aided not only by Duchamp, who was busy creating a complete collection of his oeuvre in miniature to be presented in two limited editions displayed in a kind of briefcase—the *Boîte-en-Valise,* and by Nelly, but also by a man she already knew of slightly, who was to be one of her most important guides for several years to come.

Howard Putzel was a few weeks older than Peggy. He was a highly cultivated American whose tastes ranged from classical music to great literature. Although he spoke with a stammer, it left him when he quoted from *Finnegans Wake,* which he was able to do from memory and at great length. His principal interests, however, were modern abstract art and surrealism. He had introduced the latter art form to galleries on the West Coast of America in the first half of the 1930s, during which time he also made the acquaintance of Marcel Duchamp. He became director of the small Paul Elder Gallery, situated in the back of the bookshop of the same name in San Francisco, in the summer of 1934. A year later he was exhibiting works by Max Ernst in Los Angeles, where he had become director of the Stanley Rose Gallery. He went on to exhibit works by Miró, Tanguy, Dalí, and Masson. By mid-1936 he had founded his own gallery in LA, displaying remarkable determination: The new art was becoming better established, but the West Coast had developed nothing like the taste for it that was growing in New York. Putzel, however, had close ties with local collectors like Walter and Louise Arensberg, who had moved west some time earlier, and the film actor Edward G. Robinson. Having little business sense and attracting few buyers, Putzel closed his gallery at the end of the 1937–38 season. In the summer of 1938, he set off for Paris. He remained in Europe for two years, when he left for the United States.

He had already made contact with Peggy when she opened Guggenheim Jeune (which more or less coincided with the closure of the Putzel Gallery), sending her his good wishes and later lending her several Tanguys for exhibition. Peggy met him for the first time in Paris at Mary Reynolds's and found him quite different, physically at least, from what she'd imagined: "I had expected to meet a little black hunchback. Instead of this, he turned out

to be a big fat blond." Putzel had several physical disadvantages: He was near sighted, he suffered from epilepsy, and he had a weak heart. His stammer sometimes rendered him incoherent, and he often found it difficult to express himself properly anyway. He drank too much, and his homosexuality sometimes led him into deep water. But he had a brilliant eye for modern work, he was completely passionate about promoting it, and he had a sense of what would be appreciated long before it actually was. "He immediately took me in hand," Peggy writes, loving every minute, "and escorted me, or rather forced me to accompany him, to all the artists' studios in Paris."

Putzel caused Peggy to buy a number of pieces that she didn't want, but redressed the balance by drawing her attention to other works that she might not otherwise have discovered. Nelly and he disliked one another: They were rivals for influence over Peggy, and had divergent views on the relative value of surrealism and pure abstraction. Peggy cannily played them off against each other and profited from the opinions of both, since from her point of view each of these advisers was useful in the two schools she was principally interested in collecting. They complemented each other.

In the winter of 1938–39 Putzel introduced Peggy to Max Ernst. She hadn't met the German surrealist when he'd exhibited in London in 1937, but she knew his work and wanted to buy one of his pictures. Ernst, at forty-seven a good-looking, athletic man with a mane of white hair, an aquiline nose, and penetrating eyes, was very much aware of himself. He had recently left his second wife for Leonora Carrington, with whom he was now living. The meeting seems to have gone cordially enough, but Peggy didn't buy a picture by Ernst. Instead, she bought one by Leonora, *The Horses of Lord Candlestick*, a minor work she later gave to Sindbad. (It was one of the very few canvases her family would inherit.) Leonora was elated. It was her first sale.

Through Nelly, Peggy met Anton Pevsner early in 1940. The Russian sculptor had been working in Paris for several years by then, and Peggy was intrigued by his timidity, though she liked his work and bought *Surface Développable* on the spot for $500. The meeting was to throw incidental light on Duchamp's eccentric behavior: "Pevsner was an old friend of Marcel Duchamp, but had never met Mary Reynolds. We took her to Pevsner's for dinner, and when she told him she had been Marcel's mistress for over twenty years he just could not believe it. He did not even know of her existence, and he had seen Marcel every week of his life for as many years."

Peggy adds: "Pevsner conceived a great passion for me, but as he was mouse, not man, I did not in the least reciprocate this feeling. He behaved like a schoolboy in the spring."

By now both Sindbad and Pegeen were installed in schools in France—Sindbad at Annecy, and Pegeen at Maria Jolas's school at Neuilly on the outskirts of Paris. For Easter, Peggy took them both, plus a new schoolfriend of Pegeen's, Jacqueline Ventadour, to the Col da Voza to ski, collecting them from Laurence at Megève first. Pegeen hated to leave Megève, but Sindbad and Jacqueline got along well, and Peggy picked up an Italian at the hotel they were staying in, who took up the time she had on her hands while the children were skiing. On her return to Megève she had a fall, spraining her ankle and cutting her arm badly. But she drove back to Paris alone as soon as she'd had the local doctor patch her up, rather than stay a moment longer than she needed under the same roof as Kay Boyle Vail.

Apart from her pursuit of works of art, Peggy had also spent time during the early months of 1940 in the company of the composer Virgil Thomson, with whom she became friendly after attempting to seduce him, only to discover that he was gay. He wrote a musical portrait of Peggy, for which she posed, reading his *The State of Music* while she did; but on hearing the piece—a keyboard sonatina in three movements—she found it "not in the least resembling." It is unlikely that Virgil minded this; the two remained friends when they met again in New York later on in the war. In the meantime Virgil had his work cut out one evening, comforting Peggy after she'd had a rare row with Mary Reynolds. Peggy had postulated the possibility of obtaining a truck so that she could ship her collection away from Paris in the event of a German attack. Mary characteristically retorted that if any truck could be obtained, it had far better be used for saving refugees from German oppression. Fortunately the matter never had to be put to the test. Meanwhile Peggy continued to search out and purchase works of art with complete insouciance. If she had given any thought to the threat from Germany, she quickly put it out of her head again; and it is possible that, despite the ruin Hitler had wrought in Poland, she thought France and its capital would be left alone, and that the battles would be fought as they had been in World War I, in locations that would not affect life away from them. Early in the morning of April 9, 1940, German airborne troops landed at the Oslo airport of Fornebu and quickly surrounded the capital. On the same day, Peggy

walked into Fernand Léger's studio and bought his 1919 painting *Men in the City*. Léger was astonished at her sangfroid. On the following day she made a number of purchases from Man Ray.

But she didn't stop there. To the astonishment of many, she started to cast about for a suitable place to establish the museum she had had to abandon in London. On April 9—the same day she visited Léger—she saw an apartment, a grand place where the composer Frédéric Chopin had died, in the Place Vendôme, which seemed suitable, and soon afterward, despite the discouraging warnings of its owner about the advisability of her plan, she rented it.

The other matter Peggy had to take under consideration at this time was the unfriendly rivalry of her uncle's lieutenant, the Baroness Hilla von Rebay. Funded in 1939 with $3,000 from Solomon, the Solomon R. Guggenheim Foundation's representative in Paris, Yvanhoé Rambosson, had set up a Centre Guggenheim, to promote the "study and diffusion of non-objective painting." Progress was impeded by the gathering war clouds, but Rambosson's letters to Solomon and Rebay early in 1940 show less concern for interruptions from the Germans than for the risk that Peggy might steal the center's thunder. To Hilla he wrote in January: "You see, Mrs Peggy Guggenheim seems to want to play a leading role, which the similarity of the name would facilitate. . . . Now it is to be feared (I have become aware of this through certain artists whom she subsidizes) that she would wish to give the movement a different direction from the one it now takes." Admittedly Rambosson was also touting for more funds, or at least encouragement, since Hilla, preoccupied with the New York museum and concerned about her own future, given her German nationality, wasn't giving Paris her full attention. For good measure in March, Rambosson wrote in English to Solomon himself:

> I think that it is now the time for us to continue our action with more intense activity [than] ever, so as to be at the head of the movement as soon as the hostilities stop . . . other people certainly are thinking in the same way. . . . Mrs Peggy GUGGENHEIM, who last year wished to create in London a Center of Artistic Action, has decided to do it in Paris. . . . If we do nothing, it is she who would gather up here the whole result of our efforts and our activities.

Rambosson's concern was that Peggy, with her preference for surrealism, would subvert the pure cause of nonobjective art. Rebay's response to Peggy's "rivalry" was more balanced than her previous one had been. She wrote to Rambosson reassuringly on April 18: "I think Peggy Guggenheim is trying to ride on our fame. However, I believe it can do only good if she buys lots of paintings of the poor starving painters in times like this."

Oblivious to all this, at Nelly's prompting, Peggy hired the De Stijl artist Georges Vantongerloo to redesign the large apartment as a museum and living space. The apartment was full of fin-de-siècle plasterwork and murals, and the first job was to paint over the nineteenth-century decorations and chop off all the plaster cherubs. Soon, however, it became clear even to Peggy that Paris was not going to be the healthiest place for her to stay, and that her collection was hardly likely to be left alone by an invading force whose leaders would consider it "degenerate." She paid her landlord 20,000 francs indemnity—he had allowed all the draconian work to be done on trust, since they had not yet signed a lease—and looked around for a way of getting her pictures away. But she was not alone. Every museum and dealership was looking for ways of hiding and storing threatened works of art—all would be the potential subject of pillage or destruction by the Germans—and competition for space was keen. The dealer Paul Rosenberg managed to leave 162 works of art in a bank vault near Bordeaux, including paintings by Picasso, Braque, Monet, and Matisse; Georges Wildenstein stored 329 pieces in the Banque de France in Paris. Miriam de Rothschild buried a large part of her collection in the dunes at Dieppe but failed to mark the spot and thus lost the hoard forever. Maurice Lefebvre-Foinet successfully cached a number of Tanguys, Légers, and Ozenfants throughout the war in a secret place on the rue Dareau.

Léger suggested that the Musée du Louvre might give her a cubic meter of their allowance of storage space. She had all her pictures taken off their stretchers and rolled and packed, but then the Louvre told her that it did not consider her collection sufficiently important: They were too modern. "What they considered not worth saving," Peggy wrote in her memoirs with considerable vigor, "were a Kandinsky, several Klees and Picabias, a Cubist Braque, a Gris, a Léger, a Gleizes, a Marcoussis, a Delaunay, two futurists, a Severini, a Balla, a Van Doesburg, and a 'De Stijl' Mondrian. Among the Surrealist paintings were those of Miró, Max Ernst, Chirico, Tanguy, Dalí, Magritte and Brauner. The sculpture they had not even considered, though

it comprised works by Brancusi, Lipchitz, Laurens, Pevsner, Giacometti, Moore and Arp." Quite an indication of how busy she had been. It has been estimated that by the middle of 1940, Peggy had acquired about fifty works, of which thirty-seven are still in the collection.

Many years later, when the same museum begged her to mount an exhibition based on her collection, she accepted with considerable backhanded pleasure and great *hauteur*.

In the end her friend Maria Jolas, who was moving her bilingual school to a château she had rented at St.-Gérand-le-Puy, north of Vichy, offered to keep the collection in a barn on the estate. Peggy gratefully accepted and arranged for their transportation there—in itself no mean feat. Luckily the Germans only passed through the town, and her collection escaped unscathed.

Peggy was now free to leave Paris herself, but she had become involved with another lover, Bill Whidney, whom she could not bear to leave. Her life at the time conveys something of the hysteria of the moment:

> We used to sit in cafés and drink champagne. It is really incomprehensible now to think of our idiotic life, when there was so much misery surrounding us. Trains kept pouring into Paris with refugees in the direst misery and with bodies that had been machine-gunned en route. I can't imagine why I didn't go to the aid of all these unfortunate people. But I just didn't; instead I drank champagne with Bill. At the last minute my travelling permit expired, and when I tried to renew it I was refused a new one. I had a dream that I was trapped in Paris. When I found that I could not leave, I remembered my dream and was very scared. The Germans were getting nearer every minute. All my friends had left. Bill decided to stay, as his wife was too ill to be moved.

But she hadn't been so mentally paralyzed as not to have hoarded some cans of gasoline. The Talbot had a full tank, and on June 12, 1940—two days before the Germans entered the city—Peggy left Paris in her car, with Nelly and the two Persian cats for company. They drove in the direction of Megève. By that time there was no more need for any travel documents; the roads were jammed as two million people fled before the German advance. People were mostly heading southwest toward Bordeaux, where the free

government, which had moved to Tours, would find its last refuge before the country fell. Peggy was headed southeast, and soon found the roads easier, although from time to time she was warned not to proceed. The Italians had entered the war, and Megève wasn't far from the border. However, they completed the journey safely, and within a matter of days Peggy was reunited with her children.

Laurence decreed that they should stay where they were and await events. The panic on the roads was widespread, and the risk of losing each other or meeting with an accident was high. Communication with other parts of France, especially the Occupied Zone, became difficult but not impossible. Food, though much was soon being exported to Germany, was still available and not yet in short supply. Peggy and Nelly took a house for the summer on the shores of Lake Annecy at Veyrier, far enough away from Megève for Kay Boyle Vail to be at a safe distance, but close enough to be reunited fast if the need arose. Jean and Sophie Arp, who had fled Meudon, shared the house, and for immediate neighbors they had the Kuhns, an eccentric Franco-American family with whose son, Edgar, and daughter, Yvonne, Pegeen and Sindbad were soon respectively and painfully in love. Yvonne wasn't interested in Sindbad; but Pegeen lost her virginity to Edgar, who was, much later, to play a role in the life of another of Laurence's daughters, Kathe.

As for Laurence and Kay, their relationship continued to decline; by this time she had transferred her affections to another Austrian in place of Kurt Wick. This was the Baron Josef von und zu Franckenstein, also about ten years Kay's junior. At the outbreak of war, both men had been interned in a camp near Lyons. Wick would subsequently join the Foreign Legion. Franckenstein, an outspoken opponent of Nazism, would escape to the United States. Summer 1940, however, found him back at Megève, in love with Kay but believing her still to be in love with Kurt.

The children were growing up, and it wasn't easy. Laurence had thoughtlessly and tactlessly let Kay's daughter by Ernest Walsh, Bobby, know that he wasn't her real father; and this was followed by Laurence's mother sending her $5 for Christmas, while giving all the other children $10. Pegeen and Sindbad, now fifteen and seventeen, were sexually precocious, which gave Kay some cause for concern, while Laurence (whose relationship with his sister was always too close) seems to have been flirting again with the idea of incest, taking baths with his daughters and trying to interest them in the size

of his penis. It does not appear, however, that he ever took matters further than this. Laurence was always the kind of man who liked to think that he was living dangerously.

The Arps were appalled at Germany's warmongering. It was at this stage that Arp, who had been born in Alsace and christened Hans, now changed his name to Jean. Their plan was to escape to the United States. It was a plan many thousands shared.

Once she had settled down, Peggy seems to have had little else on her mind than embarking on another affair. At this point too the first real evidence appears of what was to become a lifelong foible: She would ask anyone, regardless of their age or the slightness of her acquaintance with them, detailed questions in a purring voice about their sex lives. An eccentricity apparently inherited from her maternal grandmother, it provoked embarrassment, amusement, or disgust, but even the prepubescent daughters of Laurence and Kay were not spared her enquiries, and later her granddaughters were to be equally embarrassed by them. What caused her to become so preoccupied with sex is an open question: But the fact remains that although she slept with many men, she was attractive to (and seriously attracted by) very few.

In the absence of any better temptation, and partly, as she tells us, because of a yen (inspired by rereading D. H. Lawrence) to "have a man who belonged to a lower class," she took up with a hairdresser in the little town. It started because out of boredom she had begun to experiment with having her hair dyed various colors—hardly an indication of any serious reflection on the state of the world at the time: But as we have seen, Peggy was not a reflective person, and throughout her life she was both hampered and protected by a kind of indomitable innocence. A cruel observer might say "lack of intelligence," but the truth lies somewhere between the two, and even then eludes precise definition; Peggy certainly possessed a willful ability to ignore what she did not find agreeable, just as she was able to ride roughshod over any objections to her taking any path she might choose.

She had her hair dyed by turns chestnut (close to her natural color) and bright orange, which amused Sindbad but made the wretched and acutely embarrassed Pegeen cry; after which she switched to deep black—a color she remained faithful to for many years to come. Pegeen, who was dragged to the salon every time Peggy needed a change and was then made to sit around for hours while the coiffeur fussed with his client's hair, and who herself was

made to succumb to a permanent wave, must have been relieved when Peggy tired of her newfound beau. However, her mother was still alive to the pleasures of sex, and cast her eyes around for a replacement immediately, even considering an amorous elderly local fisherman who reminded her of Brancusi.

She settled, however, on Mr. Kuhn's brother-in-law, a soldier who had already been taken prisoner by the Germans and escaped. The affair didn't get very far. Peggy invited him to dinner, and the following night he called again; but just as he was about to leave his sister came looking for him. He hid and slipped out the back way, while Madame Kuhn became hysterical and insisted on searching the whole house. The following day the brother-in-law met Peggy while she was swimming and informed her that they could not meet again. He was nervous and backed off when Peggy tried to talk him out of it. Later on Madame Kuhn came and told Peggy to watch out for her brother, who was a pimp. Peggy retorted that she was old enough to look after herself. The mystery was never cleared up, though Mr. Kuhn, whose hatred for his wife was reciprocated, sympathized with Peggy. Mr. Kuhn became a regular visitor to the house, and on one occasion sat intrigued while a twenty-five-year-old boyfriend of Nelly's, Sourou Migan Apithy, attempted to explain the position of black people in Europe and Africa. Apithy later would be twice president of Dahomey (Benin)—in 1958 and in 1964–65.

At the end of the summer Peggy moved to a hotel in Megève. The new authorities were becoming better organized. The fact that she had no valid travel papers meant that it was better to be close to the children. From now on she restricted her journeys as much as possible. At Megève she met Josef von Franckenstein. She knew who he was and what the situation was; and as he was in a state of complete confusion about Kay she found it an easy and sweet revenge to seduce him. This squalid episode led nowhere. The baron remained in love with Kay, though Peggy's behavior afforded Sindbad some bitter satisfaction, as he regarded Kay as having betrayed Laurence.

In early autumn Peggy got Giorgio Joyce, who was living nearby, to arrange for her collection to be brought by train from St.-Gérand to Annecy, the nearest town of any size. This he did, but when the consignment arrived at the station at Annecy, nobody thought to inform her. It was there for a week before Peggy was told, during which it mercifully came to no harm.

Then there was the question—which apparently hadn't occurred to Peggy before—of where to house them. She and Nelly covered the packing cases with protective tarpaulins while they deliberated.

Peggy was still determined to show the pictures and sculptures some-where—another example of her obduracy. Fortunately Nelly knew Pierre Andry-Farcy, the curator of the Musée de Grenoble. Grenoble was not unimaginably far to the south, and Nelly traveled down to see if he would help. Andry-Farcy liked modern art, and though he could give no firm promise to mount an exhibition—no easy feat even in the Unoccupied Zone so early in the war, for informers were multiplying in the wake of the col-lapse of France—he did undertake to store the collection, a far safer option than leaving them at the Annecy railway station. Between them they arranged the move, and Peggy traveled down to Grenoble, staying at the uncomfortable Hôtel Moderne with Nelly, to oversee the storage. It emerged that Andry-Farcy's enthusiasm for modern art was not matched by much knowledge of it, and his enthusiasm for Peggy never got beyond stroking her hand. Peggy found him charming, but as he was "a funny little man in his fifties," presumably he had little chance of wooing her successfully. Nev-ertheless he always arrived for dinner with Peggy and Nelly without his wife—and it transpired that he never passed their invitations on to her.

At about this time Peggy met the elderly Robert Delaunay and his wife Sonia. He came to Grenoble from where they were living in the South of France to show her a painting, *Disks*, which she had dithered about buying in Paris. Now she took it for $425. She also gave him Giorgio, one of the Per-sian cats. They smelled awful and didn't get along; but Delaunay loved cats, and Giorgio took to him at once. (Soon afterward Delaunay, who was grate-ful for the sale as he needed the money badly, became seriously ill. He died the following year. Giorgio was by his side.)

The threat of a German occupation of all France—or at least of a Vichy government that would have no independence at all—was growing stronger. Despite arguments at home over the pros and cons, it was clear that the United States would enter the war, and then an American passport would provide no protection, especially to a Jew. Under the Nuremberg laws, Pegeen and Sindbad would be equally at risk. The British blockade was beginning to take effect, and fuel, whether for transportation or heating, as well as fruit, was in short supply. The American consulate in Lyons had been

prompting them to leave for some time, and in the winter of 1940–41, Laurence decided that they had all better make their plans for departure.

Peggy also had the collection to consider. If she was going to the States, it was coming with her. She contacted the old-established Parisian firm of Lefebvre-Foinet, which had handled all the packing and shipping of works of art between Paris and London while she had been running Guggenheim Jeune. Communication wasn't easy: Paris was in the Occupied Zone, and ordinary letters between there and the Free Zone were censored, so communication of her real intentions had to be in code. Luckily her appeal for help was understood, and she received the good news from Lefebvre-Foinet that they would take charge of everything. There should be no problem in sending her collection to New York, provided that she included some domestic items with it so that it could be sent as "household goods" in order to circumvent new regulations. Physically, despite increasing restrictions on gasoline and the movement of anything, the job could be achieved with almost as much ease as if it were still peacetime.

René Lefebvre-Foinet came down to Grenoble personally to oversee the work, and over the next two months Peggy and he managed in quite a leisurely way to get everything packed into five large crates, together with piles of bed linen and blankets. For good measure, Peggy had her little Talbot shipped as well—she hadn't been able to use it for six months because of gasoline rationing and had stored it in a garage; the only trouble was that when the time came to fetch it, she couldn't remember at first which garage she'd left it in. René's brother Maurice recalled in 1973:

> While René was in Grenoble early in 1941, I took the opportunity to ask a German official in Paris about the possibility of re-exporting furniture to America. Our business on West Fifty-fifth Street in New York had closed, but René had decided to return to America, to Los Angeles. The Germans agreed to this and loaned me a truck, into which I loaded only two pieces of furniture. We were lucky enough to find another German to let the truck pass into the Unoccupied Zone.
>
> At the Musée de Grenoble, René packed his furniture and Peggy's collection in crates. He put these on the truck together with her luggage and the materials for Marcel Duchamp's series

Box in a Valise. . . . The truck went to Marseilles and René put everything disguised as household goods on a ship for New York.

Once everything had been arranged and Lefebvre-Foinet, who had become Peggy's lover for the period of their collaboration, had left, Peggy turned her full attention to arranging the departure of her family and friends. In the meantime she had made the necessary contacts, though she was leaving things until perilously late.

Intermezzo

The newspapers, reduced to two or at most four pages, carried column after column of classified advertisements in which people tried to reunite families scattered by the war and the retreat. The notices often reflected poignant and even tragic situations: "Mother seeks baby daughter, age two, lost on the road between Tours and Poitiers on the retreat," or, "Generous reward for information leading to the recovery of my son, Jacques, age ten, last seen at Bordeaux, June 17th."

VARIAN FRY,
Surrender on Demand

I was so unhappy I wanted to go back to England and get a war job, and I began trying for a British visa. This, of course, was practically impossible, so I got the idea of marrying an Englishman whom we had met on the train and with whom we had become very friendly. In this way I could have re-entered England. Fortunately, my Englishman disappeared,

but anyhow Laurence told me I had no right to abandon my children and that it was my duty to take them to America. I therefore gave up this mad project.

PEGGY GUGGENHEIM,
Out of This Century

Max and Another
Departure—
Marseilles and Lisbon

*a*German directive of September 27, 1940, forbade all Jews to return to the Occupied Zone. This was followed on October 3 by the Vichy government's first anti-Semitic statute, which aped the Nuremberg laws in banning French Jews from executive posts in the civil service, from holding military rank of any kind (they could not even serve as NCOs), from teaching, and from working for the radio, in the theater and film, and in the press. Foreign Jews could be arrested and interned in camps. There they could expect lice, hunger, and cold; filth and disease; and the unceasing attentions of fleas by day and bedbugs by night. Peggy's American passport would continue to protect her for a while, but the clouds were gathering fast. The Vichy government needed no prompting from its Nazi masters to pursue the Jews, though emigration, especially for Jews of foreign nationality, was the preferred means of getting rid of them. At the same time, under Article 19 of the Armistice Agreement between the Nazi and Vichy governments, the French were required to "surrender on demand" any subjects of Greater Germany—Germany and the territories it already occupied—sought by the Nazis.

There was a limit to the number of refugees any foreign country would take, and the Free Zone of France in 1940 was filled not only with refugee Jews but political exiles from Greater Germany. Among these were many

artists and writers, including Frenchmen and -women, most without means, all confused and frightened, and all looking for a way out. Marseilles was the principal port of "Free" France. Always a volatile, bustling, and cosmopolitan place, in 1940 and 1941 it was a melting pot. Apart from the hopeful refugees besieging the consulates for visas, the city was filled with soldiers waiting to be demobilized:

> There were men from every branch of the French army: colonials, with bright-red fezzes, or *chéchias*, on their heads; volunteers of the Foreign Legion, wearing their *képis* in dust covers; Zouaves, in baggy, Turkish-style trousers; Spahis, with broad black sashes around their waists; Alpine *chasseurs*, in olive green uniforms and enormous berets, worn well down over the left ear; dusty moles from the tunnels of the Maginot Line, in gray jumper [sweaters]; cavalry officers, smartly dressed in khaki tunics and doe-coloured riding breeches, and wearing rakish, brown velour caps instead of *képis* or helmets; the black Senegalese, their heads done up in turbans pinned together with a single gilt star; members of the tank corps, in padded leather helmets; and ordinary infantrymen by the tens of thousands, weary, dirty and bedraggled. All day long soldiers and refugees flowed to and from the Gare St. Charles, up and down the boulevard Dugommier and the Canebière, in and out of the cafés and restaurants of the Canebière and the Vieux Port, spilling into the streets, like crowds coming from a football game, packing the front and rear platforms of the street cars, pushing, shoving, jostling. But quiet—the living flotsam and jetsam left over from a great disaster.

These words were written by an American, the thirty-three-year-old Varian Fry—until lately one of the unsung heroes of World War II. At the time, U.S. quotas for refugees were severely restricted and an anti-involvement lobby led by Representative Martin Dies opposed official commitment under the slogan "America Out of Europe and Europe Out of America." The view was understandable. The United States was just emerging from a severe economic depression, and many nationals were frightened that foreigners, once allowed in, would compete for already scarce jobs or become dependent on

public funds. There was also a fear, whipped up by the popular press, that enemy spies would infiltrate the country posing as political refugees.

Not everyone in the States shared this insular view. Three days after the fall of France, at a fund-raising banquet held at the Commodore Hotel in New York and attended by Thomas Mann's daughter Erika, an unofficial Emergency Rescue Committee was formed. Its purpose was to rescue those intellectual and political refugees most wanted by the Germans. The committee was to be based in Marseilles, but it lacked a bureau chief. No one seemed willing to take on the job, so Harvard classics major Varian Fry stepped forward. He was inexperienced in secret work—"all I know of [it] is what I've seen in the movies"—however, he had been a stickler for social justice since boyhood, he spoke French fluently, knew Europe well, and was *au fait* with contemporary politics.

He flew to Europe on the Pan Am Clipper on April 4, 1940. That in itself was an adventure: The massive forty-one-ton flying boats had only entered transatlantic service the year before. With him he carried a list of two hundred names and $3,000 in cash. His brief was to assess the refugee situation and locate people to be helped. He took a room at the Hôtel Splendide, which became his headquarters, and his first sortie lasted until August 29. Word of his arrival spread quickly throughout the Unoccupied Zone, and to deal with the overwhelming demand for his help he recruited an international team of young people. Mistrusted by U.S. diplomats and consular staff in France as well as by the French authorities, he set up a cover organization, the *Centre Américain de Secours*, in rented office space, as soon as possible; he was helped by only two sympathetic American vice-consuls in Marseilles.

The problem, which arose almost immediately, was that demand for help far outstripped capacity to do so. Fry ignored the termination date for his first sortie, writing to his wife that it would be "criminally irresponsible" to leave then. In the event, he was to remain until September 5, 1941, when he was forcibly expelled, owing to the fury of the Vichy authorities; and he was let down because the U.S. consul refused to renew his passport. By then he had saved two thousand people. Alas, his marriage was to fail as a result: Eileen left him. A year after his return, she contracted lung cancer and died; despite their separation he nursed her to the last. After his moment of glory, Fry spent his life quietly in New York City, teaching classics, French, and history. He died in 1967, aged only fifty-nine, in virtual obscurity. France had awarded him the Légion d'Honneur on April 12 that year, but it wasn't until

1991 that he was posthumously awarded the Eisenhower Liberation Medal, and not until 1996 that he was accorded a place with the Righteous Among the Nations at Yad Vashem. Among those he saved were Hannah Arendt, André Breton and his family, Marc Chagall, Lion Feuchtwanger, Wifredo Lam (the black Cuban who was the only painter Picasso accepted as a pupil), Jacques Lipchitz, Golo Mann, Heinrich Mann, André Masson, Walter Mehring, Jacques Schiffrin, and Franz Werfel and his spouse Alma (who before being married to him had been the wife first of the composer Gustav Mahler and then the architect Walter Gropius, and the lover of the painter Oskar Kokoschka). Her only luggage as she crossed the border to Spain was a suitcase full of the manuscript scores of symphonies by Mahler and Bruckner. Others on Fry's list who did not make it included the German playwright Walter Hasenclever, who killed himself with Veronal at the internment camp of Les Milles as the German army approached, and the art critic Karl Einstein, who hanged himself at the Spanish border when he was refused entry.

Shortly before Fry's departure for Marseilles in 1940, the State Department authorized a limited number of temporary emergency visas, to be issued to people of exceptional merit who were otherwise in danger of persecution or death. However, despite the U.S. entry visas, he found that the Vichy authorities would not complement them with French exit visas. It was, however, still possible in those early days to obtain Spanish transit visas, and so Fry had to establish an illegal escape route out of France to neutral Spain, from where refugees might make their way via Spanish ports or the Portuguese capital, Lisbon (Portugal was also neutral), to the free world. An alternative route lay via North Africa, but it was more difficult: French bureaucracy made sea voyages harder to undertake, there was the risk of German naval patrols, and unscrupulous mariners would offer unseaworthy ships or boats for hire. A further complication, irrespective of the route chosen, lay in the bureaucratic minefield of securing visas, transit visas, and safe conducts: In the time it took to get one set of papers in order, another set, already acquired, would have expired. Jacqueline Ventadour remembers that "You couldn't get out of France without getting visas for Portugal, for Spain, and so on, and each country would say, we'll give you a visa if you get a visa for the next country. So: a Spanish visa, a Portuguese visa, a British visa [for Bermuda: one of the stops en route]—and by the time you got to the end of the collection the first one would be out of date so you'd have to start all

over again. Peggy and my mother and the others would always be rushing from one consulate to another and then meeting up at a café down at the port and comparing notes and discussing what to do next and so on." In the meantime, Peggy, whose energy was peaking, was involved in helping get documents for the artists she saw as being in her care.

To circumvent all the bureaucracy, Fry quickly learned how to break the law. He hired the Austrian dissident cartoonist (and expert forger) Bill Freier to "create" documents.

One of his other associates was the flamboyant American Mary Jayne Gold. "[She] was young, blond, and beautiful. Before the Germans had arrived, she had had a large apartment in Paris and her own low-wing monoplane, a de Havilland Vega Gull, in which she used to zip around Europe. She would fly to Switzerland for the skiing and to the Italian Riviera for the sun. When war broke out, she gave her plane to the French government."

Escape over the Pyrenees was preferred—it was far quicker, and the Spanish authorities, though sympathetic to the Nazis, were ready to be impressed by the U.S. visas, with their baronial stamps and large seals. A route across the mountains was pioneered by Alfred "Beamish" Hirschman and the German dissidents Lisa and Hans Fittko, near Cerbère, on the coast about 250 miles west of Marseilles, where there was a blind spot—the French and Spanish frontier posts were not within sight of each other. The only problem with this route was that older escapers, like Heinrich Mann, or those who were seriously unfit, like Franz Werfel, found the going very hard indeed.

Pressure piled up on the office in Marseilles to such an extent that Fry had to move out of town to a secret location that would provide a release from the crush of "clients," and give him time to arrange his resources and beg, borrow, or steal whatever extra money and visas he could to keep his operation going. He found the ideal place in the Villa Air-Bel, on the outskirts of Marseilles. It stood in its own grounds, a solid three-story block, with a pink-tiled roof and surrounded by plane trees. In the autumn of 1940 he wrote to his wife:

> I now live in a château about half a mile [some sources say half an *hour*] out, and none of my clients knows where . . . it has an incredible Mediterranean view from the terrace. Besides four

members of my staff, André Breton and Victor Serge [a middle-aged Bolshevik] and their wives live here. Breton is particular fun: I like Surrealists. The first night, for instance, he had a bottle full of Praying Mantises, which he released at dinner like so many pets.

There was no telephone at the château. Serge's "wife" was actually his companion, Laurette Séjouréu; the immediate associates were Dany Bénédite (with his wife and young son), Mary Jayne Gold (who contributed vastly from her own wealth, but who at the same time was a liability by virtue of her *amour fou* for a Foreign Legion deserter turned petty gangster), and Miriam Davenport, who had many contacts in the art world.

The Air-Bel operated not only as a refuge but as a salon for Breton. On Sunday afternoons, many of the disciples from the Paris days—Brauner, Dominguez, Lam, Masson, and Vollner among them—would assemble and make collages, or sit around drinking and singing in the dingy dining room. They would also play the game favored by the surrealists and similar to "Consequences," called *cadavres exquis*, named for an early contribution: "the exquisite corpse will drink the new wine," and a version of the Truth Game, which Breton ruled over with a rod of iron. They rechristened the villa *Espère-visa*.

While Peggy was in Grenoble she was contacted from the United States by Kay Sage, who asked her if she could pay the fares (and all associated expenses) to the States of five "artists." It isn't clear why Kay, a rich woman herself, could not do this, but Peggy was on the spot and knew, more or less, what needed to be done. However, when she cabled back to ask who the artists were, she received the reply that the party comprised André Breton and his wife, Jacqueline, and small daughter, Aube; Max Ernst; and Pierre Mabille, a surgeon who had associated himself closely with the surrealist group around Breton. Peggy accepted that Breton and Ernst were bona fide artists, and reluctantly agreed to pay the fares of Jacqueline and Aube, though she drew the line at Mabille. She had her own family to consider. Kay Boyle was negotiating travel documents and a steamer ticket for Baron Franckenstein. Nelly van Doesburg was unable to obtain a visa, and, despite Peggy's efforts, spent the war in France. She would not see Peggy again until 1946.

* * *

Peggy made her way to Marseilles and contacted Fry's organization, in which she quickly became involved, giving him money to facilitate the departure of Breton and his family—they sailed for the States via Martinique in March 1941. Once in the United States, Peggy would pay him a stipend to supplement what money he could earn during his enforced exile. In New York, Breton gathered his court around him and lived in as much isolation from America as possible. He boasted that he refused to learn one word of English, and in truth he learned very little.

Peggy says that on her first visit to Marseilles she became so closely associated with the Emergency Rescue Committee that Fry asked her to run it briefly while he made a flying return visit to the States, but that she was scared of the wheeling and dealing necessary to circumvent the German and Vichy bureaucracies. In his memoirs, however, Fry makes no mention of this, and Peggy only makes a half-remembered appearance as a brief guest at the Villa Air-Bel, once Max Ernst was in residence there.

Ernst's position was complicated. Persona non grata in Germany, he had lived in France for years, but never taken up French citizenship as he had been advised to; with the outbreak of war he had become an enemy alien, and hence interned.

He'd moved with Leonora Carrington from Paris to the South of France in 1938, buying a derelict farmhouse at St. Martin-d'Ardèche, a village about thirty miles northwest of Avignon. Relatively poor—Max's only patrons were Paul Eluard and Joë Bousquet—they set about renovating the place, and Max decorated it with fantastic cement sculptures. For a time, much to Leonora's irritation, he also shuttled to and from Paris in an attempt to appease his second wife, Marie-Berthe Aurenche, whom he'd divorced in 1936. Leonora, meanwhile, continued to paint and discovered within herself a talent for writing.

When the war came Max was first imprisoned at Largentière, then transferred to the internment camp at Les Milles, near Aix-en-Provence, where he shared a cell-like room with his compatriot, the painter Hans Bellmer. Les Milles was a former brick factory, and Bellmer painted Max's portrait there, with a face made of bricks. Both men drew constantly to take their minds off their hunger. At Largentière, Max had done a landscape of the place at the commandant's request—Leonora had brought him paint and canvas—but offended the Frenchman because it was so unflattering. Luck-

ily Max had many influential and loyal French friends, who managed to secure his release, with Leonora's help, by Christmas. He returned to St.-Martin and an increasingly frantic Leonora, but his freedom was short-lived. In the spring he was denounced and imprisoned once again—the start of a series of frightening episodes, during which the threat of transportation to French North Africa to work on the trans-Sahara railway line raised its head. Max escaped, was recaptured, and escaped again. He returned to St.-Martin to a horrible discovery: In his absence Leonora had had a nervous breakdown, allowed herself to be persuaded to sell their house to a local businessman (the villagers had always regarded the pair of foreign artists with suspicion and mistrust) for a bottle of brandy, and vanished. At this bleak time he embarked on one of his greatest paintings: *Europe After the Rain 2*. The day before his departure from the village the local postman arrived with a selection of calendars for the new year. Max chose a landscape. The postman begged him to take one with a portrait of Maréchal Pétain—"nobody wants him."

Friends in the States, including Alfred Barr, Jr., of the Museum of Modern Art and his wife, Marga, and Max's son by his first wife, Ulrich (Jimmy), who'd managed to leave Germany in 1938, had arranged an affidavit guaranteeing Max's acceptance in the United States provided he could get out of France. As America was not yet at war, lines of communication were still open, though difficult, and Max had made his way to Marseilles to arrange his escape. Although Ernst has a reputation for treating his women badly, he did not forget his responsibility to his former wives. His second, Marie-Berthe, came from a rich family. She would spend the war in relative safety, though she became a religious maniac, never got over Max's departure, and died in Paris after the end of the hostilities. Max's first wife, Louise (Luise), was a Jew, and therefore in serious peril. She had managed to leave Paris in 1933—long after she and Max had separated—but she did not escape the Nazis and ended her days in the concentration camp at Auschwitz.

In 1966 Max had his seventy-fifth birthday, and the authorities in his home town of Brühl near Cologne wanted to make him an honorary citizen. However, an article by Georg Jappe in the *Kölner-Stadt-Anzeiger* written at the time accused Ernst of having abandoned Louise. Max replied to the accusation in a letter published by the *Anzeiger* on April 21, 1966. In it he stated that at the end of 1940 he heard from the American vice-consul, Harry Bingham (one of the few officials sympathetic to Fry's bureau), that an entry visa

had been authorized for him and his "wife" Louise. At the time he had been separated from Lou for fourteen years, and had had no word of her since the outbreak of war. Bingham suggested that in order to avoid further red tape, Ernst could remarry Lou. Ernst was willing to do this, but when he met Lou in Marseilles in 1941 and put the proposition to her, she turned it down. Ernst took her to see Fry, who tried to persuade her to change her mind, without success. It is important to establish that Ernst, like Tanguy, did not simply abandon ex-wives to their fate.

At this time Max was still very much in love with Leonora Carrington. The daughter of a wealthy Lancashire textile manufacturer, she studied art under Ozenfant in London, as well as being influenced by Tibetan Buddhism and the French mystic and explorer in Tibet, Alexandra David-Neel. Panicked by the advice of visiting friends, she had sold the farmhouse at St.-Martin at a time when she felt alone and without hope of seeing Max again, despite her efforts to have him released. She was also terrified of the German advance, so, with the friends, she traveled to Madrid, her influential father having secured travel documents for them. There, however, her mental collapse worsened. She stood outside the British Embassy threatening to assassinate Hitler—hardly a symptom of insanity—but was committed as a result to an asylum in Santander, where she was dosed with cardiazol and restrained by being strapped to her bed, experiences she recounts in her expressionistic autobiographical novella *Notes from Down Below*. She was encouraged to write the memoir by Breton and Pierre Mabille after her release, and as a consequence of having actually experienced insanity she became a major surrealist icon. The attention they paid her was a source of irritation to Peggy—but only a mild one: It might have been worse if Leonora had elected to spend the war years in New York.

Leonora was saved from the asylum of her former nanny from England, who arrived by submarine (Leonora simply says "a warship"—but the weight of her father's influence can be appreciated either way). Refusing to return to England, she went back to Madrid, where she renewed her acquaintance with a Mexican journalist, diplomat, and bullfight aficionado called Renato Leduc, whom she'd first met at Picasso's studio in Paris. Like Ernst, he was nut brown and athletic, with long white hair. He would turn out to be her savior—they later married, and although the marriage did not last long, they parted amicably; she remarried, happily, and had two sons.

With Renato she made her escape from Europe and traveled to New York by sea, taking some of Ernst's paintings with her to deliver to his dealer. She and Renato later went to Mexico, where Leonora still lives. She was generous about her rival for Max's affections in an interview she gave in the late 1980s: "I felt there was something very wrong in Max's being with Peggy. I knew he didn't love Peggy, and I still have this very puritanical streak, that you mustn't be with anyone you don't love. But Peggy is very maligned. She was rather a noble person, generous, and she never ever was unpleasant. She offered to pay for my airplane to New York, so I could go with them. But I didn't want that. I was with Renato, and eventually, we went by boat."

Peggy was less generous: So far from subscribing to the surrealist ideal of the child-woman, she compared Max and Leonora to Little Nell and her grandfather in *The Old Curiosity Shop*. She later also acknowledged that Max's love for Leonora always surpassed whatever feelings he had for her. But Peggy fell for Max, and, as always, wanted to write the script. Disagreeable realities, such as Max's own lack of love for her, had either to be ignored or steamrollered. His self-centeredness and fear, and her sensitivity despite herself, muddied the water.

Upon her return to Grenoble after her first visit to Marseilles, Peggy sought the advice of Laurence, and René Lefebvre-Foinet, about the request Kay Sage had made. Both men thought that if she was going to finance Ernst's escape, she had every right to ask him for at least one painting in exchange for the favor. Peggy had not seen Ernst since Putzel had introduced them in Paris nearly two years earlier, but as Ernst was now a resident at the Villa Air-Bel, she wrote to him there with the proposal.

He replied accepting it and sending a photograph of the painting he wanted to let her have. She wasn't all that enthusiastic, and a correspondence ensued, in the course of which he enlisted her aid in ratifying a valuation of the work left at St.-Martin, which were mainly sculptures—Ernst had managed to remove most of the paintings. Through their exchange of letters and from other sources Peggy learned the whole Leonora Carrington story, and was intrigued by it.

She arrived in Marseilles for the second time on March 31, 1941; in time to help celebrate Ernst's fiftieth birthday on April 2. She was met at the station by Victor Brauner who, as a Romanian national and a Jew, was having great difficulty in obtaining a visa—and would fail to do so entirely, despite all

efforts to help him—though he would spend the war in relative safety tucked away in a remote Pyrenean village.

On the evening of her arrival she went with Brauner to meet Max at a café, and made a date to come the next day to the Air-Bel where Max was staying—cutting a dash in a white sheepskin coat which offset his dark reddish tan and bright blue eyes—to look at the pictures he had there, which he had used to decorate the villa. To Ernst's dismay, Peggy preferred his older work to his more recent paintings, but while she was candid about her likes and dislikes, she was enthusiastic enough about the former to offer him $2,000, minus the cost of his fare to the United States, in exchange for which he would let her have a large number of his pictures. Brauner dug out a series of collages he told Peggy were of historic interest, and Max generously waved them through as well. He was getting what was for the time a large lump sum, necessary to start him off on his new life in the States, and she was getting an undreamed-of bargain, though she didn't know it yet. Max wasn't selling well. Only a few years earlier he had sold a stack of pictures to the café owner and art patroness "Mutter Ey" for $20 apiece. In the 1960s, just one of them was bought by a German gallery for $250,000.

Peggy, although she had turned down recent paintings such as *Europe After the Rain 2* and *Fascinating Cypresses*, acquired other brilliant works: *Little Machine Constructed by Minimax Dadamax in Person, Airplane Trap*, and *Le Facteur Cheval*—this last a collage in homage to the rural postman Joseph-Ferdinand Cheval, who between 1879 and 1912 built an extraordinary dream palace, the *Palais Idéal*, at his home in Hauterives, deep in the countryside midway between Vienne and Romans. The building, actually a massive piece of sculpture, was greatly admired by the surrealists. When *Le Facteur Cheval* was displayed in the Tate Gallery exhibition of Peggy's collection in the mid-1960s, its title was mistakenly translated as *The Postman Horse*.

Peggy and Max celebrated the deal with a bottle of wine Max had brought from his vineyard at St.-Martin, and he invited her to join his birthday celebration at a seafood restaurant in the Vieux Port the following day. Later Max's New York dealer for some years, Julien Levy, reported that Max had resented Peggy's purchase of his works—but this was with hindsight.

On the morning of April 2 Peggy met René Lefevbre-Foinet, who'd traveled down by train. She asked him if he'd be willing to go up to St.-Martin to

rescue the remaining Ernst paintings there, but he, exhausted, balked at the idea. For once Peggy did not insist: She even took pity on him and, although he was supposed to return to Grenoble again that evening, having made arrangements for transporting the Ernsts she had bought, she let him spend the night with her. He had after all spent the previous night standing in the corridor of a crowded train painfully covering the 140-odd miles between Grenoble and Marseilles.

By now Peggy had already developed an attraction for Max Ernst, which he, always ready to respond to an overture from a woman, reciprocated. At his party he asked her dramatically, "When, where and why shall I meet you?"—and she replied practically: "Tomorrow at four in the Café de la Paix, and you know why." At this time there was no hint of Max's continuing love for Leonora, and the new affair lasted in its first phase for ten days—until Peggy had to go up to Megève to join Laurence and the children for Easter. By now she had forged a new date on her expired travel documents in order to be able to continue to use them, and indeed, combined with an American passport and a good deal of assurance and charm, she got away with it.

Max saw her off at the station and apparently wept to see her go, promising to follow her to Megève if he could. He had given her copies of his collage books, one of which, she noticed, had been inscribed to Leonora: "To Leonora real, beautiful and naked." Peggy would not forget this inscription. Later on the best she would get from him written in a book was: "To Peggy Guggenheim from Max Ernst," and at no point in their entire relationship— they communicated for the most part in French—did he ever depart from the formal *vous* for the intimate *tu*.

But these discoveries still lay in the future. For the present she stopped off at Grenoble for a night to explain to René Lefebvre-Foinet about her feelings for Max, and then went on to join Laurence, Kay Boyle, from whom Laurence was growing farther and farther apart, and the assortment of children gathered around them. On the way she read Leonora's novellas, which Max had given her, for which he had done the illustrations. She enjoyed them, and wrote to her new lover to tell him so. Max was someone about whom she could really get serious. He was handsome, assured, and highly regarded by Breton and the leading surrealists. But at Megève Peggy waited in vain for news from Max, and became more and more unhappy.

There was enough tension between Kay and Laurence, and Kay and

Peggy, to make her stay uncomfortable even without the added complication of Max. Laurence continued to mope, ostentatiously, over the death nearly six years before of his sister Clotilde. Kay was obsessed by money, and her obsession was partly linked to her antipathy for Peggy. The two women continued to be rivals—Kay resented the fact that Peggy still paid them an allowance, and resented the fact that they needed it; Peggy made matters worse by constantly checking up on their financial affairs. Kay retaliated by announcing that John Holms had found her so attractive that he'd once pursued her into the ladies' lavatory of a restaurant. This assertion can be taken with a pinch of salt, as she related the same story about the English publisher Jonathan Cape, who, she also later asserted, had boasted of committing necrophilia with his wife's corpse. The rivalry between the women found its sharpest expression, however, over Pegeen and Sindbad. In Sindbad's later opinion, both of them "were bitches." For all her faults Kay's maternal instincts were stronger than Peggy's—though a less pleasant interpretation might be that she knew how to *play* maternal in order to manipulate the children's loyalties. Her daughters found Peggy self-centered and vain. Peggy, however, was financing everyone's (except Franckenstein's) escape from France: She drew the maximum permissible per person from the Banque de France in Marseilles, $550 each. Laurence's mother would later reimburse her for the expenses incurred by Laurence, Kay, Bobby, Apple, Kathe, and Clover.

While Peggy and Laurence planned their departure, Kay concerned herself with arranging the escape of Baron Franckenstein, and with reserving ten places on the Lisbon-to-New York flying boat. Kay had moved to Cassis to be with Franckenstein, leaving her three older daughters in Megève. They felt abandoned and ignored but continued in their unrequited love for their mother. Laurence had not wanted Kay to leave. In her absence he turned his attention to his daughters, and his self-pity made him unduly amorous toward them, which provided a further source of anxiety.

Peggy and Laurence first went to the U.S. consulate in Lyons to obtain visas for everyone: The traveling party at that point consisted of the two of them and Kay, Sindbad and Pegeen, and the four Vail-Boyle daughters. The extra seat on the Pan Am Clipper Kay hoped to give to Franckenstein; Peggy quietly hoped that fate might decree that it should go to Max, for Laurence simply would not tolerate traveling with Kay's new lover. Poor Victor Brauner, who had followed Peggy around incessantly in Marseilles in the

hope of her patronage, didn't qualify anyway on account of his incomplete set of papers, but in the meantime Max's U.S. visa had expired and had to be renewed, and Laurence had no internal travel documents. There was still a welter of red tape to unravel or cut through. Again American passports worked wonders in getting to the front of lines and cutting the time taken to get things done. In the meantime they were joined by Jacqueline Ventadour, Pegeen's friend from the Maria Jolas school, whose mother needed to be persuaded to let them take her daughter with them. Peggy noted with relief that at least Jacqueline's mother was prepared to pay all her daughter's expenses.

While all the adults were away from the chalet in Megève, Max finally found his way there. The girls—Bobby, Apple, Kathe, and Clover, and Pegeen and Jacqueline, welcomed him—Sindbad was still at the École Internationale in Geneva at that stage. Jacqueline remembers that Ernst telephoned first and then arrived:

> We all stood at the window to watch him coming up the hill—I remember there was snow, and he came plodding up that hill with his large black cape flowing behind him looking like a vampire. A rather romantic figure. And we invited him in—there were a couple of servants in the house, so we had a room made up for him, and that evening we all had dinner together, and then he kept us up in front of the fire until 2am telling us amazing stories about everything that had happened to him—his life, his adventures—and all about his recent breakup with Leonora Carrington . . . as teenagers we thought this was all very exciting.

In the end most of the arrangements were more or less achieved. Kay found Franckenstein a berth on the *Winnipeg* sailing from Marseilles, and relaxed somewhat. As Peggy was paying for everyone's flight, it was expedient for Kay to take a gentler line with her husband's ex-wife, and there was enough to do to set aside any private battles for the moment. There were evening meetings at sidewalk cafés where the adults discussed the progress they'd made. Having an American mother, Jacqueline was in possession of a preference visa, which automatically meant that all the other visas she needed would follow. Of course Peggy shared this privilege, and it would have considerably eased Ernst's situation if she had married him then and

there—there was no legal reason for them not to have taken such a step, though evidently Max resisted it. However, the possibility of Max's marrying the sixteen-year-old Jacqueline was put forward—though only frivolously: As she recalls, "My mother objected, and someone else said, 'But of course it would only be a *mariage blanc!*' It was all just banter. The times were tragic and the atmosphere was laden with unspoken unhappinesses and tensions— so that it was a release to have a laugh."

Jacqueline remembers that getting out of France was very confusing and very worrying. "We didn't know quite what was going to happen to us. When the Vails started to pack up I got into a sort of panic and I wanted to go to America with them . . . and they fixed it all for me. Laurence and Kay pleaded my cause with my mother and Peggy said she would be responsible for me. I was sent to stay with my [American] maternal grandmother in New Orleans." Jacqueline was more than happy to part from her mother. A few years earlier, as Kay Boyle's biographer, Joan Mellen, relates:

> Jacqueline had . . . cause to be grateful to Kay Boyle. When a psy-
> choanalyst friend of Maria Jolas' had persuaded Jacqueline's
> mother, Fanny, to send her to what amounted to an asylum for
> children because she was too high-spirited, Kay and Laurence
> found out. On their next trip to Paris they visited Jacqueline in
> her lonely exile. Then they persuaded Fanny to set her free. The
> Vails invited Jacqueline to Megève every summer and school hol-
> iday in 1937, 1938 and 1939. "They're the happiest family I've
> ever seen," Jacqueline thought then.

At last the chalet in Megève was to be closed up and left in the care of a housekeeper (Laurence would return after the war to resume his life there), and everyone moved to Marseilles on the first leg of their long journey back to America.

In Marseilles they ran into Marcel Duchamp again, in the middle of his own arrangements for departure. Duchamp had left Paris for Arcachon on, May 16, 1940, earlier than most, where he was soon joined by Mary Reynolds; but she lost patience once again with holing up in a rural retreat and so they returned to Paris in September to find her house and contents intact and

undamaged. Duchamp managed to get a cover profession as a wholesale cheese merchant, and in this guise (which permitted him to travel between the zones) he made three trips during 1941 between Paris and Marseilles, smuggling down all the materials for further examples of his *Boîtes-en-Valise*, which he intended to assemble in the United States later. He had already reserved two of the "luxury" versions, one for Peggy, and one for his old friend and companion in amorous adventures, Henri-Pierre Roché, at 4,000 francs apiece. (He finally left France late, after the United States had entered the war, leaving Marseilles on a steamer bound for Casablanca on May 14, 1942. He arrived in New York on, June 7. Mary Reynolds stayed on in Paris and worked for the Resistance. Her house in the rue Hallé became the home of a cell run by Picabia's daughter Jeanine, whose members included Gabrielle Buffet-Picabia and Samuel Beckett. After America joined the war, Mary was arrested and interned but subsequently released, and made her escape via Spain to Lisbon later in 1942, where she waited three months for a seat on a Clipper, so vast had the waiting hordes of refugees become. She finally arrived in New York in early April 1943 after traveling for seven months in all.)

Duchamp joined them for dinner, where Kay caused a scene by pretending to Peggy that the ship carrying her collection to the States had sunk. Matters grew worse when she further infuriated Laurence by refusing to return to Megève to complete their packing and arrangements for departure, at least until she had seen Franckenstein off safely. Laurence, true to form, started throwing plates and bottles, and then tore the marble top off the table, raising it above his head, intending to bring it smashing down on Kay's. He had had enough of her selfishness, her hauteur, her artiness, even her signature white earrings. An element of professional jealousy may also have played a role: Kay's industry was a constant reproach to his laziness.

Laurence's performance astonished Ernst, but the others had seen it all before. This time, however, matters seemed to have escalated beyond anyone's previous experience. Duchamp, normally content to be an observer even of the most grotesque scene, leaped up and set himself between Laurence and Kay. Laurence was so madly drunk, so much at the end of his tether, that Duchamp may well have saved Kay's life. She ran from the café. Laurence hurled the tabletop aside and bolted after her. Duchamp followed, and the three of them ran along the street, one man either side of Kay, in a

farcical situation. Duchamp yelled to Kay to go to his hotel, giving her its name and the room number. Laurence bellowed that if she did, he'd kill both of them. But the madness had run its course. A few moments later, all of them gasping for breath, they ground to a halt. "We have to talk this over," said Laurence. Kay agreed. They made their way back to their friends and a furious café proprietor. Peggy took the opportunity to offer Laurence and Kay her room at the Hôtel de Noailles so that they could talk things over, and returned with Max to the Air-Bel.

Varian Fry remembered her staying for some time at the Air-Bel, taking the room vacated by Mary Jayne Gold; but in this he may be mistaken—for according to Mary Jayne's more reliable account, she was still in residence when Peggy was there. Among the other guests was Antoine de St.-Exupéry's estranged wife, Consuelo, a striking figure who "arrived from nowhere one night and stayed for several weeks, climbing the plane trees, laughing and talking, and scattering her money liberally among the impecunious artists," as Mary Jayne Gold remembered.

Mary Jayne was unaware that Peggy and Max had already started their affair, and gives a vivid picture of Max, with his aquiline nose and quick movements—for all the world the personification of his own creation, Loplop, "bird superior."

> It must have been at the château that the love affair between Max and Peggy started because Peggy, who loved to tell stories about herself, recounted how one night she heard a tapping at her chamber door. She rose and rushed to open it, expecting to fall into Max's arms. Dagobert [Mary Jayne's poodle] and . . . Clovis [Varian Fry's poodle] bounded in, almost knocking her over, and jumped on her bed. She spent the night between the two of them. I guess Max showed a few nights later.

But Peggy did not find staying at the Air-Bel very congenial, and soon moved to the Grand Hôtel du Louvre et de la Paix on the Canebière.

In the meantime the French authorities had started to seek out Jews and transfer them to detention centers and camps. Max warned Peggy not to admit to being Jewish, and soon afterward she had cause to be grateful for his advice. A plainclothes policeman arrived at her hotel one morning

shortly after Max—who had no right to be there—had left, and started asking questions. He noticed that the date on her travel document had been changed, but did not press her after she had told him that the emendation had been made in Grenoble. Even so, she had not officially registered as a resident in Marseilles, and her name—she was traveling under Guggenheim, not Vail—aroused his great suspicion, though she tried to explain that it was not Jewish but Swiss. Peggy was becoming seriously frightened by now. She had a cache of black-market currency in the room that she could not account for legally; and she was frightened that if she was arrested she would put both Max and Laurence (whose papers were not in order) in jeopardy. When the detective asked her to go to the police station with him, her heart sank, but she was rescued by his superior officer, who met him in the hotel lobby and overruled him. Her American passport had saved her once again: At the time Americans were popular in France, having sent large consignments of food to compensate for the drain imposed by the Germans.

At about this time Peggy reluctantly acquired a painting (*The Shepherdess of the Sphinxes*) by Leonor Fini, a protégée of Max whose outrageous behavior had gained her a notoriety beyond her talent, but Peggy was not destined to see more of her until they met again in New York, for soon afterward Max managed to complete his set of travel documents and tickets, and was eager to leave for Spain and Portugal as soon as possible, the plan being to meet Peggy and the rest of the party in Lisbon. He left the following day with a large number of his canvases rolled up and packed in a large suitcase. His adventures were far from over. When he arrived at Campfranc, on the Spanish border, the French stationmaster pointed out that the exit visa he carried was, after all, not exactly in order, and he took it away. Max nevertheless crossed to the Spanish customs office and opened his bags. They looked at the pictures, which aroused their enthusiasm. *"Bonito!"* they cried, and the thirteen travelers accompanying him agreed. But there was still the French stationmaster to convince. As things turned out, it wasn't so hard. Max was repacking his paintings when the man said to him: "Monsieur, I respect talent." Then he returned his travel documents to him and led him out onto the platforms. Two trains were waiting. "This one," said the stationmaster, "is going to Spain. The other is going to Pau." (Pau is in France, a short distance along the line.) "Your French exit papers are not valid, but if you were to

board the train for Spain, that would be of small consequence. Officially, I have to inform you that you are not authorized to leave France, so I beg you not to take the wrong train." Max took the hint.

Peggy, often sickly and now fighting bronchitis, remained to sort out some bureaucratic loose ends relating, among other things, to the amount of money they could take out with them. In between times she rested and read Rousseau's *Confessions*. She took her leave of Nelly and saw Laurence, Kay, and the children off. Peggy herself was going to travel independently with Jacqueline Ventadour. The main delay was caused by yet another mix-up over travel documents. Peggy, however, was glad not to be making the trip to Lisbon with all the other children. Victor Brauner accompanied them on the railway journey as far as the French frontier.

The journey by train through Spain was uneventful. Peggy was struck at once by the relatively large amounts of food available compared with France, but also by the unhappiness of the people, still recovering from their savage civil war. In Lisbon, however, an unpleasant surprise awaited her. Max had discovered that Leonora was there, also waiting to leave, with her Mexican fiancé, Renato, whom she soon afterward married. Peggy put a brave face on it, but by this stage she knew how much Max still loved Leonora. Pegeen and particularly Sindbad felt very strongly this apparent rejection of their mother, who had done so much to help the German painter. Max's ticket to the States, sponsored by his son and various people at the Museum of Modern Art in New York, had not been confirmed; the spare ticket had been taken up by Jacqueline. Thus an extra seat had to be acquired for Max. Peggy was still prepared to arrange it for him.

For some time afterward Max spent his days in Leonora's company and his nights wandering around Lisbon with Laurence. Although Peggy's group had split into two hotels—Peggy, her children, and Jacqueline in one and Max, Laurence and Kay, and their children in another—they spent most of their waking hours together and the tensions between them often became acute. In the meantime Sindbad was determined to lose his virginity, and Peggy was fearful that he do so in a country where venereal disease was rife. Add to these elements the boredom and the suspense of waiting for their places on a Clipper to come up—for there were far more people waiting to leave than there were places on flying boats to accommodate

them quickly—and it is small wonder that their evenings together often ended in brawling disaster—episodes Max ironically called *"charmantes soirées."*

Max was a selfish man and made no secret of the fact that he was only happy when he was with Leonora, which he managed to be a good deal despite the presence of Renato. The situation wasn't helped by the fact that Leonora was strikingly beautiful and had the very tip-tilted nose Peggy had always yearned for. But despite Max's efforts to persuade her to return to him, she stayed with Renato. As Peggy observed with some satisfaction, "He [Renato] was like a father to her. Max was always like a baby and couldn't be anyone's father."

By this time Peggy's entire party had moved away from Lisbon to Monte Estoril, which was a cooler, pleasanter place to wait for their names to come up for the Clipper, yet close enough for forays to be easily made into the capital to check the passenger lists. There was little to do but swim, sunbathe, and drink, and there, having failed to win Leonora back, Max resumed his affair with Peggy. Not that it was clear-cut. He continued to pine for Leonora to such an extent that when Peggy met her by chance in Lisbon, she flew at her rival, telling her either to take Max back or leave him alone. Leonora retorted truthfully that she had no idea that Max was sleeping with Peggy—and in all probability Peggy imagined her own relationship with Max to be of greater significance than it was.

The fight did not stop Peggy, who thrived on emotional rollercoasters. She ran away from Monte Estoril to check in at her old Lisbon hotel again. Everyone was concerned about her disappearance, as she no doubt intended them to be, but she called Laurence the next day to tell him where she was. To her satisfaction he told her that he'd made Max wait for the last train back to Monte Estoril from Lisbon the previous night. Meanwhile Laurence had been behaving "like an angel" toward Kay—even getting his mother to arrange a $500 bond that Franckenstein needed to ensure his admission to the United States. Max, who hated Renato with a will, disapproved of Laurence's altruism and "lectured him on the sweetness of revenge." Matters were further complicated by the fact that Kay was now in the hospital. She had checked into a clinic with invented sinus trouble in order to avoid the tension that was building up at the hotel. Kay had advised Leonora to forget Max, and Max had found out; he never forgave her. No concession was made

to the children regarding the effect on them of the tensions between the adults.

Kay's oldest daughter, Bobby, was looking after the younger children with Pegeen and Laurence. The whole "family"—with the exception of Kay who put in an appearance on Sundays only, according to Peggy—sat at a large table together in the dining room of the rather stuffy Monte Estoril hotel in which they were staying. At this table sat Peggy; Max; Laurence; the seven children, whose ages ranged from eighteen (Sindbad) to two (Clover); occasionally Kay; and even, once or twice, Leonora. There was even a subplot: Jacqueline was in love with Sindbad, who was not only concerned about arriving in the States with his virginity intact but was still carrying a torch for Yvonne Kuhn. Sindbad, Jacqueline remembers, was a typical English schoolboy. He and Pegeen got along, but they were not close. The children received no education at all during their wait in Monte Estoril—they just swam, sunbathed, went to the movies, and rode—Max sometimes joined them. He was a very good horseman, and also rode with Leonora.

It is not known who shared rooms with whom at the Monte Estoril hotel—the large party had virtually a floor to themselves—but for a time at least Peggy shared with Jacqueline Ventadour: "Sometimes at night we'd sit up and talk about the future—Peggy wasn't very keen on going to the U.S.A. She'd been away for twenty years and had cut most connections with it. Her real life at the time was in England. She was worried about going back to America and didn't know how she would fit in. Her childhood memories were not that pleasant and she associated the U.S.A. with unhappiness." Peggy still entertained the idea of getting to England from Portugal, and even asked Jacqueline if she'd go with her; but finally relented, telling Jacqueline that, after all, she'd promised her mother to escort her safely to the States. Jacqueline herself was not averse to going to England. In fact she was to spend most of the war with her grandmother in New Orleans, before crossing the Atlantic again, alone and seen off by nobody, to join the Free French Forces, in 1944.

Near Monte Estoril is the little fishing port of Cascais. Often they would go there to swim, but their favorite time to visit was in the evening, when the fishing boats returned with their catches of sardines and anchovies. Peggy remembered that the atmosphere of the village, where few women were ever seen except for a handful of prostitutes and those who worked in the

fish market, was more akin to Africa than to Europe. They also frequently visited Cintra, delighting in the surrealist atmosphere of the rambling palace.

Despite the moralistic attitude of the local police (men had to wear undershorts and trunks and women had to wear skirts to swim) shops sold revealing swimsuits, and Peggy appalled Max by swimming naked at midnight—though he seems to have been more concerned about what would become of him if she drowned than that she risked arrest. She wanted to show off for him, and also to show him that she, too, was unconventional and capable of shocking the bourgeoisie. Unfortunately for her, Max was unimpressed.

Peggy swam well—she also had a beautiful body, but (despite her early prowess at tennis) the increasing weakness of her ankles meant that only in the water could she display any kind of athleticism. One night during the wait for the Clipper, which was to last five weeks, she once again "sprained" her ankle—the third time she mentions doing so (to that date) in her memoirs. Max carried her home on his back. The other sport she could indulge in was riding—but Max only took her with him when Leonora stopped accompanying him.

To counteract the boredom the adults invented little games. To shake things up one evening at their stuffy hotel, Max arrived at dinner with his hair dyed turquoise—a trick he'd played before, using mouthwash to achieve the effect. On another night Laurence picked up a young whore "in a salmon satin dress." She had "a dark face and a little black mustache." They bought her ice cream and in return, despite having not a word in common in any language, earned her devotion. She was called Jesus Concepçao and attached herself to Peggy in particular, drying her after swimming and carrying her on her back (to Max's annoyance) when she twisted her ankle yet again. She had a sister, and the two girls shared two dresses and one bathing suit. Neither was allowed into the hotel, but they spent all their time on the beach with Peggy's party, and taught them a little Portuguese, using the sand as a blackboard. So the time passed, agreeably enough, in relative safety but ultimately boringly, until it was time to depart. There was one extrasensory hiccup before they left. Peggy says that

> One day, in broad daylight, the spirit of John Holms appeared to
> me and burning two holes on my neck warned me to give up

Max, saying that I would never be happy with him. This was like a vision or stigmata. If only I had accepted his warning! But it is my fate to go through with the impossible. Whatever form I find it in, it fascinates me, while I flee from the easy things in life.

At last everything was ready, and on July 13, 1941, the Pan Am Clipper lumbered through the millpond waters of the Rio Tejo and into the air on the first leg of its journey to the States. Peggy, Max, Kay, and Laurence, together with the seven children, were aboard.

part three

Back in the USA

Through her presence in America during the forties (1941–1947), she exerted considerable influence on the development of contemporary American art. She accomplished this mainly through her AoTC gallery at 30 West 57th Street in New York City. Her personal collection of art that she placed on view there, the presence there of several European artists and members of the intelligentsia, and Guggenheim's own generosity and encouragement of young talent by exhibiting their works at the gallery—all assisted in nurturing the New York School.

MELVIN PAUL LADER,
Peggy Guggenheim's
Art of This Century:
The Surrealist Milieu and the
American Avant-Garde, 1942–1947

Peace was the one thing Max needed in order to paint, and love was the one thing I needed in order to live. As neither of us gave the other what he most desired, our union was doomed to failure.

PEGGY GUGGENHEIM,
Out of This Century

seventeen

Coming Home

\mathcal{A}lthough the enormous Boeing B-314 flying boats—the largest of their kind ever built—carried seventy-four passengers in luxury, the journey from Lisbon to New York took nearly two days, with refueling stopovers at the Azores and Bermuda. Peggy found the trip tedious, and though she relieved the monotony by buying herself a huge straw hat during the first break in the journey, she found the second intolerable: The passengers spent half a day hanging around in intense heat, while the British authorities searched their baggage and read through all the papers they were carrying, including books and correspondence, as well as quizzing those who had come from France about conditions there. The tensions begun in Lisbon continued on board: Sleeping berths, naturally reserved in advance, were only available for about half the passengers, and Max had an argument with Pegeen over the ownership of one such bed. Peggy resolved this by taking Pegeen in with her, but the children were unhappy. Unused to flying, they were airsick, and "kept vomiting into paper bags and losing the braces which they were wearing for the purpose of straightening their teeth." Jacqueline Ventadour, who had never flown before, found the experience scary but exciting; for the adults, the sometimes bumpy ride in each other's enforced company was less than thrilling. There were some compensations, however: The views were spectacular, and at one point they flew over the

ship that was carrying Leonora and Renato to New York. On board were Max's paintings, which could not travel with him on the Clipper.

Most of the time, though, the adults in Peggy's party sat in one of the three day rooms (traveling by Clipper was more like sailing in a liner than flying), and drank whiskey or Clipper cocktails—white rum, sweet vermouth, and grenadine poured over cracked ice. Peggy writes that toward the end of the journey Max asked her to live with him, but in view of his general attitude to her, which was less than passionate, this seems unlikely.

Their first sight of America, late on July 14, was Jones Beach on Long Island, swiftly followed by the Statue of Liberty and the Manhattan skyline. Many of their friends were on hand to meet them, including the English surrealist Gordon Onslow Ford, currently lecturing on contemporary European art at the New School for Social Research, and his wife, Jacqueline. They were accompanying Max's son, Jimmy. Jimmy had received a cable the day before from Lisbon informing him that "Max Ernst and party" would arrive the following day. One thing he did know: His mother, Lou, would not be in it. News of Ernst's abortive attempt through Varian Fry to get his first wife out had percolated to the director of the Museum of Modern Art, Alfred Barr.

At the Marine Air Terminal at LaGuardia Airport, Peggy made an immediate and vivid impression on Jimmy: She

> came toward me, her body and walk suggesting considerable hesitation. Her legs seemed absurdly thin even for her fragile, angular figure. Her face was strangely childlike, but it expressed something I imagined the ugly duckling must have felt the first time it saw its own reflection in the water. All the features of that face seemed to be intent on wanting to draw attention away from an unnaturally bulbous nose. The anxiety-ridden eyes were warm and almost pleading, and the bony hands, at a loss where to go, moved like the ends of broken windmills around an undisciplined coiffure of dark hair. There was something about her that wanted me to reach out to her, even before she spoke.

Meeting Max was interrupted. There was an initial awkwardness, during which Max managed to get out in English: "Hello Jimmy, how are you?" But hardly had father and son laid eyes on each other and moved toward each

other to embrace, than Max was taken away for questioning by officials. As a German national, he would have to undergo immigration procedure at Ellis Island before being admitted to the country, and no amount of bond or surety, which Peggy immediately offered, could save him from this process. The last ferry to the island had left for that day, however, so Max was obliged to spend the night under the eye of an airline detective at the Belmont-Plaza Hotel, courtesy of Pan American.

Laurence Vail's mother, who also met the group, had reserved a suite of rooms at another hotel, the Great Northern on Fifty-seventh Street, and invited the entire party there as her guests. She pleased Peggy by immediately paying her back the fares for Laurence, Kay, and their four girls; but Peggy didn't join the others at the Great Northern. Instead she slipped away and followed Max and his minder to the Belmont-Plaza, where she took a room.

She proceeded to try to contact Max by telephone, and at the third attempt he told her that his detective had assented to their meeting in the hotel bar. A bizarre evening ensued, as Peggy and Max, shadowed by the increasingly amiable detective (who had decided that Peggy was Max's sister), dined together at a little restaurant. There they ran into Katherine Yarrow, the woman who had helped Leonora escape from France but who had also been instrumental in panicking her into selling the house at St.-Martin. Max couldn't bring himself to shake hands with Yarrow, and, to avoid a scene, the couple left for the bar of the Pierre Hotel, against the wishes of the detective, who proposed a trip to Chinatown as a much cheaper and better alternative.

By now, however, the detective had taken a shine to Peggy, and when they returned to the Belmont, he said it would be all right with him if she spent the night in Max's room. He himself would sit outside all night, guarding them. Peggy decided that it would be better all around if she returned to her own room, where she was awakened by the detective the next morning with the news that it was time to go to Ellis Island. He also apologized, mysteriously, to her for not having realized who she really was the night before. To express thanks for his genial behavior, Max gave the detective a cheap straw hat and cane he'd bought in the Azores, which the detective had admired, and they parted company with this oddball official at the ferry, where another Pan Am employee took charge of them. They were also accompanied by Julien Levy, Max's U.S. dealer, who had opened a modern art gallery in New York late in 1931. In that year Levy had bought Dalí's *The Persistence of Memory* (rechristened *The Limp Watches*) for $250. That Christmas, Levy's

tree was decorated by the artist Joseph Cornell. Soon afterward, Levy's gallery was established as the center for showing surrealist works, and as early as 1932 his stable included Calder, Cocteau, Cornell, Dalí, Duchamp, Ernst, and Man Ray, as well as Eugen and Leonid Berman, de Chirico, Leonor Fini, Gris, Frida Kahlo, Magritte, and Pavel Tchelitchew.

On arrival at Ellis Island, Max, agreeably if wryly surprised at the spotless conditions there, compared with what he'd been used to at similar places in France, was taken away to wait for his application to enter the States to be processed. As a large number of people from a Spanish ship had docked shortly before the Clipper's arrival and were therefore ahead of him, a tense three-day wait followed. Peggy went out by launch to the island every day, accompanied the first two times by Julien, who was ready to testify on his client's account. Levy's memory of the occasion is concise, and not altogether pleasant, though he was presumably aware of Peggy's art-world activities. Perhaps he had not been prepared for such a potentially aggressive rival:

> I continually saw Max Ernst in Paris and exhibited his work until the outbreak of the war in Europe. One day in 1941 Peggy Guggenheim came into my gallery and asked innumerable questions, expressing the lively, youthful curiosity she still has today. She invited me to go with her to visit Max on Ellis Island, where he had been detained on his arrival from Europe. . . .
>
> Peggy hired a little launch, and we chugged out to the island. I was not permitted to leave the boat, but Peggy spent an hour with the despondent Max, who was held in quarantine by immigration red tape. Rocking in the boat, I waited for her, and on the return voyage she informed me that she and Max were going to be married. She also told me she planned to open her own gallery-museum in New York and, since Max was to be her husband, his pictures would naturally be exhibited and sold in the future in her gallery and not in mine. From hearing this, and the turbulent boat ride, I began to feel a little sick.

Peggy gave Max what moral support she could, and sought any help available from the various relief organizations operating on the island, but in the end there was nothing anyone could do but wait for Max's turn in line to come up. On the third day, which turned out to be the day of Max's hearing,

Peggy was joined by Jimmy Ernst, who brought with him a sheaf of papers in Max's support, notably from the Museum of Modern Art. The director, Alfred Barr, had written a letter, and enlisted the aid of such powerful patrons of the museum as Nelson Rockefeller and John Hay Whitney. Julien Levy was also on hand once more. So was Peggy, with Ernest Lundell, an American Smelting Company executive who had also met the Clipper, in attendance for good measure.

Jimmy found himself unexpectedly called as a principal witness. He was required to assume responsibility for Max's welfare in the United States, and shortly thereafter Max was a free man. It was the end of a tense wait for Peggy, who had been terrified that her lover might be sent back to Europe.

At the Manhattan end of the ferry from Ellis Island a string of limousines was waiting to take the principals back to the Belmont-Plaza. Max was whisked off, leaving Peggy and Jimmy to follow in a cab—a slight to Peggy that she managed to overcome with difficulty. At the hotel Tanguy and Kay Sage were waiting, along with Matta, André Breton, Nicolas Calas, and Bernard and Rebecca Reis—she was a painter, he an accountant and collector whose clientele included many artists—and Howard Putzel. Putzel was eager to continue his association with Peggy as well as to greet Ernst. He brought with him the welcome news that Peggy's Lefebvre-Foinet consignment had arrived safely. The pictures had yet to clear customs, however, and Peggy immediately became concerned that she'd have to pay duty on at least some of them.

Peggy was quick to make friends with Jimmy, establishing a rapport that was reciprocated from the moment of their first meeting. Jimmy, just past his twenty-first birthday, was working in the mail room of the Museum of Modern Art for $60 a month, a job secured for him by Julien Levy, but which he hated, as he was treated with rudeness and contempt by coworkers despite Barr's protective but distant influence.

Jimmy, effectively abandoned by Max at the age of two, when his father went off to live with Paul and Gala Eluard, longed for his father's affection, but Max found it hard to be close to his son. Peggy was able to step into the breach, and acquired another "son." Max, too, she saw as a "baby," but every moment of their relationship was tinged with anxiety for her. In her own memoirs, moments of insight are crosscut with moments of self-delusion. She writes that "I always felt that when I would no longer be useful to Max he would have no further use for me. I not only tried to obtain everything he

needed, but also everything he wanted." Almost in the same breath, however, she says: "It was the first time in my life that I had felt maternal towards a man"—a curious confession from one whose maternal instincts were only ever aroused in the context of a sexual relationship. But when she told Max that he was "a baby deposited on my doorstep," he replied with an insight that she acknowledged, "You are a lost girl." Meanwhile, Yves Tanguy, already arrived and married to Kay Sage, mischievously wrote to his dealer, Pierre Matisse, from Hewitt Lake, Minerva, New York, that "Max Ernst is now said to be Peggy Guggenheim's consort no. 3,812."

Max, who was beginning to earn some money from his paintings but also had limited access to Peggy's funds, gave Jimmy a $100 bill to buy him time to look for another job, but a mild form of rivalry grew up between father and son for Peggy's attention, and it was one she was not slow to exploit. No one was harmed by it, however, and Peggy may well have seen her role actually as that of providing a bridge between the two men. If she wasn't entirely successful, that was not her fault.

She showered Max with gifts and had long since decided that she wanted to marry him and settle down:

> I felt much more at home with Jimmy than with Max. He was
> awfully happy to have a stepmother and we got on wonderfully
> well. Everything I didn't do with Max I did with Jimmy. I took
> him to shops, while I replenished my wardrobe (I had given away
> all my clothes in France). But if I took Jimmy to buy clothes with
> me, Max couldn't go shopping without me. He made me choose
> everything he ordered. I encouraged him to buy a trousseau. He
> looked so beautiful in American clothes, for he had a perfect fig-
> ure and was extremely elegant by nature. I gave him the diamond
> and platinum lorgnon with the watch that had belonged to my
> mother, and he used it instead of glasses. It suited him perfectly,
> making him look English and aristocratic.

Peggy was trying—an insane ambition—to mold Max; Max the actor, fond of clothes and set decorating, responded. Max the painter remained inviolate. Jimmy was more malleable. When she offered him work as her secretary at $100 a month, he accepted, having discussed the move with the architect and designer Frederick Kiesler and the painter William Baziotes

first. Both these friends urged him to take the job. Before too long they too would become involved in Peggy's New York life and plans.

In the meantime, another surrealist was in need of her bounty. Kay Sage had installed André Breton and his family in an apartment in Greenwich Village for six months, until he found his feet, and Peggy complemented the gesture with a stipend of $200 a month for a year. Breton, cocooned, was intent on rebuilding the surrealist circle, and Ernst was important to him—Ernst had long been the jewel in Breton's crown, and he had come close to losing him at the time of the split with Paul Eluard.

Max and Peggy toured the modern art collections of New York. The Museum of Modern Art had a good selection of Ernsts, since Alfred Barr had bought fourteen of them, but to Peggy's indignation most of them were stored in the basement. Though the museum had a fine cross-section of paintings, and was in addition hosting Roland Penrose's collection, sent over for the duration of the war, Peggy was unimpressed, despite the fact that most of the artists represented were ones she favored—Arp, Braque, Calder, Léger, Picasso, and Tanguy among them. She compared the atmosphere of the place to a cross between a girls' college and a millionaires' yacht club.

By contrast they found that her uncle Solomon's collection, masterminded by Hilla von Rebay and dominated by the works of the mediocre Rudolf Bauer, "really was a joke"; though the twenty-odd Kandinskys were worth seeing, as well as a handful of others by Delaunay, Gris, and Léger. Max nicknamed the first two collections the Barr House and the Bauer House. A third, Gallatin's collection at New York University, he dismissed as the Bore House. Appreciation of modern art in New York was in its infancy. There was only a handful of dealers, pioneers like Levy, Sidney Janis, and Pierre Matisse, and paintings changed hands, if they changed hands at all (war was looming and few were in the mood to buy art), for modest amounts. Jimmy Ernst, a good painter himself, gives a perceptive view of the period, displaying his own tendency to distance himself from the European art scene and associate himself with that of the United States:

> It would have been easy in New York to have fallen into the art world that had survived from Europe. I saw no reason to turn my back on them, but they never absorbed me. The relatively small number of galleries on Fifty-seventh Street showing contempo-

rary art had been increased by newly arrived dealers from pre-Hitler Germany. Curt Valentin had opened the Buchholz Gallery. J. B. Neumann ran his New Art Circle and Karl Nierendorf, who had emulated his brother's activities in Cologne, operated a gallery under his own name. They ran their businesses pretty much in the same manner as they had in Europe. Their stock consisted mostly of Klee, Kandinsky, Jankel Adler, Marc Chagall, Beckmann, Emil Nolde, Picasso, Braque, Juan Gris and other examples of the School of Paris and German Expressionism.

Many pictures had been bought from the Nazi auctions in Switzerland, to be recycled across the Atlantic. Max, along with most of his fellow Europeans, looked down on the home-grown offerings. But Europe's loss, occasioned by the rise of Nazism, would turn out to be America's gain.

Of all the galleries and museums in New York, Max's favorites were the Natural History Museum and the Museum of the American Indian. The one really impressive collection, according to Peggy, was her uncle Solomon's private hoard at the suite he shared with Aunt Irene at the Plaza Hotel.

New York City can be uncomfortably hot in summer, and an added discomfort was the arrival of Leonora Carrington, with Max's paintings. These were exhibited at Julien Levy's gallery and much admired, but Peggy was made uneasy by Max's seeing Leonora again. Providentially at that moment they received an invitation from Peggy's sister, Hazel, remarried for the fourth time and living in Santa Monica, to visit.

The little Talbot car that had served Peggy so well in France had been shipped over by Lefebvre-Foinet with her other effects and her pictures, and Peggy now gave it to Sindbad, who drove off in it to join Laurence and his daughters Apple and Kathe at Mantunuck Beach, Rhode Island, where he had taken lodgings. Kay Boyle had gone with Franckenstein to stay with friends at Nyack, north of New York City on the Hudson. The separation had been bitter. Not only were the daughters divided, there had been an unpleasant argument over who would have custody of the family dog, Diane, which had come over by ship. Kay won on that: The dog loved her so much that it howled when it was out of her company.

Pegeen and Jimmy accompanied Max and Peggy on their trip west. At the last moment Hazel, Peggy's rival in so many other ways, announced that she was having plastic surgery on her nose, and could they delay their visit by a few days? The flight being booked, they couldn't change their plans, but decided to spend some time in San Francisco first. Max and Peggy enjoyed the spectacular views from the plane—a novelty even for sophisticated people: Pegeen and Jimmy were airsick.

In San Francisco, Peggy, who had not given up the idea of the museum of modern art she'd originally planned for London, and had decided to use the trip as a means of scouting out a home for her collection, met Grace McCann Morley, who ran the museum of art there. Morley was delighted to meet Max and got along well with Peggy. The introduction was made by Sidney Janis, to whom Peggy had said that she was already married to Ernst. The visit was marred only by Max telling a journalist from the *Art Digest* that an exhibition at the San Francisco Museum of primitive American painting contained the best work that he'd seen in the United States—which was misinterpreted, perhaps owing to Max's very basic grasp of English at the time, as an insult to later American art. They had cocktails with Man Ray and his fiancée, the dancer Julie Browner, and managed deliberately to snub another guest, the artist George Biddle, who had made some cutting remarks in print about contemporary European art. Pegeen, who adored Kay Boyle, also got into a fight with Max, who detested Kay, and as a result nearly refused to accompany them on their onward journey to Santa Monica, relenting only at the last moment.

They found Hazel completely happy with her new husband, an aviator called Charles "Chick" McKinley. A USAAF pilot, he was to die not long after America's entry into the war, but for the moment their existence seemed enviable. Chick was a handsome young man, and "seemed such a contrast to Max who looked so old," as Peggy remarked later. Max, who drank little and took care of his physique, could be forgiven, one would have thought, any ravages his time in French camps had wrought on him; certainly he had no trouble attracting women; but Peggy's judgment in this case may have been affected by his inflexible attitude to her siege of him; though her aunt Irene had also remarked that Max looked "ten years older" than Laurence, his close contemporary.

They stayed three weeks with Hazel and Chick, and, having no real plans about where they would put down roots, Peggy and Max began to look at

properties which might also be suitable for housing and displaying the collection. Some of those they saw were extravagant: a sixty-room "castle" at Malibu for $40,000, unfinished, since the previous owner's funds had run out, difficult of access, and wholly impractical, though its appeal lay in its resemblance to a building in a surrealist painting. Another house, which had belonged to the British film actor Charles Laughton, built on a crumbling clifftop, seemed to be in danger of falling into the sea. They also looked at a disused bowling alley, a couple of deconsecrated churches, and the former home of the silent-film actor Ramon Novarro, whose garages alone were so vast that they could have been converted into a spacious gallery. Nothing, however, quite suited. Peggy bought a large Buick convertible so that they could continue their tour in style. Max learned to drive, and once he had, could scarcely be persuaded to relinquish the wheel to anyone else.

Despite the fact that Walter and Louise Arensberg had moved west, taking their marvelous modern art collection with them, and that there were a few discerning collectors—the actors Harpo Marx and Edward G. Robinson among them—and pioneering dealers who managed to make a living, the West Coast was less ready for the impact of contemporary work than New York, and Peggy began to find the atmosphere dispiriting. Even Arensberg had lost some of his old fire, and these days was more preoccupied with proving that Francis Bacon had written the plays of Shakespeare than with the promotion of modern art. However, both Peggy and Max were suitably impressed when they saw his collection.

When their three weeks were up, Peggy and Max, with Jimmy and Pegeen, drove cross-country to the Grand Canyon to look up Peggy's old friend Emily Coleman, who was living there with a new rancher husband, Jake Scarborough. Max collected the totemic kachina and Zuni dolls of the Hopi and Pueblo Nations, having the luck to buy a whole batch cheaply from a storekeeper who was clearing out his stock and regarded the dolls as junk.

More significantly Max discovered that he had anticipated the landscapes of Arizona, of which he had never even seen photographs before, in his own work—an experience which was both moving and unsettling. As Jimmy tells it:

> On a late afternoon we got out of the car to watch a gigantic rattlesnake crossing US 66 just outside of Flagstaff, Arizona. As Max looked up at nearby San Francisco Peak, he blanched visi-

bly, his face muscles tightened. The mountain's green treeline abruptly gave way to a band of bright-red rock beneath a peak cap of sun-created pure magenta. He was staring at the very same fantastic landscape that he had repeatedly painted in Ardèche, France, not very long ago, without knowing of its actual existence. . . . That one look was to change the future of his life in America.

The reunion with Emily was not an unqualified success for Peggy— Emily told her, in her usual forthright way, that her insecurity over Max was all too obvious. But Max and Emily got along well. Pegeen continued to be ill: Her one enjoyment on this tour had been meeting Charlie Chaplin at a party. For a moment she'd entertained the thought of staying in Hollywood to pursue an acting career; but like so many things in Pegeen's life, it was not to be.

They drove on to Santa Fe, where the light and the scenery were spectacular; but although they toyed with the idea of settling there, decided that it was too remote. They continued their journey through Texas and so on to New Orleans, where, through Hazel, who had many friends there, they were lionized by the local arts community, and Pegeen was able to see her old friend Jacqueline Ventadour again, who was living with her grandmother, a woman whom Peggy described as "a Southern lady of the old school."

Peggy, meanwhile, had another agenda:

> I was . . . much interested in the state marriage laws, because I wanted to marry Max. Every time we came to a new state, I sent Jimmy to find out what were our chances of marrying at once. Pegeen, however, soon put an end to all this by making Max admit that marriage was too bourgeois for him to go through with. She was jealous of my feeling for him and was clever at putting in her oar.

This seems a harsh judgment on a neglected and emotionally confused girl of sixteen; and the fact that Max had already been married twice tends to give the lie to his finding marriage "too bourgeois . . . to go through with." Despite the fights that they had had, a situation closer to the truth was probably that Pegeen was not unattractive to Max, and that it was Peggy who was

jealous. And there is something bizarre about Peggy sending the faithful Jimmy out to check up on how quickly she could marry his father. Max's response to this maneuver was "at least two days of icy silence." But what were Jimmy's own feelings? In his memoirs he reveals a devotion to Peggy that seems as genuine as it is uncritical—did he think perhaps that he could get closer to his equally adored, but distant, father, through the medium of the woman who'd brought him to safety in America? And under how much emotional pressure was Max? He owed Peggy his security, both physical and material, though admittedly he had bought both with a generous number of paintings. Was he still scared that, despite the protection of the New York art community and the handful of political big guns they could draw up behind them, he might yet be hauled off to an internment camp? Might not marriage to an American citizen provide the greatest security of all? Or was it simply that he could not withstand Peggy's inexorable single-mindedness?

It is clear that he never loved her. These details she chose to ignore, and pressed on with her campaign. But this wouldn't be the last time her daughter would be blamed for obstruction; and in each case Peggy regarded Pegeen with less than maternal feelings: She was a nuisance, an upstart, a rival; only much later, when it was too late, did Peggy choose to show love.

From New Orleans they continued their epic car tour back to New York. There, in a city (always her favored habitat) that was also the closest major city in America to Europe, and the city that had the greatest European influence, and which was also her hometown, Peggy would choose to put down roots. Max, too, was greatly relieved that they had not had to live out on the West Coast: all his friends were in New York.

When they got back, they set up home temporarily at the Great Northern Hotel. It was late September 1941.

Art of This Century

*P*eggy was a New Yorker, and a twenty-year absence hadn't blunted her edge; but the city and the country had changed enormously in that time, and despite the refuge provided by the little Europe created by the artists-in-exile who formed a group around her, it was impossible to ignore the transformations. She had been away during the skyscraper boom, which inspired so many American paintings of the late 1920s. Its enduring symbol, the Empire State Building, went up in 1933.

After the outward-looking decade that had succeeded World War I, the Wall Street crash of October 1929, and the droughts in the Midwest farmlands in the years that followed ushered in a long period of instability and uncertainty. The Jazz Age came to an end as the ranks of the unemployed grew and the country shifted toward serious crisis. Even after Roosevelt had replaced Herbert Hoover as president in 1933, the country took a long time to rebuild confidence in itself. The horrors of the economic slump of the 1930s have been tellingly recorded in the photographs of Dorothea Lange and Margaret Bourke-White.

The new government's first tasks were to provide aid and then to regenerate employment. The most obvious means of achieving the latter was by creating a public works program. At the suggestion of the artist George Biddle (who was later to be snubbed by Peggy and Max), an old classmate of Roo-

sevelt, a scheme to provide jobs for artists within the new Civil Works Administration was inaugurated, and toward the end of 1933, thanks to the efforts of artist and government lawyer Edward Bruce, $1 million was earmarked from the CWA's budget to fund the Public Works of Art Project. Biddle would later emerge as a violent opponent of the European expatriates, but the effect of his enterprise at this stage cannot be overvalued. As reported in the British weekly cultural magazine *The Listener* on February 1, 1934:

> The American scheme organizes the States of the Union into groups of four or five states. A committee of about a dozen persons controls each group from one central HQ. The committee consists of directors of public art-galleries or teachers of art of standing and experience. Notification is made through the Press that any artist who considers himself in need may apply to the committee stating his need, the nature of his work, and his position. He is asked for his full professional history, for an account of whatever work he has done and commissions he has received. He must state his financial position in full.

Accepted artists were assigned by the committee to public bodies requiring works of art—in the main large works, sculptures, or murals. The artists were paid $35 a week by the state. Although reviled by some, the PWAP and its successor schemes supported and regenerated indigenous American art in the generally dark 1930s. Ironically, during the slump, when many professionals and businesspersons were going broke and even sleeping outdoors, artists in the program thrived.

PWAP only lasted six months, but was quickly followed by a more enduring scheme known as the Federal Art Project, part of the Works Progress Administration, the $5 billion work relief program set up by Roosevelt in 1935. The work created under its aegis tended to emphasize American culture, both regional and national, in historical and contemporary terms; but this owed less to any directive from the FAP than to a renewed awareness, stimulated by the troubles of the later 1920s and early 1930s, of the homeland. Prominent among the exponents of this art were Jackson Pollock's mentor Thomas Hart Benton, John Steuart Curry, and Grant Wood. FAP enjoyed the lion's share of that part of the WPA budget allocated to arts projects; 45 percent of FAP–payroll artists lived in New York City, and the proj-

ect was a lifeline to young artists. Despite the important outposts on the West Coast, New York quickly became the focus of and the magnet for new American art.

Almost all the exiled European artists were also staying in New York. Some sort of communication between the groups was as inevitable as it was desirable, and Peggy's house and gallery would provide the forum for it. With the outbreak of war the WPA was phased out, which was an economic horror for many, but at least those artists whose health precluded them from military service could continue to enjoy the influences of the European exiles, with Peggy, having had recent personal contact with so many of the Europeans, as mistress of ceremonies. The first moves toward contact were made not by the old-guard Europeans, who were in a strange place and on the defensive, but by their younger colleagues and the younger Americans.

The path had been prepared for Peggy by other curators, dealers, and patrons, though the commercial galleries tended to be more conservative than hers. In February 1925 Galka Scheyer had opened the first "Blue Four" exhibition at the Daniel Gallery in New York, featuring the work of Feininger, Jawlensky, Kandinsky, and Klee. The following year, only two years after the publication of Breton's *First Surrealist Manifesto*, Katherine Dreier arranged an *International Exhibition of Modern Art* at the Brooklyn Museum, which included works by de Chirico, Ernst, and Masson. At the Wadsworth Athenaeum in Hartford, Connecticut, Julien Levy mounted a *Newer Super-Realism* exhibition in 1931, brought to his own New York gallery the following year, with works by the artists just mentioned as well as the American Joseph Cornell, whose highly individual art was uninfluenced by the émigrés Dalí, Duchamp, and Picasso. Alfred H. Barr Jr., had two defining exhibitions at the Museum of Modern Art in 1936, *Cubism and Abstract Art* and *Fantastic Art: Dada and Surrealism,* following the similar London show. The latter was not universally well received critically, but it was the occasion of surrealist imagery entering American consciousness. The advertising industry quickly caught on. At the time it was an enlightened policy of big New York stores occasionally to engage artists to design their shop windows. On a different plane, the showing of Picasso's *Guernica* (itself allegedly influenced by American comic strips) at the Valentine Dudensing Gallery early in 1939 had an enormous effect on local artists. Four key surrealist objects share a case at the Museum of Modern Art today: Meret Oppen-

heim's fur teacup, saucer, and spoon, *Object* (also called *Luncheon in Fur*); Man Ray's *Indestructible Object* (a metronome displaying a photograph of Lee Miller's eye); Jean Arp's *Gift* (a flatiron with a row of tacks glued to its smooth surface, made for the composer Erik Satie); and Duchamp's *Why Not Sneeze, Rrose Sélavy?* (a birdcage filled with marble sugarcubes and a cuttlebone; "Rrose Sélavy" being one of the wordplays he rejoiced in coining: *Eros, c'est la vie*).

Peggy greatly admired Barr and had read all his books. He would mount a large exhibition of works by Dalí, by then well established in America, and Miró, late in 1941. There had been a surrealist exhibition at the Wadsworth Athenaeum in Hartford, as early as 1931; and Julien Levy had been showing the surrealists ever since he had opened his first gallery at the end of that year, as well as championing the still-young art forms of photography and film. Another important contribution was made by Hans Hoffman, a middle-aged German painter who moved to America in 1931 and established an art school in New York (a large room designed by Frederick Kiesler) two years later. Among his star pupils were Virginia Admiral and her painter-poet husband Robert de Niro (who would become the parents of the eponymous future film actor in 1943), and Lee Krasner (née Lena Krassner), who later married Jackson Pollock. Hoffman himself had been painting in the expressionist style before turning to a more abstract approach in the cubist tradition in the 1940s; a friend of Braque and Picasso, as well as of Matisse and Robert Delaunay, he had little time for the surrealists.

Fortune magazine in December 1941 was quick to note:

> The unprecedented exodus of intellectuals from Europe confers upon the US the opportunities and responsibilities of custodianship for civilization. . . . The great questions are whether, during American trusteeship, Europe's transplanted culture will flourish here with a vigor of its own, or languish for lack of acceptance, or hybridize with American culture, or simply perish from the earth.

Not all American artists approved of the foreigners. George Biddle and the regionalist and American scene painters were strongly opposed to the influence of the surrealists: "Let them play with their melting watch-chains, their rubber snakes and other childish contraptions." The most susceptible

local group, which sought out the company of the European surrealists and abstract painters Hitler had driven out of Europe, were themselves young abstract painters with left-wing sympathies, hungry for whatever they could learn from the older Europeans. Many, like Alexander Calder, John Ferren, and Buffie Johnson, had studied in France before the war; some, like Robert Motherwell, spoke fluent French, and Robert de Niro learned it in order to read French poetry. Virginia Admiral remembers that the Europeans seemed somewhat affected, and was scared, in the course of her initial meetings with Peggy, that if Peggy got to know her too well she would find her "too American—and not chi-chi—I use 'chi-chi' in a pejorative sense because I did feel that way about the Europeans."

In addition, there were a number of American artists who had been born in Europe, and who had brought influences with them: for example Josef Albers, Arshile Gorky, and László Moholy-Nagy. The exchanges of views between the old European guard and the new American one helped shift the center of the art world from Paris prewar to New York postwar. But it was a party Peggy joined late and left early. Plenty of people—dealers, collectors, and patrons alike—had been showing a serious interest in modern art long before she did; and she was to leave New York to return to Europe just as the postwar phenomenon of abstract expressionism, which, through her patronage of Pollock, she had done much to encourage, was getting under way. By then, however, modern art was moving away from the genres she understood and liked.

It was also becoming big business. New York today has about 650 art dealerships; in 1942 there were barely a dozen. One present-day New York art dealer thinks that "Peggy loved art and meant to help artists—dealers of her generation were into the general aesthetics of what they were doing—today, it's much more of a hard business. Dealers had what they perceived as a creative role as much as anything—now they are commodity brokers. At that time you didn't get into the contemporary art business with any idea of making money—that wasn't what it was about. It's hard enough now."

When Peggy and Max returned to New York the ground was partly prepared, and, though relatively new to the game, through the contacts and friendships she had established in France and England, and through her astute and concentrated buying session in France the previous year, she was in a position to provide a bridge between European and American artists,

and she was enough of a showman to carry it off. She had the means to do so, and, with most of her Guggenheim uncles dead by now, no family constraints. Uncle Solomon was still alive, and there would be the jealous Hilla von Rebay—whom Peggy referred to as "the Nazi baroness"—to contend with. But Peggy wouldn't resurrect the name Guggenheim Jeune for her New York gallery: That would be too contentious, in the same city as Solomon's now well-established Museum of Non-Objective Painting. Rebay, however, was not principally interested in promoting the work of American modern artists. There was also Cousin Harry—though their relationship would not express itself fully until much later.

The first thing to do was to find somewhere to live: The two-room suite at the Great Northern Hotel was a place where business and private lives stumbled over each other. It was too small to contain two such large egos, and with Max still avoiding matrimony, the game was one of hunter and hunted. The doting Jimmy Ernst arrived every day to work as Peggy's secretary, and sometimes didn't know where to look. His "office" was a corner of the living room, and often Max or Peggy would be sleeping in there on the sofa as the result of an argument the previous night.

America's entry into the war was still a few months off, but few doubted that it would come.

Peggy had not yet absolutely settled on New York City, though with Sindbad at Columbia University and Pegeen at the Lenox School, somewhere near them would make sense. Laurence had moved to Connecticut on Malcolm Cowley's advice, and had then proceeded to seduce Cowley's wife, thus somewhat undermining the replica Parisian Left Bank that Cowley was attempting to set up with a coterie of exiles in rural America. For a time Peggy considered moving to the same area, but after two houses fell through, she turned her attention once more to Manhattan. Tanguy had moved out of town to Connecticut with Kay Sage, and the detachment from the rest of the group was not good for him. New York wasn't Paris: The informal cafés, where you could just turn up and be sure of company, didn't exist; not everything was within walking distance. Manhattan was elongated, not circular. Montparnasse was diluted. The defined area centered on West Fifty-seventh Street, where the galleries were.

It wasn't easy to find the right kind of accommodation, but Peggy's luck didn't abandon her, and she found a house to rent at the very end of East

Fifty-first Street, on the corner of Beekman Place, overlooking the East River. Hale House, named after the twenty-one-year-old American patriot and spy Nathan Hale, executed by the British in 1776 on a scaffold somewhere nearby, was (and still is) a fine building in a good location. At the time of Peggy's occupation it had a double-height drawing room of enormous size, complete with a gallery and mullioned windows. There was a kitchen and several servants' rooms, which might double as guest rooms, and two other floors of bedrooms. Pegeen, who had been miserable as a boarder at Lenox, had one, and there was a master bedroom with a room next to it converted into a studio for Max. For a time the playwright Clifford Odets rented the top floor, and kept the household awake as he noisily rehearsed the play he was working on, *Clash by Night*, by himself into the small hours.

Hale House was a perfect retreat. It had enough space to hang the pictures and display the sculpture, but only privately: The local authorities wouldn't allow its use as a public gallery. Max added his own growing collection of native American artifacts. Ethnic crafts had been highly fashionable for some time, ever since Picasso had been influenced by African and Oceanic carving. Both André Breton and Claude Lévi-Strauss (then the French cultural attaché in New York) had collections, and New York's principal dealer in such work, Julius Carlebach, did a brisk trade. All the great artists were his customers, and he had an enormous mirror they autographed in nail polish.

Max also collected all manner of clothes, which he loved, and the occasional theatrical bibelot, such as a massive, thronelike chair in which none but he and Pegeen were allowed to sit. His other collecting hobby had to be carried out in secret: He would occasionally bring a girl back in Peggy's absence to "look at the collection." Max, though not a tall man—he was about five feet six—and no longer young, had immense charisma, and a penchant for much younger women. Another potential danger perceived by Peggy was that Leonora, though now married to Renato, was still in New York.

Although the collection was not officially on public view, Peggy held open house, and most New Yorkers either professionally or otherwise seriously interested in modern art would drop by. Among them were Alfred Barr and his deputy James Thrall Soby, and the critics Bill Coates and James Johnson Sweeney, all of whom became Peggy's friends.

There was a culture of drinking, and more. The artist and dealer David Porter remembers that "everyone in the art world went once a week at least

to a doctor called Max Jacobson who said he was giving you vitamin injections—we later found out it was amphetamine to make you feel more lively, virile, interested in sex." (Jacobson was known as "Dr. Feelgood" for his ministrations.) Hale House was perfectly suited to parties and large gatherings, and Peggy kept up a supply of potato chips and cheap Golden Wedding whiskey for guests. At one party the polymath Charles Henri Ford and the writer Nicolas Calas came to blows. "Yes, there was blood all over the floor," remembers Ford. "He was a volatile guy like so many Greeks. . . . And suddenly for no reason that I knew I saw this sort of scarecrow coming toward me flailing, and thinking that he might beat me up, and I didn't know why, all I did was just give him a few undercuts that just bloodied his nose, and he was taken to the kitchen and stretched on the table and I was asked to leave." The two remained enemies for some time afterward. Jimmy Ernst had to rescue paintings from the blood spurting from Calas's nose. James Johnson Sweeney later asked Jimmy, who had acted instinctively, why he had saved the Kandinskys before the Ernsts.

Piet Mondrian lived alone with his collection of Blue Note records and a little Victrola to play them on (he loved jazz and boogie-woogie, and into his sixties still danced well and enthusiastically), selling paintings when he could for $400. His apartment had no telephone, and like most of the European exiles he lived very humbly. He was famously invited to a meeting of the expatriate surrealists at Hale House in order to be baited; the divisions between artistic schools had been imported intact from Europe. While Breton and Ernst attempted to irritate Mondrian, he evaded their taunts with skill and dignity, until in the end the warm-hearted Tanguy, whose pictures had provided the excuse for the daggerwork, embraced Mondrian, gave him the victory in the preceding "discussion," and mended the fences. Even Breton conceded. Tanguy admired and adored Breton unconditionally, and his affection was returned; but Tanguy was drinking progressively more as his boredom with life in Connecticut grew. Peggy, not present at this meeting, admired Mondrian, who had founded the De Stijl movement with Theo van Doesburg, the late husband of her friend Nelly.

Peggy's home became a magnet for the expatriate artistic community, which had swollen by the end of 1941 to include most of the painters and sculptors she had known in Europe, though by no means all were regulars in her circle. Apart from those already mentioned, Chagall was there, and Léger, as

well as Ozenfant, Masson, and Tchelitchew. Léger learned the city on foot and became an expert on its restaurants. Tchelitchew became the lover of Charles Henri Ford. Breton, politicized by the war, worked for the propaganda radio station Voice of America, and though he professed never to have learned English, he certainly knew enough to read, if not speak, it. The stripper Gypsy Rose Lee, also a writer and painter, became one of Ernst's few paying patrons. The young American sculptor David Hare, a cousin of Kay Sage, relieved Breton of his wife, Jacqueline. Duchamp later married Pierre Matisse's former wife, Teeny (Alexina), and Pierre Matisse fell for Matta's estranged second wife, Patricia. One way and another, integration of a kind occurred, though few of the émigrés intended to stay a moment longer than they had to.

Peggy's parties were long, crowded, and drunken, and typified by a self-conscious bohemianism. Other guests included the composer Virgil Thomson, the author William Saroyan, and the filmmaker Hans Richter. On the fringes were sports celebrities and film and Broadway stars. Peggy was not only making a mark as a figure in the art world, but as a hostess, even if not one who would gain acceptance by the New York gentry; but that was the last thing she was concerned with. She was good at dealing with the people she knew, and bringing them together gave her the beginnings of a sense of confidence, and a sense of belonging. These were the things that mattered to her. Not that it always worked; she was always defensive and often gauche, and her tactlessness ensured her as many enemies as friends. Her relative wealth and her charisma carried her through, but, essentially selfish as she was, she could be just as charmless as charming. Her only serious rivals as *salonistes* were the rich accountant, wheeler-dealer, and art collector Bernard Reis and his wife, who served better and more conventional food and drink, but whose soirées lacked sparkle, despite Breton's increasingly passé patronage (the Reises put up some money for his magazine, *VVV*) and his insistence that everyone play the Truth Game. Peggy, who is generous about the Reises' parties, recalled:

> We sat around in a circle while Breton lorded it over us in a true schoolmasterly spirit [he took the game very seriously]. The object of the game was to dig out people's most intimate sexual feelings and expose them. It was like a form of psychoanalysis done in public. The worse the things that we exposed, the happier everyone was. I remember once, when it was my turn, ask-

ing Max if he had preferred making love at the age of twenty,
thirty, forty or fifty.

At their own parties, when the mood took him, Max would create com-
plicated salads and curries; Peggy's pièce de résistance was a Mexican dish,
chicken in a chocolate sauce, a recipe Breton had brought back from a recent
visit to Mexico, to which she remained faithful most of her life. In December
1960 she sent the recipe to her great friend, the photographer Roloff Beny
(her spelling and typing eccentricities are retained):

1 chicken
50 salted almonds or not salted
1 handful dry raisons
2 handfull of dried prunes
6 grisini
one half finger of cooking baking chocolate
1 teaspoonfull of cinamon powder
1 bouquet of thyme or laurel
7 small onions entire
1 carrot
cooking Grate the almons as much as possible or still better pass
them through a grinding machine, grate the grisine and the chocolate,
mix all this with the cinamon,
 salt and peper the chic. fry it in butter (cut in parts) with carrot, till
gold take out chicken put onions in chic grease until golden. Onions
entire, put chic over the onions in a culender to keep warm while the
onions cook when the onions are golden put them together with chic add
boiullon made with cubes (if no other) and add all the ingredients that
have been grated AND MIXED WITH COLD WATER TO MAKE
A SORT OF LIQUID PASTE. Cover chic and onions with this paste
and the bouillon sufficient to cover the chic / add one handful dry raisons
(SULTANINA) two handfulls of dried prunes, chopped parsley & bou-
quet and allow whole to simmer for i hour or more/ chic should be cov-
ered with this liquid not too thick to simmer in order to simmer

Peggy had festooned a wall of her bedroom with her earring collection, a
fashionable thing to do at the time. Julien Levy once said, perhaps not with-

out irony, that the display had inspired Jackson Pollock. She dazzled young local painters, to some of whom she would soon become patron. She dressed badly and madly, and so did her peers, out to shock and to display their disregard for convention. At her parties Mexican and Native American clothes were frequent; no clothes at all was not unusual. Peggy stuck to her dyed jet-black hair and smear of scarlet lipstick, wore lavish earrings and bizarre costumes designed to show off and tantalisingly reveal her attractive body.

One element of integration that had not yet taken place was marriage to Ernst. With her combination of selfishness and tenacity, Peggy hadn't given up hope of success, despite the unremittingly negative signals she received from Max and the entry of the United States into the war following the Japanese attack on Pearl Harbor on December 7, 1941, but gave new energy to her campaign. Both Sindbad and Jimmy were now eligible to be called up. Sindbad was later enlisted, and served in the army throughout the war. Jimmy was rejected as physically wanting—one of a number of artistic types around his mother who were later to earn Sindbad's scorn for being "4F" (as opposed to "1A").

The outbreak of war changed Ernst's status. He was still a German national and, despite his anti-Nazi credentials, an undesirable alien. As such he could no longer possess a short-wave radio or travel freely around the country. Once again the possibility arose that he might be interned. Though there was little real likelihood of this, Peggy was able to play on his fears, based on his memories of privations in the French camps, and expressed the view that she didn't like the idea of "living in sin with an enemy alien." Max had no wish to give up the comforts living with Peggy afforded him, not least the freedom to paint. He wasn't in love, and she only thought she was, but for her it was desirable, for him expedient, to tie the knot. Pegeen could see that Max hated the idea of marrying, and told her mother so; Peggy poured out her heart to Putzel, who told her she should marry if she wished. Max, confronted, gave in.

To avoid both the bureaucracy of New York State and also any attendant press publicity, the couple traveled to Washington, D.C., to visit Peggy's cousin Harold Loeb, who was living there. They thought they could be married with the minimum of fuss and in the minimum of time in Maryland, where no blood test was demanded, as it was in New York. None of the children was particularly happy about the match: Sindbad had a gut feeling that it was a mistake; Pegeen had a crush on Max, and didn't want his attention

deflected away from her onto her mother; Jimmy, still in touch with his own mother by letter, felt that his last chance of getting her out of Europe was slipping away.

It turned out not to be as easy as all that to marry in Maryland. There were serious complications: the Peggy–Laurence and Max–Marie-Berthe divorce papers were in French, and Max had no papers at all relating to the ending of his marriage to Louise. Peggy and Max finally married in Virginia, where restrictions were minimal, on December 30, 1941, with Harold and Vera Loeb as witnesses.

The marriage might have made Peggy surer of Max, but it actually changed nothing. If anything it made matters worse. Their fights increased: On one occasion Max infuriated Peggy by using a pair of scissors that had been used by John Holms to trim his beard. (Peggy continued to mourn Holms: Each anniversary of his death was a painful occasion for her.) Max, feeling generally cornered, responded by being aloof, cold, and cruel. There were long and grudging silences; sometimes they wouldn't speak to each other for forty-eight hours. Max was superior in intellect and talent, and knew how to make Peggy feel inadequate. He was also narcissistic; but he had a fair idea of how limited his life in America would be without Peggy, and there is little doubt that Peggy, a strong personality herself, emphasized the point. She told Emily Coleman, who had now abandoned Arizona (and her rancher) for Hartford, Connecticut, that she loved Max for three reasons: "Because he is beautiful, because he is such a good painter and because he is so famous." But she resented the fact that he spent any money he made on Native American and Oceanic art, didn't contribute to the housekeeping, and failed even to put money aside to pay his income tax. Jimmy Ernst points out, however:

> A number of [Max's] extraordinary paintings went into Peggy's collection as part of a straightforward exchange arrangement under which Max's share of household expenses and his personal bills, a healthy share of which were owed to Julius Carlebach's treasure shop of primitive art on Third Avenue, were totalled against a fair market price for new paintings. It was a measure of Max's pride that he always insisted on a contribution from his side that far exceeded his obligations. What Peggy received in

value, more often than not, just about covered all of the establishment's running costs. It was unfortunately part of my job to keep the records and to participate in the embarrassing, strangely formal, bimonthly negotiations between my father and the woman with whom he was living. He must have been aware of my squirming during those long silent periods when Peggy studiously pored over the minutiae of detailed figures, sometimes coming up with a small discrepancy or a forgotten outlay. After each of these sessions he went out of his way to relieve my obvious distress. "I have never been much of a father to you, but it seems that I am teaching you things in spite of that. None of this is as strange as it may look to you now. I don't want to owe anything to anyone, and Peggy has to do it that way . . . it came with mother's milk. . . . Try to remember it if you ever get rich."

The artist Charles Seliger, who knew Jimmy, also remembers Max as self-important and self-absorbed: "He wouldn't help Jimmy, who was living in one room, and pretty poor and neglected." The core of Max and Peggy's relationship is summed up by the sculptor David Hare, a man closely involved with the émigrés, who told Peggy's biographer Jacqueline Bograd Weld that Peggy

> was a rich woman, a Guggenheim. She liked art and Max wanted to get here. Perhaps he was afraid that if he didn't marry her, he couldn't stay. He probably felt, "Why not?" Max wasn't a gentle person. . . . He was Germanic, sadistic. . . . He gave Leonora a rough time and Peggy, too. I don't think he was ever in love with Peggy.
>
> Max was cold-blooded about using her. But he did a lot for her too. She wanted to be bohemian. With Vail, Peggy was the boss, Vail was a ne'er-do-well, a hanger on; with Max, she was no longer the boss, and Peggy worried about toeing the line. Max was frightened about being here in America with no cash.

No simple lines can be drawn when discussing relationships: The participants themselves change their ground so often, and can be protean. The artist Dorothea Tanning, Max's fourth wife, whose marriage lasted until his

death in 1976, has scarcely a word of reproof for him in her memoir. However, Max, in need of a canvas, did once paint over one of her paintings for his use without asking her.

Peggy pestered Max about his infidelities and his continuing preoccupation with Leonora; though this appears justified in a wife, its justification may be diluted in the case of a husband *malgré lui*. Hence the problem Peggy herself defined: She wanted love, and Max wanted peace. Neither got what they required. At least it was a relief when Leonora finally left with Renato for Mexico.

Despite everything Max painted prolifically and well during this period. The work most directly allusive to their life together is *The Antipope*, completed early in 1942. There are two versions of this painting. Peggy refers to the first one, which she called *The Mystic Marriage*, in her autobiography as containing a direct reference to her:

> One day when I went into his studio I had a great shock. There on his easel was a little painting I had never seen before. In it was portrayed a strange figure with the head of a horse, which was Max's own head, and the body of a man dressed in shining armor. Facing this strange creature, and with her hand between his legs, was a portrait of me. Not of me as Max had ever known me, but of me as my face appeared as a child of eight. . . . In the center was a figure which Max admitted to be Pegeen's back, and on the left hand side was a terrifying sort of monster.

In the second version, the lines of battle are more fully drawn, as far as the principal figures are concerned. The armored horse on the right is Max, protecting a child-bride Pegeen, whose hand is on a spear positioned close to his genitals. On his forehead is an amulet of the hand of Fatima to ward off evil. The sad monster shrinking away on the left has Peggy's breast and belly, by her own admission. It also unmistakably has her narrow ankles and red shoes. The painting is still in Peggy's collection—an example, perhaps, of her resilience, or perhaps of a sense that any reference that may be taken personally in a work of art is a kind of compliment.

By the early summer of 1942 Max had generated enough new work for an exhibition. Julien Levy had temporarily shut up shop and enlisted in the army, and since Peggy's own gallery was as yet no more than an idea, it fell to

the Valentine Gallery to mount the show. To Max's great chagrin, it was not a success; Peggy herself, aided by Howard Putzel, did rather better at selling his work privately. The disadvantage of this was that she felt she should be in complete control of the disposal of his work. If he sold something independently, she would always consider the price disadvantageous. If he gave anything away, she would be furious. In one piece of bartering, however, Max met with Peggy's approval. He exchanged a painting with the collector Bridget Tichenor for a small dog, a Lhasa apso puppy. Little Oriental dogs—Lhasas, Pekingese, and shih tzus—were very popular at the time: Among many others Nancy Cunard's friend Jean Guérin, and Julien Levy, had them. Peggy fell in love with Kachina, as the animal was called, and would keep Lhasas from then until she died. They were not always very well groomed, or even housebroken; but they were loved, and they loved unconditionally in return: Peggy's most successful relationships were with animals and works of art.

Peggy remained intent on establishing a public gallery for her collection, which would also form a base for its expansion and a place for selling exhibitions. Her search was noticed by the jealous eye of Hilla von Rebay, who already thought the Museum of Modern Art had muscled in on her territory. Rebay had not forgotten the Guggenheim Jeune incident, and Solomon allowed her as much free rein as she allowed her adored Rudolf Bauer. No love was lost between the two women, but though it has been said that Rebay tried to suborn real estate agents into taking an unhelpful line with Peggy, she had no power to stop her. Solomon may have become her lover, and he may have been in thrall to her, but his patience had a limit, for all his kindhearted, optimistic, and generally easygoing nature. Hilla would have to be content with her dominion at 24 East Fifty-fourth Street, the converted car showroom that housed her museum, and leave Peggy to hers.

Soon enough, Hilla would have so many worries at home that Peggy would seem like a minor irritation by contrast. Her old lover Rudolf Bauer, still living on Solomon's generosity, had first tried to curry favor with the Nazis, but had then been jailed for illegal currency speculation. Hilla interceded for him, with the help of Solomon's money and a Nazi relative, and secured not only his release but his admission to the United States, with all his property, including his car, intact. He had arrived on August 3, 1939, and rewarded his former mistress by trying to usurp her position at the Museum

of Non-objective Painting. As a bona fide fugitive from the Nazis, he had complete freedom of movement; as a German citizen, despite the years she had spent in America, the baroness suffered the same restrictions as Max Ernst. For much of the time, unable to travel freely, she was stuck at her luxurious home in Connecticut, while Bauer spread rumors that she was a spy. Her house was searched; she was found to be hoarding food and almost went to prison. Bauer meanwhile added injury to insult by marrying the German-speaking housekeeper of the large house he had been provided with in Deal, New Jersey. This caused the ultimate rift with Bauer, whose own life then began to unravel (apparently he never painted again). His wife left him, he was unable to get by without Hilla's support, and he died insane in 1953. Hilla too, unpopular on account of her high-handed manner with artists and employees alike, never regained her former preeminence.

It didn't take Peggy long to find a location, above a grocery store at 30 West Fifty-seventh Street. The premises had formerly been a tailor's shop (they are again today), but they were high-ceilinged and light, if long and narrow. West Fifty-seventh Street, not so very far from the Museum of Modern Art and the Museum of Non-objective Painting, was beginning to be a center for modern-art dealers, and was conveniently located in midtown. The next problem was finding a designer. Peggy wanted her gallery to reflect the art it would be showing. She didn't want anything plush, opulent, and conventional, she wanted something that would in itself raise eyebrows and complement the works she was going to exhibit. Charles Seliger remembers that "as for the other galleries, like Knoedler and Rosenberg, you had to go into them like churches, whispering." Peggy was aware that Julien Levy had experimented with curved walls in one of his galleries—he had also been among the first to realize that modern works did not look their best against red velvet backgrounds—and wanted to take the idea further. Fortunately she had two ready and willing advisers at hand: Howard Putzel and, a little later, Marcel Duchamp.

Both have been credited with putting forward the name of Frederick Kiesler to her, and no doubt Duchamp endorsed Putzel's suggestion when he arrived in New York. Kiesler, then in his early fifties, was a German-speaking Jew originally from Romania (via Vienna), possessed of an ego in inverse proportion to his height (he was about four feet ten inches), and a highly talented, iconoclastic architect and designer whose theoretical work far outstripped the number of commissions he had received. Hilla von Rebay had

considered him for a time as the architect for *her* museum, and his major achievements included a theater-in-the-round, the first in modern times, in Vienna in 1924. Kiesler was friendly with the exiled Surrealists, and his apartment at 56 Seventh Avenue was another meeting place for the émigrés. He was a polymath and genius whose ideas were sometimes too wild to gain acceptance: Even the most daring architectural clients would choose Wright, Gropius, Mies van der Rohe, or Breuer before him. The one great building he designed (with his much younger colleague, Armand Bartos), the Shrine of the Book in Jerusalem, opened its doors in 1965, the year of his death. At his funeral Robert Rauschenberg painted a car tire red, white, blue, yellow, and green, and a string quartet played Schoenberg.

Kiesler had lived in the United States since 1926, and was currently earning a living by designing sets for the Juilliard School in New York. A meeting was soon arranged, and it was clear that he was full of original ideas. Peggy worried about the cost, but Kiesler submitted modest projections, and did not in fact go far over budget despite the clamor Peggy made when he did, and the arguments that ensued between them. Basically they were kindred spirits, and Peggy respected his originality. But the process would be slower than she had hoped or anticipated. Raw materials were less easy to find now that America was at war, and Kiesler was not a man to compromise. But his fee of $1,200 seemed not unreasonable, and for Kiesler this was a chance to vindicate his ideas on a major scale.

Peggy was, as always, open to innovation, and she was prepared to trust Kiesler as he came with the imprimatur of his old acquaintance Duchamp. Kiesler had not taken on a whole art gallery before, but his self-confidence, coupled with his innate sense of theater, made him the perfect person to design the kind of space Peggy had in mind. Both she and he agreed that the pictures should be displayed unframed—a new idea for the time, and one through which the painting was "freed"—and that the light and surrounding decor should complement the works of art to the fullest degree possible, while not detracting from them. Peggy didn't like the arrangements at the Museum of Non-Objective Painting, where the large, heavily framed canvases were hung at floor level and softly played Bach and Chopin were piped into every room: There the ambience seemed to get in the way of the pictures. "When I went there," recalls Charles Seliger, "I got so pissed off I did a double somersault right on their rug and they threw me out."

Peggy was eager for her gallery to open as soon as possible, but Kiesler

cautioned her in a letter as early as March 7, 1942, that "the development of new ideas . . . demand[s] a certain time—especially if [it] must be most practical—and it would be neither your nor my intention to ruin this excellent chance for a new art center in New York by rushing it through." Work was farmed out to a number of small workshops scattered throughout New York. However, even Kiesler's proposed May opening turned out to be too ambitious. It at last began to look as if the task would be completed by the autumn.

In the meantime Peggy worked on the catalog of her collection that she had started in Grenoble and, still using the list Herbert Read had drawn up for her (subsequently reworked by Duchamp and Nelly van Doesburg), continued to add to it. With so many European painters now living and working in New York and in need of an income, she was able to continue to buy advantageously from them, as well as to acquire works by other modern masters. Advised by Max and Jimmy Ernst, despite the latter's interest in local art, her taste remained rooted in what she knew, though she did begin sparingly to buy paintings by American artists, one of the first being John Ferren's *Tempora*, purchased late in 1941. She kept Herbert Read apprised by letter of her purchasing and dealing activities—he retained his status as father figure. In a flurry of activity almost rivaling that of Paris in 1940, she bought works by, among others, Archipenko, Calder (an important *Mobile* of 1941), de Chirico, Cornell, Giacometti, Klee, Lipchitz, Malevich, Miró, Mondrian, Ozenfant, and Tanguy. After his arrival in New York, Duchamp again assumed the role of her adviser.

In addition Peggy bought two Picassos, including an early Cubist work, *The Poet*, today one of the most valuable pictures in the collection, and Duchamp's *Sad Young Man on a Train*, which she bought from Walter Pach, who had long been a supporter of the modern art movement, for $4,000. Duchamp had been expecting the piece to go to his principal collector, Walter Arensberg; but as Pach didn't like Arensberg he sold it to Peggy to spite him. This painting is one of the most important in the collection. Peggy did come unstuck occasionally: she bought what she thought was a 1914 de Chirico, only to discover from Alfred Barr that the Museum of Modern Art had the original: Alas, de Chirico had taken to replicating his own works. Peggy subsequently exchanged an Ernst for a Malevich with Barr.

The new acquisitions were added to the catalog as they came in, keeping

its publisher, John Ferren's wife, Inez, busy. At the same time Breton, with
the help of Jimmy Ernst, who had had professional experience before the
war as a typesetter in Hamburg, set about expanding and improving the text,
which he had been highly critical of when first invited to look at it.

Taking over the editing of the catalog, which contained works by so many
of his surrealist colleagues and disciples, gave Breton a golden opportunity
not only to reaffirm his own doctrine but to introduce it to his new country.
Jean Arp contributed an introductory essay on abstract and concrete art. Bre-
ton's on surrealism was much longer, running to fourteen pages; along with
other contributions in French, it took Laurence Vail so long to translate that
publication had to be deferred. Mondrian and Ben Nicholson also con-
tributed articles, and Ernst designed the cover. The overall concept was Bre-
ton's. He included short personal statements by each artist, and where
possible a photograph of his or her eyes only. Laurence came up with a title,
Art of This Century, which, innocuous and factual as it was, still managed to
affront Hilla von Rebay, who saw it as a plagiarism of her own subtitle for
her museum, "Art of Tomorrow."

Breton had also been affronted—another reason why he wanted to keep
Peggy in his camp. Surrealism in its pure form was under threat; already it
had begun its decline. His immediate concern, however, was with rivals and
apostates. Dalí, with whom the surrealists had not been comfortable for
some time, had been in the United States long enough by now to have
achieved a good deal of remunerative notoriety. First, in a deal brokered by
Julien Levy, he had decorated the windows of the New York department
store Bonwit Teller. As Levy tells it (there are numerous versions):

> The story of the fracas made the evening papers. As Dalí con-
> ceived it, the central object of interest in his display was the old-
> fashioned white enamel tub in which was to lie a fully-clothed
> mannequin, wearing one of the dresses Bonwits was promoting.
> The window had been carefully arranged to Dalí's satisfaction
> the night before, but when he came back the next morning to
> look at it again, he found the management . . . had removed the
> prone mannequin from the tub and stood it to one side, to better
> display the costume. Seeing this, Dalí plunged raging into the
> store, into the window scene—and somehow, in the mêlée and

confusion, the tub was shoved through the huge plate-glass window. Opinion was divided as to whether or not Dalí had planned the entire episode as a publicity stunt.

Dalí had also been behind the original designs for an exhibit at the 1939–40 New York World's Fair, symbol of America's economic recovery, where Julien Levy had arranged for a surrealist pavilion, but compromises had to be made to meet the demands of the rubber baron who was backing it. An embarrassing aquatic theme under the title "Dream of Venus" was the result, complete with buxom, bare-breasted mermaids.

These ventures led Breton not only to cast Dalí out of the brotherhood, but also to saddle him with the nickname "Avida Dollars"—one of the best anagrams ever coined. Ernst snubbed Dalí less for his betrayal and vulgarization of surrealism than for his supportive attitudes toward Franco in his native Spain, and even toward Nazi Germany. "*Ce chien couchant*" (that toadying [lying] dog), he muttered to Jimmy as they crossed the street to avoid Dalí, who was approaching them, hand outstretched. Dalí himself always said he was less of a fascist than an opportunist, but for most such distinctions were not a matter for levity. Breton, on the other hand, was not above accusing his old friend but now enemy Paul Eluard, then working for the French resistance, of collaboration. Jimmy had his own reasons for avoiding Dalí. A couple of years earlier he had turned down a very unambiguous invitation from Gala. She never forgave him.

Ernst in his best work was a narrative political artist. Dalí, whose style was relatively easy and approachable, was still new for America, but the veristic surrealism he went in for had gained a wider audience than the abstract surrealism of, say, Miró or Masson; and his reputation was enhanced by the first full study of his work by James Soby, which accompanied Barr's Museum of Modern Art exhibition in November 1941. Sweeney wrote a similar work on Miró, whose art on a superficial level is also readily accessible, and who therefore provided an acceptable foil for Dalí in an exhibition that was probably designed to provide Americans with a palatable introduction to surrealism.

Breton found that his strict ideals were being either eroded or misunderstood. There was another problem: Young Americans who belonged to the art scene were keen to add their opinions. Charles Henri Ford, who had spent a good deal of time in Europe before the war, had one magazine, called

Blues, to his credit already, produced in his native Mississippi when he was still in his teens, which had been praised by Gertrude Stein. In 1940 he established a new title, *View*, with his colleague and friend Parker Tyler. The magazine ran from autumn 1940 until spring 1947, and was loyal to the tenets of surrealism, even to the extent of excluding Dalí from its pages, except for one scathing attack on him by Nicolas Calas ("Those who would like to see crutches in such abundance can go to Europe after the war; but those who want to paint the horrors of war should first look at the drawings of Goya!"). Dalí's only other appearance in *View* was in an advertisement he drew for Schiaparelli. There were those who wondered about Elsa Schiaparelli too—she kept her Paris shop open throughout the occupation.

Ford intended *View* to be the successor to the great European magazines put out of print by the war—the *London Bulletin, transition*, and *Minotaure*—and it quickly established itself as a leading commentator on the New York art scene, though it often concentrated on the work and influence of the older artists now living in exile in New York. It was partly paid for by advertising itself influenced by surrealism, which annoyed Breton; but some time after its establishment it gained as a background mentor that perpetual *éminence grise* Marcel Duchamp, who happened to have a friend in the advertising business. *View* subsequently published the first-ever monograph on Duchamp's work (in 1945), and devoted another entire issue to Tchelitchew and Tanguy (1942). It also published new poetry and a broad range of critical articles, with contributions from, among many others, James Johnson Sweeney, Sidney Janis, Paul Bowles, James T. Farrell, Henry Miller, Mina Loy, Wallace Stevens, and E. E. Cummings.

Well funded, *View* could afford to look handsome, and did. It was lavishly illustrated (artists asked no reproduction rights for their work, since the airing the magazine gave them was worth it), and elegantly laid out by Parker Tyler, one of whose jobs was picture editor. That the whole thing was produced from a cramped pair of rooms above the Stork Club (on Fifty-third Street just east of Fifth Avenue) made it even more miraculous. Its influence and readership went well beyond New York City, and it spread knowledge of the new movements in art and literature effectively and thoroughly. In 1942 there was a Max Ernst issue, with articles by Henry Miller, Julien Levy, and Ernst himself, and a portrait photograph of Ernst on his theatrical throne by Berenice Abbott. Trade advertisements in the same issue included one from Levy offering original Ernst collages at $25 apiece, and Peggy ran

an advertisement for her catalog ($3, but today a collector's item itself), as well as announcing the opening of her gallery towards the end of the year, "a research studio for new ideas of the creative effort"—itself a wonderfully 1940s concept. She had helped Ford canvass for advertisements for this issue, "and nobody said no to Peggy!"

Breton disliked *View* because he had no influence on it (he had proposed collaboration with Ford, but the wary Ford had turned him down: He didn't want to be taken over), and because its editors were gay—Breton was a homophobe. He also believed that he and his circle were the true custodians of the surrealist ideal and didn't want to see it vulgarized. Clearly a rival publication was necessary, to defend the authentic criteria of surrealism, and this Breton set about to create. The result was *VVV*—an acronym for *"pour la Victoire! Victoire! Victoire!,"* but elsewhere interpreted as "Vow/Victory, View, Veil."

VVV didn't want to exclude the Americans and needed an American editorial team. Having impeccable French connections, the painter Robert Motherwell coedited the magazine with Milton Gendel, who remembers that Breton played the role of idea man rather than working as a hands-on editor:

> He was very autocratic, imperial even—he wouldn't brook anything that questioned his code—which is how Motherwell and I came to be thrown out as editors of VVV. When we sent out Christmas cards in 1941, the action struck Breton as so bourgeois that he hit the ceiling. He said he'd been fighting the bourgeoisie all his life and we were vipers in his bosom. We were proud of the cards which were etchings we'd done at Bill Hayter's Atelier Dix-Sept in New York. We didn't see them as bourgeois, just as something which had come out of the Atelier. But we weren't "excommunicated"—we were just thrown out. We were amazed at the decision, more than anything.

They were succeeded by David Hare, who also had strong Continental associations. It was during his editorship that Hare met and fell in love with Breton's wife.

Duchamp, arriving back in the United States in June 1942, immediately

associated himself with the new publication. Less populist than *View*, but introspective, with many articles in French, *VVV* put out a mere three issues, the last publishing Leonora Carrington's account of her time in a Spanish mental hospital. Carrington, a darling of the surrealists, also published in *View*.

The failure of *VVV* may be seen as symptomatic of the whole fate of the surrealists abroad. Though it would be a very long time yet before their work would be called into critical question, the movement was foundering. It was based on a social order very different from that of New York. There were other problems: Not only could Breton no longer hold absolute sway here, but the group could not maintain its cohesion. There were too many new influences, and the artists, now middle-aged, were themselves too confused to maintain their loyalty to a cause that historical events were inexorably sweeping away. It was a time of enormous flux. Artists were among the first to recognize this, and artists worth their salt changed with the change. A corollary to the sense of cultural bewilderment was the fact that now the group was artificially held together: A group of exiles, most of them with an imperfect understanding of English and an imperfect understanding of the new world they had entered. They didn't necessarily like one another, but there was no escape from one another. The contact with American fellow artists was tentative, and most of the Americans were younger than the Europeans, and they asked questions. *View* supported surrealist tenets, but still put up a lot of homegrown creative work, and by its mere existence threatened Breton's hegemony. Disoriented by their new surroundings, disinclined to adapt, upset by their experiences at home, the exiles found that their sense of group identity lacked the validity they had hitherto believed in. Cracks appeared. At his *Artists in Exile* exhibition in March 1942, Pierre Matisse sadly noted the number of people present at the opening who tried to avoid one another.

Their gift to American painters and sculptors was that, even as their own movement was dying, they were able to pass on ideas that would be an inspiration to the development of the next forward thrust in modern art. It was a flawed gift, but in the main it was valid. The influential art critic Clement Greenberg, who soon after the war was able to claim some of the credit for promoting Jackson Pollock's career (Virginia Admiral says that Lee Krasner

persuaded him to lobby Peggy on Pollock's behalf) was dismissive about the true influence of the surrealists, but he was speaking from a partisan point of view, and his target was the dream surrealists rather than those who used abstract, semiabstract, and biomorphic form to express themselves. The great influences on the Americans were the abstract painters, but, as Greenberg admits, Miró and Klee were not without their sway. Those who did not survive the war stylistically were artists like Dalí and Tanguy. Others, such as Ernst, made their major contribution in the prewar and wartime years.

Ford, Motherwell, and Hare were able to bridge the Continental gap with relative assurance; the painter Roberto Matta Echaurren, born in Chile in 1912 and possessed of a very healthy ego, was another who did so. His early work inevitably suggests European influence: He studied in Europe but had lived in New York since 1939, from which time he had determined to challenge Breton's rigid tenets. Matta spoke fluent English and was energetic in his desire to bring about some kind of crossfertilization between Europe and America. Coming from a background affected by European cultural influence, not least of such poets as Apollinaire and Rimbaud, he was keen to introduce American fellow artists to them, without sacrificing local integrity in artistic expression to outside pull. His aim was to adapt Breton's surrealism to a version more suitable to exploitation by younger artists who were not part of the European tradition. However, not everyone wanted to belong to a school at all. This was a period in which everything was thrown into question, even the authority of the protean Picasso, who cast such a long shadow over so many. Charles Seliger observes that "so many US painters were so overpowered by Picasso that they could never get out from under him and so remained little Picassos all their lives." Even Pollock owed a debt to the master. The problem with Picasso was that as soon as you started to imitate a new approach he had invented, he himself would have moved on to another. The only way to escape from this bind would be to find a type of expression that circumvented Picasso's fundamental idea of form.

Peggy and Max intended to spend the summer of 1942 with Pegeen on Cape Cod. Max and Pegeen left New York before Peggy, who went to Washington in an attempt to usher through a visa for Nelly van Doesburg, still stranded in France. They took a house in Wellfleet, Massachusetts, where Matta was also staying. Max had chosen a remote house on the coast, but became worried when he learned that a few days earlier an American ship

had been sunk by a U-boat nearby. He moved back inland. When she joined them, Peggy found this house far from her liking and moved the family to a better place in Provincetown. There Max again quarreled with Pegeen, who had started to paint seriously, this time over studio space. The move also brought Max his first unfriendly contact with the FBI since his marriage, an indication of how little marriage to Peggy might have protected him if the authorities had felt like pursuing him seriously.

The move from Wellfleet—where Peggy may have aroused the ire of their landlady by reneging on the rental contract—to Provincetown was not reported to the police, as it should have been. Max was promptly arrested and questioned as a possible spy; his relationship with Matta, who was also regarded with suspicion, didn't help. In the end the Boston district attorney, once he had been apprised of Peggy's connections, sent Max back to New York, where Bernard Reis was able to sort out the misunderstanding and secure his release. Abandoning the idea of a summer out of town, Peggy rejoined him at Hale House.

The atmosphere there wasn't good. Sindbad had acquired a girlfriend, and had been looking forward to using the house for uninterrupted dates; Jimmy Ernst, similarly preoccupied with a girl, had lived in the same hopes. But there was another houseguest anyway, in the form of Marcel Duchamp, who had moved in following his arrival from Casablanca. Despite his familiarity with America (he would spend the rest of his life there), Duchamp did not make a universally great impression on the younger generation of local artists. They were not prepared to accept him uncritically, and he was not in touch with their ideas. For the moment, however, he was a welcome and influential support to Peggy as she continued to make progress in her new project.

Among other guests at Hale House that summer were the young composer John Cage and his wife, Xenia, herself a painter, who had met Max at an exhibition of his work in Chicago the previous year. Cage was keen on modern art, and had already stretched his modest means to buy a Jawlensky from Galka Scheyer for $25. Max had casually invited him to visit if he were ever in New York. Cage took the invitation at face value, and when he arrived in the city he telephoned Hale House from the bus station. Max answered the phone, clearly didn't remember who Cage was, but invited him and Xenia for drinks the following Monday. Cage, discouraged, hung up, but when Xenia reminded him that they had twenty cents between them

and nowhere to stay, he called back. This time Max (Peggy having jogged his memory) was much warmer, and told them to come over right away. The couple were given a guest room in the old servants' quarters, and Max introduced them to Peggy. She made a big impression on Cage, who responded to her enthusiasm and cosmopolitanism, though he found something indefinably unattractive in her personality at the same time. Any reservations he may have had were soon forgotten, however, and they became good friends and remained so for many, many years.

The Cages loved the atmosphere at Hale House, and the opportunity it gave them of meeting such a wide cross-section of artists. However, they were not spared a sexual initiation. One evening, toward the end of a drunken party, someone suggested a game that was designed to test the players' indifference, or lack of it, toward one another. The Cages, Max, and Duchamp stripped, while Peggy and Frederick and Stefi Kiesler looked on—the latter two "with contempt," as Peggy remembered. Duchamp folded his clothes neatly as he disrobed; Max immediately failed in the indifference stakes, as his eyes took in Xenia's naked body and his penis responded appropriately. The game ended in an orgy of sorts, in which Cage took Peggy to bed while Max did the same with Xenia. It was nothing serious: Sex for Peggy was, unless she decided otherwise, strictly without strings. But this was a crazy time for her. One night she went out late, alone and drunk, found a bar, and got into the company of some gangsters, who relieved her of the $10 she had on her but seem to have otherwise done nothing worse than take her for a Chinese meal at 5 A.M. Luckily none of them recognized her: She had told them she was a governess from New Rochelle.

Friendship could, however, be conditional, as Cage would discover after he and Xenia had been enjoying Peggy's hospitality for several weeks. The rift came when he announced that he had been engaged to give a concert at the Museum of Modern Art. Peggy, who had counted on his giving a concert for her own opening, was appalled that he was giving one for a rival institution, and announced in the middle of one of her endless parties that she would now neither offer him an engagement herself nor pay for the transporting of his instruments from Chicago to New York, to which she had previously agreed. Stunned, Cage made his way to what he thought was an empty room, where he broke down. In fact the room was not empty. He became aware of the smell of cigar smoke, and looked up to see Duchamp, sitting in a rocking chair. "Somehow his presence made me feel calmer,"

Cage remembered. He couldn't afterward remember precisely what Duchamp said to him, but it was something to do with not depending on the Peggy Guggenheims of this world. The advice was prophetic. Soon after this *contretemps*, Peggy announced that as she and Max were leaving Hale House, the Cages would have to find alternative accommodation. Though no lasting damage was done to the friendship, Cage had seen Peggy's claws unsheathed, and would be aware in future of her quickness to take offense.

In August 1942 Peggy gave a big party for her forty-fourth birthday, and at it Gypsy Rose Lee announced her engagement to the actor Alexander Kirkland. Many of the great and the good were also present, but the party was not an outstanding success. Not least for Peggy. Gypsy had already bought one of Max's paintings, and now Howard Putzel took her upstairs with Max to look at some more. Somehow the proposed sale was bungled, and Max ended up selling Gypsy one painting at a very low price, while throwing in another free as a wedding present. Peggy didn't hide her anger at this, and Gypsy, perhaps embarrassed, remarked that it was unfair that she should get a present when it was Peggy's birthday. Peggy herself had other things on her mind. While Max had been upstairs Duchamp (according to Peggy), who had been her platonic friend for twenty years, suddenly drew her aside and kissed her passionately.

Some weeks later, after Gypsy and her actor had been married at a theatrical midnight ceremony at Gypsy's country house, Duchamp, Max, and Peggy were dining alone. Peggy, drunk, left the room to strip off and slip on a transparent green silk coat, in which she came back and flirted outrageously with Duchamp. Max asked Duchamp if he "wanted" Peggy, and Duchamp, embarrassed but probably also amused, said no. Peggy proceeded to insult Max—she does not say how, but she does say she held nothing back—and he hit her, while Duchamp looked on. This bizarre scene did not bode well for any affair with Duchamp, and although Peggy insists that she did indeed have one with him, it is unlikely that it either lasted very long or attained much heat. Neither Hazel Guggenheim nor Pierre Matisse believed that it existed at all outside Peggy's mind, and David Hare felt that Duchamp's fastidiousness would have prevented him from making love to such a "vulgar-looking" woman—though Duchamp himself had spoken in the past to his great friend Henri-Pierre Roché about the joys of making love to women with beautiful bodies but ugly faces. He had also discussed with

Julien Levy the idea of a female robot whose lower parts could be lubricated mechanically by means of inserting one's tongue into its mouth.

Peggy's jealousy of Max, however, did not abate, and he delighted to play on it. Once at a house party in the Hamptons, the guests were about to return from the beach. Max and a young woman called Rosamond Bernier—later European features editor for *Vogue*—who Peggy says had begun to flirt with him, went on ahead on bicycles, arriving ten or fifteen minutes before the main party. Peggy, falsely suspecting the worst, made a terrible scene, though Max insisted that not even he could make love on a bicycle. "That quip was typical of him," Rosamond Bernier recalls. She and Peggy later became friends, but for the moment Peggy's weekend was ruined; she had made a fool of herself, and she was still jealous. The worst of it all was that her sex life with Max, never very active, had now ground virtually to a halt.

As the deadline for the opening of her new gallery approached, Peggy found herself coming into closer and at times disconcerting contact with Kiesler. Kiesler was not that badly over budget: He had quoted $5,700, perhaps deliberately underestimating in order to pander to Peggy's well-known parsimony and so secure the contract, and the final figures suggested something in the region of $7,000. Peggy accepted the increase grudgingly. She knew materials were in short supply and consequently expensive; and Kiesler wanted to have the best available: linen, oak, canvas, complex lighting, not to mention the degree of craftsmanship demanded by his designs. His eye for, and insistence upon, detail may have frustrated Peggy at times, but she acknowledged his talent and respected it.

More worrying was the way in which Kiesler saw the gallery less as a place for her collection to hang than as a testimony to the originality and brilliance of his design: He told her that the gallery's fame would ultimately rest on the latter, not the former. Kiesler triggered different responses in different people: He irritated some, charmed and intrigued others. The chief problem was that he had an ego to match Peggy's, though he had the sense to recognize the career benefit this commission would be to him, and despite spats and even fights with his employer, he was not going to walk off the project. He was also conscientious and professional. The gallery seemed set to open in October.

Peggy was not as concerned as Kiesler when a surrealist exhibition spon-

sored by the couturier Elsa Schiaparelli looked as if it might eclipse the open-
ing of the new Art of This Century gallery. The exhibition, to be held at the
Whitelaw-Reid mansion on Madison Avenue and called *First Papers of Sur-
realism*—a reference to the papers immigrants to the United States filled in at
the start of their naturalization process—was intended to raise money to
benefit French prisoners of war. Peggy gave her support, along with the
Arensbergs, Katherine Dreier, Mary Jayne Gold, Sidney Janis, Pierre
Matisse, the Reises, and others, but was too busy to be involved otherwise.
Schiaparelli had already acknowledged the influence of surrealism in gen-
eral and Dalí in particular in her designs, and a few years later would com-
mission Dalí to design her Roi Soleil perfume bottles; despite her
commercial interest in his movement, Breton was delighted to take on the
role of exhibition organizer, and enlisted the aid of Duchamp (always gener-
ous when it came to helping with such ventures) and Ernst.

Duchamp, an experienced installer of surrealist exhibitions, swathed the
interior of the building in a spiderweb of two miles of string, which impeded
spectators' progress and crisscrossed pictures. He had ordered sixteen miles
of it, fearful of running short, but obviously there was no shortage of string
in wartime New York. For the opening he secretly arranged for Sidney
Janis's eleven-year-old son, Carroll, and other children to play games under
the feet of the guests. Duchamp himself, according to his custom, didn't
attend; but here was a man who had once arrived at a dinner party to
announce that he wouldn't be coming.

The important contribution of the exhibition, which ran for just over
three weeks, was that it brought together works by contemporary European
masters and some of the younger Americans, notably those who had already
made contact in some way with the exiles: Motherwell, Hare, and Jimmy
Ernst, and also William Baziotes and Joseph Cornell. Breton, who had been
persuaded to include Picasso and Klee in the show, seemed to be broadening
his church: the "new" pictures extended to drawings of Superman and car-
toons by *The New Yorker*'s William Steig.

When the Art of This Century gallery opened on October 20, 1942, six
days after *First Papers*, any fears Peggy might have had of being overshad-
owed were dispelled. Kiesler had kept everyone away—even Ernst hadn't
been allowed in until two days before the opening—and now he was ready
to unveil his magnificent gallery to the world. The press was issued photo-

graphs of the installations taken by Berenice Abbott. The show comprised Peggy's total collection to date: 171 pieces, one of the most comprehensive collections of modern art in the country.

It is hard to convey the impression of originality that the gallery gave in 1942. At the opening, for which Peggy wore a white evening dress and one earring made for her by Calder and another by Tanguy, to express her equal commitment to the schools of art she supported, hundreds of people gathered and were astonished. Sidney Janis, not yet a dealer himself, was there, as were Breton and Leonora Carrington. Many invitations had been lost in the mail, but in the end that hardly mattered at all.

The earrings, however, did matter: Peggy was nonpartisan; she wasn't concerned with art theory and didn't discuss such questions. She was challenged on her views by Klaus Mann, a son of the novelist Thomas Mann, in an article in the *American Mercury* in February 1943, excerpts from which were reprinted in *Art Digest* in May. In his article, entitled "Surrealist Circus," Mann roundly attacked the movement and accused Peggy of bankrolling it. He called her gallery an "amusement area at a second-rate World's Fair." Peggy replied in a letter to *Art Digest* in June. While denying that she was a supporter or defender of surrealism, which seems odd, she proceeds both to support and defend it with some style: "It would seem that many of Mr Mann's 'facts' are entirely products of a rather malicious bad temper or of an abysmal ignorance. With regard to Surrealism, he seems to be in perfect accord with Hitler, even though his own hysteria may seem at this time slightly less impressive."

The large gallery space, which described a narrow U with its horns toward Fifty-seventh Street, had been divided into four distinct areas. Kiesler's innate and uninhibited theatricality showed itself everywhere, yet so skillful had he been that his designs enhanced rather than overshadowed the works of art. There were detractors, and among the established dealers, to some of whom Peggy was a *parvenue*, there was jealousy. Some said it was difficult to know where fairground ended and gallery began. But Kiesler's underlying intention was serious: to provide a space that interacted with the works it showed, and in that he seems by consensus to have succeeded.

With Kiesler's experience in the theater, each section's fixtures were so designed that they could be quickly dismantled and reassembled, giving great potential for fluidity and change. The walls of the room in which the

abstract and cubist paintings and sculptures were displayed were made of stretched canvas, like a theater cyclorama, but in ultramarine, and the floor was painted turquoise, Peggy's favorite colour. Peggy had her desk behind the screens near the entrance, but she preferred to spend her time in the gallery, rubbing shoulders with the visitors. The pictures were displayed unframed, supported by narrow cables stretched from floor to ceiling, thus appearing to float in space.

The Surrealist Room had a black floor and ceiling, and its walls were concave gumwood, from which wooden projections (often mistakenly referred to as "sawed-off baseball bats") held the paintings on gimbal mounts, so that the viewer (or rather a gallery assistant, though Robert Motherwell remembered that you could do it yourself) could angle the picture to view it from whatever angle he or she chose. The room was lit by lights that switched on and off every few seconds, illuminating one painting after another in a random sequence—this was so confusing that it was soon abandoned, at Putzel's suggestion. Additionally, and perhaps in mocking reference to Hilla von Rebay's Bach at the Museum of Non-Objective Painting, could be heard from time to time the roar of a train passing. A narrow adjoining room, the Kinetic Gallery, displayed Duchamp's *Boîtes-en-Valise* by means of an ingenious viewing machine based on the principle of the paternoster, and an object/poem by Breton, complete with the artist's portrait. On a revolving wheel viewed through a hole, seven works by Paul Klee were shown. Kiesler used great inventiveness in maximizing the space available to show as many works as possible, but he showed them in a highly original way. So reminiscent were some of his displays of peep shows, however, that the press happily nicknamed this section of the gallery "Coney Island."

The Daylight Gallery, the last room, was designed for temporary exhibitions. This was more conventional, having white walls, and windows screened by linen shades to diffuse the light. Here lesser paintings were stored on specially designed racks which visitors could leaf through, and special selling exhibitions, at the core of Peggy's achievement over the next couple of years, were mounted on the walls during the life of the gallery. Throughout, seating and display stands for sculptures were provided in the form of brightly colored biomorphic shapes, made of oak (some sources say ash, others birch, still others beech, but the surviving pieces suggest oak, which was Kiesler's own recollection) and using ordinary floor linoleum as their "upholstery," in four basic designs that could be used and placed in

eighteen different ways. They cost $6 each to produce. There were also additional collapsible canvas chairs in ultramarine.

Jimmy Ernst wrote the press release, and Peggy borrowed Alfred Barr's MoMA press list for the mailing. The press reaction was predictable. Most (typically Emily Genauer in the *New York World-Telegram*) reacted initially to the space more than the art, as Kiesler had predicted. *Newsweek*'s subheading ran: "Isms Rampant: Peggy Guggenheim's Dream World Goes Abstract, Cubist, and Generally Non-Real." The popular press yelled its outrage, while among the broadsheets and serious art reviews there were concern, criticism, and a sense of intrigue. Henry McBride, a respectable and open-minded critic for the *New York Sun*, said that his "eyes had never bulged further from their sockets"; the more daring Edward Alden Jewell at the *New York Times* wrote that he was "filled with a sense of wonders never ceasing." Of the Surrealist Room he wrote, "it looks faintly menacing—as if in the end it might prove that the spectator would be fixed to the wall and the art would stroll around making comments, sweet or sour as the case might be." Young artists like Paul Resika, who visited later, were knocked out:

> In the middle were stands that held all these Metzingers and
> Picassos and Delaunays, and then there was another room which
> was all dark, like a fun room, and that was the Surrealist Room
> with Ernst and David Hare, and then behind a curtain all the
> Pollocks were always on view and we kids who were the
> groupies of Pollock would always be able to see his paintings.
> And he was the only underground artist you could always see—
> you could never see a de Kooning or a Hofmann or a Rothko or
> anyone except Pollock because he was always there on view and
> people could come and acclimatize themselves to him.

Peggy could congratulate herself. By daring to engage Kiesler, she had broken far away from the more staid galleries and established something more than a *succès de scandale*. Visitors had been challenged to think differently about the way they saw the new art, at a time when the art itself was so new that it took some getting used to.

So successful was the gallery that Peggy, who charged a $1 entrance fee for the opening, in aid of the Red Cross, but who had allowed herself to be persuaded that entry should be free thereafter, now decided that a quarter

wasn't too much to ask for admission after all. Such a move was unheard-of among gallery owners, but Peggy's built-in moneygrubbing streak prevailed, and she set a bowl and a tambourine by the entrance for people to toss their contributions into. It was a more or less informal arrangement: Paradoxically Peggy was never a particularly good businesswoman, and could be generous and altruistic when it suited her. However, as always where small-time money was concerned, she was beadyeyed. She was quite happy to charge her colleague Sidney Janis a quarter when he came to view the gallery, and when Jimmy Ernst, deputizing for her when she went out to lunch, tried to let some of his poorer artist friends in free, he was caught: Peggy had waited downstairs in the lobby to watch the elevator dial and count the number of people going in, which was very small; on her return she counted the takings and informed Jimmy that they were $2.75 short: Eleven people had not paid.

In the end Laurence and Howard Putzel made her stop charging, but she did so unwillingly, and then not for six months, remarking with her usual hit-and-miss self-knowledge that she "couldn't give up [the] business of peddling a little."

Catalogs cost $3 apiece, and there were no complimentary copies. Even Aunt Irene had to buy hers. Meanwhile, arguments with Kiesler about his overspending led to a serious rift between Peggy and him. Defensively, he had even had to prevail on Jimmy Ernst to hide some of the bills—a futile tactic where Peggy was concerned. Only some time later was the fight patched up, when Kiesler gave a party for the second edition of *VVV*. Peggy wasn't invited but went anyway, disguised as a boy in Sindbad's clothes, with a burned cork moustache and beard. When Kiesler discovered her, he was so amused that they made up immediately and remained friends thereafter.

Peggy found herself spending more and more time at the gallery as her relationship with Ernst gradually deteriorated. The gallery opened at ten, and she would arrive an hour or so later, staying until after six. Ernst would wait until she had left before emerging to make himself breakfast, and then retire to his studio to work. Neither was any good at housekeeping, and there was never any food in the house, so Pegeen, generally ignored, led a miserable existence when she was at home. On the whole, though Peggy tried to put a brave face on it, the couple avoided each other; there is little doubt that Ernst would have left her if he had had anywhere to go. Meanwhile she matched

his infidelities, sometimes engaging Putzel's help to cover her tracks. It didn't always work out perfectly:

> One night when I had a rendezvous I told Max I was going to a concert with Putzel. He often really took me to concerts on Sunday afternoons. This particular evening Max must have suspected that I was not with Putzel because he suddenly phoned him to ask how much money he could get for a Chirico drawing that he wanted to sell. I had warned Putzel, but he had fallen asleep. When the phone rang, he awoke with a start and answered it, and to his horror it was Max. Of course it was too late to do anything about it, but he pulled himself together and hung up, saying, "I will phone you later." He phoned Max back and said he had left me at the opera to go home and turn off an electric stove he had left on by mistake. When I got home I found Putzel at my streetcorner waiting for me in pajamas over which he had hastily thrown an overcoat. It was snowing. He told me what had happened, and when we got to the house Max opened the door for us and I burst out laughing. There was nothing else to do. Putzel fled.

The gallery provided significant compensation for her unhappy home life, and there was plenty to occupy her in the setting up of temporary exhibitions. The first of these, before Christmas 1942, displayed Duchamp's *Boîte-en-Valise*, as well as a collection of Laurence Vail's bottle collages, about which Laurence wrote: "I still occasionally, and quite frequently, and very perpetually, empty a bottle. This is apt to give one a guilty feeling. Is it not possible, I moaned and mooned, that I have neglected the exterior (of the bottle) for the interior (of the bottle). Why cast away the empty bottle? The spirits in the bottle are not necessarily the spirit of the bottle."

There was also a number of Joseph Cornell boxes, which Peggy hoped visitors to the gallery might buy as Christmas presents—at the time they could be bought for around $50 apiece; she even gave away a handful as encouragements, but as a selling exhibition it was not a success. Laurence's bottles were not of great quality as art, and the Duchamp and Cornell pieces were too rarefied at the time to attract purchasers. But Peggy was not about to tread a safer line, and if the gallery didn't make money, she could afford to

subsidize it, at least for a while. Another element was that at no time did she intend to settle in New York permanently. From the outset her intention was to return to Europe as soon as the war was over and it was safe to do so, provided, of course, that Germany lost. By the end of 1942, with the vast resources of the Soviet Union and the United States ranged against it, that seemed increasingly likely.

In New York, Peggy initially followed the line of her old advisers Breton, Duchamp, and, to a lesser extent, Ernst, and continued to promote work very much in line with what formed the greater part of her permanent collection, and what she had exhibited at Guggenheim Jeune; but she was also innovative in her approach to themes. The first exhibition of 1943, which ran through January, showed works by thirty-one women artists. This was the first all-woman show in the United States, and credit for the idea is hard to place. Duchamp had probably suggested it to Peggy at some point earlier in their association, and Buffie Johnson mentions that she talked about it to Putzel, whom she'd gotten to know on the West Coast and in Paris. Whoever was responsible, the exhibition gained Peggy considerable cachet, and was of great significance for women artists; many excellent female painters and sculptors were active at the time, but the art world was dominated by men, and men commanded the lion's share of attention. It was to be a very long time before women artists gained anything like the attention their male counterparts enjoyed, and even today those prominent among the artists shown by Peggy are relatively unknown. What Buffie Johnson wrote in 1943 may still be true:

> Because there have been no geniuses among women painters, it has been assumed that they were not particularly gifted in painting. In view of the extraordinary and completely neglected painters we have rediscovered, and the signs of great talent emerging through the feminine emancipation of the last half century, a revaluation of women in painting is in order.

For her part Peggy never claimed to be a feminist, or even a protofeminist, as some have argued on her behalf since; but the effect of her exhibition certainly made it easier for women to be acknowledged as artists on a par with men, though the process didn't happen overnight. In the 1970s Peggy remarked to Jacqueline Bograd Weld, "I'm not a women's liberationist—at

least, I hate the exaggerated, overdone way it goes on nowadays. I certainly
believe in all the things they want and stand for, but I think they're making
too much of a fuss over it. They seem to be trying to do the world over in
their own image." Peggy, ready to stand up for herself though she was, and
able to afford to do exactly what she wanted, never questioned the male
domination of the art world of her time, and she herself did not get along
with many women; she wasn't especially friendly toward them, and she
regarded many as potential rivals, a feeling exacerbated by her own insecu-
rity. But she knew the publicity potential of an all-women exhibition.

Peggy was the only woman on the selection committee, which consisted of
Breton, Duchamp, Ernst, Jimmy Ernst, James Thrall Soby, and James John-
son Sweeney. The exhibition was predominantly of surrealist art, and they
decided on works by, among others, Leonora Carrington, Leonor Fini, Elsa
von Freytag-Loringhoven, Buffie Johnson, Frida Kahlo, Jacqueline Lamba,
Louise Nevelson, Meret Oppenheim (already famous for her fur-covered
cup, saucer, and spoon), Barbara Reis, Irene Rice-Pereira, Kay Sage, and
Sophie Täuber-Arp, as well as contributions from Djuna Barnes, Xenia
Cage, Hazel Guggenheim-McKinley (back in New York following the
death of Chick McKinley) and Pegeen Vail. One old friend now back in
New York who was not in the show was Mina Loy. Mina sold a drawing by
Richard Oelze to Peggy for $150, which she used to try to patent an inven-
tion, but otherwise she seems to have decided to withdraw from her old
friends of the Paris days, and she retained no happy memories of the shop
venture she had entered into with Peggy. She maintained contact with Julien
Levy, now her ex-son-in-law, but though Peggy invited her to parties and
she often intended to go, she could never quite bring herself to. It is interest-
ing to note that Peggy's committee showed no interest in the work of Gracie
Allen, subsequently famous as a comedienne in her pairing with her hus-
band, George Burns. Georgia O'Keeffe was approached, but turned Peggy
down: at fifty-five, she would continue to stand on her own feet as a painter;
she would not be categorized as a "woman" painter. Another contributor
represented was a thirty-one-year-old American called Dorothea Tanning.

It had fallen to Max Ernst to visit the studios of each artist, to view the pic-
tures selected, and to make the final choices. Peggy later joked that she
wished she had restricted the number of women represented to thirty, mean-
ing that the extra one—the one who was to prove fatal to her faltering mar-
riage—was Dorothea. Having long admired Ernst's work and having tried

and failed to meet him in Paris in 1939, Dorothea was delighted to have the opportunity now. In fact their first meeting had been the previous May, but in the public circumstances of Julien Levy's gallery. Her paintings had especial appeal for Max—resonances and complements exist in their work—and he selected a self-portrait, *Birthday*, which shows Dorothea bare-breasted in an extravagant costume before a series of open doors, a winged monster crouching at her feet. Max was as taken by the picture as he was by the artist. The couple felt drawn to each other almost instantly.

Dorothea was not too happily married to a naval officer away on duty, so the liaison—as it quickly became—between Max and her caused raised eyebrows once the secret was out: Max was, after all, a German. Though Peggy acknowledged Dorothea's talent as a painter, she found other reasons to disapprove of her: she was provincial and pushy, even tarty. She dyed her hair green (as Max had twice in the past dyed his blue), and wore outlandish clothes—one frock was pinned all over with little photographs of Max. But Peggy could hardly criticise outlandish dress: at one of her parties she wore an outfit skilfully torn to show that she had nothing on underneath. And it was a sore point that Max liked to dress his women.

The impression Dorothea herself gives in her autobiography, *Birthday*, is quite different from the one put about by Peggy and her friends. The critic Katharine Kuh remembered her as "special and delightful . . . a very understanding friend." Max too found the tranquillity with her that he couldn't have with Peggy. Dorothea's own account of their first meeting gushes:

> It was snowing hard when he rang the doorbell. . . . "Please come in," I smiled, trying to say it as if to just anyone. . . . We moved to the studio . . . and there on an easel was the portrait, not quite finished. He looked at it while I tried not to. At last, "What do you call it?" he asked. "I really haven't a title." "Then you can call it *Birthday*." Just like that.
>
> Something else draws his attention then, a chess photograph pinned over my drawing board. "Ah, you play chess!" He lifts the phrase like a question and sets it down as a fact, so that my yes is no more than an echo of some distant past exchange. . . .
>
> We play. It has grown dark, stopped snowing. Utter silence pervades this room. My queen has been checked twice and is in a very bad posture. Finally I lose. What else could I do under the

circumstances? All thoughts of defense, counterattack and general strategy are crowded off the chessboard and I see only the room with two pieces in it, my space challenged, my face burning.

Peggy could not play chess.

She reacted to Max's infidelity immediately: Leonora Carrington, beautiful and poised, had at least been a worthy rival, one whom Peggy could understand Max falling for. Now Peggy had loved and lost again, and she couldn't accept it. With all her insecurities about her looks, and now also about her age—she was in her mid-forties—she started to sleep around again, in the hope that it would make Max jealous. Charles Henri Ford remembers meeting her at a party, "and there was a rather attractive young man there too and Peggy and I took him back to her apartment, and everybody got undressed and Peggy was looking over his shoulder at me and said to me, 'You have a very good body'; and so we all got into bed and had a sort of threesome, and when it was over he asked for $20, and I guess Peggy always had what was called mad money so, no problem, he got the $20 and left—I guess it'd be $100 today; everything has gone up, especially sex."

Peggy tried to banish Max from Hale House, only to find that this drove him further into Dorothea's arms. She mocked his poor command of English: Laurence, having broken his leg in a skiing accident, came to convalesce with her, and she would say to him in Max's presence, "Go out and fetch some whiskey—you're the only one who can speak English." Fights became more frequent: She threatened suicide; he countered by saying that he wished to go away with his new lover to Arizona, that he was only really after a fling. Max's own sense of guilt—after all, if it hadn't been for Peggy, heaven knew what fate might have awaited him—compounded the complexity of their situation. But after a time it becomes impossible to go on lying, even to oneself, about feelings. Max knew he could never go back to her. Everything she did confirmed it. Jimmy was pleased to be out of the firing line; he had private griefs, too: Since Germany had annexed Vichy France, his mother's fate was sealed.

Peggy leaned on both Duchamp—their brief affair, if it was ever really that, had come to an end after Mary Reynolds's arrival from France early in April 1943—and Howard Putzel; but they could offer only empty words of comfort. Duchamp had problems of his own at the time: he had escaped the war entirely, but Mary had worked for the Resistance, and helped many,

including Jean Hélion, to escape. Katharine Kuh remarked: "Duchamp I think must have felt somewhat guilty because he escaped the whole war by coming to America. He always remained devoted to [Mary] in a way, but I don't think they ever lived together again."

Peggy's misery continued. She suffered from insomnia, cried all the time, and became ill. Within the little village that was the New York art world, it was impossible to avoid coming into contact with Dorothea, and her apartment on Fifty-eighth Street was not far from Peggy's gallery. But Peggy would not give up her place in that world, and her gallery became all the more important to her. In the end she also found some relief in writing about the breakup, painting Dorothea in the darkest colors. Rosamond Bernier, who knew Peggy then, sums it up:

> I always liked Peggy—there was never any antagonism between us. The problem with Max was that she was always so very jealous of him—he didn't love her and she knew it, and she knew very well why he had married her, but she was possessive and she hung on as long as she could—until Dorothea came along, and the rest is history. If anything I felt sorry for her—there was something very vulnerable about her and one felt that she wanted to be liked and wanted to be loved and didn't really know how to go about it, and although I was very much younger than she I was very conscious of this vulnerability, so that later on, on postwar visits to Venice, I'd always look Peggy up and ask her out to drinks or lunch at Harry's Bar.

The first season at Art of This Century continued with a retrospective exhibition by Jean Hélion. Much had happened to him since his last meeting with Peggy in Paris a couple of years earlier. Before the war he had been a member of the *Abstraction-Création* school founded by Anton Pevsner and his brother, Naum Gabo, under the leadership of Vantongerloo in 1931, and his cool abstract forms (he later reverted to figurative painting) were gaining him a considerable reputation. He had lived for a time in Virginia before the war, where he'd married and had a son, but had returned to France to fight. He was now approaching thirty-nine, and had managed to return to the United States following a dramatic escape from a German prisoner-of-war camp. The publisher Dutton had approached him to write an account of his

wartime experiences, which appeared in 1943 under the title *They Shall Not Have Me*—a book that not only gave Americans an idea of conditions in Europe but carried considerable propaganda value. It is written with great sensitivity and restraint, and conveys the impression of a decent, fair-minded, and kind man who, had he wished, might have made as much of a career as a writer as he did as a painter.

Hélion was delighted to have a one-man exhibition: He had been captured in June 1940, escaped in February 1942, and arrived in New York later that year. The opening, on February 8, 1943, was held in aid of the Free French Forces, and Hélion gave a talk on his experiences. Afterwards there was a party at Hale House, attended by, among others, John and Xenia Cage, Charles Henri Ford, the painters William Baziotes and Robert Motherwell, and the dancer and choreographer Merce Cunningham. Also there was the seventeen-year-old Pegeen. Hélion talked to her, and found her an unhappy creature, partly protected by an acquired hard veneer but transparently vulnerable underneath.

Pegeen was partly responsible for a catastrophe that befell plans for the next exhibition, a series of cover art (not all of which was, of course, ever used) for Breton's magazine VVV. Breton and Peggy had already had a row about whether or not she should pay for an advertisement in the magazine for the show. Despite the fact that Peggy had been supporting him financially for some time—he was still writing begging letters to her as late as 1965—Breton refused to allow her a free advertisement. Pegeen added fuel to the fire by calling the surrealists "cheap," which deeply offended Breton. The exhibition was canceled, and an alternative had to be arranged at short notice.

The replacement was a review of fifteen early and fifteen recent paintings by the central group of surrealist painters, as well as Kandinsky, Mondrian, and Picasso. Peggy also included, to spite Breton, three works by Dalí. This was followed by a general art of collage show, of interest because it marked the first appearance of Jackson Pollock's work at the gallery (almost certainly through Robert Motherwell's intercession), and because it was the first international collage show ever mounted in the United States.

The next significant exhibition was held between mid-May and mid-June. The so-called Spring Salon stemmed from an idea conceived originally by Herbert Read in 1939 as part of the policy for the projected London modern art museum. One of Peggy's tenets in the press release for Art of This

Century read: "Opening this Gallery and its collection to the public during a time when people are fighting for their lives and freedom is a responsibility of which I am fully conscious. This undertaking will serve its purpose only if it succeeds in serving the future instead of recording the past." As her relationships with Ernst and Breton cooled, so their influence over her waned. The European artists were, in the main, older, established, and set in their styles. If she was to serve the future, she would have to look at the young American artists who had been so keen to rub shoulders with the Europeans, but who were not necessarily going to hang on their every word. Serious American art critics came to Peggy's shows and wrote intrigued reviews. She was also coming much more under the influence of her American colleagues—James Johnson Sweeney, James Thrall Soby, Alfred Barr, and, particularly, Howard Putzel. Putzel had become, if not disaffected with European art, at least aware that there was little new to see by the end of the 1930s. As soon as he got back to New York in late July 1940 he wrote to the owner of the Downtown Gallery, Edith Halpert, asking for a job, giving an impressive list of references, and adding: "Although I looked for new talent in Europe for about two years, at the expiration of half that time it seemed clear that for the past decade nothing really new was painted in Europe. (The exception of Picasso is, after all, an exception.) This continent will very likely be the new home of art." He didn't get a job with Halpert, but he soon started to make his own contacts, meeting young American artists at parties held at filmmaker Francis Lee's Tenth Street loft.

Several young Americans had had work in Peggy's collage show, and now the gallery threw open its doors and invited submissions from any artist under the age of thirty-five. Once again a selection committee was formed, this time consisting of Barr, Duchamp, Mondrian, Putzel, Soby, Sweeney, and Peggy—a group suggesting a significant shift away from the surrealists, and also marking the coolness that had arisen between Peggy and Max, and Peggy and Breton. Jimmy Ernst came back to help, but he had quit his job as Peggy's secretary to cofound a gallery of his own. His gallery, the Norlyst, which opened early in 1943, was the brainchild of his girlfriend and now business partner Elenor Lust. Helping them in their venture was Charles Seliger, who had already been an awed visitor to Art of This Century, and who would become, at nineteen, the youngest painter to show there.

* * *

With Jimmy's departure from Art of This Century and his replacement soon afterward by Howard Putzel, the change of emphasis and influence would be complete. Putzel is so important not only to Peggy but to the history of American appreciation of modern art in the twentieth century that a short digression on his career is valid here. Putzel is an unsung hero of modern art patronage. He was a true enthusiast and pioneer, and his eye was both educated and instinctively good. He was born in New Jersey in 1898, his father, like Peggy's maternal grandfather, an importer of lace. Never a good businessman, Putzel failed to manage the family firm after his father's death, and by the age of thirty he was already involved in the modern art movement as a critic, and soon afterward as a dealer; though here again, despite his instinct for what really had staying power in the new art, his calamitous business sense let him down. With his other weaknesses, physical and psychological, his inability to make money helped shape his sad fate. He was also notoriously clumsy: James Thrall Soby remembered him as "a born assassin of works of art . . . he broke something almost every time he moved things in from the storage space."

Lacking funds himself, Putzel was eager to hitch his wagon to someone who had them, and probably from his first meeting with the equally enthusiastic Peggy Guggenheim back in New York, he set his cap at her. After unsuccessful ventures on the West Coast and his prewar period in Paris, he had returned to the United States relatively rootless, but with his enthusiasm undiminished, especially now for modern American art. At the time he took over secretarial duties at Art of This Century from Jimmy Ernst he was well qualified to take over artistic policy as well, and effectively did so, with Peggy's compliance, until he felt confident enough (and fed up enough with Peggy's bossiness) to go solo. His influence over Peggy was great: She respected him, felt relaxed with him, and trusted his judgment. For a time it was a perfectly symbiotic relationship. What ultimately went wrong was caused by her envy of his cachet and mistrust of his financial reliability, as well as his increasing resentment of being put down by her.

Putzel had a great influence on Peggy. His major achievement was in convincing her that Jackson Pollock was worth supporting. But there were many other considerable young artists whom she might not have reacted to without him, such as Mark Rothko, who had also been introduced to Putzel by Buffie Johnson. Peggy acknowledged her debt to Putzel when she wrote to Hermine Bernheim, author of a biographical study of him:

I would like to say that Putzel had much more influence over me than I over him. . . . I think he had a great influence in discovering, encouraging, and exhibiting the artists of the abstract American school. As far as I remember [a typically disingenuous Peggyism] he specifically admired Pollock . . . Rothko, Gottlieb, Pousette d'Arte [*sic*], Motherwell and Baziotes. . . . He was in a way my master: surely not my pupil.

The opportunity of showing at Art of This Century was irresistible to all the young artists who heard of it, and word spread quickly through the studios and attics downtown around Tenth Street. It is hard today to realize how small a world was the one encompassed by modern art, how few the sales and how rare the opportunities to get one's work seen. Certainly interest had grown over the past decade or so, and the work of Barr and Rebay, as well as gallery owners like Levy (who, as the son of a major property developer, was, like Peggy, wealthy in his own right and so could afford to subsidize his artists to some extent) was of immense importance. Other established dealers tended to sell established European artists whose work was rooted in prewar styles.

With the coming of war, whatever growing interest there had been had slackened. Younger male artists not in the armed forces, generally for reasons of health, were nevertheless frowned on by the general public. Sindbad, in the army and based at Tampa, Florida, commented that his mother and her circle didn't know there was a war on. The soil did not appear to be fertile, though for those few enthusiasts who had an eye, the opportunities for making immeasurably profitable investments in modern art were great. Paradoxically that was not how the business worked: It was scarcely even a business—one bought not because one expected a painting to appreciate, but because one loved it. If Peggy was penny-pinching on things like food and her clothing budget, it was in order to keep as much as possible to spend on art. Her income from capital was relatively not that great. In the early to mid-1940s it was around $35,000 a year. Not hay, as someone remarked in another context, but not John Hay Whitney either. And she continued her Guggenheim Jeune policy of buying from her own exhibitions. Peggy was hugely important, after the end of the Works Progress Administration, to the furtherance of the careers and the relative financial well-being of many young American avant-garde artists. Her passion was genuine. She wouldn't

spend more than $125 a year on clothes, giving rise to a famous "one dress a year" legend. Her money, when it went anywhere generously, went into art, into buying paintings, and running her loss-making gallery. In the end she even cut off Laurence Vail's long-standing "allowance" in the interest of keeping her gallery (and her own exchequer) afloat.

The artist and dealer David Porter's personal memory of Peggy is as "a very warm, very talkative person—who often talked without first considering what she was saying—she had certain off-the-cuff opinions. But she was also a good listener and humble enough to know that she didn't know much about certain things." He is unsure whether or not she had a good eye for a painting, but agrees that her taste in advisers was unerring:

> Life was a game to her—Marion [his wife] thinks she was too much in love with herself to have anything left over to love a man with. She liked being the centre of attention, and had a big ego, as if she were saying: "Why shouldn't people love me? I'm rich and sexy and fun to be with." Everything dollarwise went into her art. I remember her wearing a dirty old black skirt and cowskin ankle boots in brown and white, scuffed. She wore them all the time, even at parties. But she was a marvellous cook—I remember she did chicken livers and mushrooms in red wine, and she used real copper pans, and took her cooking seriously.

If the jury remains out on the question of whether or not Peggy had a good "eye," there can be no doubt that she chose good advisers and had the humility to listen to them. Both Charles Henri Ford and the art critic John Russell remember her as having a "passive" personality. She waited to receive impressions. That seems to run counter to the person who founded Guggenheim Jeune and Art of This Century; but Peggy was unsure of her taste. In her favor must be placed the fact that the people she did gather around her did not need to be there, and she was always alert to the point of paranoia to the possibility of being exploited. Their presence gives the lie to the impression of empty-headedness she sometimes imparts, especially in her own writing. Lillian Kiesler, Frederick's second wife, says:

> It's true that she was at the same time aggressive and defensive, that she never managed to have a really fulfilling relationship,

that she was lonely and that she lacked self-esteem. But she had an extraordinary gift, and achieved great things, without even knowing that she was doing it! She was egocentric, she could be small-minded, her hauteur and affected coldness could put people off; she was isolated and lonely, and desperately unsure of herself; but she was not a fool.

Matta was a major pro-American influence on Peggy. He tried to persuade her to use her gallery to promote the "new American automatists," and had ambitions of his own to assume Breton's mantle in the United States. Peggy didn't fall absolutely into line with his ambitions, but he encouraged artists he believed to be of promise to submit work for the Spring Salon, and he may have suggested to William Baziotes and Robert Motherwell that they ask Jackson Pollock, who was establishing a modest reputation, to do so. Pollock, whose famous soubriquet "Jack the Dripper" belied the serious intent of his work, had been preceded in experimentation with automatist and random techniques by, Gerome Kamrowski, Motherwell, and even Ernst, but he was the first to take them to such an extreme. Arriving in New York in 1930, aged eighteen, difficult, violent and unsure of himself and of his sexual orientation, coming from a rural Wyoming background, Pollock at first fitted uneasily into the city's art milieu; but he had a faith, if deeply hidden, in his talent that was rewarded. He came to personify the new American voice, something the publicists were not slow to exploit, despite the fact that Pollock's spiritual father was Picasso. The farm boy with a wild streak, the independent, hard-drinking, tough guy: That was the image, far from reality, that appealed. He just preceded the American heroes of the tradition ushered in by James Dean, Jack Kerouac, and Elvis Presley.

The Spring Salon exhibition included works by Baziotes, Motherwell, and Pollock, as well as Virginia Admiral, Peter Busa, Matta, and Hedda Sterne, but it was Pollock—his entry was his 1942 *Stenographic Figure*—who most excited the selection committee. That it was included at all was owing to Mondrian. The first of the selection committee to arrive, he lingered by the Pollock while Peggy was ready to dismiss it. His enthusiasm for the work stunned her at first, then intrigued her, and finally, inevitably, because of her admiration for Mondrian, she was won over. In fact Mondrian had an ulterior motive: He was on the jury largely because wanted to plead the case for the inclusion of a sculpture by his benefactor Harry Holtzmann, then on the

West Coast: Holtzmann had saved Mondrian from semistarvation in Paris
in 1940. Mondrian wanted to show his gratitude, and anyway admired
Holtzmann's work. The quietly achieved tradeoff worked. Mondrian's
acceptance of Pollock encouraged Peggy to be equally open-minded about
Holtzmann. Luckily the other members of the committee concurred.

Press reaction to the Spring Salon was favorable if not ecstatic. Robert
Coates, in *The New Yorker*, wrote: "despite a faint air of the haphazard about
the hanging and a certain amount of dead wood in the paintings, the new
show at Art of This Century deserves your attention . . . in Jackson
Pollock . . . we have a real discovery." In *The Nation* Clement Greenberg
wrote: "It is a good [show], and for once the future reveals a gleam of
hope . . . there is a large painting by Jackson Pollock which, I am told, made
the jury starry-eyed."

After the show, almost certainly at Putzel's prompting (Peggy preferred
Baziotes's work), Peggy not only agreed to arrange a one-man show for Jack-
son, but also put him under a one-year contract; this was an unusual step in
those days, though not unheard of; and Peggy wasn't taking any great risks.
She undertook to pay him $150 a month, virtually in return for Pollock's
entire output during the period, given that his sales had small hope of out-
stripping the value of the year's stipend: The gallery would have to sell $1,800
worth of his paintings, plus a one-third commission of $900, for Pollock to
break even. Any shortfall would have to be made up in paintings. Neverthe-
less the contract enabled Pollock to give up the poorly paid employment—as
an odd-job man at the Museum of Non-objective Painting—he had taken to
support himself; he would now have greater freedom to paint. In Rebay's
defense, it should be said that she employed artists at her gallery to help them
support themselves, and regularly doled out small sums ($15 a time) for
painting materials. Very cordial letters from Pollock to Rebay exist from the
spring of 1943. However, Peggy's patronage of Pollock was to start a trend as
dealerships expanded after the war.

Baziotes had sold his two paintings at the Spring Salon for $150 each. Pol-
lock hadn't sold then. Peggy's offer of $150 a month was still pretty tight for
the Pollocks; Peggy did not get along well with Lee Krasner, Pollock's wife,
and the feeling was mutual; but Lee, who had largely abandoned her own
career to further her husband's (his biographers point out that she fell in love
not with him but with his art), always acknowledged the importance of the
help Peggy gave them. Peggy paints a picture of herself as the self-sacrificing

dealer and patron, selling a much-loved Delaunay in order to keep "Pollock and the gallery" going, and bemoans the fact that she never sold a Pollock for more than $1,000. She gave many away, sometimes in order to gain tax concessions; but she was irritated by the fact that Lee, who hung onto her Pollocks long after his untimely death, was able to see them increase in value to millions of dollars each. Peggy's bitterness in this context led her unsuccessfully to sue Lee in later years over Pollocks still in Lee's possession that Peggy believed to be hers by right contractually. Pollock, who was forty-four when he died in a car crash in 1956, at the end of a long road of alcoholism and self-doubt, could never have dreamed what an iconic figure he would become posthumously.

Though her first meeting with the Pollocks at Jackson's studio had been disastrous (he'd been late, turning up drunk from the artist Peter Busa's wedding, where he'd been best man, making Peggy furious), she launched the career of one of the most important and controversial American painters of the twentieth century. His painting *Alchemy* still in the Peggy Guggenheim Collection, is its most valuable work. Whether Peggy would have given him such support without prompting is another question: But Peggy needed backup for every decision she made. It would be a mistake to assume, however, that Pollock would not have succeeded without Peggy: He had champions in Putzel and in Piet Mondrian, and both James Johnson Sweeney and James Thrall Soby, as well as the critic Clement Greenberg, were strong supporters. One other thing seems clear: Peggy and Pollock were never lovers, though the thought crossed both their minds on at least one occasion. They may have made it into bed once, but only at Peggy's insistence. Jackson found her totally unattractive: He's reputed to have said, "to fuck Peggy you'd have to put a towel over her head first." But if an attempted coupling did take place, he would certainly have been too drunk to do more than urinate. Of all the legends that have grown up about Peggy's sexuality, including those involving bestiality, this is one of the most open to scepticism.

The Spring Salon marked the end of the first season for Art of This Century. That summer the rupture with Max Ernst became complete—he would later move with Dorothea, whom he subsequently married, to Arizona. The breakup was not without bitter arguments over the ownership of his paint-

ings, and even the dog, Kachina, became a focus for acrimonious disagreement: Max finally managed to kidnap it when she was out.

Peggy, humiliated and desperate for love, and finding little consolation in profligacy, brooded about what to do next. To remain in Hale House was not an option she viewed with any enthusiasm—it was too full of memories of her brief marriage. Earlier in the year she had met a rich Englishman, Kenneth Macpherson, reputed to be in the secret service, who had helped produce a letter in support of Ernst's application to enter the United States. A collector himself, he'd been interested in buying some of Max's paintings, and had visited her with that end in view. Later on she'd sat next to him at a performance of *Don Giovanni*, "and a strange current seemed to pass between us." Now she decided that she had fallen in love with him. How far she believed in this self-delusion is unclear, but Macpherson was openly homosexual, and was in fact, having stepped into Robert McAlmon's shoes, in a marriage of convenience to the vastly wealthy English lesbian poet Bryher. Bryher, however, had remained in Europe with her lover, and now the war separated them—a fact neither spouse regretted. Kenneth was also a friend of Howard Putzel.

Perhaps Peggy entertained some idea of platonic love, having found so little satisfaction in the other kind. Certainly Macpherson shared her interests, and as, through his marriage, he was wealthy in his own right—Bryher had inherited a large part of the enormous estate left by her father—would make no claim on her purse. Peggy had always been an Anglophile, and Macpherson had very cleancut, English good looks. It is true that he was feckless and narcissistic, with wardrobes full of impeccable suits, and that his dressing table was loaded with more cosmetics than most women's, and Peggy was not blind to these features of his personality; but she needed to be with someone, and Kenneth's cultivation, charm, and urbanity suggested a safe haven for her unanchored heart. The fact that she was settling for another egoist seems to have passed her by. It is possible that menopause may have affected her behavior at this time.

Within the budget she allowed herself, she made every effort to refine her extremely haphazard dress and to dye her hair and apply makeup more carefully. Hitherto her approach had always been so slapdash that it seemed she wanted to make herself appear less attractive than she was: a kind of inverted bravado. As far as Kenneth was concerned, she went to great efforts to justify her feelings to herself: "He needed to be admired and to be loved.

Partially his mentality was that of a college boy; intrigues were an important pastime with him. He liked to have a lot of people in love with him. Not that this brought him any real satisfaction, because his life was fundamentally unhappy." There was something else: "[H]e seemed to spend most of his time listening to [classical] music. His phonograph played all day. He drank more than anyone I have ever known, except John Holms."

All this was having a terrible effect on Pegeen, in whose childlike paintings sad, doll-like people inhabit the same space but never share it. In the summer of 1943 Pegeen traveled down to Acapulco with the Reises' daughter, Barbara, and after spending a few nights (at his invitation) on Errol Flynn's yacht, she picked up a young Mexican who was one of those who dived from the great cliffs to earn money by amusing the tourists. She fell for him and moved in with his family. Barbara raised the alarm at home, as did Leonora Carrington, now living in Mexico. By October, Pegeen had not returned. Laurence, whose leg was still not completely healed, set off to retrieve his daughter.

Peggy and Kenneth decided that they would find a house or an apartment to share. He found his present one too small and Peggy needed to get out of Hale House, which by now had changed hands. Each, they told themselves, would be glad of the other's company, but they needed somewhere that would give each of them a measure of independence and privacy. They found a large duplex apartment for October, and Peggy, who'd grown closer in friendship to Laurence as her personal life became more unsettled, decided to spend the summer near where he was living in Connecticut. The problem was that residences on the shore of Candlewood Lake were not rented to Jews. Peggy seems to have taken this affront philosophically and, when Macpherson refused to sign the lease for her, she asked a young friend whom she'd met through Virgil Thomson, the composer and writer Paul Bowles, to do it. Paul Bowles remembered:

> Peggy called me and asked me if I would mind leasing the place in my name and then "inviting" her to spend the summer. I said that I was not good at deception, but that I would do it. I had to go downtown to an office high above Broadway and talk with a jovial man who took my check and made out a three-month lease in my name. Jane [Bowles's wife] and I went with Peggy and Kenneth MacPherson [*sic*] one weekend ... friends were staying

in the other house, and we all ate a jolly, enormous, endless meal. When the season was over, Peggy gave me the keys, and I returned them to the office on lower Broadway.

Peggy and Paul Bowles later had a professional connection through a short-lived venture into recording modern music: Art of This Century Recordings cut only one album. Volume 1 was a sonata for flute and piano by Bowles, recorded, finally, in October 1944 by René le Roy and George Reeves. Volume 2 was "Two Mexican Dances," played by pianists Robert Fizdale and Arthur Gold, then young music students. The album's cover was designed by Ernst. The friendship with Bowles and his wife, Jane, herself Jewish, lasted the rest of Peggy's life.

As a result of Paul's cooperation, she was able to spend the month of August sunbathing nude—much to the consternation of Laurence's Boyle daughters—on the shores of the Gentiles-only lake, under the name of "Mrs. Bowles." She was joined for much of the time by Kenneth, and they discussed their future apartment-sharing venture with enthusiasm. Among her other visitors was Howard Putzel.

In the autumn they returned to New York and moved into the duplex they'd found at 155 East Sixty-first Street. The place was large—two whole floors of a double-fronted brownstone house, connected by a spiral staircase. The fact that there was only one small kitchen didn't concern them unduly: Neither had much use for kitchens. The layout of the place wasn't ideal, either. Peggy had four bathrooms, Kenneth one, and on Peggy's floor they had to pull down three walls to make a decent living room for her out of three servants' rooms; but each of them had a floor, there was plenty of room for Peggy's paintings, and they had each other's company whenever they needed it. Peggy also invited a newfound friend, whom she'd met in Connecticut as a neighbor, to move in with her. This was the American journalist Jean Connolly, a pretty young woman in her early thirties, and the former wife of the English man of letters Cyril Connolly. Jean was in love with Laurence, and Peggy approved of her, wondering only why Jean had moved in with her rather than him. Laurence and Jean did marry later on, though she was to die young, in 1951.

It was to the duplex that Laurence brought Pegeen back from her Mexican adventure. She did and didn't want to return. Miserable as she was at home,

she could not break free of her mother or stop craving the love she never really got. It was to be the tragedy of her life.

Peggy had made Kenneth sign the lease to anchor him, as he was so unreliable, floating more or less amiably through life on a sea of whiskey. They couldn't agree on decor—he was all for prewar gentility, she for a modern look; but he hadn't objected when she'd proposed commissioning Jackson Pollock to paint a mural for the entrance hall. This was an important commission for Pollock; but it was also nerve-racking: It was the largest painting he had undertaken to date, and it required, at a time when he was drinking heavily, physical and spiritual strength.

She commissioned the work in July, but by December, Pollock, who'd pulled down a wall in his studio to accommodate it, still hadn't started work. It was to be twenty-three feet long and six feet high, and at Duchamp's suggestion it was to be done on canvas so that it could be removed when Peggy left the apartment. By December, Peggy's patience was running out. She hinted that if she didn't have her commissioned work by January, when Jean Connolly was giving a party, the monthly stipend might cease. The rest of the story is dramatic. Pollock remained unable to work on the piece until the very last moment, in the week before the party was to take place, when in a frenzied session lasting fifteen hours he completed the whole gigantic picture. As soon as the paint was dry to the touch, he took it off its stretcher, rolled the canvas, and went over to Peggy's with it. This was the actual day of the Connolly party. When unrolled and ready to be restretched, it turned out to be eight inches too long. Peggy herself, away at the gallery, had hidden her booze; but Jackson found it and, in a panic, began to drink. He phoned her repeatedly to beg her to come home and help him solve the problem. She in turn summoned Duchamp's and David Hare's aid. When they all arrived at the duplex, Duchamp decided that the simplest thing to do would be to cut eight inches off one end—Hare remembered later that Duchamp said that in this kind of painting it wasn't relevant. Pollock either didn't care or was by then too drunk to care. He wandered out of the hall and into the party, unzipped his fly, and urinated into the fireplace.

Mural prefigured the paintings of his greatest period, which he would accomplish after Peggy had returned to Europe. Duchamp had no enthusiasm for Pollock's work—his chief protégé was Cornell—and as abstract expressionism established itself, so Duchamp's standing diminished.

The duplex quickly became a new center for long parties—at one, Lee Krasner was coopted to help make a meatloaf for fifty people. Here too were the beginnings of the gay male coterie Peggy would have around her for the rest of her life—her "Athenians"—a euphemism proposed by Kenneth Macpherson. (It should be remembered that homosexuality among men was still a criminal offense in those days: The New York State law was not struck down until 1980.)

For Peggy gay men were much easier to get along with—they enjoyed her company and there was no sexual tension, although occasionally she would try to convert one of them. Despite her professed love for Kenneth, for a time Peggy continued in a life of wanton profligacy. There was even malicious and unfounded gossip about her debauching Pegeen, taking her to bed with a man, and that Pegeen had been debauched by Ernst and Matta at Wellfleet. Despite Ernst's arguments with Pegeen, who could also be a very tiresome adolescent, both men, especially Matta, had a sincere, fatherly interest in the girl.

Peggy behaved as if she could lose herself in the act of love, if one could call it that. She wasn't interested in wooing or foreplay or tenderness—she was interested in the act itself, and once it was over, it was over. She consumed men, and occasionally women, but she so signally failed to overcome her isolation that one has to wonder whether she could have done so even if she had genuinely wanted to. She claimed, in any case, that she had had far more lovers than she had actually had. It was all part of an increasingly desperate bravado. But for what? Worst of all, she seemed incapable of entering into any real, mature relationship. After Max, she never remarried; though she referred to herself increasingly as "Mrs. Guggenheim," and somehow saw herself as married—but to whom? The love of her life was still John Holms. The Art of This Century catalog had been dedicated to his memory. But was it his early death that had transmuted that flawed relationship into something perfect in her mind? Temperamentally they were relatively well suited; but would they have stayed together had he lived?

Relationships within the duplex were not the happiest. Jean Connolly irritated Kenneth by raiding his part of the duplex in search of Scotch. On one occasion she helped herself to his last bottle in his absence, causing an uproar. The kitchen-sharing arrangements turned out to get on everyone's nerves after all, and Kenneth instituted a closed-door policy when he decided that Jean's uninvited company whenever she heard the ice cubes clink was no

longer desirable. His alcoholism led to unpleasant and unpredictable mood swings. Peggy, always fond of animals and rarely without one, got herself a pair of Persian cats (an odd choice, given her experience with the last pair), and Kenneth got himself a boxer dog, Imperator. The dog and the cats got along well, but Imperator's fondness for Peggy made Kenneth jealous. Doors had to be kept open to allow the dog its freedom. The smell of the cats permeated the whole duplex and annoyed Kenneth—finally they had to be given away. Then Imperator started to defecate on the floors, and followed the cats to a new home. Peggy tried sleeping with Jean, and with Kenneth, and with Jean and Kenneth together, but none of them got much fun out of any combination. The subsequent arrival of a soldier-boyfriend of Kenneth, medically discharged, made the ménage even more fragile; but through it all, Peggy declares winningly, her friendship with Kenneth survived: "... one lives and learns, or maybe one lives too much to learn."

What continued to hold her steady, if anything did, was the gallery. Another sort of equilibrium was established by the fact that, at last, and before the duplex had become too disorderly, Pegeen could move out to a place of her own, a little one-room apartment in Greenwich Village. There, she renewed her acquaintance with Jean Hélion. Laurence encouraged, even stage-managed, this. Hélion was estranged but not yet divorced from his Virginian wife: Jean Blair was suffering from cancer in the later 1930s, and later died of it. Hélion looked after her as well as he could before leaving to fight for France. When he did so, he left their young son, Louis, in the care of a sister-in-law. His deceased wife's family regarded Hélion as having deserted her. Louis would not see his father again until he visited him in France in 1982.

Hélion was more than twenty years older than Pegeen, but Laurence felt that the Frenchman's steadying influence would be good for his lost daughter. His wish was realized: Hélion fell in love with Pegeen, and they were married. The marriage lasted thirteen years and produced three sons; it was not enough to save Pegeen, though she was to have one more great chance of happiness. For the time being Peggy, approving of her daughter's match, gushed love. Meanwhile the business of running the gallery carried on.

The new season at Art of This Century had opened on October 5, 1943, with a de Chirico retrospective, which was followed by Pollock's promised one-man show. James Johnson Sweeney, who was rapidly becoming the new mentor in Peggy's life, wrote the preface to the catalog, and Kenneth, who

had a very good eye, helped hang the exhibition. Coates, Greenberg, and Motherwell all wrote enthusiastic reviews: Here was an American painter to stand with and even supersede the Europeans, in the sense of taking painting on a stage. Sometime afterward the Museum of Modern Art bought *The She-Wolf* from this show, for $600 (some sources say $650—in any case, a large sum at the time). Pollock might have hoped for more; but Peggy liked Barr and gave him a "friendly" price. Neither of them, though they admired his work, actually liked Pollock. Bernard Reis estimated that Pollock "earned no more than $25,000 from his painting in his lifetime." By the end of 1946, Peggy had paid him a total of $7,836.08, for works on hand, for his *Mural*, and including a personal loan of some $1,260. In 1956 the collector Ben Heller bought *Blue Poles* for $32,000—the first big price paid. Pollock had died only a short time before.

The Pollock exhibition was followed by a Christmas show called *Natural Insane Surrealist Art*—comprising works by some of the European surrealists, as well as contributions from Calder, Cornell, Matta, and Motherwell, interspersed with natural forms, driftwood, jawbones, root clusters, and artwork culled from mental institutions in Europe—an area Peggy had already mined for Guggenheim Jeune. Early in 1944 Rice-Pereira had a one-woman show at the gallery, followed by an Arp retrospective, and then Hans Hofmann. April brought a group show in which the Americans were much more significantly to the fore than hitherto, as they were in 1944's Spring Salon—though that salon raised the age limit to forty, and the jury received a withering broadside from Maude Riley, writing in *Art Digest*, for lack of adventurousness.

The first three shows of the third season, which began in the autumn of 1944, were all one-man shows—of Baziotes, Motherwell, and Hare. Again inspired by Putzel, and enthusiastically supported by David Porter, who ran the G-Place Gallery in Washington, D.C., a Mark Rothko one-man show was scheduled for early 1945, and after a Laurence Vail bottle-collage show that followed, there were exhibitions of Giacometti, Pollock again (with his *Mural* on display at the duplex in the afternoons), Wolfgang and then Alice Paalen, and another all-women show—*The Women*—in the summer, which Peggy had worked on with David Porter, who had a similar exhibition at his Washington gallery at the same time, brought the season to a close. (Porter scored another first about now: an exhibition of works exclusively by African Americans.) At the Art of This Century exhibition Louise Bourgeois showed

with Peggy for the one and only time—a sculpture in wood. Bourgeois has little time for Peggy now, but her brownstone on West Twentieth Street has resonances with the bohemianism of Hale House—the wall by the telephone, for example, is covered with scribbled numbers.

The year 1944 also saw the birth of Art of This Century Films Inc., through which Macpherson and Peggy helped subsidize the work of the experimental filmmaker Hans Richter. The film produced, *Dreams That Money Can Buy*, involved Duchamp, Ernst (a veteran of Buñuel's *L'Age d'Or*), Léger, and Man Ray.

(If Willem de Kooning was conspicuous by his absence, it was not for want of encouragement: He just hadn't felt ready to exhibit. In fact he had one painting in Peggy's Autumn Salon of 1945. Clyfford Still, another artist promoted early in his career by Peggy, showed at the same exhibition. Still, already in his early forties, was one of the last major talents to have a one-man show at Art of This Century, in February 1946. Clement Greenberg and David Porter stretched the canvases.)

Porter worked closely with Peggy on a number of occasions. He had moved from his native Chicago to Washington, D.C., in 1942 and there met Caresse Crosby at Jimmy White's gallery on Dupont Circle. Caresse, a rich socialite who had been one of the great figures in Left Bank American society in Paris in the 1920s, running the Black Sun Press, had been married to Harry Crosby, the son of a J. P. Morgan partner, whose double suicide with a young woman called Josephine in a hotel at Christmas 1929, following an opium orgy, had symbolized the end of what had been an age of optimism, if not exactly innocence. Porter and Caresse opened a gallery of their own—the G Place—and showed their own choice of paintings on two separate floors. They had a year-long affair and she hoped for marriage, but the differences in their ages—she was fourteen years his senior—was too great, and they split up, both as business partners and as lovers, though they remained friends. David continued to run the gallery on his own, renaming it the David Porter Gallery.

Porter had met Peggy on buying trips to New York and had a fling with her while she was living in the duplex. Peggy, he remembers, kept a little book in which she listed all the men she'd been to bed with—Clement Greenberg claimed to be the only heterosexual male in their circle who wasn't in it. Porter's own sexual contact with Peggy was brief and without significance. The sexual act seemed to mean nothing more than itself—

going to bed with her was "like drinking a glass of water." But, like Caresse, "she had an enormous zest for life which was extremely infectious."

By the beginning of the third season, during which so many of his protégés exhibited there, Putzel had left Art of This Century, to be replaced by Marius Bewley, a gay student of literature who went on to have a formidable academic career. With financial backing from Kenneth Macpherson, Putzel had been able to open his own gallery, the 67, at 67 East Fifty-seventh Street.

The third season marked the high point of Art of This Century's life in terms of its encouragement of young American painters. Putzel left because he felt he didn't want to be Peggy's "office boy" any longer. Despite his poor business acumen, he had made important contacts, and artists respected, supported, and trusted him. Charles Seliger remembers his first encounter with Putzel at the Wakefield Gallery during an exhibition of the early work of Alfred Schulze Wols. Putzel, seeing Seliger, broke off his conversation with Matta to remark lubriciously, "At my age he'd be just the right age." The young Seliger got very scared, but Putzel was interested more than anything in his paintings for his new gallery. For Putzel, as indeed for Peggy in the end, art was far better than sex.

Peggy had made no secret of the fact that as soon as the war was over she would return to Europe, so for most artists it made sense to find a dealer and a gallery which would continue to be around after the end of the war. Robert Motherwell and his friend William Baziotes both left her to go to Samuel Kootz, a dealer who was planning to set up his own gallery, early in 1945. This defection alarmed Peggy: She doubled Pollock's stipend and early in 1946 lent Lee and him $2,000 as the down payment on a house in Springs, Long Island. Lee had to do some energetic fence mending to get it. Peggy lent the money gracelessly, and only after Lee had told her that Sam Kootz would do so if Pollock joined him.

Putzel's gallery opened in the autumn of 1944, and almost immediately nailed his colors to the mast with an exhibition of *40 American Moderns* that featured works by, among others, Baziotes, Cornell, Jimmy Ernst, Adolph Gottlieb, Hare, Hofmann, Matta, Motherwell, Pollock, Rothko, Kay Sage, Charles Seliger, David Smith, Dorothea Tanning, and Mark Tobey. The most important exhibition in the gallery's short life was in June 1945. Entitled *A Problem for Critics* and hung by Charles Seliger and Jackson Pollock, it was a show of the most important new American painters, juxtaposed for comparative purposes with works by Arp, Miró, and Picasso. The problem

was, how to categorize the new painters? The exhibition had been immediately preceded by a similar show in Washington, D.C., put on by David Porter and entitled *A Painting Prophecy, 1950*, which posed the same question. For Porter it was his most significant show. He wrote a sixteen-page booklet to accompany it, including artists' statements. "There was a Pollock for $500, a de Kooning for $300—though the work wasn't typical of what subsequently made them famous."

The critical response to these shows was vigorous. As a result Robert M. Coates and dealer Sidney Janis both have some claim to have coined the title that has stuck: abstract expressionism. But just as this seminal new movement was getting under way, shifting the center of the modern-art world from prewar Paris to postwar New York and instigating the most exciting forward thrust in art for half a century, Peggy was preparing to pack her bags. She was still encouraging and commissioning works: From Alexander Calder she ordered an intricate headboard with a marine theme, which he had to make out of silver, bizarrely the only metal he could find in sufficient quantity under wartime restrictions. David Porter remembers playing with the silver fish hung on it when he slept with Peggy.

As for Putzel, he would not see the seed he had helped plant grow to full flower. As always, his business sense let him down: He would put a $20 painting in a $40 frame and sell it for $50. Macpherson withdrew his support, and the 67 Gallery was soon on the ropes. Putzel had to let his apartment go and had a camp bed in the gallery. He struggled on for a short while, but his fragile health buckled under the strain, and on August 7, 1945, he was found dead in the gallery. Charles Seliger remembers:

> Howard was very affected—you would have thought he was an Englishman, cool, unruffled that is, like we see Englishmen in the movies [Marius Bewley had similar affectations]. The day he died he was supposed to have lunch with me and he called me up the night before to cry off because he felt unwell. The week before that, he had a huge Hoffman on the right-hand wall of the gallery—it was a heavy painting on plywood—and when I went back to the gallery after his death the painting was on the left-hand wall. And I wonder if he hadn't moved that painting himself and given himself a heart attack. He was living and sleeping in the gallery. I don't know where else he had to go. I do know

that I arrived there one morning earlier than I was expected and I caught him half-dressed and I could see a cot made up in the bathroom where he'd obviously been sleeping. He was a really mysterious individual. He would say to me, "Would you go over to the Plaza Hotel and get me a container of coffee and a brioche." And I didn't know what a brioche was so I had to keep repeating the word over and over. But it was typical of him. He wouldn't go to the local deli for his coffee, but the Plaza. And he kept that up all the time. It was necessary for his self-respect.

Most of Putzel's colleagues realized what a great loss he was to their world. Peggy told Hermine Bernheim that it had been her intention to hand Art of This Century over to Putzel when she returned to Europe, but evidently she had never mentioned this to him. Things might have been very different if she had, but the truth is probably that she had no such serious intention at the time: she knew only too well how disastrous Putzel was at managing money.

The fourth and fifth seasons at Art of This Century, running from October 1945 to May 1947, confirmed the tendency to show exclusively American artists. Peggy gave her daughter Pegeen an exhibition, and there were also solo shows by Janet Sobel, Virginia Admiral, and Robert de Niro, Richard Pousette Dart, David Hare, and Peggy's youngest protégé, Charles Seliger, who had his first one-man show in October 1945. Seliger had shown at Porter's *Painting Prophecy*, and Peggy had already bought one of his pictures from Putzel, who had been representing him at his 67 Gallery. But her initial interest in Seliger was probably aroused by a window display (featuring large phallic cut-outs) for Saks 5th Avenue in July 1945, a display that became a great cause célèbre for the surrealists. Pollock had his third and fourth one-man shows, the latter featuring the *Sounds in the Grass* and *Accabonac Creek* series. Once again *Mural* was on display at the duplex. Peggy later gave it to the University of Iowa.

On the whole Peggy was dissatisfied with the closing phase of Art of This Century. Sales were low, and the losses she was sustaining confirmed her resolve to shut up shop. The final Pollock show was more successful than the others had been, but still Peggy, with dozens of unsold paintings on her hands by several artists, was desperate to make some sales. When she gave a small

Pollock to Jimmy Ernst as a wedding present, his new wife complained, "Oh, Jimmy, we don't need paintings. We need a can-opener." Eleven years later, in 1957, Jimmy sold the Pollock for $3,000 and gave the money to his wife, saying, "Here is your can-opener, my dear." In 1946 the collector Lydia Winston Malbin had acquired Pollock's *Moon Vessel* of the previous year for $275.

In the early 1970s Bernard Reis wrote to Virginia Dortch:

> My records indicate that Peggy's purchases for her collection in Europe and New York, as of 31 December 1942, amounted to $74,725.52. Total expenditures as of December 1946 amounted to $92,921.94. The printing expenses of her 1942 catalogue, *Art of This Century*, came to $2,890.45. Construction of the gallery cost $6,807.31.
>
> Art of This Century made a profit in 1942 [*sic*], but with one exception lost money the following years. Operating expenses from October 1942 to 30 May 1947 were in excess of $29,081. Even after sales, Peggy lost $5,086.53 in 1944. Total sales of works from Peggy's collection came to $17,835. Sales of works on consignment amounted to $29,183.

The last exhibition of all was a Theo van Doesburg retrospective, his first in the United States, a kind of tribute by Peggy to her old friend and only female adviser, his widow, Nelly. Perhaps it was also an indication that Peggy's thoughts and spirit had already returned to Europe. Nelly brought over the works to be shown, and Peggy sold a 1919 Cubist sculpture by Henri Laurens, *Man with a Clarinet*, and a Klee watercolor to pay her friend's fare. The gallery closed its doors for the last time on the evening of Saturday, May 31, 1947.

It was an odd time for Peggy to choose to leave. In 1947 Baziotes and Motherwell, among others, were developing their truly individualistic styles and moving away from the more formal automatism of the Europeans. Pollock too was getting into his real stride. But Peggy closed the gallery with finality, selling off all its furniture and fittings, some of them to MoMA. There was no sense then of the potential "collectability" of Kiesler's designs. Kiesler himself didn't have an opportunity to keep a single item as a souvenir, though Charles Seliger managed to buy a couple of the biomorphic chairs for a few dollars. They were later lost when his first wife lent them to

a local framing store which, not understanding that they weren't a gift, threw them out when they were done with them. Sidney Janis bought three Kiesler chairs and donated them to MoMA. Recently seven others turned up at auction and were sold to three private collectors for a total of $50,000. The curved wall of the Surrealist Room went to the [now long defunct] Franklin Simon department store. Peggy's own collection went into storage until she knew where she was going to put down roots.

Peggy tried her best to see "her" artists placed with other dealers before she left. It wasn't always easy; only Betty Parsons, Samuel Kootz and Marian Willard had a serious commitment to the New York group, and Parsons, who agreed to take on Pollock, did not do so on a contract basis. Pollock was, after all, by no means established as bankable, and personally he was an unpredictable drunk. (Pollock later approached Pierre Matisse; Matisse consulted Duchamp, Duchamp shrugged, and Matisse turned Pollock down. In 1952 he went to Sidney Janis.) Parsons also represented Buffie Johnson, Rothko, Still, and Hofmann. Charles Seliger went to Willard; David Hare joined Kootz. Peggy never saw or spoke to Pollock, her greatest American discovery, again after her return to Europe, following which his career was to experience a temporary dip. He had his supporters, but few with Peggy's combination of drive and money. It should also be remembered that he had not yet found his mature style, when he used the drip-technique to its fullest effect. *Untitled (Composition with Pouring I)* of 1943, a small piece, had marked the beginning of pure abstraction for him. *Alchemy* (1947) was one of the first in which he used aluminum paint, and a drip-and-pour technique.

In an article about Peggy in *The Nation*, reviewing the Van Doesburg exhibition and marking the end of Art of This Century, Clement Greenberg wrote:

> Her departure is in my opinion a serious loss to living American art. The erratic gaiety with which Miss Guggenheim promoted "non-realistic" art may have misled some people, as perhaps her [1946] autobiography did too, but the fact remains that in the three or four years of her career as a New York gallery director she gave first showings to more serious new artists than anyone else in the country. . . . I am convinced that her place in the history of American art will grow larger as time passes and as the artists she encouraged mature.

Years later, in the late 1970s and early 1980s, Roland Penrose, David Hare, Lee Krasner Pollock, James Johnson Sweeney, and Robert Motherwell all paid tribute to Peggy's achievement in interviews with Angelica Zander Rudenstine, creator of the definitive catalog of the Peggy Guggenheim Collection. Lee Krasner's of March 6, 1981, may stand here for all:

> Art of This Century was of the utmost importance as the first place where the New York School could be seen. That can never be minimized, and Peggy's achievement should not be underestimated; she did major things for the so-called Abstract-Expressionist group. Her gallery was the foundation, it's where it all started to happen. There was nowhere else in New York where one could expect an open-minded reaction. Peggy was invaluable in founding and creating what she did. That must be kept in the history.

There were practical factors behind Peggy's abandoning her gallery: Even with works priced in the low hundreds of dollars, modern art was not yet selling; and the postwar wind of change was blowing away the popularity of the art Peggy had grown up with and remained loyal to, surrealism and early abstractionism. Her taste and her collection reflect the years, roughly, 1910–50. Virginia Admiral believes Peggy wasn't interested in the developments in modern art which followed World War II. It is no coincidence that Julien Levy, himself an ardent champion of the surrealists, closed his own gallery in the spring of 1949. He was only forty-three years old, but, like Peggy, his crucial moment as a dealer appears to have passed; it was time for both of them to move on to something else. Peggy, though, in backing Pollock, had moved ahead. Levy's health was undermined by alcohol, and, never a dedicated businessman, he understood that he would no longer be able to compete in the new art world of the postwar era. He ultimately retired to Connecticut to write his memoirs and breed fighting cocks, emerging now and then to lecture on surrealism. David Porter closed his gallery in 1946—he could not sustain losses of $3,000—and moved on to other things. At the time of writing he is still, at the age of eighty-eight, an active artist and real-estate agent on Long Island.

As early as 1955, *Fortune* magazine ran an article on works of art as investments. It reported that the beginner could make a start with a de Kooning, Pollock, or Rothko for between $550 and $3,500. The business

boom had begun. It was too late for Peggy, who hated the commercialization of modern art anyway, but as Lawrence B. Salander, a dealer working in New York today, points out:

> Anyone who could support Pollock as she did at the time when he was making some of the best pictures he ever made and really needed the support, and she made it possible for him to do so, deserves the highest praise for that alone, let alone whatever else she did in the art world. Don't dismiss her as a rich fool just because she wasn't too sure of herself and lived a flamboyant life in defiance of her straitlaced upbringing. My impression is that Clem Greenberg took her seriously, and that's enough for me because he was just about the most serious art critic of the whole century. Don't go by what she looked like or whom she slept with or how she dressed—go by what she did in her profession, which was the collection and promotion of modern art. If I achieved half as much I'd consider my life nourishingly creative.

Peggy also had a knack of being the right person in the right place at the right time.

With her last great love, Raoul Gregorich, at the palazzo in the early 1950s.

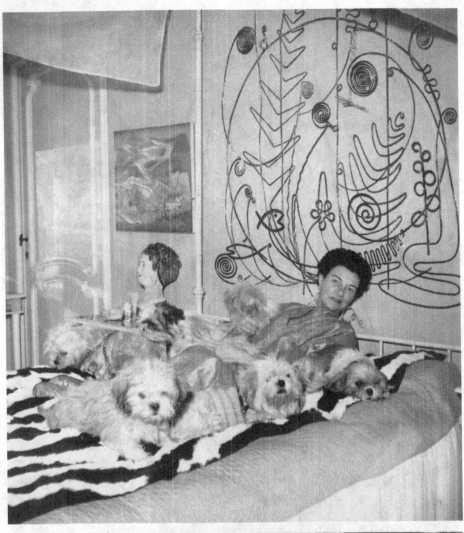

On her bed at the palazzo, surrounded as usual by Lhasa apsos, with, behind her on the wall, the silver headboard by Calder. David Porter remembers playing postcoitally with the upper of the two fish.

The Palazzo Venier dei Leoni, Grand Canal frontage, in the 1960s.

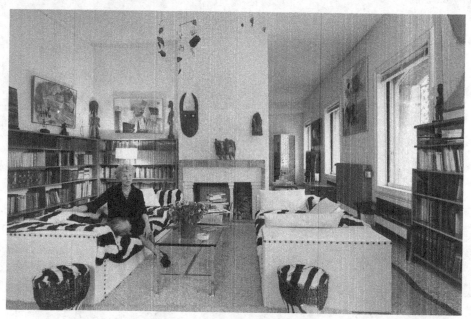

Peggy in the drawing room of the palazzo.

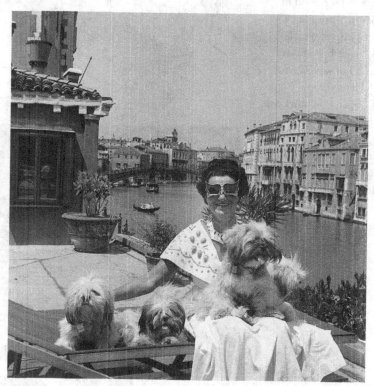

Peggy in one of her pairs of Edward Melcarth gesso sunglasses (the butterfly), specially made for her, on her sun roof at the palazzo in 1950.

Al Hirschfeld drew this cartoon of the great and the good in Harry's Bar in Venice in 1958. Among the patrons are: (*1*) Hirschfeld, with his wife and daughter, (*2*) Barbara Hutton, (*3*) Katharine Hepburn, (*4*) Gary Cooper, (*5*) Gian Carlo Menotti, (*6*) Peggy Guggenheim, (*7*) Orson Welles, (*8*) Frank Lloyd Wright, (*9*) Joe DiMaggio, (*10*) Truman Capote, and (*11*) Ernest Hemingway.

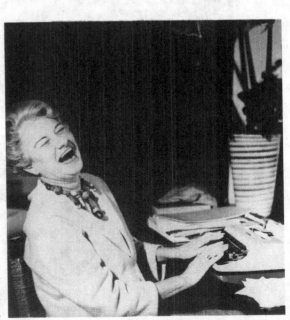

A happy Peggy seated at her faithful portable manual typewriter.

Jean Arp "smoking" the Angel's penis—which prior to 1960 could be unscrewed from
Marino Marini's equestrian sculpture *The Angel of the Citadel*.

Peggy with the *Angel*—penis removed in this picture—
on the canalside terrace of the Palazzo Venier.

Peggy and Sindbad in a gondola, during one of his visits to Venice from Paris with his second wife and family.

Peggy in her black-and-gold Ken Scott dress (1966) and her Melcarth "bat" sunglasses.

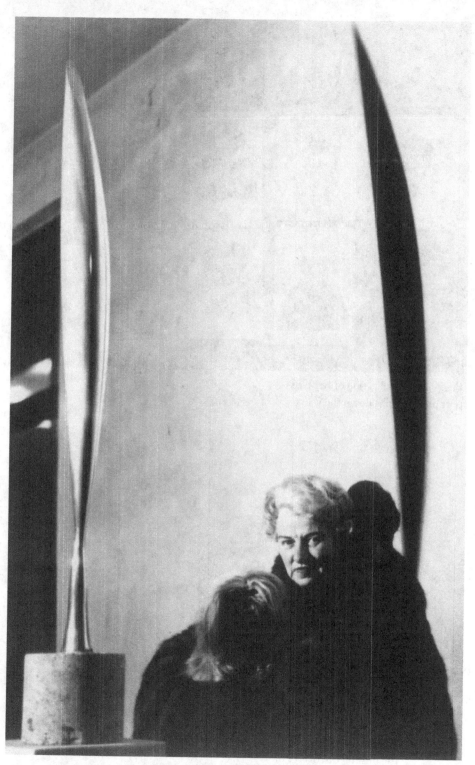

With her Brancusi *Bird in Space*.

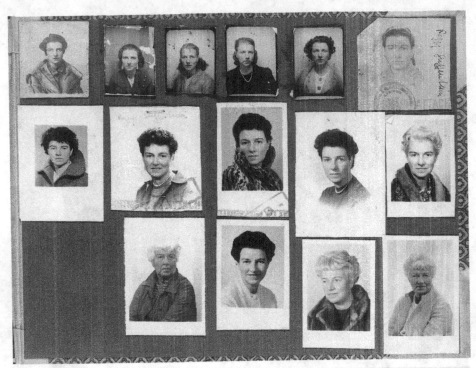

Peggy kept a collection of her pass-
port photographs down the years.

A portrait drawing by Charles
Seliger of Howard Putzel, one of
Peggy's principal advisers during
the New York years, and arguably
the unsung discoverer of
Jackson Pollock.

n i n e t e e n

Memoir

\mathcal{A}lthough Peggy tells us she started to write a memoir sometime in 1923, she didn't get very far with it. Her letters, interesting though they are in piecing together background, and often fascinating in themselves, were written mainly for practical reasons and for the moment. They are not narrative accounts with one eye on future publication. Although Peggy had a strong literary bent, it was not a discipline into which she had any great desire to enter. However, when she was approached by the Dial Press in New York in late spring 1944 to write her autobiography, she was intrigued. She also had a lot of steam to let off, and frequent bouts of ill-ness—mainly of colds and flu variety—left her with time to dabble in writing. The gallery was well managed and did not require all her time, provided that she kept a close eye on the accounts, but between them Bernard Reis and Howard Putzel, and Putzel's successor Marius Bewley, could be trusted to do a good job. The art historian Melvin Lader notes that: "In the 'Personal Column' of the *Art Digest* in October the notice was made that 'Miss Guggenheim . . . spent several weeks on Fire Island away from the demands of art and made headway with writing her memoirs.' " Off and on, she took a year to write them. The resulting book was 365 pages long, and sold at $2 a copy in hardcover.

Once she had started her autobiography, called *Out of This Century* at

Laurence's suggestion, Peggy immediately found a certain fluency, born of a natural tendency to write just as it came. Despite her grounding in the classics, she fortunately had no ambition or desire to emulate Dostoevsky or Henry James. Never pretentious, and with a realistic grasp of her own limitations, she was able to pick up her pen confidently within the bounds of her literary capability. Her completely natural style worked perfectly. She was encouraged at every stage by Clement Greenberg, to whom she showed each chapter as she wrote it. After the book was published, Ernst and Greenberg came to blows—but Greenberg had also attacked Ernst's work in *The Nation*, and Max is not flatteringly portrayed in *Out of This Century*.

Peggy's motivation for writing when she did was partly to exorcise her pain over her breakup with Max, and give vent to her feelings about Dorothea Tanning. But she had also reached a hiatus. Despite the fact that she was only halfway through her life, there is something valedictory about the book. It is as if she wanted to sum things up. She also knew that the day when she would return to Europe could not be far off. This didn't diminish her commitment to the gallery, but it did stimulate her interest in a future that lay in the Old World that she had come to regard as home. She preferred the architecture, culture, and landscapes of England, Italy, and France to those of America; and New York held associations with a suffocating upbringing and an anti-Semitism from which she preferred to distance herself.

Like many autobiographers Peggy can be hazy about when events took place, and she jumbles up chronology. Her memory is extremely selective, sometimes deliberately so, and she makes no attempt to hide her prejudices. Her partial judgments of people's characters or talents could be construed as far more damaging to their reputations than any sexual exploits she involved them in—as we have seen, Roland Penrose didn't give a damn about being described as using handcuffs in sex games, but was concerned that Peggy should describe him as a second-rate painter; in later editions of her book this slur was excised. Her ability to hold long-term grudges, too, is nowhere more evident than here. But the person she spares least, and is most bent on belittling, is herself. Her book is entertaining and lively: It is also a clear map of a confused psyche, where bravado and fear, boastfulness and self-contempt, lack of reflectiveness and keen self-knowledge jostle. Peggy gives away more of herself in the book than she either knew or intended.

She was quite candid about describing her sexual exploits, which, if any-

thing, she played up. To protect the people she mentions in personal con-
texts, throughout the book she gives them cover names in the manner of a
roman à clef, but these are variable in their penetrability, and convey some
sense of Peggy's approval or disapproval of the actual person. Kay Boyle thus
becomes Ray Soil, and Dorothea Tanning becomes Annacia Tinning. One
senses the hand of Laurence Vail behind this—he himself was a dab hand at
the thinly disguised pseudonym in *Murder! Murder!*. Laurence becomes Flo-
renz Dale, and Duchamp becomes Luigi—but only when Peggy is making
reference to their sexual liaison. Other people have neutral approximations
to their real names: Roland Penrose becomes Donald Wrenclose; E. L. T.
Mesens becomes Mittens—the nickname she actually gave him; Douglas
Garman becomes Sherman. Pegeen is buried more deeply under Deirdre.
There is no absolute system: Some, such as John Holms and Sindbad, retain
their own names. Those maligned would find no protection under their
noms à clef, since they were so close that everyone would immediately make
the connection, and did. If anyone failed to, the photographs included in the
book left no room for doubt.

When Peggy's autobiography came out in March 1946 (coinciding with
Pegeen's first solo show at Art of This Century, which went unnoticed), in a
striking jacket designed by Ernst (front) and Pollock (back), there was a
small but intense furor. The family, which had not minded the gallery so
much, was concerned at the name of Guggenheim being associated with
such irregular goings-on, and there was even a rumor, long perpetuated, that
they organized a massive buy-up of all copies in order to suppress it. Hilla
von Rebay's reaction is better imagined than described. In fact the book sold
well, especially among the Fifty-seventh Street fraternity, though it was not
reprinted. The reason for this was a poor critical response and, after the ini-
tial flurry, a falling-off of interest. Peggy, after all, would soon be leaving for
Europe. She had in fact, by the time the book appeared, metaphorically
packed her bags. But for the moment it was a great succès de scandale.

Peggy's friends in general liked the book—cautiously. Herbert Read
wrote that she had outdone Casanova and Rousseau (a slightly double-edged
compliment), and added, also ambivalently, "it is only the lack of introspec-
tion and self analysis which prevents it from being a human psychological
document (masterpiece?) like *Nightwood*." Peggy was pleased, sat in a book-
shop to do a signing session, and relished the thought of the royalties. Max
Ernst, despite his artwork for the cover, professed himself horrified by the

book's contents, but his son's reaction was probably more sincere. Jimmy recalled a meeting with Peggy:

> "Well, I don't care if you think it is terrible. I am not going to change one comma in it. Your father can consider himself fortunate that I am not more explicit." Peggy had taken me back to her little office during an Art of This Century opening and asked me to read the Max Ernst chapter of her manuscript, which was to be published by the Dial Press the following year. I was appalled by its devastating pettiness and I could not believe that she could let such vindictiveness stand. Barely avoiding vulgarity, it seemed almost an act of self-flagellation in its frequent failure of rational thinking. It was tailor-made for the scandal press and it would hurt her almost as much as the intended subject of destruction, my father.
>
> "How dare you say to me, 'You can't do that, Peggy'? How can you possibly defend him? Oh, I see it now, you are against me too. . . . Probably always were. And why? What kind of father has he been to you?" . . . Peggy and I did not see each other for a long time after that.

Time disapproved: "Stylistically her book is as flat and witless as a harmonica rendition of the *Liebestod*, but it does furnish a few peeks—between boudoir blackouts—at some of the men who make art a mystery," it commented stiffly and obscurely. Harry Hansen and Katharine Kuh both attacked the book on the grounds that it was badly written, chronicled essentially immoral behavior with no sense of remorse, and would undermine Peggy's standing. Their reviews, and *Time*'s, demonstrate, if nothing else, just how long a shadow the nineteenth century cast. Everett McManus (a pseudonym of Parker Tyler), writing in *View*, is wonderfully pretentious and goes too far the other way, but at least he scores some hits very near the bull's-eye:

> The book convinces us the way Flaubert convinces us of Madame Bovary, because it is about the feelings of a woman—not necessarily of a particular woman but of a modern woman. . . . Her book is not the autobiography of an art connoisseur or critic but

of a human being. From this viewpoint, Miss Guggenheim reveals her progressive spiritualization. She passed through respective stages of infatuation with a lusty bohemian, a temperamental idealist, an enthusiastic Communist, a more or less carnal and calculating painter, and finally to a platonically-minded "Athenian"; that is, in descending scale so far as the male's carnal reaction to her went. She was always earnestly in love and regularly plunged into the despair of which she was capable. It is significant that her most frequently applied adjective for the moods of her own friends is "sad". It recurs with striking force. . . . But she has not been saddened.

It is interesting that Peggy herself quotes this review with approval in the last edition of her autobiography (1979): "She has not been saddened." No one is in a position to say whether she genuinely believed that of herself, but it would be interesting to know how "McManus" arrived at his impression.

Peggy may well have closed the door on her own sadness. In the end, she had her "children"—her pictures and her dogs—for company. By the time *Out of This Century* was published she had acquired two of Kachina's puppies from Max: Emily and White Angel. They would accompany her on her return to Europe.

Interest in *Out of This Century* did not end with the Dial Press edition. Many years later, long after she had settled in Venice, Peggy received an overture from Nicolas Bentley, a partner in the English publishing firm André Deutsch. Bentley visited her in Venice, and his entry in her guest book on September 6, 1959, shows the degree of his enthusiasm for the project:

> *With love and gratitude to the most*
> *P atient*
> *E nthusiastic*
> *G enerous*
> *G ood-hearted*
> *Y oung-in-heart author that any publisher ever had.*

Bentley paid several visits to Venice, where he was impressed by Peggy's knowledge of the city, and touched by the generosity with which she lent him her gondola. His entries in the guest books become increasingly effusive.

When Peggy visited London to discuss the book, Bentley's colleague Diana Athill noticed that she was quick to offer invitations to visit her in Venice, but was not convinced that she meant them. Athill remembers Peggy in her early sixties as a "plain little woman, neatly made up and conventionally dressed, with a nose so large that one could not help looking at it."

The result of the collaboration was *Confessions of an Art Addict*, published by André Deutsch in 1960 (and dedicated to Alfred Barr, who wrote an introduction), which brought the story up to date and restored many real names, but also lost vast tracts of the original, including the sexual adventures and almost all the Garman and Holms stories, while the accounts of both Guggenheim Jeune and Art of This Century were greatly shortened. A significant departure from the first book was a curtly reported reaction to Holms's death that included the telling sentence, "When the doctors told me he was dead it was as though I was suddenly released from a prison."

Peggy's comment, made soon after, on the new edition of her memoirs was: "I seem to have written the first book as an uninhibited woman and the second one as a lady who was trying to establish her place in the history of modern art." *Confessions of an Art Addict* was not a success, and sold few copies—which didn't worry Peggy unduly. Many years later another English publisher, George Weidenfeld, who had had success with biographies and autobiographies, asked Peggy in Venice whether she had done any more work on her memoirs. On hearing that she had, he began his overtures, only to withdraw when he learned that the "work" amounted to one additional page. It was left to Deutsch to resurrect the original 1946 edition, amended, updated, and with almost all the real names restored, in 1979, the year of Peggy's death. *Out of This Century: Confessions of an Art Addict* is still in print.

part four

Venice

Every hour of the day is a miracle of light. In summer with day-break the rising sun produces such a tender magic on the water that it nearly breaks one's heart. As the hours progress the light becomes more and more violet until it envelops the city with a diamond-like haze. Then it commences slowly to sink into the magic sunset, the *capolavoro* of the day. This is the moment to be on the water. It is imperative. The canals lure you, call you, cry to you to come and embrace them on a gondola. More pity to those who cannot afford this poetic luxury. In this brief hour all of Venice's intoxicating charm is powered forth on its waters. It is an experience never to be forgotten. Day after day one is drawn from *terrafirma* to float in the lagoon, to watch the sunset, or to go gently past the palaces seeing their images reflected in the canal. The reflections are like paintings more beautiful than any painted by the greatest masters. The striped *pali*, when seen in the water, deny their functional use and appeared like colored snakes. If anything can rival Venice in its beauty, it must be its reflection at sunset in the Grand Canal.

PEGGY GUGGENHEIM,
Out of This Century (1979)

twenty

Transition

orld War II came to an end in Europe in early May 1945, during Wolfgang Paalen's show at Art of This Century. News of the war's devastation began to filter through to the United States quickly, but for most of the exiles home was home, and the relative material comfort and safety of America was no substitute for it. After the jubilation that followed Germany's and, a few months later, Japan's surrenders, people began to wake up to a very different world from that of 1939. Europe would soon be ideologically divided into two rigidly sequestered parts, with the United States and the USSR identifying each other as the new enemy; and the experience of the Nazi concentration camps and the dropping of the atomic bomb on Hiroshima and Nagasaki suddenly made the world a crueler place than it had been. The twentieth century had been split in two almost exactly at its halfway point, and art had to respond to the change. Most of the European artists in Peggy's circle were middle-aged or older by 1945; their heyday had been the 1920s and 1930s. There could be no re-creation of those days in the light of what had happened since.

The exodus began just as the New York School was starting to establish itself. There was no question now about where the initiative lay for the immediate future of modern art. Breton returned to Paris to continue to promote the cause of surrealism, but the movement had passed its peak and held

little significance for the generation that had come of age during the war. *VVV* was already finished; the last issue of *View* appeared in March 1947, with articles by Marius Bewley, Marshall McLuhan, and Louise Bourgeois's husband, Robert Goldwater. Ernst and Dorothea Tanning married in Beverly Hills in a double ceremony with Man Ray and Julie Browner in October 1946. The Ernsts then went to live in Sedona, Arizona, where they built a house and enjoyed a period of intense artistic creativity before leaving for France in the 1950s. Mondrian and Kandinsky had both died in New York in 1944. One by one the others drifted back to France.

Duchamp, typically, went against the stream, withdrawing into himself. He had lived with the Kieslers until autumn 1943, when he rented a modest one-room apartment at 210 West Fourteenth Street, which he kept for twenty-two years. He applied for U.S. citizenship in 1947 and became naturalized in December 1955. The Ernsts had introduced him to Teeny Matisse in 1951—her marriage to Pierre had foundered two years earlier when he'd fallen for Matta's estranged wife, Patricia—and Duchamp and Teeny were married in January 1954. He remained ascetic: For many years he owned only one suit, which he cleaned himself; he had few possessions, and ate and lived simply, almost monastically. His status as an arbiter of artistic thinking was reduced as new ideas overtook him, but he retained many admirers and was rediscovered in the 1960s. He died in 1968. Mary Reynolds, by contrast, left for Paris as soon as she possibly could, two months before VE-day. She died there of cancer in 1950; Duchamp, summoned by her brother, was at her bedside.

Another artist who stayed was Yves Tanguy. He had gone to the United States earlier than most, and was married to an American, Kay Sage. The couple had traveled to Reno to secure their respective divorces, and on the way Tanguy, like Ernst, had been struck by the landscape and light of Arizona, Colorado, and New Mexico. For a short time he and Kay had lived in Greenwich Village, but in 1941 she moved him out to the countryside near Woodbury, Connecticut. This was not isolation, though. David Hare had a place in Roxbury, and the area became a center for writers and painters. But it was not ideal for a man like Yves, whose temperament made it very hard for him to settle down in bourgeois American society, and who was used to cities and the sea. His isolation in rural America would increase after his fellow exiles returned to Europe during 1946.

Kay and he bought a large colonial mansion, which they renovated, and a

pond was dug in a shape that had appeared in one of Yves's paintings. They even landscaped part of the estate's perimeter to look like a scene from one of his canvases. The first year they were there, Kay also set about transforming her husband. The Breton sailor was outfitted at Abercrombie & Fitch in full country-gentleman gear, complete with a corduroy hunting cap and jackets with leather shoulderpieces, and at Christmas she gave him a shotgun and a rifle. He felt ridiculous and trapped. He grew increasingly apart from his fellow artists-in-exile, and his drinking, always heavy, increased. At first he drank martinis; then, when the war meant no more Gordon's London Dry Gin, he switched to daiquiris.

At the same time he painted less. When he had company, he'd talk loudly and long about his days at sea, and, as alcohol made him aggressive, he liked to argue the Dreyfus case with people who didn't share his sympathetic view of the Jewish artillery captain. If he could get into a fight over it, he would. Julien Levy remembered: "His method of fighting was to suddenly grab the ears of an opponent . . . and bash his head against theirs . . . he claimed that his head was harder than anyone's. As hard as an ivory ball, he'd insist." By 1945 Breton, to whom he remained devoted, had not only broken with him but denounced him as *embourgeoisé*, the most damning description in his vocabulary, in the presence of Ernst and Matisse. This was hurtful and humiliating, and if Breton was attacking Tanguy's lifestyle, he could scarcely criticize his art, which remained unaffected by his new surroundings, except that it reflected their light and colors. As for being affected by the attitudes of his neighbors, if anything Tanguy found American puritanism provincial and oppressive. His thoughts turned to Jeannette, the wife he'd abandoned, and he wrote frequently to his sister and to his old friend Duhamel in France. Jeanette's mental state, already precarious, had foundered when Yves left her, and Duhamel was able to trace her to the psychiatric hospital of Sainte-Anne. Yves and Kay thereafter supported her for the rest of their lives.

To counter his boredom and frustration, Kay persuaded him to have a billiard table installed in their vast and lordly drawing room. He took to playing billiards morning, noon, and night, and cut down his alcohol intake. But he continued to neglect his work. He and Kay each had their own studio in a barn to one side of the house. Kay worked hard, and was well on the way to becoming a proficient surrealist painter, though her debt to Tanguy is easy to see. Both studios were neat and tidy (neatness and tidiness were qualities the

couple shared), but when his old friend and now dealer, Pierre Matisse, visited, he noticed that while Kay's studio seemed lived in and showed signs of activity, there were cobwebs on the brushes in Tanguy's.

Alcoholic and lonely, Yves died on January 15, 1955, in his fifty-fifth year. Falling out of bed, he had struck his head and damaged his cervical vertebrae. Left alone, Kay fought a losing battle with her own isolation. She continued to paint, published a book of verse, entertained. But the void Yves had left could not be filled, and another blow fell when she learned that she was gradually losing her sight. She devoted herself to cataloging her late husband's works, and when the task was completed, on the eighth anniversary of his death, she shot herself in the heart with a revolver, "leaving a statement, it was said, that her mind was too good to be blown to pieces, but that her heart was sick."

As the exodus continued, there were few reasons for Peggy to remain in New York. Laurence married Jean Connolly, and in June 1946 they left for Europe, where Laurence would reclaim his house in Megève, and his late father's Paris apartment. Sindbad was already in Paris, still in the army and working as an interpreter. There he would meet Jacqueline Ventadour again. She had returned alone in 1944 to fight with the Free French Forces. They married in 1946. Pegeen and Jean Hélion returned to France in the early spring of the same year, after Pegeen's one-woman show at Art of This Century. With most of her family gone, and another compelling reason for leaving—the presence of Max and Dorothea—Peggy started to make her own preparations as the fourth season at Art of This Century drew to a close.

She intended to spend summer 1946 in Europe: a kind of reconnaissance trip during which she could also tidy up any loose ends left ravelled before the war. In England there was the question of the collection of a large silver tea service left to her by her mother, and the rescuing of the massive Italian chest immured in Yew Tree Cottage by Douglas Garman's building activities. In France it was important to revisit Paris, first on Peggy's list as a possible new home. Before leaving, with the joint lease on the duplex nearing its end and Kenneth Macpherson also inclined to return to Europe, she arranged lodgings to await her on her return, writing to her friend the sculptor Louise Nevelson on May 15, 1946:

> This is to confirm our telephone conversation of this morning,
> and to state that I will be delighted to rent the top two floors of
> your home from October 1 on at $150 a month, each floor. It is
> understood that you will install a frigidaire and a gas range ade-
> quate to cook large meals. I would appreciate your answering
> this letter, so that we can avoid drawing up a lease. It is with great
> relief that I write you this, knowing that when I come back from
> Europe I will not be on the streets.

Anglophile though she was, and remained, postwar England was no place
for her. London, gray, gloomy and austere, held too many sad memories, and
most of those whom she had known well had moved on, mentally or physi-
cally. In any case, there was the question of mandatory rabies quarantine,
which meant that her two Lhasa apsos would have had to spend six months
in kennels. As she was traveling with the dogs, and armed with a visa pro-
vided by Claude Lévi-Strauss, she made Paris her first port of call, leaving
the dogs with her mother's former housekeeper while she visited her chil-
dren and surveyed the city of her wild youth. She loved being back, but that
did not blind her to the fact that, like London, Paris had changed. The war
had left a legacy of exhaustion and depression in both cities, and destroyed
the world she had enjoyed in the 1920s and 1930s, though Paris had at least
escaped the degree of bomb damage suffered by London. Existentialism
appropriately replaced Surrealism, and it would be a decade and a half at
least before any real sense of optimism returned. On a practical level, scarcity
made everything expensive, from food to property. Peggy needed a large
space for her collection. The art world she'd known had gone from Paris
now: She remembered how the Louvre had refused to give shelter to her
paintings and wondered if France really deserved to be home to the collec-
tion. Above all, there was the cost of any suitable home-cum-gallery. But if
not Paris, and if not London, where?

Though she makes no mention of it in her autobiography, it was while she
was in this state of indecision in Paris that she ran into the writer Mary
McCarthy and her then-husband, Bowden Broadwater, whose acquaintance
she had made in New York. They were traveling to Venice and suggested
that she might like to join them. Peggy leaped at the offer. She knew Venice
well, and loved the city, but had not visited it for many years. Laden with

luggage, they set out on their journey by train from Paris, but had to give up
the relative comfort of their first-class compartment when the locomotive
broke down at Dijon. They continued on in much less comfort as far as Lau-
sanne, where Mary fell ill and was unable to continue. Peggy stayed with
them for a while, flirting, according to McCarthy, outrageously with the doc-
tor who attended her, but then continued on to Venice alone. By the time
they arrived, Peggy was well settled in, and met them at the station with a
gondola. She already had a sketchy knowledge of Italian, and had formed
the idea that Venice would be the ideal place to put down roots. The city had
been undamaged by the war, and the cost of living and property were rela-
tively cheap—there was an excellent exchange rate on the dollar, and
tourism in that city had not yet become a form of pollution.

Peggy had already started the hunt for a home for herself and her collec-
tion, activating most of the real estate agents in the city. There was some-
thing apart from its inherent beauty that appealed to her—an entirely
man-made environment that would be hard to find anywhere else except in
that other urbanized island—Manhattan. Peggy had, of course, no idea of
the kind of society Venice harbored, but even if she had, it is unlikely that she
would have changed her plans. To the arriving Mary and Bowden, Peggy
appeared already almost a native of the place.

She quickly took up with a chance Italian traveling companion of Mary
and Bowden, and the time they all spent together in Venice inspired Mary to
write a long short story, "The Cicerone," in which she paints an accurate if
cruel portrait of Peggy—Mary was later to regret the degree of unpleasant-
ness with which she painted her picture. The name she gives Peggy—Polly
Herkeimer Grabbe—is unfriendly, and it is no wonder that McCarthy gets
no mention in Peggy's memoir. Later, when she read "The Cicerone," Peggy
was livid, though the two women were, in the end, to patch up the rift caused
by the story. The perceptiveness of "The Cicerone" is undeniable:

> Miss Grabbe's intelligence was flighty . . . but her estimates were
> sharp; no contractor or husband had ever padded a bill on her;
> she always put on her glasses to add up a dinner cheque. Men, it
> was true, had injured her, and movements had left her flat, but
> these misadventures she had cheerfully added to her capital. An
> indefatigable Narcissa, she adapted herself spryly to comedy
> when she perceived that the world was sailing; she was always

the second to laugh at a pratfall of her spirit. . . . Miss Grabbe went on to talk, in the dipping, swaying gondola, of the intense, insular experience she had found, blazing as the native grappa, in the small, hot squares, the working-class restaurants and dirty churches of Venice. . . . Miss Grabbe was an explorer . . . her brown face had a weather-beaten look, as though it had been exposed to the glare of many merciless suns; and her eyes blazed out of the sun-tan powder around them with the bright blue stare of a scout; only her pretty, tanned legs suggested a life less hardy—they might have been going to the beach. . . . Miss Grabbe seemed to have been parched and baked by exposure, hardened and chapped by the winds of rebuff and failure. . . . Miss Grabbe was aware of her legend; it half-pleased her, and yet she resented it, for, at bottom, she was naively unconscious of the plain purport of her acts. . . . Sexual intercourse, someone had taught her, was a quick transaction with the beautiful, and she proceeded to make love, whenever she travelled, as ingenuously as she trotted into a cathedral: men were a continental commodity of which one naturally took advantage, along with the wine and the olives, the bitter coffee and the crusty bread. Miss Grabbe, despite her boldness, was not an original woman, and her boldness, in fact, consisted in taking everything literally.

There is much more in this vein, and it would be hard to find a better vignette of Peggy's character. Her relative, the eminent American publisher Roger Straus commented, "I published Mary McCarthy's book with its story about Peggy and I said to Mary, 'You know, I'm really embarrassed—I seem to be the only person she never fucked. I mean, she never even asked me to fuck her. What kind of reference is that? Am I really so unattractive?' "

Soon after Peggy returned to New York in the autumn it became clear that it was simply to wrap things up. The final season still carried important exhibitions, but to those close to her it was clear that Peggy's spirit had already moved on. To some it was distressing that she appeared to be losing interest in the New York School, which she had helped get started, just as it was beginning to hit its stride. To others it was questionable whether she had ever had any personal enthusiasm for the school, but allowed herself instead to be channeled by the enthusiasms of Putzel, Greenberg, and Sweeney. It is

unlikely that there was anything consciously calculated in her decision: She wasn't reflective, she followed her instincts, and in the end she always pleased herself. In the event, though to some going to Venice looked like a kind of retirement, it was no bad move. It allowed her to set her collection up in a permanent home in a country that had been starved of modern art since Mussolini came to power in 1922, sufficiently far away from her uncle's collection for it to have its own identity, and in a place she loved. If she had entertained thoughts of enjoying the life of a big fish in a small pond, she would have been disappointed. To outsiders and visitors, she became a celebrity in Venice, one of the sights to be seen, and she enjoyed the role to a certain extent. But the outsiders and visitors did not have to live in relative isolation in a small city ridden with gossip and ruled by a narrow and intrigue-ridden upper-class elite. Nor did they have to endure the long, dank, lonely winters, when all who could left for warmer, pleasanter places.

But much of this lay in the future. For now Peggy had fallen in love again with Venice, and as soon as Art of This Century had closed and she had disposed of its effects, stored her collection, and said her good-byes, she hastened to return there. Never sentimental, she did not look back. If difficulties lay ahead, she was well used to overcoming them.

twenty-one

Palazzo

\mathcal{P}eggy wasted no time in getting to know the artistic fraternity in Venice. As early as in 1946, she had found out where they congregated—the All'Angelo restaurant just north of St. Mark's Square, in the Calle Larga San Marco. There she quickly came to know the owners, the brothers Renato (later killed in a car crash) and Vittorio Carrain. Vittorio became a friend, helped her find her feet in Venice, attended to the flock of hopeful painters who surrounded her once she became established in Venice, and from 1948 until 1952 worked as what she calls her "secretary," though he prefers to think of himself as secretary of the collection. Certainly his contribution to the setting up of her collection in Venice was considerable. At the outset he had a considerable influence over her. Once again she had found a mentor.

The All'Angelo is still there, its walls covered with pictures. Until she found a home of her own in Venice, Peggy ate there regularly, enjoying the company and struggling with the Venetian dialect. The Carrain family—Vittorio in particular—are collectors in their own right, and in the past exchanged meals with artists for paintings.

Peggy's first contacts were the abstractionists Emilio Vedova and Giuseppe Santomaso. Her reputation as a collector had gone before her, and both men, starved of contact with modern art to look at and to study, were no

less enthusiastic about the plans she had to bring her collection to Venice than about the possibility that they, too, might benefit from her patronage. Both were locals, Vedova dedicated to the cause of international socialism. Neither was a great artist, neither was especially interested in Peggy personally, but they were the members of the new ersatz family Peggy would try to build around her in Italy.

On her return in 1947, she resumed her hunt for somewhere to live, enlisting as many people as she could, from waiters to bemused but polite contessas, to help spread the word. In the meantime she rented the top floor of the Palazzo Barbaro—just across the Grand Canal, as it turned out, from the palazzo that not long afterward would become her home for the rest of her life. Three floors of the Palazzo Barbaro had belonged to the patrician Boston Curtis family since 1875, and the building, which already had associations with Robert Browning, then acquired further artistic connections. A second cousin of the Curtises, John Singer Sargent, painted a family group in the salon in 1898, and soon afterward Henry James wrote *The Wings of the Dove* (published in 1902) in the magnificent library while staying there. Peggy was invited by the Curtises to take the top floor of the palazzo, and she stayed for about eight months. Peggy wanted to buy the apartment, but there was some friction between her and Nina Curtis, her hostess, on account of her unconventional lifestyle, and in any case the Curtises were not interested in selling. The present incumbent of the Barbaro, Patricia Curtis Vigano, remembers as a girl "going up to the apartment with my parents to visit her. She had transformed the dining room, which is not so very small, into her bedroom, and she had these beautiful furs which she also later had at the Palazzo Venier dei Leoni on her bed, and on the bed were her famous dogs; and to my young eyes this was a very new thing—to see those dogs on her bed. But at the same time she appeared to be frightening, intimidating." There is no elevator at the Barbaro, and access to the upper floors is by a steep stone staircase that begins in the courtyard. Peggy's dogs would not climb those steps, so she carried them. It is a steep climb.

Peggy was interrupted late in 1947 by the arrival in Venice of Laurence and Jean Vail, full of liquor (and money from somewhere), intent on persuading Peggy to accompany them to Capri, where Kenneth Macpherson had established himself in a villa. There was no legislation against homosexuality in Italy, and the postwar country had attracted many foreign gays. If her rather baroque letters are to be believed, Peggy here entered another

period of sexual profligacy, with a measure of bisexuality to add spice to the mixture; but it is more likely that she simply found congenial company among the gay community. She returned to Venice after Christmas, and to her comfortable eyrie at the top of the Palazzo Barbaro.

It wasn't long before visitors from abroad began to arrive—the first of a stream that would continue for most of the rest of her life. Bernard and Rebecca Reis came, bringing with them a male Lhasa apso in response to Peggy's complaints in her letters that Emily and White Angel had been receiving improper advances from all the mongrels in the district. The new arrival was given the Italian name Pecora (sheep) on account of his white coat, and misbehaved around the apartment in a manner that started the story that Peggy never housebroke her animals properly. But he was welcomed into the Guggenheim household, and the Reises received a good return on their investment: Pollock's *Cathedral* as a Christmas present. Peggy took advantage of Reis's presence to consult him about realizing capital in order to buy property. Later, again on his advice, she would give thirty-four Pollocks to the Tel Aviv Museum.

Another early arrival was a twenty-five-year-old homosexual Canadian photographer called Roloff Beny (born Wilfred Roy Beny) who'd read and admired *Out of This Century*. A prodigy who had moved from painting to photography, he is remembered as a photographer of monuments of the ancient and classical worlds. He had twenty-five one-man shows internationally between 1941 and 1952, and his first major exhibition was at London's Institute of Contemporary Arts at the invitation of Herbert Read in 1955. Roloff understood that if you were going to get anywhere nearly close to Peggy you had to establish from day one that you were not a scrounger, and that you were prepared without question to go dutch on any mutual expense. Peggy and he became good friends; in her letters she called him "Minxie."

She was most at ease with people who didn't intimidate her; but she sought the company of her intellectual superiors, who automatically had that effect.

The search for a suitable home continued, though for a short period it was interrupted early in 1948 when Peggy was invited to show her collection at the twenty-fourth Biennale—the international contemporary art fair held in Venice every two years since the mid-1890s, at which the world's leading nations each had a pavilion, but interrupted by the war and Mussolini, dur-

ing whose era the Biennale had been given over to the kind of aggressive-sentimental art that is the taste of most extremists.

At the time Greece was in the grip of a civil war and unable to make use of its pavilion; Santomaso suggested to the Biennale's secretary-general, Rodolfo Pallucchini, that Peggy be offered the use of it. Pallucchini was a scholar of Renaissance art, and pleased to have guidance, though Peggy found him intimidating—"he reminded me of an Episcopalian minister." She was, however, flattered and delighted at the opportunity, which had the ancillary usefulness of raising her status in Venice—"I felt," she wrote famously, "as if I were a new European country." At the same time she was worried that her collection was not solid enough to stand up in competition with collections of works exhibited by nations. She had remained in close touch with her friends and colleagues in New York and London, keen to be kept abreast of what had been going on in the short time since she had left the center of the art scene; but she hadn't bought much of any significance since leaving New York.

All the arrangements, costs, and insurance fees concerning the transporting of Peggy's collection from the United States to Italy were borne by the Biennale. The Greek pavilion was renovated and restored by the Italian architect Carlo Scarpa. Much reconstruction was necessary for this first truly international exhibition since the war as the site had been neglected for years. The American pavilion opened late, and thus it was that Peggy was the first person to show examples of the New York School in Europe.

The Biennale was opened on June 6 by the Italian president, Luigi Einaudi. After the ceremony he paid a brief visit to each of the pavilions, visiting Peggy's last. She greeted him wearing huge marguerite earrings, as if their reflection of her name represented a national flag. Count Elio Zorzi, head of the Biennale's press and publicity office, gave her five minutes to outline modern art to the president.

Peggy still looked for approval, but there may have been an element of mischief in her desire to meet Bernard Berenson, the great art historian of the Renaissance and her early guide, through his books, in the world of painting. Berenson visited her pavilion at the Biennale and was duly horrified by her collection, though he had some time for Pollock's and Ernst's work. "I greeted him as he came up my steps and told him how much I had studied his books and how much they meant to me. His reply was, 'Then why do you go in for this?' I knew beforehand how much he hated modern art and said,

'I couldn't afford Old Masters, and anyhow I consider it my duty to protect the art of one's time.' He replied, 'You should have come to me, my dear, I would have found you bargains.'" Another memoir of this meeting is recorded by the painter Derek Hill, who attended this first postwar Biennale with Henry Moore and John Rothenstein. "Peggy rushed up to Berenson and said, 'Oh, this is the greatest moment of my life Mr Berenson—you were the first person to teach me about painting.' And he replied, looking around, 'My dear, what a tragedy that I wasn't the last.'"

When Berenson and Peggy met again later at I Tatti, his villa near Florence, he asked her to whom she intended to leave her collection at her death. She replied without blinking an eye, "To you, Mr Berenson." But Berenson's reaction to her pictures was at least a professional one. She was more amused by the view of a Venetian aristocrat, Princess Pignatelli, who observed after visiting her, "If only you threw all those dreadful paintings into the canal, what a lovely home you would have." This attitude is an exaggerated example of what many Venetians thought of the collection. They were used to Renaissance and baroque art; even today, to enter the Peggy Guggenheim Collection is a stimulating shock after the tenebrous splendors of the Scuola San Rocco or the Accademia. Some have argued that this sharp contrast makes the collection seem better than it actually is.

The Biennale ran throughout the summer, and Peggy's contribution was a great success, though a Calder mobile was almost thrown away by accident as scrap and a small David Hare sculpture was stolen. Italians had been deprived of modern art for many years, and had a lot of catching up to do. Peggy's pavilion was one of the best—its 136 exhibits carried a greater cross-section of twentieth-century and modern American work than any other—the national pavilions had a tendency to promote their own painters, not all necessarily good, and to play safe. Austria showed Egon Schiele; Belgium, Delvaux, Ensor, and Magritte; France, Braque, Chagall, Lipchitz, and Rouault; Great Britain, Henry Moore and (for the net was cast wide) J. M. W. Turner; and the United States, Baziotes, Feininger, Gorky, Hopper, O'Keeffe, and Rothko. Santomaso and Vedova were exhibited in the Italian pavilion.

For Peggy it was like the opening of Guggenheim Jeune or Art of This Century all over again. She was involved in succeeding Biennales, but only went so far as buying the odd picture, giving parties for visiting friends in the art world, and occasionally lending a piece for exhibition. As the years

passed, even those connections waned, along with her interest in and enthusiasm for the continuing development of modern art. There was also the question of rising prices.

The year 1948, though, was a defining moment for her establishment in Italy. Other cities wanted to show her collection after Venice. Turin made an offer, only to have the city council withdraw it at the last moment as it deemed the pictures to be *arte degenerata* in the old fascist sense; but Florence showed it in three consecutive exhibitions—the Strozzina, the basement gallery of the Strozzi Palace, was too small to show everything at once—through early 1949. The Strozzina took the modest Biennale catalog and worked it up into a much more professional publication, which Peggy used as the model for her own collection catalog. She stayed with Roloff Beny, then resident in Florence, during the shows, and continued to have a strenuous social life: One of her acquaintances expressed her surprise that Peggy had ever found the time to "paint all those pictures." From Florence the collection moved on to be exhibited in Milan, and thereafter in other cities in Italy.

Incidentally, the great curator Giovanni Carandente, who became a friend during his incumbency of the directorship of the Veneto museums and galleries, was unable to mount an exhibition at the Palazzo Venezia in Rome in the 1960s, "where I was then director (the project fell through owing to malicious, jealous bureaucratic and political interventions which it would be futile to recall). Peggy's major resentment was not being able to see her name draped across the famous balcony of the Palazzo, where the most vicious anathemas against the Jews had been uttered!"

Peggy, meanwhile, faced the question of what to do with the collection once it ceased to be itinerant. The main problem was posed by the Italian government. Byzantine tax laws decreed that if the collection were to stay in the country as her private property, she would have to pay a heavy import duty on it—3 percent of its total value. This she wished to avoid by all means possible, even offering to bequeath the collection to Italy in return for the relaxation of the duty, to no avail. It was frustrating, because by the end of 1948 she had found, through Count Zorzi, an ideal home for her paintings and sculptures.

The Palazzo Venier dei Leoni stands on the Dorsoduro bank of the Grand Canal, just below the Accademia Bridge as you travel toward the

Canale di San Marco. It was begun almost exactly two hundred years before Peggy acquired it, for the old Venetian family of Venier, who reputedly kept a lion in its grounds; the allusion to lions in the palazzo's name is probably due to the series of stone lions' heads along the canalside facade of the building. The Lion of Saint Mark is also the emblem of Venice.

Building was slow, and interrupted permanently when the French took Venice in 1797, only the first floor and a basement having been completed. In appearance it is unique among the palazzi of Venice, and its long low front, painted white today, overgrown with creeper when Peggy lived there, gives an uncomplicated, modern aspect. As an unfinished edifice, it was not subject to the strict building controls of the city, which was to Peggy's advantage. It had ample room for her collection to be displayed, as well as providing more than enough living space, and Peggy was to arrange it as a home that contained works of art, rather than separate them from her living area (though she did retain some private rooms). In addition it had the advantage of one of the largest gardens in Venice, a city where any garden is a rarity.

Among its recent owners had been two exotic women: From 1910 it had for a time been the home of Luisa, the Marchesa Casati, a wealthy bohemian socialite and femme fatale who redecorated the palazzo entirely in black and white, with a great deal of gold leaf, which she also applied to her page boys, who wore nothing else at her parties. She kept two cheetahs with diamond-studded collars, she transported from her Roman mansion an entire black-and-white marble floor to Venice each season, she had St. Mark's Square closed to the public for a private party—and in 1957 finally died in a one-room apartment in Knightsbridge, having in her time run up debts amounting to about $40 million in today's money. Latterly Viscountess Diana Castlerosse had lived there. She bought it in 1938, some time after Casati's departure, and refurbished it before immediately renting it to Douglas Fairbanks Jr. for a year. Diana Castlerosse, remembered by the painter Derek Hill as "one of the chic-est and most attractive people ever," who'd managed to have an affair of sorts with Cecil Beaton, was responsible for more of the decor Peggy inherited, which featured six black marble bathrooms complete with sunken baths. Lady Castlerosse also figures as the only male character in Lord Berners's mischievous roman à clef, *The Girls of Radcliff Hall*, in which all the other (female) characters are, of course, men—Cecil Beaton, Oliver Messel, Peter Watson, and so on—disguised as schoolgirls and their mistresses.

Owing to the depredations of war, the palazzo was in a run-down condition when Peggy bought it from Diana Castlerosse's brother for about $60,000. She set about overhauling the interior, renovating the flat roof (which she used as a sun-terrace, sunbathing nude from the beginning of spring onward to the delight of the employees of the *prefettura* on the opposite bank of the canal, but causing a mixed reaction among the grander Venetian families), and replanning the garden, which would in time become a sculpture garden. To begin with the garden was arranged according to the English pattern, and later the director of the Tate Gallery in London, Sir Norman Reid, would supply her with rose bushes, which did extraordinarily and unexpectedly well. The garden had mature trees and an ornate well, and Peggy soon acquired and installed a large Byzantine marble throne, on which she was often photographed with her dogs in later life. Nowadays the flowerbeds in the canalside forecourt of the palazzo are planted with marguerites in season, in her memory.

She ended up with a plain, modern, white interior—though the private drawing room and the library remained an inherited dark blue for ten years. In 1959 she wrote to her friend Robert Brady, "I'm about to paint my sitting room the yellow colour of the Budist [*sic*] priests clothes." It's uncertain that this scheme was ever followed through since photographs show the walls to be white. The drawing room had large no-nonsense sofas by Elsie de Wolfe in white fake wipable leather (because of the dogs, but in any case Peggy did not much care about interior design), rugs, a glass coffee table, bookshelves, and bits and pieces of Africana along with the pictures and sculpture—originally only the few the Italian government allowed her for private enjoyment: Without payment of the duty, the collection still did not have an official home in Italy, and the bulk of it was stored in the Ca' Pesaro. For the time being small exhibitions were held using part of the collection—one showing British Art was arranged by Michael Combe Martin of the British Council, who became a good friend.

The dining room at the Palazzo Venier dei Leoni had a refectory table and the great Italian chest rescued from Yew Tree Cottage, both of which Peggy had bought with Laurence years before when they had originally intended to live in Venice. Calder's silver headboard was installed in her bedroom, the jewelry collection hung on the walls on either side of it, along with the Lenbach portraits of Benita and her as children. The walls were painted turquoise. In the main the private rooms on the principal floor (except for the

dining room) fronted the canal; the rooms overlooking the garden were given over to servants' quarters and the exhibition area.

The *pali* are the poles outside each palazzo on the Grand Canal to which gondolas are roped. Traditionally the *pali* are painted in barber's-pole stripes of the colors of the family to which the palazzo belongs, though nowadays only one palazzo in Venice still belongs entirely to one family: Most are divided into apartments. Peggy had her *pali* painted her favorite color—turquoise—and white. Her gondoliers dressed in white with turquoise sashes. To begin with she had two gondoliers for her private gondola—the correct number: One at the front and one at the back. There is only one gondolier per gondola today because the gondola as a mode of transport is dying out, supplanted by the *vaporetto* and the water taxi, and kept alive only by the tourist trade. Peggy was the last person in Venice to have her own private gondola. Instead of the traditional *cavalli* to which the tasseled ropes are attached on either side of the boat, she insisted upon Lhasa apsos—though they look rather like little Lions of Saint Mark rampant, to judge by the photographs. A daily four-hour tour of the city (later reduced to two) in her gondola in the afternoon quickly became part of her routine in her adored adopted city. Guests were invited to share this pleasure. Margaret Barr told the artist Saul Steinberg: "She will certainly take you for a ride in her gondola and then, if she takes your hand, I suggest you let her, on the principle of *ça coûte si peu et ça donne tellement de plaisir* [it costs so little and gives such pleasure]."

She moved into her palazzo early in 1949. The Venetians quickly came to call her *L'Americana con i cani* or, later on, *La Dogaressa*. The latter name was not always applied to her without irony. Venetian society was slow to accept the newcomer; Peggy's collection didn't meet with approval, and the fact that she was Jewish didn't help. Local university students from Ca' Foscari scattered dead kittens around her garden to tease her.

Vittorio Carrain joined Peggy at about this time, with the principal first task of overhauling the collection catalog. Their collaboration was suggested by the artist Peter Ruta. Carrain, who was born in 1924, a year after Sindbad, recalls: "She was generous to me. She always gave me money when I needed it, and she treated me like a son." The work he did for her was never formally contracted or waged.

Peggy was not without company. There was the small Anglo-American

community whose unofficial club was Harry's Bar, where Peggy frequently ate and double-checked the bill; and so steady was the flow of guests from elsewhere in Europe and America that the costs of entertaining them began to irritate her, though she enjoyed the parties, which she fueled with cheap wine and snacks much in the manner of her entertaining at Hale House. Favorite guests and old friends could be indulged. In the early 1950s Herbert Read visited with his mistress, a minor Czech artist called Ruth Franchen; Peggy loved the idea of aiding and abetting her former mentor in his *amour*. She kept a series of visitors' books that are still extant, and that are filled with little drawings, vignettes, and poems by the people who passed through, from family to artist friends to—as time passed and her reputation spread—film stars. Among early visitors were Nelly van Doesburg, now back in Meudon and a little too eager to go on telling Peggy what to do; Pegeen and Jean Hélion, now the parents of Fabrice, born in 1947, and David, born in 1948; Alberto Giacometti; Charles Henri Ford; and Pavel Tchelitchew. As an autograph collection the guest-books are beyond comparison: Joan Miró; Marc Chagall; Jean Cocteau; Saul Steinberg and his wife, the artist Hedda Sterne; the Bouchés from the Hayford Hall days; and Cecil Beaton are among the many who visited just in the early years. Other visitors included old friends like Alfred Barr, Henry Moore, and Virgil Thomson, as well as Somerset Maugham, Tennessee Williams, Joseph Losey, Paul Newman, and Igor and Vera Stravinsky. Friends from the Guggenheim Jeune days, such as Wyn Henderson, also visited. Some just came for a drink or dinner, some stayed a few days, some—occasionally—for weeks. But a tradition grew that a visit to Venice was not complete without a visit to Peggy, to the extent that she came to feel her privacy invaded, and began to guard it with increasing jealousy. She never became a recluse, but her old fear of being exploited tended to make her increasingly careful about whom she'd let in. There would be loneliness, and problems with the small expatriate community. She saw nothing of Ezra Pound and his wife, Olga Rudge, who spent their last years in Venice, on account of Pound's wartime support for fascism.

Not all Peggy's guests were grateful. Truman Capote stayed for a few weeks in the later 1950s and wrote an account of a trip made to the USSR in 1955–56 with a touring production of *Porgy and Bess*, entitled *The Muses are Heard* (1957). Later on, in his "unfinished novel" *Answered Prayers*, published posthumously, Capote, who uses the book liberally to savage many contem-

poraries, is unsparing when it comes to Peggy. The married narrator, P. B. Jones, remembers her thus:

> I might have married the Guggenheim woman, even though she was maybe thirty years my senior, maybe more. And if I had, it wouldn't have been because she tickled me—despite her habit of rattling her false teeth and even though she did rather look like a long-haired Bert Lahr. It was pleasant to spend a Venetian winter's evening in the compact white Palazzo dei Leoni, where she lived with eleven Tibetan terriers and a Scottish butler who was always bolting off to London to meet his lover, a circumstance his employer did not complain about because she was snobbish and the lover was said to be Prince Philip's valet; pleasant to drink the lady's good red wine and listen while she remembered aloud her marriages and affairs—it astonished me to hear, situated inside that gigolo-ish brigade, the name Samuel Beckett. Hard to conceive of an odder coupling, this rich and worldly Jewess, and the monkish author of *Molloy* and *Waiting for Godot*. It makes one wonder about Beckett . . . and his pretentious aloofness, austerity. Because impoverished, unpublished scribes, which is what Beckett was at the time of the liaison, do not take as mistresses homely American copper heiresses without having something more than love in mind. Myself, my admiration for her notwithstanding, I guess I would have been pretty interested in her swag anyway, but the only reason I didn't run true to form by trying to get some of it away from her was that conceit had turned me into a plain damned fool.

Like the guests, the Lhasa apsos began to proliferate. There were usually half a dozen or so in residence, and over the years dozens of puppies were littered, most of which Peggy gave away. Her own pets—"my beloved babies"—are buried beside her in her garden at the palazzo: Capucchino, Pegeen, Peacock, Toro, Foglia, Madame Butterfly, Baby, Emily, White Angel, Sir Herbert (named after Herbert Read, in anticipation of his knighthood), Sable, Gypsy, Hong Kong, and Cellida. Latterly not all of the dogs were pure Lhasas: In a letter to her friend the artist Robert Brady dated April 12, 1964, she writes: "My new dog, Gypsy, was married to a Peke (as I

could not find one of her race) and is expecting babies." Apparently the supply from Audrey Fowler, a Lhasa breeder who lived in Trevor Place, Knightsbridge, had dried up by then.

There remained the problem of what to do about the collection, still in the custody of the Biennale administration. Peggy was eager to found her museum-gallery at last, but the import duty question seemed insoluble. She was able to "borrow" some of her sculptures for an exhibition in her garden in 1949, which featured work by Arp, Brancusi, Calder, Consagra, Giacometti, Hare, Lipchitz, Marini, Mirko, Moore, Pevsner, Salvatore, and Viani. The exhibition was a great success despite the fact that curious visitors kept wandering from the garden into the house and had to be flushed out. She was also asked to mount an exhibition of her Pollock paintings in the Correr Museum in the Ala Napoleonica on St. Mark's Square in the summer of 1950, the same year that Alfred Barr chose Pollock as one of the artists to represent the United States at the twenty-fifth Biennale.

The organizers of Peggy's exhibition did little beyond providing a catalog, and Peggy and Carrain had to see to the transportation and hanging of the pictures themselves, helped by waiters from the All'Angelo. So great was Carrain's personal contribution to the exhibition that Peggy gave him a small Pollock, then worth $90, by way of thanks. It was Pollock's first European exhibition, and was at least popular with the local painters who went to see it. Venice at heart is a conservative city; but international critical reaction, apart from that of Pollock's champions, also remained reserved. There followed a less than successful exhibition of Jean Hélion's work at the Palazzo Giustiniani, bedeviled by Italian bureaucracy when it came to importing the works to be shown, and then plagued by bad weather when the first difficulties, largely thanks to Carrain, were overcome. Meanwhile Peggy had become fed up with the Pollocks' rudeness to her—she was always a stickler for conventional good manners—and gave up on them when they ceased to reply to her letters or send her reviews. She was right in feeling that Pollock's nascent success was going to his head.

Finally, early in 1951, a solution to the import problem besetting her own collection presented itself: The Stedelijk Museum in Amsterdam invited Peggy to show her collection there. This meant that the collection left Italy. After Amsterdam, there were shows in Brussels and Zurich. When the collection was due to return to Peggy, it was brought in at night via a small mountain frontier post whose officials had no idea of its true worth and

allowed it in at a far lower valuation than its actual worth—Peggy remembered a valuation of about $1,000 for the lot. The Italian authorities were not pleased to have been tricked, but they could do nothing except examine what, in the truly labyrinthine corridors of their law, they could find to keep the collection in Italy, now that it was there. It was, after all, potentially a national asset; but that was a problem that would raise its head much later. For the moment Peggy at last had full legal control over her collection again and could make her museum a reality.

Soon the Palazzo Venier dei Leoni was transformed, though there wasn't room to hang everything, and several paintings were stored (to their detriment) in the damp basement. Peggy's huge Calder mobile, *Arc of Petals*, was installed in the entrance hall where it still hangs (one or two of Peggy's grandchildren have confessed to a desire to swing on it when young), and a recent postwar acquisition, *Angel of the Citadel (L'Angelo della Città)* by Marino Marini, placed on the terrace fronting the canal. Peggy had met Marini at the home of a British Council official, Maurice Cardiff, and his wife, Leonora, in Milan. The Cardiffs themselves had met Peggy with Freya Stark at the Palazzo Dario, next door to Peggy's palazzo, a short time before, and this exchange of visits was to be the start of a long friendship, cemented by the remarks of their young son Charles on a subsequent Venetian visit: Not only did he admire the pictures but he remarked that Peggy looked far too young to be a grandmother.

The *Angel* had made its first appearance at the sculpture exhibition. It is of a young, naked man, his penis erect and his arms stretched wide, astride a horse. Marini had at first soldered the penis onto the torso, but later cast it separately, so that it could be unscrewed and removed as occasion demanded. Peggy rejoiced in watching the reaction of visitors to the statue (something it is still amusing to see), of which she had a good view from her drawing room window. However, as Peggy recalled: "When the nuns came to be blessed by the Patriarch, who on special holy days went by my house in a motorboat, I detached the phallus of the horseman and hid it in a drawer. I also did this on certain days when I had to receive stuffy visitors, but occasionally I forgot, and when confronted with this phallus found myself in great embarrassment."

Stories about the sculpture and its appendage abound. There is a photograph of the visiting Jean Arp "smoking" the detached phallus like a cigar, and another of Peggy's friend the art historian James Lord riding the horse behind the bronze figure in 1959: "That was very wicked of Peggy [who took

the picture] because when the photo was taken she was well aware that it would look as if I were fucking this person." In the same year the English art forger Eric Hebborn visited Venice, and Peggy invited him "to admire a sculpture by Marino Marini. It represented a boy on a horse; the horse's head and neck had been modelled to suggest a phallus, and the boy's arms were sticking out at right angles to his trunk, as was his penis. Peggy put her hand on the bronze erection and said in a sultry, sexy kind of voice . . . 'Eric, the whole heat of Venice seems to concentrate itself in this spot.' With which she unscrewed the object, and to my horror, thrust it into my hand and invited me to kiss her." Hebborn was gay, which Peggy knew; nevertheless, "Thinking it impolite to refuse a lady, I gave her a gallant peck on the cheek and returned the metal penis with: 'I'm sorry, Peggy, but this is a lot harder than mine is.' " Simon Stuart, the son of Peggy's cousin Eleanor, quotes Cecil Roberts's surely apocryphal anecdote about Somerset Maugham's first visit: It appears that Peggy had been trying to get the writer to call at her palazzo for years, and eventually, having refused many times, Maugham accepted an invitation. Peggy saw him coming up in a gondola, whereupon she ran out onto the terrace, unscrewed the phallus from the *Angel* and waved it in the air at Maugham, crying, "I've got you at last!" Maugham took one look and told the gondolier just to row on without stopping. That Maugham did however pay Peggy a visit is attested to by his comment on the excellence of her martinis. There was only one moment of panic: Shortly before the great man's visit, Peggy telephoned Michael Combe Martin: "Where can I get a book by Somerset Maugham? I need him to sign it!"

In 1960 some visitor or other unscrewed the penis and made off with it; Marini cast a replacement, but this time it was once more firmly soldered on, and remains so.

Peggy admitted visitors to the collection between 3 and 5 P.M. on Mondays, Wednesdays, and Fridays during the summer season. At the outset people were allowed to wander freely throughout the house, but guests sleeping in after carousing found themselves woken by strangers gawping at them. Peggy quickly issued friends who were staying with room keys, and banned the public from her drawing room. What she couldn't do was prevent the odd hungover guest from wandering into the public areas forgetfully in a state of rather too great *déshabille*. Otherwise friends could escape to the roof, banned to visitors, and sunbathe and drink cocktails during the two afternoon hours. But it was important to Peggy to show her works of art

to people who were interested. This was part of her raison d'être, and she identified ever more closely with the collection. The works of art became her "children" more even than the dogs, and certainly more than Sindbad and Pegeen.

Sindbad had started a literary magazine in Paris early in 1949 called *Points*, dedicated to new American, British, French, and Irish writing. It was not an unqualified success, though it published interesting work, including, in 1950, a short story by James Lord, "The Lizard." Lord remembered: "It is the tale of a young man's approach to maturity and contains a detailed description of masturbation. Peggy was very much taken with this passage, said it was the best evocation of an orgasm she had ever read, and insisted that I copy it word for word into her guest book, which I did with reluctance."

Sindbad's heart was not really in *Points*; it was the kind of publication that belonged more to the prewar years, and it did not last long. Sindbad then worked for a time in the real estate business, before becoming an insurance broker. His real love remained cricket, and he became president of the English club in Paris. He suffered even more than his sister from parental, and especially maternal, neglect. A generous and kind man forced to grow up out of his depth, and a heavy drinker like his father, he died of cancer in 1986. Michael Combe Martin remembers him coming to London for five days in the 1960s—"a 10:00 am snifter then an all-day pub crawl every day."

People remember Sindbad with rueful affection. In his mother's guest book he wrote of her with the same sort of emotion:

Indeed it is hard
To be an eternal bard
To tax one's imagination
is a perpetual frustration
It is also banal
To talk of a canal
or love and sex
as an eternal hex
What a pity
to be witty
without the ability.
Je ne puis écrir plus
Car je dois garder un surplus

pour mon proche retour
A cette ville où on ne trouve pas toujours L'AMOUR.

Sindbad Vail with all my love to Moma [sic], June 12, 1955

The collection, Peggy came increasingly to think, is the collector. Without the collection, there is no collector. She had already toyed with the idea of leaving all of it to Italy. There seems never to have been any question in her mind of leaving even a handful of major works to her children, though she did give Pegeen an Ernst, and the family ultimately inherited a few relatively unimportant works—Leonor Fini's *The Shepherdess of the Sphinxes*, and Leonora Carrington's *The Horses of Lord Candlestick* (a title perhaps suggested by the fact that when in England before the war, Arp had only learned one English word—"candlestick"). Her main concern as the years passed and her sense of isolation increased would become: How do I protect all this intact after my death? It is my empire. It is my museum. It is what says to the world that I was here. If it ceases to exist, so do I.

But these considerations would take some time to come to the fore. At the moment she was contented—her collection was in place and open to the public. The servants were coopted to act as guides and learned something about art in the process, once reporting to Peggy that they had heard a professor talking to a group of students about a cubist Braque, but telling them mistakenly that it was a Picasso. The servants were too much in awe of his rank to correct him. Admission was free, but you could not find your way around the collection without a catalog, for which payment was required. Just as she had at Art of This Century, Peggy enjoyed collecting the money—it wasn't much; running the Palazzo Venier dei Leoni would absorb most of her income, but she couldn't deny herself the pleasure of collecting a bit of cash. Just as she had at Art of This Century, if she had guests, she would scoop money out of the collecting bowl to take them out to the Montin or the Cantonina Istorica. Catalogs cost about 2,000 lire each and profits went back toward running costs, which they came nowhere near covering.

Peggy's life was not without its domestic problems. Now in her early fifties, she had not lost her taste for sex, though the flings were becoming farther and farther between, however much she pretended that they were not. She longed for a proper lover and real company. She missed playing Maece-

nas to artists—Vedova was wrapped up in the class struggle, and the gentle, rotund, and amiable Santomaso showed a disquieting tendency toward independence of her. And there was the question of Pegeen.

The early 1950s brought a number of crises with them. In 1952 Laurence Vail's new wife, Jean, died, still only in her early forties. Laurence was devastated, and did not marry again—though a few years later Peggy had to bail him out over a breach-of-promise suit. Laurence was a rare visitor to Venice, and continued to go his own way, combining a little activity in the plastic arts with a little writing and a great deal of drinking. Illness and ulcers were not far away. He remained well liked, though he was never a man able fully to confront trouble when it presented itself. Not very long afterward it became apparent that all was not well between Pegeen and her husband. Hélion remained in their Paris apartment while Pegeen made increasingly frequent visits to her mother. By this time Peggy had made the acquaintance, through her friend the American artist William Congdon, of another young Italian painter, a loner called Tancredi Parmeggiani. Full of enthusiasm for his work, but lacking an adviser to guide her enthusiasm (though James Johnson Sweeney liked his work, too, which gave her confidence), she decided to back him in much the way that she had backed Pollock, paying him a stipend of $75 a month and allowing him the use of space in her basement as a studio, a facility she had already extended to her daughter, who continued to produce childlike scenes peopled by doll- or puppetlike creatures who communicate nothing so much as isolation, and who bear a curious resemblance to the figures in Hazel's paintings. Tancredi moved in to work, but was soon driving everyone mad because he had a habit of wandering around the house in paint-stained clothes and shoes, dappling color everywhere. He was also clumsy and uncoordinated, and thus broke things frequently. "Tancredi was very fey," says the painter Paul Resika, who knew him in Venice at that time. "He was not serious, and rotten, but at the same time good company and quite a charmer. . . . Peggy really chose wrong with Tancredi. He wasn't able to cope with what she tried to build him up as. . . . He ended up painting tiny watercolors."

Pegeen, who has been accused of aping her mother in sexual profligacy during this period, certainly had an affair with Tancredi, though gossip that she shared him with her mother was unfounded. Peggy wasn't supportive of her daughter, and the affair did Pegeen little good: Both she and Tancredi had insecure personalities, but he had a history of mental instability, and his

mother had died in a psychiatric institution. The affair staggered on for a handful of years, but in the end, luckily, Tancredi decided that Peggy was exploiting him and wished to break free of their arrangement. By the mid-1950s it was all over. Tancredi moved to Rome, where he married and had two children, but the demons within him would not be silenced, and in 1964 he committed suicide by flinging himself into the Tiber.

In 1951 Peggy embarked on the last serious love affair of her life. She met Raoul Gregorich at a party given by the rich homosexual art dealer and bon viveur Arthur Jeffress.

Gregorich came from Mestre, the mainland town joined to Venice by the Ponte della Ferrovia and the Ponte della Libertà. His background was dubious: He had apparently been in the Resistance during the war, and had since reputedly been involved in some minor criminal activity; one rumor persisted that he had killed a man in the course of a holdup. The art dealer Gaspero del Corso, however, remembered that when, in 1943, he had been in the Italian army and mistakenly transferred to Tunis, it was the local second-in-command, Raoul Gregorich, who arranged for him to be sent away from the fierce fighting and back to Rome. From that day on, del Corso regarded Raoul as "his saviour." After the war they met again, and del Corso had a different take on the holdup:

> One day in Rome around 1949, Lello Levi, an attorney from Venice, entered my gallery, l'Obelisco, and said, "I bring you greetings from Gregorich, who is in prison in Venice." "In prison?" I exclaimed. "But what has he done, my saviour?" I knew Raoul was of good family and that his father was an important judge. Levi informed me that Raoul had been involved in an armed robbery on the Venice-Mestre causeway against the Prince Thurn und Taxis. This news astonished me, as you can imagine. Six months later a thin young man who resembled—like two drops of water—Gregory Peck, opened the door of my gallery in Via Sistina. "Do you remember me? I am Raoul." Raoul in Tunis had been obese: I couldn't believe my eyes. Evidently prison had been good for him. He said that he was working in Milan with a furrier.

When he met Peggy, Raoul, who'd regained a good deal of weight by then, was occasionally working as a mechanic, and his ruling passion was sports cars. He was strong, muscular, and uncomplicated. Their only means of communication was Italian. When they met he was thirty: twenty-three years her junior and only two years older than her son.

Setting aside the waspish comments that surrounded this relationship—Peggy was doing nothing to ingratiate herself with the Venetian *haute volée*, and Raoul caused some concern among her expatriate homosexual coterie as well—a genuine affection seems to have existed between Raoul and Peggy. He had little interest in art and tended to be overawed by Peggy's friends, but he adored her and the dogs, and his feelings seem not to have been entirely dependent on her money: She would not have tolerated him if that had been the case. As it was, she enjoyed the sense of rejuvenation having a much younger lover gave her, and she enjoyed spoiling him—she bought him three sports cars, including a pale blue one, which he loved to drive at top speed along the roads linking Venice to Padua, Treviso, and Udine. He called her *"mia cara bambina."* His fondness for Peggy was genuine, though he had a roving eye and soon found another mistress of his own age. This Peggy, realistic about the situation, did not resent.

Venice, however, disapproved. In those days the grand families still maintained their palazzi and jealously guarded their closed society (and its sense of propriety) from interlopers. In September 1951 Peggy was not invited to the Beistegui ball. This was one of the great social events of the Venetian calendar, given by the vastly wealthy Mexican silver magnate Charles de Beistegui (various sources give different spellings of the name and different attributions both of the metal and the nationality) at the Palazzo Labia. Others were also excluded—among them Arthur Jeffress, who left town in order to minimize the slight. Peggy was fortunate in that the ball coincided with the world premiere, at La Fenice opera house, of Igor Stravinsky's *The Rake's Progress*, conducted by the composer, with Elisabeth Schwarzkopf and Jennie Tourel, and Otakar Kraus as Nick Shadow. The Stravinskys were old friends, and they invited Peggy to the first night. Gradually she would come to be accepted (in 1960 she writes of having been to the Volpi Ball), but the process was a slow one. Her resident friends were for the time being largely members of the expatriate gay community, and, as she remained an Anglophile to the end of her days, the British consul and members of the

staff of the British Council. Now and then she still toyed with the fantasy of marrying an English aristocrat.

In the matter of entertaining, Peggy's hospitality was variable. Close friends like Roloff Beny, and the American painter Robert Brady, who lived in Venice during the mid-to-late 1950s, could expect good food and wine when they came to dinner. Others were less fortunate. Almost all were subjected to specific questioning, in public, about their sex lives. Peggy took after her maternal grandmother in this, and no one was spared, not even her grandchildren. Paul Bowles, visiting from Tangier, where he had made his home, recalled staying with Peggy en route from the Far East with his friend, the Moroccan painter Ahmed Yacoubi:

> The first morning after breakfast Peggy sent a servant to say that she was on the terrace. I went up first and found her sunbathing in the nude. "Do you mind?" she said. At that moment Ahmed appeared in the doorway. His face froze. For him the situation was wholly without precedent. "We'd better go down, hadn't we?" he muttered.
>
> "Oh, is he embarrassed?" Peggy cried. "Tell him to come on out. In a minute I'll put on my bathrobe." Ahmed was still talking out of the corner of his mouth. "He doesn't think it's right for women to sit naked in front of strange men," I told her, translating and censoring the gist of his remarks.
>
> "How strange. You mean they don't do that where he comes from? I'm sure they do. Tell us, Ahmed."

Somehow the situation was resolved, and later Ahmed unbent enough to take over the kitchen, happily preparing delicious tajines. Peggy, always soft-spoken and archly disingenuous, had evidently won another heart.

During the summers, when the collection was open to the public, Peggy occasionally wandered among the visitors incognito to eavesdrop on their comments; or she could sunbathe and surround herself with people, and time passed agreeably. The winters, cold and damp in Venice, when the city draws in upon itself and hibernates, were harder; especially after the death of Raoul, who crashed his pale blue car avoiding a motorbike in September 1954, some time after an argument he and Peggy had had over getting him a faster model.

Two people close to Peggy who did not visit Venice were Marcel Duchamp and Djuna Barnes. Djuna, now living in her old stamping ground, Patchin Place in Greenwich Village, only made one more trip to Europe, in 1950. Ten years earlier she had been temporarily deprived of the stipend Peggy had regularly sent her for so long. Peggy sent her occasional sums to meet her old friend's immediate needs, but Djuna's alcoholism frustrated her—she viewed it as a "moral collapse." She thought that her subsidy got in the way of Barnes's creativity. Now, the stipend long since restored after the beginning of Djuna's long hard climb from drink, the two women kept in touch by letter. They were closer to each other than either suspected. Djuna's health was wrecked, but her mind was as incisive as ever. After Raoul's gondola-hearse had delivered his body to San Michele [Venice's cemetery-island], Peggy told Djuna by letter: "I don't think I'll ever love anyone again; I hope and pray not."

She wrote the truth. There are several stories about subsequent dalliances with British and American naval officers visiting Venice in their warships, and even a story about an admiral having to escape from Peggy's bedroom window onto the canalside terrace and thence into his waiting dinghy when the two were surprised in bed by the arrival of Pegeen and her second husband; but these are apocryphal. There may have been flings, but from now on Peggy was essentially alone; and the loneliness was of her own making, as it had always been. In the words of the adage, "They say everything we do is our fault, but that's not our fault."

There was another storm to weather that autumn. Max Ernst had not enjoyed much public acclaim since winning a competition sponsored by United Artists soon after the war for a *Temptation of Saint Anthony* that would feature in Albert Lewin's film *The Private Affairs of Bel Ami*. The film, however, with George Sanders and Angela Lansbury, was as poor as Ernst's painting. Max had by now returned to Europe, and won the painting prize at the 1954 Biennale. It was a long time since Peggy and he had met. Ernst had not forgotten the time in New York, as his biographer John Russell records,

> Outwardly his situation was highly advantageous: the splendid studio overlooking the East River, the marriage to a prominent figure in the New York art world, the freedom from the petty discomforts and humiliations which awaited other refugees from Europe. But these circumstances did not, even so, make for hap-

piness. . . . Max Ernst began to find New York, as he once said, "as
much a desert as Arizona, and much more difficult to work in."

As early as 1942, Max had painted *Young Man Intrigued by the Flight of a
Non-Euclidean Fly,* an exercise in drip-technique that prefigured Pollock's
(though far more cautious and technically fussy). It was a technique of which
he (along with others) claimed to be the pioneer, but it was too imprecise for
his manner. He had been happy in Sedona, Arizona. He would try to find his
way again in Seillans, France.

It was awkward for Peggy to meet Max and Dorothea. The two women
were tense—so much so that Peggy nervously slopped a glass of red wine
into Dorothea's lap. But Max was all for reconciliation. After all, he was free
of her and could afford to be generous. At last, and perhaps with only uncon-
scious hypocrisy, he wrote affectionately in Peggy's guest book, "Peace for-
ever, *un vrai ami est revenu,* . . . darling Peggy, Max." Peggy bit her lip.

She had spent part of the winter visiting her children and their families in
Paris—Sindbad and Jacqueline had two sons now, Clovis and Mark, born in
1946 and 1950; and Pegeen and Jean had had a third son, Nicolas, (whose
paternity was scandalously attributed to an Italian lover of Pegeen) in 1952.

After the loss of Raoul in 1954, Peggy decided that a long voyage was in
order, and left Venice for Ceylon (as Sri Lanka was then) and India. She
went to Ceylon first, where Paul Bowles had bought Tabrobane, a small
island only just offshore; you could wade out to it in a matter of minutes, but
the experience was uncomfortable because "the waves usually wet one's bot-
tom." Though the place was primitive—there was no fresh water on the
island, and the rooms in the house were simply divided by curtains—Peggy
seems to have spent an enjoyable five weeks there, being lionized as a "great
art authority" in Ceylon.

Paul Bowles remembered her visit:

> We went to fetch Peggy Guggenheim at the railway station of
> Weligama in a rattling bullock cart. She was rapturous about the
> island and could not really understand why Jane [Bowles' wife]
> hated it. . . . The day after Peggy arrived at Tabrobane, a fat,
> legal-sized envelope was delivered to her, sent by the government
> in Colombo. It contained a set of tax forms which she was to fill
> out in triplicate, declaring her global income. Peggy did not wait;

we went to Galle to consult a lawyer. The man calmed her and advised her to disregard the letter.

Peggy's comment on the Bowles's little Sri Lankan island was: "I think it's wonderful that you have this place . . . but of course you can't afford it." (This was true.)

From Ceylon, Peggy traveled alone in India, cutting down the ambitious itinerary planned for her by the Indian ambassador in Colombo but still managing to cover twenty cities—traveling the length and breadth of the country—in seven weeks. She achieved her ambition to meet a maharajah—of Mysore—and she was enthusiastic about Le Corbusier's Chandigarh, still pristine then, before the humidity soiled the concrete, but was disappointed in Indian modern art, in which she had proposed to invest. She bought a large number of earrings instead. In Darjeeling, in quest of Lhasa apsos to bring fresh blood to her own inbred Venetian pets, she met Sherpa Tenzing Norgay. He had six Lhasas but wouldn't part with any of them.

In 1956 another blow fell: On August 11 Peggy had a call from New York to tell her the news of Jackson Pollock's death—in a car crash, like Raoul. Earlier the same year she had refused hospitality to Lee Krasner, making her first European visit. The animosity between the two women, already established, would fester throughout their lives, and Peggy never felt that anyone gave her enough credit for getting Pollock started.

Peggy hardened her heart. Only those who made no claim on her found the door open. And she had more domestic problems to contend with. In the mid-1950s, the marriages of both her children foundered. Sindbad and Jacqueline separated in 1955. Two years later he remarried the Englishwoman Peggy Angela Yeomans, and would have two daughters, Karole and Julia. Peggy *mère*, whose son in her opinion had not come up to expectations, didn't meet the new bride or go to the wedding or the subsequent christenings. Her several grandchildren would receive attention commensurate only with what they paid her. Her granddaughters were much fonder of their maternal grandmother, the wife of a Fleet Street typesetter. It took Peggy a long time to become reconciled to her new daughter-in-law, but when they occasionally met in London she and Sindbad's new mother-in-law got along well.

Several years later, in 1963, Jean Hélion and Jacqueline Ventadour would

marry. In the same year Jacqueline's sons by Sindbad, Mark and Clovis, went to live with their father's new family.

Pegeen had always been Peggy's favorite, and now Peggy planned, quite specifically, a new match for her with a minor English aristocrat. This would have had various advantages for Peggy: vicarious wish-fulfillment, a decent extrication from a marriage that had become unfortunate, and an end to the increasingly distressing affair with Tancredi. To that end she took her daughter to England, and there the scheme misfired—disastrously for Peggy, but romantically for Pegeen.

The visit to England to introduce Pegeen to the aristocrat took place in 1957. Hélion and Pegeen were separated but not yet divorced—that would happen the following year. For some time Hélion had found it increasingly hard to cope with his wife's neurotic behavior, and the strain of preventing several suicide attempts—which may have been more histrionic than genuine. Peggy sided with her daughter, and had in any case cooled in her attitude toward Hélion, who had returned to figurative painting. Naturally while in London Peggy took in the art galleries, among them the Redfern, where there was a show by a twenty-three-year-old artist called Ralph Rumney. Already the founder and editor of a small arts magazine, *Other Voices*, which ran to six issues, Rumney was shortly to become one of the founding members of the Situationist International school (though he no longer likes to be associated with any "movement"). Nine years Pegeen's junior and the son of an Anglican clergyman in Halifax in the north of England, he was already gaining notoriety as an original talent. During Peggy's visit to his show, Ralph suggested to her that she might like to go to the opening of Francis Bacon's new exhibition at the Hanover Gallery, which was taking place that night. In the event, Peggy was too tired to go, and sent Pegeen instead. There, Ralph met Pegeen, without knowing who she was, and flirted with her. When her group left the opening he followed in a taxi, gate-crashed the party they'd gone to, and spirited Pegeen off to the Neal Street studio he was renting for five shillings a week. For him the meeting was a *coup de foudre*. The following day Peggy felt better. Accompanied by Pegeen, she acquired a Bacon, *Study for Chimpanzee*, from the Hanover Gallery, and then, a few days later, revisited the Redfern, where she tried to buy *The Change*, the largest picture in the show, from Rumney privately, in order to avoid paying the gallery's commission and thus negotiate a "friendly" price. Ralph refused, and soon afterward gave the painting to Pegeen. *The Change*,

a big painting measuring 1,524 mm by 1,985 mm, is now in the possession (since 1989) of Tate Britain. Peggy was less than happy. Rumney remembers that when she found out, she said to her daughter in front of several art world mandarins, including Herbert Read: "You're fucking your way up to quite a collection." Ralph says that from then on Peggy hated him. Over the years that followed, the feeling became mutual: "Peggy could be pleasant, witty and charming; but she was also a silver-plated bitch." At no point did Laurence Vail, with whom Ralph became friendly in later years, intervene: Rumney, who has great regard for Vail both as a man and an artist, concedes that he found facing realities difficult.

Things got worse. As soon as Peggy learned that her daughter and Ralph were in love, she became both jealous and envious. Ralph's art (and that of his peers) was something she found threatening; Ralph was substantially younger than her daughter, not the comforting father figure Peggy preferred for her daughter. It may also be that in Ralph, tall, handsome, big-boned, a big drinker, and with more than an element of danger in his personality, she perceived a genuine risk to her daughter; but the greater danger for Peggy was that Pegeen would cease to be under her control. Peggy, as Kathe Vail has mentioned, was always envious of Pegeen's relationships with men—even those she arranged herself. As Ralph himself has observed, Pegeen loved her mother and at the same time resented that control, never quite managing to liberate herself from it. Meanwhile the lovers divided their time between London and Paris, and later between Paris and Venice, where Pegeen took a flat in Castello. There, their son Sandro (named for Botticelli) was born on June 28, 1958. His "honorary" godfather was Jean Cocteau, who stood up for Pegeen and Ralph and wrote to Peggy the following year, "By ostracising your daughter, you are damaging yourself and hurting her, yet destiny weaves exactly the same threads as if you were seeing her. So—let the stars manage things without interfering. When we meddle with our lifeline we only achieve muddle, and we distance ourselves from those who could help us to live."

Pegeen's divorce had not yet been finalized when her fourth son was born, but as soon as it was, the couple married in Bloomsbury, London, and had their reception in the Hotel Russell in Russell Square. Ralph remembers that Hélion sent a bailiff over from Paris to ensure that he was not saddled with a patrimony suit.

Ralph by now had come into a modest inheritance, and with it bought an

apartment on the rue du Dragon in Paris, where the family lived for some time (Pegeen's youngest son by Hélion joined them; the older boys stayed with their father, since Pegeen had neither the psychological nor the material means to look after all four of her sons), before moving to a more spacious apartment on the Île St.-Louis, bought with the money raised on Ralph's apartment and an Ernst painting Pegeen owned. Peggy did not help, but nor did she help Sindbad in such matters: In her defense one must remember the running costs of the Palazzo Venier dei Leoni, which, to her mind, had to come before everything else. Pegeen had a monthly allowance of $300 from a trust set up by her grandmother Florette, and another $150 from Peggy. "Pegeen really loved Ralph Rumney," Peggy's friend John Hohnsbeen recalls. "Peggy really hated him. Neither Ralph nor Pegeen ever had a dime except for what Peggy tossed them." Pegeen's paintings didn't sell, nor did Ralph's, many of which were huge canvases. Nevertheless they could afford a substantial apartment and a servant.

The Rumney family went on to divide its time between Paris and a new apartment-cum-studio in Venice on Giudecca island, and lived thus for the next ten years. In no photographs does Pegeen look happier than in those where she is with Ralph; but she could never quite escape her mother's influence. Perhaps she met Ralph too late.

Peggy insisted that the Paris flat be in Pegeen's name, though Ralph had paid more than 60 percent of its value, but Ralph agreed to the terms. Peggy's hatred of him continued—for her, he was tactless and boorish; he didn't kowtow to her. He also caught her: When she asked him to help himself to a Scotch, he poured whiskey from a bottle of good malt but found that what was in his glass was a cheap blend Peggy had surreptitiously filled the bottle with. When he innocently suggested to Peggy that her supplier might be cheating her, not suspecting the truth, she was furious that he'd seen through her little deception. On another occasion, at the end of an informal dinner after an Artur Rubinstein concert at La Fenice, attended by Ralph and Pegeen, Peggy, Rubinstein himself, and Una Guinness, Peggy asked for the bill and proceeded to work out exactly who owed how much. Ralph took the bill from her in embarrassment and paid it, which can't have endeared him to Peggy. The following day Una Guinness sent him the money. Peggy did her best to damage his reputation; but friends like the Beat poet Alan Ansen remained loyal. Peggy, however, did not let up. She took every opportunity to undermine the marriage and at one point took Rumney out to lunch and

offered him $50,000 "to disappear"; when he later told Pegeen about it, she laughed, and told him he should have accepted the offer—they could have used the money to disappear together—or buy a house. The battle went on and on, and did not end even with the tragedy that should have been its conclusion.

Meanwhile Peggy continued to buy pictures, though sparingly as prices rose. She went on investing in African art, then immensely modish, and found a fourth Italian painter to add to her stable—Edmondo Bacci, a follower of Kandinsky. She also bought pictures by, among others, the American William Congdon, and the Scottish artist Alan Davie, whom she regarded as a follower of Pollock. In the mid-1950s she sold a Bacci to a rising young Czech émigré museum curator in the United States, Thomas Messer.

In the spring of 1958 James Lord paid another of his frequent visits to Venice. He called on Peggy accompanied by his friend Bernard Minoret and by Picasso's former mistress, Dora Maar. "It seemed fitting," Lord wrote later, "that two ladies who had in one way or another made themselves important in the art of their era should come face to face. Peggy was always content to parade her pictures and I thought she'd be flattered to have under her roof a woman who had so often inspired Picasso. The meeting was not a success, because both ladies liked being catered to, though not at all in the same manner. When we left the Palazzo Venier dei Leoni, Dora said: 'Madame Guggenheim merits our compassion, but she wouldn't know how to go about being worthy of it.' " Lord remembers: "Dora was very straitlaced and very religious, and she would not have approved of Peggy's scandalous behaviour, though Dora had had plenty of lovers before Picasso—her last. But she felt that Peggy was a scandalous person; and Peggy wasn't all that keen on having other famous women around. Peggy liked to be the centre of attention and so did Dora, so they didn't hit it off too well, though they had wanted to meet one another. Also, Dora was much more of the world that Peggy wanted to belong to than Peggy was; and I'm sure Peggy would have liked to have been Picasso's lover too."

The collection was outgrowing the confines of the palazzo. In the late 1950s, Peggy commissioned the Milanese architects Belgioioso, Peressutti, and Rogers (the last an uncle of Richard Rogers) to draw up plans for two upper storeys, but the result was out of sympathy with the rest of the building. Peggy felt sure that the local planning authority, the Belle Arti, would

never permit construction, and in any case, the cost was prohibitive—as much as the palazzo had originally cost her. Another solution would have to be found. With the consent of the Belle Arti, after much consultation, an additional wing was built in the form of a *barchessa*, a kind of granary traditional in the Veneto, and when it was finished Peggy gave an equally traditional dinner for the workmen. At the end, everyone had to sign her guest book, and she appended, in a very wobbly handwriting: "The nicest night of my life in Venice, 1948–58, Peggy G." The work had gone quickly. Begun on October 1, it was completed by December 8, when Peggy wrote to her friend Robert Brady: "The *barchessa* is finished. It looks very much bigger and much prettier. All I have to do now is move some trees into the spaces at the ends. The new little garden at the end is very cute." The new building would be destined to hold the surrealist collection. Guests who knew the collection during these first ten years or so felt that half its charm lay in its setting. Some ventured that the setting made the collection, and without it, the collection was, perhaps, dutiful rather than original.

In 1961 new gates were erected in the portal that led from the landward-side lane into the palazzo. Their creator was Claire Falkenstein, who'd known Peggy in New York and visited her in Venice in 1957, when Falkenstein had completed a commission to make gates for another Venetian palazzo, which attracted Peggy enough for her to offer Falkenstein a commission herself. (Ironically the 1957 gates were for Princess Luciana Pignatelli, who had so disparaged Peggy's collection.) Having decided to order the gates, Peggy started to dither, since Herbert Read, who generally liked Falkenstein's work, had reservations about the project. Pegeen was vastly enthusiastic about the gates, though this too had a negative effect on Peggy at first.

The gates are a marvelous confection of open ironwork trapping a random grouping of lumps of Murano glass like huge uncut precious stones in vivid colors. The only hurdle remaining, and Peggy seemed to cling to this as a possible excuse for not installing the gates, even though she had paid for them, was to get the approval of the Belle Arti committee, but their enthusiasm was as great as Pegeen's. At last Read changed his mind and approved. With such imprimaturs, Peggy was finally convinced, and shed her reservations. She was grateful to Falkenstein for the rest of her life, admired her as an artist, and, as Falkenstein puts it, "I think she was kind of amazed at me, that I, as a woman, had established an independent road for myself. And she

was very pleased." However, it was clear to Falkenstein that the idea of following such an independent road herself appeared to scare Peggy stiff. The gates quickly acquired a nickname: Claire's knitting.

Playing up to her growing image as a grande dame, Peggy had begun to dress better, although she was still careful about how much she spent on clothes, and she still "worked away endlessly with her lipstick," and still "sniffed to emphasise her points." She had two elegant outfits: a silvery-gold gown by Fortuny, which she wore on almost every formal occasion, and later on she had a striking red-and-gold outfit designed (in 1966) by her friend Ken Scott, an artist turned textile designer. Needing to wear glasses she commissioned the neo-Romantic socialist painter Edward Melcarth (the Westminster-educated son of an American Bourbon whiskey magnate called Epstein) to create several outrageous pairs of spectacles for her, in the form of butterflies and bats. These more than anything became her trademark in later life. Melcarth himself, another expatriate living in Venice, became a friend, though his work was far from Peggy's taste. As she grew older Peggy's fear of death increased; but it still comes as a surprise to learn that she refused to visit this old friend during the long illness which led to his death of cancer in 1973, aged only fifty-nine.

In 1959 the Solomon R. Guggenheim Museum on Fifth Avenue, New York, was completed, ten years after the death of Uncle Solomon, and only shortly after the death of its architect, Frank Lloyd Wright, at ninety. The completion lay at the end of a long period of disagreement and struggle between the interested parties, but all was now finally more or less resolved, and at any rate the building was a fait accompli. Hilla von Rebay was still alive, but she had resigned as director in 1952, replaced by James Johnson Sweeney when Solomon's son Harry took over the running of his father's foundation, after a short interregnum by Solomon's son-in-law, the Earl Castle Stewart.

Harry invited his cousin over from Venice. The two Guggenheims hadn't seen each other for thirty-five years. Their reunion was a success, and on her return to Venice, she found a letter from him awaiting her in which he broached the subject of what would happen to her collection after her death:

> Before your arrival, and before we had a chance to become reacquainted after all these years, I had the general feeling that perhaps some day you might want to leave your collection to the Foundation to be housed in the new Frank Lloyd Wright

Museum. However, after thinking the matter through, I most sincerely believe that your Foundation and your palace, which has [*sic*], thanks to your initiative, become world-renowned, should, after your death, be bequeathed, as you have planned, to Italy.

But another seed had been sown. At no time does it appear to have occurred to Peggy that she might leave her collection to her children.

She decided to make the trip to New York via Mexico, where she'd been invited to spend a holiday with the British Council friend whom she'd met in Milan eleven years earlier, Maurice Cardiff. Peggy blissfully describes the trips they made in her memoirs, but Cardiff, though always fond of Peggy, has other memories. Among other things, they made a journey to Guatemala and Peru together. In the hotel in Guatemala City, Peggy was so obsessed by the idea that a very young girl receptionist had cheated her of five cents when taking the money to mail some cards and letters that it ruined an entire day trip to the hill village of Chichicastanego, famous for its Sunday market, and Lake Atitlán. She spent the day making mental calculations to ascertain the degree to which she imagined she'd been swindled.

She wore her usual unconventional clothes, with strapless shoes "which not only failed to support her rickety ankles but offered no protection from bloodsuckers or poisoned fangs." In Peru, in the face of dire poverty, she wore an inordinate amount of flashy jewelry. The elegant shoes led to her picking up crab lice. On the other hand Cardiff remembers that "she was always the easiest, most appreciative and uncomplaining of guests." As a hostess, however, "she expected to be entertained by the guests in return for her hospitality. This could be wearying."

Peggy arrived in New York in the early spring. She stayed with the Reises, looked up old friends, and boggled at the prices modern art was now fetching, reflecting not a little on how much Pollocks had gone up in value, and regretting that she had been so quick to part with so many. Although hers belonged to an earlier period of his work, their value now was appreciably more than she had paid for them. So great was the appreciation that two years later Peggy would return to New York and file the $122,000 lawsuit against Lee Krasner already referred to. The episode led to considerable bitterness, and the rift that opened between Peggy and Lee never healed. None of what happened in the course of a suit which dragged on for four years

reflects well on Peggy, but her motivation was complex: it may be that she felt cheated, and whenever she felt cheated, she hit out without mercy and bore long grudges; but envy was added to the sense of injustice. In fact, Peggy had simply not perceived that Pollock prices would soar. Like her uncle William, who left the family business just as it was striking gold, she tried to sue for what she saw as her right. The sense of being a "poor" Guggenheim still rankled with her, and meeting cousin Harry again recently had brought it all back to the surface. In the event she failed, because she'd admitted in *Confessions of an Art Addict* that all the Pollocks due to her had been handed over, but not before she'd succeeded in dragging the art dealer Betty Parsons into the fray as well. In the end Peggy settled out of court for two pictures then worth $400 in total.

At the time, there were problems for Peggy both at home and in the United States. At the end of October 1959 she wrote to Robert Brady:

> I miss you terribly and Venice is not the same without you. I had a horrid summer. Sindbad and his wife and their children and the Reises all at once; the Reises had to leave to make room for Nick Bentley [of the publishers André Deutsch]. That was a blessing but there were terrible histoires and Bernard made a scene. The only good thing that happened was that Nick came out here to edit my book. He did a very good job and he is going to publish it next year.
>
> ... the Guggenheim Museum opened this week. I could not go out there at such short notice. I'm longing to see it but do not want ever again to stay with the Reises. I don't like New York but without the Reises it might be better.
>
> ... My new motor boat [*Cleopatra*] is a dream. I wish you could experience that excitement. It goes so fast all up in the front. I keep Guido [the driver] all the year round now. I had two cooks but they fought so much that I had to send one away ... Anyway I got too fat and have just spent a month losing 8 pounds.

When she did see it, Peggy didn't like the Solomon R. Guggenheim Museum: "[It] resembles a huge garage," she wrote later. "It is built on a site that is inadequate for its size and looks very cramped. . . . Around an enor-

mous space intended for sculpture displays, the rising ramp, Wright's famous invention, coils like an evil serpent."

It was not just a question of Peggy's not having the money to pay the kind of prices now being asked for contemporary works of art, though that was certainly part of it: In the twelve years since she had left the New York art world, a whole generation of artists had come along with whom she was out of sympathy—Johns, Kline, Oldenburg, Rauschenberg, and Frank Stella. Her favorite visits to galleries while she was in the United States were to the Barnes Collection and the Philadelphia Museum. Pop art, was beginning to be noticed with Lichtenstein, Rosenquist, and Wesselmann; they would truly start to make their mark three years later—and 1962 also saw Andy Warhol's *The Six Marilyns*. These were forms Peggy would not or could not adapt to. She did not like what she perceived as the commercialization of the contemporary art market either. She did however now start to invest in ethnic pieces from Africa, South America, and Oceania, which she had sent back to Venice; but their presence among her paintings reinforced the impression of a past era—albeit very recently past—the era when, prompted by Picasso, men such as Breton and Ernst had turned to "primitive" art for inspiration. She even used their dealer, Julius Carlebach.

She would also continue to buy and exchange pictures, but pictures that generally belonged to the era she understood, or, like those of her new Italian protégés (few of whom were in the same league as the artists she'd been associated with earlier), were largely influenced by that era. It should be remembered that Peggy didn't start collecting until the late 1930s, and most of the artists she collected had been working since the second decade of the twentieth century. Pollock was the only truly emerging artist she associated herself with closely, though one should not forget her encouragement of his colleagues and contemporaries in the United States. Since she had neither a mentor nor a guide, her taste stayed with what she knew and what she'd learned, despite forays into new work. In Venice she was away from the mainstream, and apparently she was happy for things to be that way, even though her "retirement" dated from the relatively young age of fifty. Some of the paintings she bought in the later postwar period were downright duds, but by no means all were, and as an indication of her interests and activity as a postwar collector, it is worth listing some of her acquisitions during that period: Pierre Alechinsky, *Peignoir* (1972)—which she bought from the artist at the 1972 Biennale; Karel Appel, *The Crying Crocodile Tries to Catch the Sun*

(1956), bought from the artist in Paris in 1957; Jean Arp, *Fruit-Amphore*, bought at the 1954 Biennale; Francis Bacon, *Study for Chimpanzee* (1957)— bought the same year from the Hanover Gallery in London: Peggy said it was the only Bacon she wasn't scared of living with; Umberto Boccioni, *Dinamismo di un Cavallo in Corsa Case* (1914–15), purchased in 1958; Alan Davie, *Peggy's Guessing Box* (1950) and bought the same year from the artist. Peggy bought a 1965 Piero Dorazio, *Unitas*, in 1966 from Paolo Barozzi's Venice gallery, and a 1951 Jean Dubuffet in Paris in 1964. In 1960 she bought two recent de Koonings from the artist in New York. At the 1954 Biennale she bought Magritte's *Empire of Light*, one of her favorite paintings, from the artist. Twenty years later she told Thomas Messer that "my son made me buy it," which throws an interesting though rather solitary light on Sindbad's interest in art. In 1957 she bought a Ben Nicholson in London. She acquired a Graham Sutherland in 1968 from the artist, and at a sale at Sotheby's, London, in support of the ICA, she acquired a Vasarely, *FAK*. In 1961 she started to promote the work of Egidio Constantini, who embarked on a series of glass sculptures inspired by the works of many of the stars in her galaxy—Arp, Calder, Chagall, Cocteau, Ernst, Matta, and Picasso. She also acquired works by other Italian artists than those already mentioned, including Consagra, Minguzzi, Mirko, and Pomodoro, and kinetic and op-art works by Martha Boto, Marina Apollonio, Francisco Sorbino, and Günther Vecker.

Some years earlier, through a letter of introduction from a mutual friend, the novelist William Gaddis, Peggy had made the acquaintance of Alan Ansen, who lived in Venice from 1954 to 1958 and thereafter divided his time between Venice and Athens. He had in turn introduced her to Allen Ginsberg, but to judge by an apologetic letter Ginsberg wrote her in late July 1957, he'd overstepped the mark—something which it was easy to do with Peggy. At least he seems to have been forgiven (as was Ansen, who was also implicated):

> Thank you for saying OK on my coming to your house tomor-row night. I've never been in a great formal historic salon before and naturally have been eager to go there, be accepted, see the picture at leisure, sip big cocktails, gaze over [the] grand canal, be a poet in Venice surrounded by famous ladies, echoes of *Partisan Review* & the 20's & Surrealists, butlers and gondolas . . . all

tempting, especially the sense of acceptance. So I was disgusted that our original meet at Ansen's turned out so bad; I didn't actually know you were mad till Alan came back and told us . . . it seemed too small a matter—the towel—to be really offensive.

Ginsberg goes on to defend his boyfriend Peter Orlovsky, who may have been responsible for what was evidently an innocent offense—Ansen today doesn't remember what it was—and ends, "So what I mean, is please let us both come & thus in mercy & forgiveness we end the difficulty which has only perhaps bothered me most of all, but which has been a rue in Venice."

When Peggy turned sixty-one in August 1959, Alan Ansen arranged a production of his masque, *Return from Greece*, written for his friend David Jackson and his boyfriend, the poet James Merrill, who were indeed coming back from Greece at the same time. Despite the fact that Peggy apparently cut the guest list for the performance to seventy-five, the show was a success, and the first of three masques by Ansen, with music by Frank Amey, to be performed in Peggy's garden. John Bernard Myers, a patron of painting and poetry in New York, where he'd run an art gallery and where he'd first met Peggy, was the Chorus, Ansen took the role of Venice, and Paolo Barozzi, a young Venetian who would become Peggy's associate soon afterward, took the role of "The Garbage Man"—taken from the play of the same name by John Dos Passos. The second masque was *The Available Garden*, given in 1960, and the third was *The First Men on the Moon*, in 1961. A fourth was planned for 1962, but before it could be done, Ansen had to leave Venice.

At about this time Peggy decided that she would no longer dye her hair black, and allowed it to grow in its natural color, which was now white. She told Rosamond Bernier, "I've given up sex and I've given up dyeing my hair." She was also having problems with her weight, and wrote ruefully to Brady in December 1960, "I used to diet to weigh 48 kilos but now I diet to weigh 53." The early 1960s saw her dieting all the time. Her guests had to abstain with her. Many people speak of delicious cooking smells, only to discover that these came from the meals the servants were cooking for themselves. But even when she wasn't dieting, Peggy's hospitality was usually sparse.

Peggy's letters of the period refer increasingly to loneliness and boredom in Venice, feelings shared by Pegeen: "Venice seems terribly provincial, and really rather boring, to me now. But I love being with Peggy. And of course

Venice is allways [sic] so beautiful. I have finally joined Peggy in hating Italians, also. Especially Venetians."

In 1961 Joseph Losey made his film *Eva* (aka *Eve*), released the following year, set in Venice, and starring Stanley Baker and Jeanne Moreau. It is not one of Losey's memorable films, but Peggy agreed to appear in it as an extra, for which she was paid about $125. That was the extent of her thespian adventures, though there is a reference to her in another film, Vincente Minnelli's *An American in Paris* (1951), in which Nina Foch plays Milo, a rich, sexually predatory American art collector.

Peggy's enjoyment of her homosexual friends' company was soon to be interrupted. The expatriate gay community in Venice was becoming an embarrassment to the city, and in 1962 the local police chief decided to do something about it. Among those expelled from the city on a variety of charges were Alan Ansen, Robert Brady, and Arthur Jeffress. Jeffress was refused reentry to the city on his return from Corfu, and only at the intervention of Annamaria Cicogna, one of Venice's grandest ladies, was he at least permitted to land.

Jeffress coran the Hanover Gallery in London, and in Venice had lived a life of cultivated ease on a considerable income. Like Peggy, he had two gondoliers, in white with yellow sashes, and his palazzo was exquisitely decorated in classical taste. Jeffress's banishment, one of many rumors has it, was on account of some disparaging remarks he made about the mayor's wife that were overheard by the wrong people. Or he may have been denounced by an enemy. In a letter to her friend Michael Combe Martin, Peggy wrote: "I got a letter from him . . . asking if he should kill himself but I didn't believe he would do it. He must have been denounced by his gondolier whom he dismissed as he was buying a motor boat and giving up the gondola."

Whatever the cause, the experience broke Jeffress. He moved to Paris, where soon afterward he took his own life. John Richardson tells us that "He had always loved sailors, and left much of his considerable fortune to a home for old salts."

The purge in Venice prompted Peggy to travel again, and she seized the opportunity offered by her old friend John Cage, now an internationally renowned composer, to accompany him on a tour of Japan in the autumn of 1962. There she made the acquaintance of Yoko Ono, who was to travel with

them as interpreter. Peggy and Yoko often shared a hotel room. Yoko was having an affair. Peggy connived at it and allowed the lovers to use the bedroom. She enjoyed being involved in amorous liaisons, even if only vicariously. Eight years later she wrote to Polly Devlin: "I liked her [Ono] immensely otherwise I would not have allowed her to make love in my room with me in bed." An intriguing thought, especially as the letter is typed, but those last four words are added in handwriting.

Still interested in travel, Peggy managed to get away to visit Bangkok, Hong Kong, and the temples of Angkor Wat in Cambodia (now Kampuchea).

In the early 1960s she was paid a visit by Pegeen's old friend and the daughter of her ex-lover of prewar days, Debbie Garman, now married to the English sculptor William Chattaway and living in Paris. The garden had become overgrown and looked shabby. Debbie wondered if she might help tidy it up. Peggy didn't mind in the least, but enlisted a gardener to help, who, under Debbie's direction, in moving the Brancusi *Bird in Space*, dropped it. "It fell to the ground with a great crash and broke." Debbie feared the worst, but "Peggy wasn't cross with me at all, nor with the gardener—she realised it was an accident. I felt awful. I was covered in confusion and apologised; but Peggy fixed drinks for everyone and smoothed shattered nerves." The Brancusi was repaired, and the garden tidied up. Over time, however, both it and the interior of the house, and the pictures, would suffer neglect; and the Brancusi would be broken again during a New York exhibition in 1969. Debbie retained fond memories of Peggy, who'd also given her an old fur coat after the war, which she'd worn happily for a couple of years before selling it for enough money to buy a piano. Several younger women recount similar stories of Peggy's kindness or forbearance as she got older—her former granddaughter-in-law Cathérine Gary remembers being swiftly and unfussily forgiven for losing the key to the palazzo, which had been entrusted her; but the reason for this change in Peggy's nature lies further on in the story.

Paolo Barozzi started to work at the palazzo later in 1962. He would sell catalogs on the days that the gallery was open, and he would show people around and keep an eye on the exhibits (there were no serious security precautions, the place having very much the atmosphere of a private house informally accessible to the public). He also wrote letters and handled any day-to-day administration, while Peggy dabbled in a little picture dealing

from a small gallery and office in the basement, where she would sell works by her Italian protégés, and the occasional painting by Pegeen or bottle by Laurence. Barozzi stayed on the job for three years, but left when he felt himself becoming overwhelmed.

Barozzi, who came from an old Venetian family and later went into art dealing on his own, relates that during the period of his employment he was paid a stipend and enjoyed a small percentage on the paintings in which she dealt. Above all, he remembers Peggy's stinginess, as does everyone who was on the receiving end.

It was impossible to have a relationship with Peggy that was strictly on a business footing, especially if you saw her every day. The atmosphere of the palazzo was not businesslike, and Peggy leaped on the slightest intimation of friendship, since she was both lonely and needy. On the other hand, she could be prickly and quick to take offense, and as she grew older, these alienating character traits became more pronounced. Above all, there remained her inability to give anything in return for what she took. She could leave a person with a sense of having been spiritually cannibalized. Barozzi remembers that "she made many wills in her time." She said that she would leave him $25,000, which he regarded as modest in relation to all the work he'd done for her in the three years of their association. As he tells the story it appears that Peggy summoned him to the palazzo and for once didn't keep him waiting. He saw that on her desk, normally covered with papers, only one sheaf lay, and she told him that this was the new will, containing her legacy to him. He said, jokingly, that it was kind of her to leave him the money, but he didn't want to wait until she died, and could he have the money now? She flew into a rage and tore up the will. He left, and avoided seeing her thereafter.

Peggy's mind was not one that easily engaged with the thought of death; but as she approached her sixty-fifth year, she not only herself acknowledged the need to do something about the future of her collection, but had already begun to attract suitors for it—a new kind of suitor, but one she didn't find unattractive. Handling the situation that arose from the resulting rivalry was a new experience too: Her sense of self-importance was flattered, but alongside it her sense of vulnerability grew particularly acute. Resolution was not easy.

twenty-two

Legacy

Harry's letter to Peggy following her visit to New York in 1959, with its idea—immediately abandoned—that after her death her collection should stay "within the family," remained at the back of her mind. In the meantime, Peggy the Anglophile started to explore other routes. The Tate Gallery in London, the principal home of contemporary art in Britain, was still feeling its way toward the truly modern; the war had put an end forever to regimes as blinkered as that of J. B. Manson, but there was still some way to go, and the possibility of attracting a complete collection as representative as Peggy's was immensely stimulating. That she had put out feelers relatively soon after returning from New York to Venice is evidenced by a letter from Sir John Rothenstein, then director of the Tate, to Allan D. Emil, a New York lawyer who was also secretary and treasurer of the American Friends of the Tate, written early in November 1961: ". . . A certain collector—whose name I am not at liberty to mention—has it in mind to leave an extremely important collection of modern painting and sculpture to the Tate. The collector in question, though for many years a resident in Europe, is an American citizen, but such a bequest would only be possible if there were no American death duties payable. I should be most grateful if you could give me an idea as to how American law would affect a bequest of this kind."

Peggy hadn't forgotten the tax complications that had surrounded getting her collection into Italy. As has been mentioned, she had originally explored the possibility of leaving the collection to the Italian state, for it to be kept in Venice; and she had made a similar offer to the Venetian city fathers; but her offers had been declined. The reasons for these decisions are unclear; but cost played a great part in reaching them. Peggy had maintained her collection in her palazzo as well as she could on her own money, and if her income from capital had risen to $45,000 per year since the war, the increase was balanced by expenses. She wanted to be sure that any transfer of her collection to an institution after her death would not incur large extra claims on her estate. In the story that follows, tax law and its serpentine application play the role of bête noire.

For the moment, in these early days, all appeared to be plain sailing. Emil replied about two weeks later to say that such a bequest would not incur death duties in the States. Rothenstein asked Sir Herbert Read, Peggy's old friend, to write to welcome her still tentative offer. Read agreed but sensibly advised Rothenstein to write officially to Peggy to reassure her that there were no tax problems attending the putative bequest. For her part Peggy, strongly encouraged by Pegeen, was all for leaving her collection to the Tate; all that seemed to stand in its way was clarification of the tax situation; that, and one other equally if not more important consideration. On her old portable typewriter with its blue ribbon she wrote to Rothenstein on December 1: "Before making this final decision I should like to know what guarantees you will give me about housing the collection in suitable rooms all together, and also what promises you can make about not selling any of the pictures or sculptures. I wish everything to remain exactly as I have chosen them and of course forever." Rothenstein replied immediately to reassure her that "the Tate is prohibited by Act of Parliament from ever selling any of its possessions," but hedged on the other questions: "May I take it that I am free to discuss the matter with the Trustees?"

Meanwhile Rothenstein sought further reassurance from Read. Writing to the man who was one of the chief architects of the collection on December 6, 1961, Rothenstein says: ". . . while I have visited the Palazzo Venier on a good many occasions I have no precise notion of the scope of the collection. Do you know whether there is any readily accessible account of it?" This seems a little lame, of course: but what Rothenstein was really after was a copy of the collection's catalog to show to the Tate's trustees. Read obliged,

and by December 15 the chairman of the trustees, Sir Colin Anderson, wrote to Rothenstein expressing minor misgivings about "the African and Oceanic sculpture" some of which he found "rather depressing." Peggy, however, was accommodating, and after a meeting of the trustees Rothenstein was able to give her an assurance that "an entire floor or a group of galleries" would be dedicated to Peggy's collection. The same day—December 21—Anderson wrote effusively to Peggy:

> This afternoon the Trustees heard, officially, about the possibility that you might be having the electric and *glorious* notion of choosing this place as the final shrine for your collection. I find myself using the word "shrine" and can only suppose it is because there is something so terrifically personal about your collection, which means that it will always represent a sort of physical emanation of you (like the scent behind the wallpapers at Malmaison) wherever it may be housed. Of *course* it mustn't be split up.

The trustees agreed in fact to all Peggy's conditions, as well they might, considering what seemed to be about to fall into their lap. But shortly after Christmas the Italians, who had gotten wind of what was happening, started to murmur about taxing the collection if it left the country—invoking Statute 1089 of 1939 and others. Peggy wrote to the Tate about this on January 4, 1962, suggesting that she should come over and discuss the matter, and postulating the possibility that she make over the collection immediately, "with the privilege of keeping it till I die."

The Italian tax problem for the moment went away, only to be replaced by other difficulties. Roland Penrose wondered if the collection might be split between the National Gallery and the Tate—a point on which Rothenstein was quickly able to reassure Peggy, though she remained worried. Peggy had domestic distractions too. She wrote to Penrose on January 24: "I cannot come to London until next month, as I am still occupied in having my house made thief proof. I had two robberies here in the past two years, and though no pictures were stolen, I lost three beautiful fur coats and my check book, which caused me no end of trouble." She wrote to Roloff Beny and Robert Brady along the same lines at the same time—luckily one of the coats had merely been mislaid and turned up again.

Then, on February 5, 1962, and surely no coincidence, Venice made

Peggy an honorary citizen. In her opinion it was overdue. The press release from the Direzione Belle Arti del Commune di Venezia that announced the honor made things crystal clear: ". . . while being American, Peggy Guggenheim has become in fact a Venetian citizen through her love of Venice, and her collection has acquired particular significance in the art treasures of Venice."

Aware of the moral blackmail under which she was being placed, she wrote nervously to Rothenstein: "Yesterday I was made an honorary citizen of Venice and have to be careful what I say to the Press, so as not to have my life in Venice made too impossible." She was still worried about the collection being split up between the National and the Tate, and now it emerged that American death duties would only be exempted if the collection were left to the American Friends of the Tate. In Venice "they write . . . that I am more than Machiavellian." There would, as it turned out, be some truth in that, but for the moment the complexities of the transaction were making her more and more panicky. Worse, there was no adviser to stand by her and tell her what to do. Meanwhile, Colin Anderson continued to be restive about having to keep the collection exactly as it was, though the terms of the National Gallery and Tate Gallery Act tended to indicate that under the Act the Tate's trustees could give Peggy no such absolute guarantee in perpetuity. Then, on February 21, Peggy's New York lawyers, White and Case, in sending her copies of her new will, reported that Allan Emil had run into difficulties with the IRS regarding tax exemption even for the American Friends of the Tate.

It would almost seem as if both the Italian and the American authorities were conspiring against Peggy. The Italians clearly wanted to keep the collection in Italy. What game were the Americans playing? Immediately after hearing from White and Case, Peggy wrote to Rothenstein, "the situation seems to be getting worse instead of better."

Negotiations dragged on through the summer, while resolutions to financial and legal problems were sought. At the end of August, Peter Pollack of the American Federation of Arts (AFA) wrote to Peggy to suggest that in order to avoid U.S. tax she could make her bequest to the Tate via the AFA; the paintings wouldn't even have to go to the U.S. physically before transfer to London. However, the transaction would have to be not a *bequest* but a *donation*. Peggy again balked at making a donation before her death—she wanted to have control over her collection for as long as she lived; but Pol-

lack replied that *any* posthumous bequest would attract U.S. duty. By January 1963. Peggy is calmer and more philosophical than she has been throughout 1962, but also clearly despairing of the machinations of tax law. In August she writes to Rothenstein in the friendliest terms about a visit she's just had from his daughter Lucy and her husband, Richard.

Under the surface, however, the situation was still volatile. A month later, irritated by the continual irresolution, Peggy wrote to Rothenstein again, in a very different mood. She was hurt and furious that Colin Anderson had been in Venice but hadn't come to see her—the kind of slight to which Peggy could be extremely sensitive. Her letter contains a veiled threat: "[Anderson] did not even come to visit me, as he said I had offered my collection to the Tate and then changed my mind. I think the matter should be explained to him. I mean that none of this is my fault. The Tate is still the gallery which I personally wish to leave my collection/and still hope it may be possible." In fact, her desire to stick to her guns, and her inability to understand legal terminology, and the complicated tax laws bearing on her bequest tended to frustrate the British establishment—which also failed to grasp that Peggy needed to be wooed, needed a personal touch and a little warmth. Their desire to have the collection was undiminished, however, and they were also frustrated by their own tax laws, which denied the nation an important acquisition.

All was not lost: The apparent snub from Anderson was explained and patched up, and a highly capable lawyer deeply involved in the British art scene and a member of the Tate's board of trustees, Anthony (later Sir Anthony) Lousada, entered the fray directly in an attempt to clarify things. A British-born Sephardic Jew from a long-established family, and a man who'd inherited an interest in the arts—and especially contemporary sculpture and painting—from his father, Lousada was to play a key role at the British end of all subsequent negotiations. By October he was engaged in amiable but highly complex exchanges of letters with avvocato Luciano Manozzi of the Roman law firm Ercole Graziadei (a correspondence in which Lousada had prudently not divulged Peggy's identity), regarding the conditions under which Peggy's collection would be allowed out of the country. They were extremely stringent, and contained some worrying corollaries: The Italian Government had the ability to "exercise a sort of pre-emptive right, and purchase the collection at the price indicated in the application [to export]"; and even if that didn't happen, an "exportation tax of between 8%

and 30% is imposed." One wonders why no one had written directly to an Italian lawyer before.

And so the matter continued throughout the winter, the correspondence taken up at the Italian end by Graziadei himself, who got along well with Lousada. As his firm was being retained by the Tate, he and his colleagues were enjoined to secrecy, which they scrupulously observed. Early in 1964 Lousada sent White and Case a suggested new codicil to Peggy's will, incorporating the words "Tate Gallery" and "permanent loan," with a rider that the collection be kept inviolate. This was another attempt to circumvent the Italian tax laws, which still remained unclear anyway. Tension was running high again by now, and then, on April 9, the London *Daily Mail* published a short article about an interview given by Peggy in which she said that she'd agreed to sign the codicil—in fact she had done nothing of the kind; but the story was taken up by the *Herald Tribune*: "Peggy snorted in her Venetian palace . . . about press reports that she plans to leave her fabulous modern art collection to London's Tate Gallery." Peggy was furious and upset, but Lousada now tried another tack: perhaps the duty could be avoided if the collection was given to either the ICA or the Contemporary Art Society in London—both options led to nothing.

At the same time, the idea of mounting a major exhibition of Peggy's paintings at the Tate was coming to fruition. This had first been discussed between Peggy and Rothenstein as early as April 1951, but their lively correspondence had dried up by November of that year. By November 1963, however, it had not only been revived but was being actively planned for the following year. But now, on April 26, 1964, Peggy wrote to Rothenstein: "I have had lots of letters from Lucada [*sic*] and from my lawyer, and I have the feeling that nothing has been accomplished. My wishes in regard to the Tate getting my collection at the time of my death is [*sic*] still very positive. If I live long enough some way may be found. However, if I die soon, I'm terribly afraid the collection will go to Boston (if the Italians let it out)." The last sentence strikes an even more ominous note than before: Peggy had indeed been looking at the possibility of leaving her collection to a prominent American university. Going on to write about the impending London exhibition, she adds: "I had an awful time here denying the last article, which appeared in the *Daily Mail*. After all this is my home, and such things make my life here uncomfortable." She further adds that she's "afraid of the English press."

Rothenstein was afraid that the entire exhibition might be in jeopardy. As a personal relations coup to keep Peggy interested in leaving the collection to the Tate, the exhibition was of great importance.

By October, however, all was still on course. On the eighth of that month Norman (later Sir Norman) Reid, who had succeeded Rothenstein as director of the Tate, wrote to Peggy about the impending visit to Venice of Stefan Slabczynski, the Tate's chief restorer, to view works for the exhibition and work on them if necessary. Soon afterward another letter arrived from Gabriel White, director of art at the Arts Council of Great Britain (as it then was) giving a value for insurance purposes on the 189 selected pieces of $5,328,950. Picasso's *Poet* was valued at $250,000.

Then, on October 17, the eminent art critic and historian John Russell wrote to Reid: ". . . By the way, I don't know if it's any of my business, but I was distressed to hear from Peggy Guggenheim that she had definitely abandoned the idea of leaving her collection to the Tate. I only mention this because she is such a strange old bird that she might well not have thought to pass on this news. . . ." Naturally Reid was distressed too, and replied to tell Russell so, but does not appear to have confronted Peggy with this new information. There were other matters to preoccupy him. Slabczynski wrote on October 22 and 29 to report that more restoration work than expected would be required: "The collection is in a very poor state; however I cannot frighten her with too detailed reports. . . . I am afraid she is completely ignorant of the basic knowledge of what can happen to pictures, and therefore may prove difficult in accepting right suggestions." He adds that Peggy was treating him very well, but that he was working from 9 A.M. to 6 P.M. every day and hadn't had time to see Venice at all. A week after the first letter he writes, "I was perfectly blunt with Mrs Guggenheim and told her that the condition of her collection and safety of [those hanging?] in her house are very bad indeed, and she is determined now to devote more time and money to safeguard them."

The restoration work continued at the Tate's expense, and apart from a worrying article in the *Corriere della Sera* in mid-November to the effect that the collection might be leaving Italy for the Tate permanently—a fear dismissed later in the same article—everything proceeded as planned. The exhibition opened on December 31, 1964. As Peggy wanted a formal opening, a select dinner party was planned for January 6, 1965, followed by a

party. Among the guests invited to the dinner party were Freddy Mayor, Peggy's old neighbour in Cork Street in the days of Guggenheim Jeune, and his wife. In the early 1950s Peggy, on a visit to London, had visited the Mayor Gallery when Freddy was out at lunch. The gallery assistant gave her the price of a picture she wanted to buy, but Peggy said she'd return when Freddy himself was there, as he would give her a better price. When she came back to see Freddy, he wouldn't reduce the price. She was furious, thinking that he wouldn't give her a discount because she was rich. Now, when she saw his name and that of his wife on the guest list, she had them removed: "I'm not having the Mayors. . . ." The perceived affront of some twelve years earlier had been remembered. But Peggy was a great rememberer when it came to money.

Peggy, who stayed in Knightsbridge with Audrey Fowler, was delighted with the exhibition, and even more so when it proved so successful—it attracted 86,193 visitors—that it was extended by a month, to March 7. Visiting the exhibition with her friend Milton Gendel, she was approached by a woman who said to her, "I saw your collection in Venice, and now that it's here it seems to fill the entire Tate Gallery." Peggy replied, "Yes. I've no idea how I'm going to get it all to fit back in again."

Shortly before the exhibition was due to close, Peggy wrote to Reid that she would take Slabczynski's advice on looking after her collection: "I shall do better in the future about my children." (She was beginning habitually to refer to her paintings as her children.)

After the return of the restored paintings to Venice, negotiations continued for the bequest. On August 17, 1966, Peggy wrote to Bob Brady in London:

> I have a little painting by Dalí [*Woman Sleeping in a Landscape*] at the Tate gallery where it went to be restored end of June. The director, Norman Reid, took it back with him in his brief case, when he left Venice. Now though he is coming back he prefers not to bring it back with him as the British recently have a very strict currency regulations and he might be thought to be bringing it out of England to sell abroad. Of course you, as an American, would not be searched for this defraction [*sic*] of British law. And anyhow as a painter you could be travelling with a painting of your own.

In December 1966 the Italian state made Peggy a *commendatore*, a high honor that was not without its political implications. Toward the end of the year there was a flood in Venice, but luckily pictures that would have been in the basement were in the Barchessa, packed and waiting to go off to an exhibition in Stockholm. As there were several inches of water in the basement, they might otherwise have been ruined. The Italians were so exercised by this stage that it looked as if they might not release the pictures even for the Swedish exhibition. But it took place and ran from November to January.

And Lousada and Reid continued to try to secure the collection. By January 1967 all that had happened was that Peggy had acquired a new typewriter. She was planning a trip to Mexico to visit Robert Brady, and so turned down an invitation to a reception at the Tate attended by the British queen.

She was in Mexico when she received dreadful news. Pegeen, aged only forty-one, had died. Whether it was suicide or an accident remains unclear, but the effect on Peggy was profound. In reply to a telegram of sympathy sent by Reid on March 8, soon after he had heard the news, she wrote:

> Thank you for your kind words of sympathy. I would like to know if the English papers referred to Pegeen's death as a suicide. In Italy they did not do so. Anyhow we are all convinced that it was an accident. That does not make it any easier to take, as we are not Catholics. But I know she would never have deserted her children. She told me so over and over. The night of her death she wrote me a letter to come back quickly from Mexico. . . . She was having terrible rows with her husband and as usual on such occasions took tranquillisers and drank a lot. We think the combination killed her.

Peggy now had to consider the legal position of Pegeen's four sons—all minors—she felt guilty about the daughter she had neglected, she convinced herself that Ralph Rumney was responsible for the death, and she fell into a severe depression. Nevertheless the business of securing the future of the collection had to go on. Pegeen had always been strongly in favour of its going to the Tate. Peggy's chief concern was that the collection should not be broken up; she was worried that she would die before assurance on that had been achieved, and she was desperately in need of someone to lean on. The

niceties of Italian tax law remained impenetrable. It was clear that the Italians were moving heaven and earth to keep all, or at least part, of the collection in Venice.

Peggy decided to form a foundation to protect the collection, and in July 1967 eight trustees were invited to manage it. They were Herbert Read, Sindbad, James Johnson Sweeney, Alfred Barr, Bernard Reis, Robert Brady, Roland Penrose, and Norman Reid. By August, Reis, whom Peggy had already involved in the negotiations, was threatening to upset the apple cart by tampering with agreements already reached. He was angling for a "contribution" to be made to an American "institution."

But another cloud was gathering. In March of that year, Peggy had bought an early Fernand Léger, *Contraste des Formes*—one of several done by the artist; many were already in the collection of Douglas Cooper—from a Paris dealer, Theodore Schempp. The price was $125,000. Peggy had asked Reid to go over and look at it for her. He was unable to do so, but the keeper of the modern collection, Ronald Alley, a highly experienced curator who had been in his job at the Tate for two years, happened to be in Paris, saw the picture, and approved it. Peggy went ahead with the purchase. The bombshell burst later in the year, when Nelly van Doesburg, Daniel Kahnweiler (who had been Léger's dealer at the time of the *Contraste des Formes*), and the just-mentioned distinguished collector and expert on cubism, Douglas Cooper (who, however, had a habit of stirring things up and was unpopular), all told Peggy that the picture was a mere sketch. Peggy got it into her head that a more realistic price would have been $80,000 or at most $90,000. She withheld payment of the balance of $10,000 she still owed Schempp, and he sued. Peggy hated the idea of having lost so much money on a deal, she felt betrayed by advisers—people whom in the past she had always successfully trusted—and blamed Alley in particular and the Tate in general for her plight. She was also furious that she had sold a Giacometti and a Hartung in order to pay for the Léger. In November there was a sharp exchange of letters between her and Reid, in which she was extremely rude and he endeavored to defend his position (and Alley's), while at the same time trying to pour oil on very troubled waters. Reid also wrote to Lousada, who was by now at the end of his patience with Peggy and the whole business. It looked as if Peggy was using the Léger affair to prevaricate. On November 24 she wrote to Robert Brady:

You will soon hear from Bernard [Reis] as he must have the approval of the Trustees. I have just given 100 works of the collection to the Foundation. Shall give 90 more on January first. I want to tell you very confidentially that I am all for leaving the collection in the house and not to the Tate. They just got me into an awful mess. [There follows an account of the Léger affair.] All this makes me feel that the Tate can go to hell.

As far as the Tate was concerned, Peggy fell silent. Then, at the end of March 1968, Reid discovered that she had replaced the invited trustees of her foundation with an all-American team, without telling the original members, whose positions had not yet been legally ratified. In a letter to Brady as early as December 17, 1967, on Peggy Guggenheim Foundation letterhead she had written: "Just in time I was able to change the English trustees for American ones. So they are now you, Bernard [Reis], Sindbad, Fred Licht, a professor of art at Browns College [*sic*] Providence RI, his wife, Marius Bewley . . . and myself. I think Bernard may call a meeting some time in January. . . ." In a handwritten postscript she adds, underlined: "This is all very secret."

Peggy had now found someone to lean on—her old financial adviser Bernard Reis, who had always been hopeful—in all probability in association with others—that the collection would go to the States. On March 26, 1968, Reid anxiously consulted Sir Herbert Read by letter. Sir Herbert was extremely ill (he died the same year), but replied by return:

I don't see what we can do, given Peggy's temperament. I believe that her strongest personal motive is vanity, and she would like her collection, other things being equal . . . to have a permanent place where it would be most effective, as a memorial. In the States it would be just another Guggenheim bequest, and would either be swallowed up by the MOMA, or go to some remote State. Peggy's "Europeanism" is quite strong and genuine, but against this one must reckon a complete lack of constancy, a capriciousness that is almost schizophrenia.

There was little left to do but lick wounds, although Read was wrong in one respect: Peggy had already discussed with the Tate the possibility that

her collection should remain in Venice, in the palazzo, inviolate but administered by them. The Tate had told her that the expense of such a scheme would be prohibitive for them, and so she had appeared to settle for the option of a new home in London for the collection, provided that it remain inviolate, and thus her monument. Once she had broken with the Tate, she reverted to the idea that her collection and the palazzo should remain intact and together—as Paolo Barozzi pointed out, she was becoming like a pharaoh planning his tomb. If her family had hoped that at least they might inherit the palazzo, they would now be disappointed. In the meantime a large number of her pictures had been expensively restored by the Tate at their expense, a sum saved which compensated for the overpayment on the Léger. Quite unconsciously rubbing salt into the wound she wrote to Reid at the end of March 1968, acknowledging receipt of an Ernst, *The Entire City*, which the Tate, having restored, had returned (officially) to her. The letterhead is that of the "Peggy Guggenheim Foundation." Apart from going on and on once more about what she perceived as her betrayal by Alley, she concludes bluntly: "I was so fed up with everything and I just decided to give away all my collection. It is now no longer my property having been referred to the above Foundation. This is all most regrettable but I feel that you should be informed. Again many thanks for the Ernst which is marvellous. Love, Peggy." In fact she gave the collection over to the Foundation in large installments, but as the letter to Brady quoted above indicates, she started long before she told the Tate.

It is quite hard to believe that she could have had so much assurance. Reid sent the letter to Sir Herbert with a note. Sir Herbert replied, "This is a mean letter and I can only offer you my sympathy. There has been this fault in her ever since I first knew her, and one can only ascribe it to what she has suffered, both as a child of impossible parents, and as a much abused woman. I feel I don't ever want to see her again." Reid replied to Peggy with cold politeness, which was water off a duck's back. On April 22, she replied, thanking him belatedly and incidentally for an art book he'd sent her the previous Christmas, and adding: "If only you had hopped over to Paris instead of sending Ronald Aley [*sic*], I would not have gotten into this awful mess and been bothered from March till October besides loosing [*sic*] my Giacometti bronze. As a result of all this extremely unpleasant incident [*sic*] I have decided that the Tate cannot have my collection (as they obviously do not need it) and shall approve of the directors of my Foundation arranging to

leave it and my house to an American University [added in hand: "to be kept in Venice"] . . . With love always, Peggy."

Reid then exchanged letters with Lousada, in which Reis's role was identified, with distaste. On June 7 he wrote to Peggy again—a courteous letter in which he made one last attempt to sway her, though he had to reiterate that the Tate could not afford to maintain the collection in Venice: "It is, as you must know, simply untrue to say that the Tate does not need your Collection. It would have been the greatest single gift to the Nation since Turner's own bequest over a century ago. It is a loss which cannot be made good in any other way."

It was all far too late. Thomas Messer had first met Peggy in Venice with his wife, Remi, in 1956, when he'd just resigned as director of the American Federation of Arts in New York and was about to become director of the Institute of Contemporary Art in Boston. Since 1961 Messer had been in charge of the Solomon R. Guggenheim Museum in New York. Peggy remained convinced that the collection should stay in Venice, but in August 1964 there was an exchange of letters between Harry Guggenheim and Peggy regarding Peggy's "inquiry concerning the possibility of the Solomon R. Guggenheim Foundation ultimately taking over the administration of your gallery in Venice and operating it." Encouraged by Harry, Messer started to pay court to Peggy. Harry's nephew, Roger W. Straus, acted for a time as an intermediary. It wasn't easy even for them. Peggy changed her mind, and on March 8, 1965—the date is not insignificant—wrote to Harry distancing herself from the idea "as I [am] a little afraid of being swallowed up by your much more important Foundation." Plans were subsequently set in train for a New York exhibition of the collection, but Peggy prevaricated and procrastinated throughout 1966, and when Messer visited her in the course of a visit to Venice in June which included other business, she kept him at arm's length. It was the first of a dozen visits Messer would make over time to the palazzo. For the moment, the death of Pegeen early in 1967 brought discussions of a New York exhibition to a standstill. Peggy's mood was sombre and defensive, and even Messer's charm could not penetrate or change it. But gradually a dialogue was restarted, though Peggy put difficulties in the way of the proposed exhibition almost until the last minute. In the end, the opening was set for January 15, 1969. But Peggy remained touchy, and Messer uneasy.

Negotiations with Peggy over the eventual fate of the collection were

always delicate: Straus remembers that Peggy "dragged her feet until the end." She needed warmth, a personal touch, and just the right amount of deference—too little or too much would put her on the defensive. Messer was well attuned to her needs, and aware of her unreliability—you could never take on face value the things she said, particularly when what was at stake was the most important thing in her life. When he visited, he took her flowers, and his courtly letters have almost the tone of a *cavaliere servente*. A massive correspondence from 1968 and 1969 between him and Peggy exists in the Solomon R. Guggenheim Foundation Archive, discreetly discussing the possibility of the foundation's taking over the collection. The Guggenheim Museum's exhibition of Peggy's collection did indeed open on January 15, 1969, running until the end of March. Offered a first-class ticket to come over, Peggy characteristically flew economy on the very day of the opening. Messer couldn't find her at JFK airport, and when he did, discovered that her luggage had been misrouted. That didn't worry her unduly, and she attended the formal opening reception "in her boots." By now Harry Guggenheim was seriously ill. He died in 1971, in his eighty-second year. But by the end of March 1969, the fate of the Peggy Guggenheim Collection had already been decided.

Norman Reid wrote dryly to Peggy on March 28 to congratulate her, and on the thirty-first he wrote to Messer: "Sometime I must let you have all the record of examination and of treatment in connection with Peggy's collection. . . . In all, we spent quite a lot of time mending her pictures, but I am happy that your Museum is to have the benefit." Messer replied on April 2: "I felt in my bones that I would hear from you and meant to write you before you beat me to it. Yes, we feel very content and happy about the way the Peggy situation resolved itself. . . . I am also very much aware that we benefited from the work of others and particularly yours and that of your staff. . . . I cannot say without hypocrisy that I would some day be glad to do the same for you, but if it should so happen I would consider it nothing less than poetic justice."

It was a blow for the Tate. Peggy's collection would have, particularly at that time, given an enormous boost to a nascent real interest, especially dating from Reid's incumbency, by that gallery in twentieth-century art. From Peggy's point of view, though she was guilty of greater Machiavellianism than anyone had suspected, the matter worked out perfectly. The Solomon R. Guggenheim Foundation could afford to maintain her collection in

Venice properly, which neither the Tate nor the Italians were able to do. Mr. Slabczynski ("Mr Slab," as she affectionately called him) had made her aware of the need to care for her paintings better, and now there was someone to pay the bills. In 1969 she turned seventy-one. She'd restored, through her cousin Harry, relations with her American family, and it was as if her collection was being gathered to its bosom. She believed, too, that she had a rock-solid agreement that the integrity of her collection—her monument— would be respected and observed in perpetuity. So obsessive was she that she'd even added a handwritten postscript to a letter of agreement addressed to Harry and dated January 27, 1969: "If Venice sinks, the collection should be preserved somewhere in the vicinity of Venice."

By April 1969 she and Norman Reid were again on cordial terms. Ironically the Ernst, *The Entire City*, which the Tate had spent six months restoring the previous year, had been left in the rain by the Venetian customs on its return from the New York exhibition and was damaged. "Too bad it should be just that one again," she wrote to Messer.

"The Last Red Leaf Is Whirl'd Away . . ."

egeen died on March 1, 1967. It may have been a tragic accident, but the likelihood that it was suicide is also strong. Her first husband, Jean Hélion, saved her on several occasions from what may or may not have been serious attempts to take her own life, and Ralph Rumney had a similar experience: He remembers seventeen "rescues." They used to entertain a good deal in Paris. One evening, for example, at the end of a dinner party, she announced to the guests: "OK, I'm off to the bathroom now to kill myself." The guests laughed but Ralph didn't. This time it was the real thing. By the time he'd managed to get the bathroom door open, she'd swallowed a tube full of Valium. Her husband and his friend Albert Diato spent the night making her vomit and forcing her to walk up and down. Such events were not infrequent. Pegeen told Ralph that her mother had entirely ignored her twenty-first birthday; as a result Pegeen cut her wrists. Peggy sent her to a public hospital and left her there unvisited. One of the staff in the hospital raped her. There are other similar stories from Pegeen, and it is hard to assess where fact and fiction lie. That she had a persecution complex is clear; that it stemmed from her relationship with her mother is equally so. Peggy is famously quoted as having told Pegeen that she'd rather have a painting by Picasso than her daughter, but the context makes clear that the remark was born of the irritation of a mother for a tiresome adolescent. That

Peggy was a bad mother is certain; whether she was always deliberately so is a harder charge to lay.

Sandro Rumney remembers his mother as "terribly kind—we were terribly close"; but adds that there was something ethereal about her. Her addiction to drugs and drink may have been a way of trying to attract attention. Kathe Vail, Pegeen's half-sister, wonders astutely whether Peggy didn't "kind of make Pegeen up"; that she invested her daughter with an idealized character that she didn't really have, and that in turn it was hard for her to live up to. But there was another gulf: Pegeen was capable of introspection; Peggy wasn't.

Pegeen wanted to be independent of her mother but also clung to her. Profound neglect in childhood may have sharpened inherent tendencies in her; mother and daughter irritated each other and loved each other at the same time; but Peggy was the more dominant of the two, the one from whom love was expected but who would not or could not give it. Pegeen's intense artistic sensibility, coupled with a talent that could never match its own expectations, scarcely helped matters.

When Ralph and Pegeen lived in Paris, she was taking Equanel and Valium, and drinking whiskey heavily. He tried to wean her off the drugs, and destroyed the repeat prescriptions she had for them, but he had only limited success. Max Ernst, who lived only a short distance away, refused to help when Ralph asked him to take Pegeen down to the South of France with him so that she could rest. Despite his having been fond of Pegeen in the past, it was clear that now Ernst wanted no more to do with Vails or Guggenheims. He also suspected Ralph of trying to touch him for money, of which he sent a little around with his maid; but that was all.

One day Ralph returned home to find Pegeen gone. For a few days he heard nothing of her, and then he had a call from a Swiss sanatorium. It appeared that, acting under Peggy's instructions following a phone call from Pegeen, Fabrice, Pegeen's oldest son, had taken her there to recuperate. Soon afterward, Ralph went to Venice to retrieve Pegeen, at her request, from the Palazzo Venier dei Leoni, where she was recovering after her treatment in the sanatorium, where they had once again prescribed drugs. It was then that Peggy offered Ralph $50,000 to "disappear." He also found himself barred from the palazzo.

Peggy may have had cause to mistrust Ralph and the wild life he led, but she had no right to tamper with her daughter's private affairs in the way that she did, despite the fact that from her point of view the marriage was a tem-

pestuous disaster. She didn't see the passion that fueled it; or if she did, she envied it. In any event her dislike of Ralph deepened and hardened. If there was also sexual attraction there, which is unlikely, it was never expressed. It may also be that Ralph's youth was an uncomfortable reminder of her own age, but the real struggle was over Pegeen. Ralph believes that if only Pegeen could have broken completely free of her mother's influence (and material support) she might have saved herself. Peggy's sense of love was the same as her sense of possession.

The couple returned to Paris, but there was no easing of Pegeen's mind. In February 1967 Ralph was summoned to Venice by his friend Jeanne Modigliani to help her in a missing persons inquiry. He went to the police commissariat on her behalf and was confronted by an officer he knew, who even had a picture of Rumney's hanging on the wall behind his desk, a gift of the artist. A surreal scene followed: The officer repeatedly asked Rumney to identify himself, using the usual formal "Name? Date of birth? Address?" format. After four or five repetitions of this, Ralph began to feel irritated, laughed, and asked the policeman if he hadn't gone mad. Upon which the policeman called the attention of colleagues to this, Ralph was accused of offensive behavior to an officer of the law in the execution of his duty, arrested, handcuffed, and led to a cell. The following day he was sentenced to expulsion from Italy, and escorted, handcuffed, to the French border. He had been banned from Venice. (Not for the first time, however—it had happened before, in 1957.)

He spent the night traveling back to Paris by train, and arrived at his quai de Bourbon apartment at dawn. Pegeen and the children, Nicolas and Sandro, were there to greet him. Once the boys had gone to school, Ralph told Pegeen the whole story. She was appalled, convinced that her mother had orchestrated the whole thing. It is unlikely that Peggy had the power to suborn the police, and one must also take into consideration Rumney's own reputation as a hellraiser: There is, for example, a report that a friend of his, Umberto Sartori, accompanied by him, once went around the town throwing balloons filled with paint at monuments and statues. It may be that there was some justification in Rumney's expulsion. What is important here is Pegeen's perception of why he had been kicked out. The occurrence may have been a trigger for what, sooner or later, was bound to happen.

Pegeen had started drinking again, and had managed, by hoarding and

other means, to build up a supply of sleeping pills. The pair spent the day going over the business in Venice—the "missing person" had turned up in police custody, too, accused of nonpayment of a restaurant bill. Both Pegeen and Ralph drank too much. Ralph, tired after his adventures and the long overnight train journey, went to bed early. Nicolas and Sandro were already in their bedrooms. Pegeen kissed her husband good night, told him that she'd sleep in the maid's room—which she'd done before on occasion when, as now, the maid had time off and was away—so as not to disturb him, and asked him to see the children to school in the morning, and to feed the cats. She would probably sleep late.

The following day Ralph duly sent Nicolas off to his school and took Sandro, aged eight, to his. When he returned he remembered that he hadn't fed the cats, but they were nowhere to be found. Assuming that they must have gone in with Pegeen, he went to open the door of the maid's room, only to find it locked. He managed to push the key through the keyhole onto a sheet of paper he'd slipped under the door, and having retrieved it unlocked the door, to find Pegeen lying on the floor. He picked her up and laid her on the bed. She was dead. Forensics revealed that she had died as a result of a drug overdose exacerbated by alcohol.

This is Ralph Rumney's account, and it is the only coherent one we have. The consequences for him were hard. Peggy first wanted to bring charges of murder against him, and then, when that proved untenable, a charge under French law of nonassistance of a person in danger. He was denied access to Nicolas and Sandro. Nicolas joined his father, and Sandro was taken, ironically at Ralph's instigation, straight from school on the day of his mother's death to the home of Kathe Vail (then resident in Paris, with a family of her own), whom Sandro knew and liked, and whom Ralph trusted. Lawyers put pressure on Hélion's sons to confirm that Ralph had on occasion beaten Pegeen. A friend of his, Dixie Nimmo, was offered $10,000 to bear witness against him. He was followed by private detectives. Peggy's reaction may have been hysterical, but at no point did she acknowledge that her own treatment of her daughter contributed to Pegeen's tragic end. Sandro comments, "She was the major architect of her daughter's pain."

Kay Boyle, who was prompt to assign responsibility for Pegeen's death to Peggy, had no right to cast the first stone: Three of her daughters, Bobby, Apple and Clover, had all attempted suicide by the time of Pegeen's death. In Clover's case her mother had her committed to a mental hospital. Apple

became an alcoholic and an anorexic, though she later went into a recovery program, but died at only fifty-seven. Peggy was not the only bad mother, and Laurence, the father of all but one of these girls, and effectively Bobby's father too, cannot be held to be without blame. There is a tragic postscript to all this: Pegeen's son Fabrice, a film director, killed himself in 1990, in his forty-third year.

Not yet under arrest but forbidden to leave France, Ralph could only be sure of avoiding jail by committing himself to the care of a psychiatric clinic as a patient, which he did on the advice of his friend Albert Diato. The La Borde clinic was a progressive institution run by Félix Guattari. Even as an outpatient of the clinic, Rumney was safe from arrest under French law. But it was a year before he could leave. He couldn't bring himself to stay in the Île St.-Louis flat, which was in Pegeen's name, and though an arrangement had been reached under which he'd be permitted to stay if he covered its running expenses, Peggy knew he couldn't afford it. While he was still in shock she bought him out of any subsequent claims for $3,000. Pegeen had a small collection of works of art of her own, including a Fritz Hundertwasser and a number of Cocteau drawings. Cocteau was a friend of Ralph and Pegeen (and, as we know, Sandro's unofficial godfather), and he had given the young Sandro several drawings. All these Peggy acquired for next to nothing after Pegeen's death, or simply took them, if they weren't specifically mentioned in Pegeen's estate.

As soon as he could, Ralph returned to England, where he worked, among other things, as a bilingual night-telephone operator. Later he worked in art schools in Canterbury and Winchester. He had tried to get custody of Sandro, but he was powerless against Peggy's lawyers and didn't have the means to fight her. He was also reluctant to put Sandro through any further stress. Meanwhile Peggy had set in train a procedure for Kathe to adopt Sandro. It would be ten years before father and son were reunited. When Sandro was nineteen, he thought, "Well, my father's around somewhere, I'd like to see him." But he had no idea where he was. "So when I was in Venice I asked Peggy for her help, and she said, 'No, I will not help you, and what's more, I'll tell everyone I know not to help you either.'" Vittorio Carrain knew that Peggy was opposed to Sandro's tracking his father down, but told him that although he himself didn't know where Ralph was, he could put him in touch with someone who did. Carrain enjoined Sandro to tell no one that he'd given him this information. The contact—Ralph's former Parisian art dealer—told Sandro that she had lost touch with his father

but knew approximately where he was living. "So I got the phone book and called every goddamn Rumney that was in the book, and I found him, in one evening, after about the fiftieth call." When speaking of their reunion, Ralph wept. "I knew he'd find me once he'd grown up."

At the time Kathe Vail took on the job of bringing Sandro up, she had been married to her second husband for six years—the same Edgar Kuhn with whom Pegeen had had her first affair so many years earlier on the shores of Lake Annecy. Kuhn seems to have been an unpleasant character: Ralph Rumney has no good word to say for him ("a shit at first sight"). Sandro spent much of his boyhood away at boarding school in Switzerland. His relationship with Kathe is close. He is happily married and has a family of his own. Ralph subsequently returned to France and remarried, but now lives alone in Provence. A recent autobiographical book has appeared, *Le Consul*—a reference to his nickname, "the Consul," from the alcoholic hero of Malcolm Lowry's *Under the Volcano*.

Pegeen's death hit Peggy very hard indeed, and old and new friends rallied to give what comfort they could. On March 3 she wrote by hand from Paris to Robert Brady, whose home in Mexico she had left immediately on hearing the news. The letter shows the picture from her point of view. Peggy was determined to believe that Rumney treated her daughter badly and that Pegeen wanted a divorce. "Pegeen did kill herself with sleeping pills because Ralph was thrown out of Italy and came back to her and she could not cope with him any more. There is now an autopsy and no-one knows when the funeral will be. Ralph wants the child, but Sindbad expects to keep him since R has been judged incapable of looking after him. The other child Helion [*sic*] will keep. Its [*sic*] all terribly sad." As a postscript, she adds: "The young child is hidden away." Sandro remembers: "She actually forbade me to see my father."

Djuna Barnes wrote a muddled letter of condolence in mid-April, ending rather movingly, though one spies the novelist rather than the spontaneous sympathizer in the words: "Strange to think of the down-thrust chin, the floating golden hair, the stubborn and lost wandering walk . . . to know that it is not there—but, once the grief is over, then . . . she can't be tortured any more. But we can."

Pegeen was cremated and her ashes interred at Père Lachaise cemetery in Paris. Her funeral was attended by Sindbad and his second wife, Margaret, and by Ralph. Because of Ralph's presence, Peggy would not attend. Ralph

says of Peggy: "I hated her; but I also felt sorry for her." Peggy herself had often been a mistress but never, as she had hoped, been a muse. Her daughter had not only tried to be an artist but had inspired another. Peggy found that altogether unforgivable. But when it was all too late, she yearned for the daughter she had never loved when she was alive.

The year leading up to Pegeen's death had seen the deaths of several artists and friends with whom Peggy had been closely associated: Jean Arp, Victor Brauner, André Breton, and Alberto Giacometti had all died in 1966. Hilla von Rebay died in 1967 (having gotten into trouble with the IRS and having accused James Johnson Sweeney of being a Communist before she died). In 1968 Marcel Duchamp and Herbert Read died; and in the same year, in April, Laurence died too. Late the previous year he'd made a last trip to the States to see his daughters, and his old friend Djuna Barnes, "the hermit of Patchin Place." Djuna wrote to Peggy in December that Laurence was "so old, so ill, so shattered, yet holding together with incredible 'ferocity' . . . tho a wind lays him, like a leaf, in the gutter . . ."

For a man who had drunk so hard, seventy-seven was not a bad age to attain. Laurence had been suffering from ulcers for years, he had had a skiing accident in the 1950s from which he had never fully recovered, and a fall, drunk, from a hotel window onto spiked railings, in the early 1960s. He had never got over the death of Jean Connolly, and the death of Pegeen, combined with cancer, finally broke him. His daughter Kathe says, "I think Peggy liked Laurence very much, but I don't think he ever really forgave her. He never forgave my mother [Kay Boyle] either, for taking his family. He was essentially a family man."

Peggy grieved for Pegeen in her way. Now that she was gone, she remembered her in her 1979 memoirs as:

> My darling Pegeen, who was not only a daughter, but also a mother, a friend and a sister to me. We seemed also to have had a perpetual love affair. Her untimely and mysterious death left me quite desolate. There was no-one in the world I loved so much. I felt all the light had gone out of my life. Pegeen was a most talented primitive painter. For years I had fostered her talent and sold her paintings.

She created a memorial gallery for Pegeen's work in her palazzo, with a plaque commemorating her. After Pegeen's death, Peggy became nicer in manner to younger women—as if she saw in them a substitute for the daughter she didn't really know she'd had until she was gone. Milton Gendel remembers that a few months after Pegeen's death Peggy rang him up and asked him to go to Venice from Rome the following Thursday since Pegeen's older sons were coming to visit and she was "embarrassed"—"She was afraid that they would blame her in some way. I did go, and in fact one of the boys . . . did have a go at her during their stay. She had been right, she did need a buffer, poor old thing. One of the boys said to me scornfully, 'Well, she's put up this shrine to our mother so I suppose she thinks that makes everything OK'—and I said, 'You can't take that attitude: you've lost your mother; but don't forget that she's lost her daughter. . . .' "

Polly Devlin Garnett, features editor of London *Vogue*, whose husband Adrian (Andy) had been a friend of Pegeen and who now met Peggy in Venice (later in 1967) for the first time, remembers a curious trait in her character. Polly's daughter Rose was a few months old at the time, and Peggy took a great interest in the baby: "But her interest in Rose wasn't as for a baby, or a child, but as for an object. It was almost a cold interest, as if she had never had any children of her own—and indeed it would have been more understandable if she hadn't. It was a prurient interest." Polly adds that her own maternal protective instincts were aroused by this interest: "It wasn't as if I thought she was about to snatch my baby away; but there was a definite sense of intrusion which was uncomfortable." This experience is one shared by Patricia Curtis Vigano: "When I saw Peggy the most was in the 1960s, up to about 1971 or so. She remained intimidating to everyone I think, because of the force of her personality, and she would either like or dislike a person, and communicate her feeling immediately and very strongly." Other members of the family have described this directness as very much a Guggenheim trait; but Patricia Vigano goes on: "She adored my young son, Daniel, who was a very beautiful curly haired blond baby. Every day she would pass in her gondola, and she would ask my mother to have Daniel with his nurse either on the balcony or at the watergate so that she could see him; and she continued this habit until he was about three. But she wasn't at all maternal, and the attraction seemed to be more aesthetic than anything else." Was Peggy trying to reinvent her children?

Friendships, new and old, were, despite or perhaps because of her increas-

ing isolation, extremely important to her. The photographer and artist Ziva Kraus, who worked with Peggy in the early 1970s, remembers: "She was basically gentle and well-meaning. However, she lived for her collection and any admiration she attracted was intellectual. I don't think she was loved by people."

There were exceptions to this. Among Venetian expatriate society, she had come into contact with the young Lady Rose Lauritzen, whose mother had an apartment in Cannaregio, and her American husband, Peter, an art historian. Peter bore a resemblance to John Holms, which further endeared him to Peggy. The Lauritzens remember above all Peggy's loyalty, once a friendship had been established. But there were hurdles to overcome first— "She couldn't stand the thought of being made use of . . . that was something she found unforgivable." The Lauritzens became firm friends and in the course of time introduced Peggy to another young couple, Philip and Jane Rylands, who were to have a profound effect on the latter years of her life. A quintessentially English academic married to an American provided a combination perfectly suited to appeal to Peggy. Lady Rose remembers: "It was in 1974 that the Rylands met Peggy. I was living here and I introduced them to her. Philip was doing his doctorate on Palma Vecchio and his wife was teaching at a U.S. Army base as part of the University of Maryland Extension Program. Peggy was amused to meet them, and they made themselves virtually indispensable to her." The Rylands were very kind, repainting her bedroom, looking after her and the dogs.

In the late 1960s the Renaissance scholar John Hale inaugurated a university art history program in Venice, and he and his wife, Sheila, spent the autumns of 1967 to 1969 there. They met Peggy through John Fleming and Hugh Honour, and she took to them and their infant son immediately. Hale was an intellectual, which Peggy loved, and he was easygoing, which made her feel comfortable. Lonely in the winters, when everybody who could left after the first *acqua alta* (high water, or flood tide), she was especially stimulated by new, younger company, and the Hales would help rescue paintings from the basement when the floodwaters came. She was unable to leave because of the dogs, and because she was uneasy about leaving the collection unguarded. (The dogs themselves would slowly become as neglected as the palazzo and the pictures: Unkempt, they began to smell. Many a guest shrank from their desire to snuggle up.)

As the friendship grew, Peggy happily allowed the Hales' son to play

with the Cornell boxes, which news later horrified Angelica Z. Rudenstine, the collator of the official catalog of the collection. Peggy was mourning Pegeen when she and the Hales first met, and took to Sheila Hale greatly. "I was in my twenties, a lot younger than Pegeen, but I was a young American woman who had nothing to do with her past." Something else the two women shared was an inability to be attracted to a man who wasn't their intellectual superior. Peggy, Sheila remembers, "was childlike and childish. . . . She never referred to Pegeen's death except as 'the great sorrow,' and never discussed it with us. When she talked about it at all it was obvious that it had completely changed her. After that event, she became an old woman." It is true that from about the time of Pegeen's death Peggy's own outlook became more conservative. She disapproved of such things as free love and hippies; earlier in her life she wouldn't have turned a hair at such things. Lovers of her own had long since vanished, with varying degrees of regret. Ziva Kraus observes that "she should have been more beautiful and less intelligent. Also, because they couldn't own her or control her, they had to belittle her." What was sad in her last years was that she had no hand to hold.

Peggy confided in the Hales that she wished she had never brought the collection to Venice, but that feeling may have been due to a number of factors: Pegeen's death, and her winter loneliness—Peggy had by then fallen out with her great friend Martyn Coleman, who did stay in Venice all year, and who was a cultivated, art-loving man; but now they stayed on their own, opposite sides of the Grand Canal and bitched about each other. Her main companions were her pictures. She told the Hales she no longer had any confidence in her own "eye." Her favorites were two Picassos—*On the Beach* and *The Studio*.

Early in 1968 she sought solace in travel. She went east again, this time in the company of Roloff Beny, who was working on a photographic essay on India. They journeyed hard—4,500 miles in five weeks, often staying in primitive guesthouses, but Peggy never minded living rough, and despite her advancing years, had the stamina to tolerate it. She was also blessed with an unflagging curiosity for life. By the end of March she was home, writing to Beny: "There is so much to do here. Imagine 2 months mail to answer, and the house to put in order and the gallery to get ready. Spring has come and the garden full of yellow flowers. Very pretty. The dogs are fine. You can imagine how I miss Pegeen when I get back. It is so painful/Anyhow thank you for let-

ting me follow you everywhere. It was quite an experience and I learnt so much and saw so many wonderful things. Im sure the book will be divine."

The year 1969 saw the exhibition of the Peggy Guggenheim Collection in New York. It was a great success, following a glittering opening. Too unwell to continue as president of the Solomon R. Guggenheim Foundation, Harry Guggenheim had handed the reins on to the son of his cousin Barbara, Solomon's grandson Peter Lawson-Johnston. (Earl Castle Stewart, Lawson-Johnston's cousin, incidentally remembers with some anger that their joint grandmother's definitive collection of Renaissance art had been sold off, though Barbara spoke out against "this outrage.")

Lawson-Johnston remembers that the family reunion was not just between Peggy and Harry, but with a number of other members of the family, including his own mother. While in New York, Peggy spent her time staying with friends—with Marius Bewley for example, who had a mansion on Staten Island, where she met Andy Warhol: "Andy . . . sat on a sofa near Peggy and said, 'Oh, I am so honored to be at the same party with Mrs. Guggenheim!' Peggy turned to me and said, 'Who is that man?' She had never met him."

Peggy also stayed with the Reises, matters having been patched up between them, and, after a tour around the country visiting other friends, with Andy and Polly Garnett, who had an apartment on East Eighty-eighth Street, which adjoined the Guggenheim Museum. Peggy would knock on the wall in the evenings and say good night to her "children" next door.

But the Solomon R. Guggenheim Foundation would soon discover that despite all the restoration work done by the Tate, a large amount still remained to be done, and the palazzo itself, for which they had also taken responsibility, was beginning to fall into the canal. Thomas Messer remembers that Peggy hadn't spent a penny on maintenance of the building. The garden was unpaved, so that when it rained it became a bog; there were no public lavatories, so that visitors either relieved themselves behind trees, or they were directed to the nearest café. James Lord remembers that the palazzo, when Peggy lived in it, was fairly shabby. Ziva Kraus points out that "Peggy didn't belong to the world of curators and trained museum directors. She was a free spirit, and collecting was to her a creative activity—she didn't belong to the world of functionaries and in a sense she preceded it." Nevertheless, the place was a ruin when she died: Whole parts of the palazzo were uninhabitable, the roof leaked, and the basement was covered with mold and barely livable.

Not only was the palace a mess, but the damp atmosphere and the years of neglect were taking their toll on its contents. Peggy liked her pictures in a slightly decayed state, and never, despite her protestations to the Tate, really grasped the need for conservation. Messer found himself wondering whether, if Peggy had lived another decade, the unrestored paintings, let alone the palace, wouldn't have gone past repair.

The job of full restoration would be large, and far more costly than anticipated: It was lucky that the Solomon R. Guggenheim Foundation was richly endowed. Peggy even saw the foundation as a meal ticket, wondering if she could be put on some kind of payroll, and obtain health insurance. Lawson-Johnston says, "This may sound unfair of me but we were worried at having to spend so much money before we actually owned the collection." The board of the foundation was well aware of the Tate's experience, and although Peggy had agreed in principle to come under the aegis of the foundation, it would be years yet before her agreement was legally ratified.

Security remained neglected at the palazzo until a serious burglary in February 1971. Peggy was in London after visiting her son in Paris, when Sindbad received a telephone call from Venice telling him that thieves had broken in through a basement window and made off with fifteen small pictures, which were discovered by the police following a tip-off two weeks later hidden by the railway tracks leading out of town. The Lauritzens recall: "One night soon after the burglary there was a ring at the gate—the servants were on their night off—and Peggy went down alone in the dark and there was a man there, and she said, 'What do you want?' And he said, 'Mrs. Guggenheim, don't ask any questions, just tell me the name of your insurers.' 'For what?' 'For your paintings.' And she said, 'What are you talking about? I don't have any insurers for my paintings.' And the man said, 'What?!...' And he went away, and a few days later the paintings were found."

After it was all over, Peggy joked to her friend Milton Gendel, when he called her up to commiserate, having read about the theft in the papers: "They've all come back, and the odd thing is they stole fifteen and sixteen have come back." Gendel remembers that "Peggy was always kidding like that"—and it would be a mistake to forget how many people really loved her. "She was good company, she could be hilarious; she mellowed progressively in Venice, and the most touching side of her personality emerged after the death of Pegeen." James Lord, who visited her in 1971, felt that she had

lost some of her *élan vital*. However, this didn't prevent her from touring Bavaria with her friend Peter Cannon-Brookes, the keeper of art at the Birmingham (England) City Art Gallery. When she visited the Cannon-Brookeses in England, Peter's wife, Caroline, remembers that "she remained totally immersed in her fur coat, even to go to the bathroom."

In November, Peggy wrote to Thomas Messer, evidently piqued at the neglect she felt she was receiving from the hands of the organization in whose power she had placed herself: "No one came to see about the restoration of the pictures or to see about security measures. Does that mean the Guggenheim Museum has given up the project? . . . It seems ages since our gay dinner at the Angelo." Messer replied a little later in the month, "You are jumping to conclusions. . . . Orrin Riley's [Messer's representative] trip was postponed for unrelated reasons and he is scheduled now to be in Venice [in January 1972]."

In December there was another burglary in which seventeen paintings were taken. Peggy wrote to Tom Messer immediately, the wildness of her typing (here tidied) an indication of how upset she was. Evidently the foundation had been dragging its feet about installing better security:

> I am very sorry to have to tell you that January is too late/Why did you put it off so long/Last night thieves came, broke thru the grills of the sitting room window and carried off the Still Life Braque, The Rose Tower of De Chirico. Five Kupkas, Armatura of Masson. A new Brauner I had just bought, a Tancredi gouache. The Juan Gris, the Balla, both Klees, The Forest of Max Ernst. The voice of the winds of Magritte, and Upwards of Kandinsky/17 in all/Why do you take so long to send Mr Riley/? We dont know what to do/I suppose the police will get them back but it is very upsetting anyhow/

Peggy found it hard to find anyone to repair the grille immediately after the robbery, but still insisted on sleeping in the palazzo alone. The pictures were again recovered, and finally the foundation installed a proper burglar alarm system. Funds to pay for it were raised by the curious expedient of Peggy selling a painting, at Lawson-Johnston's suggestion, to the foundation. In itself the new system was fine, but Peggy often forgot to switch it on, or alternatively set it off by accident herself. It was wearying for the local police,

who often came round to confront Peggy crying defensively, *"Prova! Prova!"* ("Testing! Testing!")

Attempted thefts went on—Peggy's friend and associate John Hohnsbeen remembers intercepting a visitor who calmly took a small Tanguy gouache off the wall and slipped it into a bag. He returned it meekly when Hohnsbeen accosted him.

Peggy had ceased to have live-in servants by this time. Servants had always been a problem for her, since she was too tightfisted to pay them properly, and cross-examined them constantly about how much they'd spent on food shopping. She'd had her share of eccentric help as well—one Yugoslav butler decided to attempt suicide (he had been crossed in love) at the beginning of a dinner party. Her last servants were Isia Brecciaroli and her *fidanzato*, Roberto. Isia ruled the household with a rod of iron.

By the early to mid-1970s Peggy had ceased to buy pictures. She stopped replacing her dogs as they died. By now they were no longer all pure Lhasas—she had acquired a shih tzu by accident, and, as we have seen, she had bred in Pekingese stock. But the main reason for not acquiring any puppies was that she was scared that they would outlive her and have no one to look after them. Many years earlier she had given a puppy to the art collector Douglas Cooper, on a regular visit to Venice with his companion, John Richardson. Richardson, the biographer of Picasso, recalled:

> In the course of one of our annual visits to her Venetian palazzo, she had decided that something had to be done about Douglas's "vile disposition." It was getting out of hand. She had always thought of him as a friend, but he had written an article denouncing her collection as of interest only insofar as it reflected the modish taste of a mid-twentieth-century American millionairess. Hard knocks had left Peggy with skin as thick as an elephant's— proof against snubs and slights, not to mention rejections—but Douglas had hit her in her raison *d'être*, her collection, and this had really hurt. With some justice, she attributed Douglas's sneers at her expense to competitiveness; also to homosexual misogyny and bitterness—traits of which she had too often been the victim. "I am furious when I think of all the men who have slept with me while thinking of other men who have slept with

me before" is one of several similar *cris de coeur* in her memoirs. Peggy had the perfect cure for Douglas's condition: a dog. "It will bring out the mother in him," she told me. Next time we went to Venice, she presented him with one of the offspring of the famous Lhasa apso that she and her former husband, Max Ernst, had acquired when they were married. The dogs had done wonders for Max's meanness, she said.

Douglas Cooper, a wealthy Australian, had an incomparable and selective collection—the cubist works of four painters: Braque, Gris, Léger, and Picasso. Since his death it has been split up. Had it remained together it would today be worth in the region of $500 million. The value of Peggy's collection today is hard to compute, but toward $350 million would not be inaccurate. Peggy's original outlay for the principal buying activities of the 1930s and 1940s was about $250,000.

It was not market value but intrinsic value that concerned her. Without the collection there will be no collector. Had she left it to her family, it would, she feared, be split up. Cooper died some years after Peggy—outside specialized circles, scarcely anyone knows his name today. As Rosamond Bernier says, "The collection was her identity—she had no other—don't you think? Why did people look her up in Venice? Why did people make a fuss of her more and more?" Sandro Rumney adds "She was a much more sensitive person than she let other people know and she disguised herself with glasses, alcohol, extravagant behavior, to hide the fragility of the personality."

Messer feels that the collection is "not like a private collection—there is no predilection for one artist over another, and no quirkiness except for nepotism—Pegeen and Laurence would be unknown if it hadn't been for Peggy. She was also conscientious—she didn't like Dalí but felt she had to have one to complete the collection, so she got one—Gala wanted her to have more, of course." It is as if it were a reflection of a dutiful public taste: The best examples of a broad cross-section of artists working between about 1910 and 1950. Messer interviewed Peggy in detail about this in 1974: The root of his question was, why stop at two or three paintings by one artist before moving on to the next? It was a question Peggy couldn't adequately answer. Messer admits, however, that he wanted to acquire the collection practically from the first moment he was in a position to do something about it, because it had

a richer cross-section of paintings than the Solomon R. Guggenheim Foundation originally had.

Peggy's Italian was never more than adequate, and as the years passed, her social circle dwindled. The American consulate had closed. Many old friends had died, and the winters became colder and lonelier, though the stalwarts of the expatriate community remained—people like Christina Thoresby, a formidable elderly music critic who played the organ at the English Church. The English-speaking community numbered about forty, so that the permutations at parties were limited. The Lauritzens do, however, remember one grand party—the only one they remembered in the twenty years they knew Peggy that was quite so crammed with the great and the good. "Peggy went up to a man and said, 'Oh, I admire your films so much, Mr. Newman.' At which the embarrassed man had to point out to her that that was Paul Newman over there—but one never knew whether she was genuinely vague at moments like that or was being mischievous. Either way it was typical of Peggy. Either she didn't have a clue who Paul Newman was, or she approached a stranger in order to tease the star." Lady Rose thinks she genuinely didn't know who Newman was; all she knew was that Gore Vidal was bringing a big film star to whom she wanted to be nice for Gore's sake and for the sake of politeness. Newman wasn't the only person Peggy didn't recognize at that particular bash. Spying a large man looking rather lost in a corner she went up to him and asked him where he came from. "Canberra," was the reply. "Who are you?" "Gough Whitlam." "And what do you do?" "I am the prime minister of Australia."

For some time Peggy continued to send the cheap, vulgar Christmas cards she habitually bought, but there were ever fewer people to send them to. There was still a stream of visitors, all of whom came away with original experiences. Peter Lawson-Johnston, admitting to succumbing to the Guggenheim trait of noticing small things, remembers that at the table the napkins would be beautifully folded but not actually laundered. He also remembers Peggy questioning the bill at Harry's Bar (where she was given a discount anyway)—a memory many share, along with that of Peggy flying in the face of Venetian society by entertaining gondoliers at the same establishment. Roger Straus remembers going to the Cantonine Storica with her and his wife. They drank only half the carafe of house wine they'd ordered, and she insisted that they not be charged for the full carafe. Pennypinching remained her unconscious obsession. She would get cross if you overtipped a

gondolier. Others have stories of how she counted the slices of ham left in the refrigerator, or of how for the duration of their visit nothing would be served except for canned sardines, since she'd bought up a job lot cheaply from a closing-down grocery. After a cocktail party, nothing would be served to eat except leftover canapés until they were used up. Peggy had already bemused Venetian high society by offering them a kind of vegetable-extract-flavored cracker with their drinks.

More than one grandchild remembers, at a time when kidnapping the children of the rich for ransom was current in Italy, that Peggy told them she'd pay nothing to redeem them. Sindbad's wife gave their daughters personal alarms just in case. Sindbad's own protection against his mother had been, since maturity, a sense of ironic detachment bolstered by drink, and a conscious Anglophilia, though his accent was Franco-American. People remember him with a mixture of sadness and warmth.

Rather than use a letter stamp on a postcard, Peggy would go to the post office to buy the correct one, saving less than she'd used in shoe leather and time. Guests froze in their rooms in spring because the central heating was kept off; on asking for an electric heater, they were given one but told that if more than one bar were used, the electricity for the whole palazzo would blow. Lights were switched off the minute they weren't needed. One old friend remembers staying at the Gritti when on official business in Venice, and not telling Peggy he was in town. But by chance he met her butler in St. Mark's Square. Peggy issued an invitation, and he reluctantly had to abandon the warmth and comfort of the hotel for the Spartan atmosphere of the palazzo.

Younger guests, meeting Peggy for the first time, found her charming, and younger male guests were aware of an earthiness, a primal quality that even when she was seventy lent her a certain sex appeal, which she still played on, even though the recipient of her charms might be forty years her junior. But her charm didn't overwhelm criticism: "The term 'poor little rich girl' suited her perfectly," says one friend who met her when he was twenty-eight, in 1968: "I think she was never satisfied—either with personal relationships, or the amount of money she had, or sex, or her position in society. . . . There was a slight feeling of the desert island castaway about her in Venice. She was lost in time—the time she truly belonged to had passed, and the group she'd belonged to had largely dispersed." But as long as she could, she enjoyed going out to local restaurants close by—the Cantonine, or

the Cici, or the Cugnai. "We'd always treat her," Sheila Hale remembers, "though she'd always buy the apéritif, and in any case she didn't eat much."

Nicolas—Peggy's favorite grandson toward the end of her life—remembers visits to the palazzo with pleasure, though he concedes that she was tightfisted. As for birthday and Christmas presents, the grandchildren would generally get checks for $50 or $100, or perhaps little artists' drawings or sketches. "There was rarely anything personal." Peggy was getting stuffy too, disapproving of long hair and jeans, though at the same time the grandchildren were not spared candid questions about their sex lives. Sindbad's daughter Julia (who now lives in Australia, married to an Australian who, when they met on a kibbutz, had, to her delight, never heard of Peggy Guggenheim), remembers that as a grandmother Peggy was far from conventional; and she sought to distance herself from Peggy's self-conscious bohemianism whenever the family visited, which they did for short periods and infrequently, since Sindbad and his second wife tried to protect their daughters from Peggy's influence. Julia, however, remembers as a thirteen-year-old in Paris, in her mother's absence, having to prepare salads for Peggy and her aging artistic entourage when they met at Sindbad's apartment in Boulogne-sur-Seine. She also remembers how she and her older sister Karole dreaded visiting Venice, usually at Easter time. "We used to call her Grandma-the-Dogs to distinguish her from our other grandmother. For about two weeks before we left Paris Karole would be sick every day. On the way down on the train she would be unwell. Every day in Venice she was unwell. Once she was back on the train to go home she was as right as rain." Karole herself remembers tension between her grandmother and her father, "and I would get very ill and upset when I came here [to Venice]." She adds, "And the times were not very pleasant . . . she was very domineering, and she was so direct with her questions—I remember when I was not quite yet a teenager she was quizzing me about a boyfriend and about whether I was still a virgin. When you're eleven or twelve years old and you're just coming to terms with your first period, you don't expect your grandmother to ask you that kind of question, especially not in a room full of people. It's excruciatingly embarrassing, and it's even worse a bit later when you reach your teens and everything your older relatives do is embarrassing anyway. . . . When I was here on my own later for a week at her request, when I was eighteen, I would have to go around with her on the gondola every afternoon, and she would deposit me at various churches, and I'd go and look,

and she'd wait in the gondola, and I'd have to report back, something I didn't particularly enjoy doing when I was that age. . . . I was rather in awe of her—she wasn't particularly affectionate—though she did want me there and presumably wanted to attempt some greater closeness; but her distance put me off asking her questions which now I wish I had." When Karole was eighteen, she wanted to work in a hotel in Germany to improve her German. "Peggy was horrified: 'She can't go there, it's full of Nazis, she's too young.' It seemed a bit late by then for her to start worrying about her granddaughter."

Sandro remembers that he enjoyed visiting Peggy at the palazzo for a week or so, no more, and especially if he could take a friend along. "She had compassion—poor little boy, lost his mother, got to care for him. But she wasn't nice, she didn't know how to do it, she didn't know how to care. . . . I was sent to boarding school in Switzerland. Once, she decided to come and see me. She traveled by train, second class, because she hated the thought of spending money, at least more than was necessary, and she invited me out to lunch, which was great, I was about eleven at the time, anything to break the routine. . . . It was a fairly rich school so all the kids had stereos and skis and what have you . . . so she asked me what I'd like for my birthday. . . . I asked her please to get me a stereo, so we went into Geneva and we bought a pretty simple stereo set, nothing like what my friends had but I was extremely happy—it was my present, the best present I'd had in my life, and I took it back and installed it in my room, and she was still with me, getting bored because I was taken up with my new acquisition, putting on records and so on. And then she asked me if I'd like to have dinner with her that night, and I said, well, if you don't mind, I'd rather show my stereo to all my friends—can we have lunch tomorrow? And she was so upset, and took it so personally, that she left. But she never really remembered birthdays normally—she'd just send you a check for $50."

Meanwhile the fabric of the palazzo disintegrated around her. She spent much time in bed reading, as, along with her home, the fabric of her body deteriorated.

She let her motorboat and her open-topped Fiat-Ghia roadster go, but kept her gondola, though now with only one gondolier, Gianni, old and drunken, who also rowed a gondola for the funeral cortèges to San Michele. Peggy only needed him for her daily late-afternoon two-hour tour of the canals, which she knew so well that she directed him by a wave of her left or right hand to let him know where she wanted to go. She loved her gondola, and kept up the

rides for as long as she could, even when pain from illness required an effort of will to use the boat, one of the hardest to get into and out of in the world. With truth, she wrote to Djuna Barnes: "I adore floating to such an extent, I can't think of anything as nice since I gave up sex, or rather, since it gave me up."

On land, her weakened limbs dictated an ever-diminishing semicircle of narrow streets around her palazzo on the Dorsoduro side. She was still able to get to her favorite *trattorie*, which she preferred to expensive restaurants, and she still quibbled over the bills. Nevertheless, the longer she lived in Venice and the older she got, the calmer she became, though she never lost her sense of being an eternal outsider. "Her nose was always pressed to the glass," as one friend said.

In 1973 John Hohnsbeen came to Venice. He was an art dealer, originally from Oklahoma, who had started his career working with Curt Valentin in New York. Hohnsbeen, the longtime partner of architect Philip Johnson, had latterly been dividing his time between Paris and Rome, and had met Peggy first in 1970 at the Rome apartment of Roloff Beny. The two had hit it off, having many friends in common in the art world, and Peggy had been attracted to Hohnsbeen's sociability. It was partly because of this that she invited him to come to Venice as her houseguest, to help her run the collection during the summers, when it was open to the public, as its curator—a title that was never formally adopted, but a role that Hohnsbeen certainly filled. She was lucky to be able to enlist such educated help at this point: The number of visitors to the palazzo each year was rising, and the amateurish administration of the collection was beginning to feel the strain. Hohnsbeen remembers maintaining the pictures "as best I could—sweeping the maggots off their backs." The damp conditions at the palazzo were the worst possible for the paintings; and there was no money for their maintenance. The artist Ziva Kraus, who helped out with secretarial and administrative work, remembers that no Venetians visited the collection. "They watched her all the time, a kind of voyeurism."

In the mid-1970s, the next-door Palazzo Dario, whose owners had been plagued by such bad luck that the place was considered jinxed, was bought by Kit Lambert. The son of the English composer Constant Lambert, Kit had a financial interest in two major pop groups of the period—the Who and the Rolling Stones. He thus became immensely rich, but he was also gay, unhappy about it, and deeply into drugs. He was a great fan of Peggy, though, and as soon as he had moved in, began to besiege her with invita-

tions. When they met, they got along like the proverbial house on fire. Kit was the last of a wild, brilliant, self-destructive type who had hovered around Venice up until the early 1960s. To celebrate the purchase of his palazzo, he gave a grand dinner party at the Gritti, with all the food flown in from London, and sent a gondola across the canal for Peggy. But this gaudy beginning did not fulfill its promise. In due course, unable to rid himself of his personal demons, Kit took his own life.

Though she still gave dinner parties herself, Peggy's increasing parsimony ensured that the food was poor and unvarying—every dinner began with canned tomato soup—and Hohnsbeen learned to seek his pleasures elsewhere—something that led to tensions between the two, as Peggy's old possessive and jealous nature asserted itself, and she felt lonely and neglected. Hohnsbeen was loyal to Peggy, and her conception of the collection. And as always, her stinginess was selective. She gave $15,000 a year to the Venice in Peril Fund. But, as one of her grandchildren remembers, "she was always a bit of a Fafnir."

Following the great successes of the exhibitions of her collection at the Tate and the Guggenheim Museum, Peggy could at last taste a bittersweet vindication when the Louvre invited her to show it there. It was the first time that the Louvre had so honored a living collector. She had never forgiven them for refusing to help save her collection as the Germans prepared their invasion, but at the same time she was reluctant to refuse them because Paris had been so much a part of her life, and the Louvre was, despite her mixed feelings about its directors, one of the great art museums of the world. She also had the satisfaction of seeing the story of their refusal to help in 1940 printed in all the newspapers. She still managed to have an argument with the designer of the exhibition, and found most of the Louvre personnel "disagreeable."

The exhibition was due to run from December 1974 until March 1975 at the Orangerie. Peggy was not too old to enjoy a sense of revenge as well, and she was delighted that the show was so popular that its run had to be extended, just as the Tate's exhibition had been. She liked being lionized as well; like so many people who cannot communicate properly with their fellow human beings, she found it easier to relate to crowds than individuals. She dressed either shabbily or outrageously, she made sure to dress down for the opening, but in the end she felt that the ultimate seal had been placed on her life's work.

Paris may no longer have been the leading city for modern art, but for her Paris remained the Paris of the 1920s and the 1930s—the Paris of her youth, and the Paris of her first steps as a collector. It was in a sense her apotheosis.

The 1975 summer season at the palazzo saw Peggy gradually more retiring. Sandro remembers that her "real tragedy toward the end was that she found herself so alone . . . we all wanted to love her, but we didn't know how to. Peggy would be patently uninterested in what we had to say . . . we had more fun with the staff." Meanwhile the succession was beginning to occupy the minds of all those directly concerned.

Peggy felt lonelier, less at home with her Italian neighbors, and increasingly frail. A lifetime of excess was catching up with her. She had high blood pressure and poor circulation. A bad fall in May 1976 broke several ribs and put her into a hospital for two weeks. But she tried to keep slim, and when she had guests, she dressed up as originally as ever, and applied the lipstick and the eyebrow pencil with the same hit-and-miss *élan* as ever. Her grandson, Nicolas, and a friend made a short documentary film about her. She continued to toy with the notion of getting John Holms's letters published, and even with the idea of having another operation on what George Melly has referred to as her "tapir-like nose."

The year 1976 also saw another triumphant exhibition of her collection—in Turin, the city whose authorities had changed their minds about showing it when it first arrived in Italy. In the same year, after long negotiations in the course of which Peggy had shown herself to be characteristically suspicious, the Peggy Guggenheim Foundation was formally subsumed within the Solomon R. Guggenheim Foundation. The palazzo and the collection were now legally the property of the latter organization. It was a moment Peggy didn't regret—it was a relief not to have all that responsibility anymore—but it gave her a *frisson*, an intimation of mortality, nevertheless. Still, she had done everything in her power to protect the future of the collection—even the dining-room furniture was covered. The offending Léger *Contraste des Formes* still rankled, however. Messer was told that he could sell that if he wished. He remained as courteous and gallant as ever, and felt genuine affection for Peggy, though she does not escape criticism:

> She had a warm and authentic relationship toward art and artists, but her collecting taste was never methodic and often not even

attentive. She was neither a scholar nor an intellectual, although she appreciated and admired the company of both and moved within such circles with ease and tact. She was nothing if not direct and outspoken, yet her straightforwardness . . . masked greater complexities of which she may or may not have been aware. Above all, there was something indescribably sad, even tragic, about Peggy. To my mind, the strokes of fate that she suffered did not fully account for this. In some strange way, she seemed troubled about her very existence, and her tendency to surround herself with men and women of quality was rooted perhaps in her need for attachments that would uphold her. Despite such constraints, Peggy was capable of great courage, style and grandeur, and she translated these attributes into an admirable life.

In early 1978 Peggy survived a heart attack that John Hohnsbeen felt sure would kill her, but she recovered sufficiently to celebrate her eightieth birthday on August 28 at a party held in her honor at the Gritti Palace, and given by the hotel's director, Dr. Passante. Sindbad made a speech, as did Joseph Losey, tactlessly referring to Peggy as the personification of *belle-laide*, and the director of the Museum of Modern Art in Venice, Guido Perocco. Among the twenty-two personally chosen guests were Philip and Jane Rylands. John Hohnsbeen remembers mentioning to Peggy that she'd left off her guest list "some woman or other" whom she really should have invited. She replied: "I don't have to do anything—just remember one thing about me: I am totally selfish, and I do not have to do anything I don't want to." She never realized that that was precisely what made her lonely. She did not invite Vittorio Carrain either, her first guide in Venice, which earned her his resentment.

At the party there was a banner wishing a happy birthday to *l'Ultima Dogaressa*—this time there was no ironic intent. The year was given an additional fillip when Peggy was contacted by Jacqueline Bograd Weld, her first biographer, though friends say that Peggy didn't take to her and would call up when she was due to visit, to summon them around to give moral support.

Her health continued its decline. It was hard for her to negotiate the bridges, though she could still use the vaporetto, and so did her dogs—sometimes independently, knowing their stops, something not unusual in Venice. By now she was suffering seriously from arteriosclerosis, and in addition was

having problems with cataracts. Incipient blindness was alarming. Peggy still listened to classical music, but her chief pleasure, increasingly as she spent more and more time alone, was reading—apart, of course, from looking at her pictures. In 1979 she went to England to have a double operation on her eyes, performed at Moorfields Hospital by the ophthalmic surgeon Patrick Trevor-Roper (brother of the historian). When the operation was over, she spent time convalescing at the homes of various friends, including Maurice and Leonora Cardiff, the artist Jim Moon, the Godley sisters, and Andy and Polly Garnett.

(The operation had been a painful one and it took her many weeks to recover. There was an added strain in that Sindbad had recently undergone an operation for cancer of the mouth. At the time, however, when Sindbad was unable to work, his wife went out to work instead of staying at home to care for her husband, since there was no subsidy from Peggy. Sindbad died relatively young, in 1986; his wife passed away exactly two years later.)

Polly Devlin Garnett remembers that "one tired and pain-filled night, [Peggy] said she wished she were dead. The next day she came downstairs in purple dress and purple tights. 'I wish I hadn't said what I said. I never have talked like that and I don't want to start now.'" Peggy had telephoned them from the hospital "to say she was leaving hospital. She'd only just had the operation, so we were surprised and concerned, and asked her where she was going to stay, and she said, 'I don't know where I'm going, I'll have to find a hotel.' And we asked if she weren't going to a convalescent home and she said, No, nobody seemed to mind what she did—she sounded pathetic and full of self-pity, which was unlike her." On reflection Polly wonders whether in fact Peggy was simply too worried about the expense of a nursing home. In any case she was soon installed in the Garnetts' large Elizabethan house in Gloucestershire—Bradley Court, Wootton-under-Edge.

Peggy's autobiography had been out of print since the condensed version, *Confessions of an Art Addict*, had appeared in 1960. She'd thought of reviving it with the help of James Lord, but at the time his insistence on absolute candor scared her off. Now it was proposed to reissue the original 1946 version with the scantily clad identities of the characters fully revealed, and with updates. There was a renewed interest in Peggy, including many press interviews, and from England George Melly came over with a film crew to feature two pictures from her collection—Ernst's *The Robing of the Bride* and

Magritte's *The Empire of Light*—for a television series called *100 Great Paintings*. Melly and his wife, Diana, had met Peggy many years before with the Garnetts. "I quite liked her, but not her entourage of hissing queens," he remembers of their first meeting. They went for a stroll, Peggy walking like a dancer with her feet turned out, and accompanied by the dogs. "And I said to her, 'I suppose they've learned not to fall into the canals?' She replied, 'They fall in all the time!' When I asked her what she did about it, she told me that she hauled them out with a special, long, thin stick. 'And who designed it for you?' I asked. 'Giacometti?' There was a deep intake of breath from the entourage which had followed us, but then she laughed in a rasping kind of way. And that was my first meeting with her." When he saw her again in 1979, she received him in bed, and suggested that he do an interview with her while he was there. "She was ever so frail, but her awful servants got her dressed and wheeled her out to the hall, where she sat under the big Picasso and did the interview." Melly remembers that many of the pictures were cracking and flaking. Their condition wasn't helped by the fact that many were early works, when the artists were unknown and only had money for the cheapest materials, which were least likely to withstand the abrasions of time. As we already know, Peggy herself seems to have preferred her paintings in a slightly decayed state.

The reviews of the book, when it appeared, remained indifferent, while acknowledging her role as a Maecenas of contemporary art. By then in the summer of 1979, she scarcely cared: She was in such pain from her thickened arteries that even a short walk was agony, and her last surviving dog, Cellida, named after an artist, died in extreme old age shortly before its mistress.

It was as if the last ties were being cut. In September she went with friends to dinner at Cipriani's on the Lido. It was late when they finished, and in getting into the boat which was to take them back to Dorsoduro, she slipped and hurt her foot. Once arrived at the palazzo, her friends carried her from the boat to her bedroom and laid her on the bed, where she only complained of slight pain. An X ray taken the next day revealed that she had cracked a bone, which made it impossible for her to put any weight on the foot. She stayed in bed, propped up with cushions, and switched from Henry James to Thomas Hardy, finding the former too heavy going for her condition. Hohnsbeen had moved out of the palazzo at the end of the summer.

Her friends hovered around. There was talk of her going to Yugoslavia to

consult Dese Trevisan, whom Marshal Tito had seen for arteriosclerosis. But it came to nothing. Finally, in mid-November, she was taken, "quite terrified," by boat to the Piazzale Romana and from there by ambulance to a hospital in Padua, the Camposanpiero, where there was some hope that it was not too late for an operation, since the crack refused to heal with rest. Peggy took with her a copy of *The Brothers Karamazov*—she expected a long stay. Arriving, there was confusion—no doctor had been assigned to her—but she was taken to a private room. She was still well enough to ask its price, and on learning it, decided that it was too expensive. She was moved to a room with two other beds. Isolated from Venice, she found her loneliness heightened, though the Rylands made the day-long train journey once a week, and she was in daily contact with friends by telephone. She asked the Rylands not to trouble Sindbad to come down from Paris. Her friend Giovanni Carandente visited her: "She told me, I want to die; and she was amazed that I'd made the effort to come and see her, regarding it as an affectionate gesture."

Everyone knew that it would not be long. As soon as she had arrived at Camposanpiero, she had suffered a pulmonary edema. It took a month for tests to determine if an operation was advisable, and when it proved possible Peggy did not want it—the ordeal seemed too exhausting—though she remained optimistic that she'd be home by Christmas. Finally, she did agree to the operation, but soon afterward she was found in the morning on the floor by her bed, having fallen out during the night. That day she suffered a stroke that paralyzed her right side. The Rylands summoned Sindbad, who arrived the next day with his wife. "Please kiss me," Peggy said when she saw him.

She died on Sunday, December 23. The Rylands were having tea with Sindbad when they heard the news. It had been raining for two days, and the Vails and the Rylands spent Christmas rescuing paintings from the basement.

Immediately after her death, her uncle's foundation sent Thomas Messer to assess the state of the palazzo and its contents. He had taken the precaution the previous year to arm himself with an authorization from Peggy:

> I felt free to raise the issue of postmortem access to the palazzo, pointing out that I might have trouble taking possession of the premises if someone were inside, to say nothing of the difficulties of scaling the high garden wall if no one were. Peggy considered the matter with the utmost seriousness and then took two charac-

teristically simple measures. Addressing herself to the first eventuality, she let me prepare a brief "To Whom it May Concern" for her signature. Dated May 3, it said, "This is to certify that the Palazzo Venier dei Leoni and the art collection contained therein is the property of the Solomon R. Guggenheim Foundation in New York. It is therefore my wish that Mr. Thomas M. Messer, Director of the Guggenheim Museum in New York, or his deputy be admitted to the above premises upon my death." Having considered the alternate situation, she simply handed me the one key that would open the garden gate as well as the palazzo portals.

Several years earlier, in 1973, Peggy had suggested to Messer that Nicolas Hélion be considered for the post of curator after her death, a post Nicolas himself was eager to take up. Messer demurred, but suggested that Nicolas should take a suitable degree course. In the event, Nicolas was to go his own way. Nicolas says that he failed to obtain the curatorship because he didn't wish to study at Brown University, but at the Ecole du Louvre, since he is based in Paris (and is more French than anything, as are all the surviving Vail-Hélion-Rumney boys). Of the two granddaughters, Julia now speaks English with an Australian accent. Karole has an Anglo-American accent, with Franco-Italian overtones. (Peggy's own internationalism lives on.)

The other heir apparent was John Hohnsbeen, but the foundation felt that Philip Rylands was the most suitable candidate. Hohnsbeen was away in Puerto Rico at the time of Peggy's death (his health required that he spend winters in warm climates), and in any case his relationship with Peggy, who had become ever more needy and possessive, had declined. Rylands rang Hohnsbeen after Peggy's death to say that he should return as soon as possible, but when Hohnsbeen called Messer, he was told not to bother. Rylands had the advantage of being in situ, and since 1973, when he came to Venice to research his thesis, he had been close to Peggy. Furthermore, following her death, matters had to be arranged quickly. Philip remembers being taken to dinner at the Bauer-Grünwald Hotel in Venice by Messer and invited to take over pro tem. There followed several grueling months of working alone with no backup from New York—until Messer appeared two weeks before the official reopening. Rylands's temporary appointment was soon ratified as permanent, and he remains in charge of the collection at the time of writing.

In her will, Peggy left her son $400,000, appointing him her executor. He allocated $100,000 to his nephews. All Peggy and Hazel's grandchildren were also benefiting from trusts set up for them by their prescient great-grandmother, Florette. After legal expenses and taxes, Sindbad calculated that he'd be left with $150,000; but in fact the will was more complicated than had at first been suspected, and the final sum devolving to Sindbad amounted to an extra $1 million, of which $700,000 were tied up in trust. A similar amount went to Pegeen's sons collectively. However, all were heavily taxed. While by no means left badly off, the family was chastened by the fact that Peggy had not left them a single good painting from the collection. Sindbad was not permitted to stay in the palazzo from the moment his mother died, and he admitted to being "pissed off" that Peggy hadn't left him a single decent canvas. His older daughter feels that he was disgusted by his mother's vanity. He was envious of Peter Lawson-Johnston, which he admitted in a letter, adding that it was all he could do to be nice to his distant cousin. But privately he acknowledged that had Peggy left the collection to the family, it would have been dispersed. He himself was never greatly interested in modern art. After all, it had deprived him of his mother. Once, sleeping in Peggy's bed (in her absence) he is reputed to have thrown the Calder headboard down the corridor because it made so much noise in the night. Peggy's granddaughters, Karole and Julia, received her personal effects—the Lenbach portraits, the earrings, and so forth.

Sandro also acknowledges that the possibility of dispersal would have been strong had the collection gone to the family.

Peggy was taken to San Michele on January 9, 1980, and her remains cremated. Only Philip Rylands attended the funeral. Her ashes were interred in her garden, next to her "beloved babies," on April 4. Sindbad, his wife, and Philip and Jane Rylands were present. They opened a bottle of champagne and drank to Peggy's memory.

Two days later the Peggy Guggenheim Collection opened as a public museum. Sandro remembers that the family was in general sidelined if not snubbed. Sindbad wasn't invited to make a speech, and the feeling was "OK guys—good-bye. Have a last look and get out of here." (Sandro has called his oldest son Sindbad.) There was a grand but poorly arranged dinner at which Thomas Messer referred fulsomely to the wife of the U.S. ambassador, who had agreed to serve on a fund-raising committee for the collection. A

drunken Sindbad was heard loudly to drawl, "Big deal." On the whole, given a wretched catering company after which the Rylands were constrained to clear up, the evening was not a success.

A schism not yet fully resolved opened between the family and the foundation, though there is a family committee (with little executive power) representing its interests. A lawsuit filed by the Hélion-Rumney grandsons suing the foundation for mismanagement in 1991 and claiming compensation in that the foundation hadn't upheld Peggy's wishes to display her collection exactly as she had, came to nothing. Now, with the passing of time, real or imagined grievances are being put in proportion. Time, as they say, makes all the arrangements. Each side has compromised, but some of the changes still rankle.

In 1982 the Associated Press reported with some inaccuracies in the *Herald Tribune* that the Peggy Guggenheim Collection had closed its doors for a $1 million renovation. Peggy's garden is now the Nasher Sculpture Garden, named after the wealthy Texan collectors who donated $1 million to the Peggy Guggenheim Collection. There is a shop and a restaurant. The Peggy Guggenheim Collection is one of the major attractions of Venice today.

Messer believes that a collector who is collecting just for her- or himself likes to consider the private collection a reflection of her- or himself. A public collection, however, which is what Peggy's has, *mutatis mutandis*, become, has the job of changing to reflect new trends and advances, and the world in which it exists; and the collection has to grow because it has a life of its own, and is, in a sense, immortal—it must keep on growing and changing. The New York art dealer Larry Salander shares this view, and thinks that Peggy would have liked her collection to remain as vital as possible, and not be turned into a mausoleum. "Why can't you preserve it as a memorial to her, and develop it as a museum? Otherwise what happens is that people go there once and do not return because nothing changes and the art ceases to be responsive to its time." Some of Peggy's grandchildren would regard some of this as casuistry, of course: She wanted the collection to remain her collection, representing what it does and no more: static, but providing a very precise point of reference. Nicolas Hélion sees his efforts, with David and Sandro, to preserve the integrity of the collection, as important. An attempt to take down the Pegeen Vail memorial collection was successfully countered; but in the wide context it is hard to make a case, other than a personal one, for maintaining it. The dialogue continues.

* * *

Not everyone thinks the collection is a great one. James Lord doesn't, though he concedes that it is "extraordinarily illustrative of creative currents characteristic of their era." Many of those who knew the palazzo when Peggy lived in it disapprove of the clinical nature they feel it now has, stripped of any vestige of Peggy's personality. These are personal views, and should not vitiate the work done since Peggy's death. Peggy left the collection with no cash endowment, so that it has had to find its own way of fund-raising—a task at which the present curator has shown himself a master, according to, among others, Peggy's distant cousin, the Earl Castle Stewart, who serves on the Peggy Guggenheim Collection Advisory Board. The collection today attracts 300,000 visitors a year. A *Premio* Peggy Guggenheim was inaugurated in the mid-1980s and continues to be awarded periodically to encourage artists or the sponsorship of the arts.

If there are fears that the collection may be split up, they should be allayed by the fact that Italian law would probably never allow it. From time to time the collection lends pictures and, in return, hosts visiting exhibitions. This may not be to the liking of those who hold that the collection should remain immutable, but it is in the nature of a collection to change with time. In the end what is most important is that Peggy understood, and it does not matter if she understood it imperfectly or unconsciously, that art can challenge you and make you think. Her pioneering of forms little appreciated at the time she was championing them should be regarded as her major contribution to our cultural history.

Coda

A supreme masochist, she is as relentlessly honest about her-
self as she is about her "friends." She leaves us with a picture of
a lonely woman, too hard, too hurt, to have retained normal
sensitivities.

KATHARINE KUH,
review of *Out of This Century,* 1946

*P*eggy's status as a collector is based on two short, intense periods of
acquisition: from about 1938 to 1940 in England and, principally,
France; and from about 1941 to 1946 in the United States. She was not
the only collector of her day; and there were more women than men among
her peers. She only took to the art world at someone else's instigation, and
she scarcely ever made a move within it without someone else's advice. Eight
years' collecting in a lifetime of eighty years (if one discounts the relatively
desultory activity after she had moved to Venice) is not much, especially
when one looks at the careers of Edward James, or Walter Arensberg, or the
Cone sisters, or Katherine Dreier.

One wonders why she gave up when she did, but her protean personality

often remains one step ahead of us. There isn't even agreement that her collection reflects a personal taste, and the argument that supports the contrary view is hard to refute when one considers that it is not the product of one person's taste, but at least five apart from her own—Read, Duchamp, Nelly van Doesburg, Max Ernst, and Putzel. Peggy's individuality of taste shows itself chiefly in well-meant nepotism toward her first husband and her daughter.

The collection does, however, represent an excellent cross-section of specific schools over a specific period, and as a reference point for them its importance is undeniable. If it were split up or diluted or allowed to continue to develop, would that matter? After all, along very different lines, the Frick Collection in New York has changed by around 35 percent since the death of its originator in 1919, without, however, deviating from the kind of collecting he would have continued with.

Peggy's greatest claim to fame lies in her ambition to found a modern art museum. There is another point, however, to be answered: That had her private life been less colorful, would what she did for art seem less interesting? In starting such a line of enquiry one ventures onto thin ice, because again the scope for disagreement is wide. As things stand the Peggy Guggenheim Foundation is, at least nominally, separate from the Solomon R. Guggenheim Foundation, though as far as the foundation's merchandising is concerned, Venice is lumped together with Berlin, Bilbao, and New York, and this is the perception of most popular journalism today. The importance of its continuing separate identity, is a moot point, though no one who accepts Peggy's integrity as a collector—and after all, her advisers advised, they did not and could not dictate—would think it other than sad to contemplate the subsumption of her gallery's contents within the stock of her uncle's organization. Whether that is a possibility or not cannot be answered here: under its present energetic management, the Solomon R. Guggenheim organization plans fast and major expansion, with second museums in New York and Venice, cooperative tie-ups with St. Petersburg and Vienna, a new museum in Rio de Janeiro and a hotel-casino-art center in Las Vegas. The small Peggy Guggenheim Collection may be left alone, or it may be swamped.

Peggy had her own views on modern art, and had her own agenda. The value of the collection is attested to by the zeal with which established institutional galleries—then far behind her in their acquisitions—sought to

inherit it. In 1998, the centenary year of her birth, the Italians put her palazzo on a postage stamp. Peggy created one of the most accessible private collections there is and placed it in a city where it would be offset by the completely different traditions of the Renaissance and the baroque that surround it. She used to say to visitors, "What are you doing here, you should be at the Accademia, you can see modern art anywhere"; but to see her collection in Venice after sessions in the city's other principal art gallery or any of its churches or *scuole* is to have one's aesthetic sense refreshed and revived; in contrast can lie strength. Whatever the future holds for the collection, her achievement and her contribution in creating it will remain her permanent memorial.

source notes

In the notes that follow, I have given only brief titles of books and other sources. Full titles are given in the acknowledgments or the bibliography. Any direct quotations in the text not from books or other published data come from unpublished written sources or conversations. All translations into English from foreign languages are my own unless otherwise indicated. I acknowledge my debt to Peggy Guggenheim's autobiography, *Out of This Century*, in both the 1946 and the 1979 editions, though I have mainly used the latter, and to a small extent her 1960 version, *Confessions of an Art Addict*; and to Jacqueline Bograd Weld's biography, *Peggy: The Wayward Guggenheim* (New York: E. P. Dutton, 1986). When referring to John H. Davis's book *The Guggenheims: An American Epic* I have used both the William Morrow edition of 1978 and the Shapolsky edition of 1988. As all these books were referred to off and on throughout the present work, they are not mentioned again in the chapter breakdown of sources that follows. Details of the exhibitions held at Guggenheim Jeune and Art of This Century can be found in Angela Z. Rudenstine's excellent standard catalog to the Peggy Guggenheim Collection, and textual variations between the 1946, 1960, and 1979 editions of Peggy's autobiography are of small relevance.

Abbreviations Used in the Source Notes and Bibliography
 AAA Archives of American Art
 PG Peggy Guggenheim
 PGC Peggy Guggenheim Collection, Venice
 SRGF Solomon R. Guggenheim Foundation (Archives)

Chapter One: Shipwreck
 Books: Walter Lord, *A Night to Remember; Encyclopaedia Judaica*.
 Sources: Hazel Guggenheim McKinley, private papers; contemporary American and British press reports; various registers of birth and marriage; conversations with Barbara Shukman.

Chapter Two: Heiress
 Books: Biographical essays by Laurence Tacou-Rumney and Karole Vail; Virginia Dortch, *Peggy Guggenheim and Friends*.
 Sources: PG correspondence and papers, SRGF and private collections; private papers of Hazel Guggenheim McKinley.

Chapter Three: Guggenheims and Seligmans
 Books: Stephen Birmingham, *Our Crowd*; George S. Hellman, *The Seligman Story*; Edwin P. Hoyt, *The Guggenheims and the American Dream*; Milton Lomask, *Seed Money*; Gatenby Williams, *William Guggenheim*.
 Sources: Baiersdorf and Lengnau town records; private papers.

Chapter Four: Growing Up
 Books: Dortch, *Peggy Guggenheim and Her Friends*, Harold Loeb, *How It Was*.
 Sources: Private papers, Hazel Guggenheim McKinley and PG; PG correspondence and papers; Seligman papers.

Chapter Five: Harold and Lucile
 Books: Carlos Baker, *Ernest Hemingway: A Life Story*; Dortch, *Peggy Guggenheim and Her Friends*; Loeb, *How It Was*; John Glassco, *Memoirs of Montparnasse*; Ernest Hemingway, *The Sun Also Rises*; Philip Herring, *Djuna Barnes*; Robert Hughes, *The Shock of the New;* Matthew Josephson, *Life Among the Surrealists*; Tacou-Rumney, *Peggy Guggenheim: A Collectors Album*; Alfred, Lord Tennyson, *Idylls of the King*, "Gareth and Lynette," 1.576.
 Sources: *Broom* magazine. Conversations with John Hohnsbeen, Peter Lawson-Johnston, Charles Seliger, the Earl Castle Stewart, and Simon Stuart.

Chapter Six: Departure
 Books: Exhibition catalog, *The American Century, Art and Culture, 1900–1950* (Whitney, 1999); Carolyn Burke, *Becoming Modern*; Herring, *Djuna Barnes*; Joan Mellen, *Kay Boyle*.
 Sources: Conversation with Philip Rylands.

Chapter Seven: Paris
 Books: Arts Council of Great Britain, *Dada and Surrealism Reviewed*, 1978; Kay Boyle and Robert McAlmon, *Being Geniuses Together*; memoirs by Malcolm Cowley, Glassco,

"Jimmie the Barman," Josephson, Gertrude Stein; Bernard Berenson, *The Italian Painters of the Renaissance*; Noel Riley Fitch, *Hemingway in Paris*; Ernest Hemingway, *A Moveable Feast*; Tacou-Rumney, *Peggy Guggenheim: A Collector Album*; Laurence Vail, *Murder! Murder!*; William Carlos Williams, *A Voyage to Pagany*.

Sources: *Minotaure; transition*. Conversations with David Hélion, James Lord, and Ralph Rumney.

Chapter Eight: Laurence, Motherhood, and "Bohemia"

Books: Boyle and McAlmon, *Being Geniuses Together*; Maurice Cardiff, *Friends Abroad*; memoirs by Cowley, Glassco, "Jimmie the Barman," Gertrude Stein; Hemingway, *A Moveable Feast*; Burke, *Becoming Modern*; Herring, *Djuna;* Mellen, *Kay Boyle*; Laurence Vail, *Murder! Murder!*

Sources: Private papers, correspondence. Conversations with Maurice Cardiff, Charles Henri Ford.

Chapter Nine: Pramousquier

Books: *Clare College Almanac* (bound copy, London Library); Burke, *Becoming Modern*; Glassco, *Memoirs of Montparnasse;* "Jimmie the Barman," *This Must Be the Place*; Josephson, *Life Among the Surrealists*; Mellen, *Kay Boyle;* Tacou-Rumney, *Peggy Guggenheim: A Collector's Album*; Djuna Barnes, *Nightwood*; Emily Coleman, *The Shutter of Snow*.

Sources: Emily Coleman Archive; Laurence Vail "Here Goes" unpublished memoir; contemporary press archives; NYPD Archive; Conversations with John King-Farlow, Barbara Shukman, Harold Shukman.

Note: Alain Lamerdie's name is elsewhere spelled "Le Merdie," "Lemerdie," and "Lemerdy." He is described as a "soldier and vintner." Certainly his family had estates in the South of France.

Chapter Ten: Love and Literature

Books: *The Calendar of Modern Letters* (bound edition) and an essay, "A Review in Retrospect," by Malcolm Bradbury; contributions to the *Calendar* by John Holms; Michael Holroyd, *Hugh Kingsmill*; Hugh Kingsmill, *Behind Both Lines*; Edwin Muir, *An Autobiography*; Josephson, *Life Among the Surrealists*; Mellen, *Kay Boyle*.

Sources: National Army Museum; "Here Goes"; Highland Light Infantry Archive; Imperial War Museum; Laurence Vail, letters (private collection); contemporary press; conversation with Mrs. William Chattaway (*née* Debbie Garman).

Chapter Eleven: Hayford

Books: Herring, *Djuna*; Tacou-Rumney, *Peggy Guggenheim: A Collector's Album*; Karole Vail, *Peggy Guggenheim: A Celebration*.

Sources: Djuna Barnes, letters; Emily Coleman, letters. Conversations with Mrs. William Chattaway, Charles Henri Ford, Karole Vail.

Chapter Twelve: Love and Death
 Books: *Calendar of Modern Letters*; Holroyd, *Hugh Kingsmill;* Kingsmill, *Behind Both Lines*; Muir, *An Autobiography*.
 Sources: Correspondence (private collections).

Chapter Thirteen: An English Country Garden
 Books: *Calendar of Modern Letters*; Bradbury, "A Review in Retrospect"; Mellen, *Kay Boyle*.
 Sources: Communist Party of Great Britain; John Cunningham, article on Lorna Wishart, *The Guardian*, January 21, 2000; MI6; conversation with Mrs. William Chattaway.

Chapter Fourteen: Turning Point
 Books: *The American Century* catalog; *Dada and Surrealism* catalog; *National Geographic*, October 1998; André Breton, *Nadia*; Lautréamont, *Les Chants de Maldoror*; Julien Levy, *Memoir of an Art Gallery*; Roland Penrose, *Scrap Book*; Angelica Z. Rudenstine, *Peggy Guggenheim Collection, Venice*; Burke, *Becoming Modern*; Dortch, *Peggy Guggenheim and Her Friends*; Hughes, *The Shock of the New!*
 Sources: Contemporary press; *International Surrealist Bulletin; Minotaure*. Conversations with Mr. and Mrs. William Chattaway, John King-Farlow, James Mayor, Barbara Shukman, Rebecca Wallersteiner.

Chapter Fifteen: "Guggenheim Jeune"
 Books: Charlotte Gere and Marina Vaizey, *Great Women Collectors*; George Melly, *Don't Tell Sybil*; John Richardson, *The Sorcerer's Apprentice*; A.J.P. Taylor, *English History 1914–1945*; biographies of Beckett (Knowlson), Duchamp, Ernst (Spies), Henry Moore (Berthoud, Russell), Read, Rebay, and Tanguy; Dortch, *Peggy Guggenheim and Her Friends;* Penrose, *Scrap Book*; Rudenstine, *The Peggy Guggenheim Collection, Venice;* Tacou-Rumney, *Peggy Guggenheim: A Collector's Album;* Karole Vail, *Peggy Guggenheim: A Celebration*.
 Sources: AAA: material on Putzel (Bernheim, Lader); *Arts Magazine,* March 1982; newspaper reports in ITVE 1 & 2; contemporary press; PG Archive at SRGF; Rebay Archive at SRGF; Emily Coleman, letters; Lee Miller Archive; *London Bulletin*; Mayor Gallery Press books; Melvin P. Lader, *Peggy Guggenheim's Art of This Century: The Surrealist Milieu and the American Avant-Garde, 1942–1947*. Conversations with Mrs. William Chattaway, Walter Hayley, John King-Farlow, James Mayor, George Melly, Wies van Moorsel, Antony Penrose, and Barbara Shukman.
 Note: Some sources give the original address for the Mayor Gallery as 37 Sackville Street, London W1. The gallery's archive to 1940 was destroyed by a German bomb. No one can ascertain how or why the discrepancy arose.

Chapter Sixteen: Paris Again
 Books: Lynn M. Nicholas, *The Rape of Europa*; biographies of Beckett, Boyle, Rebay; Dortch, *Peggy Guggenheim and Her Friends;* Rudenstine, *The Peggy Guggenheim Collection, Venice*.

Sources: AAA: Putzel (Bernheim, Lader); Bibliothèque Nationale; Coleman letters. Conversations/correspondence with Jacqueline Ventadour-Hélion, Wies van Moorsel.

Intermezzo: Max and Another Departure

Books: Leonora Carrington, *The House of Fear: Notes from Down Below*; Lisa Fittko, *Mein Weg über die Pyrenäen*; Varian Fry, *Assignment Rescue* and *Surrender on Demand*; Mary Jayne Gold, *Crossroads Marseilles 1940*; Michael R. Marrus and Robert O. Paxton, *Vichy France and the Jews*; Dorothea Tanning, *Birthday;* biographies of Boyle, Duchamp, Ernst; Nicholas, *The Rape of Europa*; Karole Vail, *Peggy Guggenheim: A Celebration*.

Sources: *Assignment Rescue*, documentary film by Richard Kaplan (pre-1996); *Max Ernst*, documentary film on Max Ernst by Peter Schamoni (1991); Lee Miller Archive, articles on Carrington. Conversations/correspondence with Jacqueline Ventadour-Hélion, Wies van Moorsel.

Chapter Seventeen: Coming Home

Books: Jimmy Ernst, *A Not-So-Still Life*; Ingrid Schaffner and Lisa Jacobs, *Portrait of an Art Gallery*; John Russell, *Matisse: Father and Son*; biographies of Boyle, Duchamp, Ernst, Loy; Levy, *Memoir of an Art Gallery*; Karole Vail, *Peggy Guggenheim: A Celebration*.

Sources: AAA (various); Bernheim, Lader: material on Putzel; CIA; FBI; Lader, *Peggy Guggenheim's Art of This Century*; Boeing Web site (re: B-314). Conversation with Jacqueline Ventadour-Hélion.

Chapter Eighteen: Art of This Century

Books: Daniel Abadie, *Hélion, ou la Force des Choses; American Century* catalog; *Art of This Century: The Women* catalog; *Dada and Surrealism* catalog; Vivian Barnett and Josef Helfenstein, eds., *The Blue Four*; Paul Bowles, *Without Stopping;* Flint, *The Peggy Guggenheim Collection;* Charles Henri Ford, ed., *View; They Shall Not Have Me* (Hélion); *Hélion* (Mayor Gallery catalog); Lewison, *Interpreting Pollock*; Steven Naifeh and Gregory White Smith, biography of Jackson Pollock; *Kiesler* catalog (Phillips); Saarinen, *The Proud Possessors*; biographies of Duchamp, Ernst, Rothko; Dortch, *Peggy Guggenheim and Her Friends;* Ernst, *A-Not-So-Still Life*; Rudenstine, *The Peggy Guggenheim Collection, Venice*; Tacou-Rumney, *Peggy Guggenheim: A Collector's Album*.

Sources: AAA papers (*inter alia*): Baziotes, Castelli, Greenberg, PG, Johnson, Kiesler, Kuh, Motherwell, Parsons, Porter, Reis, Rothko; also Bernheim, Lader on Putzel; Roloff Beny Archive, PG correspondence; Kiesler Foundation and Archive, Vienna; MoMA papers: Kiesler; U.S. Embassy (London) Information Service; *View; Close Up: Love and Death on Long Island*, BBC documentary film on Pollock (1999, Teresa Griffiths). Conversations with Virginia Admiral, Rosamond Bernier and John Russell, Louise Bourgeois, Charles Henri Ford, Lisa Jacobs, Lillian Kiesler, David and Marion Porter, Paul Resika, Peter Ruta, Lawrence B. Salander, Charles Seliger, and Roger W. Straus Jr.

Chapter Nineteen: Memoir

Books: Biographies of Max Ernst, Pollock; Ernst, *A Not-So-Still Life*; Levy, *Memoir of an Art Gallery*; Rudenstine, *The Peggy Guggenheim Collection, Venice*; Karole Vail, *Peggy Guggenheim: A Celebration*.

Sources: AAA papers: PG, Nevelson; Lader, *Peggy Guggenheim's Art of This Century*; contemporary press; Peggy Guggenheim's guest books (courtesy of Karole Vail). Conversations with Diana Athill, Charles Henri Ford, Thomas M. Messer, Antony Penrose, and Jacqueline Ventadour-Hélion.

Chapter Twenty: Transition

Books: McCarthy, "The Cicerone"; biographies of Ernst, Pollock, Tanguy.

Sources: AAA papers: PG letters; PG letters (private collection); Mary McCarthy, letters; *View*. Conversations with Charles Henri Ford, Thomas M. Messer, Roger W. Straus, Jr. and Karole Vail.

Chapter Twenty-One: Palazzo

Books: Paolo Barozzi, *Peggy Guggenheim—una Donna, una Collezione, Viaggio nel' Arte Contemporanea* (Barozzi); Lord Berners, *The Girls of Radcliff Hall*; Virgil Burnett, *Edward Melcarth: A Hercynian Memoir*; Giovanni Carandente, *Ricordo di Peggy Guggenheim*; Polly Devlin, *Only Sometimes Looking Sideways*; James Lord, *Giacometti*; Lord, *A Gift for Admiration* ("A Palace in the City of Love and Death"); Lord, *Picasso and Dora*; Ralph Rumney, *Le Consul*; Ned Rorem, *Knowing When to Stop*; Malise Ruthven, *A Traveller in Time*; biographies of Barnes, Bowles (autobiography), Cage, Ernst, Pollock, Read, Rebay; Cardiff, "Peggy Guggenheim"; Dortch, *Peggy Guggenheim and Her Friends*; Hughes, *The Shock of the New*; Melly, *Don't Tell Sybil*; Richardson, *The Sorcerer's Apprentice*; Rudenstine, *The Peggy Guggenheim Collection, Venice*; Tacou-Rumney, *Peggy Guggenheim: A Collector's Album*; and Karole Vail, *Peggy Guggenheim: A Celebration*.

Sources: AAA papers: Biennale 1948 correspondence, Falkenstein; Barnes, letters; Beny, letters; Brady, letters; Coleman, letters; contemporary press (Paul Bowles's obituary in *The Times*, November 19, 1999; Eric Hebborn's autobiography quoted in "The Collectors' Collector," an article about PG by Lee Marshall, *Independent on Sunday*, September 13, 1998); ground plans, Palazzo Venier dei Leoni (before conversion to a museum), courtesy PGC; PG Archive in SRGF; PG guestbooks; Michael Combe Martin, letters (private collection); Thomas Messer, interviews with PG, 1974, in SRGF Archive; Herbert Read Archive; Rebay Archive in SRGF; *Catalogo della XXIV Biennale di Venezia* (1948); Philip Rylands, *Peggy Guggenheim in Venezia; Per una Cronista dell' Esposizione della raccolta di Peggy Guggenheim alla Biennale di Venezia del 1948* (Maria Cristina Bandera Viani). Conversations with Alan Ansen, Paolo Barozzi, Rosamond Bernier, Paul Bowles, Maurice Cardiff, Vittorio Carrain, William and Deborah Chattaway, Annamaria Cicogna, Michael Combe Martin, Domingo de la Cueva, Patricia Curtis Vigano, Polly Devlin, Joan Fitzgerald, Cathérine Gary, Milton Gendel, David Hélion, Nicolas Hélion, Derek Hill, John Hohnsbeen, Julie Lawson, James Lord, George Melly, Thomas M. Messer, Paul Resika, Ned Rorem, Ralph Rumney, Sandro Rumney, Peter Ruta,

Malise Ruthven, Philip Rylands, Simon Stuart, Laurence Tacou-Rumney, Karole Vail, Kathe Vail, Julia Vail Mouland, and Jacqueline Ventadour-Hélion.

Chapter Twenty-two: Legacy

Sources: AAA; "How the Tate Might Have Got Peggy Guggenheim's Collection," *Art Newspaper*, January 1997; letter from Sir Norman Reid; "The Real Story of Why Peggy Guggenheim's Collection Stayed in Venice," *Art Newspaper*, February 1997; Beny, letters; Brady, letters; contemporary press; *L'Ultima Dogaressa*, documentary film (1976, Nicolas Hélion, Olivier Lorquin); Messer, PG interviews, 1974 (typescript); Obituaries: Sir Anthony Lousada (*Independent*, June 27, 1994; *Times*, July 5, 1994); Ronald Alley (*Guardian*, May 17, 1999, *Daily Telegraph*, May 21, 1999); SRG Archive and Museum correspondence/catalog for PGC exhibition, 1969 (*Works from the Peggy Guggenheim Collection*); SRGF Archive: PG correspondence; Tate Gallery Archives: PG correspondence/ bequest/Tate exhibition of PGC, 1964–1965/catalog. Conversations with Milton Gendel, Peter Lawson-Johnston, James Mayor, Thomas M. Messer, and Roger W. Straus Jr.

Chapter Twenty-three: "The Last Red Leaf Is Whirl'd Away . . ."

Books: Dorothea Straus, *Palaces and Prisons*; biography of Boyle; Carandente, *Ricordo di Peggy Guggenheim*; Cardiff, Dortch, *Peggy Guggenheim and Her Friends*; Devlin, *Only Sometimes Looking Sideways*; Lord, *A Gift for Admiration*; Melly, *Don't Tell Sybil*; Richardson, *The Sorcerer's Apprentice*; Rumney, *Le Consul*.

Sources: AAA, PG, letters; Barnes, letters; Beny, letters; Brady, letters; contemporary press (France, Germany, Italy, Britain, and America); PG, late letters (private collections); SRGF Archive, PG, letters. Conversations with Rosamond Bernier, Peter and Caroline Cannon-Brookes, Maurice Cardiff, the Earl Castle Stewart, Domingo de la Cueva, Polly Devlin, Joan Fitzgerald, Milton Gendel, Lord Gowrie, Professor Sir John and Lady Hale, David Hélion, Nicolas Hélion, John Hohnsbeen, Ziva Kraus, Dr. Peter and Lady Rose Lauritzen, Peter O. Lawson-Johnston, James Lord, George Melly, Thomas M. Messer, Ralph Rumney, Sandro Rumney, Philip Rylands, Lawrence B. Salander, Roger W. Straus Jr., Laurence Tacou-Rumney, Karole Vail, and Julia Vail Mouland.

bibliography

What follows is a selection of books consulted. I have not included film or Web site sources, though one or two long articles are included.

Peggy Guggenheim: Biographical Material/Material Relating to Her Collection
Art of This Century: The Guggenheim Museum and Its Collections. New York: SRGF, 1993.

Barozzi, Paolo. *Peggy Guggenheim: Una Donna, una Collezione.* Milan: Rusconi/Immagini, 1983.

Weld, Jacqueline Bograd. *Peggy: The Wayward Guggenheim.* New York: E. P Dutton, 1986.

Carandente, Giovanni. *Ricordo di Peggy Guggenheim.* Milan: Naviglio, 1989.

Cardiff, Maurice. "Peggy Guggenheim: An Exchange of Visits." In *Friends Abroad.* London and New York: Radcliffe Press, 1997.

Conaty, Siobhán M., and Philip Rylands et al. *Art of This Century: The Women.* Stony Brook, N.Y.: SRGF, 1997.

Dortch, Virginia M. *Peggy Guggenheim and Her Friends.* Milan: Berenice, 1994.

Flint, Lucy, and Thomas Messer. *The Peggy Guggenheim Collection Handbook.* New York: SRGF, 1983.

Guggenheim, Peggy. *Out of This Century: The Informal Memoirs of Peggy Guggenheim.* New York: Dial Press, 1946.

―――. *Confessions of an Art Addict.* London: André Deutsch, 1960.

―――. *Out of This Century: Confessions of an Art Addict.* New York: Universe Books, 1979; London: André Deutsch, 1979.

Lader, Melvin P. *Peggy Guggenheim's Art of This Century: The Surrealist Milieu and the*

American Avant-Garde, 1942–1947. Ph.D. diss. 1981, distributed by University Microfilms International, Ann Arbor, Mich., 1998.

Licht, Fred. "Peggy Guggenheim, 1898–1979." In *Art in America*, February 1980.

Licht, Fred, and Melvin P. Lader. *Peggy Guggenheim's Other Legacy*. Milan: Mondadori, 1987.

Lord, James. "A Palace in the City of Love and Death." In *A Gift for Admiration*. New York: Farrar, Straus & Giroux, 1998.

Rudenstine, Angelica Zander. *The Peggy Guggenheim Collection, Venice*. New York: Harry N. Abrams and SRGF, 1985.

Seemann, Annette. *Peggy Guggenheim: Ich bin eine befreite Frau*. Düsseldorf and Munich: Econ und List, Rebellische Frauen series, 1998.

Tacou-Rumney, Laurence. *Peggy Guggenheim: A Collector's Album*. Paris and New York: Flammarion, 1996.

Vail, Karole P. B. with an essay by Thomas Messer. *Peggy Guggenheim: A Celebration*. New York: Guggenheim Museum, 1998. (Memoir by Peggy's granddaughter to accompany the birth-centennial exhibition she curated.)

Works from the Peggy Guggenheim Foundation. New York: SRGF, 1969)

Note: Further works on Peggy Guggenheim, by Mary V. Dearborn and Lisa M. Rüll, are in preparation. A *Festschrift* by Philip Rylands is also awaited.

General

Abadie, Daniel. *Hélion ou la force des choses*. Brussels: La Connaissance, 1975.

Ades, Dawn. *Dada and Surrealism Reviewed*. London: Arts Council of Great Britain, 1978.

Aus der jüdischen Geschichte Baiersdorfs [From Baiersdorfs Jewish history]. Baiersdorf, Germany: n.p., 1992–93.

Baker, Carlos. *Ernest Hemingway: A Life Story*. Harmondsworth: Penguin, 1987.

Barbero, Luca Massimo. *Spazialismo: Arte Astratta Venezia 1950–1960*. Venice: Cardo, 1996.

———. *L'Officina del Contemporaneo Venezia '50–'60*. Milan: Charta, 1997.

Barnes, Djuna. *Nightwood*. London: Faber, 1936.

Barnett, Vivian Endicott, and Josef Helfenstein, eds., *The Blue Four*. Cologne, Germany, and New Haven, Conn.: Dumont and Yale University Press, 1997.

Barozzi, Paolo. *Viaggo nell' Arte Contemporanea*. Milan: Pesce d'Oro, 1981.

Berenson, Bernard. *The Italian Painters of the Renaissance*. London: Fontana, 1962.

Lord Berners. *The Girls of Radcliff Hall*. Montcalm: Cygnet Press, London, 2000.

Berthoud, Roger. *The Life of Henry Moore*. London: Faber, 1987.

Birmingham, Stephen. *Our Crowd*. New York: Harper & Row, 1967.

Bowles, Paul. *Without Stopping*. London: Peter Owen, 1972.

Boyle, Kay, and Robert McAlmon. *Being Geniuses Together*. Baltimore and London: Johns Hopkins University Press, 1997.

Bradbury, Malcolm. "A Review in Retrospect." In *The Calendar of Modern Letters*. (Bound edition, London: Frank Cass, 1966, reprinted from 1925–27 edition.)

Breslin, James E. B. *Mark Rothko*. Chicago and London: University of Chicago Press, 1993.

Breton, André. "Genesis and Perspective of Surrealism." Preface to *Art of This Century* catalog, ed. Peggy Guggenheim. New York: Art of This Century, 1942.

Breton, André. *Nadia*. Paris: Livre de Poche, 1964.

Burke, Carolyn. *Becoming Modern: The Life of Mina Loy*. New York: Farrar, Straus & Giroux, 1996.

Burnett, Virgil. *Edward Melcarth: A Hercynian Memoir*. Stratford, Ontario: Pasdeloup, 1999.

Cabanne, Pierre. *The Great Collectors*. New York: Farrar, Straus & Giroux, 1968.

Capote, Truman. *The Muses Are Heard*. London: Heinemann, 1957.

———. *Answered Prayers*. London: Hamish Hamilton, 1986.

Carrington, Leonora. *The House of Fear: Notes from Down Below*. London: Virago, 1989.

Checkland, Sarah Jane. *Ben Nicholson*. London: John Murray, 2000.

Chitty, Susan. *Now to My Mother: A Very Personal Memoir of Antonia White*. London: Weidenfeld & Nicolson, 1985.

Coleman, Emily Holmes. *The Shutter of Snow*. London: Routledge, 1930.

Core, Philip. *The Original Eye: Arbiters of Twentieth-Century Taste*. London: Quartet, 1984.

Cowley, Malcolm. *A Second Flowering: Works and Days of the Lost Generation*. New York: Viking, 1973.

Crosby, Caresse. *The Passionate Years*. Carbondale and Edwardsville: Southern Illinois University Press, 1968.

Davis, John H. *The Guggenheims: An American Epic*. New York: William Morrow, 1978; rev. ed. New York: Shapolsky, 1988.

Devlin, Polly. *Only Sometimes Looking Sideways*. Dublin: O'Brien, 1998.

Dunn, Jane. *Antonia White*. London: Cape, 1998.

Ernst, Jimmy. *A Not-So-Still Life*. New York: Pushcart, 1984.

Fielding, Daphne. *Emerald and Nancy*. London: Eyre and Spottiswoode, 1968.

Fischer, Lothar, ed. *Max Ernst*. Reinbek/Hamburg: Rowohlt, 1969.

Fitch, Noel Riley. *Hemingway in Paris*. London: Equation, 1989.

Fittko, Lisa. *Mein Weg über die Pyrenäen*. Munich: Hanser, 1988.

Ford, Charles Henri, ed. *View: Parade of the Avant-Garde, 1940–1947*. New York: Thunder's Mouth, 1991.

Fry, Varian. *Assignment Rescue*. New York: Scholastic, 1945.

———. *Surrender on Demand*. New York: Random House, 1945; reprint Boulder: Johnson Books, 1997.

Gere, Charlotte, and Marina Vaizey. *Great Women Collectors*. New York and London: Harry N. Abrams and Philip Wilson, 1999.

Gerhardi, William. *Resurrection*. New York: Harcourt, Brace, 1934.

Gill, Anton. *The Journey Back from Hell*. London: HarperCollins, 1998–2002.

Glassco, John *Memoirs of Montparnasse*. New York and Toronto: Oxford University Press, 1970.

Gold, Mary Jayne. *Crossroads Marseilles 1940*. New York: Doubleday, 1980.

Goodway, David. ed. *Herbert Read Reassessed*. Liverpool University Press, 1998.

Haskell, Barbara. *The American Century: Art and Culture, 1900–1950*. New York: Whitney Museum and W. W. Norton, 1999.

Hélion, Jean. *They Shall Not Have Me*. New York: Dutton, 1943.

Hélion. London: Mayor Gallery, July–September 1998.

Hemingway, Ernest. *The Sun Also Rises*. New York: Scribner's, 1926.

——. *A Moveable Feast*. London: Cape, 1964.

Herring, Philip. *Djuna: The Life and Work of Djuna Barnes*. New York: Viking, 1995.

Holms, John Ferrar. "A Death." In *The Calendar of Modern Letters*. (March–August 1925); and various literary reviews.

Holroyd, Michael. *Hugh Kingsmill*. London: Unicorn, 1964.

Hoyt, Edwin P. *The Guggenheims and the American Dream*. New York: Funk and Wagnalls, 1967.

Huddleston, Sisley. *Paris Salons, Cafés, Studios*. New York: Blue Ribbon, 1928.

Hughes, Robert. *The Shock of the New*. London: BBC Books, 1980.

Jackman, J., and C. Borden, eds. *The Muses Flee Hitler*. Washington, D.C.: Smithsonian Institution, 1983.

"Jimmie the Barman" (Charters, James, as told to Morrill Cody). *This Must Be the Place*. New York: Lee Furman, 1937.

Josephson, Matthew. *Life Among the Surrealists*. New York: Holt, Rinehart & Winston, 1962.

Kiesler, Frederick. *Inside the Endless House*. New York: Simon & Schuster, 1966.

Kingsmill, Hugh. *Behind Both Lines*. London: Morley and Mitchell Kennedy, Jr., 1930.

Kluver, Billy, and Julie Martin. *Kiki's Paris: Artists and Lovers 1900–1930*. New York: Harry N. Abrams, 1989.

Knowlson, James. *Damned to Fame: The Life of Samuel Beckett*. London: Bloomsbury, 1996.

Lader, Melvin P. "Putzel, Proponent of Surrealism and Early Abstract Expressionism in America." In *Arts Magazine*, March 1982. (For more on Putzel, see Hermine Benheim's unpublished biographical study in AAA, Reel 3482.)

Le Comte de Lautréamont (Isidore Ducasse), trans. Paul Knight. *Les Chants de Maldoror*. Harmondsworth, England: Penguin, 1978.

Leja, Michael, and Jeremy Lewison, and Tim Marlow. "Jackson Pollock." In *Tate* 17, (spring 1999).

Levy, Julien. *Memoir of an Art Gallery*. New York: G.P. Putnam's Sons, 1977.

Lewison, Jeremy. *Interpreting Pollock*. London: Tate Gallery, 1999.

Linder, Ines, ed. *Blick-Wechsel: Konstruktionen von Männlichkeit und Weiblichkeit in Kunst und Kunstgeschichte*. Berlin: Reimer, 1989.

Lomask, Milton. *Seed Money (The Guggenheim Story)*. New York: Farrar, Straus Co., 1964.

Lord, Walter. *A Night to Remember*. Harmondsworth, England: Penguin, 1991.

Lukach, Joan M. *Hilla Rebay: In Search of the Spirit in Art*. New York: Braziller, 1983.

McCarthy, Mary. "The Cicerone." In *Cast a Cold Eye*. New York: Harcourt, Brace and World, 1993.

Marrus, Michael R., and Robert O. Paxton. Trans. Marguerite Delmotte, *Vichy et les Juifs*. Paris: Calmann-Lévy, 1977.

Mellen, Joan. *Kay Boyle: Author of Herself*. New York: Farrar, Straus & Giroux, 1994.

Melly, George. *Don't Tell Sybil: An Intimate Memoir of E. L. T. Mesens*. London: Heinemann, 1997.

van Moorsel, Wies. *De Doorsnee is Mij Niet Genoeg*. Nijmegen, the Netherlands: Sun, 2000.

Muir, Edwin. *An Autobiography*. London: Hogarth, 1954. (Revised and expanded version of *The Story and the Fable*.)

Naifeh, Steven, and Gregory White Smith. *Jackson Pollock: An American Saga*. Aiken, S.C.: Woodward/White, 1989.

Nicholas, Lynn H. *The Rape of Europa*. London: Papermac, 1995.

Nick Carter Stories, no. 1, September 14th, 1912. London: Street and Smith, 1912.

O'Neal, Hank. *Life Is Painful, Nasty and Short*. New York: Paragon House, 1990.

Penrose, Antony. *The Lives of Lee Miller*. London: Thames & Hudson, 1988.

Penrose, Antony, and George Melly. *Roland Penrose*. London: Prestel, 2001.

Penrose, Roland. *Scrap Book*. London: Thames & Hudson, 1981.

Phillips, Lisa. *Frederick Kiesler*. New York: Whitney Museum and W. W. Norton, 1989.

Read, Herbert, ed., and Nikos Stangos. rev. ed. *Dictionary of Art and Artists*. London: Thames & Hudson, 1966 and 1985.

Richardson, John. *The Sorcerer's Apprentice*. London: Jonathan Cape, 1999.

Rorem, Ned. *Knowing When to Stop*. New York: Simon & Schuster, 1994.

Rumney, Ralph. *Le Consul*. Paris: Allia, 1999.

Russell, John. *Max Ernst, Life and Work*. London: Thames & Hudson, 1967.

———. *Henry Moore*. Harmondsworth, England: Penguin, 1968.

———. *Matisse: Father and Son*. New York: Harry N. Abrams, 1999.

Ryerson, Scot D., and Michael Orlando Yaccarino. *Infinite Variety*. London: Pimlico, 2000.

Saarinen, Aline B. *The Proud Possessors*. New York: Random House, 1958.

Schaffner, Ingrid, and Lisa Jacobs, eds., *Julien Levy: Portrait of an Art Gallery*. Cambridge, Mass., and London: MIT Press, 1998.

Spies, Werner, ed., *Max Ernst, A Retrospective*. London: Tate Gallery/Prestel, 1991.

Stein, Gertrude. *Everybody's Autobiography*. New York: Random House, 1937.

———. *The Autobiography of Alice B. Toklas*. London: Penguin, 1966.

Straus, Dorothea. *Palaces and Prisons*. Boston: Houghton Mifflin, 1976.

Tanning, Dorothea. *Birthday*. Santa Monica, Calif.: Lapis, 1986.

Taylor, A. J. P. *English History, 1914–1945*. Harmondsworth, England: Penguin-Pelican, 1985.

Tomkins, Calvin. *Duchamp*. London: Chatto & Windus, 1997.

Vail, Laurence. *Murder! Murder!* London: Peter Davies, 1931; see also his *Piri and I* and *What D'You Want?*

Waldberg, Patrick. *Yves Tanguy*. Brussels: André de Rache, 1977.

Webster, Paul. *The Life and Death of the Little Prince*. London: Papermac, 1994.

Whitford, Frank. "The Great Kandinsky." In *Royal Academy Magazine* 62, (spring 1999); see also *On the Spiritual in Art*.

Williams, Gatenby (pseudonym of William Guggenheim). *William Guggenheim: The Story of an Adventurous Career*. New York: Lone Voice Publishing Co., 1934. (Lone Voice was Guggenheim's own private publishing house, set up for this book. Its address was that of his apartment at 3 Riverside Drive.)

Williams, William Carlos. *A Voyage to Pagany*. New York: Macaulay, 1928.

Woods, Alan. *The Map is Not the Territory*. Manchester University Press, 2001.

acknowledgments

No book of this sort can be written without the participation of a large number of individuals. For a writer like me, the first course of action before starting work must be to verify that key figures are willing to give their support and encouragement to the project. At the outset therefore three people emerged to whom I owe a fundamental debt of gratitude: Peter O. Lawson-Johnston, chairman of the Solomon R. Guggenheim Foundation in New York City, and through him Professor Philip Rylands, curator of the Peggy Guggenheim Collection in Venice, and Peggy's granddaughter Karole P. B. Vail, Project Curatorial Assistant at the Solomon R. Guggenheim Museum in New York. The last two were unstintingly generous with their time and support, both put me in contact with people I might not otherwise have found, both were most hospitable and even helped me to find accommodation during periods of field research. I am additionally indebted to Professor Rylands for perceptive insights into Peggy's nature as a collector, and to Karole Vail for her own centennial exhibition about her grandmother, her attendant biographical study, and for allowing me access to her private collection. I also specially wish to thank Richard Johnson, friend and masterly editor, for his sure touch in refining the manuscript. Further professional help in the production of this book came from its copy editor, Robert Lacey; its picture editor, Juliet Davis; and

from its brilliant picture researcher, Anna Turville. Kathryn Carr at the Solomon R. Guggenheim Foundation in New York was fantastically helpful in the location and provision of photographic material.

I believe I have interviewed almost everyone who knew Peggy and was willing and able to talk about her. In the list that follows, I apologize for any omissions of people to whom I owe thanks. Of all the people I approached, only a handful refused to help, and a slightly larger number failed to reply. In all, this accounts for fewer than ten. The vast majority were generous with their time and support, and I must thank particularly Peggy's niece, Barbara Shukman, and her husband, Dr. Harold Shukman, for their help, hospitality, and friendship, and for allowing me access to important private papers; as well as Peggy's other grandchildren: Karole's sister, Julia Vail Mouland, and her husband Bruce Mouland (who live in Australia but whom I met in Venice); and in Paris, David Hélion, who lent me books and private papers as well as providing welcome perceptions of Peggy's personality, as did his brothers Nicolas Hélion and Sandro Rumney. Sandro and his wife, Laurence Tacou-Rumney, herself a biographer of Peggy, have been especially helpful.

In Canada I have to thank Peggy's nephew, Professor John King-Farlow and his wife, Elizabeth; in France, William Chattaway and Deborah Chattaway (*née* Garman), the late Fabrice Hélion's former wife, Cathérine Gary, Jacqueline Ventadour-Hélion, James Lord, Ralph Rumney, and Kathe Vail; in Germany, Birgit Brandau and Hartmut Schickert, Christiane Koch, Wolfgang Koch, and Kunigunda Messerschmitt; in Greece, Alan Ansen; in Holland, Nelly van Doesburg's niece, Dr. Wies van Moorsel, whose new biography of her aunt is just out; in Italy, Paolo Barozzi, Vittorio Carrain (and for his hospitality), Domingo de la Cueva, Joan Fitzgerald (and for her hospitality), Dr. Milton Gendel, Ziva Kraus, Mr. Peter and Lady Rose Lauritzen (and for their hospitality), Patricia Curtis Vigano and Carlo Vigano; in the United Kingdom, Diana Athill, Caroline and Peter Cannon-Brookes, Maurice Cardiff (and for his hospitality), Michael Combe Martin (and for generously lending me important documents), Polly Devlin (Garnett) (and for giving me important documents), Lord Gowrie, P.C., Professor Sir John Hale, Lady (Sheila) Hale, Walter Hayley, Derek Hill, Dr. Adrian Hodge, John Hohnsbeen, Amelia Kaye, Julie Lawson, James Mayor, George Melly, Antony Penrose (with additional thanks for allowing me access to private papers and for granting me permission to use material from his then unpub-

lished biography of his father, Sir Roland Penrose), Piers Paul Read, Sir Norman Reid, Ruth Olitzky Rubinstein, Lisa M. Rüll, Malise Ruthven, the Earl Castle Stewart, Simon Stuart, Anthony Vivis, and Rebecca Wallersteiner; in the United States, Virginia Admiral, Rosamond Bernier, and John Russell (and for their hospitality), Louise Bourgeois, Peter Capriotti, and George Stilo, Siobhán Conaty, Charles Henri Ford (with additional thanks for giving me valuable documentary material), Lisa Jacobs, Buffie Johnson, Lillian Kiesler, Professor Melvin P. Lader, Dr. Thomas M. Messer (with additional thanks for giving me valuable documentary material), Werner, Gina, and Andrew Messerschmitt, David and Marion Porter (and for their hospitality), Paul and Blair Resika, Ned Rorem (and for giving me valuable source material), Peter and Suzanne Ruta (and for their hospitality), Lawrence B. Salander, Charles and Lenore Seliger (with additional thanks not only for their hospitality but for giving me access to private papers and archive material), and Roger W. Straus Jr.

Among the many others who have helped I must also acknowledge with gratitude Sofia Akbar, Deborah Blackman, Daniel Campi, Matthew Campi, Kathryn Carr, Doris Cramer, Nicci Crowther Gooden, Juliet Davis, Keith and Marjorie Dawson, Mary Donat, Chris and Gloria Early, Peter Ewence, Anne Marlow Gaskin, Derrick Greaves, Celia Hayley, Frances Hegarty, Dale Hodges, Teresa Hunt, Maggie Hyland, Rui Lopes, Ian McKinnell (for help with an impenetrable new computer), Dennis Marks, Mia Mouland, Patsy Murray, Cresta Norris, Pradip Patel, MPS, Chris Peachment, Marian Reid, Professor John Richardson, Jane Rylands (and for her hospitality), Professor Virginia Spate, Barbara Stewart, Dr. Thomas Stuttaford, Michael Sweeney, David Sylvester, Lucy Vanderbilt, Susan Walby, Guido Waldman, and Peter and Sophia Wickham. Last but not least, I thank Marji Campi for her patience and support throughout this project, for accompanying me on some of the field trips, and for reading, correcting, and helping improve the manuscript.

For the American edition, which contains important corrections and revisions, I have greatly to thank my editor in New York, Alison Callahan, and my American copy editor, Sue Llewellyn.

The present book has taken several years of work, and, in common with all writers of similar works, I have had to contend with the usual limitations of time, space, and money. What appears in these pages represents a percentage of the total research material acquired, which will now be collated and

stored as part of the archive at the Peggy Guggenheim Collection, Venice, for the benefit of future students. Every step of the way I have relied on the cooperation of a number of institutions, organizations, and their staffs, among which I must thank the following: the Archives of American Art, Washington, D.C., and New York (Judy Throm, Valerie Komor, and Nancy Molloy); the Australian Society of Authors (Stella Collier); the Australian Writers' Guild; Baiersdorf Town Council; Djuna Barnes Archive, University of Maryland; Roloff Beny Archive (National Archives of Canada); the Bibliothèque Nationale, Paris; Biennale Administration, Venice; the Robert Brady Foundation, Mexico; the British Library, London; the British Library Newspaper and Periodical Library, Colindale; the Central Intelligence Agency; the Emily Holmes Coleman Archive, University of Delaware (L. Rebecca Johnson Melvin); the Communist Party of Great Britain (Siân Price); the Federal Bureau of Investigation (John M. Kelson); Varian Fry Archive, Columbia University (Bernard R. Crystal); the Peggy Guggenheim Collection, Venice (Claudia Rech, Chiara Barbieri); the Solomon R. Guggenheim Foundation; the Solomon R. Guggenheim Foundation Archive (Ilene Magaras); the Solomon R. Guggenheim Museum, New York City; the Kennel Club of Great Britain; the Kiesler Archive, Vienna; Lengnau Town Council; the London Library; the Mayor Gallery, London; the Lee Miller Archive; the Museum of Modern Art, New York, Archive and Library (Michelle Elligott, Erin Grace); the National Gallery of Modern Art, Washington, D.C., the New York Historical Association; the New York Public Library (David Smith); the Musée Picasso, Paris; the Pollock-Krasner House; the Herbert Read Archive, University of Victoria, Canada; the Hilla von Rebay Foundation; John Sandoe (Books) Ltd., London (for the hunting down of rare and other books with an efficiency beyond expectation); Peter Schamoni Filmproduktion; the Scottish National Gallery of Modern Art, Library and Archive (Anne Simpson); the J. and W. Seligman Archive; Tate Britain; the Tate Gallery Archive and Library (Jennifer Booth, Maggie Hills); Tate Modern; the United States Embassy, London (Reference Section); University Microfilms International; the Victoria and Albert Museum National Art Library; Westminster Art Reference Library; the Whitney Museum; the Wiener Library and Institute of Contemporary History, London (with special thanks to Rosemarie Nief)—and finally, to the John Jameson Bow Street Distillery in Dublin, for providing the fuel that got me through all this.

index